Walter Gropius

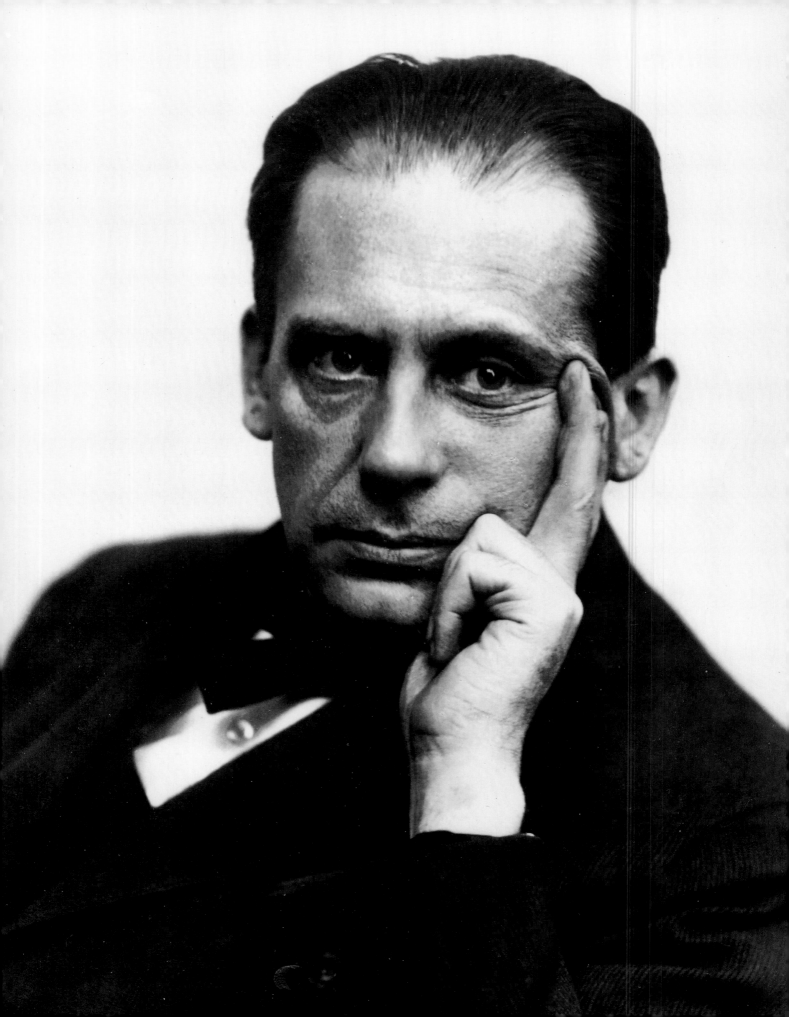

BY REGINALD ISAACS

GROPIUS

AN ILLUSTRATED BIOGRAPHY OF
THE CREATOR OF THE BAUHAUS

A Bulfinch Press Book
Little, Brown, and Company
Boston • Toronto • London

First English-language edition.

This book is an abridgement of the original, English-language manuscript. The complete text was published in German translation as *Walter Gropius: Der Mensch und sein Werk,* Volumes I and II in 1983 and 1984 by Gebr. Mann Verlag GmbH & Co. KG, Berlin.

Isaacs, Reginald R., 1911- 1986
 Gropius : an illustrated biography of the creator of the Bauhaus / by
 Reginald Isaacs. — 1st ed.
 p. cm.
 "A Bulfinch Press book."
 ISBN 0-8212-1753-4
 1. Gropius, Walter, 1883-1969. 2. Architects — Germany
 — Biography.
 I. Title.
 NA1088.G85I79 1991
 720' .92 — dc20
 [B] 90-13481

Designed by DeFrancis Studio, edited by Betty Childs and Debra Edelstein

Quotations from the letters of Walter Gropius are published with the kind permission of the Estate of Walter Gropius.

Bulfinch Press is an imprint and trademark of Little, Brown and Company (Inc.)

Published simultaneously in Canada by Little, Brown & Company (Canada) Limited

Frontispiece: Walter Gropius as director of the Weimar Bauhaus, circa 1921

Printed in the United States of America

To two patient wives:
Ise Frank Gropius and Charlotte Aldes Isaacs

In 1986, at the time of Reginald Isaacs's death, my brother, sister, and I reread my father's preface and found it ironic that he was saddened by the fact that Gropius had died before having the opportunity to see this book in its ultimate edition. We also are sad that Reginald Isaacs was unable to see his own life's work come to fruition in this English-language edition that was his continuing preoccupation and goal for so many years. Rewriting, re-researching, adapting this book were Reg Isaacs's constant labor in his last years. His life was truly centered in this project.

We would like to extend the dedication of this edition to Reginald Isaacs's tenacity in his vision of excellence.

I know that with the help of editors Gerard Van der Leun and Betty Childs and designer Lisa DeFrancis, we have done our best to carry this work forward to as broad an audience as possible.

Henry Isaacs
Norwich, Vermont
November 1990

CONTENTS

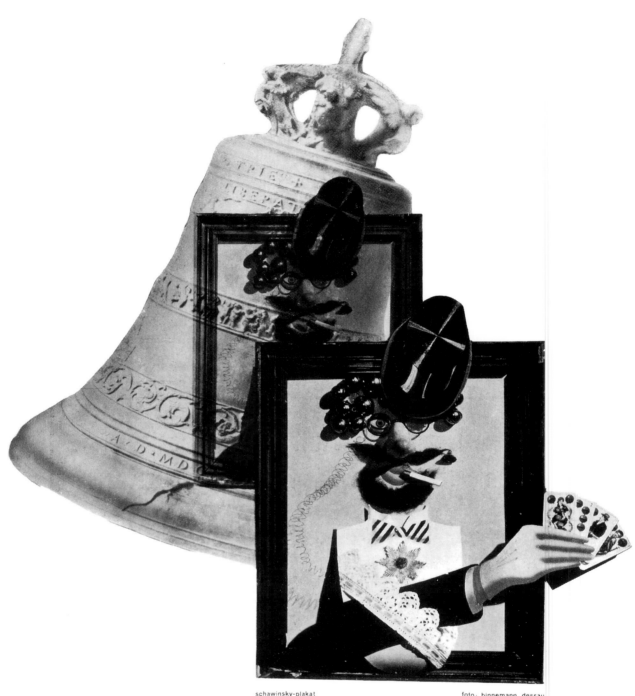

schawinsky-plakat foto: binnemann, dessau

am 9. februar 1929 fasching im bauhaus
metallisches fest
glocken - klingel - und schellenfest

FOREWORD

by Walter Gropius

Throughout my life I searched for a comprehensive method of forming our physical environment and society. My concern for context, for the relatedness of all parts, drew me naturally into the field of urban and regional planning. My interest in this field was expressed early as a logical extension of my own approach to architecture in theory as well as practice. The subsequent growth of this interest was stimulated through association with many who were involved directly with larger societal concerns and responsibilities. As spectator and participant I have witnessed several epochs of urban area growth, crisis, deterioration, and regrowth. I have seen the increasingly rapid spread of urbanization across regions and nations, accompanied by the destruction of their traditional social patterns and aesthetic assets.

Poster by Xanti Schawinsky for Bauhaus Metallic Festival, 1929

Thus it is that Reginald Isaacs attributed the shaping of my character, attitudes, and principles to a continuum of historical events and a succession of environments, very different as to their peoples, cultures, social institutions, and influences. In this book, he has interwoven my life with my work in a total environmental context.

Today, when the problems of the world and its urban area have become ever more complex, Isaacs records my view that not only have the number and variety of the opportunities and legal, scientific, and economic instruments for solving these problems grown, but our powers of intuition and judgment can still be greatly increased.

Though he looks back a century and a quarter for a beginning point for his work, he goes on to deal extensively with my contemporaries, his own, and the following generation. His writing is directed to our children and grandchildren, who did not know these periods. He also includes my views of the future, for which I claim no special insight, but rather offer some form of synthesis.

Though I am surprised by the sheer magnitude of this book, I cannot be other than pleased with this total examination of my concerns. In itself conceived and carried out most comprehensively, its development epitomizes the belief in an idea and consistency of application which I prize.

Lincoln, Massachusetts
August 1968

a.

b.

c.

d.

e.

f.

g.

h.

Pappenheimstr.

Eing

Tannenkuppenstr.

N

10 0 10 20 30m

EDITOR'S NOTE

This book represents both Reginald Isaacs's major life's work and a long collaboration between Isaacs and Gropius. While alterations and additions were made after the architect's death, Gropius did have the opportunity to read early drafts of the text.

The completed manuscript of the book ran to well over a million words and as a consequence was extremely difficult for American publishers to issue. A German translation of this entire manuscript, together with illustrations, was published as *Walter Gropius: Der Mensch und sein Werk* (Berlin: Gebr. Mann Verlag, 1983–84). This edition ran to two volumes and nearly 1,300 pages.

Plans for Aschrott Home for the Aged, Kassel, competition 1929

Professor Isaacs continued to search for a publisher for the English edition until his death in 1986, but such efforts always foundered on the questions of length and economic considerations. Following the death of Professor Isaacs, the family retained this editor to cut the manuscript to an acceptable length and secure a publisher for it. I am pleased to be able to say that, through the visionary enthusiasm of Betty Childs of Bulfinch Press, this has now been achieved.

Throughout the year and a half it has taken to edit this biography, I have been at pains to leave Isaacs's intent and structure intact at all points. In large measure I have only reduced certain redundant passages and eliminated those that were clearly asides or departed from the main themes of Walter Gropius's life and work. However, this edition is meant for a somewhat broader audience than that of the unabridged version, and a very few passages (clearly marked) have been added where they seemed essential to the reader's understanding. Otherwise, aside from certain phrases and sentences inserted for the sake of clarity and a smooth transition from one event to the next, I have added nothing that was not contained elsewhere within the manuscript or the notes. There were many moments when I regretted not having either Isaacs or Gropius at hand to question, but I have done the best I could with the skills and resources I possess. Any flaws and omissions must of course be laid at my door. Scholars who desire to see the entire manuscript without changes or alterations are referred to the German edition. For the rest, it is my hope that this version of Isaacs's *Walter Gropius* will bring to a wide audience the life and the work of one of the most protean figures of art and architecture in the twentieth century.

Gerard Van der Leun

Southport, Connecticut February 1989

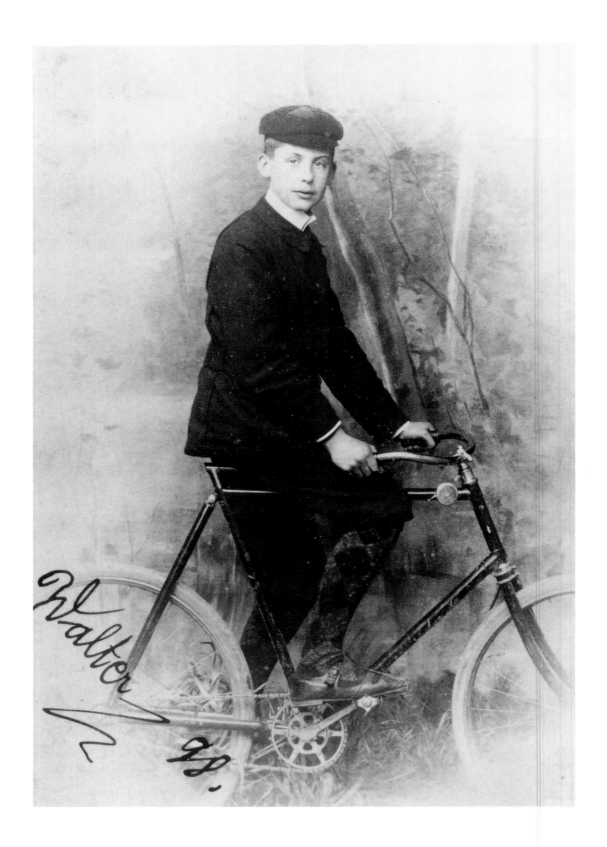

PREFACE

From the very outset of work on this book, Walter Gropius became involved in the search into his own history. It became the occasion for much retrospection on his part, as suggested by a letter he wrote to his sister in 1963:

> Recently I have thought a great deal backwards — symptoms of an aging man — and I wish I could sit together with you and reconstruct times of the past. Somebody is writing a book about me and pokes into Ise and me for facts and dates. What seemed up to now unimportant to me, suddenly is made to seem important. And I admit that I begin to get interested to find out why I became who I am.[1]

This, however, was not the first effort to engage Gropius in a book about his life, ideas, and work. Some fifteen years earlier I had proposed to the Museum of Modern Art that it sponsor a truly comprehensive book by Gropius himself. In 1951 Herbert Bayer also attempted to persuade him to write an autobiography — and nearly succeeded. At the time Gropius wrote to him:

> I could show what I have been after by arranging my work in the way I see it myself. Critical appraisal of the work can then be done by others, if they see fit, before or after my death. In addition to the visible work, I will also try to put together the best of my articles and lectures, etc., and make another volume out of that.
>
> As to personalities writing a book on my work, I wonder whether it should be done by somebody who has had no direct insight into the Bauhaus movement and the whole exterior conditions and situations in which this work grew up. Maybe I am wrong, but for the time being I hope you will understand me since so far nobody else stepped in to write such a book that I want to publish my material first myself.[2]

There was further correspondence with Bayer as to possible biographers, but Gropius finally "decided to write it myself":

> I quite agree with you that a third person writing about oneself can never create the atmosphere oneself is living in. It was a curious experience for me to feel so much detached and objective towards Argan's book [about me] when I read it as though it was written on somebody else.[3]

Though at least two publishers invited Gropius to write an autobiography, he did not accept because his architectural practice had expanded. Subsequently, Sigfried Giedion hastily wrote a slim biography,[4] almost as a prerequisite for the Matarazzo Prize of the São Paulo Biennale, and Gropius's own collection of essays, *The Scope of Total Architecture,* was published.[5] Gropius then dismissed from his mind any further idea of an autobiography. Later he explained his reluctance:

As some publishers have already found out to their annoyance, I am a very poor prospect in this respect for, to this day, I have been unable to recapitulate and reassess my own life in a biography, mainly because I was too busy living it. I also have my doubts whether anybody looking back on his own history can truly relate the impact of events on his mind or, conversely, the impact his mind had on events. After all, he has reached another phase of life, he lives in a changed emotional climate, and his present vision is conditioned by new experiences, new horizons.[6]

Prodded by these remarks and encouraged by colleagues and by Gropius himself, I undertook the task in 1962. I believed that I had sufficient knowledge of Walter Gropius to convey an accurate understanding of his life, work, and ideas. Further, I could count on his collaboration, insight, and encouragement — all vital to such an undertaking.

Gropius and I held almost weekly discussions over a period of nearly seven years. My role was not that of a Boswell; Gropius would never have permitted this. Nor were these meetings inquisitorial; rather, they were reflective — evaluating the past hundred years, the uneasy present, and, to him, a hopeful future. The years produced almost unlimited resource materials of extraordinary richness. It was a formidable task to select those which would present a full understanding of Gropius in the context of the history and the environments — physical, intellectual, socioeconomic, political, and psychological — to which he himself related his life, work, and ideas.

Gropius's career continued until his death, still premature at the age of 86, on July 5, 1969. This book could hardly have been completed without the collaboration of Ise Gropius [who died in 1983]. Her dedication to the dissemination and understanding of her husband's principles began with their earliest association: "When I joined the Bauhaus in 1923, I found a knight in armour." Her translation of Gropius's letters provided previously unpublished biographical information, and her orderly organization of the Gropius archive gave depth to the book.

No less meticulous in his care of family genealogical documents is Gropius's cousin, Dr. Klaus Karbe of Bad Godesburg; his assistance to the author was authoritative and unstinting.

Frau Anna Mahler, Dr. Reiner Hildebrandt, and Dr. Joachim Benemann graciously consented to the use of their respective mothers' correspondence with Gropius.

There were no walls between the two Germanys as far as their hospitality and unstinting aid to me were concerned. Past consuls general of the German Federal Republic in Boston, Philip Schmidt-Schlegel and Edgar von Schmidt-Pauli, were most helpful in providing both introductions and advice for my research there. Inter Nationes enabled me to meet with officials and others throughout the German Federal Republic. The courtesies extended to me by Dr. Hans Hopp, President of the Bund Deutscher Architekten, and by Mr. and Mrs. Walter Mickin of its Secretariat during my visits to the German Democratic Republic grew into friendship. I must also mention Dr. Christian Schadlich of the Hochschule für Architektur und Bauwesen in Weimar, and Dr. Karl-Heinz Hüter, an architectural historian of the Deutsche Akademie der Wissenschaften in East Berlin. In the search for Gropius's earliest work in Pomerania and Posen, I was assisted by Dr. and Mrs. Andrzej Poczatek of Drawsko Pomorskie (formerly Dramberg), who spent days with me in this effort and alone rediscovered the still-standing early workers' housing and granary by Gropius in Janikow.

I acknowledge the assistance of the libraries of Harvard University, the Massachusetts Institute of Technology, and The Architects Collaborative of Cambridge, Massachusetts. I must mention also the libraries of the Royal Institute of British Architects, Kunstakademie in Stuttgart, Technische Universitat in Berlin, Technische Hochschule in Munich, University of Frankfurt am Main, as well as the Landesarchiv and Bibliotheken in Dessau and Weimar.

I knew to a varying extent many of the Bauhaus masters, among them Josef Albers, Herbert Bayer, Max Bill, Marcel Breuer (who was also my teacher), Ludwig Hilberseimer, Johannes Itten, Gerhard Marcks, Ludwig Mies van der Rohe, László Moholy-Nagy, Mart Stam, Lothar Schreyer, and Georg Muche. As student and colleague I have known most of the teachers who served with Gropius at Harvard and have collaborated with several of his post-Harvard associates. Another of my teachers introduced me to the works of Tonnies, Weber, and Simmel, thus providing clues to the shaping of Gropius's principles.

It would have been difficult to present a full view of Gropius in England without the memories of E. Maxwell Fry and Jack C. Pritchard. It would have been equally difficult to understand the Bauhaus and its time without the advice of Dr. Hans Maria Wingler, director of the Bauhaus-Archiv, who made available its resources. The cooperation of Dr. Peter Hahn and Dr. Christian Wolsdorff of the Archiv was essential to the completion of the book.

I am both appreciative and proud of the contribution to this book made by members of my family. My wife, Charlotte Aldes Isaacs, performed endless authorial tasks over all the years of preparation. Our sons, Mark and Henry, traveled through England, East and West Germany, and elsewhere to photograph the work of Gropius, whose friendship they knew and prized; they also interviewed his friends and former associates in England. Our daughter-in-law, Lisa DeFrancis, selected illustrations and gave new life to archival photographs and drawings. Our daughter, Dr. Merry Isaacs White, edited the extensive account of the Gropius visit to Japan and the many references to this memorable and influential experience.

My colleague François Claude Vigier discussed the work throughout its development, gave constant encouragement, and made careful translations from the French.

The Frank Backus Williams bequest to Harvard's Department of City and Regional Planning enabled the employment of Japanese, Italian, Greek, and German translators during the initial years of research. The Graham Foundation for Advanced Studies in the Fine Arts provided financial assistance that enabled me to interview former Bauhaus students and masters in Europe. This grant, as well as that of Inter Nationes, made possible my visits to several English cities, some thirty in East and West Germany, and those in what is now Poland where Gropius studied, taught, or worked.

In the end, it is to Walter Gropius that my affection and appreciation are directed — to him as a person as much as for his contributions to society, education, and the professions. I am thankful that he reviewed early drafts and wrote the Foreword. I am saddened he did not live to see the book's publication and blame myself for procrastination, believing as I did that he would have an even longer life. I acknowledge in the preparation of this book a debt to him unpaid these forty-five years.

Reginald R. Isaacs

Cambridge, Massachusetts March 1982

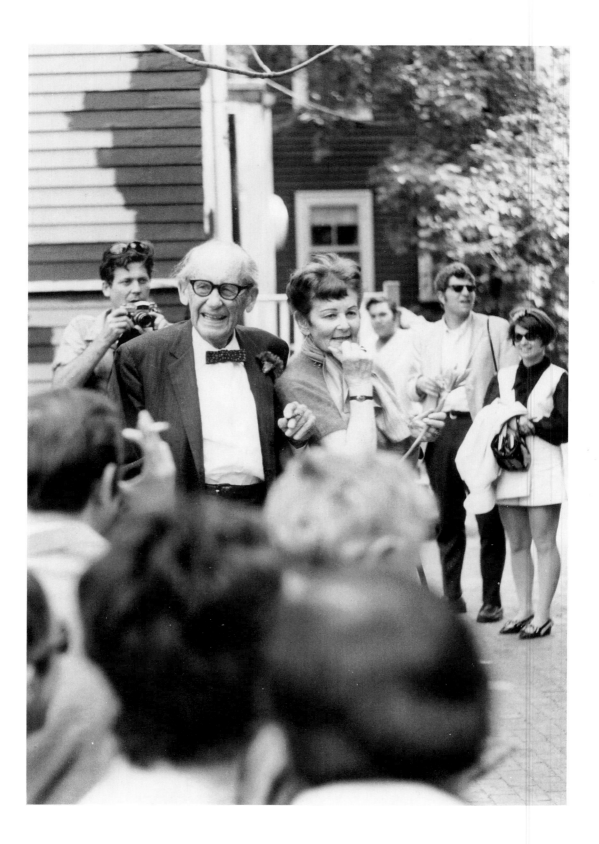

PROLOGUE

In 1933 the present and future prospects of Germany were deeply depressing to Walter Gropius. The Bauhaus, now directed by Ludwig Mies van der Rohe, was constantly harassed. Under the Nazis there was little prospect of work for Gropius's architectural office. His marriage had also been disrupted. Gropius was nearly fifty but felt, that spring, much older. Despondent, and with some foreboding about his future, Gropius drafted his will. In part it stated:

> It would be beautiful if all my friends of the present and of the past would get together in a little while for a fiesta — à la Bauhaus — drinking, laughing, loving. Then I shall surely join in, more than in life. It is more fruitful than the graveyard oratory.[1]

Gropius at his eighty-sixth-birthday celebration, Cambridge, May 18, 1969

Thirty-seven years later — and a year after his death — Gropius's partners and other friends carried out this wish. Days of gray New England coastal fog had dampened spirits, and by the evening of Monday, May 18, 1970 (which would have been Gropius's eighty-seventh birthday), gusty rain had emptied Harvard Square and Common of hippies and street people, and Harvard Yard of groups talking of the killings at Kent State. Yet there had been a mounting and pervasive sense of excitement in the community; at MIT and Harvard the annual "Fest" for Gropius had not diminished in its attraction.

By mid-evening it was obvious to the sponsors of the party, The Architects Collaborative, that the five hundred invited to attend the "Metallisches Fest" at the TAC building had grown to more than three times that number. Admission was open to anyone wearing a metallic ornament, device, or costume, simple or lavish, "à la Bauhaus." The crush of guests spread to the strobe-lit basement "Laughing Gallery" and by stair and elevator through three floors of electronic, jazz, and other music, dance and decoration, contemporary theater, strawberries and champagne. Passage opened only for a thirty-foot-long metal-clad dragon edging through the milling crowd.

In the midst of film clips of Gropius's life and the sound of his voice, while raising wine glasses and greeting his widow, Ise, his family and close friends, there was still time for moments of quiet appreciation for the great architect. The spontaneity of the evening's entertainment and the exuberance of the crowd made for the kind of party that would have transformed Gropius. For while shy and uncomfortable at the usual cocktail party, he could enjoy the unique exuberance of the Bauhaus parties and of his annual birthday celebrations and, as Ise said, could

"be fully there, grasping wholly what was happening and enjoying with friends the moment."

Who was Walter Gropius that his charisma would project beyond his long life to draw together an eager, expectant crowd of some two thousand to celebrate his birthday? What were his ideas and his activities that they could attract not only associates, artists, designers, alumni, students, and faculties of German and American universities, but also politicians, clients, bankers, building contractors, and merchants? A thousand letters, telegrams, newspaper articles, and radio and television notices during the year after his death only emphasized the great diversity of his public.

Gropius's personality and character, attitudes, philosophy, and actions have often been described. He has been called the architectural and planning heir to Schinkel and Semper, an interpreter of the Chicago School, and, erroneously, the founder of the International Style. He is known as a Goethian philosopher and intellectual socialist rather than as a Utopian one, an innovator in education, a student of Zen, an exponent of team collaboration in the professions and group activity in society, a synthesizer and prophet of change.

Yet Gropius was not one of these to the exclusion of any other. A desire to integrate all aspects of life with the environment informed his response to any question and was part of an almost automatic synthesis. Such an approach could only have been the distillate of a richly textured, multicolored tapestry of history. It is this tapestry of society and environment which is spread here and in which Gropius — architect, teacher, humanist, and philosopher — is a golden thread, affected by the whole and in turn contributing to its richness.

THE GROPIUS FAMILY

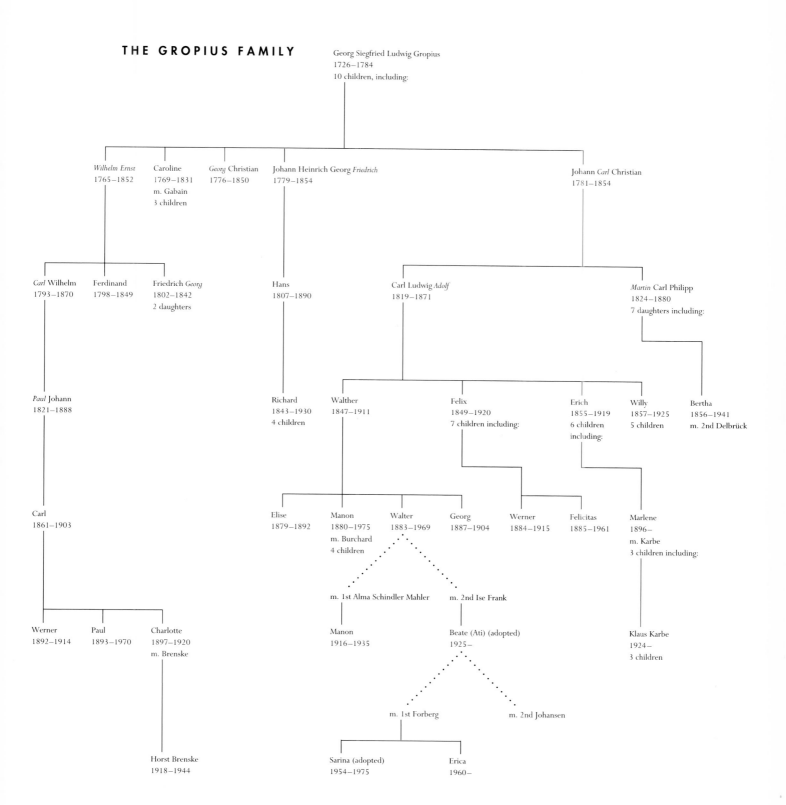

Georg Siegfried Ludwig Gropius
1726–1784
10 children, including:

Wilhelm Ernst
1765–1852

Caroline
1769–1831
m. Gabain
3 children

Georg Christian
1776–1850

Johann Heinrich Georg Friedrich
1779–1854

Johann Carl Christian
1781–1854

Carl Wilhelm
1793–1870

Ferdinand
1798–1849

Friedrich Georg
1802–1842
2 daughters

Hans
1807–1890

Carl Ludwig Adolf
1819–1871

Martin Carl Philipp
1824–1880
7 daughters including:

Paul Johann
1821–1888

Richard
1843–1930
4 children

Walther
1847–1911

Felix
1849–1920
7 children including:

Erich
1855–1919
6 children
including:

Willy
1857–1925
5 children

Bertha
1856–1941
m. 2nd Delbrück

Carl
1861–1903

Elise
1879–1892

Manon
1880–1975
m. Burchard
4 children

Walter
1883–1969

Georg
1887–1904

Werner
1884–1915

Felicitas
1885–1961

Marlene
1896–
m. Karbe
3 children including:

m. 1st Alma Schindler Mahler

m. 2nd Ise Frank

Werner
1892–1914

Paul
1893–1970

Charlotte
1897–1920
m. Brenske

Manon
1916–1935

Beate (Ati) (adopted)
1925–

Klaus Karbe
1924–
3 children

m. 1st Forberg

m. 2nd Johansen

Horst Brenske
1918–1944

Sarina (adopted)
1954–1975

Erica
1960–

GROPIUS

AN ILLUSTRATED BIOGRAPHY OF
THE CREATOR OF THE BAUHAUS

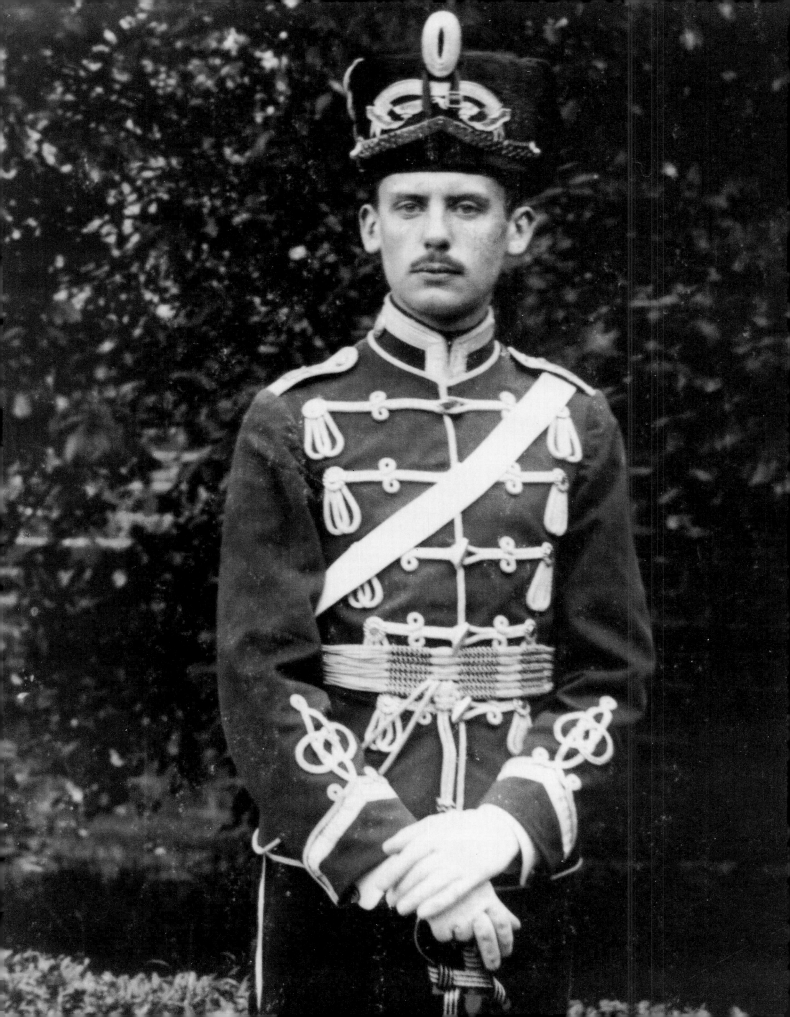

THE FORGE 1883–1907

The shattered village on the Soissons-Rheims line, so tenuously held by German forces, had no strategic value following the Allied counterattack in late June 1918. The summer heat was stifling, the air thick with clouds of choking dust raised by the bombardment. The air still reverberated with distant waves of cannonade, laced with the acrid taste of explosives and the stench of corpses of horses and men. A chance shell had fallen directly upon the *mairie,* whose stone walls and oak beams thought to provide invulnerability for the German regimental post only assured entombment and death for its staff.

The miracle of his own survival was lost upon Lieutenant Walter Gropius, who only days before was brevetted to this command. With the pain of his wounds and concussion mercifully eased by hours of semiconsciousness, he lay oblivious to his fate, immobilized by the rubble of stone and broken timbers and the corpses of his comrades, his life supported by soot-flecked air passing through a chimney which, though toppled, still rose above the carnage. Thus imprisoned, he passed two days and nights in pain and fear-racked thought and dreams.

The Gropius Heritage: Years later Gropius said that in those desperate hours he envisioned not only his own life, but that of his family and its soldiers: his father, a veteran who had never spoken of his role in the Franco-Prussian War; Uncle Felix who bragged of his own participation and now, near seventy, had served four years in World War I; most of all, his cousin Richard, who had been in the military from 1863 and at seventy-five still served his country. His records listing battles, ranks, and decorations kept alive the military achievements of every generation.

Richard was also the family historian and traced its genealogy back to the sixteenth century. Parish registries in the Gropius ancestral towns of Halberstadt and Helmstedt in Braunschweig record members of the family not only as soldiers, but also as attorney general, dye master, master cook, schoolteachers, and churchmen.[1]

The great-great-grandfather of Walter Gropius, Georg Siegfried Ludwig Gropius, was a parson in Helmstedt, a scholar, and the father of ten children. Perhaps more than any other forebear he represented the beginning of the solidly bourgeois Gropius family, which was to be replete with civil officials, merchants, and painters, though its members were predominantly churchmen, architects, and teachers; a few became landowners. (See genealogy, page xix.)

Walter as a cadet in the 15th Hussar Regiment, Wandsbeck, 1904

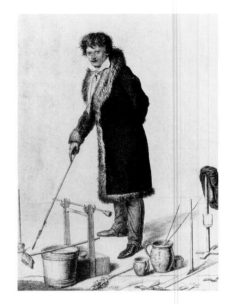

Carl Wilhelm
Gropius, proprietor
of the Gropius
diorama, circa
1840, sketch by
Ludwig Buchhorn

The artistic and architectural tradition in the Gropius family can be traced back to his great-grandfather, Johann Carl Christian Gropius, and his brothers, Wilhelm Ernst and Georg Christian. Carl, a soldier in the Napoleonic wars, became his brother-in-law's partner in a silk-weaving works in Berlin. Wilhelm Ernst became proprietor of a theatrical mask factory early in the nineteenth century. He also acquired a theater containing a landscape backdrop, which he animated and made appear three-dimensional by means of changing lights and moving sculptural figures, accompanied by music and oral description. Georg, who went to Greece as a general consul, achieved recognition for his archaeological explorations and restorations; he was a founder of the Greek Archaeological Society, which preceded official German efforts by some fifty years.[2]

Both Carl and Wilhelm Ernst were friends of the great Prussian architect Karl Friedrich Schinkel. Schinkel was a frequent visitor at the Gropius family home in Berlin, at 22 Breitestrasse, close by the silk works. There he taught Wilhelm Ernst's eldest son, Carl Wilhelm, to draw and paint, talents he employed for his father's animated figure stage. Still relatively unknown, Schinkel painted and designed to augment his income from a struggling architectural practice. The Gropiuses commissioned him to create a theater proscenium and curtains and displayed Schinkel's paintings in their theater's Christmas exhibitions from 1807 to 1815.

Wilhelm Ernst's sons continued their father's work on the displays. Inspired by Bouton's and Daguerre's diorama in Paris in 1822, and guided by sketches prepared by Schinkel, who visited Paris in 1826, they created their own diorama.[3] There, in the semidarkness, the audience could see in sequence three gigantic scenic paintings, more than sixty feet wide and forty feet high, cleverly lighted and accompanied at certain hours by four-part choral music. There were several showings each day, some attended by as many as three thousand visitors. This became a major attraction in Berlin, particularly during the Christmas holiday season. Schinkel's role was known, and through public acclaim and royal recognition his career was assured.

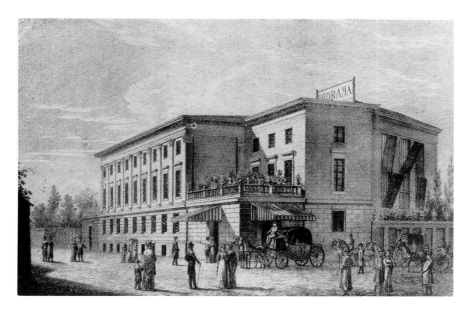

The Gropius
diorama, Berlin

The Gropius diorama continued until 1850, when, at the czar's request, the paintings were sent to Saint Petersburg. The exhibit's most profitable years were past. Other imitative processes were attracting the public.[4]

Even more than Wilhelm Ernst's sons, Carl's son Martin Carl Philipp reflects the tremendous influence that Schinkel had upon the Gropius family. Martin was only seventeen when Schinkel died, but he became a student of Schinkel's disciple Botticher. Like his master, Botticher believed that the form of architecture was interdependent with its purpose, materials, and methods of construction. Subsequently Martin Gropius became prominent in education and cultural activities and was an internationally famous architect.

He was an inspiring model for his nephew, the architect Walther Gropius, Walter's father, who was in this way attracted to the work and ideas of Schinkel. His father's personality inhibited his achievement, according to Gropius, who described him as "a rather withdrawn and timid man without sufficient self-reliance, so therefore he never penetrated to the first rank." In fact, he "designed and built some buildings only in the first part of his career before he became a municipal employee."[5]

Manon Scharnweber, Gropius's mother, was a descendant of French Huguenot emigrés, some twenty thousand of whom had sought religious asylum in Prussia at the end of the seventeenth century. Traditionally, the Huguenots provided a link between German liberalism and the intellectual trends of the French Revolution, which emphasized freedom, equality, and the philosophy of enlightenment. Manon Scharnweber's father, Karl August George, was a district councilor in Barnim (Berlin). Another ancestor was one Daniel Baudesson, goldsmith at the court of Frederick the Great.

The Gropius family was a liberal one, maintaining conservative attitudes with respect to socialist activities but opposing the rightist movements of the day. Long established in Mark Brandenburg

and Berlin, Walter's parents and theirs before them had been exposed to the freedoms and intellectual life of Germany's foremost city. The family and its friends did not maintain the accepted views of the upper-class Prussian society of which they were a part; thus, the initial shaping of Walter's attitudes took place within a privileged but humanistic environment. He later recognized the importance of this liberal background; in a letter to his sister, Manon Burchard, he reflected:

> In thinking about the tradition of our family and its moral temperature in comparison to the more conservative uncles, our parents came off well in their liberal breadth and in their indestructible kindness and tolerance. ...It seems to me that just these liberal families like Max's [Burchard, his brother-in-law] were equipped in the most flexible way to absorb the immense revolutions of our time and to make them positive in a human way. ...I personally feel very clearly that my liberal inheritance has given me a cosmopolitan attitude and breadth of thinking. We owe this particularly to our Mother who was unusually capable in adapting quickly to changed conditions.[6]

Despite their liberal Republican politics, according to Manon, their parents had bourgeois minds, which inevitably led to opposition from young Walter.

Although it was the Gropius artistic-architectural heritage that had most affected Walter in his early years, as he lay buried in the rubble of war, he reflected on the family's military tradition and the discipline that had brought him near death in the wasted French village.

The Formative Years: Walter was the third child and first son of Walther and Manon Scharnweber Gropius and was born in Berlin on May 18, 1883, in the family home at Genthinerstrasse 23 in the vicinity of the Tiergarten, not far from the site of the family silk mill. On June 20 he was christened Adolf Georg Walter Gropius in a ceremony at the Gothic style Friedrichswerdersche Kirche. Though the family did not ordinarily attend this church, Walther had selected it because of his lifelong admiration for its architect, Schinkel, who lay buried in its cemetery.[7] At age thirty-three Walther Gropius was a state building official and hoped that his son would follow his path as an architect in the image of Schinkel.

Walter's earliest years, relatively uneventful, were spent in an overly protective home that shielded him from the vicissitudes and discoveries of childhood. Prior to his school years, he received simple instruction from his mother and older sister. Then, like any child of an upper-class German family in the 1890s, he was educated from age six to ten in a private elementary school in Berlin. These years were followed by nine more in the Humanistische Gymnasium, schools that stressed Latin and Greek.[8]

The gymnasiums, originally a private effort, had become publicly sponsored and were part of the larger educational system of the city. The first that Walter attended, from 1893 to 1895, was the Leibniz Gymnasium in an area then called East Berlin. Built in 1875, its design was in advance of the pompous classicism of other contemporary schools of the Grunderzeit. Well located in an upper-class residential district and constructed in a warm, light-colored brick, the school and its environs must have appeared friendly and welcoming to the boy — a most auspicious beginning for his rigorous studies. Yet it was in this gymnasium that he drew the attention of a cruel and unsympathetic teacher, who singled him out to be disciplined publicly, not for mischief, but for his unusual quiet, for his inability to respond quickly, and for raising questions considered "inappropriate."

Walter's second gymnasium was the Kaiserin Augusta in Berlin-Charlottenburg, which he attended from 1895 to 1900. This was a cheerless, classic building, forbidding in its approach, crowding the sidewalk and street. To a boy of twelve years it must have appeared as overpowering and demanding as the studies within.

Subsequently, Walter attended the gymnasium in Steglitz. It was a structure of nondescript design, having none of the strengths or weaknesses of the buildings in which the boy had studied previously. If Walter found the first of these visually friendly and the second cheerless, this building could have aroused little emotional response. He remained there for three years.

Shortly before he was to take his final tests — he was now nearly twenty — his doting grandmother, Luise Honig Gropius, wrote to her son:

> Did I tell you of the beastly bad luck which befell our poor Walty? He has been in bed since January 26 with severe influenza while he was to have had his written examination on the 31st and going on into the next week. …Got up on Sunday for a few hours, but was very weak. I visited him in the afternoon and found him brooding and gloomy. My God, how well I sympathize with him! He is liked by the director and his teachers, but will they be permitted to examine him later? He will be very weak since he eats so little, has a very sore mouth and throat. Oh, my poor Walty![9]

Walter recovered and took his examinations. The Latin and Greek requirements bore fruit, and Walter's crowning achievement was a major translation of Sappho's "Ode." With great joy, grandmother Luise was able to write:

> I am particularly thankful today because just now my beloved Walty was here, clad for the first time in a great topcoat instead of his informal jacket and coming from his examination, which he passed very well. He was terribly happy, the young student! Director and examining teachers had been extremely gracious, full of sympathy because of his having had such bad luck for reason of illness. He has been received most cordially by his father, who took him immediately to Kempinski's, fed him beautifully, and toasted him with champagne.[10]

Walter, as a boy and youth, followed a solitary course, preoccupied with his studies and lost in his

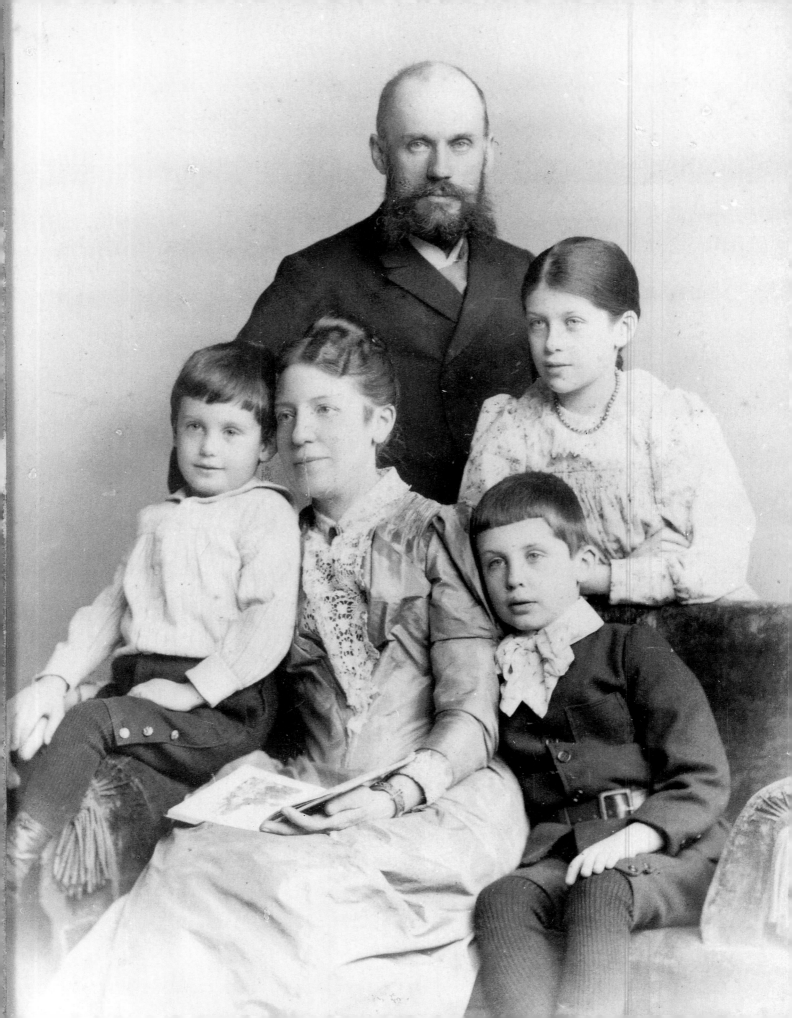

thoughts. His friends were chiefly classmates and former classmates. He considered his brother, Georg, his junior by four years, too young to be included in his activities. He worshiped his sister, Manon, some two years older, and was·greatly influenced by her.[11]

The social life of the family and its friends while in Berlin was carried on in the decorous manner of the time; calls were made and received punctiliously throughout the year. The important national and religious holidays were festive and informal; the rarer balls and cotillions were formal. Painfully shy, Walter actually hid from these social events. The family attended the opera, concerts, and the ballet, and, more often, went to lectures and the theater.

Most family entertainment took place in the home. Walter studied the cello for a number of years, but did not excel at it. He did join his brother, Georg, already a gifted violinist, and his sister, Manon, a sympathetic pianist coached by her mother, in playing trios and chamber music. When joined by a fourth, they attempted the late Beethoven quartets.

Beyond the walls of the Gropius house, Germany was transforming itself. There were electric light bulbs and stained-glass windows. Horse-drawn carriages and wagons shared the streets with the electric streetcar, the omnibus, and soon the automobile. The military was obvious, and uniforms were everywhere, worn by officers, conscripts, police, doormen, and messengers. There was a choice of entertainment, from symphony to music hall, from literary societies to declaiming street poets.

High society danced while the poor led wretched lives. Labor was plentiful and cheap. Germany's industrial growth had created a growing middle class, but the distance between rich and poor gaped wider. In Berlin those of middle income and the poor lived in the progressively shabby inner courts of the city blocks, while the wealthy lived in houses facing the avenues and boulevards. Unter den Linden was a street for society's promenade, or for watching others from sidewalk cafés. The markets and great stores prospered; grand ladies and trailing servants mingled with market men, sweepers, housewives, and the young women then entering service trades and offices.

Sun and water became fashionable, and the seaside resorts flourished. At one of these, Timmendorf Strand on the Baltic, the Gropius family had a comfortable second home near the beach.[12] It was here that many of Walter's childhood vacations were spent. The family's next-door neighbors and friends were the Grisebachs of Berlin. Hans Grisebach, who had designed both houses, was a fashionable architect and had built the houses of the art historian Wilhelm von Bode, the writer Gerhard Hauptmann, and other personalities of Berlin society.

With the spread of Germany's influence and of its shipping and railroad companies, Germans had become world travelers rivaling the English. There were venturesome members of the Gropius family in every generation, and Walter's was no exception. With Baedekers in hand, Manon Gropius led her children on holiday excursions through Italy, Switzerland, Austria, France, and the Low Countries. They reported dutifully to the German consuls and were directed to the museums, monuments, and hospitable members of the German colony. It was only as adults that the children would recall with fondness what had seemed to them wearisome walking tours.

What Walter loved most, however, were the reunions with his grandparents, uncles, and cousins. On occasion they would visit Walter's mother's family, the Scharnwebers, at their small estate,

Hohenschönhausen Niederbarnim.[13] He also had close ties with members of his father's family. Walter and his paternal grandmother, Luise Honig Gropius, enjoyed a rare friendship which was carried on in correspondence between his visits to her home in Gross-Schönfeld,[14] some twelve miles south of Stettin.

This estate was large, well-staffed, and efficient, managed as it was by Walter's grandfather, Carl Ludwig Adolf, who had been a soldier and a civil servant and was now a lawyer and an agronomist. But despite the witty and lively grandmother, life at Gross-Schönfeld was apt to be formal, and the young Walter would more often choose to spend his holidays at the Hohenstein estate[15] of his uncle Felix Gropius, in the province of Posen. Three of Uncle Felix's seven children were Walter's contemporaries: Annemarie, Werner, and Felicitas. Hohenstein was a particularly easy choice when he knew that Felicitas would be there, for she was, as he reminisced after her death, "my earliest love during unforgettable summers in Hohenstein."[16]

Uncle Felix, formerly a dashing officer in the Kaiser's Guard Artillery, had become a landowner, though not a very successful farmer, by inheriting Hohenstein in 1881 from his mother's family. Young Walter was considerably impressed on those occasions when Felix donned his regimental dress uniform. He thus provided a militaristic model that his own father, also an 1870 veteran, had eschewed because he did not believe in war.

The most benign influence and immediate encouragement were to result from the young man's annual summer visits, most often without his family, to his Uncle Erich's great estates, Janikow and Golzengut. Adjacent to Dramburg, Pomerania, and only a twenty-minute walk to Lake Lubbes,[17] they contained rolling fields, woods, and trout ponds.

In those days the Janikow estate in Pomerania was less than five thousand acres, small compared to that of Uncle Erich's in-laws, the von Kilitzings, whose estate, Zuchow, was more than eleven thousand acres.[18] Although Erich was a newcomer to Janikow, which he had purchased in 1883, the families of his Polish farmhands had lived there for generations.[19] Experimental methods of agricultural production, including animal breeding and fish hatching, were developed under Erich's proprietorship. Janikow grew to some thirty thousand acres by purchase of the neighboring Golzengut, which occupied fertile land and included farm workers' homes as well as agricultural and ancillary buildings.

The six children of Uncle Erich were too young to be Walter's companions, but the visits of Uncle Willy, a London sugar broker, Aunt Wiene, and Walter's English cousins provided occasional vacation comradeship. Other children from neighboring estates were infrequent visitors, and their visits were formal ones, more to be tolerated than enjoyed. As a result, Walter's friends were apt to be the children of tenant farmers, or his uncles themselves, whose footsteps he dogged.

When the condition of the country roads permitted, he rode his bicycle between estates. With his friends, Walter roamed the fields and woods on foot, by horse or farm wagon, or joined his elders in pursuit of the hare and roebuck. He was keenly aware of the beauty of the landscape, of the cultivated fields, the ponds, hedgerows, and wood lots.

Despite the freedom he was granted within the family, Walter was restless. His parents did not exercise the restrictive discipline characteristic of the German home, nor was he subjected to the

Vacationing with
his parents (seated)
and brother Georg
in Timmendorf,
1897

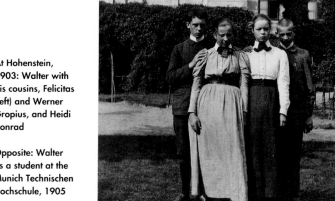

At Hohenstein, 1903: Walter with his cousins, Felicitas (left) and Werner Gropius, and Heidi Conrad

Opposite: Walter as a student at the Munich Technischen Hochschule, 1905

controls or pressures of a familial hierarchy, since the concentration of the family in the Brandenburg-Berlin area was not large. Nor did the Gropius family follow the usual upper-class practice of pressuring their sons to enter professional or administrative careers. Although there were architects, engineers, and artists among Gropius's forebears, they account only partly for his interest in architecture.

Gropius traced his initial interest in construction to his studies in the classics. Encountering Caesar's description of his bridge across the Rhine,[20] he had drawn its plans and had built it to careful model scale. It was natural, then, for Walter, upon completing his gymnasium classes on February 28, 1903, to enter the Munich Technische Hochschule.

That spring, settling in rooms in an old gabled house a few blocks away from the Hochschule, he enrolled in an ambitiously full program of studies, including building construction for architects, an elementary design studio, classical composition and proportion, history, and graphics. This constituted an early morning to evening program on six days of the week. The architectural studies were under the direction of the renowned August Thiersch, professor of architectural design; Josef Buhlmann taught history, and Professors Mecenseffy, Pfann, and Jummerspach taught construction. It is doubtful that Gropius heard more than an occasional lecture by these authorities, as the educational program, especially for new students, was in the hands of assistants.

The already world-famous Alte and Neue Pinakothek museums were directly across from the Hochschule, and Walter spent his few free hours in their galleries admiring the work of German, Dutch, and Italian masters and studying the French Impressionists.

The earliest existing letter from Gropius is one written to his mother in that first summer in Munich, noting a possible interruption to his studies as well as interference with his vacation travel plans. He was eligible for an interview in August for a select cavalry regiment in which he could fulfill his requisite training year. He wrote of his indecision:

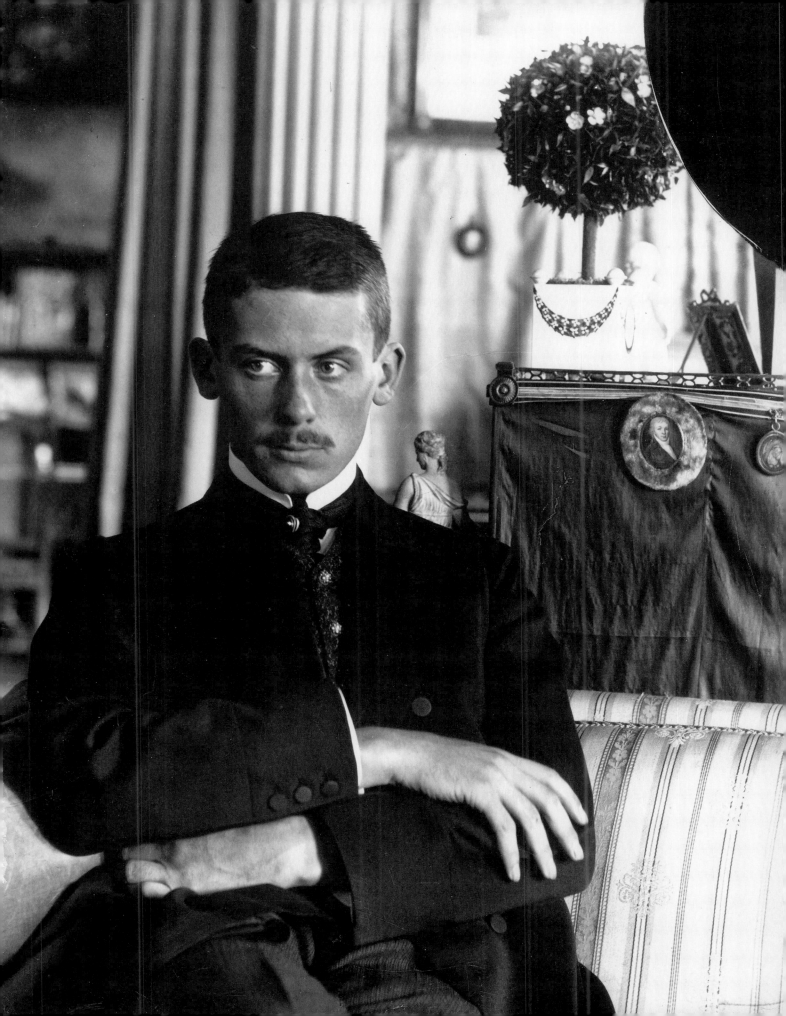

Shall I pack everything and leave it here or send it home? And if I do the latter they may not take me and I will have to lug it all back. Also I don't want to give up my lovely apartment (in the Turkenstrasse which is the envy of all my friends).

In the morning I am modeling now with great eagerness an almost life-size antique female torso after having delivered the male one in plasticine to the professor. It is really fun and for the time being better than drawing.[21]

Less than a week later Walter wrote again, both academic and military training now of far less concern to him than the serious illness (believed to have been Bright's disease, a kidney disorder) of his younger brother, Georg (Orda):

For heaven's sake, what you have to go through! I see you now sitting in fear next to Orda's bed. Please keep your courage up, dear Muttchen. . . . If I am not taken by the military I shall come to Berlin this winter. . . . I hadn't wanted to have my military time interfere with my profession, but under these circumstances all that is unimportant now.[22]

When Georg's illness worsened, Walter decided to postpone his military service and left Munich in mid-July to rejoin his family. In January of 1904 Georg died. The house on Rankestrasse became even more somber, the servants moving quietly to receive family and friends offering condolences. The mourning lasted through the year.

But 1903 had proved to be advantageous as well as sad for Walter. Recommended by Wilhelm Martens, he entered the architectural firm of Solf and Wichards as an apprentice.[23] Older than the other apprentices, Walter advanced quickly from ordinary office drafting to fieldwork and clerk-of-works responsibilities. Munich and the Technische Hochschule faded as he relearned architecture.

In the summer of 1904 Walter applied and was accepted for his voluntary military service into the 15th Hussar Regiment at Wandsbeck near Hamburg. It appears to have had an auspicious beginning: "I live here very nicely in a big, very old rural Gasthof. . . . My uniforms fit me well and I shall look very elegant in them. . . . I am well and I have no fear of the exertions ahead." His frequent letters to his mother detail the exhausting daily training schedule, which began at five in the morning with cleaning stables, currying the horses, and polishing the harness and saddles and was followed by riding and other lessons until late afternoon. His horse, as he described it, was very difficult to ride and was aptly named Devil. Still, he was able to master it and "to trot without stirrups and without bridle, to ride sidesaddle, backwards and standing up." He looked forward to the next challenge, the obstacle course, happily, "in contrast to my comrades, who have not been successful."[24]

Gropius was one of the few sons of bourgeois families admitted to the 15th Hussars, and he initially thought he would encounter no "difficulties in getting along with my comrades." He optimistically wrote to his family, "I have established my own rules of conduct and shown how far I am allowed to go. Everybody in my barracks have declared themselves against gambling."[25] The truth was that he was a loner and not an aristocrat, and could not be a member of the regiment's inner circle.

The daily routine of military life centered on horsemanship, care of the horse, and cavalry tactics. Lectures on Germany were second to those on the history of the regiment, its battles, banners, and glory. There were few cultural and intellectual opportunities. Because of this, and also because they

were both isolated among the aristocrats, Walter befriended an even greater exception in the unit, a Jew. "Doctor" Lehman, Gropius wrote, "is a very nice person. Inexperienced, naive, and clumsy, he is not at all ostentatious or profligate. I have not discovered any Jewish trait in him. He is the best educated man in the regiment."[26]

Gropius's acceptance in nonmilitary activities was limited. On November 14 he was already anticipating a Christmas furlough more than five weeks away: "I am very much looking forward to it. The strange atmosphere here presses on me. I miss not being able to cultivate my own interests. After this year I will be mentally completely dull." He asked his family for introductions to Hamburg society:

> Ask Aunt Lisbeth to write to Count Hoffmannssegg. I am learning only now how important it is to have connections, particularly in military circles. Please remind Conrad to write his recommendation to the commandant *now*. Since he will probably be appointed to the General Staff in January, he can be very useful to me.[27]

After his Christmas furlough, he was more successful socially:

> Yesterday, for the first time, I went into the Hamburg high society: 90 people (at Senator Westphal's), musical evening, singing middling, very good piano playing, afterwards dancing. An Italian woman sang "Caro me ben"; very beautiful. Otherwise, extremely cold, superficial formal people...Hamburg beaux, typical ladies' men, but reserve officers and rich in money as well as in phrases. Very beautiful girls, but all cold Hanseatic blood.[28]

His social successes increased over the winter season. By early February he could inform his mother that his calendar was filled two months in advance.[29] In several letters he noted that he had been the guest of the commanding officer at lunch, at the races, and at a military function.

But Gropius did not rely only on influence to win recognition; he worked assiduously at every task and every riding lesson. His love for horses and his ability to bring every type of horse under quick control had been recognized by his officers in their award of spurs to him in October. He lost no time in reporting this achievement to his family: "I can stand everything better than my comrades, who complain about sore feet, sore behinds and muscular pains, things which I know nothing about." He also boasted, "I am the best jumper in my group, 1.10 meters without a take-off,"[30] and reported that he had won the respect of the stable crew, the recruits, and the corporals through horsemanship and not by means of money or beer. In the spring reviews Gropius was praised by the commanding general, who called him "an ornament not only to your outfit, but also the whole squadron."[31]

Though comfortable, the Gropius family was not rich, and from the beginning they had found the costs of this training year to be a burden. Almost every letter from Walter to his family aggravated the problem:

> The main bills will arrive November 1 and will be rather large sums: the horse, saddle money and in advance all the fodder for the next year, altogether around 900 marks. The tailor, saddler, and shoe-maker bills. ...As soon as I know the figure, I will write.
>
> It is horrible for me to have to ask for money, and you can be sure that I do it only in the most extreme case. I had to ask Dr. Lehman for 100 M. I did not take part in anything here this week to the annoyance of my friends. ... The sum of 300 M. per month simply is too low.
>
> You have no idea how much I economize and how much I deny myself, which the others don't have to do. Imagine

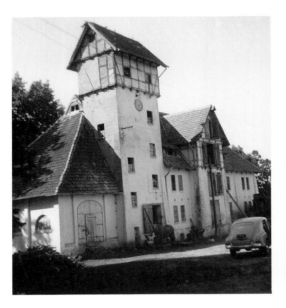

then my shock when Father sent me only 200-MK. …Why do you take me for a spendthrift when I have never yet given you trouble in this respect?

I shall have to pay lots of bills here: 200 marks to the shoemaker, tailor, saddler, two months Squadron (rent, cleaning, casino, photographs), so I need far more than one month's check. Thank God, this will be the last time that I shall have to ask for money. I also have to pay endless goodbye visits.[32]

As an afterthought to the last request he added, "Please send me a program for the Technische Hochschule." Walter's parents were pleased by his decision to return to formal studies in architecture and particularly by his choice of the Konigliche Technische Hochschule in Berlin-Charlottenburg. In September 1905, his military requirement completed, Gropius enrolled.

The program was rigorous. It involved a schedule of some seventeen courses spread over a twelve-hour day. A dozen professors and numerous assistants conducted the curricula. Among them were some of Germany's best. Gropius was to endure two years of the formal program interrupted only by privileged opportunities to design and carry out architectural work for family and friends in Dramburg and the vicinity and by vacations in Timmendorf and Janikow.

Early Experience: Hardly had Walter begun his studies in the autumn of 1905 when Uncle Erich suggested that he try his architectural skills on much-needed farm service buildings for Janikow. These buildings, including a smithy, a laundry, and a courtyard wall, were the very first of Gropius's works.[33] They were well under way before the end of 1905, and Gropius was hard-pressed to maintain both his academic schedule and the occasional visit to the construction sites. Satisfied with their progress, Uncle Erich asked for a *Kornspeicher* (granary) as well. Gropius would refer to these early experiences as "my youthful sins."

When family friends, the Metzners, asked the young architect to design a house for them in nearby Dramburg, he promptly accepted and began sketches for his first house commission;[34] his

work was obviously influenced by his Uncle Erich's house at Janikow (designed by Franz Wichards of Solf and Wichards and much admired by the Metzners). Before long he found it necessary to engage a skilled draftsman for working drawings and details. With the spring thaw, work began on the site, and by early summer the house was well under way, but not without problems. On his return to Berlin from an inspection trip in June, Walter reported:

> The master bricklayer had cheated everywhere and it was my task to find out everything. My head was throbbing intensely. For three hours I walked through the building with two foremen, two carpenters, one plumber, and the client, while everybody had to listen to my wisdom. But they couldn't embarrass me and I found 22 mistakes which the master bricklayer must change. It was hard work. Uncle Erich's granary is also up to the second floor.[35]

It was not all work at the estates in Pomerania. In January, in connection with an inspection trip, Walter had been invigorated by "three really delicious days of hunting":

> I got smoothly to Stargard, but then a crazy trip of three hours began in an ice-cold rickety little train so that I felt I was going to Siberia through a waste of snowfields. In Kallies, after a long try, I got a room in which the water was frozen inch deep. At 5:30 a.m. we left on a sleigh for Zuchow. It was so dark and snowed so heavily that somebody who knew the road always had to walk ahead. …After a royal breakfast we started off at minus 10 degrees C. in an east wind for the hunt. There were Wagenheim with both sons, two Rosenstiels, their sons-in-laws, all of them gigantic, Uncle Erich, two Klitzings and I. …I didn't get a single shot and on the next day during the stag hunt we saw nothing. …It is impossible to describe how exquisite the Zuchow forest looked in hoarfrost at -15 degrees C.[36]

Walter did not find it too difficult to persuade his devoted Uncle Erich to engage him for further architectural work, to prepare plans and oversee the construction of housing for the farm workers on Janikow. This interested him, because the usual housing of farm workers was frequently inferior to that for the farm stock.

Erich Gropius, though politically conservative, was open-minded and liberal in his daily life. He was respected by his people and tacitly admired by his peers. A generous and sensitive person, he was concerned with social justice. Gropius later attributed much of his own viewpoint and success to this devoted uncle. Gropius also credited an old friend and Jewish advisor to Erich with having shaped his determination to succeed: "Ask yourself," this man would counsel, "at the end of each day whether you have moved a little nearer toward your goal."[37] Erich saw the potential of his nephew, reiterated his friend's advice, and placed his confidence in Walter as an architect. He also taught him to smoke and drink — wisely and as a gentleman.

For the farm housing Walter went to work on sketches and working drawings for four structures, each containing two attached dwellings for the large families of that era. Simple in design, the buildings were similar in their size, fenestration, masonry (such as cobbled brick courses), and other features. The buildings, with gardens, were openly and variously spaced at the outskirts of the estate's farm fields along the road to Dramburg. The actual construction was supervised by Gropius and, unlike the Metzner house, carried out meticulously by a Dramburg contractor.[38] So successful was the project that other nearby estates soon built housing.

It is impressive that Erich Gropius took so great a risk in entrusting this commission to his nephew. At that time Gropius was neither professionally qualified nor experienced, except for the service buildings and a single house. Impressive too is the senior Gropius's interest in building high-

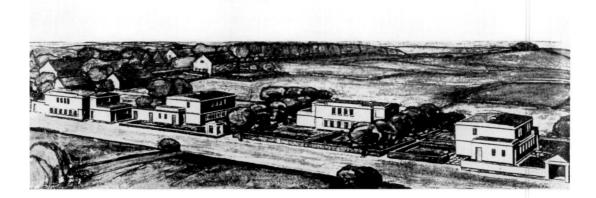

quality housing for his farm workers, which contrasted with the normal poor treatment in Prussia of farm workers, particularly those of Polish origin.[39] The sometimes harsh treatment, more than the type of housing itself, was to have a very considerable impact on Walter's developing view of architecture and society.

Life at school was not so successful. Walter's parents were concerned with his well-being, self-discipline, financial problems, and progress at the Hochschule. To one worried letter from his mother, he responded:

> Frau Heyden looks after me very well. ...She wakens me at 8 o'clock, breakfast and I then work with my draftsman until 3:30. ...I have some work to do for the Hochschule and I go there regularly every afternoon. ...My money chest is rather sick from the results of the military training period and since the casino has reminded me, I have to beg for your help again. ...I feel like a silly schoolboy that I cannot solve the problem on my own.[40]

To her concerns about school, he replied:

> My private things are now far enough advanced so that I could devote myself to the finishing of my Hochschule drawings. I cannot follow the lectures after the long pause. They are, anyway, illusory except maybe for geniuses. I don't go anymore and work according to the printed matter.[41]

But his mother still expressed concern about what she considered his disorganized ways. Hoping to reassure her of his maturity, he wrote:

> I have divided my life sensibly between work and pleasure. ...I am well-armed for life now; I have acquired self-confidence and a good idea of my goals. There are times when a son does not fit particularly well into the home and therefore a certain alienation takes place. ...You imagine me as a kind of student bum. But think of all the work I have done during the winter. I have to work daily for my buildings and no client has ever complained yet about me. Nothing is left undone and my interest in my work is as great as ever.[42]

For all their nagging, Gropius's family continued to encourage him in his architectural career. Though his father was concerned because Walter did not follow the more traditional pattern of

study and practice, he was a humble man, wisely patient and forbearing in criticism. Walter's mother, in many ways more of an influence on her son than her husband, sought out new European and American books and articles of architectural interest and called her son's attention to forthcoming public and university lectures.

In the fall of 1906 Walter began to find his architectural studies dull, restrictive, and irrelevant to the outside world. He didn't enjoy algebra, though he did well in the more visual forms of mathematics, such as descriptive geometry, and excelled in the construction courses. The gap between what he was being taught and what he himself had already experienced in design and construction was substantial. He was already growing dissatisfied with learning to apply historical styles to new buildings.

Still, one work he studied on the development of historic architecture made a lasting impression on him. This was a published lecture on the *Bauhütten* (masons' lodges) of the Middle Ages.[43] The roster of the great cathedrals of Europe stirred him as he came to understand how these structures were constructed stone upon stone by associations of artists-craftsmen living and working together on the building sites, bound together by a common religious credo and purpose.

He continued to receive commissions. Among his clients was another friend of his Uncle Erich, von Brockhausen, a rich bachelor in Mittelfelde, well traveled and ambitious. He had a number of projects in mind for the young architect that would develop over several years. Walter reported to his parents during a weekend visit to the von Brockhausen estate:

> Some large perspectives are opening here for me. Brockhausen has some American ideas, turns everything upside
> down and seems to want to spend considerable sums. ...So far I am going to change the entry drive with great walls
> and gate. Then he wants a rather opulent four-family house and, very probably, a large plant for oak fabrication.[44]

Erich Gropius was well satisfied with the workers' housing at Janikow, and when he purchased the adjoining estate of Golzengut in 1908, he asked Walter to oversee the building of similar accommodations there.[45] These buildings, fewer in number, progressed rapidly, given Walter's growing experience.

Such commissions made Walter more than ever restless and impatient with his studies, and his second year at the Technische Hochschule proved to be his final one. Without completing the program or taking the final examination, Gropius left the school in 1907. Having recently received a substantial inheritance from his grandaunt, he decided to embark on a yearlong trip to Spain to, as he put it, "push forward from the beaten path into unknown regions, in order to know myself better."

How well he succeeded is revealed by the letters recounting his adventures with his traveling companion Helmuth Grisebach, son of a Timmendorf neighbor. Aboard the *Albingia,* Gropius described the ship, the passengers, the seven daily meals, their venture into the nightlife of one port of call, Le Havre — "In the sinister harbor, always the revolver at the ready..." — and "the storm in the Gulf of Biscay during which everyone was seasick," except himself. His letters are filled with similar displays of bravado, as well as with disparagement, at least initially, of Helmuth:

> He is filled with such unchangeable dullness that not even the most wonderful thing in the world can raise him from
> his slumber. He has not once said anything interesting. ...All travel arrangements have to be made by me, he

With Helmuth
Grisebach in Spain

forgets everything, never knows how to help himself, and has learned hardly more than three words of Spanish.[46] The boat docked in Bilbao, where the two men visited churches and cathedrals before embarking on an extensive journey through most of Spain. Near Burgos they visited the Monastery of Santa Domingo de Silos, where they were welcomed most hospitably by the abbot and monks.[47] The impressionable young architect was deeply touched by the great beauty of the Catholic mass, the old Gregorian chants, and the ecclesiastical buildings constructed with devotion, skill, and superb design.

His perceptive impressions of structures and walled cities were capped by his view of Coca Castle, "which appeared like a fairy-tale piece with its thousand pinnacles and towers…wonderful, grand, and monumental in the melancholy desolation of its environment."[48] Avila, too, stirred him with its dramatic site and two-thousand-year-old Roman wall, towers, and gates, its eleventh-century cathedral, and its women, who were "almost all beautiful and beside whose strong faces a feeble Nordic face would not stand up."[49]

This was not the first time he had noticed the beauty of Spanish women. In his letters he casually mentions "girls slim up to their twentieth year and thereafter plump and matronly…their coal black hair which goes very well with the pale faces and the blood red lips…and blonde heads with blue eyes of Basque descent,"[50] and notes that in Madrid he found such "ravishing women in such splendid outfits that it is one of my favorite pursuits to put my best things on and stroll along as a perfect gentleman of the world."[51] He was just twenty-four and enjoying the flirtations travel encouraged:

> One otherwise boring evening we spent at the Vogels and I met there the two most beautiful girls in Madrid. Two young Cubans, both so ravishingly beautiful in figure and face that my breath stood still, but I tamed my embarrassment and escorted one to the dining table and discovered that she was also intelligent and amiable, a rare combination.

"My heart," he assured his mother, "is not yet broken in two — so don't worry."[52]

In Spain, 1907

He found more to admire than the women. Madrid he thought sophisticated and bustling with "metropolitan activity":

> There is nothing in beautiful buildings but the city is laid out in a generous and elegant manner, beautiful plazas and promenades and much good taste...there is an incredible number of rich people who drive about in luxurious carriages and are dressed in highly elegant outfits. ...In the afternoon the elegant world walks or drives on the great paseos.

Without irony he reported that "apparently nobody works, there is no industry and hardly a middle class," but even such a protected and naive view did not prevent his noticing that "there are lots of beggars and cripples who lay siege to every halfway decent looking man."[53] Within two months he acquired a different view of life in Spain. He admired "the vigor and health of the broad masses of this people" and lamented, "Only the upper ten thousand are idlers and good-for-nothings and from them are recruited the leaders of the country. What a pity."[54]

The German Embassy in the fashion of the day had prepared the German colony for the arrival of the young travelers. There were many introductions and calls were exchanged. Their evenings were filled with dinners, theater, and music. One of the people Walter met in Madrid became a lifelong friend, Josef (Pepe) Weissberger, a successful businessman whom Walter described as "a well-traveled bachelor of the most pleasant and refined type who speaks six languages, among them Arabic, and knows his way in every field."[55]

Through friends such as Weissberger, Gropius had access to private collections of art, though he did not neglect the public museums. The Prado alone he visited nine times, for the most part to view the works of Velázquez. His fascination with the works of the old masters led him and Helmuth into an initially casual search of antiquarian shops, then to progressively more exciting discoveries of old paintings and ceramics. "We have," he wrote his parents, "turned whole shops upside down and bought many things which are surely of high value for very acceptable prices."[56]

These excursions led to a change in Walter's feelings toward Helmuth,[57] who exhibited artistic

and business acumen by his discovery of an "original" Murillo. "Helmuth is fully awake now and hatches big plans,"[58] Walter announced, and he expressed his admiration for Helmuth's "steadiness," which he felt "will be a great support for our plans."[59]

The great enterprise of purchasing paintings at a fraction of their believed worth and shipping them to Germany for exhibition and sale was intended to build the prestige and profit of the two young entrepreneurs. The growth of Walter's self-assurance was rapid, and that of his ambition even greater:

> I have never learned so fast. I knew almost every painting there, but now I see them with new eyes and much greater understanding. . . . Through buying and choosing I have learned much more than by mere viewing. . . . And I now even have proof that I am able to engage in a professional judgment.[60]

The young Gropius's excitement and conviction were persuasive, and his mother sent him his aunt's bequest as well as funds of her own — without telling her husband.

From early January until late spring, there are no letters to explain what happened to the travelers' painting discoveries and purchases. Perhaps their entrepreneurial enterprise foundered during a trip Helmuth made to the Louvre to show a Claudio Coello and other paintings to the director. In 1975 Gerhard Marcks recalled that these paintings had been appraised by experts as folk art or, at the most, of the school of Murillo, and of no great intrinsic value. A grandnephew of Helmuth accounted for the collected works: "The paintings. . .were in his possession until his death, and I think they are now with his son. We always thought he had collected most valuable masterworks, but they were just old paintings."[61] Though later in life Gropius made no further reference to this venture into the fine arts market, at the time his youthful enthusiasm for new ventures was hardly dampened.

During a pre-Christmas journey with Helmuth and Weissberger to Segovia, Granada, and the Andalusian coast, he was seized by nostalgia and wrote to his parents, first describing his travels, then expressing a bit of homesickness:

> Now, my dear old ones, I will get a lot more Christmas-like. In this strange, distressing feeling, having to celebrate the Feast completely without you and knowing that you are alone, I have for days wavered in writing this letter so that it will just make it in time to drop on your calm Christmas table. . . . I see you sitting under a modest little tree which you have placed there against Father's wish, but out of piety, although in the feeling that it was useless since the gayest are missing. But be sure that during the festive days there will be a strong thread of love and longing between Berlin, Alfeld, and Madrid.
>
> I embrace you a thousand times and wish that you may spend the holidays as well as it is possible without us and with the friends that stay with you and will take care of you, not so completely alone, during the festive days. Do you hear, Father? Don't shut yourself in, it's not good for Mother.[62]

Walther Gropius senior, tired and approaching the end of his civil service career, appeared withdrawn from his wife and family; and in a separate letter to his father Walter expressed his warm wishes for his "dear old Dad" in the coming year: "I wish for you what you really need this New Year: retirement and a well-earned rest. Maybe the realization that I shall make my way will be a good reason for you to lay down your sword."[63]

Walter's interests in Spain were unlimited, and he had the boundless energy to follow them:

travel, social life with many attractive diversions, the monumental architecture, and the old masters. To these should be added a particular interest in the *alicatados,* work inlaid with tiles in Moorish style, and in the *azulejos,* blue and white Catalonian tiles. He pursued this interest everywhere.

> I have been fed with ceramics to the hilt here and saw the best collections of Madrid. …The most beautiful one is owned by the Finance Minister de Osma. …The arrangement is much more beautiful than in any museum. I can only compare it with Poldi Pezzoli in Milan. …De Osma is blissful when somebody properly enjoys it.[64]

Through the embassy, Gropius met Hans Wendland, who shared his interests and became his comrade. Together they visited Barcelona, where they found the old crafts, textiles, carvings, and especially ceramics to be of extraordinary quality, and sought the very special tiles of Catalonia. The tiles suggested an opportunity; as Gropius described it, "I had the idea to reawaken the old ceramic production as wall coverings for our contemporary architecture."[65]

He admired especially the projects of the artisan craftsmen in a ceramic tile factory near Seville and obtained permission to work there as a craftsman himself. His idea was to learn enough of the craft to be able to develop new methods and to use ceramics later in his own buildings. He wrote to his mother about his work, noting that he had prepared his own sketches and designed some friezes of animals in clay, cut them into large tiles of irregular forms, glazed and kiln-fired them. These he reassembled to form a ceramic mural, a frieze. But his interest was as much in the methods of producing the tiles and their assembly to form mural walls as in their detail of design; and indeed, glazed murals derived from these attempts were later used in buildings he designed.[66]

The progressive spirit in Barcelona greatly appealed to Gropius. There, with Wendland, he saw the Parque Güell, the apartment blocks, and other buildings of Antoni Gaudí, whom he saw at work in his shop near La Sagrada Familia cathedral.[67]

> He was absorbed in his work and quite uncommunicative. His devotion and concentration on his task impressed me deeply, though his architectural production stood far away from my own still-vague ideas. His intensity struck me as a most desirable quality in a man's work, but I was still too immature to understand his unique daring and inventiveness as a structural engineer.[68]

It was in Madrid, through Weissberger, that Gropius met Karl Ernst Osthaus, director of the Folkwang Museum of Hagen in Westphalia. A distinguished and perceptive collector of contemporary art and a patron of artists and architects, Osthaus was impressed by the young Gropius, who had drawn his attention to several pieces of Spanish ceramics, which he bought. They soon developed a close friendship, and Osthaus advised Gropius to seek employment in the office of the architect Peter Behrens in Berlin. Indeed, he wrote to Behrens on behalf of the young man, as Gropius reported to his mother: "Last night Mr. Osthaus departed. Before he left he wrote to Peter B. [Behrens] and recommended me highly. So everything has been started in the best conceivable way."[69] It was a fitting finale to the Spanish sojourn and was indeed a new start. Gropius, who was looking forward to seeing Germany again, soon set sail for home and the architecture career now open to him.

THE YOUNG ARCHITECT
1908–1918

Early in 1908 Gropius returned to Berlin, went for an interview with Behrens, and was hired. Behrens, the first significant practitioner of the utilitarian style, was then forty years old and was yet to produce his greatest works. As "art director" for the Allgemeine Elektrizitats-Gesellschaft (AEG), the German General Electric Company, Behrens had responsibility for the aesthetic considerations of all aspects of the company's image — its products, advertising, and buildings.[1] Gropius was joined in Behrens's office by Ludwig Mies van der Rohe and Dietrich Marcks. Though some accounts placed Gropius, Mies, and Le Corbusier there simultaneously, it was not until sometime after Gropius had left Behrens's office that Le Corbusier entered it.

The Behrens Office: Behrens, a kind and thoughtful man, was an effective mentor to Gropius. In the Behrens home, Gropius often seemed less a guest than a member of the family. He was an ardent tennis player and taught the game to his employer's daughter, Petra. So intense was his ordinary game that he developed a wrist and hand tremor that further limited his already minimal ability to draw, which had been a source of frustration for some time.

> My total inability to draw the simplest thing on paper is very discouraging and I often look with sorrow on my future profession. I cannot draw a straight line. When I was 12 years old I could draw much better. It seems to be a physical disability because I immediately get a cramp in my hand, break off the pencil points and have to rest after five minutes. With my handwriting it is the same thing. It gets worse every day.[2]

Behrens recognized the potential of the young architect and provided him with unique opportunities to learn. Gropius accompanied Behrens on an inspection trip to England in 1908, where they visited not only industrial estates and buildings, but also monuments. During Gropius's stay in his office Behrens designed the great turbine building for the AEG in Moabit (Berlin) and the Lehmann Department Store in Cologne, whose office interior and furnishings were the only designs he credited to Gropius alone. In the manner of the day, Behrens rarely acknowledged the work of the younger men in his office.

Gropius was excited by the industrial processes of the AEG, an excitement heightened early in 1909 during a trip to the Ruhr. There Gropius saw parts of the vast Krupp industrial empire and,

Corner of the office building designed by Gropius for the Werkbund Exhibition, Cologne, 1914

Left: Double house for workers, Golzengut, the estate adjoining Janikow purchased by Erich Gropius, 1909–10

Right: Prefabricated house offered in Sears, Roebuck catalogue, 1908

more importantly, saw what sixty years of Krupp's involvement in housing projects for its workmen had created. The juxtaposition of industrial technology in the factories with hand construction methods in their large-scale housing sparked Gropius's thoughts on industrialization of housing production.

Understanding the needs of cities, and recognizing the indifference of government, institutions, and individuals toward urban problems, particularly housing, Gropius began in 1909 to systematize his thoughts on housing to be produced by industry. In March 1910 he met with Walther Rathenau, president of the AEG of Berlin and son of its founder, Emil Rathenau, to discuss these ideas; Gropius had become acquainted with both through the Behrens office. He presented a proposal entitled "Program for the Establishment of a Company for the Provision of Housing on Aesthetically Consistent Principles"[3] that suggested the AEG invest in prefabricated housing.

Gropius did not claim to have invented the idea and methodology of prefabricated housing, but in his presentation for Rathenau commented on the need to raise its standards: "To a certain extent industrial production has already entered this field. The types introduced by entrepreneurs for profits are immature and technically as well as aesthetically bad and inferior in quality to houses whose parts are still produced by hand."[4] The reference to the "extent industrial production has already entered this field" was based on his examination of catalogs distributed in Europe by Sears, Roebuck and Company and by the Hodgson Company of Dover, Massachusetts. Both firms offered components for houses in various sizes, styles, and plans, complete except for foundations, and all of which could be ordered by mail.

Behrens's own studies on the relationship of housing and industry had begun at this time, but he had little comment on the proposal. In 1910 the AEG was itself concerned with large-scale housing and commissioned Behrens to design a company estate at Henningsdorf. But the AEG was not convinced that prefabricated housing was the answer, and it did not take

up the Gropius proposal, feeling it remote from its own products and dubious as an investment.

In 1910 Gropius would be stimulated by still other ideas from the United States. At this time Frank Lloyd Wright made his influential visit to Germany in conjunction with the exhibition of one hundred drawings of his works at the Academy of Art. The first German publication of Wright's works appeared at the same time.[5] Gropius had been intrigued by the illustrations of the works in American magazines and, with his mother, who had called his attention to the designs, he visited Wright's exhibition. He later acknowledged that both the exhibition and the publication of Wright's works had a significant effect on his own designs.

By early 1910 Gropius also felt that he had arrived at a plateau in his work for Behrens. Moreover, he had "lately had various disagreements" with his mentor, and in March he wrote to Osthaus of his intention to leave the firm.[6] Despite the break, the association of the two men resulted in a lifelong friendship that survived war and revolution, the vicissitudes of the Bauhaus, and the schisms of professional societies.

The Gropius Office: Gropius now began vigorously pursuing the tasks involved in establishing his own office, first in Neu Babelsberg and later in Berlin. He took with him in this venture Adolf Meyer, a fellow employee at Behrens's office, who proved a highly capable right-hand man and devoted assistant. The excellent working relationship between them and Gropius's insistence on recognition for Meyer led many to believe that it was a partnership between equals. But, without diminishing Meyer's importance, Gropius later stated that Meyer was not his partner but a "salaried assistant" at the time.

Gropius wrote letters to scores of individuals and firms who he had heard intended to build. His family's prominent position and the works he had carried out successfully in Pomerania in 1906 also served him well. He and Meyer were quickly involved in new work in the same region. In 1910-11 they designed a starch factory for Herr Kleffel in Baumgarten in Kreis Karwitz and residential work for Uncle Erich in Golzengut. Other residential and estate service buildings followed, but the office was not yet overly taxed.

The most important commission of his early career was the design of the Faguswerk, a shoe-last factory in Alfeld-an-der-Leine that is now generally regarded as one of the crucial founding monuments of European modernism. On December 7, 1910, Gropius had written to Karl Benscheidt, who, in conjunction with the United Shoe Machinery Corporation of Beverly, Massachusetts, was founding the new plant, expressing interest in procuring the commission and giving the name of an Alfeld relative, Landrat Max Burchard, as a personal reference. Benscheidt was a progressive industrialist, paternalistic and humane in his dealings with his employees. Something he sensed in Gropius's letter made him see the possibilities of fulfilling his own ideas through the young architect.[7]

Benscheidt was further encouraged by the social import of a talk he had heard Gropius give at the Folkwang Museum in Hagen, Westphalia, in January 1911. The lecture was on the subject of industrial construction and monumental art, and Gropius noted particularly the qualities of fitness of design and construction to the function of grain elevators and silos in the United States.

**Faguswerk,
Alfeld-an-der-Leine,
1911. Gropius with
Adolf Meyer**

**Opposite:
Faguswerk,
entrance**

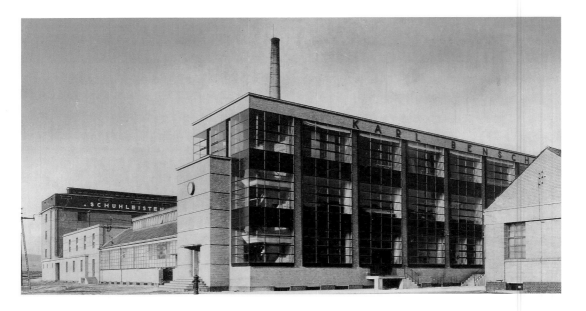

Innovative though such ideas on design might have been, Gropius's comments on the quality of the work environment were even more advanced:

> Work must be established in places that give the workman, now a slave to industrial labor, not only light, air, and hygiene, but also an indication of the great common idea that drives everything. Only then can the individual submit to the impersonal without losing the joy of working together for that greater common good previously unattainable by a single individual. Farsighted managers have long known that with the satisfaction of individual workers, the common work spirit also grows, and with it the efficiency of the whole plant. The sophisticated industrialist will take all profitable steps to relieve the deadening monotony of factory work and alleviate its constraints. That is, he will attend not only to light, air, and cleanliness in the design of his buildings and work spaces, but will also take cognizance of those basic sentiments of beauty that even uneducated workers possess.[8]

Gropius and Benscheidt met in the first week of February and quickly came to an agreement on the redesign of the Faguswerk. Benscheidt had already received a finished site plan, floor plans, and construction proposals from architect Eduard Werner for the usual type of factory building. It had very little aesthetic ambition, and Benscheidt felt that a well-designed facade would improve it. Although his commission was for the facade only, and he was entering the design phase after the building foundations had already been laid, Gropius was able to create for his client a version of the American Daylight factories Benscheidt had admired in the United States.

Reyner Banham describes Gropius's achievement in the Faguswerk as follows [Ed.]:

> The drawings submitted by Gropius to the Baupolizei in September of 1911 show a reduced and economized version of the Werner plan. One bay of the single-story production sheds in the heart of the layout was eliminated, but the general disposition, dimensions, and apparently, the structure as well remained effectively as Werner designed them — a range of north-lit, single-story work sheds with ancillary stores across the northwestern gable ends, and beyond them a four-story warehouse with an attic story above the cornice... .

> The new Gropius facade for the office block...ran along two of the three exposed faces of the work sheds.

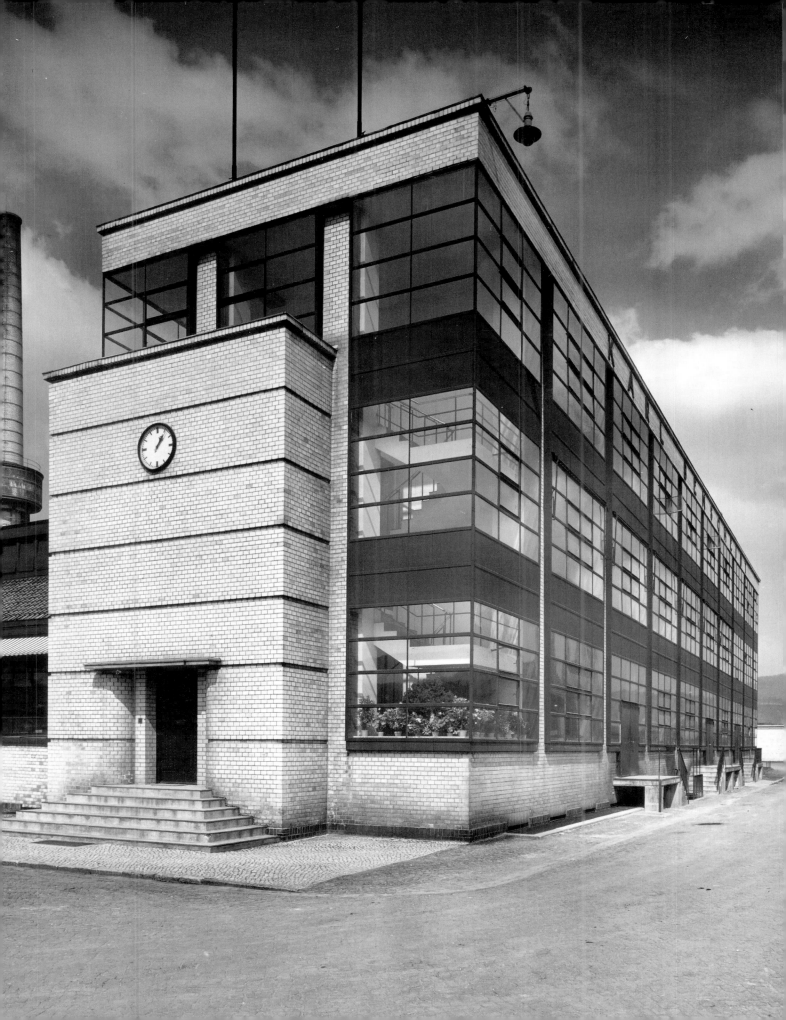

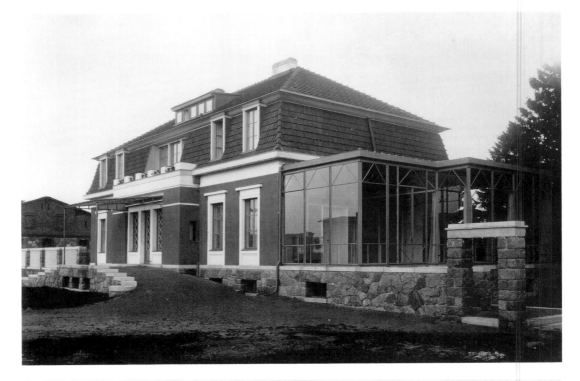

Von Arnim house,
Falkenhagen,
Pomerania, 1911–
12

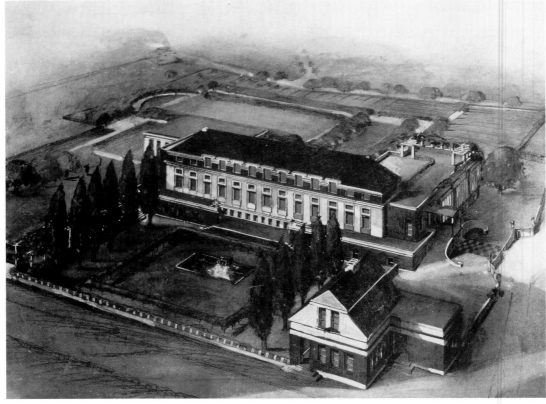

Hospital, Alfeld-an-
der-Leine, 1912–13.
Gropius with Adolf
Meyer

Diesel passenger car designed by Gropius for the Prussian Railroad Locomotive Works, 1913

However, this was more than just a facade; behind the now famous glass wall ran three stories of extensively reworked office space, which may be seen as the real contribution of Gropius and his partner Adolf Meyer.... .

It was only in the greatly expanded second phase of the design, undertaken in 1912, completed in 1914, that Gropius and Meyer were able to extend these innovative facades as far as the public corner, where they created the famous glazed staircase and added that massively stylish entrance block...in the monumental manner of Peter Behrens.

That "glazed corner," whose staircase "seemingly floats free," is a space that, according to Banham, "must be one of the classic locations of the modern sensibility in architecture," for "it has the kind of open, limpid, *unbegrentzt* (unenclosed) space that would, in due course, become the International Style's most beguiling contribution to the vocabulary of architecture."[9] It was a unique and highly successful beginning for Gropius and Meyer.

In the early years smaller commissions occupied the new office. In 1911 he designed several homes; they were undistinguished and eclectic, as they bowed to the desires of the clients. In 1912 there were new and continuing tasks in connection with the Faguswerk and several commissions that grew out of his Pomeranian work; these included housing for farm workers, farm service buildings, storage buildings, offices, and a bank. The success of the Faguswerk led to a commission for a hospital in Alfeld, though there is nothing in the design of this small medical complex that reflects the pioneer accomplishment of the factory. Gropius and Meyer also designed interiors and furnishings for the Langerfeld and Mendel families in Berlin. Gropius's designs for interiors shown at the 1913 World Exhibition in Ghent were awarded a gold medal.

Gropius was commissioned in 1913 to design a car for the Prussian Railroad Locomotive Works in Königsberg. This locomotive was unique — the first of its kind in Germany and perhaps in Europe. "The client [Waggonfabrik] was very satisfied with the design of the car because the hot air of the motor was smoothly pulled out under the slanting nose."[10]

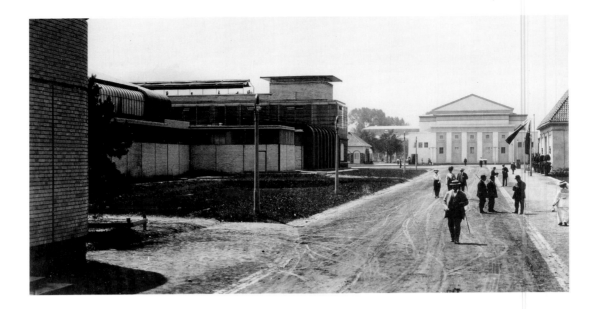

Office and factory building designed by Gropius for the Werkbund Exhibition, Cologne, 1914 (seen from side and rear)

Gropius continued to be concerned with the problems of providing housing, communal facilities, and services for low-income families. In 1913 he and Meyer were commissioned by the Landesgesellschaft Eigene Scholle GmbH to design thirty single and attached dwelling units in a rural area near the north side of Wittenberg. These were intended as subsistence homes for skilled and semiskilled workers employed in sewing machine, railroad, and other nearby factories. Through his Uncle Felix, who had sold his estate in Hohenstein and was now business manager in the conservative Chamber of Agriculture for the province of Posen, Gropius also learned of a competition to design a large new sector in the expanding city of Posen.[11] Gropius and Meyer submitted a plan with considerable emphasis on housing requirements. Though they did not win, the competition gave Gropius his first large-scale project experience.

The reputation of Gropius's office grew and new clients appeared. One of these was the Bernburg Machine Company at Alfeld-Delligsen, makers of cast-iron agricultural equipment and counterbalance wheels. The company's general director, Dr. Max Meyer, a man with strong social concerns, persuaded the company of its responsibility to construct adequate housing for its workers. During 1913-14, the company commissioned Gropius to design a small housing project for its employees in a rural area near Alfeld.

There was much correspondence and activity in the spring of 1914 in connection with Gropius's participation in the Deutscher Werkbund, an association of "independent artists and craft firms…determined to combat conservative trends in design, and to grapple with the impact of mechanical production on the arts."[12] Gropius had joined this organization in 1910, only three years after it had been established in Munich, and was appointed to the board in 1914. The first major demonstration of the Werkbund's efforts to bring together the work of artists, architects, craftsmen, scientists, engineers, and industrialists and to bring art and design into the public sphere was its exhibition in Cologne in 1914.[13] The exhibition would provide Gropius

with his second major opportunity to display his maturing and innovative design capabilities.

Through the Werkbund secretary, Gropius urged Carl Rehorst, the exhibition's planner, to assign him the job of designing the exhibition offices, the machinery-display pavilion, and the workshops. There were, inevitably, problems of coordination with other architects and artists and with Rehorst himself. But Gropius's bold ideas and designs had won the support of Behrens, Henry van de Velde, Josef Hoffmann, and others, and his ideas carried. He worked intensely:

> My workload is now downright inhuman and I can only do it under stress, but I am boundlessly happy because I definitely know that my Cologne factory will be something quite good. Everyone whose judgment I value congratulates me spontaneously. Therefore, I am working extremely hard to give this work every attention.[14]

Gropius moved to Cologne in April (the Berlin office was left to Meyer's capable direction). At the exhibition Gropius also displayed a variety of projects, including his designs for automobiles, model furnished rooms, and a sleeping compartment for railway cars.

At the annual meeting of the Werkbund on July 2-6, 1914, a schism developed between those "who championed the unfettered…genius of the artist, and those who stressed the need for *typical* high-quality design handled by large firms with the ability to turn out the products in bulk mechanically and distribute them effectively."[15] A thousand people witnessed the resulting clash, which was initiated by Hermann Muthesius's speech urging that architecture and other Werkbund activities be governed by a more unified and significant style. He saw mass production as the industrial form of the future and felt that by adopting a single style, German art and production would be enhanced, and its influence throughout the world assured. For this reason, export firms particularly, he said, should join the Werkbund effort, which would be supplemented by exhibitions, publications, and other means of promotion.

Muthesius's position had long been known, and his opponents had organized in anticipation of his remarks. August Endell, in a letter written on May 28, more than a month before the meeting,

fulminated against Muthesius, declaring him to be not only outside the modern movement but overtly hostile to its proponents.

> The important thing during the meeting will be who should be top dog, artist or industrialist? Should we tolerate the Werkbund's becoming the tool of industrialists and the artists being used as fronts for those who do not have the least understanding of our work and our aims?[16]

Henry van de Velde, Hermann Obrist, and Bruno Taut, among others, defended the individuality of the artist against the spread of standardization and anonymity. Though Gropius believed in standardization for certain purposes and shared Muthesius's "longing for a Zeitstil,"[17] he also believed in freedom for the artist, and he supported van de Velde. He found Muthesius's behavior offensive and, more importantly, felt that the methods he suggested for achieving a modern style and form were wrong:

> Muthesius was not clear in his statement. His main error was his belief that one can establish and fix a style by organizational methods from above. Against this the artists in the Werkbund reacted violently.
>
> He mixed up taste with creation. A type develops only by slowly growing connections, i.e., by the preference of the free wills of many individuals. Harmony of style cannot be dictated, but is a supraindividual, slow result.[18]

"Modern living," Gropius had argued in his Folkwang lecture, needs "new building organisms expressing the life forms of our times." Those forms could be created only after "a time of inwardness," during which will emerge a "great common idea" that will propel "art...to achieve the heights."[19]

Alma Schindler Mahler: The task of establishing his practice took its toll on Gropius, and in the spring of 1910, troubled by a persistent cold, he visited Tobelbad, a small sanatorium not far from Toblach in the Tyrol. There, on June 4, he met Alma Maria Schindler Mahler, age thirty-one, daughter of Viennese artist-teacher Emil Schindler and wife of the great composer-conductor Gustav Mahler, who was twenty years her senior. She was accompanied by their young daughter, Anna (Gucki).

Though Alma, four years older and more worldly than Gropius, would claim that he had immediately fallen in love with her, later events and letters show that their affair was at least mutually spontaneous. Following dinner that first evening together, Alma and Gropius strolled, sat beside a creek in the moonlight, and talked late into the night. On Alma's return to Toblach, where Mahler was working on his Tenth Symphony, she and Gropius began exchanging love letters.

Despite the secrecy provided by post office boxes, their affair was disclosed almost immediately. It was revealed by Gropius himself, who sent one of his love letters to her husband. Though Alma wanted desperately to believe that Gropius had not intentionally dispatched his revealing letter to Gustav, she suspected otherwise. She may have been right, for in subsequent affairs with married or otherwise attached women, Gropius, out of either conscience or compulsion, communicated with their spouses or companions.

Alma feared for Gustav's health, always precarious, and fretted over his knowledge of her infidelity: "Because it was revealed to him by accident and not by a frank confession on my part, he has lost all trust and faith in me!" She also expressed her doubts about the misaddressed letter: "I fetched two letters from you yesterday, a.m. 40 [post box] — everything in order. Now I

Sleeping-car interior by Gropius, Werkbund Exhibition, Cologne, 1914

understand what happened the day before yesterday less and less. The only thing that makes me believe your letter…in which you openly wrote about the secrets of our relationship, was intentionally addressed to Herr Gustav Mahler, Toblach, Tyrol,…is the remark in your letter of today: 'Did your husband not notice anything?'" Alma begged Gropius not to come to Toblach, but to send letters to her private post office box. "I await with feverish longing your letter, in which you *must* explain everything to me." She apparently did not want to end their affair, writing "I hope you can say something to save you and me."[20]

Gropius's response was immediate, brief, and concerned: "Your letter gives me horrible anxiety for you both. …I'll go out of my mind if you don't call me to come over. I want to justify myself before you both and to clear up the mystery!"[21]

He did come to Toblach. According to Alma's autobiography, his visit was not announced; she wrote that "it was on a ride through the village that [I] saw Walter Gropius hiding under a bridge." Mahler, on hearing Alma's story of this strange young man, whom she had described as resembling Walther von Stolzing of *Die Meistersinger* fame, went after Gropius and brought him home. There, Gropius is believed to have respectfully, formally, asked the great man to divorce his young wife so that he could perform the honorable act of marrying her. Forced by Mahler to choose between them, Alma elected to remain with Gustav. The next day she placed Gropius on the train, from which, at every stop, he sent her pleading telegrams and letters.[22]

Despite their protestations to Mahler, Alma and Gropius remained in communication with each other. Within a few days of the meeting in Toblach, Alma reported that Mahler, who had been overburdened with work as conductor of the Vienna Opera and inattentive to his young wife, had now frantically renewed his interest in her. She was in a quandary. "On my side I experienced something that I had not thought possible. Namely, that Gustav's love is so boundless — that my remaining with him — in spite of all that has happened — means life to him — and my leaving — will be death to him. …Gustav is like a sick, magnificent child." Now she asked Gropius, "What would happen if I…would decide for a life of love with you. Oh — when I think about it, my Walter, that I should be without your…love for my whole life. Help me — I don't know what to do — what I have the right to."[23] Alma now realized that her love for Gropius was not a mere summer interlude but the only thing that was "healthy in [her] life."[24] They wrote each other often, and Gropius traveled to Vienna for clandestine meetings with her.

One result of Gropius's unfortunate letter to Gustav was Alma's constant anxiety about their communication. In many letters she directed him to take precautions to assure the secrecy of their correspondence and meetings: send letters via her sympathetic mother or use separate post office boxes, arrange discreet meeting places, adjust the hours for their trysts to Gustav's own schedule for travel and rehearsals, use pseudonyms for hotels and trains, and "to always play dumb whenever the conversation turns to us."

Mahler still suffered the effects of that letter too. Having been so long the adored of audiences, salons, and worshiping women, he was unable to comprehend the loss of his young wife's full attention. Now on brief trips to conduct orchestras, he would send hourly telegrams, letters, flowers, and gifts. Alma interpreted this demonstration of affection as a sign of incipient insanity,

"because the idolatrous love and worship which he shows me now can hardly be considered normal."

In some of her letters to Gropius, Alma rationalized her love for him and their passionate secret meetings as necessary for her physical well-being.

> I feel that for my heart and all my other organs nothing is worse than enforced asceticism. I mean not only the sensual lust, the lack of which has made me prematurely into a detached, resigned old woman, but also the continuous rest for my body... .
>
> Now I am in bed. ...I am with you so intensely that you must feel me.[25]

By early September, only three months after they met, her letters had become evocative in their eroticism. She asked him "when will there be the time when you lie naked next to me at night, when nothing can separate us any more except sleep?" and pledged her love by writing "I know that I only live for the time when I can become wholly yours" and by signing her letters "Your wife."[26] Letter followed letter, and their separation stimulated their desire:

> My Walter, from you I want a child and I will cherish it and care for it until *the* day comes when we, without regret, secure and composed, sink smiling and forever, into each other's arms. Wire me, Walter, whether this wish is still as strong in you as a month ago?[27]

Gropius responded in kind to Alma's letters, although many that he sent appear to have been studied in draft and corrected before the final copy was made. The result was frequently a more measured, somewhat stilted letter:

> For the first time I was again sitting absorbed by my work for [the Bismarck memorial competition] when your letter arrived!...I see a younger, more beautiful life arise from the pain endured. ...What we experience together is the highest, greatest thing that can happen to men's souls. I feel festive; my movements, actions, and words become more solemn. I shall have to become a *pater ecstaticus* at your side.[28]

In early September Alma wrote that she and Gustav were going to Munich, where he would conduct his Eighth Symphony, and asked Gropius to come to her there. The young romantic could not refuse. He waited for her in the entrance of the Hotel Regina, their trysting place during the orchestra's rehearsal hours. Alma had already announced a much longer separation: Gustav, pleading that he could not live one day without her, insisted that she accompany him to New York, where he would conduct the Metropolitan Opera. Making the utmost effort to salvage some time to be together, the lovers took every discreet opportunity to meet; Alma's train journey to the port of embarkation provided one such, and she planned carefully:

> Rendez-vous would be Munich.
>
> I shall leave Friday 14th October at 11:55 on the Orient Express from Vienna. My coupe-bed Number 13 is in the second sleeping car. I have not been to town and so I don't know your answer yet. I write and hope into the blue. I would advise you (if you are going) to take your ticket in the name of Walter Grote since Gustav leaves two days later and might have the lists of travelers shown to him. Please answer soon.[29]

Gropius traveled from Munich to Paris on the Orient Express for rapturous hours with Alma before her sailing.

She wrote almost immediately upon her arrival in New York and both promised and demanded faithfulness. Her desire was obvious: "Don't squander your lovely youth, which belongs to me. I

felt quite dizzy when I saw you and felt again what has made me so infinitely and singularly happy. I love you. I would like to say it as if I were your wife, were on a trip and were waiting for you. . . . Keep yourself healthy for me. You know why."[30]

Gropius's letters followed Alma to New York via general delivery. She responded ecstatically, attempting to recapture their passionate encounters. But separated, the lovers were depressed. Alma's mother, Frau Anna Moll, who had known of the love affair for some time, was sympathetic. A letter she wrote to Gropius indicates that she saw him as more than an ephemeral friend of her daughter: "That is the sadness, that one cannot do anything at the moment; one has to leave it all to a development over time — I believe firmly that with both of you, your love will last beyond everything. I have unlimited trust in you. . . I am firmly convinced that you like my child so much that you will do everything not to make her more unhappy."[31] The separation was made more difficult by the intermittent communication, caused by the delay of transatlantic mail and Alma's need for discretion in sending and receiving letters and cables.

The Mahlers returned to Vienna in late February 1911, and on March 28 Alma wrote to Gropius (signing "Your bride") reporting that Gustav, already living with a heart problem, had been ill with endocarditis for five weeks. The last twelve days had been so worrisome that Alma "literally did not get out of my clothes. . .was nurse, mother, and housewife." Though her feelings were "frozen," she knew they would "bloom again" when she saw Walter. "Love me with those feelings which have made me so tremendously happy. I want you! But you? Do you want me also?"

Mahler improved only enough to travel to Paris and a clinic in Neuilly. In letters dated April 30 and May 1, Alma asked Gropius to visit her, for she supposed she would have to remain there a long time. Mahler's condition slowly deteriorated, and she wrote of her "misery" that "such a noble man is struck down." But she also expressed her longing for Gropius's "warm, soft, dear hands" and thanked Gropius for his cable and his picture, which she kept secretly in her room.

In early May Mahler and entourage returned to Vienna, where he died on May 18. Despite her bereavement, Alma noted the coincidence of Gropius's birth date and saw it as a hopeful sign. During the period of mourning, she wrote daily letters to him, many of them while lying in bed, "sick" or "desperate."

Gropius's letters were sympathetic. On hearing of Mahler's death, he wrote immediately: "I mourn Gustav with a sincere heart. I knew him still too little as an artist, but as a human being he met me in such a noble way that the memory of those hours is inextinguishable in me."[32] This was hardly comforting to the young widow whose desire was for Gropius's presence, but his own father had died in mid-February and he had become somewhat distracted, if not depressed.

Nonetheless, he did visit. His encounters with Alma were passionate, their discussions serious. In one such meeting Alma trustfully recounted her complete attention to Mahler's need for love and tender care in his last days, perhaps hoping that Gropius would be empathetic and perhaps even admire her compassion. Unfortunately, at twenty-eight, Gropius lacked the understanding and the tolerance that would mark his later years, and he accused Alma of having become once again Gustav's lover:

One important question which you have to answer, please! When did you become his lover again for the first

Alma Schindler Mahler, circa 1910

time?...It is hard to credit the story that you followed him, cared for him, and looked after him until his end, but that you were not his lover. ...You have called your passion for me a mistake and said it only reflects on me....Like Tristan, I am too much the idealist. ...My sense of chastity, I have come to realize, is something overwhelming; my hair stands on end when I think of the unthinkable. I hate it for you and for me, and I know that I shall remain faithful to you for years.[33]

Returning to Berlin, he immediately received a worried letter from Alma. She apparently believed herself to be pregnant: "Yes, my behavior must seem strange to you. I am a puzzle to myself. Now, among other things, I fear that something might have happened to me and I rack my brain as to what I should do in that case."[34] But now memories pricked Gropius's conscience, and remorse set in, distracting and depressing him. He tried to avoid Alma to salve his sense of responsibility; he informed her that he could not meet her in Berlin on September 25:

A hot feeling of shame is welling up in me which tells me to avoid you. I want to go away for a while and test...whether I shall really be able to put my love into such beautiful form that it would be worthy of you if you would want it. Only this would balance the suffering I have caused Gustav and you on account of my lack of mature precaution. Today I do *not* know it and feel deeply saddened about myself.[35]

Their meetings became infrequent, though their correspondence continued uninterrupted. In November 1911 Alma wrote from Paris that her life had become regulated, that she had an apartment and Gropius should come to her. Gropius himself was unwell, suffering from "tooth poisoning" but also no doubt from the physical and emotional stresses of this extraordinary year. In December he entered a sanatorium near Dresden for treatment and rest. He reassured his mother, "I am quite well but I know now how feeble I really am and how necessary it is to have a rest." He thanked her for letters and books and reported that he took "lonely walks" by himself.[36]

He soon returned to Berlin and was joined by Alma. The visit was obviously a disappointment for her. She claimed that the city overwhelmed her, but animosity toward Gropius's mother and

his sister, neither of whom she had met, may have been the most important reason for her aversion to Berlin.

Following that late December visit, their correspondence became irregular, with Alma writing most of the letters. On May 18, the anniversary of Mahler's death, she recalled that her husband had been most intense and happy only at Semmering; she made no mention that this day was also Gropius's twenty-ninth birthday.

She repeatedly called for replies to her letters, and on June 3 she asked both "Why no answer?" and "Why don't you come to Vienna?" On November 21 she demanded the return of magazines she had lent to him and asked, "Aren't we beings who had understood each other fully?"

Gropius, who seems to have been depressed during this period, finally replied:

> I was glad that you thought of me with love. But I don't really understand the meaning of your words. You have drifted too far away from me and therefore the intimacy of mutual understanding has suffered. And you seriously wonder and ask, 'Don't these things grow?' No, it cannot be as it used to be; everything has become basically different now. Is it possible to change very strong feelings of togetherness arbitrarily into feelings of friendship? Would these keys sound for you if I played them? No. Too little time has passed since the days of most painful realization. I don't know what will happen; it doesn't depend on me. Everything is topsy-turvy, ice and sun, pearls and dirt, devils and angels.[37]

Little more than a year after Mahler's death, Alma met the painter Oskar Kokoschka in the home of her mother and stepfather. She made no mention of the painter to Gropius, nor of Gropius to Kokoschka. By Christmas 1912 the artist had created the very important double portrait of himself and Alma, an almost hymnic climax of their relationship, which was doubtless already an amorous one.

In 1912 Gropius had seen the works of Kokoschka at the newly opened Der Sturm gallery but was little moved by them. But early in 1913 at the Berlin Secession exhibition, he saw the portrait of Kokoschka and Alma and immediately grasped its significance. From that time until May 1914 there appears to have been no communication between the former lovers. Then Alma wrote:

> How do I live? — After fights and errings — I have come back to myself! I am more mature — freer — most of all I know that I don't have something to search for — because in my life, I have found as much — all. — I don't stop at any milestone. — If you want my friendship, you have it. I have a great desire to speak with you. Your image is dear and pure in me and people who have gone through so many beautiful and strange experiences should not lose each other. Come here if you have the time and the inclination.

The woman who used to sign her letters "Your bride" here signed herself "Alma Mahler (and nothing else anymore in this life)."[38]

The War Years: The personal and professional stresses soon took second place to political conflicts. On June 28, 1914, the Austrian archduke Franz Ferdinand and his wife were assassinated in Sarajevo. War was declared on August 1. A period of more than four long, almost unproductive years began for Walter Gropius, who, as a reservist, was immediately called into military service. The small Berlin office was left in the hands of Adolf Meyer to complete as best he could the projects under way. Meyer soon became involved in home front activities and closed the office.

The war began quickly for Gropius. On August 5 he reported to the 9th Wandsbeck Hussar Reserve Regiment, returning at the rank of sergeant major. There was a new spirit of camaraderie surrounding what was believed to be a brief exercise in mobilization. On August 8 orders were received from Berlin, and Gropius was permitted to telegraph his parents no more than "Tonight departure for France." The regiment immediately saw action in the Vosges in Alsace.

Assigned to field reconnaissance duties, Gropius was ordered to learn the locations of enemy troop concentrations. Evading the enemy patrols, Gropius and a few horsemen reached Mount Aubry overlooking a valley near Senones.

> I was trusted, together with six horsemen, to take over the patrol. We had to climb a thickly wooded hill…to find out whether a crossing was free of the enemy, if machine guns could be brought up, and how the whole left-flank of the enemy looked. I arrived at the summit, found the way free, set up sentries, and crawled on my belly up a neighboring height.
>
> Below me I saw the valley of the Meurthe. All roads in the valley were jammed with enemy troops. I had just enough time to make an accurate count when I suddenly received fire from the bushes and two enemy chasseurs appeared. I withdrew quickly and waited an hour with my horses.
>
> Then I tried another time on horseback to look into the valley and established that the enemy army had not changed its position. But now a whole chain of riflemen stepped out of the woods and gave fire. We dashed off without suffering casualties; they were shooting too badly. …A good deal of luck and the caution of the French were in my favor. I was able to send messages of such importance that they decided the day and perhaps more… .
>
> On the 14th we were in Belval. I was sent on patrol to find out if the road to Raon was free. I was to ride on until fired upon. In Raon I noticed the inhabitants were behaving strangely, and when I interrogated them with drawn pistol, I learned that enemy chasseurs had just passed through. When I had ridden 50 meters along the main road somebody opened fire from a house. A young corporal next to me was hit…but since they believed we were the first troops of a large approaching force they withdrew… .
>
> Early next morning I was ordered to cross the Vosges mountains with twelve men to watch the roads from Celles. Infantry was supposed to cover me, but when I got there, it was retreating and I had no cover.
>
> The enemy could easily strike out from Meyenmoutier and cut me off. In a case like that you can only swallow dryly and trust your luck. I had to penetrate a very thick forest; on the right was a deep abyss and on the other side steep heights; it was impossible to escape from the road. I got to an excellent observation point where I saw all movements of the enemy and sent back a detailed report.
>
> That night I returned to the infantry front line 9 km. behind me. A terrible ride in pouring rain, totally dark, with an electric lantern. …We spent the night in the muddy road, shaking with cold. No sleep at all.
>
> At dawn I had the horses fed and advanced again.[39]

Encountering and driving off enemy scouts by shouts and couched lance, Gropius and his patrol retreated when faced by a squadron of dragoons. Then, forming an ambush with his few lancemen, Gropius surprised the invading cavalry, killing by rifle fire, from only thirty feet, their saber-brandishing colonel and a corporal, and forcing the others to flee. Lacking infantry support, Gropius could not take advantage of the opportunity to capture the entire enemy force, and so rode back to his regiment. Less than a week following that successful patrol, Gropius was sent with a larger number of riflemen on another reconnaissance mission.

Receiving the Iron Cross, September 1914

During Monday night, September 21, I was awakened and told to leave immediately with 15 men for a reconnaissance ride from Senones toward Celles. ...I already knew this terrible wood and entered with a hammering heart.

The French were so well hidden that we could not see them. After the first fusillades I had the horses brought to safety and then took part with my men in the first infantry line. In one hour we lost 80 out of 300.

We had to lie there motionless until evening, when we received reinforcements and threw the enemy out of his entrenchments. Then I received an insane order, totally unworkable, to ride behind the enemy to establish communication with General Neubert near Celles. After ten minutes I came upon an entrenchment of felled trees which the horses could not pass. I asked for infantry help and a sergeant arrived with a group that removed the trees. Though he had explicit orders, the trembling sergeant refused to advance further. I was forced to put myself at the head of the infantry group and to let the horses follow us... .

We walked an hour through the night. Then a voice called out to us from twenty feet away. We had marched right up to the enemy sentries. Shots were fired at our column; my sergeant disappeared and I tried to bring the detachment back. The rest of the night I spent standing in the rain on the road. The cries of the wounded who had not been found dismayed me more than my own danger.

In the morning I was asked to keep up communication with my horsemen on the road. We were constantly shot at by marksmen in the trees and in the bushes. At night our reinforcements arrived; the French were routed...and we could finally leave this terrible forest. The infantry were all between 35-40 years old and still they beat active French "Alpenjager" in superior numbers. But what losses. I got out of it alive after two dreadful days and nights without sleep, steadily buzzed by bullets, and cries of the wounded and dying in my ears.

Gropius criticized the detachment leader as being irresponsible and wrote that only his own common sense and experience brought him back alive to the regiment, where he was received by the colonel, touchingly relieved.

I was hellishly worn out and in need of rest and in my sleep I still hear the cries... .

Yesterday night I was wakened and asked to appear on an urgent matter at the commandant. I thought they were

sending me off again, but this time it was something different. In the presence of all officers he presented me solemnly with the first Iron Cross in the regiment.[40]

For a very brief period, Gropius enjoyed a respite in Strasbourg and Moussey and luxuriated in the pleasures of heat, bath, food, sleep, and horseback riding in the peaceful countryside. But it soon became clear that this was not to be a brief military exercise. The drive that had carried the disciplined German armies through Belgium and across the Marne had been stopped. On September 9, 1914, a general retreat was ordered. There would be no quick end to the war in the west, and in the east the Russian forces were advancing.

On November 1 Gropius was promoted to lieutenant. Although the period of advancement in the German army for reserve officers was ordinarily three to four years, Gropius was recognized as a man of education and courage. And casualties among officers at the front had been high. He wrote his family:

> You can congratulate me again. Two days ago I became lieutenant with patent from November 1. It is much pleasanter to rank as an officer. My colonel who loves me has invited me to join his regiment, 6. Cuirassier, Brandenburg, after the war as a reserve officer. There are rumors that we may be sent to Belgium.[41]

His elation at this was short-lived. With the offensive blunted, Gropius's regiment was sent to bolster the entrenched front-line divisions. The corps was ordered to retake a hilltop stronghold from the French. A disastrous victory was achieved, and Gropius had little heart for describing it to his family:

> Victorious but with bowed heads we have descended today from our horrible mountain, where I have seen the war in its most terrible form. The best are dead, our wonderful captain and many comrades all gone. We, the few that are left, sit here, dulled and crying with enervated nerves. We are now being relieved after being under fire for eight days without any sleep.[42]

Perhaps a week or ten days elapsed before Gropius could describe the battle; this he did to assure his family that he had survived it with no real physical harm:

> On the 28 of December my company was slated to straighten out a totally mismanaged situation on the heights on Ban de Sapt. We went with heavy hearts because we knew we had to take a French trench which seemed impregnable. Through four days and nights without sleep we dug ourselves uphill, steadily covered with enemy artillery. On January first, a 15 cm. mortar grenade burst just in front of me. I was unconscious for some minutes and then got up, oh miracle, only covered with dirt. The shock was terrible.
>
> On January second we attacked. The French had dug through to a distance of only 7 meters away. Sending a mine into the enemy trench was the beginning of the hellish dance. Our captain chose the youngest of us to jump first into the enemy trench; I led the left wing of the company. Four different artilleries started shooting. Machine guns from both sides and terrible rifle fire.... .
>
> Our captain was shot in the heart right in front of me. There were no reserves so we had to stand up to it for one more day and night. We kept awake by smoking and we had to beat the men so they wouldn't go to sleep on their feet. When we buried our captain in Laitre we almost collapsed in misery and exhaustion.
>
> Much honor...but how dear this glory! From 250 men we are now down to 134. The grenade of New Year's Day had done nothing to consolidate my nerves, and at night I got the screaming jeebies. So the doctor has sent me back from the front for a few days.[43]

His convalescence was rapid, and he attempted to cheer his mother with the prospect of a rest

furlough: "I have a terrible longing for you, particularly for the children [of his sister Manon Burchard]; I try to visualize their little personalities; they are going to be bearers of the new period. A hug and a kiss from your son, who is cheerful again."[44] The field hospital's doctor reported that Gropius's condition of "insomnia caused by nervous tension" was temporary and that he required rest before returning to the front.[45] He was moved to a hospital in Strasbourg, and then in January 1915 to Berlin, where he was sent on convalescent leave.

At home he found newspaper accounts of the Cologne Werkbund exhibition, which gave considerable recognition to the innovative architectural work of Gropius and his rise to prominence in the Werkbund. There was also an accumulation of mail, including a note written by Alma Mahler on New Year's Eve: "Will the time ever come when I may take you here, here where you measured my floor with your steps?"[46] After a silence of a year and a half, Alma had resumed writing to Gropius in the spring of 1914, when her relationship with Kokoschka began to lose its zest. (Even a new double portrait of the lovers failed to delight her. This portrait, now famous as *The Tempest,* was exhibited in Munich in May 1914 and caused an immediate sensation.) Lonely, she had written to Gropius in Cologne on May 24 that she would like to meet him in July. Gropius's response to her subsequent urgent pleas is unknown, if indeed he responded at all. Then, in the first euphoric days of the war, when the Germans swept into Belgium and France, Alma learned of Gropius's whereabouts from the newspaper stories of his heroism, and in no little excitement and anticipation she wrote to him in Strasbourg: "I will come to Berlin if the Germans march into Paris!"

Gropius responded to Alma's New Year's letter, and in late February they were reunited in Berlin. The love affair was quickly rekindled, and it became just as quickly known, for Alma, the widow of the great Mahler and recent mistress of artist Kokoschka, was a person of interest to salon gossips and newspaper columnists.

In the next months their meetings were infrequent because of the war. Gropius's military duties were exacting, and he accepted them with a grave sense of responsibility. He again distinguished himself by his courage. On March 12, 1915, he was awarded the Bavarian Military Medal IV Class with Swords for bravery while serving as a ground observer in a rash effort to locate the enemy by deliberately drawing fire upon himself. He reported, "The bullets have veritably circumscribed me: one through my fur cap, one into the sole of my shoe, one through the right side of my coat, one through the left."[47] Gropius was soon back at the front in the battle for Nancy-Epinal on the Moselle River line.

Alma and Gropius wrote to each other daily, and very emotionally. On May 2, 1915, Alma noted that exactly five years earlier she had traveled to Toblach, where she met Walter. Also that month, apparently uncertain whether she had become pregnant, she greeted him tentatively as "husband" and signed herself "wife." She was a bit uncertain of his response, but tried to assure him that everything would work out: "I am with you, not away for a second — go about with the one idea — it may have happened now. Our wildness makes me tremble...[it] was so heavenly."[48] Within a few weeks Alma found that she was not pregnant, but she had decided that marriage was what she wanted:

I am thinking that if you get a furlough, I shall go where we can meet in the quickest way. I shall bring my papers

and we will get married — without anybody knowing anything about it…I shall remain your wife incognito until you return and give me your protection… .

Alma Gropius! Alma Gropius!

Look at that! Isn't it lovely! Do write this name again in one of your letters. Want to see it written by you. Gropius! Foreign name — lovely fantasies on a moonlit night. …I am glowing and cannot sleep.[49]

Manon Gropius continued to make her disapproval of her son's liaison evident, both in her letters and when Gropius was on furlough in Berlin. Alma's character and life-style were alien to the North German mentality, and his mother was embarrassed and anguished over the affair. She wrote Gropius that there was not "the slightest hope for some understanding" and she was thinking of leaving Berlin to avoid "bitter words which would separate us."[50]

Despite his mother's misgivings, Gropius and Alma visited her in Berlin to attempt a reconciliation. None was achieved. After the visit, his mother wrote that "the embattled days passed here with you and Frau M. were like a whirlwind roaring over me. I was left bowed and exhausted."[51] The couple evidently told her of their plans to marry, and she stubbornly continued to write to her son in unhappy protest. He responded in the strongest words he had ever addressed to her. Though he acknowledged his love and her good intent, he recognized the distance and discord between them:

I am of your blood, have been raised in the school of your opinions, know them all, and therefore understand them…all these venerable views that today lie partly petrified and withered in you, I have tried in a *young* life to test their present-day value, to discard the flawed and shortsighted, to expand their limits and, in short, to adapt them to our *new* day and therefore to our justified way of life.

He reminded his mother of his lifelong struggle against convention, her own acceptance of the traditional, her belligerence, and her lack of understanding: "My philosophy of life which now shocks you need not have taken you unprepared, and my marriage to a woman who possesses the greatest inner freedom would have appeared a logical part of my development." Finally, he asked her to

write a few words to my dear Maria, who suffers from your disapproval. But for God's sake do not call her "Du," since this would be the symbol of an inner relationship that has not yet been accomplished. But I think your words would fall on fertile ground now, and then you too could share our happiness instead of standing aside without joy and sympathy.[52]

His words clearly struck a chord, for she responded to Gropius's outburst with a conciliatory letter to Alma. She wrote, "May I call you with this beautiful name [Maria]? Walter writes so much about his dear Maria, that it appears unnatural to me to address you formally."[53]

Despite all the obstacles, Gropius and Alma were secretly married in Berlin on August 18, 1915. His leave was for two days only; he then returned to the Moselle and Alma moved back to Vienna.

The tone of Alma's letters to Gropius changed almost immediately. She fretted about the secrecy of their marriage and expressed disdain for his family and for Berlin. She complained about the extra work and expense resulting from the endless stream of guests, at the same time that she claimed the guests were necessary to divert her. She bewailed her separation from him and had become almost oblivious to the war and to Gropius's military responsibilities.

To a soldier in the trenches, Alma's "sufferings" must have seemed trivial. Still, he did not forget her thirty-sixth birthday and sent an onyx necklace, a family heirloom. Her pleasure in it was great — and childlike:

> Yesterday the necklace arrived, which makes me mad with joy. I find it so wonderfully beautiful that I wore it at night in bed. Cannot leave it alone; I shall always, always wear it. It arrived just as [illegible] and Baroness von Ler were here and both were eaten up with envy. Such a sweet thing! I don't deserve it.[54]

Despite constant assurances, Alma had an almost paranoid concern about Gropius's fidelity. From the beginning she could not bring herself to trust him during his long absences. In a letter written in July before their marriage she appended, "Though my Walter hasn't written to me today, I trust him." In an August letter, she added a postscript: *"Demand of me what you want and only of me!"* In September she pleaded, "Mutzi, don't do anything bad!...Let's face this terrible trial honorably which was imposed upon me for my fickleness and on you for your weakness."[55] Her moods were changeable, and in another letter she mocked him: "I know nothing about you anymore, cannot remember your face. Know nothing about our sweet joys of love, but they must have been beautiful. How will it be. ...You wrote today about *December!* So that will mean *4 months!*...I cannot be content with eating bread soup."[56]

Despite the war, civilian institutions carried on, and despite Gropius's military service, the architectural community had not forgotten him. (Indeed, the Bund Deutscher Architekten had written in October to congratulate him on the award of the Iron Cross.) So when Henry van de Velde, director of the Grand-Ducal Saxon School of Arts and Crafts[57] in Weimar, was asked to resign because he was a Belgian national,[58] Gropius was one of three men he recommended as his successor, despite basic differences in their approach to art, architecture, and education.[59]

On April 11, 1915, van de Velde wrote to Gropius to sound him out. Reacting favorably, Gropius immediately wrote to his mother:

> Now to the most important thing — strictly between you and me — the enclosed letter came from van de Velde. I had first decided to say no, but after giving it a lot of thought I came to the conclusion that I cannot simply drop this offer. Such a position would give me strong backing and the possibility of being entrusted with interesting commissions. So, after telling van de Velde about all my scruples, I said yes. The administration will probably be less than happy with a *homo novus.* Muthesius, who is influential there, may be quite glad to get me out of his proximity, or, just as likely, may trip me up. I shall watch and wait.

He asked his mother to assemble newspaper clippings and publications about him and his projects, photos of completed work, and old Werkbund Yearbooks, all materials that had been requested by van de Velde.[60] This she did, and she expressed her approval, regarding the invitation as a great honor, but noted her fear "that Muthesius might want to trip you up out of vengeance."[61]

In July van de Velde wrote again, this time to explain that the grand duke had decided to close the School of Arts and Crafts on October 1. The Ministry of the Interior had been instructed "to establish a new institution that would benefit the industry and craftsmen of the Grand Duchy" but would not integrate instruction in the arts. Van de Velde felt that, given these events, the directorship was "no longer a position suitable" for Gropius.[62]

Delivery of van de Velde's letter was delayed some six months as military assignments took Gropius from place to place. In the meantime, Gropius had heard, in confidence, from Fritz Mackensen, then director of the Grand-Ducal Saxon Academy of Fine Art, also in Weimar, about the fate of van de Velde's school.[63] Mackensen wrote at greater length in October, this time urging Gropius to head a new architecture program at the Academy of Fine Art. He was not, he wrote, "shedding a single tear" over the dissolution of van de Velde's school, for he felt that such schools are "very seldom institutes that really advance the applied arts" and that "architecture, the important element, was neglected," with the result that the curriculum had a "feminine character" and the students created "trivial" work.[64]

In a follow-up letter Mackensen insisted that van de Velde's school was "dissolved against my wishes" and that he was committed to "sav[ing] what there is to save." Mackensen envisioned an architecture program that retained van de Velde's "active cooperation with the handicraftsmen" but that had the "more generous, artistic, and architectural approach" that only an art academy could provide. "Architecture, after all," he wrote, "develops from the study of nature, as do all arts that contribute to it. Therefore, the spirit that lives in a real academy of art, devoted entirely to the study of the visible wonders of nature, is a source of perpetual renewal for an architecture department."[65]

Gropius's reply was succinct. He felt that something "gratifying" could develop out of Mackensen's idea, but he wanted assurances that architecture would not be an adjunct of other programs but an independent school. He wanted freedom to move in new directions: "You spoke of a small, independent architecture school. …What I envision is an autonomous teaching organism. …On all essential matters I would be able to work well only according to my *own* ideas. …The *absence of restrictions* must be an explicit condition."[66]

Alma, too, had her say about the prospect of her husband becoming affiliated with the Academy of Fine Art; much of her advice was shrewd and her views perceptive:

> Mack[ensen] is a *liar.* I remember that he wrote in his first letter that he wouldn't shed a tear for the dissolved 'Kunstschule'.…According to his behavior now and his affirmation that he always stood up for van de Velde, it becomes *clear* to me that *he* helped expel v.d.V. I would not trust this man. … This position is not so grand. You should enter into it only if they give you all the authority you ask for in *writing.* Not to speak about money and title is Aryan super-*noblesse* which will be a drawback later on. …I would demand, before you commit yourself, to speak to the grand duke himself, since your contact, M., is not to my liking. Reasons that make me think of Weimar in a rosy light will be silenced if I would have to think of you in a subordinate artistic position.[67]

Shortly thereafter Mackensen stepped down as director of the Academy, and his correspondence with Gropius stopped. There was very little that Mackensen could (or would) do to further his appointment.

Gropius was called from the Vosges in January 1916 to meet in Weimar with the grand duke and duchess of Saxe-Weimar, the chief of staff, Freiherr von Fritsch, and various other government officials on the subject of the school. He was met at the gatehouse of the seventeenth-century Schloss and escorted through elegant halls and galleries, up the magnificent grand staircase, and across successive salons, each richer than the next, to the opulent private chambers of the duke.

The meetings were apparently satisfactory, and Gropius returned to his military duties. He immediately sent an optimistic telegram to Alma, and she responded with evident pleasure and a typical determination: "Your telegram of today put a bright ray of happiness in my heart! Weimar! I would like that *best!* A small house to rent there and to *begin,* away from relatives and friends....My God, that would be lovely. See that it gets done!"

In the rare hours when he was free of military duties and not worn out, Gropius began to develop ideas for the Weimar school and to correspond with the duke through his chief of staff, von Fritsch. At the latter's request Gropius drafted an extensive statement dealing with his goals for the school, the needs of the public, the kinds of students, curricula, the teachers he hoped to have, and other aspects of education.[68] In these proposals Gropius outlined the need to substitute mechanical methods for handwork, once the artist and the craftsman had collaborated in design. The industrialist and businessman would, given the economy of the technological processes, accept the artistic.

Gropius also called for careful selection of students already experienced as either artists or craftsmen, with special classes for those lacking skills. Industrial shops *outside* the school would be used to develop actual projects, thus saving money and eliminating the fear that school workshops would enter the marketplace with their products. Much later, Gropius would explain:

> I was perfectly aware that I had to be clever to write something that would not make the Chamber of Crafts in Weimar suspicious, because I knew that they would be reactionary. Thus I kept to rather general terms, and the...answer of the chairman of the Chamber of Crafts has proved that I was right in holding back. Already at that time I knew that the erection of workshops would be a definite necessity.[69]

Gropius also understood that, given the schools, the tradition, and the culture of Weimar, and the nature of the grand duke himself, real change would be a slow, step-by-step process. In 1915-16, he was certain that he had the stamina needed and the ability to conceal his impatience.

Gropius received a number of encouraging letters following the submission of his proposals, but he was again in the front lines, and the grand duke and his chief of staff were preoccupied with civil affairs in support of the military effort. There was little time for thought, let alone communication about the school. Negotiations were tabled until the end of the war.

. Wartime demands notwithstanding, Gropius still deemed it important to pacify his mother about Alma. "It seems...I have run away from you with seven-mile boots and have disappeared from your range of vision." He tried to explain why they kept the marriage secret, a secrecy she considered improper: "My wife is of a very sensitive nature; and the idea of public formalities is intolerable to her. ...Why should she be exposed, alone, to all this in Vienna, where she, as a well-known personality, would be much more affected than any one of us?" It could hardly have been reassuring to the older woman to read: "We two see in conventions a necessary evil, but a great evil nonetheless, not a joy."[70]

Manon Gropius attempted a reconciliation with her new daughter-in-law. Given Alma's sharpness in letters to him, it was evidently rejected. She raged:

> This is the first letter from your mother which comes from the heart, though from a narrow-minded one. ...She

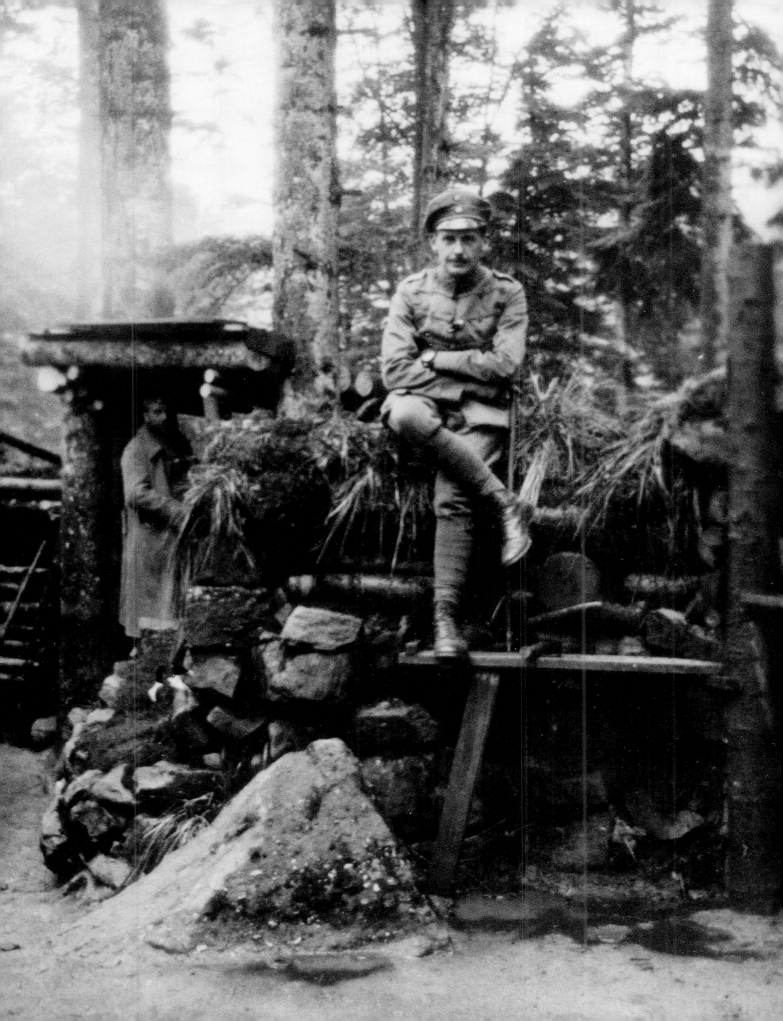

is very greedy for power and very passionate. . . . You go ahead with writing her your good, brave letters. . . Then your good relations will soon be restored, . . . Be all son!! As before, without telling her about your real life's aims. She is not capable of understanding any of them. . . . Tell her that the doors of the whole world, which are open to the name Mahler, will fly shut to the totally unknown name, Gropius. [Ask her] whether she has ever thought of what I have to give up with my present position. . . . There are a thousand *Geheimrate* [Walther Gropius's position before his death in 1911] around, but there was only one Gustav Mahler and there is only one Alma.[71]

Alma's letters formed a mélange of endearment, nostalgic yearning, complaints and bitterness, and trifles of the day. Arriving as they did in the stress of battle, or the uneasiness of stalemate, they could hardly have lifted Gropius's spirits. In another unsettling letter she announced that she would not stay in his apartment when she visited Berlin nor would she call on his mother. She warned him not to "fall back into the Philistine allée," again denigrating his family: "When I realize where you come from, then I admire and love you all the more."[72]

The correspondence within the Alma-Walter-Mother triangle continued to be intense. To Alma's plaint that his mother did not call on her at her hotel in Berlin, he diplomatically did not remind her of her own earlier insistence that there would be no visits. He asked her to end the bitterness; "the dawn will arrive presently." To her demand that he change the date of a furlough to fit a scheduled social occasion, he responded by admonishing her that they should thank God for whatever time they had together and that others would have to remain to face the enemy.

Happily, a furlough was granted and Gropius hurried to meet Alma to celebrate their first Christmas together. The war seemed remote from Vienna in the Christmas season, and that his respite was a joyous one is vouched for by the letter he wrote his mother upon his return to the front:

Now I am again orphaned among strangers, and live from the blissful memories of this happy time. I was welcomed in Vienna with such warmth and friendship that I don't know how I deserve so much love and joy. . . . The child [Anna Mahler] loves me with touching devotion. . . .

Maybe you begin to feel what great soul lives in my beloved wife, who gave you such fright first. I have only one great wish: that I may be able to live up to her expectations. She will make of me everything possible with her steady longing for perfection.[73]

He returned to the Vosges with understandable reluctance. There he found at field headquarters packages of food and letters from his mother, Gerhard Marcks, himself a veteran of the siege of Antwerp, Peter Behrens, and others. In sending his thanks to his mother, he attempted to use the opportunity to improve her opinion of Alma. Unfortunately, the letter, which began in a moderate tone, ended in a near-tirade in which he attacked her fear of "strong originality, willfulness, paradox (the mark of Cain in all talented people)" and of "Alma's strong, sovereign manners." He further chided her, "Everything peculiar about me that did not trot along the beaten path surprises you and you reject it with an uneasy feeling. This finally has resulted in your seeing me as a totally different person from what I really am."[74]

Despite her "great soul" and "sensitive nature," Alma was not above taunting Gropius with her magnetic appeal to men. She wrote with pride: "I enclose this letter from S. . . so you can see what a good, brave person he is. . . . That my beauty makes such an impression on him, I didn't know; he is in absolute control of himself." Though she implied these romantic opportunities were

sacrificed, her innuendoes could hardly have pleased Gropius: "Tomorrow Hassmann is coming. But you can be at ease. Neither he nor anybody else can ever be a danger to me. Besides, he *never* was. He is in Vienna during a short furlough. He is a first lieutenant, but he can be gay and we shall play some music together."[75]

At the beginning of February 1916, Alma found that she was pregnant. She joyously informed her mother-in-law, who wrote immediately to congratulate her and invite her to Berlin. For some weeks Alma was in high spirits, obviously moved by her condition, which seemed to her to bring Gropius closer. As yet she had made no public announcement of marriage and pregnancy.

In her letters to Gropius she continued to describe her milieu — friends, shopping, music, the attendance and gifts of musicians and conductors — and wrote of her disdain for Kokoschka, the not yet noticeable pregnancy, and the happiness the baby would bring. The war is rarely mentioned, but to give her the benefit of the kindest interpretation, perhaps this was intentional, meant to provide Gropius with at least a moment of surcease. Still, if this were true, not all her correspondence was designed to ameliorate his worries. When he wrote about the progress of the construction of a porch he had designed for her house in Semmering, she replied caustically, furious with his preoccupation:

> Sometimes you are very strange — one might also say d[umb]…!
>
> "Has the porch been enlarged to the dining room windows?" This is written by an architect — or one who would like to represent himself as one — to his pregnant wife, during the war, and for my house located at a height of 1000 meters. That boggles my mind. In peacetime and if I were in full health, such a reinforced concrete terrace would be a fatiguing enterprise because everything is more difficult here and I can get workmen only with great effort — but now! This thoughtlessness makes me wonder. *Such inconsiderateness!* If I were so foolish as to try to do such a thing, you should do everything to prevent me from going ahead with it. Open doors, drafts, dirt, strange men in the house — but mainly danger of getting overtired. And this you never realized. And *you* want to carry out a practical profession while you have no idea how much you can demand of a person! And you want to be my support while you burden me carelessly with unnecessary tasks!…
>
> As dear as your letters are, this has shocked me…because consideration is what I *demand* of you. Tell me what other kinds of labor I can perform for you? Maybe the alteration of the janitor's house?[76]

Gropius had had another narrow escape while serving as an observer for military intelligence and was able to limp away from a crashed plane in which the pilot was killed, but she was shielded from this news. None of the battle stories with which Gropius regaled his family were related to Alma — she was to be protected.

Alma had time for introspection and concern for her health and that of their unborn child. Though she had experienced pregnancies previously as Mahler's fiancée and wife, she was now without a husband at her side, and her fears were understandable. But without someone constantly at hand to listen to her worries, she conveyed them to Gropius in daily letters. These were also recitals of her great love as well as of her suspicion of his infidelity. "I am very sensual, long always for unheard of things. Want to suck you in from all sides like a polyp. Stay true to me!…pour your sweet stream into me, I am starving."[77]

She also had heard that almost everyone home from the front had a venereal infection. She

Alma, about the
time of her marriage
to Gropius

wished to be assured that he had been faithful to her: "Walter, please tell me by everything that is holy to you whether you have ever been untrue to me since we got married? Tell me the truth. I suddenly have such fear! I want us to meet pure in body and spirit."[78]

It is understandable that Gropius, intent on preparing for the future while dealing with the exigencies of the war, and always beset by fatigue, would sometimes be hasty in his correspondence. Going and returning without sleep to Bamberg to attend a Werkbund board meeting and to discuss an architectural competition for Turkey, he sent Alma no more than a brief penciled note. Her reaction was anger, exacerbated by her mother-in-law's teasing about his failure to write appropriately or to telegraph. She wrote "only because…nature is begging for you" and complained, "No argument can apologize for you though; one may not forget a wife…because of duties. …You begin to forget me! All right, my soul has wings, don't forget that!"[79] And he was not permitted to forget; in at least three subsequent letters Alma continued to scold him, to threaten an end to her own correspondence, and to insinuate her own opportunities to attract other men. "I have not had a letter from you in five days. …You never thought of that and left me alone. …I am really angry. If you are unfaithful to me, I shall do the same. Remember that! And I always find partners! Only at this time I am not keen on it."[80]

Her loneliness was briefly lifted by a visit from Gropius's mother. This time the meeting had a most salutary effect on Alma, who exulted, "Now she really knows that you have not made a misalliance…I have the feeling that we have come close to each other. Yes — even more, I have learned to love her.…Please let me know what she reports about her visit and about me." Unfortunately the older woman could not conceal her skepticism among her compliments:

> You have obviously found a real treasure, and a rare and fine human being with rich inner resources has become yours…even if many of her ideas, habits and views are foreign and strange to me. Her being very spoiled in every way worries me often…in many ways I very much admire her because she is intelligent and overwhelming. …I admire how Alma has been able in her unquiet life to keep this child her daughter so unaffected and really childlike. I never saw anyone of such a manifold nature.[81]

Alma's recently discovered affection for her mother-in-law vanished rapidly. She considered Manon Gropius to be extravagant to the point of megalomania in her shopping and in her maintenance of her large home, and neglectful in overseeing her son's apartment and other affairs. She besieged Gropius with denigrating stories, and hints of discord slipped from his mother as well.

The tensions between the two women could scarcely have left Gropius anything but depressed. The war was not going well; this was the summer of the inferno of Verdun, with the British and French launching their breakthrough efforts at the Somme. Returning to headquarters from the battlefront, Gropius wrote in a bitter mood to his mother:

> I am livid with rage, sitting here in chains through this mad war which kills any meaning of life. …Defeat is hard to take for a man. The war will ruin people. The duration destroys the nerves of the more sensitive people. The mood of the front against the government is becoming dangerous, thank God, and may these miserable writers of notes become bankrupt before all of us. Everybody should do his part in this.
>
> I found some letters from Alma which tell me that she is miserable. I don't know what to do, my nerves are shattered and my mind darkened.

His depression would lift with belated news of Alma: "Just now a telegram: 'Arrived in good shape and I am much more cheerful now in spite of the heat.' A hundredweight slid off my shoulders."[82]

Alma's love was as volatile as her temper; occasionally it dominated her letters, though her understandable loneliness was evident. Alma's friends attempted to amuse her, to provide comfort, and to lessen her loneliness: "The gaiety of Schrecker [the composer] is like medicine for me. And his wife is in no way disturbing…must surround myself with serenity. …Our child hops happily around in my belly and I am happy whenever I feel it. I love you. That it is your child is my happiness."[83]

The war dragged on and the young lieutenant conscientiously devoted himself to his prescribed military duties, which increased greatly when on September 1, 1916, he became the adjutant of the regiment. Leave from the front was granted infrequently, and Gropius's appearances at home were rare and brief. One such furlough had been granted to permit him to be with Alma at the estimated time of arrival of their firstborn. Unfortunately for Gropius, the baby met neither medical nor military schedules. After seventeen days he had to go back to the front.

On October 5 he wrote impatiently to his mother, "This child shows no wish to appear in this world gone mad. What am I to think of that?" A postscript appended the next day contains his first response to the news of his daughter's birth:

> Now my child has entered this world. I don't see it, I don't hear it; only a short telegram tells me of the birth after difficult labor. I cannot feel happy as long as I don't know about Alma's condition and I wait with chattering teeth for what fate has in store for me, who is so miserably helpless.

Within days there was the news he awaited: "Thank God the first letters bring good news. My joy is overwhelming, I am proud and happy and want to embrace the world. …Imagine, Alma's first words were: 'Now I also want to have a boy.'"[84]

Gropius got a leave to go home and see his daughter. According to Alma, "He had come from the French front, traveling all night in a locomotive to squeeze in a few hours in Vienna out of two days leave, and had hurried home directly from the station." Alma's welcome was less than cordial, however: "When I saw him, grimy, unshaven, his uniform and face blackened with railroad soot, I felt as though I were seeing a murderer." Repelled, she would not let him hold the baby:

> I stood in front of the swaddling table on which the baby was lying and refused to let him approach her. …Only after long pleading did I allow him to glance at his child from a distance.

Much later, Alma rationalized her own behavior:

> Instinctively…I would not let him share possession of the child because my fears had come true — because my feelings for him had given way to a tired twilight relationship. I, for one, could not sustain a marriage at long distance.[85]

Gropius at that time was far too distracted and weary to sense Alma's attitude; but his joy in his daughter was boundless. His two-day leave passed altogether too quickly, and he returned hastily to the front, promising that he would, no matter what, return for the christening at Christmas time.

Alma, too, was happy and her letters soon began again to reflect her renewed health, a revived social and musical life, and her love for her children and Gropius. She wrote of a new determination to endure their separation, and reported on her visitors, her piano playing, the opera, her shopping,

and strolls. There was a note of contentment in her letters at this time. This feeling persisted, and on his return for his Christmas furlough and the christening (which none of his family attended, giving the excuse of travel difficulties), Gropius conveyed some of the new spirit to his mother in his description of how he, Alma, and the two children lived "in the greatest inner harmony."[86]

Indeed, Alma now shared her happiness with her mother-in-law, whom she now addressed as "My dear Mother" and to whom she described the elaborate candle-lighted christening ceremony that Gropius had arranged. The infant, burdened with five names (Manon, Alma, Anna, Justine, Caroline) would have the protection of almost as many godmothers (Gropius's mother, Alma's mother, her sister-in-law Rose, and her daughter Gucki). She continued, "I see from your presents…that you really love me somewhat," and she encouraged her mother-in-law to visit in Gropius's absence.[87]

Alma struggled to maintain her equilibrium, her happiness, and her position; under the circumstances, and for her particularly, it was difficult. She pleaded with Gropius for an end to their separation, and she offered to move to Berlin within a week. Now even his mother would be welcome. Again she worried about his faithfulness: "I beg you to be true to me in every respect. I am determined to do the same."[88]

When Gropius did manage to obtain a more reasonable furlough, the baby was already almost six months old. He was infatuated:

> The child is simply charming. I am totally in love with her. I didn't recognize her at first, she had changed so much in the three months when I didn't see her. She is lying next to me and sings endless songs, like a little twittering bird. She is a cheerful child and full of vivacity. And very pretty though she looks so very much like me. Alma nurses her almost completely and performs amazingly well, taking care of the child without any help and at the same time finding occasion for music and social life. I felt I was in paradise and I enjoy these beautiful days which will draw to a close so soon.[89]

Inevitably these rare days ended. Gropius's new assignments were varied: the Somme, other western theaters, and a communications school at Namur, Belgium, where methods of military communications were developed. He wrote:

> I have been appointed as teacher for communication affairs for generals and general staff members….I am installed here now and very much according to my wishes. I live with my group in an abandoned Belgian castle near Namur which has been raided inside but presents the most beautiful and grandest sight I have ever beheld as far as location, gardens and terraces are concerned.[90]

Though a subsequent letter does not explain how Gropius progressed from a "castle" to a "peasant's house," it does indicate the diminishing resources of food and human energy:

> I have a nice room in a peasant's house and very independent work. Almost nobody checks up on me. My task, apart from the dog training school, is to coordinate the different communication means, like light signal apparatus, signal throwers, homing pigeons, etc. We eat rather dreadful food in a small casino, turnips and so-called liverwurst. This is more the fault of the indolence of the gentlemen around here and I shall change all that. But we can hardly complain when we think of the situation at home, which is so much worse. There *has* to be an end of it all this year. Our reserves of nerve power are used up, and we live off the capital.[91]

The work in communications was going well, and his every letter referred to its progress: "My

school has become a very big thing and we have to stand up to the critique of the whole army from West, South and East. I shall probably go to Italy on special orders and hope to go on to Vienna to see Alma."[92] His purpose in Italy, besides integrating communications, was to train Austrian soldiers in the use of dogs as message carriers under fire. For this effort he received an Austrian military decoration.[93]

But the separations and infrequent reunions of war had already proved to be unbearable for the restless and self-pitying Alma. In October 1917 she met the poet-novelist Franz Werfel. She soon became infatuated and then deeply involved with this man eleven years her junior. She was able to conceal her romance from Gropius when he came from Italy to Vienna on Christmas leave on December 17, 1917. Though the affair was bruited about and savored in the Vienna and Berlin cafés, Gropius would be among the last to know of it. Instead, writing to his mother early in January following his return to the Siegfried Line, he reported a happy Christmas with Alma and of his intent to "seek in Baden-Baden accommodations...for Alma who plans to move there with the children to be nearer to me."

Happy though his furlough may have been, it was not sufficient to divert Gropius from thoughts of the uncertain future. He confided in his friend Osthaus:

> Little by little I'm crumbling inside. . . . I've got to get away from here for a while and do some work at least, otherwise I'll be ruined as an artist and — be entirely forgotten by the world. . . . I don't want to be buried alive and must therefore get mightily busy so that the people see that I'm still here.[94]

Gropius had never become inured to the carnage of battle, and his reassignment to war zones between Soissons and Rheims early in the new year depressed him:

> Now I have returned to the gray world which I find almost unbearable. I feel that I am mentally reduced and my nerves are getting worse. All this should not go on much longer so that we shall be able to save some strength for the heavy peacetime fighting.[95]

Gropius seems to have unconsciously sought an outlet for his pent-up frustrations. Reflecting the prevalent attitudes of the German upper classes, Gropius made Jews the international scapegoat, identifying them as the source of all of Germany's economic, political, social, and spiritual problems. It should be recalled that profiteering was rampant in the last years of the war, particularly in Vienna, where Gropius had spent his Christmas leave in 1917. In a letter to his mother in January he gave vent to a strange outburst that was a contradiction of his actions and friendships throughout his life — an outburst born of a desperate search to give meaning to war and no doubt also reflecting his anguish at the waste of his talents and the frustrations of his relationship with Alma:

> We can fight battles as much as we want to but the weaklings and the pigs at home will destroy everything we achieved. The Jews, this poison which I begin to hate more and more, are destroying us. Social democracy, materialism, capitalism, profiteering — everything is their work and *we* are guilty that we have let them so dominate our world. They are the devil, the negative element.[96]

So unnerved was he by the war that he numbly received Alma's announcement of another pregnancy: "About Alma's new condition I cannot feel joy yet. The conditions are too desolate and I am afraid of the future."[97] It is an ironic response, given that, unknown to him, the child was not his but Werfel's.

Gropius's sensibilities were further exacerbated by Alma's letters bearing complaints and woeful stories of civilian hardships. Her complaints streamed steadily, monotonously, to those she believed would respond. Now she wrote "My dearest Mama Gropius" seeking sympathy and encouragement. She was depressed about her pregnancy — "as happy as I was the first time, as desperate I am now" — and complained about "our precarious situation, Walter's uncertainty, the travel difficulties, the steadily worsening food situation, Walter's growing inability to help me." Alma's letter to her mother-in-law appears, in retrospect, to intimate and excuse her infidelity: "The endless war with its excitements and the fact that Walter is not with me has resulted in my concentrating more and more on myself. This is sad for both of us."

Manon Gropius replied quickly, again inviting Alma to Berlin. The invitation was not accepted, for Alma reported that she was busy with her social plans, which even the war could not interrupt: "In spite of all the difficulties I shall give a big party for forty people in honor of Willem Mengelberg [the Dutch conductor]."[98]

As the Germans achieved some success in the war, Gropius's spirits momentarily improved. In April he reported to his mother: "I am very well in spite of fatigue and dirt. The battle looks so favorable that it lends us all wings. . . . I have taken part in the entire battle of the Oise as observation officer and have just returned from the freshly taken positions to hear about the successes at Arras." For a moment he could look ahead: "If I take a teaching position it must be one where I myself give the direction. I wouldn't work in the frame of a fixed school that doesn't seem at all to be run in a contemporary spirit."[99]

But there would be little respite within which he could dwell on more than survival; despite these successes in battle, the war was being lost; Gropius, now deeply involved in tactical moves, could not see or know what was taking place everywhere else. He was exhilarated by his latest battle:

These last days were full of incredible events. I returned just now from the Marne. I was in the middle of it from the beginning. Everything turned out so well as we couldn't have dreamed it. I was in front of the thousands of cannons and the night of the 27th was indescribable. Foch's renomée is lost now since he so badly miscalculated. I am well, though I do not have the nerves of 1914. Sleep is luxury, we eat day or night whenever possible. This is not yet the end but we have made enormous steps forward.[100]

Again he was wounded and hospitalized. On May 20, 1918, he received the "insignia for wounds received in combat."

In no way could injuries or awards distract him for his war-induced concerns. Weary in body and spirit, personally impoverished by the war, concerned for the well-being of his wife and the children, he railed against his fate in a letter to his mother, written during a short furlough to the military hospital in Vienna, where he was able to visit Alma and his daughter:

For four years I have given my all for this insane war and have lost, lost, lost, while a lot of those at home fatten themselves on our backs. I have the greatest desire to turn tables on them because I do not want to sink into the proletariat and I am near to it... .

What a gloomy fate to have to sacrifice everything that makes life worthwhile for an ever more doubtful patriotic ideal!

We have had no bread for two weeks; one can only buy things at black market prices. I rack my brain over what

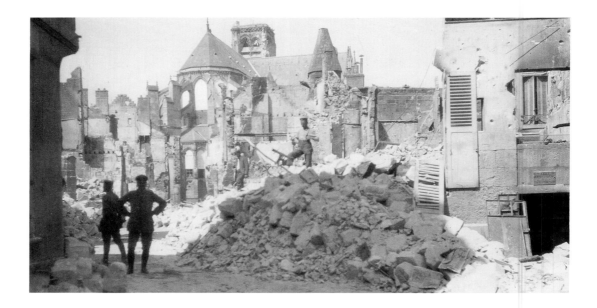

On the Soissons-
Rheims front, June
1918

is to become of us...I am near the poverty line. I shall now go to Berlin, take my furniture out of storage to put it all in the big atelier to save money and then I shall rent my place. My pride does not permit that my child be raised by money that another man [Mahler] has made. ...You have obviously never given a thought to my economic situation. It has surprised me, for instance, that you gave away one of my suits to the janitor, though I asked you not to do so. Such a thing is now worth 300-400 M. I had long speculated on this and was glad still to have some supplies. You grandly give away something of mine while I turn every penny in my pocket, never smoke, never invite anybody, in order to send everything home to Alma.

In no uncertain terms he insisted that his mother request advice from Alma, who "does everything with foresight and clarity." He was concerned, however, that, being several months pregnant, she might overstrain herself, and he worried about his inability to make life easier for her:

You cannot imagine what it means to put a child into this world right now and to look after it. The whole life style becomes bigger and there is nothing to sustain it. ...If Alma weren't so full of touching noblesse...I could not bear this passivity to which I am condemned.[101]

He was soon recalled for service at the front lines in France. Within hours of his reporting, he was buried alive in the collapse of a supposed stronghold during a bombardment in a battle between Soissons and Rheims. He was the only one of his contingent to survive, thanks to the existence of a nearby flue that opened to the air above the debris. It was here that Gropius reviewed his life and heritage.

In the stillness of dawn of the third day following the onslaught, the German troops left cover and returned to search for and bury their comrades and to abandon the no longer tenable position. Hearing Gropius's now fading calls for succor, they picked their way through the avalanche of debris, removing the stones and timber which had both pinned and saved him. Soon after he was in a field hospital, where arm, chest, and head wounds were given rudimentary treatment.

Mail, several months delayed, reached him in the hospital. One letter was from the School of Arts

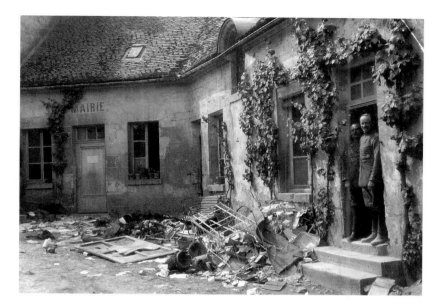

Town hall on the Soissons-Rheims line after the bombardment of June 1918

and Crafts in Hamburg, whose director, Richard Meyer, invited Gropius to fill an established teaching post there. Gropius's reply recalls his earlier one to Mackensen in 1915:

> First of all I thank you for your kind offer of April 10th, 1918. I waited for the printed matter which you announced, but it did not arrive. I thought over your inquiry very thoroughly, but I cannot decide to say yes. I cannot imagine myself fitting into an existing curriculum. I am too self-willed for that and have had my own very definite ideas for a long time, very different from the existing ways, as to how architecture is to be taught. On this one cannot compromise and I see no other way out but to continue my efforts to found a school program of my own.[102]

Meyer's invitation cheered Gropius; it was the third he had received during the war. He was encouraged to learn that institutions of higher learning, weary of their war-restricted programs and of the war itself, yet believing in Germany's ultimate destiny, were also planning for the period to follow the always imminent victory. But he was determined to set his own course. Convalescing from shock and injuries received in battle, he now had time to think about the kind of educational program he would offer were there the opportunity. More realistically, by mid-1918, with almost four years of intense service behind him and the end of hostilities not yet in sight, he still worried deeply about the future.

Gropius had been notified that Alma would probably have a difficult birth, and his request for a transfer to a military hospital at Semmering was granted on July 28, 1918. A few days later, on August 2, Alma prematurely bore Franz Werfel's son. In a letter to his mother, Gropius described the entire episode:

> This last week has put deep furrows in my brow; I feel as if years have passed. …One morning I was called to come immediately with a gynecologist to Semmering. The next train got me there…[It would be a most dangerous operation, and Alma was moved to Vienna.] First in a carriage and then in an empty cattle wagon on the train I brought Alma, the midwife and the doctor safely to the sanatorium. It was a breech birth but mother and child survived… .

At such moments one learns to understand what the most important thing in this world is, and I have lost all understanding for our war madness... .

To lure me back they have given me the Iron Cross first class and have offered me my own horse at headquarters, but too late. I no longer care. Somebody else has to stand in the breach now.[103]

And a few days later he continued: "During all this time I stood with admiration before Alma's bed. This control, this standing above it all, always thinking of others, not of herself. She has a great, magnificent heart and it is no accident that people love her so much. She deserves it."[104]

Little more than a week after this letter was written, Gropius inadvertently discovered that the child was not his own. On August 25 he overheard Werfel and Alma talking on the telephone, addressing each other in most intimate terms. Gropius, hardly recovered from battle wounds and fatigue, was momentarily stunned and silent. Then his anger flared, and he forced the pair into a reluctant confession. Blaming Gropius for his absence, Alma's reaction was as much self-justification as an admission of guilt. Many years later she wrote, "Walter crumpled as though struck by lightning."[105] He was resilient enough to regain his composure, however, for Werfel reported that Gropius was in control of himself, more concerned with the survival of the premature and ailing baby than with the dalliance of his wife and the writer. Later that day Gropius called on Werfel; not finding him in, he left a cryptic and inexplicable note: "I am here to love you with all the strength at my command. Spare Alma. The worst might happen. The excitement, the milk — if our child should die!"[106] The next days passed slowly for Gropius, who moved like a somnambulist in hours of numbness, moments of self-incrimination, furtive conversations with Alma's mother, earnest discussions with counselors-at-law.

Suddenly Gropius's furlough was cut short, and personal problems were set aside. With iron discipline, he returned hastily to the battlefront between Aisne and the Marne. Despite the defeat of the Russians and the punitive treaty of Brest-Litovsk, the war was not going well for Germany in the west. Disaster followed disaster, and communication with the front was disrupted. Gropius was now a disaffected member of the elite Wandsbecker Hussar Regiment and did not admire the military as a class. But during the war the conduct of the military was not to be questioned, and the political, social, and economic conditions were accepted without hesitation. In a letter to his mother, Gropius recounted an incident which made him recognize the myopia of the military. He overheard General Ludendorff say, when informed that the United States had joined the Allies, "Americans? Bah! Barnum and Bailey!" Erich Ludendorff, as chief of the General Staff, was an extraordinary tactician, yet his brilliance as a strategist was entirely within the theater of battle and not in geopolitics, where his ambition lay. Furthermore, his attitude was not an uncommon one. Until this incident, according to his sister, Manon, Gropius was politically conservative and somewhat naive. Now he no longer believed that after the war all would be as before.

The real military and political condition of Germany was kept from its citizenry. True, military casualties had been large but spread across the population, and for the Germans they were still offset by the glory of "dying for Kaiser and Fatherland." There had been stalemates, but these were counterbalanced by earlier victories. Even the failure of Ludendorff's last great offensive, in March

1918, was rationalized. There was austerity, but this, too, appeared to be in accordance with the wish of the kaiser.

The end of World War I came suddenly. Hindenburg and Ludendorff asked for an armistice on September 28-29, 1918, and by October 28 Germany was in turmoil. It began in Kiel, where sailors had refused to embark on a last desperate enterprise of the High Seas Fleet. Within a few days mutiny changed into revolution, which soon spread throughout Germany. The kaiser fled to Holland and twenty-two princely houses were deposed.

The debacle was now complete for Gropius. More than four years of indescribable hardship, horror, and waste were capped by the defeat of his country, revolution, spiritual fatigue as well as physical disability, the loss of his family, and the destruction of the traditions and order ingrained in him.

WEIMAR AND THE BAUHAUS
1919–1925

By November 9 the Revolution of 1918 had spread to Berlin. From a window of the Reichstag on that day, Germany was proclaimed a republic. Yet, there was continued unrest — a general strike and street fighting in Berlin and elsewhere. Two leaders of the extreme leftist Spartacus League, Rosa Luxemburg and Karl Liebknecht, were imprisoned and then murdered on January 15, 1919, by officers of a volunteer "freecorps," formed from among irregular gangs of sailors and soldiers and augmented by extremists serving conservatives and rightists. The "free-corps" suppressed the revolution, the workers' councils, and other efforts to take over the government.

Director's office, Weimar Bauhaus, 1920

On January 19, 1919, elections for a National Assembly took place. In February the assembly, with the majority Socialists in power, elected Philipp Scheidemann prime minister and Friedrich Ebert temporary president. The absence of a strong central government and the proliferation of councils, leagues, and parties led to anarchy. Nevertheless, the National Assembly provided representation in the drafting and approval of a constitution, and in August the Weimar Republic was established to cope with the problems of a fragile society. Unfortunately, the new government was more tolerated than accepted by the right. The removal of the government to conservative and peaceful Weimar was significant.

From the middle of the sixteenth to the end of the nineteenth century, the history of Weimar was formed by personalities of the highest intellect: Lucas Cranach, Johann Sebastian Bach, Johann Wolfgang von Goethe, Friedrich Schiller, and Franz Liszt, among others. Unfortunately, little of their spirit remained in Weimar after World War I; the dedication of a Friedrich Ebert was lost in a welter of selfish ends. Yet, the prevailing outlook was a positive one.

The Postwar Era: Also looking toward Weimar was Walter Gropius, who had returned to Vienna after being released from military service on November 18, 1918, with the rank of lieutenant.[1] He was then $35\frac{1}{2}$ years old to the day — the age at which he later believed an architect would begin to show his greatest development, combining training and experience with maturity. In October he had been in Berlin on medical leave from the Aisne-Marne front when the revolution broke out. Suddenly, "as in a flash of light," he realized that he had to bring himself into line with a new era

Formerly conservative, he now became progressive. "After the war," he remarked later, "it dawned on me...the old stuff was out."

Gropius's most pressing personal problem after his release was his family. On November 4, 1918, Gropius had asked for custody of his daughter, Manon, suggesting that Alma, Franz Werfel, Gucki, and their infant son, Martin, remain together. Alma dramatically refused. Martin was ailing grievously and almost every letter after his birth had carried references to "Bubi." "The little boy is very large and strong but the head has grown too fast and he is mentally retarded. ...The doctor hopes, I hope," Alma wrote in November to Manon Gropius.

The problems only multiplied. The revolution and the "Red Guard" of the literati had involved the naive and willing Werfel, and it was Gropius who warned him that he was sought by the police. By the end of November, Gropius "had gone to Germany to build us a new life," according to Alma's autobiography.[2] Yet in mid-December she could also write in her diary, "A glorious night! Werfel was with me. We clung to each other and felt the deepest oneness of our loving bodies and souls."[3]

Throughout this period, Gropius's faithful letters to his mother contain no references to Alma that would cast any suspicion upon her. Though he was unemployed and was drawing upon rapidly diminishing capital, it appears that for the sake of his daughter, Manon, if not out of love for Alma, he tried to keep the family together. A month out of the military, he described his straits in a letter to his mother: "I have seen lots of people and keep searching and searching to finally be able to create a nest for my family. I can hardly imagine anymore that this might become reality."[4]

Alma, too, was frustrated. But her frustration was with the entangled circumstances in which she found herself. And she concealed her impatience hardly better than Gropius did. In her letters to his mother, despite the constant presence of Werfel, she was only the worried mother, the faithful, loving wife, and the devoted daughter-in-law. She apologized to "My dearest Mother" for not writing more frequently, pleading her worry over the infant's health, Gropius's inability to find work, her postponed move to Berlin, their clouded future.[5]

Preoccupied with Werfel and their ailing infant, Alma had become increasingly indifferent to Gropius's feelings. Her letters grew infrequent. Unable to contain his resentment any longer, he finally protested her unresponsiveness, her unwillingness to join him in Berlin, and Werfel's continued presence in Vienna:

> I expected most of all that you would send Werfel away. You promised me when I left that you would ask him to go away so that I could find peace, and he himself told me that he would depart in a few days for Germany. I believed in that, but nothing of the sort happened — empty words.
>
> You go on living with him, you see him daily, also at Christmas, and you never let me know anything about it. Your fate is that you want to do justice to everybody, and therefore, you cannot do it to anybody in the long run.[6]

Despite his anger toward Alma, Gropius felt only sorrow and pity for the infant Martin. He reported to his mother in a letter written the same day that "the boy had been given up by the doctors. The punctures brought no improvement and the little brain remained dark." In early March Alma informed Gropius that there was no hope for the infant. "The day before I gave him to the clinic I had him christened: Martin Johannes, but he will never be called by that name."[7]

Later that spring, Gropius traveled to Vienna for a brief reunion with his wife. The visit was far

from joyful. Alma was caught up in a constant round of entertainment, Werfel was nearby, and the infant Martin was no better. Gropius did see his three-year-old Manon and Alma's daughter Anna. At one of Alma's soirées, he met the artist Johannes Itten, who would later become a colleague.

In the months following his demobilization, Gropius's efforts to reestablish his architectural practice in Berlin served as a means of escape from his domestic situation. He met with his past patrons, seeking new commissions and looking to the revival of those interrupted by the war. Karl Ernst Osthaus had not forgotten the young architect and immediately came to his aid. Gropius was appreciative, writing:

> From you comes the first ray of hope for my work, which I must thankfully acknowledge. For the past 14 days I have been storming through Berlin, looking for some job or another, but until now entirely without success, and I am already in despair about how things will turn out. After 4½ years most of the footprints one left behind have been wiped away.

Almost as an afterthought, he added:

> I am working on something entirely different now, which I've been turning over in my head for many years — a Bauhutte! With a few like-minded artists. ...I ask you to keep quiet about it until I have spoken with you face to face, otherwise the idea, which requires gentle discretion, will be trampled in the economic turmoil before it's able to live.[8]

This letter, with its reference to a *Bauhütte* — the medieval masons' lodge — and its implications for a future Bauhaus, also suggests Gropius's growing awareness of political realities. During the war, the resentments that had been growing unconsciously within Gropius over earlier experiences — the serf-like existence of the peasant farm workers on the estates of the east, the class disparities of Spain, the superciliousness of his fellow Wandsbeck cadets, the rapid promotion in rank of the elite and the demeaning treatment of conscripts in the military, the bestiality of the battlefronts — became vivid and conscious to him, and his anger became overt. The Junkers and aristocrats were not the only members of society upon whom he heaped his frustration and wrath. In a letter to his mother written two months after demobilization, Gropius raged against the landowners of his own family in Pomerania and Posen, attacking them as relics of an obsolete society:

> I have been in Matzdorf for Uncle Erich's funeral. The atmosphere around these relatives was so foreign to me that I looked in vain for anything of mutual interest. I was totally alone among them. They are excessive in the agrarian hatred, obstinately prejudiced and full of arrogant political megalomania, without ever looking at their own faults. They see only what is coming down, but not what is growing up. They know nothing about the mental processes of humanity and don't want to pay attention to it. Yesterday I was invited for dinner at Uncle Felix's but I simply cannot do that anymore.[9]

Walter Gropius was not the only member of his family who had suffered in the war. Of some twenty-five cousins who served German military forces, six died in combat. Yet he believed that those who had survived combat as well as those whose lives had been relatively unaffected or even advantaged by the war had learned little from the experience, felt no responsibility, and recognized no change. His frustration was only deepened by his own crisis and by the chaotic events of the months following his demobilization.

His anger surfaced in his defense of a stratum of society whose condition and viewpoint he had only begun to understand and appreciate. He responded, for example, quite uncharacteristically sharply to a comment by his mother about the murder of Rosa Luxemburg and Karl Liebknecht:

> Your judgment resembled that of most everybody. Have you ever read anything about them and have you tried to understand what they want? They were pure idealists who lived and died for their ideas as few people do. Unfortunately they made the same mistake as their rightist counterparts and used force. That was their tragedy. I am sure that the mean murder of these two will do us great harm abroad.[10]

Such outbursts were, however, infrequent. Ordinarily, Gropius was able to find more constructive outlets for his energies. Soon after coming to Berlin he had written his mother:

> I have come to orient myself and to take part in new artists' organizations. I shall have a meeting with Heinrich Tessenow and Bruno Taut concerning the Arbeitsrat für Kunst right now.[11]

This organization, formed in Berlin in the winter of 1918-19 by a group of architects and artists, sought the public's acceptance of innovative art and architecture and greater participation by artists and architects in the social and cultural programs of the new government.[12] Adolf Behne was secretary and Bruno Taut its first chairman. Initially Gropius was a member of a four-man management committee along with Cesar Klein, Otto Bartning, and Behne. Before Christmas 1918 Gropius worked with Bruno Taut on a manifesto, "Program for Architecture," which mentioned the recurring theme of Houses for the People, high-rise housing:

> The building is the immediate bearer of spiritual powers, creator of sensations. Only a total revolution of the spirit will create this building. … The beginning of large People's Houses not in the cities but on open land in conjunction with housing developments. …These buildings…cannot stand in the big city because it, rotten in itself, will perish just as the old power. The future lies in the newly developed land, which will nourish itself.[13]

The manifesto proclaimed that artistic and social regeneration could best be achieved through a new architecture, and it called for community centers composed of hotels, restaurants, and buildings for theater, music, and other cultural activities, located in the open countryside between cities. It prescribed well-planned housing developments, street patterns, and city quarters and called for councils consisting of architects and landscape architects who would advise on city planning.

Gropius's talents for organization and leadership were soon visible within the organization, and when Taut resigned over the failure of his political program, he became chairman. He wasted little time in putting the stamp of his own personality on the group. In March, three months after assuming his new responsibilities, he boasted to his mother:

> The 'Arbeitsrat für Kunst' gives me real joy. I have turned the whole thing upside down since I became chairman and have created a very interesting lively thing out of it… .
>
> All important modern artists, architects, painters, sculptors under one cover…all come to the meetings and that is incredibly beautiful and animating. …This is the type of life I have always had in mind, but the cleansing effect of the war was necessary for it.[14]

During Gropius's tenure as its leader, the Arbeitsrat für Kunst grew in membership from about forty to over one hundred, and with the constant turmoil over its purpose and program, it provided a focus for actions which would otherwise have been dissipated and ineffective. The Arbeitsrat für Kunst was not without competition. Another progressive organization had been founded in

Mountains for Living, utopian apartment project for the Crystal Chain, 1919. In the night view, plantings on the terraces are silhouetted against the illuminated glass walls.

November 1918 by Mies van der Rohe, the sculptor Rudolf Belling, and four other artists of Herwarth Walden's avant-garde gallery, Der Sturm. Though not formally organized until December, the group assumed the more symbolic name "Novembergruppe" and summoned "revolutionary" and "radical creative" architects and artists to join forces.[15] Its manifesto called for collaboration on architectural projects as a matter of public concern, reorganization of art schools, establishment of folk art museums, public exhibition spaces, and legislative aid for art. Although Gropius was not a member of the Novembergruppe, he attended several meetings. The two groups merged in November 1919, but the merger dissolved, because of internal disagreement, in the late spring of 1921.

One of the most unusual of Gropius's early studies dates from the early days of the Arbeitsrat and reflects the influence of Taut's utopian vision. His utopian "Mountains for Living" *(Wohnberge)*, hurriedly prepared in sketch form in the frenzied opening weeks of 1919,[16] resemble huge mounds of great height and length rather than undulating or peaked hills. They consist of regular and pyramidal sections of some thirty stories of housing. The dwellings within the mountains are of four types: for a single person, two persons living "joined in love or work relationship," families with children, and the elderly. Gropius, visualizing a change in social order, wrote that in these Mountains for Living the individual woman or man is the social unit of a more perfect society rather than of the state or family. Family duties as such would not exist; elimination of all housework would provide equal leisure time for both sexes. Women of equal capabilities would have the same earning power as men.

At the same time, the members of the Arbeitsrat für Kunst were examining their own efforts to establish a common basis for the unified work of artists and architects. In the early weeks of 1919 the Arbeitsrat placed an advertisement inviting artists and architects to submit visionary projects for a proposed exhibition. The *Ausstellung für unbekannte Architekten* (Exhibition for Unknown

Architects) was organized "because we wanted to know where the new men are" and "to discover new thoughts."[17] Gropius wrote vividly for the catalogue:

> We walk throughout streets and cities and do not wail for shame over such wastelands of ugliness! Let us be clear about this: these gray, hollow, spiritless shams in which we live and work will be shameful testimony to the spiritual descent into hell of our generation, which forgot the great and *only* art: *Architecture*. ...Buildings that satisfy purpose and necessity only do not satisfy desire...for that unity of spirit that soared to the miracle of the Gothic cathedral. ...But there is only one comfort for us: the *Idea*, the building up of a bold, glowing, far-reaching Idea of a Building, that a happier time, which must be to come, should fulfill. Artists, let us tear down the walls that our misguided book-learning put up between the "Arts" and *all become Builders again*! Let us want, invent, create together the new concepts in building. Painters and sculptors...let us become co-builders, contenders in the final goal of art: to conceive the cathedral of tomorrow, in which architecture and sculpture and painting will again be united in *one* form.[18]

The exhibition, its selections made by Gropius, Max Taut, and Rudolf Salvisberg, was shown at several locations in Berlin beginning in April 1919.[19] It featured utopian schemes by Taut, Hans and Wassili Luckhardt, and Erich Mendelsohn, among others. "In giving physical form, however fanciful, to the architectural aspirations of the Arbeitsrat für Kunst," according to Iain Boyd Whyte, "the exhibition provoked a critical furor. It also brought together a group of radical designers and artists from various parts of Germany who were later to form the Crystal Chain."[20]

The members of "Die gläserne Kette" were selected by Bruno Taut, who, in a letter of November 24, 1919, invited fourteen people from among the exhibitors and his circle of established architects to engage in a secret correspondence. "Let us consciously be 'imaginary architects,'" he exclaimed. "We believe that only a total revolution can guide us in our task." He envisioned "an exchange of ideas, questions, answers, and criticism" that would help the correspondents "gather our strength" so that "when building begins again we shall know our objectives and be strong enough to protect our movement against misinterpretation."[21] He asked each member to select a pseudonym, to protect them from "uncomprehending eyes," and the correspondence began on December 19, when Taut circulated the list of pseudonyms.

Gropius, who had tried to restructure the Arbeitsrat as a "conspiratorial brotherhood,"[22] readily accepted Taut's invitation and chose the pseudonym Mass, "meaning measure, proportion, even restraint."[23] However, he never contributed to the correspondence, although he "followed it with interest...and made comments in private letters to Taut."[24]

The program that Taut and Gropius had developed for the Arbeitsrat für Kunst, which found expression in the *Exhibition for Unknown Architects,* a later exhibition *New Building,* and in the more utopian deliberations of the Crystal Chain letters, coincided with that of the Weimar Bauhaus, which Gropius was also formulating during the early months of 1919.

The Founding of the Bauhaus: The matter of the directorship of the Weimar academy had been in suspense for two years, during which Gropius had continued to develop his ideas on art education and on the unity of the visual arts under architecture. In a letter of December 1918 to his mother, he said of the Weimar position: "If that should materialize, I would prefer it to anything else."[25]

He sought advice from Ernst Hardt, director of theater in Weimar, for he was concerned that

individual teaching positions had been filled while the directorship remained open, and thus the school lacked the unity a strong leader — an architect — could provide:

> The present tendency to fill the single artist-positions and to keep the director's position vacant until the end is, of course, insane. A useful unity and work team with a common goal — the comprehensive art of building, to which originally all "arts" belonged — would be only possible if first of all a far-sighted architect is called in and if then his proposals for the nominations of other teachers are followed objectively and without compromises. Such a community, a long-ago example of which I envision to be the medieval building lodges, could become a center of creative activity.[26]

Immediately upon receipt of an encouraging response from Hardt on January 31, 1919, Gropius wrote to the Provisional Government, reviewing his 1916 discussions with the grand duke. He was immediately invited for a new interview within a few days. Fortunately, Freiherr von Fritsch, the deposed grand duke's Oberhofmarschall, had been retained by the new government and was thus able to provide continuity.

Gropius's new plans — far broader in scope than those he put forward in 1916 — called for the amalgamation of the Grand-Ducal Saxon Academy of Fine Art with the Grand-Ducal Saxon School of Arts and Crafts. No one had previously suggested combining the two institutions and some time was required for consideration of the startling proposal. On February 28 Gropius explained the goal of his combined school and submitted a budget, noting that there would be no immediate income from the arts and crafts section as the former school's "productive workshops" had been dissolved. He wrote:

> I also point to the importance of a proliferation of the crafts and industry in the state of Weimar as a result of the remolding of the schools in accordance with a craft-oriented, practical approach. With the workshops that are to be newly established working in close cooperation with the master studios which are at hand, it should be possible to build a working community of the collective artistic disciplines, which, out of its own resources and working in closest contact with the existing crafts and industries of the state, should eventually be capable of producing everything related to *building*: architecture, sculpture, painting, furnishings, and handicrafts.[27]

Two weeks later von Fritsch indicated his approval. On March 20 Gropius requested that the combined schools be called the Staatliches Bauhaus in Weimar and persuaded the reluctant Fine Art professors to agree to this reorganization and name.[28]

Moving swiftly ahead, Gropius grasped at another opportunity. The building that had housed the School of Arts and Crafts had been used for a hospital during the war; now it stood vacant, with large spaces suitable for workshops. Gropius quickly proposed its conversion to this use, and permission was granted.[29] He announced his good news to his mother:

> The engagement in Weimar is now concluded. I achieved a great deal through my hesitation. Every time they dodged issues I left again and then they asked me back. I have now the direction of van de Velde's Kunstgewerbeschule and also of the Academy of Fine Art and I want to make one integrated Institute out of it, after adding an architectural department, under the name of 'Staatliches Bauhaus in Weimar.' I get 10,000 M salary, rent-free ateliers and a pledge for State commission which I was particularly interested in. Begin on April 1st. ...I was offered the title of 'Professor,' which I declined, a thing you probably won't understand. ...I know what I want and what I must do and I have decided to keep free of these ridiculous external things which no longer belong in our time."[30]

On the following day, April 1, Gropius concluded a formal contract.

Gropius's first thoughts were for the faculty. He inherited faculty from the old Academy of Fine Art, including professors Richard Klemm and Walther Engelmann and painters Max Thedy and Otto Fröhlich, but wanted to bring in teachers who shared his philosophy.

His first appointment was Lyonel Feininger, who had lived at Weimar at various times over the period 1906-14 and was already a noted and accomplished artist. Though he and Gropius had known each other only since their introduction at a Novembergruppe meeting in the winter of 1918-19, there was already mutual respect.

Feininger was assured that he would have complete freedom, and he accepted Gropius's offer with delight. With more than the ordinary understanding of the school's goals, he assisted Gropius in the preparation of an announcement, the first Bauhaus Manifesto, describing the school and its purposes. The cathedral design by Feininger for the cover of this four-page leaflet was as romantic as the text was lyrical:

> The ultimate aim of all visual arts is the complete building! …
>
> Together let us desire, conceive, and create the new building of the future, which will embrace architecture and sculpture and painting in one unity and which will one day rise toward heaven from the hands of a million workers like the crystal symbol of a new faith.[31]

This manifesto announced seemingly simple but in fact revolutionary ideals: it would reunify all "practical arts" — defined as "sculpture, painting, handicrafts, and crafts" — under the primacy of architecture and combine the roles of artists and craftsmen. This was the basis of the Bauhaus pedagogy.

"The school," the manifesto proclaimed, "is the servant of the workshop," in which students receive "a thorough training in the crafts," as the "indispensable basis for all artistic production." In place of the usual teacher-pupil structure, the Bauhaus adopted the relations of masters, journeymen, and apprentices. Instruction was to include "all practical and scientific areas of creative work," and students would be "trained in a craft…as well as in drawing and painting…and science and theory." The manifesto made no mention of the preliminary course, which was later to become the cornerstone of the teaching method.[32]

There was an immediate response to the declaration of the school's goals. Already in April prospective students appeared at Gropius's door in such numbers that he decided on an early opening. Later that month, Gropius noted simply in a letter to his mother the actual beginning of classes under his direction, "Tomorrow I shall be in Weimar again; the semester begins and I have to make my first steps."[33] Many years later, Gropius wrote, "The success of the Manifesto speaks for itself; young people came from Germany and from abroad, not to design 'correct' lamps, but to participate in a community that wanted to build a new man in a new environment and to liberate the creative spontaneity in everybody."[34]

There was no inaugural ceremony for the Bauhaus; students applied, were interviewed, and were assigned to one workshop and those classes that were ready to receive them. Over a period of two years, additional workshops were formed as new faculty arrived and space was prepared. There was much improvising and more enthusiasm. It was a hectic time that seemed to bring out a great strength in Gropius.

Lyonel Feininger,
"Cathedral," cover
for the first
Bauhaus manifesto,
woodcut, 1919

Sculptor Gerhard Marcks, whom Gropius had known since boyhood and had invited to Weimar, was already there in April, searching for suitable facilities for a pottery workshop and developing Gropius's charge that he "unite handiwork with art." Unfortunately, there was too little space, too small a budget, and no interest or cooperation from the Weimar stove maker Schmidt, who had kilns. Nor did the potters of nearby Bürgel show interest, though Gropius tried to persuade them by offering them apprentices and a Formmeister, Marcks, in charge of design. By summer of 1920 an arrangement was made with Max Krehan, a potter at Dornburg on the Saale, a distance of 45 kilometers from Weimar. This meant a certain isolation of the "Dornburgers" from the rest of the Bauhäuslers, but this was welcomed by Marcks. The workshop emphasized ceramics as a craft and in this sense was anti-industrial.

In the summer of 1919 Gropius invited Johannes Itten, whom Alma had introduced to him in Vienna in March of that year, to join the Bauhaus, even though he was not well known as a painter, and known only locally in Vienna as a teacher. Itten visited Weimar that summer and accepted Gropius's invitation to begin teaching in the fall semester.

Itten was placed in charge of the *Vorkurs*, the required preliminary course that was intended to rid students of preconceptions and to give them a sense of the specific qualities of materials as diverse as paper, glass, and wood as well as an understanding of basic principles of form. The value of this course was initially difficult to define; it would be more consciously manifested in other, more product-oriented, courses. In the spring of 1920 Itten's first students, protesting that they were artists, entered the workshops as apprentices to test the theories of the *Vorkurs* by learning a trade. The validity of these theories was immediately evident in the design qualities of the workshop products.

An additional benefit was the cohesiveness between teacher and student that developed in the *Vorkurs* and in certain other courses. Gropius wanted this attitude to pervade the school. He invited everyone to participate in the establishment of a Bauhaus identity; a seal for the school was the subject of a design competition held in 1919.[35] Other activities, such as team recreation, designed to build up a community spirit, were offered.

From experience and from discussions between Gropius on the one hand and the political bodies and crafts organizations of the city and the state on the other, the ultimate purposes and program of the Bauhaus were distilled. The Bauhaus, a state institution, was not intended to compete with either craft or industrial production but to act as a laboratory. Gropius hoped to convince the traditional craftsmen that their future did not lie in continuing to carry out artists' designs on paper, but rather in training a new generation of craftsmen to work out the designs and details of production models which would then be given to industry on a licensing basis.[36]

Gropius never considered handcraft training an end in itself, but only as the first step in acquainting students with the tools and materials that would enable them to understand machines and their processes. Over the years, workshops were established for stone- and plasterwork; woodwork, carpentry, and joinery; metalwork, including gold- and silversmithing; ceramics; wall painting, house painting, and color decoration; stained glass; weaving; theater; wood and stone sculpture; and the graphic arts. And though no formal course in typography was offered, there was

abcdefghi jklmnopqr stuvwxyz

an emphasis on typographic design throughout the school, which Gropius credited to László Moholy-Nagy, Herbert Bayer, and Josef Albers, who developed an alphabet. That alphabet reveals the school's skeptical attitude toward all previously accepted practices. German writing, with all its capital letters for substantives, presented a real speed obstacle for the typewriter, which required special manipulation for every capital letter used. So, in the lower left corner of the Bauhaus letterhead-diploma designed by Bayer is the following: "to save time, we write everything with small letters, and besides: why use two alphabets if we can do the same with one? why write with capitals if one cannot speak with capitals?"

In principle, the Bauhaus represented an opportunity to extend beauty and quality to every home through well-designed industrially produced objects. It was, in fact, distinguished from other schools in that its program would go far beyond the drafting boards to the actual workshops, to industry, to the consumer.

Unable to find anyone who could teach both design and technology at the same time, Gropius brought the best technicians into the workshops and put each workshop under the leadership of an artist who worked hand in hand with them. Both artist and technician provided some special emphasis, but always as part of a whole complex. Later, when former students were appointed masters, this separation of roles became unnecessary. The Bauhäuslers, as these students came to be called, were both creative artists and schooled technicians.

Except for a very few who were considered gifted as painters and sculptors, every student was required to go through workshop training and sign legal articles of apprenticeship. After three years of workshop activities the student took the journeyman's examination in his field, and also an examination in design capabilities before the Bauhaus faculty. Only after fulfilling these requirements was the candidate a full-fledged journeyman and able to secure a diploma from the Bauhaus. At this point he could proceed to the study of building, the core of the curriculum. In any case, the

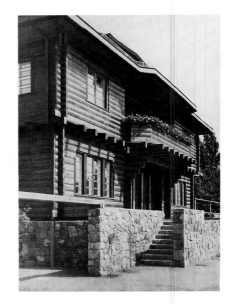

House of Adolf Sommerfeld, Berlin-Dahlem. 1920–21. Gropius with Adolf Meyer

Bauhaus training satisfied not only all public requirements but also its own special design requirements. If the graduate's artistic abilities did not provide a livelihood, he could still work as a journeyman.

Architectural Practice: Following the war, Gropius had picked up the threads of his private practice. He received approval from the state to have his architectural office in the school at Weimar. Adolf Meyer, also appointed at the Bauhaus as a teacher, had rejoined the office, and Carl Fieger, a graduate of the Mainz Kunstgewerbeschule, assisted as principal draftsman and detailer. Ultimately there would be ten to twelve people working in the Weimar office, of whom two-thirds would be Bauhäuslers, most of them apprentices.[37]

One of the early commissions was for a house in Berlin-Dahlem for lumber merchant Adolf Sommerfeld, whom Gropius first met in 1920. It was designed quickly, and employing students from the carpentry shop, which Gropius conducted, construction was completed in 1921, in the most dismal postwar time.[38] Sommerfeld had purchased the teak paneling and timber of a dismantled warship that was to be scuttled, and this was used to build the house. Gropius gave Joost Schmidt and the students wide latitude in the interior design; this was the first opportunity for the students in the workshops to show their skill in designing stained glass windows, sculptural reliefs in wood, metal screens, and lighting fixtures. Gropius left them to themselves in order not to dampen their eagerness.

The Bauhäuslers' enthusiasm was at least equaled by the pleasure evinced by Sommerfeld, who immediately commissioned Gropius to design row houses, also of wood; these were built in Berlin by Sommerfeld's own firm. Gropius subsequently proposed a great complex of lumber warehouses, yards, and offices for this rapidly growing firm; the wood construction of the buildings recalled the original Sommerfeld house. This project was abandoned in favor of Sommerfeld's most ambitious

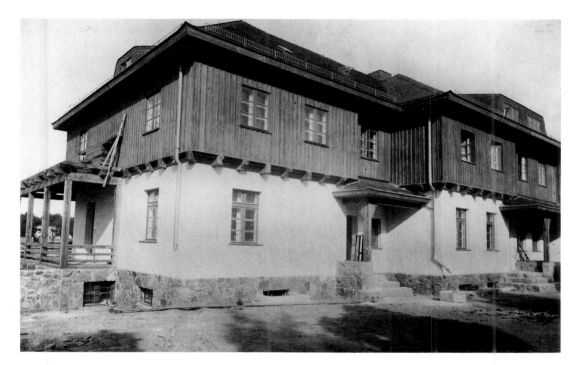

Row housing for
Adolf Sommerfeld,
construction nearly
completed, 1921

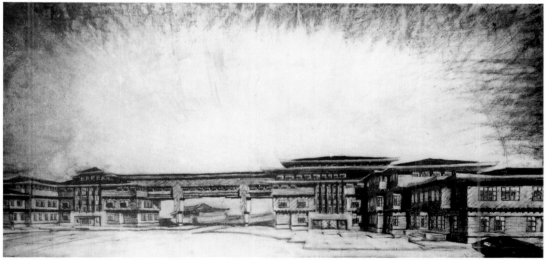

Lumberyard, ware-
house, and office
building, project
for Sommerfeld
Company, 1920.
Design by Gropius
with Adolf Meyer

proposal: a building to provide for his own enterprises and with space to lease for banks, showrooms, and offices. It was to be the length of a city block and six or seven stories in height, according to two schemes prepared by Gropius, but because of the general inflationary costs of the time it was not built. It would have been Gropius's first large-scale reinforced concrete building.

In the immediate postwar years, history moved swiftly, not only for the Weimar Bauhaus, but also for Germany. Another of the first commissions received by Gropius's new office in 1921 was for a memorial, the *Denkmal der Märzgefallenen,* in memory of the workmen who perished during the struggle against the Kapp Putsch of March 1, 1920.[39] Gropius's design was completed in early spring of 1921, and its construction followed soon thereafter.

The monument stands in the old Weimar cemetery, shaded by trees and almost hidden by bushes. It rises twelve feet from the earth in a curving, circular series of heavy plates, or scales, of concrete, building up a prow that was made prominent by its position on the cemetery path. Gropius recalled that others called it "Der Blitz" (the lightning bolt), but he said that, to the contrary, its action is upward, and its design expresses not a physical phenomenon but men's aspirations and efforts. Denying that it honored the Socialist movement, he wrote in 1948:

> The concrete memorial in Weimar was not designed for working men but for people of different circles of the population who fell in the upheaval of the *kapputsch* [sic]. It was ordered by a staatsrat in the Weimar Ministry who was a social democrat.[40]

Gropius now began to find time for research and to continue his explorations of prefabricated elements for housing. Among his and Adolf Meyer's early efforts before the war were studies for standardized serial houses.[41] These were designed from six variously sized and shaped units that could be composed according to the needs of the inhabitants. All of these units were rectilinear, as simple in form as a child's building blocks (as Gropius said, *Baukasten im Grossen*). By means of illustrations, Gropius and Meyer showed that through the use of component and modulated

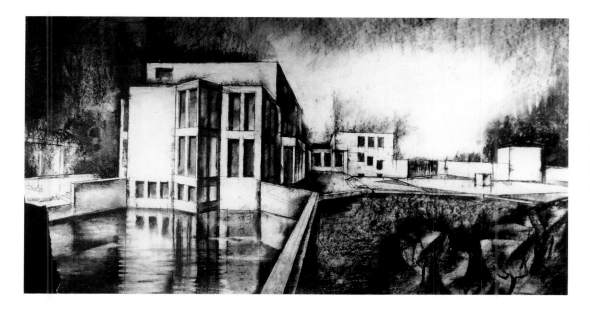

sections of houses, that is, of rooms and combinations of rooms that could be assembled in various ways, diversity of appearance could be achieved. Yet this diversity would have a basic consistency, "unity in diversity," resulting from the use of the components. Gropius wrote that realizing the idea was so important to him that he would be willing to work at first without pay.

Although these designs were not carried beyond sketch plan and model stages, their themes had a pronounced effect on Gropius's subsequent work and that of the Bauhaus teachers and students alike. The simple forms were reflected in the Otte house in Berlin-Zehlendorf, designed by Gropius with Adolf Meyer in 1921-22; in an atelier house by student Fred Forbat; and in still another house by Farkas Molnár within the same year. They were also developed in continuing studies in school and office for several years.

Another of the new office's early efforts was to participate in a competition for small houses sponsored by the Hess Shoe Company in Erfurt in 1921. Many years later Gropius still remembered the owner of the company as a singularly enlightened man, deeply interested in art. A collector of the works of Kandinsky, Klee, and other contemporary painters, he was also interested in new design. Gropius's proposal envisioned some fifty row houses, and double or attached houses with individual gardens. These were to have been of standardized construction with some variations in the assembly of the components. Since Gropius was awarded only the second prize, his project was never carried out.

For the Kallenbach family, Gropius designed a city house, one of the largest commissions of this kind he had had up to that time. Unfortunately, the house was not built because of inflationary costs.

Among the organizations that had grasped the opportunities presented by the postwar ferment to effect cultural changes was the Society for the New Theater. Its intent, expressed in Hans Brandenburg's 1919 pamphlet, called not only for improvement of drama, ballet, and the other performing arts, but also for stage and theater design appropriate to the "New Germany."[42] The

board of the society included architects, artists, writers, poets, playwrights, choreographers, stage designers, producers, actors, and patrons of the arts. Among its members were Peter Behrens, Thomas Mann, Hermann Obrist, Hermann Muthesius, Karl Ernst Osthaus, Richard Riemerschmid, and Bruno Taut. It is not then surprising that Gropius, on June 19, 1921, was selected by Ernst Hardt, Germany's National Theater director, to redesign an old theater and music hall in Jena. For economic reasons, the old hall had to be utilized if there was to be a Municipal Theater. Initially, only the interior of the building was to be remodeled. The original budget of 200,000 marks was too little to accomplish the complete job of rehabilitation that the "new theater" principles of the society would require. A few days after the award of the commission, Gropius explained the limitations of the appropriation to Hardt.[43]

If the budget were increased, architects in Jena protested, Gropius would thus profit unduly, for standard architectural contracts called for additional fees if larger sums of money were made available for the building. This group also sought to prevent him from carrying out the interior design, though it was a part of his contract, thus further limiting his fees. Gropius responded by assuring the city building director that he would not expect additional fees under any circumstance, and argued that the work, "from an artistic point of view," should be by a single hand. He wrote, "All the painters and sculptors whose talents are available to me here [at the Bauhaus] are integrated in the task."[44]

The great optical glass and scientific instrument company Zeiss and the city together provided all of the necessary funds for the Municipal Theater to be completed. Gropius and Meyer were well prepared and the reconstruction was finished in 1922.

The design of the Jena Municipal Theater was ahead of its time. The transformation of the old building, its exterior as well as its interior, was so imaginative and splendid that it won plaudits from the same Jena architects who had been so jealous of what they considered their prerogatives. Yet, since it was limited to rehabilitation and renovation rather than being a new construction, the Jena theater did not anticipate at all the Total Theater that Gropius would offer a decade later.

During April 1922 Gropius was encouraged to believe the state would provide the necessary funds to build a Bauhaus cooperative housing community, workshops, and subsistence gardens for teachers and students. He immediately began his studies, assisted by Farkas Molnár and Fred Forbat in planning and drafting. By May they had completed the site plan, overall perspective drawing, and sketches of several types of housing. Despite its utopian aspects, the design bore no resemblance to Gropius's "Mountains for Living," first conceived in 1919. The site of the cooperative housing project is some 500 meters away from the Bauhaus, between Bessel Strasse and am Horn Strasse, not far from Goethe's Garden House on the edge of the large Weimar Park. It adjoins the fruit and vegetable farm property leased by the Bauhaus for subsistence purposes with funds provided earlier by Gropius, who obtained them by selling some family heirlooms: Napoleon's silver table service and personal linen, which had been recovered by one of Gropius's soldier ancestors when they were abandoned.[45]

Gropius's plan for the housing included dwellings for the masters, row houses for young instructors and students with families, and dormitories. There were to be workshops and gardens.

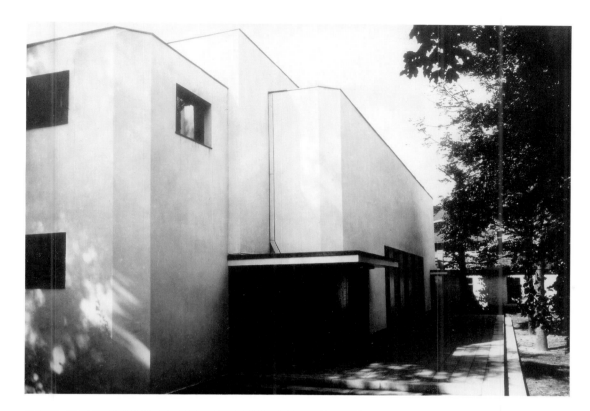

Entrance and foyer,
Municipal Theater,
Jena, 1921–22.
Gropius with Adolf
Meyer.

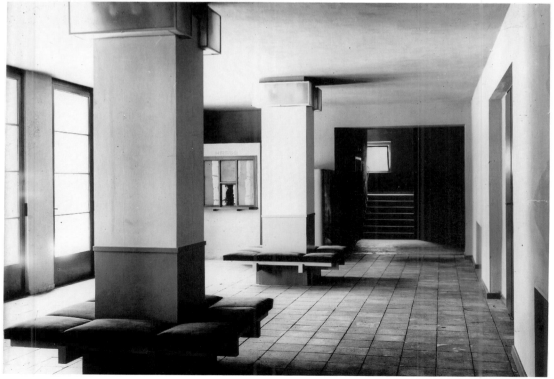

Site plan and
models for Bauhaus
cooperative hous-
ing: row houses,
detached houses,
gardens, and
workshops.
Weimar, 1922

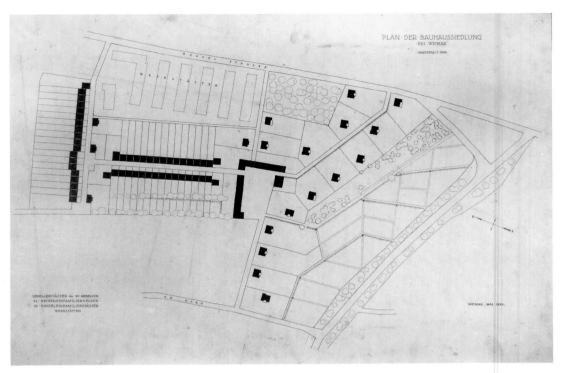

Buildings and furnishings, insofar as possible, were to be produced by the Bauhaus community. The project was even then termed utopian in the degree of integration and cooperation expected of the masters, students, and community.

Though the state had originally promised to build the colony, it dropped the idea because of the deteriorating political conditions. To compensate Gropius, Forbat, Molnár, and the students who had worked on the site and building plans, the city gave the Bauhaus wall-painting workshop a contract to paint the interior of the Rathaus. But relationships between the school and the city of Weimar had deteriorated to such a point that even this agreement was abrogated.

In 1922 Gropius and Meyer designed one of their most significant projects: their entry in the competition for the *Chicago Tribune* newspaper office building. Gropius later explained the idea behind their design:

> When I designed the Chicago Tribune Tower in 1922, I wanted to do a building which definitely would not use any historical styles, but express the modern times with modern means, in this case with a reinforced concrete skeleton which clearly should express the functions of the building.[46]

Though the design recalled Louis Sullivan's work and that of other buildings in the Chicago Loop, it was still too many years ahead of its time to win acceptance. It had very little company, as only a few of the entries — those of the Dutch architects, of Max Taut, and of Gropius and Meyer — revealed the architecture of the future.[47] The jury, oblivious to the achievements of the "Chicago School," which had been inspired by Louis Sullivan and Frank Lloyd Wright, opted for a Gothic skyscraper, a form made popular by the success of New York's Woolworth Building.

Lily Hildebrandt: Except for a brief visit to Vienna early in the spring of 1919, Gropius had not seen his family during the hectic months spent establishing the school in Weimar. A visit from Alma was often planned but just as often delayed. The reasons were various: the Spartacus League uprising at Passau, the blockades of Bohemia and Munich, the need for a new passport, Alma's loss of Gustav Mahler's royalties from the United States through the seizure of alien credits. Alma and Manon (called Mutzi) finally arrived in May, following a difficult train journey from Vienna to Berlin across the new nation of Czechoslovakia. On May 15, during Alma's visit to Berlin and Weimar, baby Martin Johannes died from congenital defects in the Vienna clinic where he had been placed in February, thus bringing to an end a tragic part of the story of the encounter of Alma and Werfel.

Gropius's and Alma's period of outward mourning was brief. Many activities and engagements had been planned for both the director and his wife, and they had to make appearances. On May 29, for example, Professor Klemm held a tea for the cultural elite of Weimar, to meet Gropius, Alma, and the members of the new faculty. The guests, it seems, were more impressed by Alma than by the faculty. Lyonel Feininger described the affair in a letter to his wife and noted particularly: "In him and her we are facing two completely free, honest, exceptionally broad-minded human beings who don't accept inhibitions, characteristics of great rarity in this country. Naturally people react against them and they are looked upon as alien and disturbing elements."[48]

Such favorable views were not shared by many of the students. They saw Alma as someone remote, with little comprehension of their zeal, their poverty, their revolution and radical style of

Chicago Tribune
Tower, competition
entry, 1922

life. And, in fact, Alma had little interest in Bauhäuslers except for such faculty members as the Klees, whose interests, principally in music, paralleled her own and who paid homage to Gustav Mahler. Alma was repelled by the students. Some were very young, as young as seventeen, and consequently immature; some, a quarter or so, were young women. Most of the men were veterans and still dressed in their ragged gray uniforms. Many came from the *Jugendbewegung* (youth movement); some were in artistic costume, unshorn and unkempt. Most were poverty-stricken. All were obsessed by the promise of a new institution which seemed to hold more answers than the conventional schools of design.

Enrollment at the school rose quickly to 150 students and soon exceeded the low teacher-student ratio hoped for by Gropius. There were already problems. He had clashed with Max Thedy, a holdover from the old Academy of Fine Art faculty, and with other classically oriented teachers and students. In July, Gropius noted his dissatisfaction with the work students exhibited for his review, which led to a demand by the students for his resignation. From the start the situation at Weimar was uneasy. The old Academy of Fine Art and the School of Arts and Crafts had won the adherence of many conservative Weimaraners, including members of the crafts organizations and some who supported, through "Citizens' Committees," the anti-Bauhaus activities of the Volkische Partei, the future Nazi Party, which was convinced from the first that the Bauhaus was a nest of Bolshevists. By December the attack upon the Bauhaus was in full voice, even though Gropius, correctly gauging the dangers of social and political attitudes in Weimar, had expressly forbidden political activities within the precincts of the Bauhaus.

> My action…to keep politics out…was simply a defense measure because I knew that, in the moment when we would officially take a political stand, it would have been the end. …As it unfortunately happens in Germany, the Bauhaus became a bargaining point between the political parties.[49]

The proper citizens of Weimar already had a poor impression of the students and were offended

by the bohemian attitude, conduct, and dress of many of them. The students included a few Jews, Hungarians, and other non-Germans, with the local Thuringian students being in a minority. An observer of the Bauhaus, Lux Feininger, son of Lyonel Feininger, described in 1968 the estrangement between the school and the surrounding community:

> In a sense the opposition between the town and the Bauhaus body resembled what we see nowadays [i.e., during the Vietnam War]. …Then, as now, an unpopular war had led large sections of the people into more than opposition, a refusal to participate, a wish to escape. … The oddities of the early Bauhaus population, which aroused the ire of the host town so much, came from the desire for purification. These people, the Bauhäuslers…were spiritually minded and abhorred the idea of being fashionable. They constituted a community of spirit, not a movement in any contemporary sense.[50]

At first the students made little effort to improve relations with the townspeople, but Gropius shrewdly organized meetings with citizens' groups, instructing the students to disperse throughout the room to avoid the appearance of a clique.

Despite its intellectual history Weimar was a small country town, characteristically reactionary. The school was attacked primarily for being different.

In this new milieu the attraction that had a decade earlier linked Gropius and Alma was to prove insufficient. She was indifferent to his sense of mission and had no genuine interest in architecture or his social goals. Under other circumstances, other cultural activities — as well as their daughter, Manon — might have held them together. But in the Bauhaus environment, it was not to be. And Alma had never broken with Werfel.

When Alma left in mid-June (supposedly in order to take a six-week cure at Franzenbad but actually to return to Werfel in Vienna), the marriage of Gropius and Alma was in fact dead. Still, they were not ready to admit as much, perhaps even to themselves. Gropius described to his mother the "great emptiness" around him following the departure of Alma and the children. He blamed the severity, deprivation, and tumult of the past winter, along with the death of Martin Johannes, for Alma's melancholy and mental disorder. "In spite of all that, these weeks were beautiful and I have savored them."[51] But although he had constantly tried to conceal the real state of his marriage from his mother, she saw plainly that her son's household was not going to be reestablished in Weimar. At least she so advised her son in an exchange of correspondence during the summer of 1919. Reflecting on this, Gropius — a month after Alma's return to Vienna — was suddenly decisive, and without revealing that he was doing so to his mother, he wrote to Alma asking for a divorce. Addressing her as "Beloved," he sent the necessary legal documents for her signature:

> I hold the news of the death of our marriage in my hand…this external bond should not continue any longer and you should not insist on it…through promises which you cannot redeem. …Your splendid nature has been made to disintegrate under Jewish persuasion [Werfel was Jewish] which overestimates the word and its momentary truth. But you will return to your Aryan origin and then you will understand me and you will search for me in your memory… .

> This is your tragedy which brought such great harm to us and which forces you again and again into new passions while the old ones are not yet exhausted. …With you, [feeling] extends only to the short time of passion and sexual fervor… .

Every one of your promises after the catastrophe last winter were just words; you have kept none of them, and a year has passed since

Our bond has come to an end and there is now only the bitter solution of divorce — because you cannot mock God.[52]

Where Gropius's letters from July on reveal that he had lost any desire to continue their marriage, Alma's are confused, alternately truculent and conciliatory. Her immediate counter to Gropius was the astonishing offer that she would spend half the year with him and half with Werfel! Gropius protested this extraordinary proposal, which only added to his determination:

How can you believe, Almschi, that through this external act, an *inner* change of such wide implications could occur to make it possible for us "to live a life full of love and beauty"? I am hurt by these words of such bitter, impossible meaning. Don't force yourself, don't do this to me, my beloved, to offer something that is a *half* measure.

I long for a companion who loves me and my work[Life] is built up of a thousand good and bad daily events of being together, not out of letters

I ask you once again to send me the slip which authorizes me to dissolve our union. I have waited a year for this; I cannot wait any longer.

We *have* to clarify everything now; the sickness of our marriage demands an operation; we should not shy away from it. Our marriage never was a real marriage; the woman was missing in it. For a short time you were a splendid lover for me, then you went away without being able to outlast and heal my war impairments with love and tenderness and trust. *That* would have been a marriage. This is not an accusation; I am without bitterness toward you. What your warmth, generosity, your intellect have done to enrich me will remain unforgotten.[53]

Just as surprising as Alma's proposal was a letter from Werfel himself, who wrote brightly to Gropius that he had spent the two previous weeks at Breitenstein with Alma, and, as a consequence, Gropius was "especially close to my heart and before my eyes." He reported in a flow of adjectives that Alma, despite constant guests, was restless, nervous, depressed, harried, and "torn apart by the heavy conflict that tortures her." Werfel confessed that he was "deeply worried," for "through what terrors has this wonderful woman, who was born only for divine purposes, gone in such a short time." He said that he had been moved to write a thousand times in these months, but everything between them had taken place so recently he could not bring himself to say what had to be said. Now, Werfel claimed undying friendship for Gropius; "no man," he said, had ever been so "very dear and close" and such "a natural blessing" for him. He blamed fate for their "inescapable collision" and termed their mutual suffering a tragedy. As proof of his own devoted friendship, he reminded Gropius that "I already felt for you as a friend when I beseeched you not to return to the Front again."[54]

Gropius did not welcome Werfel's ingratiating overtures of friendship and he merely filed the letter away without reply. It was Alma whose willfulness and disparaging words weighed most heavily on his heart and mind. Gropius's personal life was neither settled nor complete, and Alma now persistently sought to be part of it. To win his attention, she wrote describing the endearing changes in Mutzi, her growth, beauty, sweetness, intelligence, and speech. "I am looking forward to the time when you will want to see her again. But when do you want to see her?" Alma went on, complaining of his indifference to herself, begging to take part in his life, offering to come to

Weimar despite the hardships of travel, and pleading with him not to "persist in this dreadful silence which is torture for me."[55]

During this period Alma's letters show no evidence that she recognized the real state of her marriage and Gropius's desire for a divorce. For Gropius the marriage was over, broken by Alma's infidelity, broken by her lack of support of his Weimar venture, but broken, finally, as it turned out, by the relationship that was developing at this very moment between him and the beautiful Lily Hildebrandt.

Despite Gropius's involvements in school administration and pedagogy, his renewed architectural practice, and politics of every kind, life was not complete for him. Still, his aristocratic bearing, unwavering gaze, and restrained demeanor drew not only professional colleagues to his side, but also women, to whom he would sometimes be vulnerable.

Among these was the vivacious Lily Hildebrandt. She was thirty-one years old and a married woman, the wife of art historian Hans Hildebrandt. Meeting in the excitement of the postwar revolution and amid the enthusiasm of the creation of the Bauhaus, she and Gropius were initially drawn together by their common interest in the liberated vistas the time seemed to offer. Much of their ensuing four-year association, however, was vicarious, with Gropius living in Weimar and Lily residing in Stuttgart. Several hundred letters, telegrams, and telephone calls would be exchanged.[56]

At first Gropius's letters related his Bauhaus woes, and his successes, but said little of his love for her:

> My wife and child will visit me next week. …I long very much for the little *fratz*. My life has a frantic tempo, one experience replaces another, important people are visiting here…there's no money to relieve the terrible conditions of the students. …I try to raise funds but I am not gifted for that. Can't you help me to find capitalists?[57]

During the early months of the Bauhaus, Gropius's and Lily's love matured rapidly and letters grew unrestrained in their fervor. On October 14, 1919, he replied to Lily:

> Your Sunday letter today has made me wild, my senses in tumult. I have to restrain myself to keep from simply rushing to you to hold you in my arms. …You will not weaken yourself by longing…we shall both overcome this short period and kiss each other in our minds — and then — we shall rush into each other.
>
> Darling, my whole warmth shall caress you. My hands search for the sweet naked skin, the ravishing young limbs which are longing for me!? Yes? Do they? Tell me all the time. The lavender fragrance was lovely, but I want to inhale *your* fragrance! Put a flower between your lovely thighs when you are hot from thoughts of me and send it to me in a letter.

On the following day, his passion undiminished, he complained that her daily letter had not arrived and that he had "to live by the one from yesterday which excited me so much."

> Beloved, Frankfurter Hof and Carlton Hotel sent me telegrams confirming that they are reserving rooms for us. Choose the one you like better; I am not too well acquainted with Frankfurt. On the 21st!!!? You want to pose as my sister, that made me really laugh. Nobody will believe that your little nose belongs in the same family as my monster nose. . . .
>
> I want finally to touch you, feel you. Tonight I was full of tenderness for you. You can't imagine what my imagination conjured up. But I can't *talk* anymore. …Think what you want, it is all true.

Following their sojourn in Frankfurt, Lily returned to her husband in Stuttgart and Gropius to

Weimar. He hoped that Lily, as he, was now "somewhat appeased in body and soul after our dream." Nevertheless, he added,

> Our union is not focused on peace and rest — only on movement and encounter. Two meteors kiss each other in the universe. But when shall we meet again, my dear sweet darling?[58]

In mid-November Gropius, happy and more than a little surprised by his amatory successes, reassured Lily about his fidelity:

> No, I am not in love with another woman, didn't kiss anyone even at the big party the other day. It seems that I am at an age and in a state of mind which attract women. Many invite my advances. But that should not trouble you, on the contrary. After the deep saturation in Frankfurt, I am in an erotic-free phase and am completely absorbed by my mental work. …Monday and Tuesday in Berlin for a meeting of the Arbeitsrat für Kunst.

Only the proposed merger of Arbeitsrat für Kunst with the Novembergruppe, which took place that month, could have brought Gropius to the still impoverished postwar Berlin:

> This trip was awful. Seventeen people in one compartment, total darkness, broken windows and twelve hours to Berlin. The people wept because of the cold. I also arrived in a tortured state, had to be in bed for a day, the return trip just as bad.

He spoke of being frantically busy. The correspondence alone was daunting. There were letters to be answered from professional societies and clients, as well as those on the official business of the Bauhaus, which involved students, donors, masters, manufacturers, politicians, and the burghers of Weimar. Prominent among the latter was Elisabeth Förster, the sister of Friedrich Nietzsche, who wanted the Bauhaus to provide Henry van de Velde with a house and studio (though not a faculty appointment) to compensate for the injuries done to him, a Belgian national, by Germany.

Though van de Velde had recommended Gropius to be his successor, their very different approaches to education would have made him unwelcome at the school, even if not on the faculty. Gropius did not mention that, but instead pointed out the lack of studios and the fact that "though van de Velde's friends wanted him back to Weimar, nobody offered a penny or space for him."[59] Gropius recognized the influential position Frau Förster occupied in Weimar society and continued to be tactful. Still, he disliked her and felt strongly about her interpretation of her brother's work. By no means did Gropius agree completely with Nietzsche's philosophy, let alone with his sister's interpretation of it.

These were tumultuous days, and Gropius recounted the events of December 1919 to February 1920 in ardent letters to Lily:

> I have a great longing for you this morning. Am so thirsty for tenderness as I haven't been for a long time. I would like to penetrate you with the sword of love — and enveloped by your sweet body and we should stay this way for hours not knowing where the *I* ceases and the *you* begins.
>
> A big Bauhaus battle yesterday took place in the meeting of the *"Freie Vereinigung für städtische Interessen."* The theme, "The new art in Weimar… ." I knew that this would be a call to arms against the Bauhaus — and this is what it became. The speakers, narrow-minded dilettantes of the city, caught themselves in a net of the most stupid, furious, and unobjective attacks. The hall was overflowing with people…(the Bauhäuslers were there, too). I let them all talk first and then I spoke myself, sharp and witty, and my words played such havoc with the speakers that under a continuous endless applause the case was dismissed in my favor. It was the best propaganda for the Bauhaus, and the solidarity of the students made a great impression in the city.[60]

Gropius believed the personal slander against him and the press attacks on the Bauhaus to be the result of efforts by a "clique of old-time resident ignorant artists" who wanted to push him out. But he also saw that "behind this Weimar storm in a teacup is...something bigger at stake."

It is the beginning of the European intellectual revolution that *has* to come, the dispute between the old *Weltanschauung* which is based on the classical education and a very new, gothic one which has found its first symbols in expressionism. It is no accident that this battle is starting in its most blatant form here in Weimar, the bastion of classicism. I advance without compromise. ...I had to summon all my strength and calmness to stop the assault of the howling mob. After a four-hour conference of the Staatsrat the government finally backed me unanimously. But...the opposition will go on screaming.[61]

In the face of constant harassment, administrative responsibilities, lectures, fund-raising, and professional societies' activities, how did Gropius maintain steady correspondence with his mother, Lily, and Alma? Perhaps the answer lies in his tendency to prepare preliminary drafts of almost everything that he wrote and to refer to these in preparing new letters. For example, the discussion of the press, the Weimar conservatism, and "intellectual revolution" appeared first in the December 19 letter to Lily, then ten days later in one to his mother, and within another week in a letter to Alma. In a letter written after Christmas to his mother, he recounted the events in an almost identical vein: "I am in the middle of a fight about the Bauhaus idea...the idea is at stake...I am proud of this fight...I am determined to continue my way without compromise!" About himself he added: "I have become a very primitive man and I am eating the simple meals in the canteen together with the students. Christmas was beautiful with them; they spoiled me, gave me numerous presents and I was invited 5-10 times every day. The tempo in which I live is like the one before the war, but less hustle and more inner intensity."

Within a fortnight of the tumultuous meeting, Gropius had rallied new friends and taken the offensive against the critics and maligners of the Bauhaus and of himself; he had elicited support from the Arbeitsrat für Kunst, the Novembergruppe, the Musik Gesellschaft, and the Deutscher Werkbund, and had gone outside the school to support student demands for improved educational methods elsewhere. He had requested an investigation by the government into the charges made by his adversaries "that might silence the evil liars. But this country is impossible and deserves to perish."

Gropius's spirits rose and fell with the political and economic fortunes of the school. That their waning interfered with his and Lily's amorous relationship is evidenced in the course of their correspondence.

I am in the terrible vortex of dangers. The mob agitates against me with the lowest means...therefore, I cannot leave here now, but please come to me, my darling. Maybe I can accompany you to Berlin, but that is uncertain and I have to keep it open. Come as soon as you can, because it is possible that my wife may be here in the middle of the month from Vienna.

I embrace you, my dearest sweetheart, come to me soon so that I can feel again how it is to have a hot, loving heart beat against mine.[62]

Gropius's relationship and communication with Alma were strained and equally a cause for weariness. His insistence on a divorce in his otherwise indifferent replies to her letters only

intensified her desire to reestablish her power over him. Addressing him as "Beloved Walter," she wrote cajolingly of her sole desire to be with him. Her letters ranged in mood from recrimination to self-pity. Given the instability of her life, it is, in part, understandable: her father's premature death, her early marriage to a much older man, impulsive love affairs, children, wartime separation, loneliness, estrangement, and the rapid changes in society brought as much sorrow as joy. Now she expressed regret and sought compassion from Gropius:

> Love me, I deserve it in spite of everything. *I am the guilty one.*
>
> Seduced by my years of inner loneliness I failed to understand my true nature, which always wants music and is always looking for music. . . . The non-music of your path — never a sound during the month I was with you. . . has deeply discouraged me.[63]

No actress on stage performed more rapid dramatic changes than Alma in the role of estranged wife, and her letters reflected her inconstant feelings. In mid-December 1919, writing from Vienna, she had been discouraged, self-pitying, accusing, and threatening: "Your beautiful male hardness is a wall around you. I shall *not let you know* anything that may still interest you a little bit about me. You shall not know anything about me or about anybody else."[64] More than a month later, Gropius found time and inclination to respond, pleading, "Why do we have to torture each other?" He admonished Alma for her lack of compassion and answered her complaint of infrequent letters with the charge that her own dealt solely with money, a problem which he was trying to solve. He added, "I have not stopped loving you. . . . but I have a terrible and steadily growing anxiety about my child." Alma had not fulfilled any of her several promises to bring Manon to Weimar in the early summer of 1919, in the fall, and for a post-Christmas celebration, though Gropius had made all arrangements for their accommodations and entertainment. Deeply disappointed, he wrote in February:

> During the summer I received your humiliating letter with the proposal of living together *half* the time, which I declined with a heavy heart. . . . What has our misfortune made of you that you act so full of hate and so unjustly toward me? Because I refused to accept something halved? I have no way of knowing how you feel and what the reason for your inaction can be: love for him [Franz Werfel] or hatred for me, or loss of resolve brought about by our tragedy or maybe something else that I cannot articulate?

Gropius continued to believe that he was hiding from his mother his precarious relationship with Alma. In January he wrote her that he had obtained an apartment for his family and himself. Alma and Manon finally came to Weimar in March. They initially stayed at the Hotel Zum Elephanten on the Platz, but on the twentieth they moved into Gropius's new apartment. Although Alma later would write in her autobiography, "Gropius and I had settled into a harmonious friendship," the relationship was hardly harmonious, and it was not possible to conceal the marital break from Walter's mother.[65] Indeed, early in April, Alma, accompanied by Werfel, was to be seen in Berlin in the cafés and at the theater. Ignoring her son's glossed-over reports, Frau Gropius wrote Alma in anger, reproaching her for her infidelity. Alma responded defensively, blaming "the unbearable separation which made me grow colder and colder. . . . For almost four years. . . only interrupted by short adventurous visits every six months by my husband who was more and more changed by the war. . . . When the feeling of limitless devotion to the other one has stopped, marriage has ended, that is God's law. Walter is young and marvelous, his life is before him. We shall never lose each

other. His suffering is my suffering."[66] Only in the late spring of 1920, when the failure of their marriage, bruited about by Alma herself, had become commonly known, did Gropius acknowledge it to his mother, albeit a bit disingenuously:

> I love her deeply and exclusively. ...I cannot live without her. ...My child, whom I love, grows and I don't know her. ...I shall not give up my rights. ...Alma now pretends that it is I who want the divorce; I let it go if this gives support to her morbid pride. Since she has decided to leave me with the child I shall carry the sign of disgrace with me forever and cannot look anybody freely into the eye.
>
> I am still young in years but I have emerged as a cripple after the terrible war and the battles of peace and I cannot recover.[67]

Despite his protestations of exclusive love for Alma and his admirable devotion to Manon, Gropius was acquitting himself with some distinction in other affairs of the heart. Though he was much in love with Lily Hildebrandt, they were, of course, more often apart than together. His comment about being attractive to women was no idle boast. He was indeed pleasing in person, magnetic in personality, and intriguing in intellect — and the war had left widowed or stranded a large part of a generation of eligible young women now in their late twenties or early thirties.

Gropius at times felt himself to be very much alone, in need of divertissement. It was in such a frame of mind that he met an attractive young widow in March 1920. So quickly did their friendship mature that in a letter to her on April 19 he could rhapsodize about their relationship.

> I am a wandering star in this universe. I know no anchors no chains, I hide away in the bush when I am feeling blue, and come out to see others, when I'm filled with new ideas and am giving, I am bound nowhere and to no one. Wherever I go I make others feel good and by doing this, I create *life*. I am a *sting*, and a dangerous instrument!! I love LOVE, without any objective, its great ever-lasting intenseness. You wanted me and I gave myself to you and it was wonderful and pure, two stars put together their sea of flames but: ask for nothing, do not expect anything! Whatever human beings give each other, it is a gift. I know nothing; I don't promise anything; I just drink your warmth and one day the sword will drive out of me again. But now I am sitting with a never-ending passion among the ashes; I am restless and torn in pieces and need repose and solitude. Love! Write poetry! Be happy about your new universe, I take you ardently into my arms.
>
> Your shooting star.[68]

Although Gropius was pleased when she attended the newly established "Bauhaus Evenings," he was also apprehensive that she might be demonstrative and familiar. He wrote, "I don't want other people to know about my intimate relations to others because this is my very private thing. Therefore I appear to be indifferent to you in public. Please understand *that* and don't think it is against you."[69]

It seems extraordinary that Gropius's life could be so multifaceted: while he was in conflict with Alma, involved with Lily and the young widow, building an architectural practice, and participating in architectural and art organizations, he could also fend for the Bauhaus politically, teach, and direct its internal affairs. Though a business manager was eventually employed, Gropius himself carried much of the constantly increasing burden of the school's administration. He continued to lecture within the school and in other cities and to seek out and interview prospective teachers.

One of these was Georg Muche, who had been recommended by Johannes Itten. Muche joined the Bauhaus late in the spring of 1920, assisted Johannes Itten, and developed a course complementary to the *Vorkurs*. Itten also had suggested Oskar Schlemmer, who came in the early summer. Schlemmer was prominent not only as a stage designer, but also as a painter; his mural in the great hall of the school would be proof of this talent. Paul Klee also arrived by early summer 1920, having been recommended by Adolf Behne; Klee was in complete intellectual sympathy with Gropius and, at that time, supported him strongly. The faculty in 1920 also included Feininger, Marcks, Adolf Meyer, and Itten, all brought in by Gropius. Of the teachers from the old academy reappointed by him, Fröhlich had resigned later in 1919, Thedy remained until the summer of 1920, and Klemm and Engelmann left in early 1921.

It was fortunate that the school at this time was rapidly developing and clarifying its goals and directions. This created a cohesiveness among the students and good working relationships among its faculty. Gropius could hardly have battled on two fronts, within and without. The political turmoil had continued. To remain in control of the situation and to keep funding for the school alive, Gropius had to consistently fight strongly, as, for example, at the 83rd Thuringian Parliament on July 9, 1920. He had been invited by the minister of education, Max Greil, who was sympathetic to the Bauhaus and had helped Gropius counter the attacks from the right. There was, however, lingering opposition from legislators who had understood that Gropius had been called in to improve various crafts threatened by the impact of mass production, not to lead a school for architecture and industrial design. Gropius, many years later, stated: "The opposition of the local crafts was entirely political. There was no competition with them, since only new models were sold by the Bauhaus."[70]

Despite his professional stature and his antecedents, Gropius was regarded as a left-wing influence. At the time the Bauhaus was founded the state had a Socialist government which Gropius supported, though not wholeheartedly. This support made him and his school additionally suspect in the eyes of the Weimar conservatives. At the same time, the weakness of his support disenchanted his allies in the Parliament.

In addition to this surfeit of professional concerns, Gropius was also constantly preoccupied by thoughts of Alma and Manon, and of Lily, and hundreds of letters were exchanged with them during 1920. In the correspondence with Lily, at least, Gropius found momentary respite, and when the visit of Alma and Manon planned for February 1920 was postponed, Gropius wrote to Lily plaintively:

> What do you do, what are you working at, how do you live with your husband and child? I am expecting my wife any day from Amsterdam, where she was very much fêted. Then she will again disappear in the mist with my child. It is strange that since I have lost her love I have moved up into another stage. My love spread out in breadth; many people feel it and move around my pole now, but I myself do not find the happiness of complete concentration out of my own self. I must be lonely and remain so — how long?[71]

Manon and Alma finally did come in May. A Mahler memorial concert in Holland had been a triumph, and having basked in the adulation of the great audience, Alma was refreshed, sure of her own importance and independence — and unsympathetic to any proposal for change by Gropius.

Following her departure, he again addressed Lily in several erratic letters reflecting the turmoil of his thoughts:

> I am alone again, deeply depressed and discontented with myself; at the moment I am only half a man. …Don't believe, Lilychen, that *you* are connected in any way with this separation. She knows about you, but that doesn't affect her. …I would like to have you in my arms again to drink Lethe's oblivion, to divest myself of the heavy burdens, to fly, to breathe, but I sit deep down in the shadows. …Try to understand the earthquakes that shake my soul and be good and tender with me — as you always used to be. How is your husband? Has he moved further away from you since he is so often away? Let me know it, tell me everything; be close to me and kiss me. I kiss your sanctuaries.[72]

The relationship of Gropius and Lily was not always an ecstatic one, and their letters beginning in mid-1920 often reveal painful misunderstanding caused by their separations.

> I love you just as much as before and think of you with joy. …Just this morning when I awoke I thought of you lovingly…and then I found your impatient telegram.
>
> Maybe I am a very difficult person, hard to understand and making no concessions, but I am, on the other hand, without any false sentimentality. Love me all the same and come soon and without suspicion.[73]

Letters continued to stream to and from Weimar and Stuttgart, though fewer were sent during the summer since Gropius and Lily were able to meet more frequently. Following the reopening of the school, their intensive correspondence resumed. In October Gropius informed Lily of his divorce from Alma. In this letter as in many others he refers to his "free spirit," likening himself to a "shooting star" (as he had to the young widow). This self-characterization reveals Gropius's desire to assert his independence and rationalize his unpredictability. It gave no comfort to any woman seeking any degree of permanence in her relationship to him.

> I have made again a big loop through the universe and spiraled some eons higher. …I have exploded ten times in the meantime, but the shreds of my soul are still very lively; indeed, they gain in strength.
>
> In the meantime I got a divorce from my wife in full love [October 11, 1920]. She was here recently with our child whom I am missing *very much*. Now I am more than ever a nomadic star in the firmament and stand boundless toward the other sex.[74]

This single reference to the divorce passes over long months of negotiations with lawyers in Berlin and Vienna and observance of legal procedures. To satisfy statutory requirements and facilitate the divorce, Gropius agreed to be the defendant and confess his guilt. To support this a standard liaison scene was arranged in a hotel room with detectives, witnesses, and depositions. Absurd as this may now appear, it was rendered even more so then by the common knowledge of Alma's own infidelities.

Gropius's letters to Lily describe vividly the factions and schisms among students and faculty. Students became involved in the internecine problems of the Bauhaus, taking sides, espousing causes, and mixing politics and pedagogy. Easily led by devious politicians of the city, some criticized the school policies, particularly those who felt there had been inadequate scholarship awards and housing assignments and that favoritism was shown toward aliens and Jews (although only seventeen out of more than two hundred students were Jewish).

In December 1920 Gropius decided to take a drastic step and singled out one group as

troublemakers, fourteen students who had followed Itten from Vienna and had become the nucleus of his course.[75] The young Viennese were enthusiastic and creative artists, but hardly the type of students who could be persuaded to seek the integrated ends Gropius sought for Bauhäuslers. Those students who desired ultimately to become architects, product or other kinds of designers, as well as those who came from more traditional art schools, were more accepting of Gropius's policies. It is not surprising, then, that he did not refer to Bauhäuslers simply as "students," but as "Bauhaus-Studierenden," denoting an internal spirit. At times he referred to the school as a "beehive." Unfortunately, the students who had followed Itten from Vienna now constituted a clique not only in their adherence to his methods, but also in their activities, their demands upon the Bauhaus, and in their controversies with fellow students.

> The Bauhaus cracks at the seams, the people tear themselves and me to pieces out of love, out of stupidity, out of hate. I have to act as a Solomon above the quarreling factions. Hardly was the affair with Itten resolved — I let him know that his [attempt at resigning] did not impress me and was too easy, whereupon he decided to stay — when a new scandal broke loose! Itten students contra Teutonics [Germans], which became very violent. It's like this: the brainy Jewish group, Singer-Adler, has become too presumptuous and has unfortunately also influenced Itten considerably. With this lever they are trying to get the whole Bauhaus into their hands. Against that the Aryans revolted, of course. I have to reconcile them now.[76]

One of Gropius's chief concerns was how to improve the public's understanding of the Bauhaus community. He had already established a series of afternoon lectures, concerts, and recitals to which city and state officials came, as did the public in increasing numbers. There were exhibits of ongoing work as well, and the visitors were invited to look in on classes and workshops. He described one such "Tea":

> Our monster Bauhaus Tea was fabulous. I had written to you that the two state ministers came, that I had been able to engage the dancers again whom I had liked so much, and that the tea lasted until 12 midnight, very animated mood. The noisemakers in Weimar begin to listen and try to play the role of good children who want to be invited too. These are perhaps the only means to pull our good cause through against these stupid fools.[77]

Unknown to Gropius, however, opponents of the Bauhaus in the government were taking steps to separate the two schools he had united. But this coincided with Gropius's wishes, for he now advocated the separation of the Academy of Fine Art "as a wing," to be rid of its hostile faculty. On April 4, 1921, the academy was reopened in the same building but not under his direction, and Thedy, Klemm, and Engelmann rejoined its faculty. This opened up vacancies on the Bauhaus faculty, which Gropius was then able to fill with people more in line with the school he wanted.[78] Among the first of those appointed was Lothar Schreyer. Recommended by Itten, he arrived flushed with the success of the Hamburg production of his expressionist play *Crucifixion*.

Schreyer directed the Bauhaus stage workshop during the two years he was in Weimar. Gertrud Grunow, the first woman to join the Bauhaus faculty, also recommended by Itten, came in the summer of 1921. At a time when psychological themes were not yet common, she made them the center of her work.

By 1921-22 Gropius had become further involved in governmental, public, and business relations at the Bauhaus and less in teaching. In addition, the lack of a full faculty organization of

artists and craftsmen left the creation of academic policy as well as general administration to Gropius. Also, from the beginning of the Bauhaus, he had to give hundreds of talks and lectures all over Germany and beyond. These were primarily to raise money for the school, but they also helped to obtain contracts for student work and to educate public officials about the aims of the Bauhaus. Nevertheless, the difficulties inherent in such efforts, combined with disastrous inflation in Germany during the immediate postwar years, compelled him to finance the entire school on a shoestring.

At the beginning of the school year Gropius ordinarily gave the opening address. He also gave two or three other major lectures during the year to all the students, participated in reviews of student work, and taught a course in architectural geometry. He gave many informal talks in the canteen or over the drafting board and worktable. As the "student council" was self-appointed, without official status or funds to organize, Gropius invited the students in small groups to his home for more intimate conversations.[79] It was in his home, late in 1920, that Gropius began his evenings of poetry and literature for students. These evenings spent reading the works of Rilke, Whitman, and Hans Christian Andersen, among others, were attended by many students and lifted Gropius's spirits; he felt that the "constant touch with this fomenting youth does me good."[80]

Unfortunately, every encounter with students was not so rewarding. Nevertheless, whenever there was aggressive criticism from one or another of the students, Gropius's tendency was to "put him into a responsible position to cool him down." He deliberately allowed the students' work to grow out of themselves without interference. He let them make detours. The Bauhaus philosophy was not preconceived, but a general trend that was consolidated step by step. Changes in the attitude of the students and their work were to come through insight and better understanding, not through imposition from the outside. Gropius favored including, not excluding, all experiments. Not everyone appreciated the approach. As Hans Bellmann recalled: "Gropius let the students find their own way with the result that the students learned from their own errors — but it was a mess."[81]

The Bauhaus program was experimental, and the emphasis — at least at this point in the early twenties — was theoretical. There was as yet no architectural department per se, though from the school's inception many students had sought it, and the Bauhaus manifesto called building the final aim of all the visual arts. The program did not involve itself in city problems or in problems associated with larger urban areas.

Experimental standardized housing was soon, however, to become a concern, as were prefabrication and large-scale housing. Indeed, Gropius always had had the idea of establishing a department of "building" to devote itself to design, building experiments, and engineering. It would of course be patterned after the workshop preparation of a sufficient number of students in basic Bauhaus training, but he was against overemphasis on architecture at the early stages of education, believing that the fundamentals should be mastered first. He insisted that architecture be the pinnacle of design development, and for this reason the Bauhaus did not establish such a department until 1927.

Gropius's letters to Lily in the late spring of 1921 acknowledge a lessening of his passion: "I wish I could feel just as intensely about you as I did a year ago and I am striving for it; one cannot force

Gropius in 1921:
the photograph he
sent to Lily
Hildebrandt

flames to rise out of oneself, but I know that it may again happen suddenly."[82] Lily was hurt; she felt scorned and shamed. Her reply was quickly answered by a penitent Gropius. He blamed his unsettled state of mind, depression, and fatigue.

Lily continued to visit Weimar as the spirit moved her. One such occasion was in mid-summer of 1921; the days went by happily but too quickly for the lovers, and Lily extended her visit to the time that Gropius was to leave for a business conference in Berlin. Lily suffered from depression, and unfortunately, while she was still in Weimar, her depression suddenly recurred. Gravely concerned, before he departed from Weimar, Gropius made every possible arrangement with Itten and others for her care, and he informed her husband in detail. He left Lily a letter expressing great sympathy and his worry that she "might commit some silly action in a state of depression."[83]

They again became dependent on correspondence. In the early fall, he sent her a photo of himself and reasserted his love and desire to see her.

> I have nothing but this ugly photo with the strange piercing eyes; tear it up if it disturbs your better memory and send me at last your promised likeness. The train shakes very badly; I hope you can read this. …
>
> Wire me when and where we could see each other and whether you would rather meet me before or after the meeting. I can still arrange everything according to your wishes. I almost tremble to see you again. …[signed] Your planet.[84]

The letters to Lily followed a pattern. Never did he neglect to express his appreciation for her efforts on his or the school's behalf. For each missive he tried to create a unique and affectionate salutation and an endearing closing, which frequently reiterated his status as a free spirit. Few were purely love letters; his protestations of affection and arrangements for their secret meetings were frequently interrupted, *non sequitur,* by sober accounts of the day's events or by discussion of his architectural work. He appears to have deliberately detached himself by inserting in many letters reminders to Lily that she had a husband of whom he thought well and whom he had supported loyally. As time

passed and their ardor diminished, Gropius started to present himself to Lily as a conduit to better marital relations, a "medium to generate intensity in others," as he wrote in the last week of October 1919. He assured Lily that she would not lose him "if you keep further on a strong intensity which does not necessarily have to be pointed toward me." He added, "I really realize how deeply you are connected with your husband and I could almost imagine that our love, for you, might become a transitory stage which will bring an even stronger affection for your husband." In December 1920 Gropius described a visit by Hans Hildebrandt:

I didn't find it at all difficult to be with him. He was so unaggressive, without hostility or hurt feelings. I feel indebted to him and made him realize that...I had been in fear of this meeting, but as I looked into his eyes this fear left me.

Now, two years later, he complimented Lily on having selected a fine husband and again rationalized their own liaison as being a test of the strength of her marriage:

You have had infinite luck in your choice of a husband and if your marriage stands up under this test, then it has proved to be strong. And I bow to that since I am a man who knows to be respectful. We need not make any plans; everything in the future depends on our sensibilities. ...So far we are very fond of each other and we should enjoy that intensively and help each other through warmth and love. Your letter, the flower, and the telegram were lovely touches which involuntarily made me smile. ...Write to me about yourself and your husband and your return. I follow all that with deep understanding. ...Your "shimmering" star.[85]

At the beginning of their romance, he often expressed concern for the scholarly historian in such words as "We have to talk about your husband. How much I would like to help and be a friend to him!"[86] It is difficult to understand the nature of his concern for Lily's husband, who appears to have been on his mind and conscience. Was Gropius in the role of grand seigneur to the acquiescent, less powerful Hildebrandt? Was Hildebrandt so in love with Lily that he was afraid he would lose her completely if he objected? Whatever the answers, Hildebrandt continued as Lily's husband to the end of his life. It does appear that a *modus vivendi* was established, in some sense one of mutual aid. With the assistance of Hildebrandt, Gropius sold family treasures to help the students so very much affected by inflation. Gropius, in turn, found opportunities for the historian by drawing on his own broad range of contacts. Among the latter was the wealthy Dr. Rauth, who had originally commissioned him to build a palatial home for his family and who subsequently engaged Hildebrandt to create a series of guidebooks for art and other museum collections.

Lily and Gropius worked together on the preparations for an exhibition of his architectural works, including the Bauhaus housing, held the summer of 1922 in Berlin and Weimar. She also assisted in hanging the exhibition, and he was concerned that the always frantic exhibition work might further aggravate her condition. Lily's activities, however, only increased, and she was successful in her efforts to win new members for the Circle of Friends of the Bauhaus.

This organization had its beginning in Gropius's fund-raising activities soon after the school opened in 1919. It was intended to gain financial and moral support for the school. Through the Circle's lectures and musical evenings the Bauhaus gained the acceptance of intellectuals. Another of Lily's activities was to seek articles and other manuscripts worthy of publication by the Bauhaus. Gropius wrote in appreciation of her work, particularly in gaining members for the Circle:

So you have also bagged Behrens, you assassin of architects! Now you have everybody lined up.

The article of your husband hasn't appeared in "Deutschland." I would be very glad if it were accepted, but the

press here is *extremely* stupid and consciously anti-Bauhaus. Before the budget is going to be discussed, something has to happen in the big press. I have written to Düsseldorf [newspaper] directly and made some factual statements.[87]

Lily's complaints of ill health were real enough, but sometimes they appeared to be a means to gain sympathy and more frequent comforting encounters in Frankfurt, Stuttgart, Berlin, and elsewhere. Gropius was solicitous and counseled "My dearest Lily" to cure herself by "sheer will" and a "desire to be healthy." He was likely to continue with accounts of the turmoil in Weimar and the Bauhaus, the chicanery of politicians and faculty, and his occasional admissions of weariness. It is apparent that now there were as many letters postponing their meetings as expressing his desire for a reunion. The lovers did meet, though not with the joy of earlier reunions.

Life and Work at the Bauhaus: Gropius sought to bring about unity in the Bauhaus through discussion. A principal problem had been Gropius's and Itten's disagreements, which had become an open secret late in 1921. Deeply involved with Oriental philosophy and in particular with the doctrines of Persian Mazdaism, based on the teaching of Zoroaster, Itten immersed his students in a regimen of deep breathing and eurythmic exercises, a garlic diet, and the application of powders and oils. They also shaved their heads and dressed in costume. The purpose was to create an atmosphere of thought, discussion, and study that would permit the students to work with a combination of mental and physical freedom and discipline. A Spartan life and fasting were not difficult to achieve for most students, already poverty-stricken and deprived of an adequate diet. Itten was extremely successful as a teacher, and Gropius had no quarrel with him in this regard, but he disagreed with his philosophical leanings, which had brought what he considered a harmful cultist atmosphere into the school.

By the end of 1921 there were already many disagreeable moments in the *Meisterrat*. Paul Klee now attempted the role of peacemaker. Previously, he always remained aloof, but it was just that quality that made him into an unchallenged authority in the Bauhaus. In critical moments he was on hand and offered his definite opinion. Now he issued a written statement he hoped would assuage the feelings of both parties and thus avoid factions: Though he welcomed the cooperative efforts of the diverse groups at the Bauhaus, he also appreciated their disagreements, if these were objective and the result constructive. "Judgments of quality," he said, "are subjective and thus negative judgments of an individual's efforts cannot be the sole determinant of value for everyone." Klee concluded, "For the total there is no wrong or right, but it lives and develops through the interplay of forces, in the same way that, ultimately, good and bad interact productively in the world at large."[88]

Klee's efforts were to no avail. Early in 1922 Gropius sought new staff to reduce Itten's control of the metal, stained glass, and wall-painting workshops, as well as the wood-carving and carpentry shops, whose direction he shared with Gropius.

Though there were already sufficient differences between Itten's and Gropius's approaches to provide reasons for their conflict, the split was hastened, beginning in 1921, by Theo van Doesburg, a uniquely talented painter who had established himself in Weimar. Van Doesburg was a dedicated member of the "De Stijl" group, which he founded with Piet Mondrian. De Stijl's formalistic

approach, which tended to produce "painted architecture" detached from reality, was always opposed by Gropius, even though he never hesitated to acquaint the Bauhaus with its tenets. There were a few students who had just joined the Bauhaus who were attracted by van Doesburg's ideas, and they left the school in 1921, some to join the new prophet.

Gropius was not inclined to submit himself and his foundation course to the dictatorship of De Stijl or of any style. He was broad-minded enough to let himself be advised by his collaborators and to recognize what was worthy in his opponent, but he was unable to resolve their philosophical and pedagogical differences. While Gropius espoused teamwork and a scientific approach to design, he also supported the development of individual creativity. It was this latter freedom which van Doesburg particularly disliked, believing that individualism and personal expression were corrupting. Gropius did not invite van Doesburg to lecture or become a member of the Bauhaus faculty, though he did invite him to his home. However, van Doesburg and Gropius were not far apart in their view of architecture, and eventually van Doesburg would be recognized by educators and historians as having an effective external influence upon the Bauhaus.[89]

In July 1922 Gropius answered a request from Bruno Taut for a report on the Bauhaus for publication in *Frühlicht.* This was an essay on an entirely different topic, "The Free People's State and the Arts." In it, he expanded on his view of the role of the arts:

> The new state must serve the arts, in order to gain the grand attribute "free." It must give free rein to the creative
> mind. …We need a new common way of thinking of the whole nation. …The state is solely a sum of individual
> beings. Everyone must help; everyone must sweep in front of his own door…
>
> A grand, all-embracing art assumes an intellectual union with its time, it needs most intimate identification with
> the environment, with the *living person.* …Today's generation must begin anew, rejuvenate itself, create a new
> humanity, a universal mode of living for the people.

To accomplish the reintegration of the isolated "arts" into the "all-embracing art of building," Gropius would preempt for the architect the role of conductor of the orchestra — that is, leader of the artistic disciplines, "superhuman guardian and organizer of the undivided totality of their life," and "first among their servants."

> Once [the architect's soul] is as passionately involved with the problems of painters and sculptors as with his own
> architecture, all works will again be filled with the architectonic spirit.[90]

But even as Gropius wrote, inflation in Germany was reaching new levels, and in the face of the panic, poverty, and misery of the time, his words could only be regarded as utopian and set aside for another day. The never ample funds of the Bauhaus were nearing depletion. The fund of a million marks that Gropius had coaxed from patrons and other friends in 1919 had depreciated to a negligible sum. Gropius's concerns for the school's present equaled those for its future, and he doubled and redoubled efforts to salvage resources. To support not only himself, but also the Bauhaus program, Gropius again turned to selling family heirlooms and properties. In August he wrote to Lily about a small property that

> according to the present value, is worth ca. 100 millions including the site. If you should succeed in selling the
> Napoleon head to the Swiss I should be very glad. I didn't succeed in Berlin with it. I might go down to 500,000
> M. [or $500], but only if it becomes absolutely necessary.[91]

Lily was almost immediately successful in disposing of Gropius's artifacts; unfortunately, their

conversion into marks would be quickly overtaken by inflation. He wrote to thank her, to warn of the monetary complication, and to postpone again their meeting:

> The new 500,000 mark bills show our whole German wretchedness. . . . I receive from all sides telegrams and letters which call me back, since the catastrophic mark devaluation creates such a confusion. Please extricate the rest of the money they owe you for the carpet very soon; in a week it will be worth only half. Now we are all getting trapped and we won't have to wait very long for a civil war. So I cannot make any plans at the moment and I plunge myself into a serious mood into my work.

Gropius reminded Lily that the debut of Oskar Schlemmer's *Triadic Ballet* would take place the following month in the State Theater of Stuttgart, where she lived, and advised her to help Schlemmer.

Lily agreed, but in doing so suffered Schlemmer's coarse innuendoes about her relationship to Gropius. Gropius and Lily were sensitive to the gossip that reached them and frequently mentioned it in their letters; but this time, she had delayed reporting it. Still, Gropius replied:

> One thing I cannot understand: that you didn't tell me right away whatever Schlemmer had told you of importance! I am not very happy with him. I have tried my damnedest for him but he is stupid, he doesn't understand me and has behaved foolishly and in an unfriendly way.[92]

The ballet was highly successful and added greatly to the reputation of the Bauhaus.

Conscious of the need for such attention, other demonstrations, publications, and exhibits were prepared. Despite mounting inflation, inadequate budgets, and other problems, the Bauhaus somehow was able to assemble a 125-object exhibition of its work for Weimar and Berlin. This Gropius later described as "only an internal affair," though in late 1922 it was dispatched for display in Calcutta, as requested by Rabindranath Tagore, becoming the first exhibition outside Europe of the work of the Bauhaus.

With the arrival of Kandinsky in the summer of 1922, Gropius considered his faculty to be complete. He confided in his "dear Lilychild" about his coup: "Wassily Kandinsky's appointment is secured, but nobody knows it; please, strictest discretion."[93] He also wrote that he had recommended her husband for a commission, and about the Bauhaus photo collection he was assembling for her, adding happily: "Next week, I shall open my architectural exhibition. Everything is running smoothly and lively."

In October there was a new crisis. Oskar Schlemmer's brother, Carl, then employed as a master craftsman in the wall-painting workshop, had become involved in an intrigue to discredit the school. The conspirators sought to undermine public confidence by circulating rumors and false statements. These would become the basis in 1924 for the notorious "Yellow Brochure." Gropius wrote angrily to Lily:

> I am in bad condition. An intrigue of unparalleled meanness is being directed against me. Leader: Carl Schlemmer. I made short work of it by presenting the whole thing to the Meisterrat so that those violators of the temple can be kicked out. I want finally to have some clean air around me. You were right when you warned me long ago against Carl Schlemmer.[94]

And, several weeks later:

> The [Carl] Schlemmer plot was disgusting. According to Oskar's report, [Carl] collected during the last year every gossip about me in the Bauhaus. The syndic and a second Werkmeister were involved in the plot. We had to fire

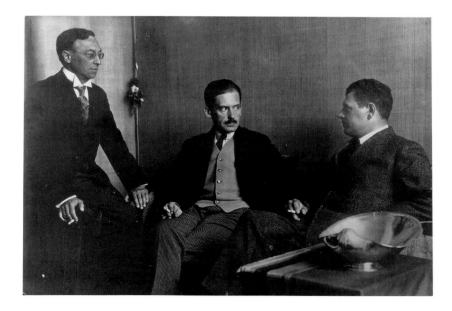

all three; there was no other possibility. This was a very bitter thing for Oskar; he is very confused and neurasthenic during such events. But I like him very much all the same, though he does not make life easy for me. The documents are now in the hands of the government and I have to fill three vacancies: syndic, master for carpentry, and a master for wall painting.[95]

Asked by Gropius to assist in the search for replacements, Lily immediately recommended Willi Baumeister, her former fellow student under Adolf Hölzel, to supplement or replace Oskar Schlemmer, whose work had understandably declined during the period of Gropius's tensions with his brother Carl. Some weeks later, having decided to retain Schlemmer, Gropius responded: "You will see that if Schlemmer will begin working again, he will leave Baumeister far behind, who, in spite of his valuable sides and though I like him very well as a character, produces only second-rate work."

As director of the Bauhaus, Gropius was, in fact, a public official. As such, he had to defend his institution and office against the charges of inefficiency in the educational program and personal moral lapses, and he instituted civil suits with this purpose in mind. In this period, Gropius received much attention from the press, both favorable and adverse, but all of it greatly disturbing to his mother and family. They thought anonymity was the appropriate role for a gentleman. But anonymity was not at all what Gropius wanted; he sought recognition and commissions through every reasonable means.

The intrigue at the Bauhaus was not the kind of attention he wanted, but as administrator, he continued to be immersed in it. In 1923, under pressure from the Weimar government, and having harbored doubts himself for almost a year, Gropius realized that he could no longer support Itten's esoteric philosophy and teaching practices. Itten tendered a highly emotional resignation. With his departure, with increasing dependence upon industry, and with a new desire to relate to the community, the older students of the Bauhaus formed a *Bauberatung,* a council to assist and advise on both academic and community matters. A more conservative stance was adopted in dress,

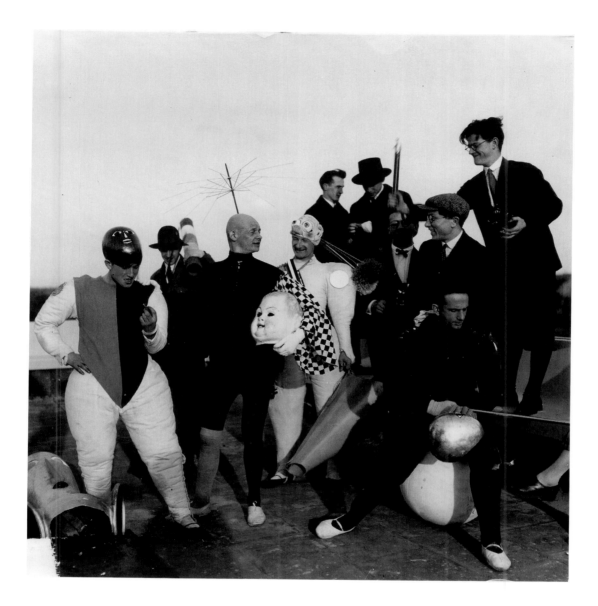

Work and play at
the Bauhaus: Stage
workshop members
in costume for
Oskar Schlemmer's
pantomime
Treppenwitz, circa
1926

Die Meisterrat
(Masters' Council),
Oskar Schlemmer
in opposition.
Sketch by
Schlemmer, 1923.
Staatsgalerie,
Stuttgart

decorum, and public statements. Unfortunately, this sense of student awareness and responsibility came very late.

Lothar Schreyer, director of the stage workshop, resigned soon after Itten's departure. But Georg Muche, who had assisted Itten, remained. In the same year Josef Albers, who was the first student to complete his course at the Bauhaus, rose to the status of "junge Meister" or "Kleinmeister." He and Muche were joined by László Moholy-Nagy in conducting the *Vorkurs*.

Gropius had met Moholy-Nagy in Berlin during the winter of 1921-22 through Adolf Behne, a writer on art and architecture well acquainted with modern art and especially with Herwarth Walden's "Der Sturm" movement. Gropius was strongly attracted by the painting he saw in Moholy's studio and was convinced by "his whole opus and his personality" that he should become a teacher in the Bauhaus. They immediately established good rapport, and Gropius engaged him to replace Itten. Gropius wanted Moholy's support in counteracting Itten's mysticism.

The preliminary course, the *Vorkurs*, was the backbone of the Bauhaus. Except in the beginning, it was a full-year course. Now Albers ran the first semester, and Moholy, the second.[96] Moholy organized his term in accordance with his own view of design and pedagogy, requiring optical, mechanical, projection, and movement studies. Moholy had great difficulties at first — his mercurial enthusiasms and activities were often misinterpreted by part of the faculty and students, since he seemed to be first on one side, then the other. In fact, he quite often placed himself in opposition to other faculty members. It was not always easy for Gropius to reconcile the different elements of his personality. It was characteristic of Moholy to share everything, in contrast to some of his colleagues, afflicted by petty jealousy. Moholy was above all a painter, an important one, with something to say, and the only Constructivist to teach at the Bauhaus. His special gift, however, was his ability to demonstrate the integration of all the arts in the many-sidedness of his own activities: painting, sculpture, photography, film, typography, and the stage.

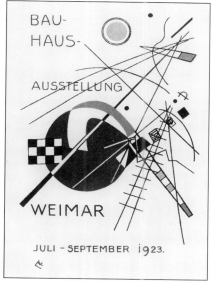

Postcards by Rudolf Baschant and (right) Wassily Kandinsky announcing the Bauhaus exhibition of 1923

The contribution of Josef Albers in his ten years on the Bauhaus faculty was as important as that of Moholy-Nagy. The latter, however, embodied his ideas in books, which became widely known, whereas Albers published little. Albers established a systematic organization of pedagogy for the *Vorkurs,* in contrast to the loose expressionist and mystical direction begun under Itten.

A major exhibition of the work of the teachers and students of the Bauhaus took place in 1923. In contrast to the "internal" exhibition of the prior year, this was intended for the public and was, in fact, organized at the insistence of the state and municipal authorities. Its purpose was to demonstrate the accomplishments of the school. Some of the participants felt that such a demonstration was premature, that their experiments were of such an unprecedented nature that it might alienate an uncomprehending public and further endanger the already shaky financial situation of the institute. While Gropius agreed with this view, he felt so pressed by the state authorities that he had to go ahead with the exhibition.

Years later Gropius said he had never before seen all the Bauhaus people work together as hard as they did for that exhibition. Not only the creative, but also the sheer physical efforts of masters and students were enormous, for there simply were not sufficient funds to pay for materials, costumes, pavilions, lecturers, musicians, refreshments, and for transportation for some events that were held in Jena. Even the wives of the masters were on their knees cleaning the Bauhaus buildings, because there was no money for janitorial work. Gropius's main contribution was to design and supervise the construction of the exhibition and, in the face of Germany's runaway inflation, to seek funds for it. He did this through lectures across the country and by direct solicitation of industrialists, friends, family, and clients.

The exhibition took place during August and September of 1923 under the banner "Art and Technology — A New Unity!" But "Unity" had not been easy to achieve despite good intentions and hard work. Among the artists of the Bauhaus there was still a fiercely individualistic spirit. It

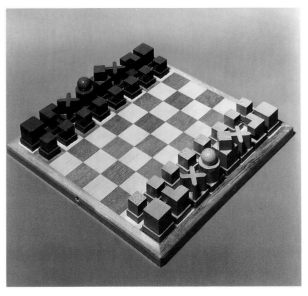

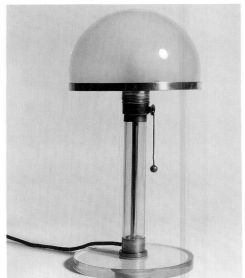

was within this spirit that an exhibition pamphlet that referred to the Bauhaus as a "Cathedral of Socialism" was prepared and released by Oskar Schlemmer while Gropius was on vacation. Gropius was horrified and withdrew the pamphlet immediately. He knew it would be misunderstood as showing support for the Socialist Party, though Schlemmer had meant it in a vague ideological sense. All but a few copies were retrieved, but in the eyes of the government in 1923, the school had made an admission, and this was thereafter held against it.[97]

The exhibition, organized within a "Bauhaus Week" that began August 15, included performances of modern dance and music by students, masters, and visiting artists and exhibits of student and faculty work illustrating all the courses. Accompanying the exhibition were a model house, demonstrations, lectures, and seminars by the masters and Gropius, and tours of old Weimar. A large display of painting and sculpture from the Bauhaus was set up in the Weimar Museum, as well as an international exhibition of designs for modern architecture, and the Jena Theater hosted concerts and other events.

The exhibition carried its message far beyond Weimar and Germany. If inflation had complicated life for the Bauhäuslers, it had also considerably increased the number of foreign visitors who could now come to Germany very cheaply. Both friends and foes poured into Weimar to see the Bauhaus for themselves. It was estimated by the city authorities that many thousands came during Bauhaus Week, and that several hundred came to the exhibits each day throughout the August-September period, with even greater attendance on weekends and holidays. Among the visitors were Igor Stravinsky, Ferruccio Busoni, and Ernst Krenek, who attended Oskar Schlemmer's and his students' elaborate *Triadic Ballet*, for which Paul Hindemith had composed music.[98]

Concerts in Gropius's Jena Theater, completed in the previous year, featured new works by Busoni, Krenek, and Hindemith. Herman Scherchen conducted the second performance of Stravinsky's *L'Histoire du soldat,* with Carl Ebert as narrator. Kurt Schmidt's *Mechanical Ballet,* for

which a visiting teacher, Hans Heinz Stuckenschmidt, composed the music, was presented as part of a Cabaret Evening. There was dancing and other festive events. The spectacle startled the burghers of old Weimar.

Among the exhibits was a display of the architectural projects and works of Le Corbusier. These illustrations were organized by the French architect himself, who provided a format and explicit instructions for their hanging. This was the beginning of the long friendship between Gropius and Le Corbusier. Years later, in a eulogy to the French architect, Gropius wrote:

> From his Esprit Nouveau, I was familiar with his philosophy. Highly attracted by it, I asked him to send me samples of his work to be shown in the Bauhaus Exhibition. He responded enthusiastically and sent me handwritten summaries and sketches of his studies for city planning and for prefabrication, which I still have, as well as photos of the very few houses he had built as yet.[99]

Gropius's own lectures attracted great numbers of artists and architects, among whom were many of his old friends and others representing a dozen European nations.[100] So moved were they by what they saw and heard that on August 17, in a spontaneously organized meeting with Gropius, they attempted to establish an international association of artists and architects.[101]

Another focus of the exhibition was the experimental Haus am Horn. This small unit on am Horn Strasse, intended as part of a housing development, was created for the exhibition. It was designed by Georg Muche with the help of Gropius's office. Muche, a painter, and not Gropius, an architect, was the designer because of the students' interest in Muche's sketches for the ideal single-family house — rooms clustered around an atrium-like living area, lighted by its clerestory. Gropius agreed to the students' demands that Muche's plan be used, but remained responsible for the location and site. As Muche himself later explained:

> Gropius, too, had to make sacrifices. He did not build the house which he, the founder and architect, would have liked to build as the symbol of his idea and the focal point of the exhibition. He was not able to because he had not succeeded in persuading the Bauhaus youth with the sober plans and examples of his architectural office.[102]

The experimental house was financed by Adolf Sommerfeld, and a private corporation was formed to support the entire housing project. The house was constructed between April and August 1923, and furnished completely by the Bauhaus workshops. Efforts to obtain financing for the entire housing project proved fruitless, given the inflation sweeping the country. The project was utopian only in the sense of an ideal established but not attained.

The am Horn house (like the entire exhibit) raised both favorable and hostile comment. While most visitors were favorably impressed, the Thuringian government, under pressure from the crafts union, the academies, and the bourgeoisie, was not. Nevertheless, the *Musterhaus am Horn* was a successful enterprise and gave renewed encouragement to the struggle to obtain an architectural department at the Bauhaus.

Ise Frank Gropius: An unexpected consequence of Gropius's efforts to defray the cost of the exhibition by lecturing was his meeting his future wife, Ilse. On May 28, 1923, he was speaking at the Provinzial-Museum in Hannover on "The Unity of Art, Technology, and Economy." For a man so aware of beauty as Gropius, it was impossible not to notice the strikingly beautiful Ilse Frank,

who was seated with her sister Hertha in front-row seats. Gropius was aware of Ilse's presence throughout the lecture and consciously directed his remarks to her. She felt drawn by his magnetism and his message, which "cut straight through the confused concepts of the day to envision a new order."

The next day, via his nephew Joachim Burchard, Gropius sent a single note to both sisters without salutation, since he did not know which one was Ilse:

> Unfortunately, through my own fault, I have failed to make your acquaintance; I wish you could have spent the evening after my lecture with us.
>
> I shall pass through Hannover again next week, coming from Cologne. May I make good then on what I missed this time?[103]

At that time Ilse Frank was working in an avant-garde bookshop in Hannover. At twenty-six, she was the oldest of three sisters orphaned some years earlier. Ilse did not attend a university but had enrolled in a school that gave young women training in scientific and practical courses. After working for a newspaper, she took a job in a bookstore, where she met such notables as her neighbor, Kurt Schwitters.

Gropius did return to Hannover to meet the sisters and Ilse was identified. He promptly initiated a whirlwind courtship. Though Ilse found him attractive, she hesitated to become fully involved with him because of her sense of responsibility to her cousin Hermann, with whom she had been living and whom she was planning to marry that summer. But Gropius was a persuasive suitor, and after he departed, she expressed her indecision and soul-searching in letters, telephone calls, and telegrams. In June she wrote,

> I am suddenly seized by an idea: may I visit you? Or would you rather that I didn't?
>
> I know you have so much to do now before the exhibition, but my heart is filled with the wish to be with you in the place where you live.
>
> I am free from Thursday to Sunday; which day could you give me? Please answer immediately even if it should be a 'no'.[104]

Gropius joyously telegraphed an invitation for all of Ilse's free days. With the warmth of his reception, and the friendly confusion of the Bauhaus, the days and nights passed quickly for Ilse. They talked of marriage, though Gropius's experience with Alma weighed on his mind and he harbored strong doubts about a hasty wedding. But Ilse wanted the security of a family. She returned to Dillenburg, where the family firm, the Frank Iron Works, was located. His letters continued to arrive in a constant stream of persuasion, and she responded:

> I went into the garden with your letter this morning and the feeling of gratitude overpowered me so that I could do nothing but kneel in the grass under the rays of the sun as if they were your eyes shining upon me. ...You said the other day that you do not believe in an urge for procreation, but I still believe in it. Marriage is in that case the sacrifice for the new generations and I thought that this idea could give me fulfillment in a marriage. I see now that this will not be possible.
>
> Morning, 6 o'clock.
>
> The letter has been with me all night. The sun shines, but I am so tired and sad that I hesitate to begin to think. How much I have written to you! Please read it with loving eyes. You must answer me, but after that do not write

anymore; otherwise, I cannot do it. Early enough I shall knock at your door again. Will you always answer?[105]
There was an immediate response from Gropius, and hurried, happy meetings between the lovers took place in Weimar and Hannover.

Sensitive to Ilse's concerns, he was able to anticipate her every doubt; his letters ranged from cajoling missives to firm statements, not all of which she could accept wholeheartedly.

Six weeks had passed since she and Gropius had first met. For a time she thought she might be pregnant, then found she was not. She still feared breaking her engagement with Hermann Frank and canceling the elaborate wedding, arranged to take place within a few days in the home of her aunt in Munich. But Gropius was determined:

On the following spread:

Left: Gropius, 1923

Right: Ilse Frank, 1923

I am not a man who can wait! I storm through life and whoever cannot keep pace will remain by the wayside. I want to create with my spirit and with my body; yes — also with my body; and life is short and needs to be grasped. . . .

As we become lovers the *whole* of life, birth, and death revolves in our hearts. . . . Ours was no game. We had formed a holy bond in blessed nights…but you leave me in uncertainty and my humility changes into anger when I find my most sacred gift disdained.

Strong people feel great tensions, their hearts are never indolent, they dissolve in love and can immediately harden into steel again.

Do you understand me, my beloved? Do you understand my being hard and unrelenting? I stand at the threshold. I must speak to you without restraint: in you slumber *wonderful* forces whose essence I had meant to develop into meaningful reality and I wanted to fight for you with all I have… .

You are standing at a crucial turning point of your life, and whatever you choose, seize it and live it *fully.* Only total dedication counts, everything else is weak. Make a clean break, liberate yourself…Goodbye…I believe in you!

Ilse was finally won over. She wrote to Gropius, telling him she had broken with Hermann, and she even accepted his change of her name to Ise. Despite the intense pressures in these weeks preceding the opening of the Bauhaus exhibition, Gropius replied immediately:

A Sunday…I am filled with a great stillness as if I were kneeling in front of something incomprehensible that was given to me…this indescribable moment when your letter arrived this morning, the constant tearing pain which I endured suddenly stilled. I understood nothing and stood, I don't know how long, in a cloud of darkness and then the light came shooting in from all sides and my heart leaped… .

I am working like a demon, day and night. My great work is now saved through you; you gave wings to my feet and these last weeks will be one gigantic work battle. But the moment you call me I shall drop everything and come right away. And my doors here are open for you at any hour.

Troubled by her dismissal of the devoted Hermann, Ise remained in Ambach (near Munich) to attain some peace of mind: "It is so solitary here, the forest, the lake. I drift about for hours in a boat and everything loses its cutting edge."[106] At the end of July, with some degree of tranquility restored, she returned to Hannover to face friends and relatives, encouragement and criticism. Family arrangements hastily completed, Ise moved to Weimar early in August 1923, for appearances' sake as the guest of Paul Klee and his wife.

Since meeting Ise, there had been a distinct change in Gropius's letters to Lily; he wrote of his problems at the school, of his practice, and about preparations for the exhibition. He not only delayed informing Lily about Ise, he deflected her suspicions. Responding to Lily's inference of

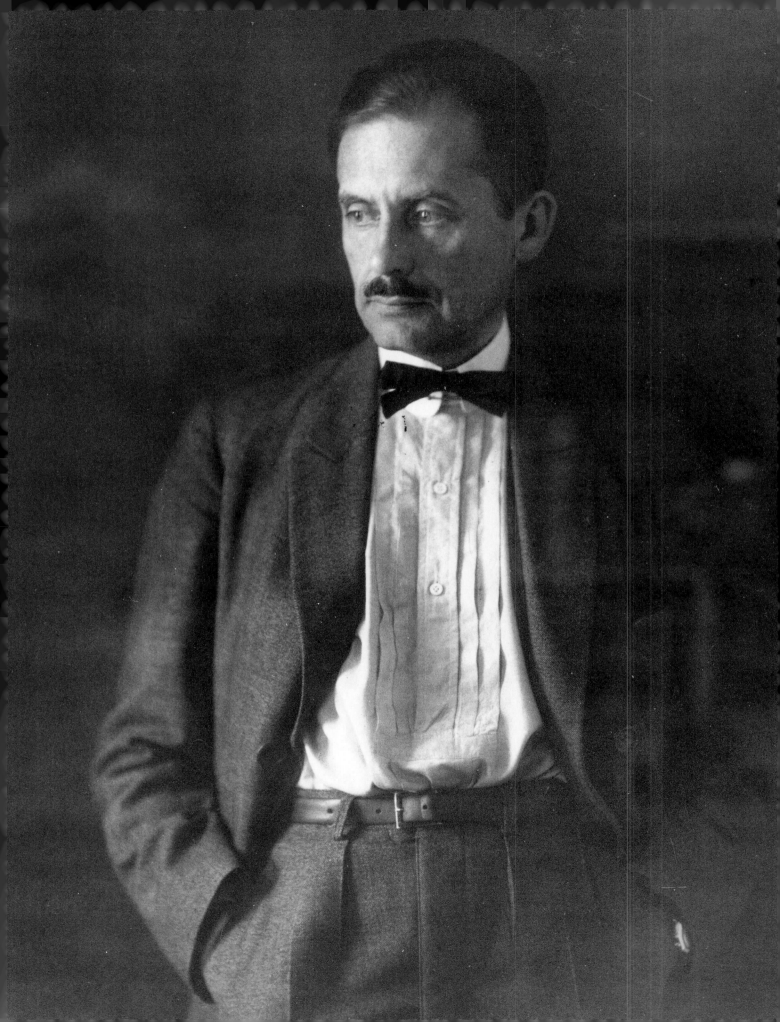

inconstancy on his part, he wrote, following an extended visit to Ise: "I was not fourteen days but only three days in Hannover. The rest of the time on building sites. If only women weren't so jealous!"[107]

And when it came time for Lily's next visit to Weimar, he wanted to avoid a meeting between the two women, so he suggested she stay in out-of-the-way accommodations at a summer resort during her visit for the opening of the exhibition.

The Bauhaus Week was successful beyond all expectations. It culminated in a great mask and costume ball which began in the late evening of August 19 and went on until sunrise. It was a pleased and exhausted Gropius who, with Ise, had stayed with the festivities through the night. The next day, before the other celebrants arose, the couple slipped out of town for a brief recuperative vacation, their destinations Verona and Venice. As they waited for an express train at Jena, Gropius wrote to his mother, who already knew of the romance, informing her of his pending wedding to Ise:

> We couldn't get the papers this quickly, so we haven't been able to marry yet and we are still incognito. There was absolutely no time for it up to now, I haven't even found time to sleep. Ise will write you from Italy and thanks you for your very dear letter. Tell our friends about us, but it won't be official before we are married.[108]

Two months later, on October 16, 1923, they were married in Weimar with Wassily Kandinsky and Paul Klee as witnesses. Neither Gropius nor Ise had desired a church wedding, and the brief civil ceremony was performed without members of their families present. Few knew of the ceremony and, their emotions and energy exhausted by the great exhibition, the Bauhäuslers did not organize a festival to celebrate. Then there came a journey which almost any newly wed couple would consider a honeymoon. Le Corbusier had earlier invited Gropius to visit for an exchange of ideas and an inspection of his recent work, so in late October Gropius and Ise traveled to Paris.

Though late in the season, they found Paris enchanting and Le Corbusier entertaining. Forty years later Gropius wrote:

> After the Bauhaus Exhibition in Weimar, we met for the first time in the Café des Deux Magots in Paris. He discussed his plans for a *ville contemporaine de 3,000,000* with me, and the idea of standardization and prefabrication of houses which we were both highly interested in at that time. I gave him a diagram which showed that, during a certain period in the USA when the cost of living doubled, the cost of the Ford car was halved. I gave him also photos of American silos which I had collected in 1910 as examples of a new industrial monumentalism, and which I published in the Werkbund Yearbook of 1913. Both the diagram and the photos, he later republished in his *Vers une Architecture*. He spent the rest of that day with me looking at two houses he had built, for Ozenfant, the painter, and "Maison la Roche," the unprecedented freshness of which greatly excited me.[109]

For Gropius this marked the beginning of a new life, one of increasing richness, beauty, and warmth. Until then he had been almost completely dominated by his drive to build up the school and his practice; he now found refreshment in the development of personal activities. He began to take vacations with Ise, including trips to Italy and Switzerland.

From their house on the Kaiserin Augustastrasse, he and Ise made walking trips in the beautiful environs of Weimar. Music was a constant source of pleasure; their home was filled with it. For their

mutual pleasure Gropius brought home the first gramophone in the Bauhaus community. Along with Gropius's records, it was in demand from morning until late at night. Klee, an accomplished musician, took unending delight in it and on occasion he attempted the role of soloist, improvising or playing a violin concerto to the accompaniment of the recorded music. At other times, unable to listen quietly, he would seize any baton-like rod and direct the orchestral or band music while marching up and down through the rooms.

Once again Gropius read aloud in his own home the works of old and new writers. To these were added Ise's extensive library of avant-garde authors so familiar to her from her days in the bookstore.

Visitors from the very beginning were numerous, and Ise quickly established a routine for their reception and entertainment. Her diary records a constant flow of the famous and not-so-famous who came to their door, expected and unexpected. Ise brought to the Bauhaus a vivacity which rivaled that of the students. As young as many of the instructors, but linked to the older generation by her marriage, Ise served as a conduit between all of them. Her sympathy was with the students; her intellectual interests were with the faculty. Alma, though a patron of musicians and literati, was the daughter of a traditional Viennese painter and could never comprehend the Bauhaus, its bohemian people, or its life; but Ise felt utterly at home. The students had felt rebuffed by Alma, but they were immediately attracted to the gracious Ise. While Alma claimed credit for introducing Itten to Gropius and through him, Georg Muche and Oskar Schlemmer, Ise stimulated the students to take part in the life of the Bauhaus, to persevere, to become teachers themselves. Fifty years later, Ise could recall how Gropius imbued her with courage, strength, and confidence for her new role in the Bauhaus community: "He said, 'I am totally immune to disappointment because I do not see people and situations for what they are at the moment but for what they might become.'"[110]

While Gropius's and Ise's first meeting in Hannover marked the end of fervent love letters between him and Lily, their correspondence continued until his death.[111] Their romance had supported Gropius as nothing else did through the difficult readjustment of his postwar years and his painful divorce from Alma and separation from his daughter, Manon. After his marriage to Ise, it is clear that the relationship with Lily became an entirely platonic one. He invariably mentioned his concern for her health and for her husband, and would send Ise's regards.

Though Gropius's personal life had bloomed since he had met Ise, the political environment in the city and state had continued to deteriorate. The very success of the exhibition only provoked the enemies of the Bauhaus to greater antagonism. These opponents from the crafts guilds, the academies, and the bourgeoisie urged their allies in the government toward increasingly repressive actions. The right-wing politicians needed no encouragement; the Reichswehr forces under General Hans von Seeckt were already, in November 1923, deployed to eliminate Socialist-Communist infiltration of the government and Lieutenant General Hasse placed Thuringia under martial law.

In this uneasy climate Gropius and the Bauhaus were accused anonymously of being parties to the current political agitation. Von Seeckt ordered a search of the Bauhaus, but no restrictions were placed on the school at that time since no incriminating evidence could be found. Gropius's own

Walter and Ise shortly after their marriage

home was also subjected to military search without notice for "subversive materials." Protesting vigorously, he wrote to the military commander on November 24,

> Yesterday morning at half-past ten I was summoned home from my office by a [Reichswehr] soldier because there was a search warrant. The house was searched by a deputy officer and six men in a sensational manner. The order can only have been issued on the strength of a malicious, irresponsible denunciation which was not checked. ...I am ashamed of my country, your Excellency, ashamed of being apparently without protection in my own country, in spite of my achievements.[112]

The search was damaging to the reputation of the school even though no evidence of subversion was found.

State elections had placed the conservative *Ordningsbund* (Coalition for Law and Order) in power, bringing the Socialist government to an end. This was the beginning of the end for the Weimar Bauhaus. Appropriations for the school, always fragile, were now in serious jeopardy. Guild leaders and friends of the academies, taking advantage of the state's vacillating attitudes, pressed for its closing on various grounds — Communism, destruction of private enterprise, immorality of faculty and students, misuse of public funds.

These enemies did not overlook the opportunity to convince students that they were being "used," hoodwinked, and inappropriately trained. The students themselves singled out Kandinsky and Moholy for criticism. The former had been particularly dogmatic about the students accepting his theories of art. Add his Russian name and his work in Russia, and he was obviously a Communist!

And Moholy? Poor Moholy! He was experimenting with intuitive design, which left some students feeling untaught. Then it had also been made clear that Moholy too was *not* a German.

In a series of meetings called by Gropius, the students' and the masters' frustrations were aired; within a few days the crisis was past, but the causes were not entirely remedied.

The constant state of turmoil had convinced Gropius that "building is the only thing that gives

me inner joy, while other people are a constant burden who always take without ever giving."[113]

Beset by political attacks and the continuing problems of the Bauhaus, the first year of the new marriage, less than idyllic, was also marred by illness. For some time, Ise had suffered from an undiagnosed stomach ailment. In March 1924, she entered the Sanatorium Konigspark in search of a cure. Gropius's visits and letters to Ise were frequent, his encouragement constant. He recounted the events of the day: the political pressures on the Bauhaus were mounting; a new commission exhilarated him; he was lonely:

> Today was a wild day. There were press notices from Jena and Berlin which openly say that the government will not extend my contract and wants to liquidate the Bauhaus. So I have to change to the offensive now and I will make the ministers sweat. First of all, I have to be sure of the support of the masters, who will probably stick with me *en bloc* and make their remaining dependent on my staying. There will be a decisive meeting on this tomorrow in my absence. …A committee will then go to the minister and confront him. If he gives no clear answer, we shall give the whole story to the national press.[114]

While such letters could hardly have hastened Ise's convalescence, she insisted on receiving unembellished accounts of the vicissitudes of the Bauhaus. Gropius reported:

> Yesterday I was called in by the minister. He looks like a long dead clerk of the court. …He has obviously never heard of the existence of cultural problems and remains a dry bureaucrat without a personal opinion. It became a serious debate when he declared that there was no inclination on the side of the various parties to extend the contract of the Bauhaus. I shall now act silently and prepare the great fight.

Ise had written him about Dresden and Leipzig society leaders, and members and friends of their families who had called upon her at the sanatorium. Walter was not impressed:

> Your aristocratic admirers! Of course they would go for you since you are a totally aristocratic human being, but I know that there is little to be expected from them. *Ungeist* and arrogance have seized them. We know why the aristocracy has lost its reputation in the general public view; it is because they have forgotten about the "noblesse oblige" in cultural matters. Who supports nowadays the living science and art? Not the aristocracy but the Jews who skillfully took their place in this inheritance. And this spiritual indolence is their [the aristocracy's] ruin.[115]

During the spring of 1924, Gropius struggled with the problems of the Bauhaus in Weimar, engaged in architectural commissions and professional and other organizational activities in several cities, worried about his ailing wife; he was lonely for his much-loved daughter, Manon, in distant Vienna, concerned for his former mistress, Lily, in Stuttgart, and felt guilty about not visiting his mother in Berlin. All of these responsibilities needed attention, if not in person, then by letter, telegram, and telephone.

Then there was Alma, with whom there were arguments over the custody of their daughter, who, it had been agreed, would visit Gropius twice each year. Alma was extremely possessive of the child and did not keep her promise, insisting instead that he come to Vienna.

During a visit to Ise in the sanatorium, the subject of a journey to Vienna arose. Gropius had been invited to lecture in Vienna, which would have given him the opportunity to see Mutzi again, but Ise refused to accompany him. Ise tried to explain her feelings of insecurity: she did not want to see Alma and him together, resented the influence Alma had had on him, and was concerned that it was still present. Yet she said she did not want him to give up the trip.

Alma with Franz
Werfel and Manon
Gropius in Venice,
circa 1925

After weeks of discussion Gropius traveled alone to Vienna. Once there he had a joyful but brief reunion with Manon, much of it spent with Alma hovering nearby. Alma was bitter; his marriage to Ise had stung her pride. His lecture was a success, and, following a farewell meeting with his daughter and many promises for an early reunion in Weimar, he departed Vienna believing that his personal and political troubles would soon be solved.

Actually, Gropius had little basis for optimism beyond his own strong will and persistence. The state elections of 1924, which had brought the conservative parties to power, were followed by increased attacks on the Bauhaus. Aiding these were the former members of the school's staff, especially Carl Schlemmer, who were dismissed for intrigue in 1922. Now in 1924 their falsehoods were perpetuated by a publication that came to be known as the "Yellow Brochure." This document, containing scurrilous allegations and charges against the Bauhaus and its members, was circulated widely in Weimar and beyond. The gist of its polemic was that the Bauhaus was political, its communal activities smacked of Bolshevism and Spartacism, foreigners were favored (receiving the best housing and largest scholarships), and therefore, the Bauhaus was anti-German, as attested by exhibition material in three languages. At best the Bauhaus was abstract, mystic, irrelevant. Before the brochure could be repudiated, it obtained much credence, resulting in damage to the Bauhaus cause.

Gropius described the situation shortly after the "Yellow Brochure" was published in late April or early May 1924:

When the dirty "Yellow Brochure" was published, the students printed posters supporting me for [distribution in] the city, and the masters made a public statement in which they castigated its obscenity. The signer of it, Arno Muller, is a straw man who has admitted that he hasn't even read the pamphlet and has named as its authors: Hans Beyer, Josef Zachmann, Carl Schlemmer, the three who were summarily dismissed.

The State and I immediately got in touch with the public prosecutor to bring suit because of offense; even *this*

> government cannot but protect me against a mean act of vengeance. Beyer had been dismissed as a swindler because he had *bought* his title of doctor. The State has forbidden that he use it.[116]

Beyer had been an accountant at the Bauhaus; Zachmann was a master craftsman in the cabinet-making workshop from 1921 to 1922; and Schlemmer was a master craftsman in the wall-painting workshop.

The Last Year in Weimar: There was little escape from the constant harassment and time-consuming demands of Weimar's political environment. Not one of the political parties, which were fearful of appearing progressive, fully supported the Bauhaus. Gropius felt he could not rely on the masters, whom he considered impractical and unworldly. Yet the Bauhaus faculty gave unanimous and overt support to Gropius. In April 1924, reacting to a rumor that Gropius's own contract might not be renewed, the faculty decided to resign if such a decision was made. A letter to this effect to the minister of state was delivered by a group of supporters, among them Kandinsky, Klee, Hartwig, and Lange, who had signed it. Their strength and aggressive stance had its effect.

Compounding Gropius's problems was the resignation of Lange, his loyal and overworked business manager, who insisted that it was impossible to keep records for an educational institution *qua* profit-making industry. In May Dr. Wilhelm Frederick Necker of the Staatsbank became his successor.

Within this climate, Gropius's forty-first birthday party on Sunday, May 18, 1924, was a strangely festive occasion at which, Ise wrote,

> he was showered with presents from students and a portfolio from the masters, feted gloriously, spontaneously — radiantly…the whole atmosphere was so open — as I've never seen before. The band was in a fantastic mood — Gropius was carried on the students' shoulders with deafening cheers. At this moment, the minister of state, Friedrich Schultz, happened to visit; he was surprised and pleasantly disappointed to see the ill-reputed Bauhaus in such spirit. …The celebration lasted through the following Saturday and Sunday, May 24 and 25. Walter was heartened.[117]

But the semester was soon over and the conditions faced by the Bauhaus had changed little. Since Gropius could only conjecture about behind-the-scenes machinations against him and the school, there appeared to him at this time to be a lull, if not an improvement, in the political atmosphere. Many artists and architects who previously disagreed with the directions of the Bauhaus now expressed themselves strongly in their favor; obviously they chose to align themselves with progressive design efforts rather than reactionary ones. The Circle of Friends of the Bauhaus, which had recently established itself more formally, had been strengthened by the viciousness of the attacks against the school. Its members included leaders in business, the arts, sciences, government, and education.[118] They called upon the public to support the Bauhaus morally and practically.

Gropius went to Timmendorf in mid-summer of 1924 for a reunion with his mother and other family members, some of whom met Ise for the first time and were delighted by her. The support of the Bauhaus and of Gropius's architectural practice by his kin had been constant, though at times the directions of the school, Gropius's first marriage, and his perplexing political stance had been embarrassing to the conservative branches of the family.

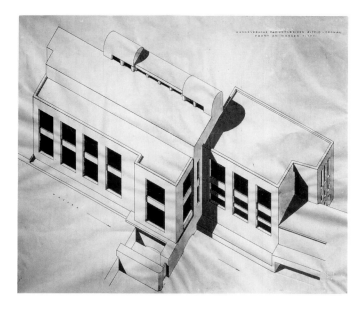

Hannover Paper
Factory, Alfeld-
Gronau, 1923 – 24.
Gropius with Adolf
Meyer

Returning to Weimar, Gropius immediately sought to further his architectural practice, which had lagged during the politicized academic year. Late in 1923 Gropius had been commissioned by the Hannover Paper Factory of Alfeld-Gronau to design an additional building for its industrial complex. By early spring of 1924, with Adolf Meyer, he completed the plans and construction followed. Designed twelve years after the Faguswerk, this building manifested less concern for workers' welfare than the earlier structure.

Also in 1923 Karl Benscheidt, the owner of the Faguswerk, again called on Gropius, this time for a warehouse and service building complex. Bearing little resemblance to the 1911 factory other than in its use of similar brick, it expressed its purpose with simple lines and volume with few windows. In 1924 Gropius began planning still another large storage warehouse building in Alfeld, for the manufacturer Kappe. Completed in 1925, it was located on the opposite side of the railroad from the Faguswerk.

There were, unfortunately, commissions that would not progress beyond preliminary designs. In a letter to Ise, Gropius wrote with excitement about a project for the quarters of an academy of philosophy. This academy had been founded in 1922 by Professor Rolf Hoffmann of the University of Erlangen, and was accommodated in an old villa.[119] Hoffmann had a keen interest in contemporary art and architecture stemming from his student days in Munich, where he became familiar with the Blaue Reiter group, Paul Klee, and the few modern-minded architects. It was not surprising, then, that he called upon Gropius to design a structure which would be appropriate to the ideals of the academy.

With general agreement by the board of the Philosophy Academy, Gropius prepared plans and a model of an ideal academy building. These were exhibited as part of a money-raising campaign by the board, since the entire project was to be financed by philanthropy. This effort was in part successful, but the rapid growth of inflation depreciated the funds. Then the balance of their capital unaccountably disappeared. The board and Hoffmann were accused of mismanagement and of

overdrawing their accounts, and an official of the Bavarian State Bank lost his job and was imprisoned for not having required adequate bonding. In late 1924 Hoffmann quietly abandoned the project and left the country for the United States.[120]

The plans and model of the academy and other projects had been developed in Gropius's architectural office at the Bauhaus within sight of the students. With such stimulus, many more became interested in joining an experimental architectural workshop. This was given under Gropius's general direction from his private office, with Adolf Meyer and Ernst Neufert as assistants. The students pushed for expansion of such studies, and by the spring of 1924 Muche and Breuer started an architectural collaborative work group which included the masters as well as Josef Hartwig, a master craftsman in the sculpture workshop.

The object of the group was to investigate the design and construction problems of dwelling units. Breuer and Muche also initiated studies of high-rise housing. Within months, Gropius's workshop and the Breuer-Muche collaborative work group became the seeds for a future architectural department. Later Gropius resumed the negotiations begun in 1919 with the government for the use of an abandoned riding academy as a space for practical training. Arguments raised by the Weimar Deutsche Volkische Partei (DVP), the precursor of the Nazi party, delayed an agreement until 1924, and lack of funds to equip the space prevented its use except for some preliminary activities.

It was a rare letter between Gropius and Ise that did not include mention of the Bauhaus, but in one such letter he spoke of the emptiness created by her absence while at the sanatorium:

> Today…no word from you, so I am only half and since I hope that you feel the same I write quickly a few words though I am absolutely dead from the work of these days. I am superhumanly longing for you. I am full of happiness that I love you, that a great reservoir of feeling for you has accumulated in me which cannot dry up.[121]

In reality, their life was far from idyllic, aggravated as it was by Bauhaus problems and exacerbated by Alma's willfulness. Now she decided not to bring Mutzi to Weimar as had been arranged during Gropius's visit that spring. Concerned that his daughter would be as disappointed as he, Gropius immediately accepted a standing offer to return to Vienna for another lecture. Ise again was not pleased, and he attempted to placate her, blaming Alma and offering to cancel his trip and lecture. Reassuringly he added that he previously "was never really married" and that he had "never spent more than two weeks at a time with a woman." He added, "You are my first and only wife and I shall never want anyone else."[122]

Ise's recuperation and extended rehabilitation at the sanatorium came to an end in late September. As an outpatient, she visited friends in Cologne and campaigned actively for the Bauhaus in nearby cities. On Sunday, September 28, she reported:

> I am revolutionizing all of Cologne including the mayor [Konrad Adenauer] with information on the Bauhaus and now there are indeed plans to bring the Bauhaus here. …I was 1½ hours with him, which astonished everybody and made things easier for me. … I explained to him our political situation and the Bauhaus work, about which he knew nothing but which obviously interested him. Fortunately he had just had a conversation with [Fritz] Schumacher [city architect for Hamburg] who told him that he had always followed your work with the greatest of interest.[123]

Their correspondence at this time confirms the fact that Gropius already believed Weimar to be

untenable for the Bauhaus and that he was actively seeking a new location. Thus Ise took pains to implant in the minds of Konrad Adenauer and other Cologne administrators the thought that the Bauhaus would be better located in their city, and that Gropius could also fulfill the role of city architect. She also gained new members for the Circle of Friends of the Bauhaus and had an outstanding prospect for its board in the person of Adenauer. She extracted promises of financial help in the form of donations and extended credit and won actual orders for the weaving workshop. Her activities filled Gropius with pride, love, and caution that she not overdo it and jeopardize her health. Addressing her as "My dearest Mrs. Bauhaus," he wrote:

> You are a veritable magician and you should burst with pride. We deeply respect your achievement, because we all know how tough people are in evading requests. I am deeply touched: you are my good star.

His concern for her health notwithstanding, he sent names of influential friends who might help place articles about the Bauhaus in a sympathetic Cologne newspaper, the *Kölnische Zeitung,* and offered others to an American reporter, Dorothy Thompson, whom Ise had already urged to send a story about the Bauhaus to her papers. He reminded her that "it is important to win over the press."

In September 1924 the Thuringian State Treasury had completed a partial audit of the Bauhaus records and found the school to be financially unstable. Other than the neatness of the workshops and the efficiency of the kitchen, the auditors had little good to report about the Bauhaus.

Gropius's numerous preoccupations did not relieve him of the responsibility for selecting and supervising a competent business manager. He had not yet shown indications of the financial acumen of his later years; nor was his selection of associates, teachers, and friends faultless. On the other hand, the most plausible explanation for the shaky financial condition is that given by the business manager, Dr. Wilhelm Necker: in the school's defense, he noted that ordinary governmental accounting systems did not accommodate an institution that was operating with state subsidies, both as a contractor for private industry — and thus in part self-sustaining — and as a school with variable income from tuition and outlays for materials, scholarships, and faculty salaries. Gifts in kind by manufacturers and Sommerfeld's underwriting of the *Haus am Horn* were sources of awkward accounting.[124]

The publication of this audit in September and the government's issuance the same month of a preliminary notice for probable disbanding of the Bauhaus by April 1925 seems to be more than a coincidence. Ordinarily, unless there were proofs of dishonesty rather than incompetence, an audit alone would not have been sufficient reason for such a drastic step. But, coupled with a long history of pressure upon the government, the audit may have sparked the decision.

The Volkische Partei had become stronger in 1923 and its leader in Thuringia, Richard Leutheusser, was also minister president of the Landtag. Gropius later described him as "a weak personality without cultural interests" who "tried cunningly [through the findings of the budget committee] to push the Bauhaus out because of the pressure from the right."[125]

Though Gropius was dismayed, he had some faith in the hearing and appeals process before the Landtag, which he expected would occur before any final decision would be made. But he was outmaneuvered by a combination of an unsympathetic rightist government, which held the purse

strings, and hostile crafts unions. Though his principal role was administration, his public relations efforts were not adequate to the task — perhaps none could have been under the circumstances. It was now too late, and the government's cease orders were quickly issued. He now informed Ise, still at the sanatorium, of "a black morning!"

> This morning I got my notice and so did all the masters and craftsmen, as I expected. There was a reference to the still not definite decision of the Landtag. I gave the news to the press so that some pressure can be applied at the negotiations. Of course, this will be a paralyzing influence on the Bauhaus. I also got a letter in the dictatorial tone of a corporal from the audit office.[126]

Ise's efforts and letters increased with his ominous news; on September 29 she wrote about the influence she had with Adenauer, noting that though she had been warned he could be incredibly rude and unpleasant if something did not interest him, she had indeed won him over.[127] (In fact, Ise quickly became an intimate of the family.) With rapidly acquired experience and growing numbers of introductions, Ise called on friends and prospective friends without hesitation in an effort to gain their support for the Bauhaus in its critical hour.

With Adenauer's advice and introductions, Ise went to Düsseldorf, where she interviewed (or rather, educated) editors and industrialists, winning over the former and convincing the latter as to the quality of the products of the Bauhaus. She was exultant: "I thought that if I could change the mind of these *feukemen,* I might also do some good in Essen."[128] There, on October 4, Ise also talked with the director of the Kunstgewerbeschule, Fischer, who told her quite honestly that though he knew that he would lose his best students to the Bauhaus, he was very much in favor of getting the Bauhaus into the Rhineland and Cologne.

There was much to be done and Gropius's review was required for every action. The students were also caught up in the struggle for survival of the school. The majority favored a protest petition, which they delivered en masse to the Thuringian Landtag on October 17.

The last months of 1924 saw only further deterioration of support for the Bauhaus from the Weimar and Thuringian governments. Offers by industrialists early in November to underwrite the reorganization of the Bauhaus as a production company with economic and cultural ends, while detaching the educational program, met with disfavor from the rightists and National Socialists, who sought the elimination of the school entirely.

Protests against the government's actions from throughout Germany and abroad were sent to the Landtag. The government majority ignored them. The nationalist movement had an anti-international tendency, and long before Hitler came to power, German democracy was not sufficiently developed to keep politics out of art. The National Socialists in Weimar made the Bauhaus a bargaining chip in their fight against the Democrats and Socialists.

Despite the valiant support of some Weimar citizens, trade unions, architectural societies, artists, teachers, scholars, and international and foreign associations, the attacks increased to such a level that on December 26, 1924, Gropius and his masters, having been notified of new governmental restrictions, decided on a coup to forestall further destructive actions on the part of the National Socialists. On that day, Gropius, together with his staff, publicly declared the Bauhaus in Weimar closed. It would, he intimated, reestablish itself elsewhere.

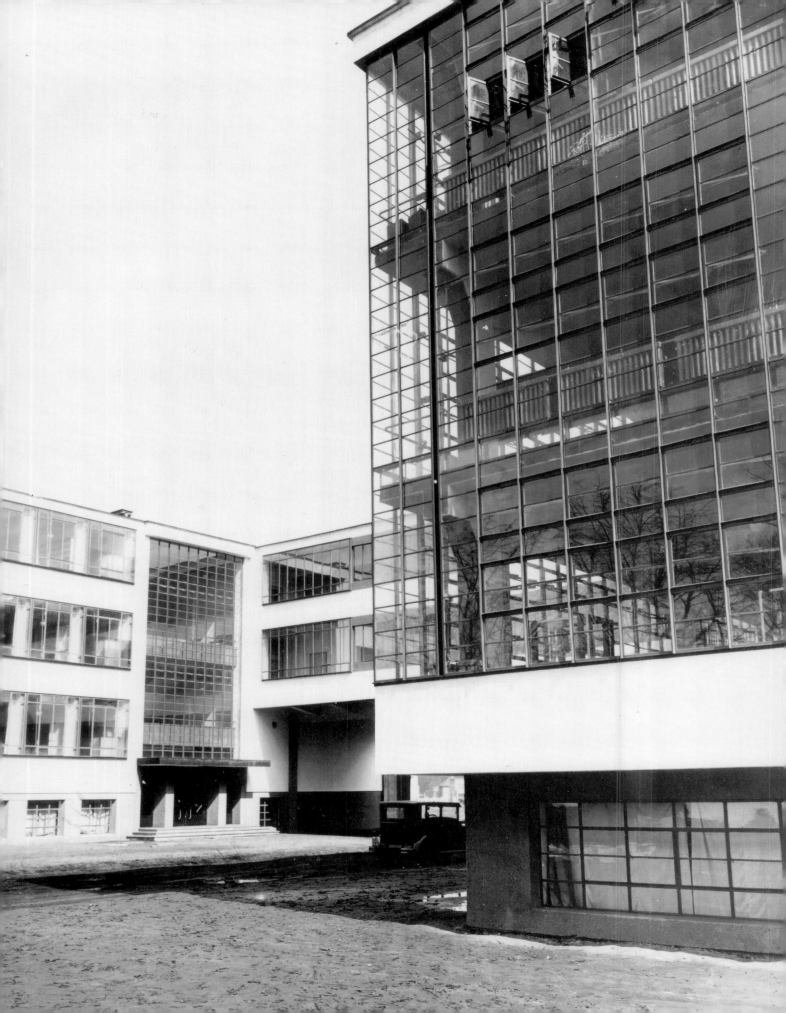

THE DESSAU BAUHAUS
1925–1928

<p>A</p>lmost immediately following the Declaration of Dissolution in Weimar, an inquiry from Dessau opened a new era for the Bauhaus. Stimulated by an article in the *Berliner Tageblatt,* Dessau's music director, Franz von Hoesslin, prevailed upon Mayor Fritz Hesse to invite the Bauhaus to Dessau. Hesse, liberal and politically progressive, turned for advice to the art historian Ludwig Grote, who persuaded Hesse of the importance and benefits of the Bauhaus should he obtain it for Dessau.[1]

The Bauhaus presented a challenge for Dessau. The town's cultural heyday lay back more than a century. Its intellectual attainments did not compare with those of Weimar, but during the nineteenth century Dessau had supported Wagner and welcomed Paganini and Liszt. The city had long encouraged opera and in 1799 had built one of Germany's greatest theater buildings, rivaled only by those in Berlin and Bayreuth.

During the nineteenth century Dessau had also become an industrial city, and it was now a thriving metropolis with seventy thousand inhabitants. To Mayor Hesse the Bauhaus represented a chance to renew the city's cultural prestige. It would be, nevertheless, a new responsibility, for in Weimar the Bauhaus had been a state institution, but in Dessau it would be a city function. The Municipal Council of Dessau approved the invitation and contract for the Bauhaus on March 24, 1925, by a vote of twenty-six to fifteen.

The Move to Dessau: At first, Gropius was appointed director of the School of Arts and Crafts and the Trade School. Earlier, it was thought that the Bauhaus would be a kind of auxiliary to these schools, but this was unacceptable to Gropius. For administrative purposes, the School of Arts and Crafts and the Trade School were subordinated and placed under the direction of the Bauhaus, although their programs were not combined. The name Bauhaus fortunately had been registered by Gropius as a property of the school and was transferred to Dessau, although not without protest from Weimar.

During a previous visit to Dessau to discuss the city's invitation, Gropius found the classrooms of the existing schools inadequate, and he was commissioned to design a new building for the school. A well-situated site within two kilometers of the city center on Friedrichsallee (now

Corner of the workshop wing, Dessau Bauhaus

Thalman Allee) was available, and the government quickly purchased it. Other than the old hospital across Friedrichsallee, the surrounding area was then undeveloped, so no preexisting structures would determine the location of the main Bauhaus building.

To facilitate the work, and with the express permission of the city government, Gropius immediately opened his own architectural office, as he had done in Weimar. Unable to win sufficient funds to establish an architectural department in the school, he again took students into his office as apprentices and draftsmen.[2] Former students Marcel Breuer, Farkas Molnár, and Joost Schmidt were engaged for design work. The closing of the school and of Gropius's private office in Weimar marked the end of his long association with Adolf Meyer, who had accepted a position in the city planning office of Frankfurt under Ernst May. Replacing Meyer was Ernst Neufert, who became manager of the office at the age of twenty-six. Ultimately the office became a much larger enterprise than the one in Weimar, numbering as many as twenty to twenty-four staff members.

Working day and night, Gropius designed the school building and directed the completion of working drawings by mid-summer 1925. Contracts were let but, delayed by a building trades strike, construction did not start until September. In April 1926 the roof "topping-out" ceremony took place. Within one year of the start of construction, the first classrooms and workshops were already in use.

The building housed the Bauhaus workshops and studios, the technical school, and an auditorium with a stage and dining hall. A bridge led to the wing that was originally to contain the Dessau School of Arts and Crafts. In the end, this school did not move into the part planned for it. Contributing greatly to the cohesive spirit of the Bauhaus students was the fact that some twenty-eight of them were housed together in a dormitory, the "Prellerhaus" on Bauhausstrasse, attached to the school building complex. Informally named for a painter of the Goethe period, it perpetuated the tradition of the students' Prellerhaus of Weimar. It was the largest "apartment" building designed and built by Gropius up to that time. As no art school or university in Germany had previously provided dormitories, it was an important step forward, an opportunity to combine living and teaching.

The interior decoration of the entire building was done by the students of the wall-painting workshop. The design and execution of all lighting fixtures in the assembly hall, dining room, and studios was carried out by the students of the metal workshop. The tubular steel furniture of the assembly hall, dining room, and studios was made from designs by Marcel Breuer.

The invitation extended to the Bauhaus by Dessau included not only provisions for facilities for the school, but also a commission to Gropius to design dwellings for the students and masters who followed the Bauhaus from Weimar to Dessau. The search for an appropriate site for the masters' housing was recalled by Mayor Hesse in his autobiography some forty years later; the task had been made memorable by the presence of Ise. He wrote fulsomely in praise of her youthful beauty, intelligence, alert mind, and sensibility: "What was true for all wives of the Bauhaus masters, also became apparent during conversation with Frau Gropius: she *lived* in the work of her husband."[3]

In their tour of vacant inlying areas, Gropius's eye fell on a site with pine trees. He said, "To live in a pine tree forest was always my ambition," and Hesse readily agreed to the site for the houses

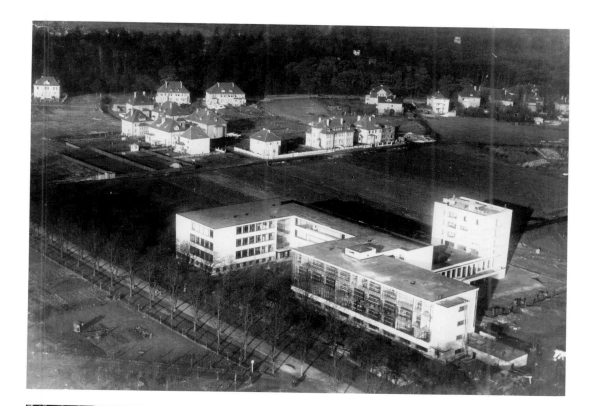

Aerial view of the Dessau Bauhaus building, the glass-walled workshop wing in the foreground

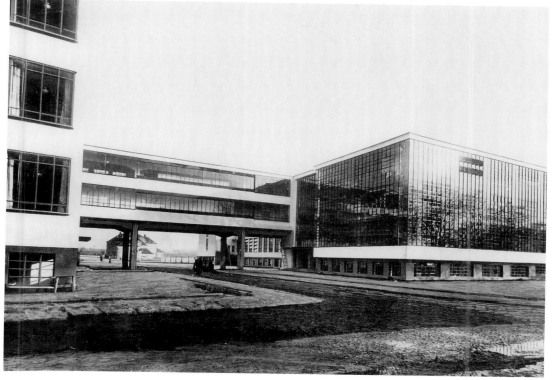

Bridge joining workshop wing and the main building, 1925–26

Master's house
under construction

Interior of master's
house

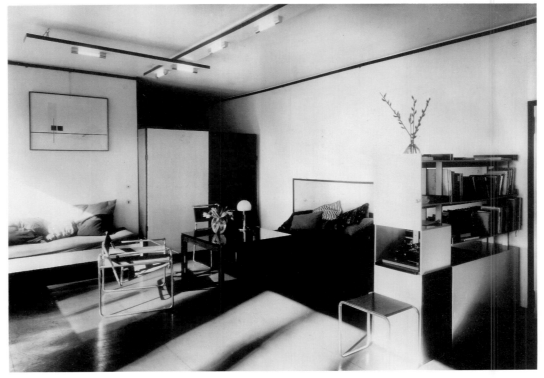

of the masters. Located on Burgkuhnauer Allee (now Ebert Allee), the site was within pleasant walking distance, only a few hundred meters, from the Bauhaus itself.

The houses were designed by Gropius with Ise's active participation. But Gropius also faced very different requests by the now outspoken wives of the masters: Frau Klee wanted a coal stove, Frau Muche an electric one, Frau Kandinsky a Kamin, and Frau Schlemmer one fueled by gas. To all these preemptory demands Gropius piously said "yes" and proceeded to design what he believed to be appropriate.[4] Three semidetached duplexes were provided for the six masters and a detached house without studio for the director and his wife. The dwellings were situated in a clearing of a pine wood, along an east-west line and about sixty-five feet apart. In furnishing their house Gropius and Ise drew upon the products of the Bauhaus workshops or designed their own furniture and fittings; there simply were few or no choices on the market to satisfy their design concept.

Classes began on October 14, 1925, in temporary quarters in an old textile mill structure at 6 Mauerstrasse. Nearby on Rennstrasse, in an unheated building previously used as a rope factory, were the art gallery, workshops, and studios. The students who followed the Bauhaus to Dessau were joined by students of the Dessau School of Arts and Crafts and by new students, some from Poland, Russia, Lithuania, and other countries to the east.[5]

Unlike the students during the early Weimar years, many of the new students had parental permission and financial support. Gropius also persuaded the Dessau government to finance indigent students once they had been accepted for study by the Masters' Council. Additionally, students were paid for their work when products or designs were sold.

Gropius again gave his general presentations on the school's goals and the correlation of the arts and had informal talks with students and faculty about his personal philosophy and practical problems. Yet he kept a distance from most students and concerned himself with the administration and with securing industrial connections for the Bauhaus.

The meetings of the Masters' Council (Meisterrat) were attended by one or two representatives of the student body, and Gropius, as well as the masters, listened attentively to their ideas. However, these were accepted as suggestions, not as directed advice, demands, or ultimatums. The students had no vote in school matters; indeed, Gropius did not permit even the faculty to vote. Rather, following the presentation of all ideas, he would retire to his office to contemplate their synthesis and then make his decisions.

Among the suggestions made to the Meisterrat by the students and young teachers were activities that would involve the community in the life of the school. It was hoped the "town-gown" estrangement and hostility that had existed between the Weimar citizenry and the Bauhaus would be avoided in Dessau. Indeed, there was already something of that sense of separation between the Dessau schools and the city to be overcome. So the children of the city were invited to such events as the White, the Metallic, the Checkered, Dotted and Striped Festivals, and those of the Masks, Lantern, and of Music. Furthermore, the students went to various outlying villages with their music and theatricals and organized their own celebrations. In good weather there were almost weekly outings on the Elbe. This was in contrast to Weimar, which was very much like a cloister for both students and masters.[6]

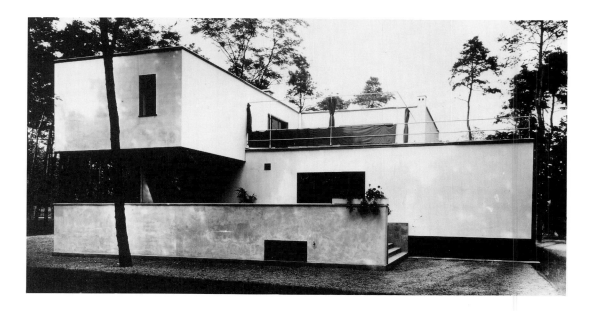

Director's house,
Dessau

Whatever the successes of the school and office, Walter and Ise's personal life had a single continuing major worry — her health. The stomach ailment for which Ise had been a patient from March to October of 1924 flared up again in August 1925, and she returned to a sanatorium. Impatient with the inability of the doctors to diagnose her problem, Ise insisted on an exploratory operation, which revealed the urgent need for an appendectomy. This was performed in August, and though her immediate condition was remedied, the operation had long-term side effects. She later commented, "In the process and through the incompetence of a doctor I lost my baby at an early stage and never became pregnant again, to our deep regret."[7]

Ise's health, the construction of the Bauhaus building and the masters' houses, and the preparations for a new school year were only part of Gropius's concerns. The responsibility for achieving profitable contracts for the Bauhaus as well as for his private office also fell to him. From his earliest professional days he believed in going straight to the top. For example, late in 1925 he wrote about housing to Oskar von Müller, who was founder of the Munich Deutsches Museum, the most important museum of technology in the world, and was influential in the Institut für Verkehrsplanung in Städtebau and Landesplanung (Institute for Traffic Research in Urban Construction and Regional Planning). Gropius proposed a factory and system for prefabrication of housing and equipment, as well as a means of providing land and financing. He estimated that this scheme could produce 1000 to 1200 dwelling units per year at prices eighteen to twenty percent lower than those prevailing.[8] Gropius also wrote to the Reichs Chancellor seeking an audience: "The Bauhaus has become well known well beyond Germany. Given the opportunity, it would contribute to the broader development of the country's housing program."[9]

To gain understanding for the Bauhaus and to obtain contracts for the students' work, Gropius wrote many articles and gave many lectures. In a period of little more than three months, he spoke in some fifteen cities in three countries. Newspaper articles reported that his subjects included "The City of the Future," "Living in the Future," and the "City in the Box."

He continued to promote industrialized housing. In March 1926 Gropius delivered a lecture in Berlin entitled "The House in Eight Days," citing developments in the United States (as he had before the war). He reported that in the United States one could open a catalogue and pick out a house, and it would be delivered complete in a week! Although the units were mass-produced, he stressed that the components (rooms, roofs, etc.) could be assembled in different ways, so the houses did not resemble each other like eggs.[10] The type of house would be consistent, but not the style.

Pamphlets and other publications appeared almost as soon as the Bauhaus was established, but after the Bauhaus Exhibition in 1923, Gropius and Moholy-Nagy began preparing what would become the school's most important series. These books, they hoped, would be a continuing exposition not only of the work and ideas of the Bauhaus, but also of artists and architects everywhere. Serious preparations were made for the first eight books. Typography, layout, and covers were designed by Moholy and others, and Gropius had written hundreds of letters to interest prospective authors and to obtain illustrations and text, but publication was delayed because of the financial difficulties of the intended publisher. The first eight of these books were finally issued in Dessau between 1925 and 1927 with Albert Langen as publisher.

Architectural Practice: Though Gropius's labors for the Bauhaus should have satisfied even his own sense of responsibility to society, he also sought improvement in the practice of architecture through such participation in professional societies as time and his distance from Berlin permitted. He had continued his membership in the conservative Deutscher Werkbund and the Bund Deutscher Architekten (BDA). But there were, in 1925, reasons to organize a new group. Modern architects were opposed to the conservative movement in Berlin supported by Muthesius and were critical of the Werkbund, which, according to Gropius, had become institutionalized. There was also dissatisfaction with the BDA's old-fashioned methods. As a result, the Berlin Ring (*Zehnerring* — Ring of Ten) was founded. The aim of "Der Ring" was to prepare the groundwork for an architectural culture appropriate for the new epoch. The original members, according to Gropius, included himself, Bruno and Max Taut, Hans and Wassili Luckhardt, Ludwig Mies van der Rohe, Richard Döcker, Hans Scharoun, Adolf Behne, and Hugo Häring, founder and permanent secretary.[11] Gropius recalled that the very organization of The Ring "was sufficient to give the BDA the jitters, and in consequence two of us were selected for the Board of the BDA. That was Hans Poelzig and myself."[12]

Soon after its formation, The Ring prepared exhibits and published articles; a special edition of the magazine *Bauwelt* was devoted to its work. The timeliness of The Ring was extraordinary. Its formation coincided with large projects designed by its members or others who also eschewed past forms and who concerned themselves with social aspects of architecture — with city and project planning, economical construction, the relationship of home to work, and the provision of necessary amenities for city living.

With Gropius's determination to maintain his private architectural practice, with his office located in the school, and with teachers and students among his professional staff, it was small wonder that their problems would interweave. Late in 1926 Otto Bartning, then head of the

Bauhochschule — the school succeeding the Bauhaus in Weimar — offered Ernst Neufert the principal architectural teaching responsibility in that school, and he left the Gropius office. Otto Meyer-Otten (Omo) succeeded Neufert as manager.

As manager of Gropius's private office, Neufert emphasized order; carried over to the details of housekeeping, this resulted in the disappearance of Gropius's earliest sketches and proposed projects — an irreparable loss. To Neufert, a man whose sense of history was subordinate to his sense of efficiency, the storage of drawings of completed jobs, and even more of aborted projects, was a waste of office space. Within the single year he spent with Gropius in Dessau all early records were discarded.[13] Neufert later claimed that the disappearance was the result of several changes in location and a succession of office managers. The drawings, he said, were left in piles, and he believed visitors may have helped themselves.[14]

Following completion of the Bauhaus buildings, a systematic accounting of the expenditures for their construction was requested by Mayor Hesse early in 1927. He explained it was in anticipation of a demand for an inquiry by the foes of the school. The full statement was completed by the city's accountants, and to Hesse's and Gropius's distress, it revealed that 100,000 marks more than had been appropriated had been committed. There had been a series of ledger mistakes by the overworked Neufert, the largest single error being his failure to record the transfer of bricks from the city of Dessau in the amount of 35,000 marks. He was ordinarily meticulous in such matters, and it is possible that he believed there would be no payment involved as both the bricks and the school were the property of Dessau. Furthermore, gifts in kind from manufacturers were received and acknowledged but not entered. Gropius scolded only himself for not closely supervising the accounts. To offset the overrun and prevent a public scandal, furnishings which were still on order were canceled and some spaces left unfinished.

A number of relatively inconsequential projects proposed or carried out during these years demonstrated Gropius's continuing efforts to make the practice profitable. In 1925 he was invited to prepare preliminary drawings for a sanatorium and special housing in Thuringia for victims of tuberculosis. It was thought that the mountainous areas of this state were particularly salubrious for patients suffering from respiratory disease. The site plan by Gropius was an open one with particular care given to the distribution of patients' rooms and other areas with respect to sun and wind and, secondarily, to the views of hills and forests.

Immensely pleased with the work Gropius and Meyer had done on the Faguswerk in 1911-14 and with the attendant publicity, the owner, Karl Benscheidt, frequently recommended Gropius for new commissions as well as engaging him for additional work at the Faguswerk. This included remodeling of a smithy, designing an exhibition cabinet for a Stuttgart fair, and designing new lighting schemes. Extensive remodeling of the Karl Benscheidt, Jr., house was also carried out during 1925.

In addition to his work for Benscheidt, Gropius was commissioned in 1925 to design a factory for Müller and Company at Kirchbraak. Its peculiar design challenge resulted from the program requirements of three tall stories for production and lower ones for the office floors, of which there were a greater number. Gropius's design integrated these awkward elements, and the building was completed in 1926.

Törten housing
development,
1926–28, and
(below) interior at
Törten

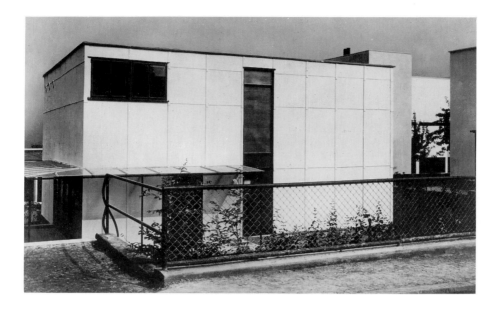

House for the
Am Weissenhof
development, 1927

Early in 1926 some 60,000 Reichsmarks from the real-estate tax fund were made available by the ministry to promote an experimental housing research project in Dessau. In June the Dessau City Council awarded a contract to Gropius for the design of sixty dwelling units in the nearby village of Törten, with the intention of sales to low-income workmen. Gropius developed a site plan allocating areas for various types of experimental houses, to be built in four stages. By mid-September, the sixty single-family houses were started, utilizing standardized construction units. Törten's construction was carried out over a period of several years, providing continuous field experience for the Bauhaus students.

With the Bauhaus built, Gropius's architectural office had time not only to continue with confirmed commissions but to seek other important work by entering competitions. The next eighteen months became the busiest period in Gropius's private office since before World War I. The majority of the projects that progressed to actual construction were for houses or housing developments. Among the commissions carried out were two dwellings of permanent though experimental character built for the city of Stuttgart. The Württemberg chapter of the Deutscher Werkbund had persuaded the city administration to sponsor the Werkbund's 1927 Housing Exhibition. The work of sixteen distinguished architects from five European countries would be shown.[15] This exhibition, the *Weissenhof,* as it came to be known, was the first demonstration of the common aims of modern architects, who up to then had worked in isolation.[16] Mies van der Rohe, commissioned for the overall planning and direction of the project, provided an integrated site plan for some 320 houses and apartments of several types. One house designed by Gropius was of steel frame and thin panel construction — "dry assembly," as he described it. The second house was built in "semi-dry" construction, with fewer prefabricated members and materials than used in the first.

Mies's ordinarily assiduous attention to organizational detail notwithstanding, discontent was

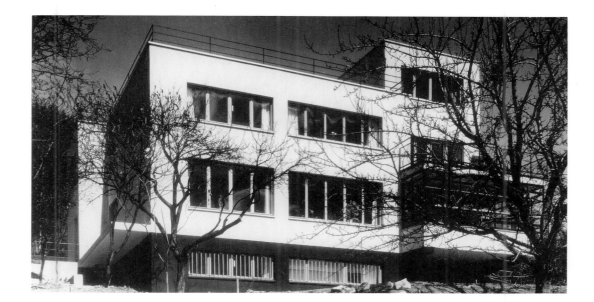

Zuckerkandl house, Jena, 1927–28 (now a national monument)

expressed at the August 26, 1927, meeting of The Ring in Berlin regarding his failure to secure sufficient publicity for the Weissenhof exhibition; the housing was to be the principal feature of that year's Werkbund meeting, soon to be held in Stuttgart. Mies felt unjustly criticized and resigned from The Ring, despite the efforts of Hans Poelzig and Gropius to dissuade him. The Ring need not have worried. The exposition of 1927 became a focus of housing study, attracting worldwide interest by its advanced designs and the international architects who participated.

One of the largest houses designed by Gropius and actually built in the 1927-28 period was for the family of Therese Zuckerkandl, whose husband had been a professor and a privy councilor of Jena. Though the desires of the family members were diverse, Frau Zuckerkandl had their real needs well in mind, and the design of this mansion took far less time than that of some smaller houses.

A commission destined not to be completed was a house in Mainz for a client named Harnischmacher. The client, the director of a shoe-polish manufacturing company, was uncertain of his requirements, but during discussions with Gropius in Mainz and Dessau he became much more enthusiastic and open to new ideas. Gropius invited Marcel Breuer, who had not previously been involved with the job, to design the interiors and otherwise continue communication with Harnischmacher.[17] Out of this introduction would grow a mutual respect between Harnisch- macher and Breuer, and in 1932, when the client decided to build in Wiesbaden, he engaged Breuer for what would be the latter's first complete house commission.

It was a rare month that a project for Adolf Sommerfeld was not on the drafting boards. On one occasion, it was to add a bowling alley and chauffeur's quarters to the garage wing of the Sommerfeld mansion; on another it was to revise sketches for the kitchen addition originally designed in 1926.

Exhibitions for the many fairs held in Germany were frequently directed and designed by architects. This was so particularly if artistic concerns and public safety were involved. The Gropius office had already acquired a reputation for its innovative work in this field and was commissioned

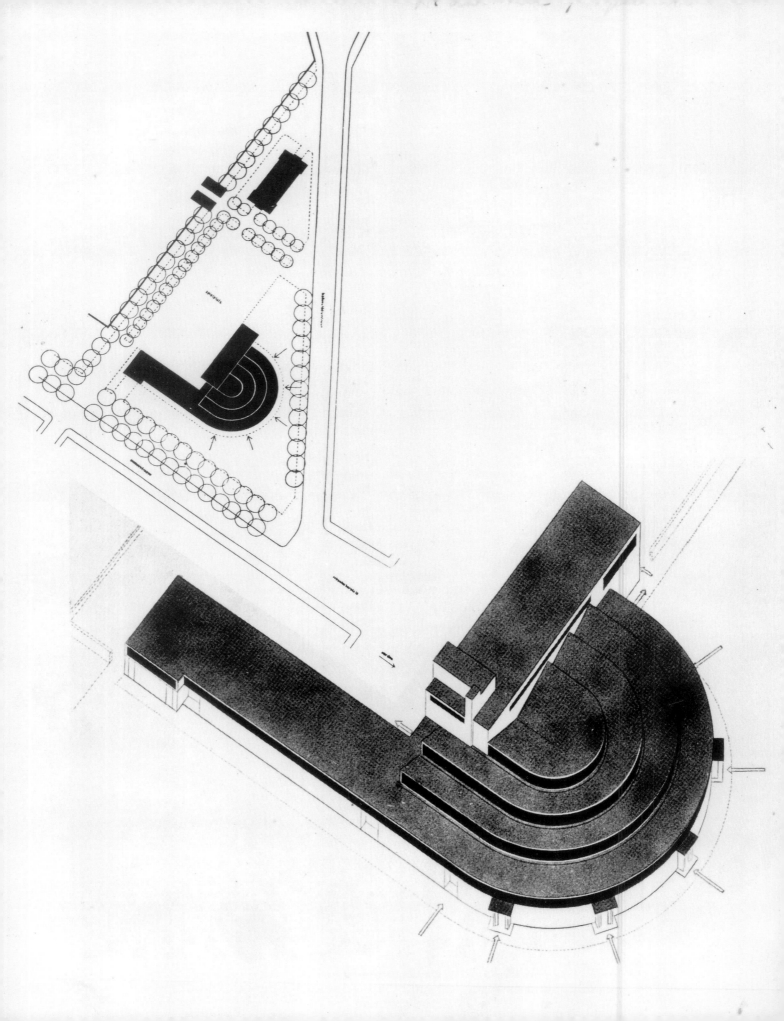

by Frau Else Weiter of the Housewives Cooperative Association of Leipzig to design and supervise a very elaborate exhibition stand for the annual fair of that city. For the German Association of Glass and Mirror Industries of Leipzig, the firm solved the unique design problem presented by the traveling display of fragile items. The display had to be collapsible and fold into packing cases, which themselves formed part of the supporting stands. The designs were successful, and the project was financially rewarding for the Gropius office.

In 1927 Gropius's entry was selected in the competition for the Municipal Employment Office building of Dessau near the center of the city; the honorarium was 1500 marks. The building is impressive in the way its design fits its purposes and in its relationship to the site and to the community, which has grown and changed around it. Once again, the Bauhaus carpentry shop supplied the furniture, the metalworking shop the lighting fixtures, and the wall-painting studio the color scheme of each room.

There were other successful ventures for the Gropius firm. In 1927 Gropius had entered a competition for the Dammerstock housing project on a site near Karlsruhe, sponsored by the city. Gropius won first prize and became the designer of the overall project and architect for certain sections of it. He also acted as coordinator for the ten collaborating architects, each commissioned to design portions of the development. Gropius later said that the goal of the housing was to achieve healthy and practical living quarters, geared to the social standards and income of the average family. Although he understood the economic necessity of multistory apartments, Gropius recognized that they were unpopular with the public, who equated them with "rent barracks," or tenements. But he wanted to improve high-rise apartments rather than abandon the idea, and Karlsruhe-Dammerstock includes both walk-up apartment blocks and single-family row houses.

Few opportunities offered Gropius as much stimulation to his innovative abilities as did the *Theaterneubau* (new theater building) for Berlin director Erwin Piscator. His 1200-seat theater on

the Nollendorfplatz was inadequate to serve the proletariat at prices it could afford. There, however, with the support of some 16,000 *Volksbuhne* (People's Stage) enthusiasts, he put on his socially and politically oriented plays.

Gropius, having attended one of these, was so impressed that he went backstage to discuss modern theater construction with Piscator; this was a most congenial meeting. Subsequently, in mid-1927 Piscator commissioned Gropius to design a "total theater" for 2000 spectators, an audience the director considered minimum.[18] Gropius responded with a theater design of unique versatility. It could accommodate audiences of varying sizes and involvement, included space for the administrative offices, and solved technical problems of sight lines and acoustics. The project was never realized. Gropius blamed this failure on the advent of the Depression, but its termination was already anticipated at the end of the 1927-28 theater season, when the primary patron's support gave out. Though Piscator's stage offerings were great artistically, none was so financially successful as to underwrite plans for, let alone construction of, the Total Theater.

Bauhaus Affairs: Changes in Gropius's architectural office were paralleled by developments in the Bauhaus itself. Some methods of pedagogy and administration that had been successful in Weimar now appeared outmoded. There the use of the usual academic titles had been shunned: though the state had offered the title, Gropius had specifically expressed his desire not to be called "Professor," and his faculty had agreed to the terms "masters" and "apprentices." Now, however, Kandinsky, Klee, and other masters thought the academic titles appropriate. Though the use of "Professor" was questioned, the new Anhalt government ruled that this status had been passed on from the Hochschule für bildenden Künst. The government approved the change in academic titles and granted university status to the Bauhaus, all of which Gropius accepted.

New faculty problems followed. Contract disagreements with industry and rising costs had led to financial shortages. Dessau was experiencing economic setbacks and was unable to provide further aid. Oskar Schlemmer had found it difficult to adjust to the stringent financial conditions of the Dessau Bauhaus budget. In reply to Frau Schlemmer's appeal in summer 1926, Gropius explained his desire as well as his helplessness to improve their situation.

> How can we succeed in getting by with the Bauhaus income, since the desperate financial situation of Germany prevents the workshops from making money? But you must not talk to me in tones of reproach. I made it absolutely clear to Schlemmer what the situation here was. ...Since the necessary production workshops had to be kept afloat, there was only a part salary available for the stage. He had to get outside work. If he has not succeeded, then it is a bitter experience for you, but I am personally unable to do anything about it so long as a higher budget by the city is beyond discussion. To the contrary, some workshops must be reduced. The promised commission for Schlemmer for the theater is the only part that is becoming tangible. ...The only other thing I can try is to get commissions from the local theaters, and Schlemmer has to try to get out-of-town work. ...But I do want to keep the theater with Schlemmer's valuable work in any event. ...What shocks me...is your mention that under these conditions you cannot move to Dessau. I cannot see that this is efficient, as two households cost more, since Schlemmer would lose the new Master's house. ...Come and see the house. ...Come soon.[19]

Schlemmer did remain at the Bauhaus, where his teaching was regarded as a great success, not only by Gropius but also by Mayor Hesse and the city's theater director.

In an attempt to balance the school's budget, Gropius proposed that the full-time teachers accept a ten percent salary reduction. Kandinsky and Klee opposed the measure, and Klee complained that the mayor, in declaring himself powerless to provide more money to the school, was drawing it into city politics. Furthermore, though he "avoided influencing any of [his] colleagues," he predicted a fight: "I look gloomily ahead to further negotiations and am afraid of something that was avoided even during the worst phase at Weimar: an inner disruption."[20] Gropius's proposal for reduced salaries was taken up for discussion early in 1927 by the Meisterrat. As anticipated, Kandinsky spoke strongly against the reduction. Klee sarcastically called for retrenchment by others, particularly in their workshop budgets; any of his suggestions would leave him untouched.[21] A compromise of a five percent reduction was achieved for a brief period.

Despite these problems, on Saturday, December 4, 1926, the Dessau Bauhaus had formally opened. The festivities planned by Georg Muche with the aid of Richard Paulick attracted fifteen hundred guests, including artists, craftsmen, architects, political figures, representatives of universities, statesmen, and industrialists from Germany and abroad. Exhibitions of student and faculty work were held; theater and concert entertainment and films were presented. There was an inauguration concert by Paul Klee (and as was expected, he had selected a Mozart violin concerto, with his wife accompanying him on the piano).[22] Tours of the Törten housing development, then already well along in construction, were arranged.

It was obvious that the Dessau Bauhaus represented a victory for Gropius's ideas. It was attracting considerable press attention, including reports by Dorothy Thompson in the United States and Ilya Ehrenburg in Russia praising the Bauhaus and its program.[23]

After the dedication of the new Bauhaus buildings, visitors continued to arrive in great numbers. Ise Gropius's diary records that on Sunday, December 12, some seven hundred visitors and prospective students were counted in and around the buildings, the site of the masters' houses, and at Törten. Ludwig Grote's lecture on December 19 at the opening of Kandinsky's exhibition in the Kunstverein drew an overflow crowd. This may have accounted for the first quiet Sunday afternoon in several months that Ise could remember.

The evening was less tranquil. Georg Muche came to their home to press his interest in directing the proposed architecture workshop rather than the weaving studio he currently headed. He supported his claim by recounting his successes beginning with the Haus am Horn in 1923 and the steel house he had recently completed with Richard Paulick. He considered his youth and inexperience an advantage, as they would provide both enthusiasm and innovation. Gropius was sympathetic but offered only the possibility of collaboration, for he already had in mind the higher qualifications for that responsible position. Muche then indicated he would probably leave at the end of the term.

The new year began with the faculty racked by internecine quarrels, jealousy, and competition. A letter to Kandinsky from Gropius illustrated the lack of communication, if not the lack of willing cooperation, between members of the faculty. There is also an inference of eroding personal relations. The letter does demonstrate Gropius's desire to delegate his responsibilities — a desire not welcomed by Kandinsky, who from the beginning carefully avoided shouldering administrative tasks. This particular incident was caused by the faculty members' disinclination to deal with a

With Paul Klee and
Béla Bartók,
Dessau, 1927

policy on discipline outlined in a letter by Gropius, which was returned to his desk without action or comment by Moholy-Nagy, Muche, Breuer, or Kandinsky, among whom it had passed, hand to hand. Gropius returned the letter to Kandinsky accompanied by still another, written in exasperation:

> You are uninformed as to the superhuman burden I have to carry here, which is further significantly increased through the malfunctioning or the seclusion of some of the masters.
>
> I have to declare today that I can only continue to work if I receive the distinct assurance of the masters to support me more than up to now. Otherwise I have to withdraw, because it is of no use to wear oneself out for nothing.[24]

There were also problems arising from the changeover of administration of the Circle of Friends of the Bauhaus from Ise Gropius to Paul Klee and Frau Luers. Frau Luers had arranged a Bauhaus musical evening featuring violinist Adolf Busch accompanied by Rudolf Serkin. Ise had suggested that Hinnerk Scheper arrange a social gathering to follow the performance. Klee, a musician in his own right, as well as director of the Circle, felt that his responsibilities had been preempted and withdrew.

Still another activity initiated by Ise disturbed Klee as well as Kandinsky. On her own initiative, she brought an instructor from Berlin to give lessons in the latest dances, including the Charleston, to the younger faculty. It was an intensive course that took place in the Gropius home, where there was a gramophone and where the teacher resided for several days while he was in Dessau.

These were but a few of countless conflicts that arose in the daily life of the Bauhaus. The members of its community were, more frequently than not, highly individualistic, with students as well as masters interpreting the assumed freedom of creative artists as their personal privilege. There was a need, however, to share the resources of workshops, dormitories, and canteen, to distribute equitably materials, food, and tasks, and to work together on class projects, in the garden, and to form teams in creation. Had Gropius been a less commanding personality and had he not insisted on a sense of discipline, too much individualism might well have resulted in a kind of anarchy rather than the spirited confusion that generally prevailed.

Gropius's Last Bauhaus Year: Early in August 1927 Gropius and Ise made a much-delayed visit to his mother and the Burchard family at the Timmendorf summer home. Traveling in their small Adler automobile, they spent three weeks luxuriating in the warmth of their family and the sun on the Baltic beaches. Later in August they motored north to Copenhagen, where Dr. Vogeler, the correspondent for the *Berliner Tageblatt*, had arranged a lecture and interviews with architects, and then they visited a corner of Sweden. It was a much-needed vacation for Gropius, and he returned to Dessau rejuvenated.

But once back, he found the administrative work at the Bauhaus endless. The use of the telephone was still, by custom, limited, and correspondence was therefore voluminous. Added to this were the daily demands of the students, the masters, and special guests. Requests for talks, lectures, interviews, and papers were never ending. Gropius accepted all such opportunities. Whatever the subject suggested, he would describe the work of the Bauhaus, and sometimes his own as well, since he was looking for contracts for both school and office.

In addition there were trips to attend meetings of professional societies. One of these was to participate in a Berliner Ring visit to Paretz to see Gill's Castle — a nostalgic occasion for Gropius, who remembered an outing for the same purpose with his architect father. Many of Gropius's Berlin trips were for meetings with the Reichsarbeitsministerium to obtain the release of funds already appropriated for the Törten housing development in the amount of 350,000 marks. Unfortunately, the internal problems at the ministry delayed the release of the funds almost a year.

However useful, these constant trips created problems for Gropius in Dessau. His initial relationship with Mayor Fritz Hesse was disintegrating. Hesse himself was in a bad mood: his party was losing out; he was having difficulty obtaining sufficient appropriations for the Bauhaus. Complaining that he could rarely find Gropius in Dessau, let alone in his office, he threatened to deduct the days that Gropius absented himself from his vacation time.

Hesse came often to the Bauhaus. He was concerned with allegations of political meetings of radical students in the canteen and was under pressure from the city council to close this gathering place. Hesse especially wanted to be rid of Moholy-Nagy, to whom he had taken a dislike. The mayor wanted Gropius to reduce the school's budget by eliminating the printing workshop and by stringently reducing other shop, studio, and class allocations. Gropius countered by asking Hesse to direct funds owed him to the Bauhaus.

Gropius could ill afford such altruism. His office had practically no profitable commissions. He had relied upon projects prepared for Sommerfeld's AGFAH, and on other large projects. These fell through, as did a commission promised to Hannes Meyer and one for Breuer, a small housing development for the junior masters to be located across from the Bauhaus.

Ise assumed many onerous and time-consuming tasks to lighten Gropius's day. There was continuing correspondence between Alma and Ise. Early in 1927 Alma had invited Gropius and Ise to visit Vienna, rather than sending Mutzi to the "strange surroundings" of Dessau and the Bauhaus. She would, if this were not feasible, arrange for a fall visit to Dessau. By late June 1927 it was clear that Alma was avoiding Dessau. She repeatedly requested that Gropius visit Vienna. In July Ise wrote her that they would vacation in Timmendorf that month and they were "expecting Mutzi's visit — it is Walter's fondest wish. Why do you dodge us on this?"

The visit was further delayed by protracted arrangements to place Mutzi in a school. She very much needed to be with children of her age, eleven, for in Vienna she had always been with her mother, private tutors, or a governess. Very shy, she would escape from her mother's salon, behaving just as her father had as a boy. When introduced to adult friends, she was composed but distant; she hated such occasions. Gropius agreed an excellent boarding school in Geneva would be very desirable. A trial enrollment in the fall of 1927 lasted only overnight, and Mutzi and her mother returned to Vienna by way of Venice. Alma then decided to bring her to Dessau and leave her there for four weeks. Mutzi and Alma finally arrived in November, later than the time planned, during which Gropius had carefully arranged to be free of other commitments. Instead, it was a period of great demand and stress. His time with his daughter, despite urgent remonstrances from Ise, was unavoidably limited. He had to content himself with occasional glimpses at meals, brief evenings, and weekends. As for Mutzi, already obviously gifted both in music and drama, she at least

enjoyed the rehearsals, a concert, and the activities of the Bauhaus stage workshop. The children of masters dutifully called upon the director's daughter, but the visits were too brief and perfunctory to permit the usual children's play. With adults always present she was still shy, and she found it difficult to communicate with the more unconventionally brought up children of the Bauhaus community. Gropius and Ise returned the child to Alma and Franz Werfel in Berlin. In the meeting of the two couples there was no warmth or compatibility. They were now from completely different worlds.

The days of his daughter's visit had passed all too quickly. Though Gropius had taken little time away from Bauhaus affairs, they had accumulated. Chief among the problems were those created by the strong individuals among the faculty.

Although Gropius had long since recognized Marcel Breuer's great abilities and had thought of him, his most gifted student, as his eventual successor, there had not been time for the young master to grow into the job. Indeed, Breuer wanted to leave the Bauhaus and enter private architectural practice; he tendered his resignation in 1927. This was the popular story of Breuer's so-called "palace revolt," but it differs from Ise's diary account. She noted that Breuer had unilaterally entered into an agreement for the manufacture of his steel furniture designs with a Hungarian craftsman. Meanwhile Heinrich König, with full authorization from the Bauhaus, had contracted with the Meissner GmbH for such production. Gropius ruled in favor of König, precipitating Breuer's resignation. A month later Breuer decided to remain.

Gropius at last considered the Bauhaus ready for a department of architecture. Mart Stam was his first choice to head it. He was invited in 1926, but the Dutch architect was far less interested in teaching and administration than in city planning, housing, and other architecture. Stam did agree to come to the Bauhaus on occasion as a guest lecturer and critic.

An intimation of Gropius's personal plans may have been revealed by the announcement that

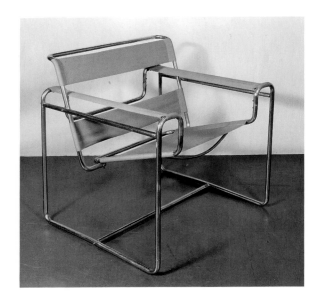

Tubular steel chair
("Wassily Chair")
by Marcel Breuer,
1925

architect Hannes Meyer would be among the lecturers at the end of 1926. Meyer's work, his reputation, and his strong interest in the social aspects of architecture had attracted Gropius, who was familiar with Meyer's and Hans Wittwer's project for the Palace of the League of Nations at Geneva in 1926-27 and with their 1926 project for the Peter School in Basel. Earlier, Meyer had assisted Georg Metzendorf in the design of a Krupp housing project. Gropius did not then know Meyer's essay, "The New World," published in 1926, in which he "formulated for the first time his position: a radical break with the past and acknowledgment of the technical and scientific facts of the present. Building [he wrote] is a technical and biological, not an aesthetic, process. The house is a machine for completing mental and bodily needs, and its form results from measurable, visible, and weighable functions."[25]

Gropius had asked Meyer as well as Wittwer to join the Bauhaus in the spring of 1927. Meyer accepted immediately and Wittwer came aboard a little later. With his invitations to Stam and later to Meyer, Gropius allowed the thought of seeking a successor to grow in his own mind. Later Gropius qualified his first impressions of Meyer:

> Meyer, when he arrived, seemed to be very cooperative and amiable, but he was the opposite of open-minded, extremely cautious, and nobody really knew him because he did not show his colors. …Since I was aware of the political difficulties of that time, I asked him point blank about his leanings, and he answered that he was politically entirely disinterested.…No indications of his leftish inclinations became apparent.…His work in that time was straightforward, and since I believe that as soon as a man has been appointed he should have his own way, I did not interfere.[26]

Gropius entrusted Meyer with the responsibility for building up the department of architecture. This Meyer did very well. Architectural studies were expanded rapidly in number and variety, to Gropius's entire satisfaction. Meyer served as head of the department and lectured on theory. He was concerned with analyzing housing in relationship to its environment. He described this process

in a variety of functions — in terms of acoustics: house to house, garden to garden, street to garden, pets and motorcycles; in terms of odors: smoke from garden fire, kitchen rubbish, compost, laundry, and traffic; in terms of view: opposite garden, intervening space; in terms of social aspects: various strata of social status; and in relation to political, communal, and neighbor-to-neighbor relations. His concerns with the relationships to the outer world touched on everything from the water inspector to coal delivery, repairs, visitors, beggars, cars, sickness, and vermin.

While Gropius was director there was little in Meyer's manner, in his statements or in his work, that suggested his inner turbulence or his political intent.

Attacks against Gropius had continued to come from many quarters: government and political parties, professional and trade groups, and conservative teachers. Perhaps as telling were satirical newspaper articles and caricatures ridiculing both Gropius and the Bauhaus.

He was greatly indignant about such attempts to denigrate his integrity and his work as an educator and architect. Perhaps the last straw was the report in a Dessau newspaper, made by a city official and the paper's publisher, which questioned the size of Gropius's fees for the Törten project and thus stimulated the Tenants' Association to do likewise. Gropius was particularly aggrieved by the newspaper's refusal to publish his factual rebuttal. In a strongly worded letter dated January 15, 1928, Gropius wrote:

> For years I have battled for cost reductions in housing construction and am well recognized in this field — and now I have to witness how just those people for whom I undertake this labor become incited against me. …
>
> *Why do you demand the voluntary renunciation of all financial gain only from me and not all others who participate in the construction work?* This type of untoward and ridiculous demand can only result in regretting one's helpfulness.[27]

Two days later he met with the publisher but received no retraction of the evidently politically motivated charges. Later that same day he wrote again, accusing the publisher of deliberately manipulating the presentation of the architectural services contract to make it appear that he had profited unduly from the social housing project. In actuality, he had previously and voluntarily relinquished a quarter of his fees, already reduced for the row housing. He added:

> Above all, it is not my habit to publicly call attention to my attitude, my activities, and my sacrifices…by the same token I have also not broadcast the fact that in the past year I have contributed more than 8000 Marks to the Bauhaus budget — which amounts to more than 75% of my salary as Director.[28]

In a session of the Masters' Council on this same day, January 17, 1928, Gropius indicated to the faculty that he would probably resign if there was not a complete retraction of the charges and insinuations made in the newspaper. There was no retraction. A belated postcard from the publisher merely stated: "I am too busy to answer. The first article was already set in type and was in page proof. It was too late. More later."[29] Gropius decided to resign.

The fact that the people of Dessau attacked the Bauhaus again and again particularly influenced the decision, since if he withdrew into private practice the abuse might be diverted away from the school and eventually subside. The decision was by no means sudden. Despite the growing success of the Bauhaus, as manifested by some two hundred inquiries into its products and for opportunities to study that arrived each week, Gropius had considered resigning for some time. He was held back in part by his concern for an adequate successor. A confidential letter to Mayor Hesse

Cartoon by Thomas Theodor Heine for *Simplicissimus*: "The Bauhaus director removing the last ornaments of his family"

Cartoon by H. M. Lindhoff satirizing Gropius and the demise of the Bauhaus: "The Dessau Bauhaus Cracks Up" (*Kladderadatsch*, March 4, 1928)

dated January 1, 1928 — before the newspaper report — summarizes some of his reasons: the internecine politics of Dessau in which he was finding himself a scapegoat, antagonism rather than encouragement, and limited resources for the Bauhaus. Gropius suggested that reorganization of the institute to meet these circumstances would better be accomplished by a new man. He added that some financial support would be necessary for his own transition to private life.

Another more formal note, dated only January 1928, requested the municipal council and mayor to release him from his contract so that he might return to private practice unhampered by official duties. He assured them the Bauhaus was solidly founded and would be in the capable hands of his collaborators. As director he recommended Hannes Meyer, "whom I consider capable according to his professional and personal qualities." On February 4, 1928, he conveyed his official letter of resignation to Mayor Hesse and issued a public statement.

His announcement, made to the students during an evening dance, aroused their protest against both his leaving and his choice of a successor. There had been rumors that Gropius would leave, but the announcement was dispiriting. The band did not want to resume playing, and the festive mood ordinarily so prevalent was shattered. Gropius exhorted the students to dance and be gay. But the situation became explosive. A student, Fritz Kuhr, delivered a long speech protesting the resignation:

> Even though we haven't always agreed with you…you are still our guarantee that the Bauhaus will not become a one-sided, stereotyped school. For the sake of an idea we have starved here in Dessau. You cannot leave now. If you do, the way will be opened for reactionaries. Hannes Meyer may be a fine fellow; I don't want to say anything against him. But Hannes Meyer as director of the Bauhaus is a catastrophe.

The students apparently thought that Meyer had forced Gropius out, and Gropius had to explain that he had hired Meyer to be his likely successor. He also answered Kuhr's charges by agreeing with what he said about the Bauhaus, while pointing out that his successor "will not be hampered by all the personal difficulties" that beset him for the last nine years. He told the assembled students that their "job now is to work constructively and positively."[30]

Although Gropius's resignation was not immediately effective, Meyer began immediately to assume his responsibilities. Though there were both masters and students who objected to this sudden change, it was helpful to Gropius, who was occupied not only with the transition of Bauhaus administration, but also with the removal of his architectural office and his move from the director's house. Early in February Meyer addressed a meeting of student representatives and revealed his own proposal for the reorganization of the Bauhaus. He said he had prepared it long before there was any thought of changing directors, in response to a kind of "neurosis of inertia."

BERLIN 1928–1934

On resigning from the Bauhaus, Gropius began preparations for moving his architectural office to Berlin. While the work in progress was being carried over to the new location, it would be under capable management, and Gropius had little worry about its conduct. This permitted him to fulfill his long-standing desire to visit the United States to study housing design and building methods. To organize his itinerary, he wrote to several building organizations for information regarding individuals, companies, and projects to visit. To one he expressed his intention to pass his time "almost exclusively with research on industrial building methods" and his desire to inspect the manufacture of "steel homes."[1]

Photograph by Gropius of the Brooklyn Bridge, 1928

A voyage to the United States in 1928 was an event of some consequence for any except the wealthy. Rarely could German professionals afford passage to the New World. In the United States, by contrast, there was great prosperity, with thriving architectural offices and new construction everywhere. Stories of this, frequently exaggerated, were brought back to the Continent by the few who did travel.

It was little wonder, then, that the restive Marcel Breuer, chafing in his secondary roles in school and practice but unable to achieve the independence he felt was overdue, would want to join Gropius in search of excitement and opportunity. And again Gropius tried to advance the career of the younger man, by seeking additional funds to make Breuer's travel possible and by writing to industries that had expressed interest in Breuer's innovative work, to his own clients, and to a Dessau privy councilor.[2] But only half the amount needed to underwrite the cost of travel was forthcoming, and Breuer reluctantly gave up his plan.

Gropius's own trip was made possible by the agreement of the city of Dessau to reimburse Gropius for his outlay for furniture they had had built into the director's house.[3] Inasmuch as these funds would not be available for several months, Gropius obtained support elsewhere.[4] Adolf Sommerfeld, unable to accompany him but desirous of learning about the newest methods of the construction industry in the United States, supplemented Gropius's own funds and sent his wife, Renée, on the trip. Following a festive farewell party given by Sommerfeld in his Berlin-Zehlendorf home, Gropius, with Ise and Mrs. Sommerfeld, departed for a seven-week tour of the United States, sailing from Bremen on the S.S. *Columbus* on March 28, 1928.[5]

Bon voyage party
at the Sommerfeld
house. From left:
Minister Braun,
Renée Sommerfeld,
Gropius, Frau
Martin Wagner,
Adolf Sommerfeld,
Ise, Martin Wagner

Travel in the United States: After a rough crossing, they arrived on April 7 in New York, where they were met by Renée Sommerfeld's brother, D. T. Brandt. Taking up residence at the Plaza Hotel, they drove that day to West Point to watch the cadets in a dress parade. There, despite the military precision, they found the event "informal in comparison with Germany, gay with girls and families as spectator-participants." As they drove, their host attempted to reply to their constant stream of questions about the city, the countryside, America, and Americans. They found traffic slower than in Berlin; Brandt explained this in terms of the greater number of cars, and it also, he said, meant fewer accidents. "The automobile horns," it seemed to Gropius, "had their own language, one of communication and courtesy. ...Chauffeurs and taxi drivers never scolded each other, and people were generally polite in traffic." Dining en route, they found the food bad and "unlovingly prepared; though the pastry makeup was tremendous, the quality of the chocolate was poor! The fruit was marvelous, but the waiter's service slow."

The theaters they found lavish, for those of Germany were then restrained in budgets. Attending the Roxy Theater and the Ziegfeld Follies, they noted that "the nakedness of the girls was not nearly as prominent as compared to that on the German stages."

Visiting New York's Mount Sinai Hospital, they later recalled being "impressed by its clinical and research contribution, by the nursing staff, their training, which was more comprehensive and thorough than in Europe, their responsibilities, and their appearance and deportment — resembling the famous Tiller Girls in beauty and manner. European Sisters [nurses] performed heavier tasks, came from less privileged and less educated classes, and were more poorly paid than their American counterparts."

But they missed the coffeehouses and sidewalk cafés of Europe, and the respite these afforded during sightseeing or business. The Barnum and Bailey Circus was to have been a break from their round of sightseeing, discussions, and inspections; but they found it "distracting, with performers in three rings competing for attention, sideshow shills vying for patrons, and general disorder."

Though Gropius spoke little English, discussion on professional subjects was not difficult, and most of the time Ise was there to interpret. But not all communication was professional. Gropius recalled his language problems at the time on the occasion of his Gold Medal award in London in 1956; his penciled draft for his response reads:

> The linguistic snares a foreigner encounters on the thorny road to learn a new language...mostly of course in the beginning....When I visited the States the first time in 1928, learning my very first English on the boat from "Gentlemen Prefer Blondes," I came across a strange word which I tried promptly to use over the phone to the desk clerk in the Plaza Hotel. Wishing to have my shoes cleaned, I asked for the *bootlegger.* Imagine the effect on the other side of the phone in prohibition time.

The information passed on to Gropius from contacts in both Germany and New York ranged from helpful to preposterous. For example, a German press representative informed them that "Americans are amiable and enthusiastic, but have short memories; everything not immediately settled is forgotten." According to their German informers, "the majority of criminals in New York were Jewish, as were the taxi drivers, and everyone knows what *they* are like!" Anti-Semitism in New York, Gropius began to believe, was much stronger than in Germany.

Gropius's and Ise's reactions similarly ranged from naiveté to sensitive perception. Their impressions initially reflected attitudes of New York and the East, but later, with wider travel, they broadened. From their own encounters, the travelers observed:

> The democratic spirit showed itself in the manners of the salesgirls — in their familiar way of dealing with patrons on an easy basis of apparent equality and camaraderie and without servility. Clothing for lower-income and middle-income women was excellent, though that for the rich was not equal to Germany's. The girls seemed to be quite cold, semivirginal, wanting a good time. Sex was private, no one wanted to discuss it. Common-law and companionate marriages were quite general but not long-lasting. One could meet new friends in church or could be picked up in the street.

Gropius remarked on American business practices as well. He noted, "There was openness in business in America. Yet all weekends were devoted entirely to relaxation, and it was considered bad manners to force someone into a business transaction." All things were based on private initiative. Gropius was surprised to learn that "New York contractors were forced to agree to a 'closed shop' by the unions, though dismissal of an unsatisfactory employee did not seem difficult. Business and society consider a man over forty to be on the decline, therefore no one ever gives his age. Both men and women get facials to appear young; bad looks are detrimental in getting jobs and credit."

He was surprised as well that "intellectualism was equated with snobbism. The son of a millionaire thought it proper to become a professor because of a new fashion for appearing learned. Intellectual collaboration between American men and women was unknown. Among the younger generation there was a tendency to grow away from accepted mores."

As construction organization and methods were of prime concern to the supporters of the trip, the Reichsforschungsgesellschaft (National Research Institute for Efficiency in Housing Construction), and also Sommerfeld, Gropius sought out or was referred to the architect Harvey Wiley Corbett and a number of firms and agencies, such as Thompson Starret, Harris and Hegemann, the Butts construction companies, members of the New York City Planning Commission, officials of the Bureau of Standards, and the Dow Service, which specialized in quantity cost surveys. All were cooperative and provided information freely when they understood the direction of Gropius's research.

Gropius was introduced to Ernest P. Goodrich, a pioneer town planner, and to Robert L. Davison of the Research Institute for Economic Housing at Columbia University. Neither Goodrich nor Davison had ever heard of Gropius. The former showed him his Flatiron Building and the latter his housing research. Davison was impressed by Gropius's "tremendous sincerity" and his modesty, as he showed his own work only on his hosts' insistence. He, in turn, was shown the Forest Hills and Sunnyside projects on Long Island by Goodrich and the architect Henry Wright, but "these were a decade behind my own work or that of others in Germany." Gropius found discussions with Davison on building and housing codes more fruitful. Davison felt Gropius was disappointed in what he had seen in the United States; he had hoped to find industrial production of housing. Indeed, Gropius "had thought that in the United States housing industry he would find a man comparable in stature to that of Henry Ford in the automotive industry." He

was "amazed by the lack of interest in [the field in] the United States." With little success he sought housing developments to study and "some person or organization actively interested in research and housing materials and methods of construction to complement the research work which I [Gropius] started in Germany fifteen years ago."[6]

On April 29 he and Ise went to Washington, D. C., by train. In Washington, Gropius met with a federal committee on construction materials standards and with another on building codes, called on the German ambassador, and visited the Lincoln Memorial and other monuments. Though Washington was presented to him as a "planned" city, Gropius found its "development to be inadequate and inconsistent, a capital city and federal district — one with separate standards for the political and social elite, for government employees and the middle class, and for Negroes" — attempting to integrate its national symbolism and responsibilities into one representing a cross section of all cities.

Unimpressed by the capital, the three travelers took the train to Chicago on May 1. After passing through "Ohio and Indiana towns and cities whose appearance seemed impermanent," they arrived in Chicago, where they were met by another brother of Mrs. Sommerfeld, who provided a whirlwind tour of the city as well as introductions to friends. They found "Chicagoans totally different from easterners. The people seemed unrepressed, unembarrassed, and filled with pride in the culture and artifacts imported from Europe." Once again the visitors were exposed to facts and fancies and dutifully recorded them. They were told that there were "no slums in Chicago, nor much poverty." They were unable to relate this to information given them that "houses into which the Negroes moved were devalued, that they were full of sickness, that there were no firm marital bonds among the Negroes, that they had the same education as whites." Though the travelers saw both black and white students at the University of Chicago, they were told that "the former rarely reached the same levels of attainment as the latter!"

They were also told that "the Great Fire of 1871 had actually proved to be fortunate, permitting more orderly rebuilding." The suburbs they were shown "appeared to have been planned decisively." The centralized steam, power, and heating plants, city tunnel, and basement shipping system were impressive, as was the story of the reversal of the flow of the Chicago River to drain pollution away from Lake Michigan and toward its neighbors west and south.

Though "overwhelmed by the city and scale of building," Gropius "was delighted with the aesthetic contribution of simple industrial structures, the pioneering concrete construction of the Sears, Roebuck Company building, silos, and grain elevators." Guided by architect Arthur Woltersdorf, he sought out the works of Frank Lloyd Wright in Chicago. After a last newspaper interview by the *Tribune*, they left Chicago for the West on May 5.

New Mexico and Arizona delighted them: they saw the Indian reservations, Yuba City, the Rio Grande, the Painted Desert, "which gave us the most overwhelming impression we ever had," and the Grand Canyon, which Gropius described as a "negative mountain." There, at the El Tovar Hotel, they engaged a guide — "a genuine American cowboy" — who won them with his gait, manners, speech, and stories. With him they visited the Hopi and Navajo Indians, and learned about the matriarchy of the former and the dancers of the latter.

Gropius described the day spent with the Havasupi Indians as the "most beautiful day and greatest adventure in the United States." Though warned against going because "the roads were bad, the village full of discomfort, and eye disease prevalent," on May 11 they traveled by car for three hours and on Indian ponies for eight. They were guests of the Indian agent, staying overnight in government "bungalows," which stood empty, spurned by the Indians. Coincidental with the arrival of Gropius and Ise there was a much-needed rainfall. Crediting the German visitors with its occurrence, the village quickly organized a festival, with lassoing and breaking wild horses as well as traditional dancing. Thereafter the visitors and their guide rode to a waterfall, where Gropius took a quick dip in the natural pool at its base.

By May 14 they were in Los Angeles, where Gropius met architect Richard Neutra; their mutual admiration and friendship endured through a lifetime. Together they drove to inspect motion-picture studios and the industrial areas and oil rigs of Long Beach, which were "seemingly manned entirely by imported labor — Greek and Mexican." The whole spirit of the city seemed to Gropius to be one of unbridled optimism — "roads pushing in every direction; followed by houses in monotonous rows of single-story bungalow design." Neutra also showed Gropius the work of Rudolph Schindler and Wright. The travelers' last impression of Los Angeles was a neon sign on a church which stated its pastor's claim, "My way is the shortest to God!"

Returning east by way of Detroit, they immediately went out to visit the General Motors plant and that company's housing for its workers, which was moderately priced but monotonous row housing. They were entertained by engineer-architect Albert Kahn at an elegant dinner and in a tour of the metropolitan area. Kahn was surprised and pleased by Gropius's appreciation of his reinforced concrete industrial buildings, but was unhappy that his more colorful "Art Deco" architectural works did not evoke a similar response. As part of their tour with Kahn, they visited the Ford complex at Dearborn and were "amazed by the efficiency of the assembly line but disturbed by the degree to which the workers became part of the line."

Back in New York on May 22, they had only three days before sailing to Germany. They met architect Clarence Stein, art historian Alfred Barr, whose Chinese collection Gropius considered "fabulous," and Carol Aronovici, whose sociological approach to housing deeply impressed Gropius. A meeting with the writer H. L. Mencken was "a highlight" of their visit. Ise and Walter were entertained at a soirée given in their honor by the owner of the Astor Hotel, dined with the banker Felix Warburg, and lunched with the architectural critic Lewis Mumford. Only on their return to New York did they discover Chinatown, with its cramped quarters; the Italian area, which they found dirty; and the Jewish lower east side ghetto whose "squalor" they contrasted with the "broad, good streets," theaters, and community centers of Yorkville, the German community. They found Harlem, where the Cotton Club became Gropius's favored place of entertainment. He and Ise enthusiastically acclaimed Duke Ellington's band as "the world's best, and its floor show excellent." They had heard from German friends that "Americans tolerate Negro art (music) though they do not really understand or appreciate it." Their own reaction was that "everything original and artistic comes from the Negro."

A. Lawrence Kocher, then managing editor of the *Architectural Record,* came to the Plaza Hotel

Gropius flat and
office, 121
Potsdamer Privat-
strasse, Berlin

to meet Gropius and to invite him to contribute an article. Kocher met Davison of the housing institute at Columbia at the same time and invited him to write an article to accompany that by Gropius. Both men were to become major factors in Gropius's future.

On Saturday, May 26, Gropius, Ise, and Renée Sommerfeld sailed for Germany.

The Berlin Office: Back in Berlin, Gropius and Ise established themselves in a twelve-room apartment on the third floor of a building of four flats at 121A Potsdamer Privatstrasse near the Leipziger Platz. The Gothic building was designed as flats thirty years earlier by Cremer and Wolffenstein; its entrance was marked by two enormous cedars of Lebanon. Equipped with their prized Bauhaus-made furnishings from Dessau, the apartment served as both home and office. There was now time for the social activities considered necessary to reintroduce them to Berlin, and they quickly became part of an invigorating and stimulating milieu of professional and cultural affairs, government and business activities, and family and friends.

Their home became a locus for artists, musicians, architects, Bauhäuslers, visitors from abroad, and others seeking kindred professionals. Their interest in music, stimulated by the opportunities of the city, became even stronger and formed a background to the entire household. The Gropius collection of phonograph recordings became notable less for its examples of Stravinsky, Krenek, Bartók, and other new composers, than for its selections of jazz (particularly Louis Armstrong), classical and contemporary Spanish guitar, and uniquely, music of Chinese and other Asian peoples.

Berlin itself was at once a focus and a symbol for all of Germany, now unified by the Treaty of Versailles. It was the center of wealth and poverty, political power and protest, social order and misery. By 1928 Germany's industry had recouped its war losses and, through manipulation of the inflated mark, was stronger than ever before. Despite unemployment in Berlin, increased by migration from the rural areas, there appeared to be a new prosperity, perhaps an exaggerated

reflection of the world's optimism in that brief period. The landed proprietors and the *nouveau riche* dominated society. But attitudes toward mobility in middle and lower-income groups had changed, and women claimed emancipation from *Kinder, Küche, Kleider,* and *Kirche.* Nowhere were these changes more evident than in the Berlin to which Gropius and Ise returned.

Gropius was now in even greater demand as a lecturer. With his architectural office reestablished and organized to carry on in his absence, he accepted many invitations to speak on the subjects of high-rise housing, industrialization of housing production, education, and building art. To be sure, he inevitably was asked to expand upon his experiences in the cities of the New World; his already extensive collection of slides had been augmented by many photographs that he had taken only a few months earlier in the United States.

At one time as many as eight rooms in the apartment on Potsdamer Privatstrasse served as Gropius's architectural office. Otto Meyer-Otten was manager and Carl Fieger and Franz Möller were the principals of a staff which grew to some twenty members, one indication of the volume of work. One of the first to employ women in professional work, Gropius hired Hilda Hartke, an architect and engineer. The office-household retinue also included "two maids, a cook, a secretary, a girl archivist, and a house and office boy."[7]

Among the first commissions received by Gropius's new office was one for a large exhibit hall and outdoor restaurant, paid for by Adolf Sommerfeld. These were temporary buildings erected to promote the sale of properties in a new housing development, Fischtalgrund, in southwest Berlin.[8] The demountable exhibition and other temporary structures elicited much comment, so different were they in character from the residential buildings themselves. For these, unfortunately, the developers, the Cooperative Corporation for Employees' Homesteads (GAGFAH), had specified traditional pitched roofs, and as a result, the Fischtalgrund housing blocked the views from the neighboring Onkel-Tom's Hütte development, which, by contrast, had flat roofs. Newspaper

stories criticized the poor site plan: one noted that the buildings "apparently had been placed by an earthquake."[9]

Gropius chose the official opening of the project, in September 1928, to state in an extensive paper that he did not approve of the housing group, especially its lack of experimentation in design. He noted that new building requirements had increased costs, and, since incomes had not kept pace, architects must attempt to solve this problem, which affected 95 percent of the people. Affordable housing, he said, must be the objective of such a project. The architect must be an artist and an organizer who, together with other specialists, creates technical solutions to social and economic problems by means of a unified plan.

In late summer of 1928 Gropius designed a major housing project of some five thousand dwelling units composed of row houses and walk-up and high-rise apartments for twenty-five thousand persons. Schools and other facilities were to be included. The project was for his loyal client Adolf Sommerfeld, but it was never built, as the proposal failed to win the necessary support of the city government. But Sommerfeld was a rare person, richly endowed with imagination and energy. He always had several enterprises under way at the same time; a setback in one meant more time for another. Thus he could immediately invite Gropius to design a project of some eleven hundred units for a cooperative society in Bad Dürrenberg. Designed with flat roofs for economy as well as aesthetics, the development also failed to win the approval of the town building council; Councilor A. Klein claimed that the project failed "to relate to existing building."[10] Gropius withdrew as architect rather than alter his design. Klein, a conservative architect apparently less troubled by principles, carried out the commission from his own private office using pitched roofs and other marks of tradition.

Away from the oppressive burdens of city and state politics, relieved of the myriad Bauhaus administration details, and with Ise now practiced in editing, Gropius became a prolific writer of technical articles and lectures.

In one article he described the desirable changes that could be made in the appearance of the city through proper building codes and their enforcement, demonstrating how past codes had created undesirable effects. He recommended that the height and placement of buildings be planned in such a way as to permit light to penetrate the surrounding spaces and their interiors; that density, not height, be the regulating factor; and that a council be created under a city building commissioner to ensure that all new buildings would contribute toward creating a unified city image.[11]

In another major article, Gropius summarized some of the knowledge that he had gained during his travels in America.[12] He compared the American, English, and German experiences and recommended for Germany rectangular street (grid) plans for the greatest economy and standardization of building elements. He also urged the modernization of building regulations, the elimination of bureaucratic red tape, and the reeducation of workers away from a narrow individual viewpoint to a more comprehensive sense of responsibility as a prerequisite to their own advancement.

In a publication devoted to building, Gropius postulated the need for multistory rather than three- or four-story apartment buildings. The walk-ups, he said, lacked the advantages of either the

single-family dwelling or the multistory apartment building, and they were less economical and more limited technically. Zoning laws, in limiting building height, increased density and ground coverage undesirably. He called for new legislation that would limit masses in relation to open spaces on the basis of sun angles and shadows.[13]

Probably with prompting by Friedrich Fischer, then its dean and a professor on its faculty, the Technische Hochschule of Hannover awarded Gropius his first honorary Doctor of Engineering degree. Undoubtedly Gropius's lecture there in the previous year had contributed to this decision. The citation noted Gropius's independent thinking and achievements, which gave direction to the field of contemporary building.

In March 1929 the French Ministry of Internal Affairs announced broad plans for a housing program for reconstruction and to meet a backlog of needs. This would utilize money and materials provided by Germany as part of World War I reparations. So large was the proposed program that all of Europe was interested. Adolf Sommerfeld was recommended as a major developer. In turn, Sommerfeld named Gropius as his architect and went with him to Paris that same month for briefing by the ministry, a two-day conference, and an inspection. In August they returned to Paris to submit their detailed proposal. Gropius had developed prefabricated housing systems, designs for apartment blocks and row housing, and large-scale area plans. These were well received, but unfortunately, with the advent of the depression in France, only a small amount of housing was built and the program of the ministry was abandoned.

Early in 1929 Gropius was awarded a first prize (of 10,000 marks) among three hundred entries in a competition conducted in September 1928 by the Reichsforschungsgesellschaft for an experimental housing project of some four thousand dwelling units on a hundred-acre site in the Spandau area. Gropius's proposal must have overwhelmed the jury, which included Otto Bartning, Ernst May, Martin Wagner, and Paul Mebes. His formidable presentation included four alternate schemes, each with detailed site analysis, and studies of development and density as well as of construction and finance.

Although he won first prize in the Spandau-Haselhorst competition, Gropius did not become the project's architect. Through political chicanery, Fred Forbat, himself not an intriguer but modest and amenable, was appointed architect. Although Forbat was a former Weimar Bauhaus student, his entry was most prosaic and had not even received an honorable mention in the competition. A member of the jury, Paul Mebes, described by Gropius as an "old horse," was brought in later by Forbat as co-architect. Despite the outcome, Gropius regarded the competition as a breakthrough in terms of interest and implementation by the government.

Then Gropius designed "Am Lindenbaum," a housing development in Frankfurt that derives its name from a magnificent linden tree, perhaps seventy feet tall and almost four feet in diameter at its base, located on the east side of its main street. Am Lindenbaum today is an unobtrusive development enlivened only by an adjacent schoolyard, street traffic, and quiet seasonal activities in the nearby, carefully separated allotment gardens. Though some two hundred families occupy the nine three-story buildings, there is little association between the families except during the two-day *Sommerfest,* when the products of their garden labors are displayed.[14]

Perhaps the best known of Gropius's housing work of this period is his part in the cooperative

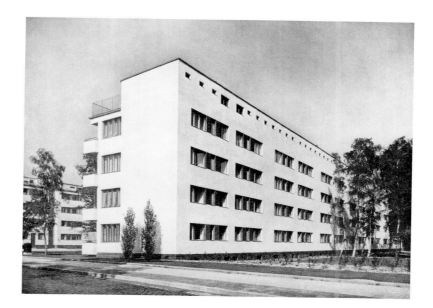

for middle-income families designed in 1929-31 for Siemensstadt in the great industrial area just west of central Berlin and almost immediately east of the Spandau-Haselhorst project. Attractive in its setting as well as distinguished in its design, it is well known to professionals and the lay public. This development, consisting of eighteen hundred apartments and a school, was planned by Hans Scharoun; Otto Bartning became responsible for the development of the plan. Buildings within the cooperative were designed by Scharoun, who did the entrance block, Hugo Häring, Fred Forbat, P. R. Henning, Bartning, and Gropius, who is credited with Siemensstadt's best-known building. Four stories in height and a city block in length, it turns a right-angle corner to form an ell. Though not the largest of the Siemensstadt structures, it gains notice for its scale, its siting, and its landscape treatment.

Gropius welcomed the variety of work that came to his office. He was particularly pleased by the request of the Feder Stores of Berlin that he design furniture for the moderate-income families who constituted the large majority of their customers. To meet this requirement, the designs had to be simplified and standardized as much as possible; some parts had to be interchangeable. Commercial sizes of carefully selected lumber, linoleum, and metal shapes had to be used efficiently with little waste. Manufacturing processes were to be those of industry and not of the crafts; handwork was to be reduced. Furniture finishes were to be applied by mechanical means, rapidly cured, and resistant to wear. Variations were to be achieved by combinations of colors and grain. Packaging was to be improved to reduce damage in shipping. The degree to which Gropius succeeded in meeting these specifications was extraordinary; with little change Feder displayed and sold the furniture for many years, calling attention to the fact that it was designed by Gropius. Among his designs were thirty-three individual pieces that could be matched as complete room sets for office and home, such as wardrobes, shelves, cabinets, desks, nightstands, tables, shoe cabinets, and buffets. The catalog also contained steel furniture designed by Breuer and Mies van der Rohe that could be used in harmony with Gropius's designs.

An unusual commission Gropius received in 1929 was for the design of automobiles for the Adler automobile works of Frankfurt. Though Gropius designed several car models over a three-year period, only two of them are known to have been assembled and marketed. These were the cabriolet and sedan. Though photographs and drawings present variations, these appear to have been accomplished with alternations of standardized body parts, accessories, and finishes. His sports car, or cabriolet, turned out to be most popular; the front seats could be converted into beds by means of collapsing their back rests, an idea adopted many years later by other automobile manufacturers. This design won first prize in several national automobile exhibitions.

The new office was running smoothly. There was a great amount of work and the many competitions the firm entered created a state of excitement, if not a dependable source of income. The increased demands for Gropius's attention were offset in part by the efficient collaboration of his staff.

Late in 1929 the German government entrusted the Deutscher Werkbund with mounting their first exhibition in Paris since before World War I. The organization then engaged Gropius for the design and selection of exhibits, and appointed a committee of three, headed by Ernst Jaeckh, to advise him. Gropius immediately went to Paris on December 5 and spent the next several days in discussions with representatives of the Société des Artistes Décorateurs regarding the allocation of space for the German exhibition, lighting, security, access and egress, and other provisions. He studied the space, made sketches, and secured measured drawings and photos. Gropius invited Moholy-Nagy, Breuer, and Bayer to be collaborators and assigned them spaces and themes for their composition.

The exhibition consisted of a display of the products of German industry, each carefully selected to show a practical standard for future mass production. Shown were a wide range of the most contemporary designs and products, jewelry, textiles, furniture, appliances, scenic tableaux,

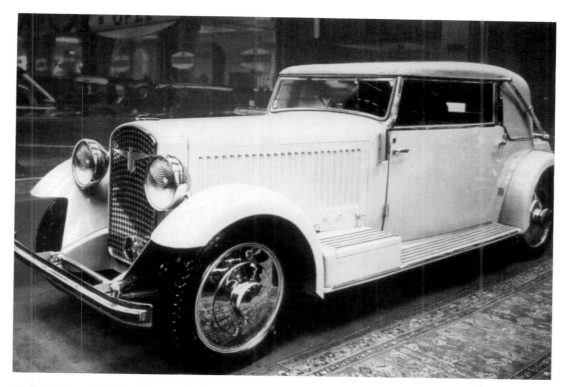

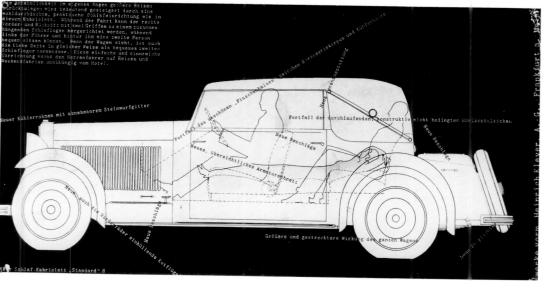

Gropius's design
for the Adler
cabriolet, with
schematic demon-
stration of its
features, 1930–33

Werkbund Exhibition, Paris, 1930: the gallery area of Gropius's communal room for a high-rise apartment

Right: Detail of stairs, showing open metal construction

architectural models, and photographs. Housing concepts were very much a part of the exhibition.

Gropius and his collaborators made several trips to Paris for the show. One was in March 1930, for major construction, and another in early May, to supervise the last details. Gropius remained in Paris for the official ceremonies on May 13 and the public opening the next day. He returned again in June to change or renew exhibits that were showing wear. The exposition continued to mid-July. It was the first from Germany to be wholeheartedly accepted by France since the war, and was as well a belated recognition of the work fostered by the Bauhaus. The exhibition had a quality of lightness much appreciated by the French. The peripatetic Count Harry Kessler wrote in his diary on May 30, 1930:

> In the afternoon, I visited the Gropius exhibition in the Salon des Artistes Décorateurs inside the Grand Palais. It has caused a considerable sensation here. There is no doubt whatever that it is more interesting than the French arts and crafts exhibition which was set alongside it.[15]

Included in the Werkbund exhibition was a section of apartment house blocks designed by Gropius early in 1930 for the Social Building Corporation of Berlin. His typical block was a high-rise building with centralized services, glass-walled swimming pool, gymnasium, and other facilities for active and passive recreation. During the following year, he developed this design in great detail with Xanti Schawinsky.

Since his visit to the United States, Gropius was attracted by the ease of design and construction of steel-framed buildings. In 1931 he found a prospective client in Berlin who saw benefits in steel-skeleton construction beyond those of reinforced concrete, and Gropius made elaborate studies and a scale model for an eleven-story apartment block. Although the first effects of the Depression prevented its construction, it was not a total loss, for this Berlin apartment design served as a prototype for several later projects.[16]

During this period, Gropius's proposals for high-rise housing as a means of improving city conditions had become explicit. His suggestions and rationale appeared in newspapers and magazines and were heard in discussions, radio debates, and lectures. In a paper presented to the third assembly of the Congrès Internationaux d'Architecture Moderne (CIAM) in Brussels, in November 1930, he said:

> The city needs to reassert itself. It needs the stimulus resulting from a development of housing peculiarly its own, a type that will combine a maximum of air, sunlight, and open parkland with a minimum of communication roads and maintenance costs. Such conditions can be fulfilled by the multi-story apartment block, and consequently its development should be one of the urgent tasks of city planning.[17]

He also promulgated these ideas in exhibitions. For one of these, the German Building Exposition in 1931, he prepared, together with Schawinsky, a series of panels presenting his arguments. The panels illustrated the social basis for housing needs, the deplorable current condition of available dwellings, the various types of dwelling units and residential buildings, means of transportation, and site and landscape development. In an article about this exhibition, Gropius described the high-rise apartment as a way to meet the desire of city dwellers for the country and country dwellers for the city:

> With horizontal development there is an increase in commuting distance from the population settlement areas to

Wannsee Shores development of high-rise apartments, Berlin, 1930–31

the city center. …With high-rise apartments there are wide spaces with light and air and areas for children's play and where nature can enter…roofs can become gardens. …Another possible advantage of high-rise buildings are community facilities and services, the costs of which may be spread over a large number of families…opportunities for informal social contact…a new form of urban living.[18]

One of Gropius's most distinguished proposals for high-rise housing was the Wannsee Shores project for a site southwest of Berlin. Recognizing the limited number of families that could enjoy single houses and anticipating the growth of Berlin and its commuter traffic, Gropius proposed high-rise housing to take advantage of the view and convenience of the site and to give a greater number of families such opportunity.[19] Unfortunately, the Depression years did not provide the opportunity to carry out this lavish project.

Even with his emphasis on high-rise housing, Gropius had not abandoned the development and fabrication of the detached house. In 1931 he designed a prefabricated copper house for Hirsch Copper and Brass Works of Finow; it found immediate favorable response, even though perhaps no more than forty were built in Finow on an experimental basis. A community of such houses was proposed but not achieved; the Hirsch-Kupfer company, under pressure from the National Socialists, was unable to continue under its Jewish owners, and the new management had little interest in Gropius's designs.

Some of the same ideas Gropius expressed in connection with high-rise housing were brought to his discussion of the detached house. In *Architectural Forum*'s publication *The Small House of Today* (March 1931), Gropius prefaced his contribution with a persuasive argument for open green spaces in the city and separation of industrial and commercial areas from those for residential use. "Through the systematic use of modern means of communication" he would bring the city closer to the country. Indeed, his final paragraph is a plea to cover every open space, balcony, roof, and terrace with plants and make "the enjoyment of nature a daily rather than a mere Sunday experience of the city dweller."

The prefabricated
Hirsch Copper
House under con-
struction, Finow,
1931

**Stove for the
Frank Iron Works
(Ise's family's firm),
1931–33**

Ise's family enterprise, the Frank Iron Works at Adolfshütte in Dillenburg, manufactured coal-and wood-burning stoves for domestic heating, among other metal products. Their designs had remained virtually unchanged for many years. In 1931 Gropius was engaged to redesign the stoves to improve their efficiency, to simplify their manufacture, and to make them more attractive in the eyes of prospective purchasers — and thus improve the company's sales. During the following two years, Gropius designed several models. One of these, the "Oranier," became the Frank Works' best-selling item.

The 1932 German Building Exposition, held in Berlin during the summer, was entitled "Sun, Air, and a House for All." It featured as overall themes the expandable house, private gardens, and weekend houses. The exposition was the responsibility of Martin Wagner, still building commissioner for Berlin despite the mounting National Socialist pressures against him. With the assistance of landscape architect Leberecht Migge, he organized it in a formal, parklike setting, though domestic vegetable gardens and fruit trees and shrubs were incorporated. Wagner invited many distinguished Berlin architects to participate.[20] For the exposition, Gropius designed more advanced versions of his copper houses, such as an expandable type with which he had been experimenting for two years. He proposed that these be built in groups of six to eight dwelling units, though in the exhibition his own pair of houses together with one by Mebes formed a smaller group with gardens.

In the same year Gropius and Franz Möller, a former employee who had moved to Buenos Aires, entered into partnership for work in Argentina; they opened a small office in the capital city. Möller had worked for Gropius over a three-year period on housing studies and had collaborated with him on the early schemes for Mountains for Living. Their communication was regular despite the distance between Berlin and Buenos Aires, and the Argentine office was very busy. One of the projects was a small house of simplified construction, planned with capability for enlargement and other changes. This was called "the Gropius standard."[21] Three such dwelling units were designed as prototypes, and each was presented in two and three stages of development. The first of these

was for Señora de Harle-Moore, and the plans for her house were presented with just the nucleus, with added garage, and with added children's room.[22]

The Bauhaus: Hannes Meyer and Mies van der Rohe: Scarcely had Gropius returned from the United States in 1928 when he was besieged from every direction with pleas and complaints about the Bauhaus, about changes made in the faculty, about courses, administration, and town-school relationships — and about Hannes Meyer himself. There had been no dispute between Meyer and Gropius. Indeed, following Gropius's retirement from the Bauhaus, he never interfered with Meyer's directorship and only helped him in a positive way during the transition stage.

He trusted Meyer to follow the guidelines of the Bauhaus. Meyer, however, began to stress scientific working methods at the expense of the influence of the abstract painters. An East German historian later remarked, "It was in line with Meyer's sturdy intellectualism to push back the emotionally artistic factors and considerably cut down the influence of the painters."[23] Another writer said that Meyer did not fight art as such, but its abstract direction.[24]

Meyer reoriented the institution toward an architectural emphasis, sacrificing in order to do so many of the basic or preliminary courses as well as those complementary courses upon which Gropius wanted to build toward architecture. The reaction in the Bauhaus was lively. As expected, Kandinsky was in sharpest opposition to Meyer's attack on abstract art education, and he was joined by Albers and other masters as well as students. Though Kandinsky accepted the role of vice-director, he was very much an individualist and opposed the collectivist tendencies of Meyer. He regarded Meyer's behavior as treachery that would bring the entire school into disfavor. Gropius himself wrote later:

> Kandinsky and Klee got Meyer's promise that he would support them and build up their courses. As soon as he became Director, he took the opposite course, severed, so to speak, the work of the painters from the curriculum of the Bauhaus and disregarded them within the Faculty setup. He was openly working against "art."[25]

Nevertheless, Albers continued his influential preliminary course. Kandinsky's course in abstract form and analytical drafting, also taught in the first semester, was complementary to it, as was Joost Schmidt's in lettering. Klee's course in design theory and Schlemmer's in life drawing followed in subsequent semesters, as did the stage, sculpture, and other courses.[26] Feininger remained on the scene as an advisor only. Mart Stam was invited as a visiting teacher for city planning and elementary building construction; during 1928-29, he lectured one week each month. In the spring of 1929 Meyer called in Ludwig Hilberseimer to give regular lectures in the first formal course in city planning and to take over the instruction in building and the housing studies, with particular emphasis on rental apartments and sale projects. At Stam's suggestion, Walter Peterhans was engaged to teach photography.

The communal life of the Bauhaus continued, particularly among the students during Meyer's first year; there was gaiety, with music, theatricals, carnivals, ballets, and festivals involving the people of Dessau. But there was less cohesiveness among the faculty, which had not yet recovered from the departure of Gropius and other masters and had not developed a new consensus on their relationship to the new administration.

A new Bauhaus exhibit in 1929 led not only to new inquiries from industry about contracts but

also to criticism in the press that the cost of house furnishings, including some by Gropius, was generally beyond what workers could afford. Breuer's steel-tube chairs were thought reasonable, but "what proletarian can afford a bookcase for 965 marks?" The lack of solutions for housing at modest rentals was also criticized.[27]

In that year Oskar Schlemmer left the Bauhaus to join the Breslau Academy. Although he had welcomed Meyer on the latter's arrival at the Bauhaus, there was no love lost between them after 1928. Meyer was negative toward the theater as such; he wanted a political stage. Schlemmer made no secret of his feeling that Meyer was boorish and tactless and that the atmosphere of the Bauhaus was not conducive to education. His diary notes Meyer's reference to himself as "Executioner for the Bauhaus" and his own characterization of Meyer as "its grave-digger" and "the wolf that has dropped his sheep's clothing." (In January 1928 he had written, "H. M. will wring W. G.'s neck!")

The school's curriculum by 1929 was also being shaped by the inadequacy of Germany's efforts to maintain economic and governmental stability. This problem, then approaching crisis levels, was not ameliorated by such actions as von Hindenburg's granting huge subsidies to assist East Elbian landowners in maintaining their great estates. Indeed, such inequities gave impetus to reaction and protest. Bauhäusler Selman Selmanagic later recounted, "Reflecting these times and his own views, Hannes Meyer introduced Marxism and Leninism into the Bauhaus as a fundamental study; probably this was the first time in any Hochschule in Europe."[28]

Thus, the Bauhaus in 1929 began openly to justify some of the many charges of politicism that had earlier been made against it. Many years later, Bauhäusler Kurt Kranz said that the majority of the students were uninterested in politics; however, a small group were active politically and forced others to support them. Wolfgang Tümpel, a Weimar Bauhäusler, believed that no more than ten percent of the Bauhaus students were Communists, although political affiliation was not forbidden.

Meyer not only tolerated but encouraged these political activities. There was an obvious and ominous growth of politicization within the student body. The young students found themselves caught between Marxist ideas in the school and the reactionary ideas of the budding Nazi Party that were forced on them from without. Most would have preferred to remain neutral, but they were pressured to choose.

The expansion of the academic program and the Bauhaus's progress toward financial and administrative autonomy under Meyer only hastened the actions of its opponents. Meyer provided them with an excuse by his continued espousal of Marxism and support for student participation in external political activities. He once asked Mayor Hesse whether the latter would permit students with communistic ideas to study in the school. Hesse agreed, but emphasized that there were to be "no politics in the Bauhaus." Meyer assured Hesse that he was a "scientific Marxist."[29] It was believed, however, that a Communist cell, which included some seventy Bauhaus students, was at work within the school.

The attacks mounted and dissension within the school increased. The students began to ask, "Why learn when we ought to change conditions — when we have to change conditions in order to get jobs?" But such social concerns were easily interpreted as political socialism in the Germany of the 1930s.

By 1930 the Bauhaus was in such ferment that Hesse telephoned Gropius to say that the "communistic doings of Meyer" endangered the whole institute. Gropius advised Hesse to dismiss Meyer immediately. With this advice, and under pressure from the conservative elements of Dessau and Anhalt, Hesse requested Meyer's resignation on July 29, 1930, charging him with encouraging political activities in the Bauhaus and for favoring "Marxist teaching methods that undermine the civic conception of *Bauwesen* and infect youth."[30] All masters, except Gunta Stölzl, supported Hesse. The reason given for Meyer's dismissal was not that he was a Communist or was dealing with the Communists, but that he was overtly involved in political organizations and was dishonest and of bad character. Gropius later acknowledged that he had made a mistake in his initial judgment of the man and referred to Meyer as a "treacherous character"[31] who lied to him and to others:

> As I recognized too late, he was scheming to keep his intentions to himself until he was in the saddle. He sacrificed his personal integrity for his hidden political intentions. Not only myself, but everyone else in the Bauhaus was completely surprised when his communistic leanings came to the open after he was installed as Director.[32]

Meyer did not accept his expulsion without protest. On August 16, 1930, he published a long "open letter" to Mayor Hesse and the newspapers protesting his discharge.[33] He noted that he had re-organized and expanded the teaching of architecture and planning, had organized sports for the Bauhaus, and that the Friends of the Bauhaus had increased to five hundred under his administration. The faculty now included guest lecturers on philosophy, psychology, and other fields of knowledge. New industrial product contracts had been made,[34] the Törten housing project was expanded, promotional lectures were being given in many cities, and a new traveling exhibit was mounted. And in his "open letter," Meyer reminded Hesse that together they had dissolved the Bauhaus Communist cell in March of that year.

Hesse initially would not permit a hearing on Meyer's dismissal; he felt a prolonged investigation needless and dangerous to the life of the school. Meyer immediately engaged a lawyer, and an arbitration committee consisting of German art commissioner Erwin Redslob, architect Hugo Häring, and the Dessau school superintendent proposed a financial settlement on November 5, 1930, to which both the city council and Meyer agreed. Following this resolution, Meyer announced, "I am going to the USSR to work there, where a true proletarian culture is being forged; where socialism is being created; where the society exists for that which we fought here under capitalism."[35] Accompanied by Konrad Püschel and six other students, he departed then for the Soviet Union.[36]

Following Meyer's departure, Hesse invited Gropius to return. But Gropius would do no more than nominate Ludwig Mies van der Rohe as head of the Bauhaus and persuade Mies to accept. Gropius said later: "I was confident that Mies van der Rohe would be able to straighten out the Institute and to fight the political activities of the students, who had been driven into this by Meyer. The political situation was not yet such that I thought of an imminent collapse."[37]

The agreement between Mies and the city of Dessau contained a six-month cancellation option. It stipulated that if the Bauhaus were dissolved, the right to the name would be the property of the last director. In addition, Mies was allowed to consult on city planning and was to be provided with an apartment. Mies was also given the patents, the licenses, and the contracts, especially those of

the very lucrative wallpaper agreements. There would be, it was hoped, a new stable period in the life of the Bauhaus:

> With Hannes Meyer and through his Marxism and Leninism the main point was not only how one built, but also what and for whom. ...But according to Mies van der Rohe who succeeded him, it was not what one built, but how. ...With Mies van der Rohe the exact measure was not important, but rather the visual effect. ...Function was a matter of course.[38]

Mies occupied one of the masters' houses and, as stipulated in his contract, continued his Berlin practice, commuting to Dessau for three days each week.

Mies's relationship to the students was a formal and proper one. Though Marxism and socialism were suppressed, the influence of the Nazi organizations now began to be felt. Meyer would later charge that the social gap between masters and students began in Dessau with the construction of "luxury" homes for the masters and a special residence for twenty-eight favored students. Under Mies, he claimed, the Bauhaus pedagogy returned to learning by rote, students had no voice in the affairs of the school, all social teaching and views disappeared, and students from the privileged classes dominated and were favored; among these were the first Nazi students in the Prellerhaus. Communist students criticized Mies and his works, claiming that these were for the elite. Indignant over the dismissal of Meyer, they demanded that Mies discuss his own appointment and his curriculum with them.

Mies did not countenance disturbance in the Bauhaus that would attract the attention of the authorities. He parried student protests against new restrictions, increased fees, and the governmental regulation of education by calling in the police and by personally interviewing every student at the Bauhaus, discharging sixteen of them.

Hesse and the Council of Masters closed the school for several weeks. During that time, the buildings were repaired and painted in an effort to "renew both container and content." This was followed by a festival, during which, a Japanese student reported in some amazement, Mies danced until dawn. The frictions between the school and the community were reduced, but not for long. Under Mies, as a Bauhäusler later wrote, the school was transformed into a pure teaching institution, the influence of the students on the curriculum was liquidated, and the sociological disciplines disappeared little by little from the curriculum.[39]

The physical distance from the Dessau Bauhaus to Gropius's Berlin office was insufficient to shield him from its problems, and almost gratefully he allowed himself to be absorbed in work and out-of-town commitments to lecture and attend meetings of professional societies. Yet these activities already had become exhausting, if not tedious.

Ise Gropius's Search for Identity: For Ise especially the routine of home and office, so inextricably linked, became humdrum. She insisted on vacations, free of other activities, and in the late spring of 1930, they had driven to Casa Hauser in Ascona. There Gropius absorbed himself in recreation as energetically as if he were in an architectural competition. In the excitement of their brief holiday, there was no presentiment that the mountains above Ascona foreshadowed the greatest alienation of their marriage, and they made plans to return to Switzerland as frequently as possible.

In early summer, as a result of the economics of staying at the Hauser place, they were able to visit Ascona again, this time followed by Bauhäuslers Xanti Schawinsky, Marcel Breuer, Herbert Bayer and his wife, and other old friends. Xanti described Ascona as "the place where brows reached the sky and bottoms traveled Third Class!" In the summer there was the beach and swimming and *bocce* (lawn bowling), in which Gropius excelled, defeating the younger men with ease amid much chafing of each loser. There were also expeditions up the hill to Bosco, the little village above Ascona. Gropius invariably excused himself from this because of his chronically weak ankles. Most frequently it would be Ise and a companion who would complete the climb for the view of the lake and valley, then descend into the town at sunset.

They all lived together, joyously and economically, as a Bauhaus family in the Casa Hauser and were sometimes joined by one of the girlfriends Xanti presented for approval.[40] But for Ise and one old friend, Bauhaus camaraderie had become a love affair. On many occasions, they had been very much alone while climbing the hills above Lake Maggiore, and sometimes in Casa Hauser. It was inevitable that they would be drawn together. Far from being casual, their love was serious, painful, and ecstatic.

Preoccupied with his practice and still with affairs of the Bauhaus, Gropius did not always join in the activities of his younger friends. Ise, whose time was relatively free, was caught up in those happy activities. Ascona became a playground for her and her Bauhäusler companions. Their laughter, ribaldry, and constant movement brought her in her early thirties something of the youthful life that had passed her by in previous years.

By 1931 Ise and Gropius were deluding themselves about the troubled state of their marriage. Communication between them became attenuated. On one occasion, with Ise vacationing and Gropius at work in Berlin, he wrote:

Shocking! Tonight no letter from you, and that after your last one, which already sounded somewhat faint, more

"The Spirit of Ascona": Ise, Xanti Schawinsky, Herbert Bayer

distanced, de-Waltered. And that to me, just now so in need of warmth and tenderness as never before,…is cold, I am dreadfully alone and I quarrel with myself and my fate, find myself expelled from humanity since I alone shall not have a vacation which I need so-o badly. My only pleasure in my loneliness has also disappeared. This beautiful woman, twenty-three years old and divorced from Th… came again, but has departed now. I drove her in my car when she left, but unfortunately I had too little time; but it was fun to see that women still fully react to me, very much so, even when they are beautiful.

Then a postscript:

Just now I got your letter. I am *shocked* that you and [———] are driving to Milan alone; you shouldn't do that — particularly when I have just now passed up the best opportunity to take revenge in advance. Listen you — : don't let anything enter our ring. It closed so well and safely up to now, and my feelings for you are just as tender as on the first day. These are not just words. …In times of separation one takes inventory, and it turned out very well for you. We have lived well together, and I miss you very much. Please stay 100% mine.[41]

As for Gropius's intimations that he too was enjoying flirtations, Ise many years later said that these were merely contrived to bring her around. Gropius, she said, had lived a full life before they met and really did not seek new experimentation, and therefore she felt no stirrings of jealousy. Ise herself at the outset of her own extramarital involvement had felt very little uneasiness, accepting the pleasure it brought as her due. For the seven years of her marriage, she had felt herself to be overly protected, "too much under Gropius's wing," and now she felt she "had to get into the arena again" to test her power of attraction for men.

This was one of the busiest periods in Gropius's practice, but nevertheless a troubling one, and his apprehension is expressed in his continuing correspondence with the influential Pierre Jay, then chairman of the Fiduciary Trust Company of New York. Jay reported the appearance of Gropius's name in American newspapers in connection with the 1931 Berlin Housing Exhibition and expressed his satisfaction that Gropius continued his efforts in this discouraging period, as in the

United States "most architects are having painfully slim business."[42] In October 1931 Gropius wrote disclaiming, but poorly concealing, his own discouragement:

> I cannot personally complain…but I see paralyzing unemployment ahead. …I have the impression that we are entering a very difficult winter in spite of the victory of the present government. The economic damage and inadequacies of the system have gradually become so broad, not only in Germany but also in other countries, that the old machine perhaps cannot be repaired any more but will have to be replaced by a new one. The rearrangement, or building up, may take a very long time.[43]

Gropius had just returned from a trip to Paris to attend the automobile show, where his Adler cars were prominent among those of German manufacture. As a designer, he had been introduced to France the previous year by his work in the Werkbund section of the Exposition de la Société des Artistes Décorateurs. Now, his Adler cabriolet was particularly acclaimed in published reviews of the show. It was also seen on the stage of a Paris theater, where its reclining seat provided a necessary and very contemporary prop for an amorous scene.

On October 2, he left Paris, hoping vainly that he would find Ise again in Berlin. He was disappointed and busied himself with office and professional association commitments and with completing a lecture he was to deliver in Stockholm.

Additionally dispiriting was the open attack by the Kampfbund für deutsche Kultur on the new architecture and art and that organization's racial policies, which followed the dictates of the Nazis. This harassment was high on the agenda of the BDA's annual meeting. A photograph of its board, Gropius among them, shows sober faces.

At a Barcelona meeting of CIAM in March 1932, the Russian invitation to meet in Moscow was unquestionably the most prominent subject of discussion. It was decided to send van Eesteren and Giedion to Moscow in December to settle all questions for a meeting there in June 1933. They were to make it clear that the theme of the proposed meeting would be "the functional city," and not "the socialist city."[44]

With reluctance and a degree of foreboding, Gropius had gone alone to the Barcelona meeting. Ise and he had decided against the expensive journey for her; instead, she was to go skiing alone. The Barcelona visit was important for Gropius, though photographs of the assembled CIAM members show him again somber and preoccupied. It was an important time for Ise and her companion as well, for they determined that she would tell Gropius of their now almost two-year-old relationship, which she could not and would not conceal from him any longer.

But it was difficult for Ise to declare herself, and three months went by before she did. So discreet had the lovers been and so trusting was Gropius that he was surprised. So unobserving had he been that he named the wrong man. He became introspective, recalling that as a young man he had, in the same kind of situation, challenged older men, first Gustav Mahler, and then Hans Hildebrandt, for the love of their wives. He said to Ise, "I know how you feel…I have done the same thing." But now *he* was the older man with a younger wife whose attractions were proving irresistible to other, younger, men.

Gropius gave little time to such introspection but immediately sought out his friend, now rival, and declared firmly, "If you insist in going on, I will fight." Through extended conversations,

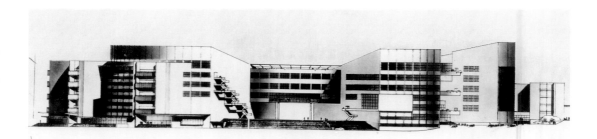

Gropius sought a rational way to replace the triangle with the "Bauhaus family relationship" that previously existed. He reported on his efforts to "my dear Ise":

> Yesterday I returned from Frankfurt in oppressive heat. ...Called [———] immediately and invited him. He acts quite free and relaxed now, and I let him go ahead in his own way and only saw to it that an atmosphere without nightmarish quality prevailed and that we had some good talks. We sat up until 5:30 a.m. in very lively conversation. You floated like an invisible in our minds. ...By the way, I found [———] looking somewhat better; I think he feels it a relief that I manage to appear at ease. I only hope we make no mistakes so that he will slowly regain his spirit.[45]

A few days later, he wrote again:

> Yesterday we had a real stag party. We went to our small lake near Ferch, swam in the rain, picked waterlilies and ploughed up the world in words. ...We had a naked picnic and then went to Ferch for a cup of coffee. Your spirit was among us, my dear. [———] was quite peaceful and looked a little better. ...Before I left [for Frankfurt] today I went for a moment to see [———]. We had coffee at Robert's and he accompanied me to [the autobahn].
>
> It was terribly hard for me to go away from Berlin to this dreary Frankfurt and to an even more dreary work which I do not fancy. I was ready now to have a real talk with [———]. ...Maybe we shall arrive at a point where we can give our friendship an even higher value than the one of spontaneous sympathy. Anyway, he seems happy that I can deal with him without constraint and heaviness; this surprises even myself. *Don't draw false conclusions from this, though.* Sometimes I cannot write because the word penned on paper is so easily misunderstood when one is separated. You know how I hate this paper life! I miss you very much. I know that our mission to each other is by no means fulfilled as yet.[46]

Hardly three weeks passed before Gropius returned to Frankfurt; at the end of a momentous and emotional day, he wrote:

> I have just said goodbye to [———], he went on to Stuttgart. He came unexpectedly this morning and we were together uninterruptedly until now. I am very glad about this encounter, which took an untroubled, relaxed course, and I think [———]...felt the same way since he was so open and confidential with me that it became possible for me to discuss everything with him that I had thought over during these last weeks... .

CIAM meeting, Barcelona, 1932. From left: José Luis Sert, Le Corbusier, Cornelius van Eesteren, unidentified, Gropius, Victor Bourgeois, unidentified

It was certainly a rare human situation and we were both very conscious of it. I talked first about myself in order to meet him halfway and to dispel any possible embarrassment, but he was really ready for an open exchange from the very beginning. He regretted not having approached me a long time ago, but his feeling of guilt had prevented this. I have tried to free him from this feeling because it should not become a hindrance to our growing understanding. I do not find him in bad condition and without doubt much better than when I left Berlin. He is certainly not at peace with himself yet — how could he be — yet the fact that he longs intensely for quiet concentrated work and talks a great deal to me about it is in itself a good sign....

We drove together to a little charming inn on the Rhine, just the right ambience for us, and from there we both wrote a postal card to you. I feel capable of proving my friendship to [——] which I want to build up between us and he felt today without distrust that I really mean it....

You yourself, my dear, are still the big unknown in my equation; I know too little about your inner self. We have been separated for four weeks now and the essential things one cannot put in a letter. But I still have a hopeful feeling about our mutual relationship and its promises for the future. There are too many strong assets on both sides and new and essential ones have been added.[47]

Following the ordeal of her revelation to Gropius and weary of the complication of the love of two men, Ise sought peace of mind. She fled to her sister Hertha at Murnau in the foothills of the Alps south of Munich. Unfortunately, Ise's still-ardent lover learned where she was, followed her there, and the romance was renewed.

Though Gropius was not immediately aware of the continuation of the affair, he no longer felt that the love of his wife and his friend was a transitory one that would disappear by itself. Giving his involvement in Adler's design work as a reason, he rented an apartment in Wiesbaden, not far from the company's plant in Frankfurt, and insisted that Ise move there with him. The quiet of Wiesbaden gave Gropius and Ise more time together, though he dared not make an issue of the triangle in which they found themselves.

By that summer of 1932 Gropius had served three years as consultant and designer for the

Skiing in Switzerland

automobiles of the Adlerwerke in Frankfurt. His designs had been innovative and well received, but in 1932 the deepening depression prevented the growth of a large domestic market, and international appreciation of German automobiles was several decades away.

Kleyer, owner of the Adlerwerke, believed the market slump would be temporary and that it was a most appropriate time to modernize their production methods and factory to prepare for the prosperity that was certain to follow the Depression and political adjustment. The company also considered it desirable to diversify its product and thus maintain the employment of its skilled workers. Gropius was now called on to assist not only in the design of a less expensive car, trucks, and other vehicles, but also to suggest from his Bauhaus experience possible products for Adler manufacture.[48]

But 1932 was a troubled year; there was great unemployment, unrest, and increasing crime. Gropius at times felt insecure during his many trips for Adler by car on little-traveled roads, and he applied for permission to carry a gun. On May 10 he was authorized to have in his possession, particularly for business travel by automobile, a small-bore (6 mm) pistol; he was forbidden to carry it in places of public assembly and in demonstrations. It was the first time as a private citizen since his youth, when he roamed the Le Havre harbor at night, that he would be so armed. In his identification photograph attached to the permit, Gropius appears grim, his eyes seeming to burn with determination, or fatigue.

There were days and weeks in this troubled period in the Gropius marriage when common interests took precedence, and the shadow of the disruptive romance seemed to fade. During this time, the Giedions, Sigfried and Carola, invited Gropius and Ise to ski at Arosa near Zurich. They accepted and late in 1932 traveled there for a winter holiday. They found Arosa as attractive for winter vacations as they had Ascona for summer holidays. They returned as often as their dwindling income permitted, together or, more frequently, Ise without Walter.

When Ise was with her lover, Arosa provided moments of unforgettable beauty, certainly not at all conducive to thoughts of their separation. Ise "adored the mountains, the air, the skiing, and being romantically in love with an attractive and passionate younger man." Yet when she was with the mature and inspiring Gropius, she felt herself to be "secure and where I belong." She was firmly wedded to the Bauhaus idea, its familial spirit, and its destiny, for which she had a feeling of responsibility. Thus, recognizing a duality rather than an ambivalence in her love of the two men, she proposed a solution. Would Walter permit her to spend time with her companion in the mountains of Arosa? She asked, "Will you let us have our fling?" Gropius agreed to a fortnight stay, knowing full well that he had little choice. At the end of that time, Gropius came to Arosa, arriving on the heels of his departing rival.

It seems extraordinary that he tolerated the situation, but he did so, given his great love for his wife, his ability to endure, and the sure insight that he would win out in the long run. Forty-five years later, Ise saw her proposal as naive, made with a feeling of hopelessness as to any other solution. The experiment was not repeated, though the liaison continued.

Politics: The Denigration of the Bauhaus and the Profession: Meanwhile, the political situation in Germany also moved from crisis to crisis. By April 1932 Chancellor Heinrich Brüning secured von Hindenburg as a presidential candidate against Hitler and the National Socialists. The aristocratic Junkers were concerned about the prospect of land reforms. The industrialists opposed both the trade unions and the Reichswehr authoritarian dictatorship. Under Franz von Papen of Meissen fortune, seven out of ten cabinet members were aristocrats and with him were instrumental in the rise of Hitler. They abolished the Prussian Social Democratic government of Braun-Severing, already shaken by the gains of the Nazi Party. By July 1932, the ban on the Storm Troops (SA) and the Black Guard (SS) was lifted. National Socialist seats in the Reichstag increased by almost 40 percent, to 230, and the Communists by 15 percent, to 89, out of a total of 608. Yet as late as November 1932 there was still an opportunity to hold back the Nazis.

But what of the Bauhaus itself? In January 1932 National Socialist members of the Dessau council demanded the closing of the school. Socialists and Communists defeated this move by a vote of 20 to 16. Mayor Hesse turned away another attack in July. Mies also astutely defended the school, parrying every attack throughout the spring and summer of 1932. In an attempt to obtain a stay against this harassment, a petition was directed to President Hindenburg in July. On the 26th of that month, Mies's effort to obtain pensions for teachers was denied on the grounds that the Bauhaus was not a recognized institution of higher learning. National Socialist officials of Anhalt and Dessau, accompanied by architect-politician Paul Schultze-Naumburg, had visited the Bauhaus and, after viewing its work, had found it to be un-German. Only the Communist members of the city council prevented the breakup of the school at this time. However, with the determined National Socialist majority in the city council constantly attacking Bauhaus pedagogy, masters, budget, "Jewish-Marxist art," and its foreign "Communistic" students, Hesse could no longer support the school.

On August 22 the Dessau council voted by a majority of 20 to 5 to close the Bauhaus; only the

few Communists and Hesse dissented. On October 1, 1932, the school was dissolved. There were then fewer than seventy-five students. Only the persistence and devotion of Hesse, the masters, and the students themselves had kept the Bauhaus open. Mies moved the school to Berlin-Steglitz, where it opened on October 18 as a private institution housed in an abandoned telephone factory building on Birkbuschstrasse. Its faculty included Hilberseimer, Albers, Kandinsky, Rudelt, Engelmann, Peterhans, Scheper, and Lilly Reich, who had joined that year. A surprising number of new students enrolled immediately.

The pace of political events had now accelerated. On January 30, 1933, persuaded by Franz von Papen, Hindenburg made Hitler chancellor, naively believing that the man could be controlled. Given German citizenship, Hitler was entrenched. Immediately thereafter, Hermann Goering reestablished the air force. Joseph Goebbels, who was slated to become propaganda minister, instigated deep rifts in the country's civil and political leadership, dividing it even in opposition to the Nazis. The Communists were undecided as to their own direction, since for them a Nazi dictatorship with an eventual civil war might be preferable to a democratic republic. However, after Goering secretly had the Reichstag torched on the night of February 27, 1933, the Communist Party was made the scapegoat in a wave of Nazi revenge. There were then six million unemployed to whom the Nazi Party promised everything; there were political crises, government by decree, and flourishing political radicalism. Even so, in the new elections on March 5, the Nazis won only 288 seats and, with their allies, had a majority of only 33 in the Reichstag — enough, however, to seize dictatorial powers by means of a bill passed on March 23. On March 31 Hitler became president and chancellor with unrestricted powers.

On April 4 another semester began at the Berlin Bauhaus with fourteen new students, but the school was not permitted a peaceful continuation. The attorney general of Dessau ordered a search of the Berlin Bauhaus in order to obtain evidence against Mayor Hesse. On April 11 the surprise search was carried out. It was alleged, untruly, that incriminating materials had been found, and despite an appeal by Mies to Nazi Party leader Alfred Rosenberg, the doors of the building were sealed. Conditions for reopening, as stated the next day by the Gestapo, were intolerable; they included injunctions against the return of Hilberseimer and Kandinsky as teachers.

A few students, frightened or lacking proper identity papers, left immediately. Some students with engrossing workshop projects managed to reenter the building surreptitiously or remove materials to improvised workplaces in their own limited quarters. Still others met for discussions in the homes of the teachers. Somehow the semester was completed; but realizing the hopelessness of the situation, the professors and officials of the Bauhaus dissolved the school officially on July 20, 1933.

The Bauhaus, which had its genesis in the turmoil out of which the Weimar Republic had grown, was ended by the same political forces that almost concurrently destroyed the idealistic and naive Weimar government. It was not the inadequacy of its constitution that caused the downfall of the Weimar Republic but the fact that the German people were not prepared to defend and uphold it with conviction. The lack of middle-class interest stood in the way of a strong and united liberal party. Still, the act of cutting down institutions of government and education, like the Bauhaus,

forced the roots of the German people to grow deeper and to spread — to reappear, multiplied many times over and around the world.

When Hitler assumed control of the government at the beginning of 1933, the board of the Werkbund tried to take a stand against the dictates of Alfred Rosenberg that required the exclusion of Jewish members for an organization to gain the approval of the Nazi Party. Only Gropius, Martin Wagner, and Bauhäusler Wilhelm Wagenfeld objected to Rosenberg's fiat. Twenty-seven other members were silent. Ernst Jaeckh, the Werkbund's secretary general, suggested compromise. Gropius felt that this was a strategic, and not a tactical, situation where compromise would lead to nothing, so, at the end of March, he resigned from the board.[49] Wagner also resigned from the board, and Wagenfeld withdrew from membership. On June 10, Wagner was expelled as a member; the remaining members of the board, Ludwig Hilberseimer, Hans Poelzig, Otto Haesler, and Ernst Jaeckh, then resigned.

The Werkbund, as well as the BDA, was now dominated by the Nazi-run Kampfbund für deutsche Kultur (KDAI). Membership in the BDA became restricted to those architects of non-Jewish descent who had not been members of the Communist or Socialist parties and supposedly to those who eschewed the new art and architecture. By the spring of 1933, membership in the Kampfbund became obligatory for practicing architects.

In the early fall of 1933 Goebbels, in overt rivalry with Alfred Rosenberg for the control of the cultural affairs of the Nazi Party, established the Reichskulturkammer (RKK) under the Propaganda Ministry with himself as its president. With Hitler's favor, Goebbels's RKK forged ahead of the KDAI and quickly commanded all cultural matters. BDA members who were eligible became members of the RKK beginning in November 1933; many still believed Goebbels's propaganda that he sought architecture and art befitting Germany. This was interpreted by the conservatives to mean restoration of eclectic forms and by the modernists to mean a search for new forms. Among those who clung to such a naive hope was Walter Gropius. On December 12, 1933, Gropius became architect-engineer member number 706 of the RKK. His signature is dramatic, but his photo shows him stern, tight-lipped, appearing less sad than resentful, and older than his fifty years. His membership was of little use; though Aryan and apolitical, he was a marked man. His protests against the new restrictions which followed swiftly were similarly of no avail. He participated in competitions for government work, but the quality of his submittals was not the reason he was passed over in the award of commissions.

Many months earlier, Gropius had been selected, with Joost Schmidt, by the Association of Nonferrous Metals Industries of Germany to design an exhibition that would display the great versatility of nonferrous metals, various German designers' innovations in metal, and the capabilities of the manufacturers themselves. He later recalled the interference of the Nazi authorities:

During my rather extended private activities in Berlin, the opposition of the Nazis was increasing, particularly after January 1933, when Hitler became Reich Chancellor. Right after that, I encountered a rather disagreeable event: A uniformed Nazi patrol came to my house and told me I would regret it if I participated in a large exhibition called "German People, German Work" in which I was building a good-sized department for the nonferrous metal industry. Furious, I went immediately to the Goebbels Ministry, to the Department Chief in charge, pounded a table

and complained about the impertinence of such a Nazi patrol. He promised to protect me, but things became worse, particularly in connection with the press, which attacked the Bauhaus and me personally. The fight became hopeless for an individual alone.[50]

This was to be Gropius's last actual work of any importance in Germany during the Nazi era.

One event early in troubled 1933 is indicative of Gropius's self-assurance — or his political naiveté. Obviously, he regarded himself — a member of a family whose history was integral to that of the country — as a law-respecting citizen, loyal to the best German traditions, as a soldier of proven courage, as an educator of reputation, and as a leader in his profession. Yet all of this, in the face of the predictable vindictive acts of his foes, could also have contributed to unwarranted self-confidence. Whether it was confidence, naiveté, or courage, Gropius accepted an invitation to lecture in Russia at a time when even the name of that country, let alone its political credo, was reviled in Germany.

The invitation to lecture in Leningrad on January 10, 1933, came as no great surprise to Gropius. Several years earlier, Ilya Ehrenburg was the first visitor from Russia to come to the Bauhaus and Törten. He was followed by Anatol Lunatscharsky, the cultural minister, and as a result of this visit, a Russian delegation of architects, engineers, and officials had been permitted to inspect the Törten settlement in 1931, despite Germany's harassment of its Communists.

Much impressed by Törten's experimental qualities and its scale, this delegation recommended that their government invite Gropius to visit Russia. Late in 1932 arrangements were well under way for his illustrated lecture "High, Middle, and Low Buildings in City Planning," to be delivered in Leningrad under the auspices of the Deutsche Kunstgesellschaft. One of the Russian hosts was the Academy of Economics, another the Academy of Material Culture. Though Gropius requested visas for Ise and himself, there would not be sufficient funds for her to accompany him. The honorarium was only 300 marks, and the money was much needed for purposes other than travel.

Gropius was able to examine the country's new architecture, but he found none that impressed him. An architect who saw him there wrote back to Germany that "Gropius looks gray, depressed, and frustrated." From this, Hitler later questioned "whether Gropius, like many others, toyed with the idea of escaping to the Soviet Union after the victory of the Third Reich movement."[51] Much later, Gropius declared that "some of the things repelled me": men of proven worth were shifted for fear that they might build up too great a prestige and following, and there was obvious suspicion, mistrust, and jealousy. Everything had to be political, and anything that was objective and rational was pushed into the background. On the other hand, he commented favorably on the priority given to social housing and on the designs by Moisei Ykovlevich Ginzburg. These, still on paper, he termed excellent, although the materials to carry them out were not available. Gropius later wrote that if he ever had any desire to flirt with the Left, it was dispelled quickly by the architects in Leningrad.

The many immigration and transit stamps in Gropius's passport indicate an extended and somewhat circuitous return trip by rail, which gave him a larger view of Russia and adjoining countries and which brought him back to Berlin on February 4.

Shortly before his trip to Russia, Gropius had arranged to lecture at the Museum of Art and History in Geneva on February 16; the subject was to be "The Creative Principles of Modern Architecture"

and the honorarium 250 marks. The announcement of the lecture had set off a round of complementary invitations, and Gropius agreed to deliver several additional lectures and to meet with artists more informally. Ise accompanied him, and after two heavily commited days and evenings, they took a skiing vacation. With the Giedions, who had journeyed from Zurich to Geneva to hear him, and followed by an admiring group of students from Geneva's Ecole des Beaux-Arts, they skied in the nearby mountains. Before returning to Berlin, they skied again in Arosa.

In Zurich Gropius consulted with Giedion about the agenda, discussions, and exhibits for the projected CIAM meeting in Moscow in June. On March 22, 1933, however, the Russian architect and spokesman, Weinschenker, telegraphed Giedion requesting that the Moscow meeting be postponed until 1934 to provide, he said, more time for the host organizations to prepare an adequate reception. Informed by Giedion, Gropius did not comment directly on the Russian's proposal, nor did he offer possible alternatives. Giedion undoubtedly understood his cryptic reply, including the Voltaire admonition with which he ended it: *"Cultivez votre jardin!"*[52]

There appeared to be very little, if any, sense of disappointment among the CIAM delegates; without hesitation, they agreed upon a sea-voyage meeting to take place in July 1933. Gropius informed Giedion that he would not take part, saying that he had very little money and that he was desperately trying to keep up his practice. He need not have explained, for Carola Giedion was a confidante of Ise.

Only two private homes were designed by Gropius and built in this difficult year of 1933. One of these, for the Bahner family, is particularly noted for its site planning. The second was for Dr. Maurer at 14a Am Erlenbusch in Berlin-Dahlem.

Early in 1933, work was scarce, even for long-established offices with influential connections in the Nazi government and aligned with Nazi-directed professional societies. It followed that Gropius's commissions would become fewer, inasmuch as he would not countenance involvement of his office in political activities or resort to opportunism to secure work. When Werner Düstmann, who succeeded Otto Meyer-Otten as manager of Gropius's office in Berlin and who was secretly a Nazi, came to the office in uniform, he was discharged, an incident that, of course, was reported to the Party.

In mid-1933 several competitions were announced by organizations of the Third Reich. These, it was hoped, would ameliorate the depression in which even Party-favored architectural offices found themselves. The first of these competitions was for an advanced school for the training of Storm Troop members, and Gropius was not inclined, let alone invited, to participate.

A second competition was for a mammoth building for the Reichsbank in Berlin. With the opportunistic Hjalmar Schacht as its president, the Reichsbank had increased greatly in size and responsibilities because of its overt and active support of the expansionist plans of the Nazi Party. Not only had the bank outgrown its main building, but newly created subsidiaries were scattered. The bank wanted a large and efficient building, one that was also suitably imposing and representative of the Third Reich. Though it might have been expected that a Party favorite would be handed the commission, the German tradition of architectural competitions was a strong one, and a program was announced early in 1933 for the design of a new building.

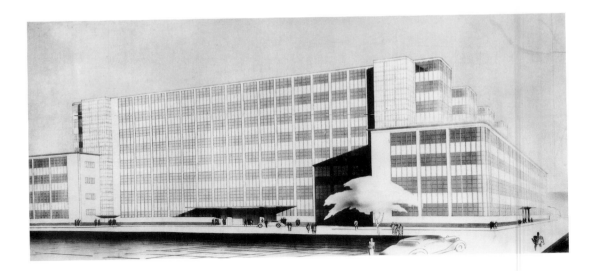

Gropius's office had little else on its drafting boards and completed an elaborate set of site and floor plans, elevations, renderings, and cost estimates — much more than was required by the program. The design leaned not at all toward the eclecticism favored by the Führer and the Party's puppet Kampfbund, Aryanized successor to the BDA and Werkbund. The monumentality of the Gropius scheme resulted from the massing of the elements required by the program and the sheer size of the building. It was also an economical proposal, established as it was on a modular basis utilizing standard materials and products. Whatever its merits, the entry was not, and could hardly have been, a prizewinner; Gropius had, after all, resigned in protest from the Werkbund board in March, when Alfred Rosenberg had ordered its reorganization along Party lines.

In May of 1934 Adolf Hitler, with the obsequious Schacht at his side, laid the cornerstone of the new Reichsbank. Almost four decades later, the Reichsbank's successor institution, the Deutsche Bundesbank, dedicated its new building in Frankfurt. Its resemblance to Gropius's entry in the 1933 competition is no doubt coincidental, but certainly surprising.

Another official competition program prepared by Willy Ley of the Third Reich's architectural bureau was for a prototype design for large *Kraft durch Freude* (Strength through Joy) education-recreation centers to be built in various locations. Gropius decided to enter the competition for a number of reasons: the project appeared to have some worthwhile social aspects; his office was not busy; it was diplomatic to evince some interest; and he wanted to make a last attempt to work in Germany without selling out to the Nazis — a test of the conditions and constraints.

Gropius, in association with Rudolf Hillebrecht,[53] proposed a city planning solution with alternative locations (one of these being the Tiergarten), transportation, and a variety of recreation facilities and spaces. The buildings were to be prototypes varying with the particular requirements of each center. Though the project was never realized, it had a long-range effect on Hillebrecht, who later became city planner for Hannover.

In 1933 Robert L. Davison returned to Berlin to visit Gropius and inspect Germany's housing efforts. He found Gropius's office quiet, a result not only of the slump in private work, but also of the disfavor of the Third Reich. Visiting his home, he noted that it reflected the austerity of the office. Gropius pointed out that his work had been described as Fascist by the Italians (though they liked and published examples of it in their professional journals), bourgeois by the Russians, and Communist by the Germans. There was no work, he explained, for anyone not closely aligned with the government.

The ski tours Ise and Gropius took together during the Christmas holidays of 1933 proved to be their last in Germany. One was with the Giedions, again to Arosa; it was a quiet, introspective meeting of old friends. The second excursion was the antithesis of the first. Accompanied by their old Bauhaus friends, they traveled in the Adler to the Riesen-Gebirge on the Czechoslovakian frontier. There in the foothills, they occupied *en famille* a simple ski hut. Walter had carefully organized the venture; he thought by bringing everyone together, everything would be as in earlier days of friendship — camaraderie rather than liaison.

Whatever the therapeutic value, it could have been a most depressing and tense week, given the politics of the time, their pocketbooks, and their emotions, painfully concealed under a kind of surface gaiety. Only Xanti could afford his usual effervescence. Though a Jew, he boasted a Swiss passport and had little to fear. Bayer, an Austrian, and Breuer, a Jew and Hungarian national, were vulnerable but tried to respond to Xanti's ribaldry. But it was the wine that did the most to ease all pain, erase the dark thoughts, and make everyone an expert skier on hills that became magically inviting by moonlight at midnight.

Despite Gropius's distaste for the Third Reich, he remained a loyal German. Both he and Martin Wagner joined in protest against a planning proposal for East Prussia that involved industrial development strung along its transportation routes rather than being utilized as bases for new cities or to strengthen older towns.[54] Though it was prepared in haste, a statement by the architects was perceptive in its analysis.[55] It pointed out that Württemberg was not a good model for East Prussia, that excessive public and private investment would be required, and that the problem of settlement was not only an economic one, but also one of humanity and civilization. The statement emphasized the reasons for the migration from the rural to urban areas. In an open letter to the government of East Prussia, Gropius and Wagner called for a city-region, to be planned and constructed as a prototype for Germany,

> which would eclipse the attempts of other countries…successfully answer the challenge of the coolie work of Japanese men [sic] with the coolie work of German machines, the challenge of the ruthless exploitation methods of the Russians with the precision of German engineers, and of American work for self-interest with the German people's work for the common good.[56]

After hearing a lecture by Eugen Hönig, president of the Reichskammer der bildenden Künst (Reich Committee for the Fine Arts), Gropius wrote him, challenging the ideas that were put forward:

> The new architecture that has evolved in the last decades, for which I feel largely responsible, was labeled before all the world as "packing-case architecture" that had to be rejected for the new Reich.… .

How do you think, dear Professor Hönig, a German like myself must feel who, after four years of hard combat duty during the war, has been working on our problems responsibly and with great intensity, incessantly fighting in an exposed position for cultural concerns also against the authorities of that time, and being respected everywhere abroad as a representative of a living *German* culture.

My homeland, being ashamed of my achievements, shuts me up and people like me while such men as Schmitthenner and Schultze-Naumburg mislead the public opinion with the claim of leadership and the patent for German-ness, whereas clearer minds are not allowed to put a stop to their irresponsible vagueness. Is it now really true that this strong, new architectural movement of German origin shall be lost for Germany? Are we forced to stop working on this movement after the whole world has begun to accept our suggestions and to further pursue what we began?...

I am convinced that the victory of this new architecture (which is distorted by a slanderous interpretation only) cannot be halted in this world, for there is no architectural movement today of equal impetus, conceptual clarity, and truthfulness....

I am proud of my own share in this architectural movement and, together with my friends and other representatives of this movement, I cannot accept always being labeled from a merely formalist point of view as originators of cubes with flat roofs; this point of view ignores the comprehensive work in design and sociology which we have been doing for German society as a whole and which can be documented by many factors. Where are the corresponding social achievements of those architects who are officially praised today such as Schmitthenner, Schultze-Naumburg, and Bestelmayer?...

Thus it is the current situation in architecture that lack of goals is wedded to unemployment and that the young are getting their political directives but not their professional ones. In the face of this situation I ask myself every day whether Germany can allow herself to jettison the new architectural movement and its leaders before there is something that can fully replace it. In his lecture to the Kampfbund in Munich, old Theodor Fischer stated warningly that the Gothic came from France, the Renaissance and Baroque from Italy, and that now, when there is finally the beginning of an indigenous, new architecture in Germany, it is abandoned by its own country. I would like to add that, aside from the vast creative potential, I see in this architecture, above all, the way to arrive at a final synthesis in our country of the two great spiritual components of the Gothic and the Classic, a synthesis for which Schinkel worked without success. Shall our country let this great opportunity go by?...

It goes thoroughly against my nature, dear Professor Hönig, to have to be negative in what I say, but it is a natural consequence of the fact that my own country forcefully represses the positive in me. You demand the German man. I feel very German — and who can make himself a judge over what is German and what is not — in my ideas and the ideas of my spiritual brothers of German origin. Nobody is in a position to clearly define this term "German." Perhaps you are surprised about what impression your speech has made on me, but since it came from above I feel after having listened to it that I am outlawed in Germany along with all that I have built in my life.[57]

Gropius's ending is unconventional: "I greet you" and "Yours." It avoids both the conventional "Hochachtungsvoll" ("with great respect") and the Nazi ending, "mit deutschem Gruss."

On his return to the United States from his visits to Germany in 1929 and 1933, Robert Davison talked with excitement to all who would listen about a German architect who was doing in Europe what he, Davison, wanted to do in the United States. Among those who took note was A. Lawrence Kocher, editor of the journal *Architectural Record*. On March 12, 1934, Kocher wrote to Gropius

suggesting that he come to the United States. Gropius replied immediately:

> The circumstances for new architecture here are really not very advantageous, and knowing all about the new building movement for more than twenty years I would be inclined to come, trying to start my own atelier; but from the economic point of view I could do that only after having found a teaching [position], because I believe that one needs at least one year to get acquainted with the different professional conditions of the U.S.A. before starting a building job in a responsible manner.
>
> Nevertheless I will think about that very attractive idea of yours.[58]

Kocher was persistent and wrote again, suggesting that Gropius and Antonin Raymond (an influential architect who had assisted Frank Lloyd Wright on the Imperial Hotel in Tokyo and introduced the International Style in Japan) form a new school.[59] Gropius did not close the door.

During the weeks of correspondence with Kocher, Gropius was preparing an exhibition and lectures for the Royal Institute of British Architects and the Design and Industries Association, respectively. On the day before his departure, Gropius informed Kocher about his intended trip: "My English friends assure me that the mere fact of an exhibition of my work in the R.I.B.A. means a kind of revolution for the architecture in England. Do you think there would be a possibility to show this exhibition also in the U.S.A.?"[60] Kocher's reply went far beyond Gropius's query and was explicit. He proposed the formation of a small group of outstanding persons who, while pursuing individual architectural and design practices, would work in close collaboration with industry. Kocher had already secured acreage near New York on which to build offices, workshops, and the school. The school curriculum would be similar to that of the Bauhaus and would also be related to industry. He also had discussed the possibility of a position for Gropius at Columbia University with Dean Hudnut of the School of Architecture, an effort that had far-reaching implications.[61]

In reply, Gropius explained his philosophy of education and industrialized housing. He expressed the hope that the means could be found to bring him as well as the exhibit to the United States, perhaps with the assistance of Columbia University:

> Running the Bauhaus taught me that it would be best to try to start workshops as laboratories which would be paid directly by industry, filled with the best skilled workmen, but headed by independent architects gifted both in design and technical skills. So the students of architecture could be taught both in the design offices and in the laboratory workshops of the school, sticking to the practical instead of a platonic curriculum. Thus the task of the institute ought to be twofold: to serve as a practical laboratory for industry and to teach modern architecture to the rising generation, one supporting the other.
>
> It could then be possible for the leaders to work successfully toward machine-made houses, in which you are interested, as I am. . . . I think the only country to accomplish that immense task, to erect machine-made dwellings in substantial fireproof construction — to work out on a large scale the toy building-blocks [den Baukasten] of children — will be America. In no other country do people seem prepared to accept houses from stock, as the long record of Sears Roebuck and Montgomery Ward in selling [prefabricated] wooden country houses would show. I would like very much to work with you and others in your school for the realization of this idea, as well as the other tasks I mentioned.[62]

There was another incentive for Gropius to be interested in Kocher's proposal. Now definitely out of favor with the officials of the Third Reich, he could receive no commissions for government

contracts, and there was little other work. As Gropius later described the situation: "The Nazi government of Hitler was one of half-educated men. They brought great confusion in all the problems of art which they did not understand. . . . There you have in nucleo the whole mix-up. So Hitler persecuted all art — which he did not understand, having a muddled notion about a Germanic spirit coming from 'blood and soil.'"[63]

This was also a desperate time for Gropius in his personal life. In the foreground of his concerns was the well-being of his daughter, Manon. In mid-June 1933 Gropius had visited her in Vienna. It was, as usual, a hurried trip but long enough to sustain the bond of affection between father and daughter. Now, in spring 1934, he was concerned for her health. Manon had contracted polio in April and was dangerously ill in Vienna. Gropius hesitated to leave Germany but finally went to England for his exhibition and lecture to the RIBA, assured of daily communication via Ise in Berlin. Every letter from her referred to Manon's condition. She found out from the police what would have to be done should he have to go to Vienna: he would have to make an application at the Ministry of the Interior, enclosing a letter from Alma describing Manon's condition. Entry permits to foreign countries would be permitted as an exception if 1000 marks were deposited.

Soon after Gropius's return to Berlin, he received news of Manon's worsening condition. Arrangements for visas and travel were hastily completed, and on June 7 he went to Vienna. There he found his daughter suffering from the inroads of the disease but cheerful and optimistic. The doctors assured him that her condition had been stabilized and that she would walk again within a year. He remained in Vienna until June 13 and left still gravely concerned. He would not see his daughter again.

Retreat from Berlin: Returning to Berlin on June 18, Gropius found that the activities of the Nazis had intensified and that they were now seeking retribution against all who did not accept their philosophy. On June 30, 1934, leaders high in the Party, including Roehm, von Schleicher, and Strasser, were assassinated. In July, Engelbert Dollfuss, chancellor of Austria, was murdered by the Austrian Nazis. Now Gropius no longer "thought that conditions might snap back." Despite the financial condition of his architectural office, he continued his research in prestressed concrete and construction materials. He corresponded with Davison from time to time, discussing research and planning a cooperative effort in the production of machine-made housing suitable for Germany, utilizing American industrial experts in connection with the building methods.

By the end of July 1934 there was neither work nor prospect of it in the Gropius office. A secretary and a draftsman were all that remained of the once extensive staff. Gropius and Ise decided to take a respite from the now threatening atmosphere. On July 30 they left Berlin and crossed Italy to Venice, where they sailed on August 1 for Yugoslavia. There they rested, mending their lives, gaining strength — and planning. On August 28 they began their return journey by way of Italy and Switzerland, arriving in Berlin on September 4, their minds fully made up as to their future.

Gropius and Ise had recently accepted an invitation to participate in a Fondaziono Alessandro Volta symposium, an international conference on theater to take place in Rome from October 8 to 14. The invitation had resulted from interest shown in Gropius's work by Dino Alfieri, the Italian minister of cultural affairs and president of the Italian Society of Authors and Editors. Gropius was

asked to discuss theater design for both large and intimate audiences.[64] Most importantly, all of his expenses, and Ise's as well, would be paid.

From Milan, Xanti Schawinsky inquired about Gropius's interest in giving two lectures in that city on his way home from the theater conference in Rome. In his usual irreverent manner, Schawinsky offered a toast: "Now let us belch heartily together to a beautiful future, to our approaching reunion, and to the hope that you will soon be in Milan where we can finally celebrate peacefully with you and Pia [Ise]."[65]

But Gropius had plans other than Milan in mind. On July 4 he had mentioned to Davison an opportunity to go to London to carry out a commission, but there was the delicate problem of obtaining permission to leave Germany. Now, on September 19, he wrote to Davison:

> I am on the point of going over to London for some months…to build a tenement block together with a British colleague. …The English people begin to care for the new development in construction, most interested in the replacing of obsolete town-districts by sound dwellings.

After Rome, he would be in London with Maxwell Fry from October 18 "until further notice." Despite the positive manner in which Gropius noted his schedule, he had not yet received approval of his travel plans.[66]

Mindful of possible reprisals against his and Ise's families and Bauhäuslers and of confiscation of their possessions were he to leave Germany without permission, Gropius wrote on the same day, September 19, to Professor Eugen Hönig requesting authorization to attend the Rome conference on theater design and a permit to work temporarily in England, to execute a small housing contract, since his Berlin practice had fallen off. His earlier involvement with the Total Theater and the resulting prestige supported him in this application for travel outside Germany. He emphasized that this would be a temporary stay, pointing out that he was maintaining his permanent office as well as his apartment in Berlin. (Bauhäusler Wils Ebert would "inherit the office" and take over responsibility for Gropius's projects.)

The respect Gropius evoked in both friends and enemies at that difficult time was extraordinary. Hönig, head of a Nazi-approved organization but a man who respected Gropius, reluctantly granted the request to go to Rome. Since the expenses were to be paid by the Italian government, the Nazis did not object to both Gropius and Ise traveling to Rome, or perhaps they did not believe Gropius to be sufficiently important politically for them to hold Ise.

On October 4 Hönig wrote granting him permission to remain in England until April 30, 1935. He also spoke of his personal belief in Gropius; but because of his own position with the Reichskammer der bildenden Kunst, he could not single out Gropius for preference, adding: "I regard you as a straightforward man with the emotions and reliability of a German, whose artistic efforts cannot be doubted in terms of seriousness of your goals."[67] Hönig noted that he himself was not a member of the Nazi Party nor was there any relationship between his office as president of the Reichskammer and the Party. He pleaded with Gropius to defend himself from his many detractors; after all, he wrote, was not Gropius also a member of the Reichskammer? That alone should constitute a sufficient reply to those critics of his loyalty to Germany and the profession. Within two months, Gropius would give a more forceful reply.

On October 3 Ise and Walter departed Berlin for Rome; they went together, knowing full well

that it was the first leg of a journey away from a now inhospitable Germany. Funds were provided by the Italian sponsors for travel, incidental expenses, and their hotel. Alfieri courteously provided a car. The twenty marks that the new law permitted them to carry out of Germany and the lire they sent in advance disappeared quickly, and they impatiently awaited the arrival of aid from a Dutch sponsor, forty-seven pounds, requested earlier by Gropius.

The Rome theater conference was outstanding, despite the language problems. In attendance were the heads of the state theaters of some twenty countries, writers, composers, critics, stage designers, and architects. Among these were Maurice Maeterlinck, William Butler Yeats, Filippo Tommaso Marinetti, H. Th. Wijdeveld, Luigi Pirandello, Denys Amiel, and Ashley Dukes. Franz Werfel had been invited, but he could not leave Alma and the ailing Manon.

The meetings took place in luxurious settings, lighted at night and filled with music, almost as if the event was a last grand gesture by Italy. The delegates were welcomed at the Campidoglio on October 8. Addresses by officials were responded to by Maeterlinck on behalf of the participants from other countries. In the evening, a reception at the Royal Academy of Italy in the Farnese Palace was followed by a formal dinner. The delegates were led into dinner by Ise Gropius on the arm of the Fascist Party secretary, Achille Starace, who was attracted not only by the political opportunity of her being the only German woman present, but also by her Nordic beauty. The pair made a handsome symbol of Italian-German unity, sealed by Hitler and Mussolini in mid-June of that year.

On October 10 Gropius, the only German in attendance, was the third of the three principal speakers. He described the stage play as "a collective undertaking, a spatial experience arising from metaphysical longing and concretizing transcendental ideas." He called for outstanding directors, universal men whose talents would encompass all artistic areas. The theater would be their instrument. He discussed the history of the theater's development and its decline in the face of the cinema. He then demanded the reform not only of the design of theaters, but of their objectives, and called for initiative on the part of governments to support experimental theater.[68]

Unfortunately, there were few present who understood German, and though the lecture was well illustrated, its content was little understood by the writers, critics, and drama directors present, who were not at all interested in the architecture of the theater. The lecture was hardly finished when architect Edward Gordon Craig was on his feet to contest it and Wijdeveld attacked the sightlines and practical operation of the "Total Theater" Gropius had proposed. Disregarding the history of change in theater architecture presented by Gropius, the writers and dramatists challenged the importance of new forms for the physical theater itself and instead called on the world to create new great plays. The Total Theater concept presented by Gropius was derided as a piece of machinery that would denigrate the actor, the art, and the drama itself.

Through a procedural misunderstanding, Gropius did not respond at once, but his intended reply was later inserted in the conference proceedings:

> I believe I can dispel easily the apprehensions Mr. Gordon Craig has expressed. The very idea of the plan for this theater is increased adaptation to very different scenic concepts. It opposes the rigid establishment of space used up to now in the theater and makes available a variety of space for different producers. …It is exactly the opposite of Mr. Gordon Craig's fear: No one is forced to do as the others do, everyone has much greater freedom in creating space possibilities than on the much too rigid stage of today's ordinary theater.[69]

The next morning, Gropius was permitted his rebuttal. Wisely choosing not to confuse the audience with technical aspects, he rebuked the playwrights and theater producers in no uncertain terms:

> Why this hysterical fear of the machine? This is only a question of secondary importance. The machine does *not* create the New Theater; it only gives new ways of expression, provided that *subject matter* is there!...
>
> Now, the main point of my message, the real problem lies not in the mechanical area, but in a vision of space which will give a more lively relationship between the actor and the audience. . . . If you wish to take away all the complicated mechanical means, you will still have the opportunity to test the diversified new possibilities of the stage, something I consider very important. This can only be achieved by actual trying![70]

Gropius's remarks would not be the most controversial of the conference. Marinetti's address, a tirade, rang out with Fascist concepts extolling the splendor and aesthetics of war and the heroism of the individual soldier as the quintessence of patriotism. It repelled Gropius and the other foreigners; the French were up-in-arms over his remarks.[71] Though Marinetti had hoped for support, if not acclamation, it was not forthcoming, and only Italian confreres encouraged him in his bravado. Alfieri, who represented the government, spoke with restraint and diplomacy in a great effort to ameliorate the tension; others rose to speak, but the spirit of the meeting was lost.

The farewell for the delegates at the Farnese Palace was quiet and pensive. The conference would prove to be the last great European meeting of intellectuals before World War II.

Following the conference, Gropius, with some trepidation, asked the board of the Theater Congress in Rome to exchange his and Ise's return tickets to Berlin for tickets to London via Zurich, where he had been invited to lecture.[72] To their joy and relief, there was ready assent, and they departed Rome on October 15. After the Zurich lecture, they quit the Continent for London. With little money, the heavy shadow of Manon's serious illness, some understandable regrets, and only Ise able to speak English, they began a new phase of their lives.

THE TRANSITION 1934–1937

The journey from Italy via Switzerland to England was uneventful. Though Gropius and Ise had considered all the unhappy consequences of their move, they had a growing sense of excitement as each kilometer fell behind them. On October 18, 1934, they were met at Victoria Station in London by Jack Pritchard, an early champion of modernism in England, and Maxwell Fry, soon to be Gropius's partner. The two did not know Gropius well, but had been encouraged by Morton Shand, who was conscious of the growing dangers in Germany, to make arrangements to bring him to England.

Gropius in London, 1935

Introduction to England: Jack Pritchard was able to offer Gropius and Ise a small apartment in his Lawn Road Flats in the Hampstead section of London, completed only a few months earlier. It was to be their home for the two and a half years they remained in England. The Lawn Road Flats building, the forward-looking work of Wells Coates, became a haven during the prewar period not only for Gropius and his colleagues László Moholy-Nagy,[1] Marcel Breuer, and architect Arthur Korn, but also for refugees from the Spanish Civil War. Agatha Christie, the architect John Gloag, and Jacquetta Hawkes were among its famous tenants.

The Flats were centrally located in Hampstead among the "colony" of contemporary artists, sculptors, and writers who constituted England's avant-garde. At the the end of World War I, art in England was introspective, nostalgic, and conservative. By the early thirties, in the face of depression and unsettled international conditions, a small waiting public welcomed the appearance of a number of new and promising artists and architects. By coincidence, many of them settled in Hampstead, which became an oasis for artists, musicians, writers, philosophers, and scientists. Among the Hampstead residents already recognized of rising importance in fields outside the visual arts were Stephen Spender, George Orwell, Louis Macneice, Julian Huxley, and Sigmund and Anna Freud.[2] The British artists living there included Ben Nicholson and his wife, Barbara Hepworth, and Henry Moore; among the foreigners were John Heartfield, Naum Gabo, Oskar Kokoschka, and Piet Mondrian.

Initially, the public was ill-prepared for the work of progressive artists such as these, and only a small number of patrons appreciated the abstract and surrealist painters and sculptors. The

encouragement of well-known architects like Erich Mendelsohn, Berthold Lubetkin, Breuer, and Gropius, the perceptive pen of Herbert Read, and the financial support of patrons like Mr. and Mrs. Leonard Elmhirst sustained the Hampstead colony in the difficult thirties.

In architecture England was almost the last European country to be affected by the modern movement. For example, the contributions of the Scotsman Charles Rennie Mackintosh to the Vienna Secession had been acclaimed early in the century on the Continent, but they were not then or later recognized in his own country. The completion of his School of Art in Glasgow in 1909 had made a great impression on the Continent and upon the young Gropius. Sixty years later he wrote of the school, "I liked it very much in my youth. It was the beginning of a breakthrough."[3]

At that time, advancing machine technology was eliminating the artisans and handcrafters of England, resulting in a loss not only in employment but also in artistry and quality. In 1915, inspired by the example of the Deutscher Werkbund, the Design and Industries Association was founded in England, with similar aims. The DIA also encouraged the belief that machine production could improve quality and need not debase it. Later, there were even efforts by Pritchard (who had visited Dessau just before the Bauhaus closed), Hepworth, Nicholson, and Moholy-Nagy to start a Bauhaus in London.

British architecture, heavy-handed and mired in the traditional classic styles during the nineteenth century, entered a neo-Georgian period at the beginning of the twentieth. By the end of the twenties, it had become frankly derivative of contemporary Scandinavian, Dutch, or German work. By the mid-thirties, the established firms were cautiously moving into competition with the new immigrant architects, such as Mendelsohn and Lubetkin; with the younger progressive Englishmen like Maxwell Fry, George Checkly, and Wells Coates; and with the avant-garde firms like the Tecton group and the influential Modern Architectural Research (MARS) Group, led by Serge Chermayeff.

Many architects nostalgically clung to the rationale that the new socially conscious design was basically classic without extravagant ornament. And while some resisted architecture's expansion into planning, others recognized the need for planning but saw it only as an extension of the profession. A few hoped that the new direction was only a transitional stage, like that which existed between Roman and medieval, or between Gothic and the Renaissance.

The England that received Gropius in 1934 was the sum of its cultural attainment and social change, of the vicissitudes of its long economic and political history, affected by its physical separation from the Continent as well as its world-circling ties. When the general conditions of this new environment were explained to him in German, Gropius could quickly synthesize and understand the conditions of the country and make the necessary accommodation to live and work within them. More difficult were the language, the regulations, measurements, customs, and myriad day-to-day exigencies. It was many months before he trusted himself to drive on English streets.

Pritchard later described Gropius during the time he was in England as a quiet, patriotic German, saddened by affairs in his homeland. Still, his plethora of personal, professional, and civic interests and activities continued unabated. Invitations to participate in British international and profes-

Jack Pritchard,
lithograph by E. X.
Kapp, 1942

sional societies and in academic work became more numerous than he could accept. Instead, he would often escape into the comfort of the London "melting pot" composed of the former masters, students, and friends of the Bauhaus, as well as of other refugee artists, scientists, and academicians. Through these intellectuals, and his own reputation, Gropius attained a wide circle of friends.

All in all, Gropius considered himself to be in a sympathetic milieu. Though he felt that younger people in England lacked exposure to innovative thinking, he found them open-minded and did not have to struggle to make his ideas understood. He appreciated British society, and its tolerance and understanding, even though he believed that some aspects of the arts might be beyond its ken.

During their first weekend in England, Gropius and Ise, accompanied by Jack Pritchard, went to Stonehenge. The megaliths astounded Gropius. Thirty years later, he still conjectured as to how the lintels could have been placed, given the limited means of the Bronze Age. Astonished as he was by the structures, he was even more impressed by the simplicity with which the English recognized the importance of such a historical treasure. On Salisbury Plain, unrelieved by heavy tree growth, the great stones are stark against the horizon, barely set apart from the pasturage and tilled fields. It seemed to Gropius throughout his stay in England that this remarkable quality of understatement applied to design, to intellectual activity, and to all other aspects of life.[4]

The two men who had met Gropius on his arrival in England continued to play major roles in his life throughout his stay. Pritchard was constantly helpful, and in a position to be so. He had established Isokon,[5] a company through which he developed properties, and then, through a subsidiary, Isokon Furniture, he sponsored progressive design. (The plywood Isokon Long Chair became a modern classic. It was designed by Marcel Breuer at Gropius's suggestion to Pritchard, to take advantage of the latter's connection with Venesta, the plywood company. — Ed.) Isokon's first project, Isokon No. 1, was the Lawn Road Flats.

Pritchard also sponsored the partnership of Gropius with Maxwell Fry, who was already a

Birthday tea, May
18, 1935: Gropius
chats with Molly
Pritchard, Ise with
Jack Pritchard

member of the firm of Adams, Thompson and Fry, and was himself a leading exponent of modern architecture in England. During the first months in England, Gropius confined his efforts almost entirely to the practice of architecture, and the partnership with Fry was to prove a mutually rewarding one.

On his brief trip to England the previous spring, Gropius had been the houseguest of Fry, and despite the handicap of language and Fry's tendency to speak softly, they managed to communicate well enough, but now the need was more pressing. Gropius immediately began English lessons with a tutor from the Anglo-German Academy and enrolled as well in its "English Language Course for German Students."

> As I stumbled along, murmuring a language meant to be English, and facing amongst other difficulties a terrific army of quite unfamiliar definitions for measuring and counting, I was enormously encouraged by the patient and appreciative attitude towards shy and awkward people which has been specially developed by the English and which has turned this country into a place where one needn't shout to be heard.[6]

As Gropius's vocabulary increased, his confidence grew and working with Fry became easier. He was impressed by Fry's work and its serious approach. In retrospect, Pritchard found Fry enigmatic but believed that he, more than anyone else, understood both Gropius and the English well enough to interpret them to each other.

Among Pritchard's contacts and a Gropius admirer was A. P. Simon, chairman of the Manchester branch of the Design and Industries Association. Pritchard persuaded him to construct an apartment building on the riverfront property Simon owned in Manchester and to bring Gropius up to design it with Fry. Pritchard had to wait for at least 80 percent of the flats on Lawn Road to be rented and for some 10,000 pounds to be raised before the new project, known as Isokon No. 2, could begin. The architectural fees would be modest, about 6 percent — some 225 to 250 pounds for each partner after office expenses.[7] The commission was the first for the new partnership, although Fry and Pritchard already had leads on others.

Adapting to England: In some respects, the routine of Gropius's life in England went on as it had in Germany. He maintained his extensive and varied correspondence; there were details to attend to such as the duplication of his collection of slides for the Victoria and Albert Museum and following up Herbert Read's suggestion of an American publisher for his works. Much more of Gropius's correspondence continued to be directed to him through his Berlin office. Though his communication was constant with Hedy Schiefer, his secretary there, she wrote to him asking whether in view of the reduced amount of work, she could also work for Neufert.

That first year Gropius's spirits appeared to fluctuate as frequently as London's weather. At the beginning of their stay, Gropius was uncertain as to whether he and Ise would remain more than six months. Exercising caution, he wrote to his brother-in-law, Max Burchard, instructing him to try to sell either Timmendorf, formerly his parents' summer home on the Baltic, or Hohenschön-hausen, a ten-acre housing property near Niederbarnim, in order to finance his return to Germany. But then a fortnight following his less-than-optimistic letter to Max Burchard, he wrote more hopefully to his sister, Manon:

> I [have] found this visit [to Cambridge] really interesting; there is no doubt that this is a center of culture with very old humus which could not easily be replaced. Now I understand the conservative attitude of the Englishman, which makes it difficult for him to recognize anything new.[8]

Even small setbacks or successes would discourage or encourage him. On November 23, in a letter to Martin Wagner, he wrote that English should be the world language and recalled his experience with the sad confusion of tongues at the Rome Theater Congress. "How many misunderstandings could be avoided if the schools of all countries could teach such a language."[9] The next day, in an amusing letter to Wagner, he wrote that despite his 850 "Basic English" words he was still having trouble converting meters and kilograms into feet and pounds.

He wrote about the biting cold and damp drafts, which, according to English theory, should drive out bacteria, and decried the British heating method, which roasted the side turned to the fireplace while chilling the other. London's antique chimneys added gases and unburned particles to the fog, so that "one literally gets to eat them."

> Why are the English not doing anything against this continuing misery? I think the reason is puritan self-punishment. By the way, it is similar with the food...which is prepared in such a way one never gets pleasure out of it.
>
> Puritan education has indeed formed the disciplined and serious European...[but] creates reserve in the individual and in this neutralized air, all spirit and imagination die.
>
> Nevertheless, I like it here in this sentimental but anti-Muse world, for the people are so attractive.[10]

Despite language difficulties, Gropius's reputation made him sought after as a lecturer. Early in December 1934 he discussed the growth of the modern architectural movement at the Edinburgh College of Art.[11] A few days later he was a guest of honor at a Design and Industries Association dinner.

In coming to England, Gropius had no intention of returning to teaching or of creating a new school. Nevertheless, he was invited immediately by English educational authorities to participate in discussions of policy and program. One such invitation was from the Council for Art and Industry to discuss shortcomings in art education in primary and secondary schools.[12] Gropius accepted with some hesitation because of his English, and asked that the questions be submitted in advance and in writing.

In December, Gropius and Ise visited Leonard and Dorothy Elmhirst at the ancient manor of Dartington Hall, at Totnes, Devonshire. Mrs. Elmhirst was an American, a member of the Whitney family, and a director of Dartington Hall, Ltd, whose multitude of social, scientific, literary, art, and other educational and cultural activities were supported by the Whitney family, which had some 620,000 pounds at its disposal each year. The institution was formed to find the means to halt the decay of English rural areas and traditions:

> They [the founders] recognized that the possibility of earning a decent living in the country does not necessarily imply a high or qualitative standard of life...nor any satisfactory fulfillment of social and individual needs. ...They proposed to develop the countryside on sound business lines using the latest results of scientific research in agriculture, horticulture and forestry, and to establish rural industries suitable to the district.[13]

Beginning with the Dartington estate in 1925, the school acquired facilities that included the

Barton and Old Parsonage farms, gardens, orchards, and a cider house. The activities were then expanded to include the ancient Devon industries of cider making and textile weaving, forestry, and saw milling, agriculture, poultry, horticulture, and home economics, to which were added a laboratory and a drafting studio. There were coeducational and progressive elementary and secondary schools and educational programs for adults. A department of arts included an art studio, a music section, a school of dance, the Jooss Ballet, and a drama theater. A London office and showrooms for the school's products were located on Regent Street.

Mrs. Elmhirst, whose support of *The New Republic* was well known, gave aid to refugee intellectuals, assisting them in reestablishing themselves in England and the United States. Introduced to Gropius upon his arrival in England, the Elmhirsts later spoke of their "concern to find him work and to get him established at a very difficult time in the depression years of the early thirties. …Those were very difficult years in Britain with heavy unemployment and very little work for architects."[14]

It was obvious to the Elmhirsts that their guests were in difficult financial straits, and a week after the visit they sent financial assistance in the guise of a Christmas gift "to [make you] feel that you are warmly welcomed to this country." Gropius replied on Christmas Day:

Your Christmas letter was like a fairy tale and gave us great surprise and delight. I wish I could find the right words in English. …

But apart from the material point of view it means so much to me to find in this country people who are really interested in the work I am doing.[15]

Although the hospitable Elmhirsts had offered him a responsible and "leading position" with Dartington Hall, Gropius "wanted a looser connection" with what he described to Wagner as "a kind of an English Bauhaus that is going up there." The Elmhirsts did, however, obviously contribute to his judgment of the English. Gropius confided in Wagner:

Nobody in Germany has a notion

— how rich this place is

— how good, willing people are

— how incapable in terms of art the average man is

— how little people know about the arts.[16]

To the Dartington trustees Gropius proposed a year's trial collaboration on furniture design with the purpose of obtaining "a unified character for the Dartington products and as a final result influence to some extent the English market." He outlined an approach to the experiment:

Study the English market and English taste.

Prepare a scheme for trends and price levels.

Choose a suitable group (5-6) of young architects to design all the fittings for an exhibition room, textiles, light fixtures, furniture, etc., for which they would receive fees and royalties.

Organize periodic discussions, criticize each piece, gradually improving them, but carefully preserving individual note of each designer.

Draw into the activity other related industries.[17]

Early in February, the trustees agreed that the idea was indeed worth pursuing and offered Gropius

an annual fee of a hundred guineas to direct the effort. Explaining that much time and effort were required to establish the collaboration of a group of designers "to produce the unified atmosphere favorable to the creation of products of a unified character," he replied that it would probably be impossible to attain the desired results with such an annual fee. His counteroffer was to help select the architects and to review their plans — but not accept any fees, "being so much obliged to Dartington Hall."[18] However, the Elmhirsts, realizing the slowness of Gropius's practice, sent another unsolicited check in March.

During the winter of 1934-35 Gropius advised on the construction of two cottages for the estate manager and farm workers of Dartington Hall. The remodeling of a large barn into a two-hundred-seat theater presented a greater challenge; fortunately for Gropius, the contractor was a German and communication was easy. In mid-1935 the actor-director Michael Chekhov was invited to present the opening play in the theater. He was concerned about the unfinished state of the theater, but in November he wrote that "the show must go on" and that he would perform under any conditions provided the boxes, curtains, and lights were installed. The performance was evidently successful, for this nephew of playwright Anton Chekhov remained to found the Theater-Studio.

Hardly established in London himself, Gropius sought new opportunities for his old Bauhaus colleagues, Breuer and Moholy-Nagy. Breuer wrote that he did not want to leave Budapest unless there was something concrete waiting for him, and conditions were such that he could produce a decent and unpetty piece of work; he did not want to have to return to Hungary repentant.[19] Gropius persisted and in March 1935 was able to offer Breuer the possibility of work with Isokon on the design of aluminum objects.[20]

Over the winter of 1935 he wrote to Moholy-Nagy, still in Germany, urging him to expedite his application for a permit to leave Germany and enter England.[21] Gropius offered to introduce him to the Elmhirsts so that he might demonstrate his theater design, or to present it to them himself on Moholy's behalf; he also hoped that commissions would become available through Hobson, head of a large advertising house. Finally, Moholy reported that his permit had been approved for mid-May, when he would be the guest of Jack Pritchard at Number 16 in the Lawn Road Flats.[22]

Gropius continued in his efforts to establish himself as part of the English milieu, offering friendship as well as his professional skills. To housing advocate Elizabeth Denby he sent *The American Housing Book* by Catherine K. Bauer, *America Can't Have Housing* by Aronovici, and a subscription to the *Deutsche Bauzeitung*.[23] He asked Munich publisher Albert Langen to send a Bauhaus Book Number 4 to Ashley Dukes, director of the Mercury Theatre, who replied, "I shall be very proud of it — and also of being one of the first of your many friends in England."[24]

From early spring 1935 on, Gropius was in constant communication with Faber and Faber regarding the publication of his *New Architecture and the Bauhaus.* He concerned himself with every aspect: Morton Shand's complaint about the translation from the German; the layout, typeface, illustrations, and size of the book; the quality of paper; and the jacket design by Moholy-Nagy. He even suggested some changes in Frank Pick's draft of an introduction to the book: "There might arise an impression that the value of the modern architectonic movement lies more in the negative work of removing antiquated forms than in an original new creation. The reader might thereby lose

confidence in the creative power of the new architect... ." He was also concerned that Pick's reference to his staying longer in England would bring retribution by the Nazi government, and requested changes in the wording:

> The conditions in Germany are very strained and complicated just now, and a reference to my remaining in England during a "period of crisis" might entail some very unpleasant results for me, such as the stopping of my bank account in Germany and the withdrawal of my permission to work there at all. So I am still forced to describe my stay in this country as a "visit" so as not to get into difficulties with the German authorities. I should be grateful therefore if you could replace the word "crisis" by the word "transition."[25]

Pick readily assented to the suggested changes and the book was published in mid-June.

Although Gropius had not been permitted to bring money out of Germany, he was too proud to ask for an advance on his writing and other work. Somehow, the Gropiuses managed, eschewing all luxuries, even walking to and from glamorous dinners and receptions to save the taxi fare, and facing up to country-house weekends with their austere wardrobes. The greatest change that took place in leaving Germany for England was not in the kinds of friends he and Ise had, but in their style of living. They moved from a very large apartment in Berlin with servants to an efficiency apartment with shared and limited household assistance at the Lawn Road Flats. The Flats were innovative socially as well as architecturally. Their code, largely the work of Molly Pritchard, mandated not only the furnishings and equipment in the individual flats, but also the communal services of housekeeping. The building was one of very few places in London with central heating. Its tenants were bound by rules regarding the use and care of the flats and the common spaces, all established in the interest of quiet, privacy, safety, cleanliness, and other amenities.

In the voluminous Gropius archives is warm and revealing correspondence about his daily life. An example is his exchange with Pritchard in April regarding the Gropiuses' use of Flat 15 at Lawn Road at a time of utmost financial stringency:

> We are both very thankful not only for having been so very well lodged and boarded but particularly for the extreme warmheartedness and friendship you and your wife have extended to us all the time since we have come to this country. ...
>
> All the more I am ashamed not to be on my own legs yet after six months' work, but since Manchester had to be canceled, my budget collapsed and new jobs had to be looked for. In two or three weeks, however, say from the first of May, I shall be able to pay at least our board.[26]

Gropius offered to pay in German marks if another of Pritchard's companies, the Venesta plywood firm, had negotiations in Germany. Otherwise, a delay in rental payments was requested until Isokon No. 3 (in Windsor) or some other work got started. Pritchard agreed and redoubled his efforts to make the Gropiuses feel at home. Solicitous as ever, he inquired about Gropius's preferences in liquor to be stocked in the commissary at Lawn Road. In the same manner, Pritchard took responsibility for Gropius's failure to register as an alien with the police, saw to the repair of Ise's typewriter, found work for Breuer, and thanked a donor for an electric heater given to Gropius.

In April 1935 Gropius's daughter, Mutzi, died. She had been ill for some time, but on Good Friday, April 19, and on Saturday she appeared to be getting better. The diagnosis was bowel and

stomach paralysis. Although the paralytic symptoms of poliomyelitis had been disappearing slowly, there had been a new attack.

At 1:30 p.m. on Saturday, Mutzi's condition was considered serious but not hopeless. However, the X-ray treatment ordered seemed to result in higher temperatures, headaches, and nausea. At 10:00 p.m. the doctors departed, still hopeful, leaving one of their number and two nurses on an all-night vigil. That night her condition was not good, and on the morning of Easter Sunday Mutzi asked for the priest. By 7:00 a.m., when the situation seemed to be deteriorating, the doctors met again for consultation. Alma then belatedly cabled Gropius to take the first plane available to Vienna. She naively believed that on Easter Sunday morning he could cut through the bureaucratic red tape of two governments to obtain permission to leave one country and enter the other. She later wrote, "With our notice to you of the serious illness of your child, no government would refuse you!" Hardly four hours after the cable had been sent, at 11:00 a.m., Mutzi was given last rites, and at 3:40 p.m. on April 21 she died. Unaware of her death, Gropius and the faithful Pritchard continued their efforts to obtain the papers, succeeding only by evening, at the same time they received the news that their hard-won success had come too late.

Alma cabled that municipal and medical regulations demanded immediate interment and Gropius's wish for a delay "was considered but could not be fulfilled — the dispositions were already announced in the press." Indeed, Mutzi's protracted illness and her mother's solicitous attention had provided a steady source of copy for the newspapers during the preceding months. A few hours before Mutzi's death, the Austrian chancellor had personally called at their home to inquire as to her health.

Gropius had visited his daughter the previous June, shortly after she had first become ill. Now Alma reproached him for not visiting in Mutzi's last days: "For a year, I have sent cables and letters and you would not come. You cannot make me responsible for rules and laws of interment that have to be followed." She did, in a moment of grace, thank Gropius for his "part in bringing Mutzi into this world even though her road was short. There was incredible inner growth in the last six months of her life."[27]

Though grief shaded his eyes and his manner, there was little outward mourning on Gropius's part. Self-disciplined and beset by concern for his friends, family, and homeland and, more often, by self-doubts, he attempted to assuage his grief by immersing himself in work. He and Ise did go to Germany on April 23, spending April 25 and 26 with his sister, Manon, in Hannover and one week in Berlin moving their furnishings from their large Potsdamer Privatstrasse apartment to a much smaller one on Clausewitzstrasse and arranging for the storage of the contents of his office. Gropius requested permission to go to Vienna to visit Mutzi's grave but this was denied, and he and Ise returned directly to London on May 7, 1935.

Private Practice and Activities: A project begun earlier brought together Gropius and Professor Philip Sargent Florence. An internationally famous English economist, Florence had been in Germany in 1913-14 to study in his field and had been impressed by the progressive architecture of the pre-World War I period. He visited Margaretteville near Essen and the Werkbund exhibition in

Manon Gropius

Cologne, among other unique projects. Though he saw Gropius's buildings, he did not meet him at that time. Returning to England, Florence continued his academic career; among his first students was Jack Pritchard.

Established in Birmingham, Florence purchased a handsome house surrounded by several acres of landscaped grounds in Selly Park on Kensington Road, and for many years the family enjoyed the secluded parklike setting. In 1934 Florence decided he wanted to develop a portion of the land without sacrificing its essential aesthetic qualities and its integrity. He proposed to his former student, Pritchard, that Isokon purchase and develop the property. Pritchard assented, much taken with the possibilities of the beautiful rolling site and the likelihood that its charm and the amenity of the neighborhood could be preserved.

Since the project in Manchester was then under study, Gropius and Fry combined inspection and conference trips to both cities in March 1935. With some reticence because of his poor command of the English language, Gropius addressed Birmingham's Design and Industries Association. With Florence, he made a side trip to Stratford and Chipping Camden. Florence remembers that Gropius appreciated the design and structural qualities of the towns' early architecture and compared German and English domestic architecture, recalling Muthesius's early efforts to make the English house known in Germany.

Although Gropius and Fry's schemes for development of the property preserved the beauty and open areas, they did not meet the quarter-acre single-lot requirements of the prevailing covenants. Florence's personal appeals to the Birmingham town council were not accepted. The councilmen, as well as Florence's neighbors, had little in their backgrounds that would enable them to understand that the development as designed would preserve the amenity of the area far more than would the quarter-acre lots permitted under the covenant.

All through the period of the Birmingham project the pressures and exigencies of daily life and work in England had mounted. There were few commissions in 1935 but many invitations to lecture or participate in discussions. Among them was the invitation from the London Central School of Arts and Crafts to deliver six lectures for a fee of five guineas each during the autumn term. Gropius regretted his inability to accept, for, under the direction of the architect William Richard Lethaby, it was this school that contributed to the philosophy of art and design education upon which the Weimar Bauhaus was fashioned. Established in 1894 on the principles of William Morris, it was the first school anywhere to include teaching workshops for crafts.

Perhaps the most sophisticated housing proposal ever made by the team of Gropius and Fry was for St. Leonard's Hill, an estate in Windsor, once the property of William Henry, Duke of Gloucester and brother of George III. Following the destruction of an Elizabethan manor, itself a successor to a structure of an earlier period, the present mansion was built between 1761 and 1772 for Lady Waldegrave, mistress and later wife of the duke. The site overlooks Windsor Castle and Forest to the northeast and the Royal Park to the south and southeast, as well as Eton College.

The opportunity came about through the death of the owner, Walter Thornton Smith, as one of the heirs wanted to sell the land quickly for profit. Morton Shand brought the executor together with Jack Pritchard. On inspecting the property, Pritchard saw its possibilities and purchased a six-month option for Isokon, having Fry and Gropius in mind for its development.

St. Leonard's Hill housing development, Windsor, 1935, with Maxwell Fry

The architects sought a scheme that would preserve the amenity of the site through proper development of a historic estate park and yet provide a reasonable opportunity for investment in terms of the numbers of upper-middle-income families accommodated. The king's permission to build was necessary, since the project would look down upon Windsor Castle, some two and a quarter miles away. The Crown gave its approval, but specified the maintenance of open space in the vicinity. Gropius reported optimistically to Wils Ebert: "It looks as if the big Windsor project will soon become reality,"[28] and the next day inquired if Ebert would be interested in coming to England to work it.

Unfortunately, the Windsor scheme, unlike the Manchester and Birmingham projects, depended upon raising money in the market, since it involved a far greater investment. Psychosomatically ill during most of the period of the option, Pritchard was unable to win full financing. The project fell through, a bitter disappointment to the three principals. Pritchard expressed his dejection: "You will think me a broken reed. First No. 2 goes phut — then No. 3…and you will think that we asked you to London for nothing."[29] Although the Gropius-Fry landmark proposal for Windsor was not realized, its attendant publication and exhibition won it immediate admiration within the profession and emulation.

With his characteristic optimism, Pritchard was already launching Isokon No. 1 ½ — the extension of Lawn Road Flats to the north by the addition of two studios, an office, and a restaurant — with the intention of having Gropius design it. Furthermore, he was still certain that he could proceed with the Birmingham project, Isokon No. 4. He also announced that he was leaving for Berlin, Riga, Tallin, Lohja, and Stockholm on the affairs of an Isokon subsidiary, Venesta.

By October, Gropius's financial affairs had not improved. He wrote to Pritchard, noting that a year had passed since their arrival in England and thanking him and his wife for their hospitality. He expressed his regret over the failure of the Windsor project and his own inability to have aided more, but indicated some hope for a better future:

Gropius is a bad job for Isokon and you may believe I did not feel very well in my job situation. You and I, we both have risked and I hope to be as good a loser as you are, making a new start. I have made up my mind to provide for a little money by a friend of mine to be secured for the next month at least.[30]

He asked for permission to continue at Lawn Road Flats, but without the catering service in order to reduce his expenses, in the expectation that Ise, who was recovering from a serious illness, would be well enough by November to undertake their own cooking.

Pritchard immediately reassured Gropius, and asked him to stay on at Lawn Road Flats and to continue to use the catering service until Ise was entirely well, since for Gropius even the making of coffee and toast was a great culinary feat.

You must not worry about the risk I took and lost. The risks you have to take are so much bigger than mine, which are in the ordinary way of business.

You have been a tremendous help to us already and I hope that in the near future we can begin to put it on a profitable basis. So please don't decide to start paying for the flat just yet.

It is grand having you in any case and I feel very hopeful that things will begin becoming well again soon.[31]

At the end of October, Pritchard invited Gropius to serve as design consultant to a furniture company he was organizing, the London Aluminium Company, Ltd. Gropius was asked to design as well as to assist in selecting a staff designer, and Pritchard suggested that "the fee should be somewhat the equivalent of the rent of your flat."[32] The invitation lifted a great worry, and within days Gropius requested that improvements be made in the flat, its furniture and decoration, and specified a beige and white color scheme. The work was to be done while Ise was convalescing at Dartington Hall under the watchful eyes of the Elmhirsts.

Gropius had written for funds to his friend C. H. van der Leeuw, with whom he had worked out a method of utilizing his own frozen bank accounts in Berlin. Within a few days he received 300 pounds through van der Leeuw's London bankers.[33] He now thanked van der Leeuw for his check and "other signs of friendship," reporting:

In the last days I have been occupied with the town planning book by Adams, which they were friendly enough to send me from America some time ago. On the occasion of a dinner in honor of the American architect, Corbett, I sat next to Thomas Adams and had laughingly to make the discovery that he — as first partner of the firm Adams, Thompson and Fry with which I am working — at the same time, has written this book whose author I presumed to be an unknown American. The book is very good in detail, but as often the general idea which he had in mind is rather old-fashioned despite modern details.

On this evening, I also made the acquaintance of H. G. Wells, who much to my astonishment made a thoughtful and withdrawn impression, much to the contrary of what I knew of him and how my ideas about him were. For the time being, unfortunately, I have to depend on my eyes and feeling in such cases since, with my three words of English, I dare not yet have interesting conversations with such fastidious personalities.[34]

There was a constant stream of letters from Germany, and Gropius felt compelled to reply to each. His ties were strong. He wished to be informed, and he desired to assist his friends when possible. Ludwig Hilberseimer, in an unusually loquacious mood, had written that Gropius was missed in Germany. *Der Grundstein* had published an editorial: "Wo ist Gropius?" He also reported that Martin Wagner was doing well in Istanbul — that he had become a "super Turk." Poelzig, he said, was to join Wagner there.[35]

Poelzig was Gropius's friend and had shared with him the experiences of the Werkbund, the BDA, and the Ring. For reason of his friendships, his architecture, and his stated principles, he was being harassed by the Nazis. In late 1935 the Reichskammer der bildenden Künst, limiting its membership to Aryans, demanded that he prove the purity of his ancestry. Hans, the son of Carla Ames, born Countess Poelzig, wrote in desperation to Gropius for help in establishing the non-Jewish identity of his mother's English husband, George Ackland Ames. Born after the countess had left her husband, Hans had always considered Ames his father, but Ames had denied his paternity. At the age of sixteen, Hans changed his name to Poelzig. He wrote to Gropius that he had never given any credence to the story that his true father had been a Hohenzollern, and in any case, Ames was named as his father in his birth certificate. He thus needed a statement that Ames was a Protestant.[36]

Gropius began a scrupulous investigation. Church and registry records in England did not indicate ancestry by race or religion. Impeccable proof, however, lay in the fact that a member of the Ames family had been Master of the Hounds of the Worcestershire pack; it was more likely that the Hohenzollerns would have tainted blood than a Master of the Hounds. This may have been beyond the Reichskammer's understanding, but a few months later Poelzig wrote that he had received more acceptable proof: a note from the church in which he had been christened stating that both of his parents were Evangelical Protestants: "This should be enough for my children who have to fight for the Aryan proof. I also have dug out my Mother's line back to the year 1000; the Hönsteins were knight raiders in Hesse."[37]

The proof did nothing at all for Poelzig in terms of new commissions via the Reichskammer. Tired and ill, he went to Turkey, where he anticipated an appointment to Wagner's school. On May 20, 1936, Wagner reported to Gropius that Poelzig arrived suffering from complications of pneumonia and heart disease. Returning to Germany, he died in June at age sixty-seven. On learning of Poelzig's death, Gropius wrote to Wagner: "Poelzig was not young enough to start again. The poverty of spirit in Germany could not be shown more clearly than if work or honor were not granted to a man like him."[38] Wagner, himself homesick for Germany, now hoped that Bruno Taut would come.

There was much discontent in Germany; little of it was overt. In early November 1935 Herbert Bayer wrote about his uneasiness in Berlin and that "altogether the devil was on the loose here. There would be much to tell. . . . Right now a new effort is made which may have more chances: Mies [van der Rohe] is supposed to get the entire direction of the exhibition 'Germany' during the Olympics."[39]

At the same time Otto Haesler responded to Gropius's request for illustrations of the former's work for lectures and publications. In his extraordinary reply on an open postcard addressed to Gropius's apartment in Berlin rather than to England, Haesler said that the Third Reich would get a wrong impression were Gropius to publish works done previously or abroad, adding that he had been without work two and a half years. "I am as good as out. I take care of the land and feed my chickens and from next year on, pigs!"

Much year-end correspondence in 1935 was devoted to work for Pritchard's London Aluminium Company, Ltd. Among the products Gropius designed were a teapot, folding chairs,

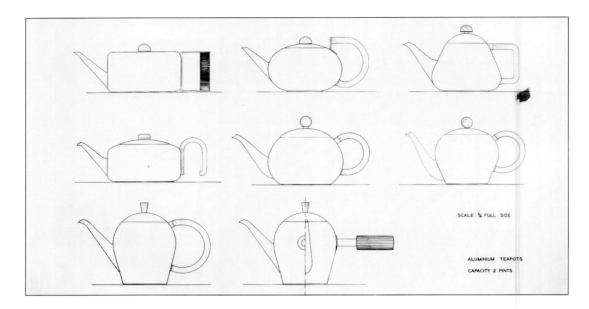

SCALE : ¼ FULL SIZE

ALUMINIUM TEAPOTS
CAPACITY 2 PINTS

wastebaskets, small tables, trays, and other objects for household and office use. Of these, the wastepaper basket was the most popular, though the financial return to Gropius from all the items was small. His role in Isokon was increasingly important. With the rapid expansion of the original company's interests, and with the formation of a subsidiary, Isokon Furniture Company, Gropius was appointed controller of design in January 1936. As such, he was responsible not only for the selection of the designers and the quality of the designs for furniture, accessories, and equipment, but also for their feasibility for manufacturing.

The year 1936 would prove to be momentous in the lives of Gropius and Ise. It began sadly with the death of Ise's sister Hertha on the first day of January. Ise immediately went to Germany, returning to England at the end of the month with her eleven-year-old niece, Beate (Ati), whom they later adopted. Settling well in the new environment, Ati later that year enrolled in Bertrand Russell's school, then directed by his former wife, Dorah.

Gropius's calendar was filled with engagements, both social and professional. Early in January he spoke on the use of wood in architecture at an awards presentation for a competition for house design. Fry, a member of the jury, had suggested to the sponsoring lumber association that Gropius participate; the latter stated in his remarks:

> The modern form of a building is only conditionally dependent on the newness of the construction material. The wooden structure is the earliest form of a skeleton construction and it has a close relationship to skeletons in steel and reinforced concrete today. …The really creative architect does not tie himself up with only some special materials.[40]

This was not a busy period for the Gropius-Fry office, and though the A. P. Simon project for Manchester had failed to mature, the architects continued to develop alternative ideas — in fact, three attractive and economically sound proposals. In a letter of February 16, 1936, to Pritchard, Gropius, displaying an amazing command of English, described their most recent ideas for

designing an efficient and low-cost structure for Simon that would overcome the constraints of the land, the problems of cost and market, and any possible objections of nearby residents. Located in a good residential district, it should find, they believed, a market among the staffs of educational and business organizations. There were, however, some legal difficulties in respect to the land; the problem of financing was a lesser one. The success of the project depended upon close collaboration with the owner, but it was not achieved; though he was to have shared in the profits, the constraints which he placed on the design were stringent. Worse, Simon had sold parts of adjacent properties that were necessary for the integrity of the project.

Gropius and the firm of Adams, Thompson and Fry got a "pot-boiler" project at the Film Processing Laboratory for the Denham Laboratories, Ltd, in Oxbridge. The architects called in after the steel frame had been designed and erected provided working drawings to complete the building; the laboratories brought in engineers, a quantity surveyor, and a clerk of works. Though Gropius presumably had full control of the design and construction stages,[41] the earlier construction, the building and fire laws, and the clients themselves were heavy constraints. An associate of Fry later wrote:

> In normal times I am sure Walter would never have tackled a job under such circumstances but he was pretty desperate. The clients were a couple of tycoons who behaved disgracefully. They gave instructions and counter-instructions to the contractors and sub-contractors without any reference to us. Consequently many things went wrong and proper organization was almost impossible. Finally there was an almighty row between Gropius and the client, who realizing that he had gone too far, said: "Dr. Gropius, you must not be angry with me because I have a great building to build and I would like you to be the architect." Walter, still not knowing where the next job was coming from, told the client, "If you have five hundred buildings I wouldn't touch one of them!"[42]

Although the Denham Laboratory did not provide much from an artistic point of view, it did bring in some money: Gropius's fee was 700 pounds, a not inconsiderable sum in those difficult days. Another 50 pounds was provided for travel and other expenses. The building was completed and was later used as the J. Arthur Rank Studios.

Regardless of the increasingly strained international atmosphere, Gropius was determined to remain apolitical. On occasion he was forced to exercise great diplomacy to explain his sensitive position. Invited by the BBC's literary weekly, *The Listener*, to write an article about the current state of modern art and architecture in relation to the social crisis, Gropius declined. The invitation had proposed a discussion of art and politics: Was art "free or fettered? Or in involuntary service to the political regime? And what in fact, were its ideals under Nazism, Fascism, and Communism?" Opposing views for Germany, Italy, and Russia were sought.[43] Gropius's reply barely concealed his feelings:

> I have made it a rule for my work to avoid pure criticism as far as possible. I am always prepared to explain my own point of view quite frankly and that involves, of course, a certain criticism of others, but I would rather not write an article for the main purpose of criticizing. I have stated my own opinion about the relationship between Art and the State in the Education Yearbook of this year, but I feel unable to make any comments to whatever opinion a German official may express, because I am still a German subject and am working here with the legal permission of the present government. As there is in Germany — as well as in Russia and Italy — no art which is not approved

of by the government any criticizing remark about the present policy made by me would easily be taken as a hostile act. I cannot have my name put up against an official report from Germany without risking very unpleasant consequences.[44]

From France early in May 1936, Hélène de Mandrot, patron of CIAM, wrote to invite Gropius to the September 9-12 meeting of the Comité International pour la Résolution des Problèmes de L'Architecture (CIRPAC) that she was hosting in La Sarraz. She asked him to be her guest for three weeks in August as well. Characteristically, she would not settle for fewer days, much less accept a refusal.[45] Gropius turned down her "tempting" invitation, which did not extend to Ise, as Madame de Mandrot customarily ignored the wives of her distinguished men. They had had a hard winter and "my wife wants me to have my only holidays together with her."[46] Madame de Mandrot reluctantly conceded "it is very natural that your wife wants you," but she nevertheless asked Gropius to come three days before the other CIRPAC delegates to participate in a final party for the Art Congress she was hosting: "You will rest the 8th and be in the place — having your room for the arrival of the CIRPAC. *I would be glad.* I don't know anything of Le Corbusier and will write to him also to come the day before."[47]

Her blandishments succeeded and Gropius accepted the invitation for the dinner meeting on September 5. He strongly recommended that she also invite Hans Scharoun, "who is fighting for our ideas in Germany without any compromising," and Oskar Schlemmer, whom he described as a "painter of genius. ...Both of them need really an encouragement after a very hard time."[48] She accepted Schlemmer as "a splendid chap. I am so glad to have him."[49] At La Sarraz the painter Max Ernst was also on hand, and, charmed by Gropius's knowledge of his work, he presented him with a symbolic portrait made on a tile as a souvenir of the occasion.

Meanwhile, other Bauhäuslers and friends had crossed the Atlantic to the United States, and a few to Latin America. Among these was Xanti Schawinsky, who reported that he would go to Black Mountain College in North Carolina for two years. In the same letter he described the Triennale at Milan. He admired the Finnish Pavilion, with its white birch wood, "everything else is white. It is done beautifully." He facetiously described the clash between the German Pavilion and the other structures: "Right in the middle, there cuts, with Jewish *chutzpah,* a long red banner with a giant swastika and destroys the whole tender virginity, because there one enters into the Nazis."[50]

Discouraged by events in Germany, and hopeful for his prospects in England, Gropius directed a request to the British undersecretary of state for permission to settle permanently. His letter of June 19, 1936, was supported by one prepared by Ian MacAlister, secretary of the Royal Institute of British Architects. Soon thereafter, Fry and Gropius established a formal partnership contract. In August Walter's and Ise's residence permits were extended indefinitely. Their friends rejoiced and redoubled their efforts to make them feel at home. But Gropius was not permitted to forget the travail of Germany. Correspondence with his friends there continued unabated. Former mayor of Dessau Fritz Hesse wrote in mid-August that the new government of the city and the Party now held him responsible for the political-economic vicissitudes of the Bauhaus. As he had earlier been accused in the violent Yellow Brochure diatribe and the subsequent charges by the architect Dr. Nonn, Hesse now became a scapegoat for the Nazis, who were only too pleased to have at hand

Caricature of
Gropius painted on
a tile by Max Ernst,
1936 (destroyed)

someone who would serve as a public warning against any softened attitudes on Socialist-Communist ideas. Based on the decade-old accusation, Hesse was prosecuted. He was now appealing to Gropius for a deposition answering Nonn's charges.[51] Despite the deposition and the testimony on his behalf by Mies and Muche, Hesse was found guilty and his pension was halved. He fled Dessau, not to return until after the war.

Correspondence with friends on the Continent revealed the hard times and austerity there. Lily Hildebrandt, who was a Jew, and her husband, Hans, suspect because of his marriage to her, now had even greater difficulty in finding work. To assist them — and in a reversal of their positions in 1922, when the Hildebrandts sought buyers for Gropius's artifacts to aid the Bauhaus students — Gropius offered to sell her paintings in England.[52]

When a manufacturer, Max Friedlaender, wrote to Gropius about possible English markets for his building products, his inquiry barely concealed his anxiety about his survival as a Jewish manufacturer in Berlin. He suggested there might be a commission for Gropius. A penciled note by Gropius on the margin of the letter reads: "I will answer it gracefully. Jews are appreciative." The correspondence continued with new requests for information, for statistics, for price comparisons, for anything that would maintain communication with Gropius. Compassionately, he replied to each letter, painstakingly converting and comparing English prices, measures, and construction requirements. With the intensified censorship of 1936, the Berlin letters suddenly came to an end.

Throughout his career, Gropius stressed the contribution the well-designed building made to the program it housed. In this respect he was greatly impressed by the Pioneer Health Centre on St. Mary's Road, Peackamin, London, and the contributions to health education made by its directors, Dr. G. Scott Williamson and Dr. Innes Pearse:

> Two English biologists, Dr. Williamson and Dr. Pearse…created a platform upon which the possibilities of a rich, diversified social life might be offered to average families. …In a specially-designed, bulb-like building with swimming pool, cafeteria, nursery, gym and playrooms, hundreds of average London families found release from their previous social isolation…all the initiative for command activities came from social intercourse among these families…opportunities were provided by the right type of a building.[53]

The Centre had a lasting influence on Gropius, and he would frequently refer to its social principles or recommend its examination as a prototype for similar or related efforts.

Another concept of education for a broader public had been shaping for over a decade in the mind of Henry Morris, secretary to the education committee of the Cambridgeshire city council. He observed that the progressive depopulation of the villages caused by the migration to the industrial towns would fatally sap rural culture. There also was a loss in agricultural development, and in the villages' services and amenities, which then became confined to the towns. The communal spirit of the village and the rural region was almost dead, as the chance collections of residents lacked any bond of unity or common interest. Earlier efforts to revive the peculiar humanism of the village had failed; such efforts had been artificial and without reference to modern conditions and developments in social structure. Morris had proposed his solutions as early as February 1925. They involved establishing "village colleges," each of which would serve as a center for some five or six villages in a fifty-square-mile area.

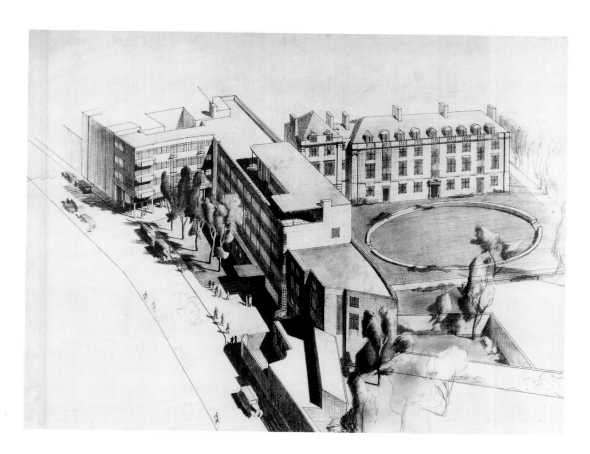

Project for a
dormitory, Christ's
College, Cambridge,
1935–36, with
Maxwell Fry

The college...would "comprise and coordinate within a single range of buildings all the educational and social agencies, both statutory and voluntary, from pre-natal and infant welfare to agricultural, handcraft, and academic activities for adults". ...

It was an equally essential feature of Morris's plan that the buildings of the village college should be sited in beautiful surroundings, architecturally distinguished, and equipped with taste and dignity.[54]

Jack Pritchard, who had met Morris in the winter of 1919-20, was interested in his ideas. But he was disappointed in the neo-Georgian architecture of Sawston, the first of the village colleges in Cambridgeshire, which was opened with celebration by the Prince of Wales in October 1930. He felt that it did not meet the needs of the educational system proposed by Morris and frankly told him so. In the first weeks after Gropius's arrival in England Pritchard introduced Gropius to Morris in Cambridge "with two purposes in mind: to bring kindred minds together and to see the design of a college fitting to Morris's aims."[55] They talked late into the night. Morris's ideas interested Gropius deeply. He vividly recalled their meeting: "I remember he succeeded in loosing my tongue in our architectural discussions in spite of my poor stuttering English."[56] Shortly after that visit, Morris, also impressed, wrote to a friend:

We have decided to put up three more village colleges and I've engaged all my working hours thinking out the architecture and equipment. I had Gropius, the German architect, staying with me a few weeks ago...and his conversation and many months of study of modern architectural techniques confirm me in the necessity of doing all contemporary buildings without regard to traditional style.[57]

Morris gave much thought to the possibility of engaging Gropius to design a village college that could serve as a prototype for subsequent building. He was aware, however, that if the county architect was bypassed in favor of an outsider, the architect's fee would have to be raised from private sources, such as the Council for Art in Industry.

Meanwhile he refined his program for a village college at Histon. It was not until early 1936 that

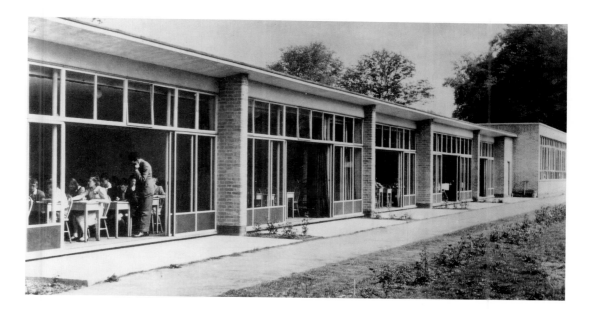

he sent the program to Pritchard,[58] who immediately launched a campaign to gather support for Morris's idea and the Gropius-Fry fee. Some 1200 pounds were necessary, and he wrote countless letters pleading for contributions; for example: "We have less than a fortnight to do it in and every little bit helps — from five guineas upwards."[59] He received immediate cooperation from E. M. Nicholson and William G. Constable, Slade Professor of Fine Art at Cambridge.[60] Though he did not contribute funds, John Maynard Keynes participated in a valuable supporting letter for fundraising, published in the *New Statesman* and the *Nation.* The statement praised the appropriateness of the Fry and Gropius partnership for the work:

> Mr. Fry brings to the partnership feeling for the English tradition and a highly developed practical sense, while Professor Gropius possesses one of the most original architectural minds of our time, deeply interested in the social aspect of building and most accomplished in using all the results of modern research.[61]

Gropius was impressed by the fact that his fee was subscribed by private sources, including many individuals and organizations. Since it seemed that the goal would be achieved, the architects' employment was confirmed on May 7, 1936. About this time it was decided to build the college at Impington rather than Histon, a determining factor being the increase of an initial gift of twelve acres to some twenty, through an additional contribution by the John Chivers family, whose fruit preserves factories were near Impington.

The college grew out of extensive discussions among Morris, the architects, the townspeople, and others. Countless sketches were made and abandoned before the final scheme was agreed upon. The funds required for the actual construction were well above the 20,000 pounds allocated, and Gropius wrote for advice to Keynes, noting that he and Fry had prepared six alternatives, and the least of these required an additional 7200 pounds to cover the new estimated 35,000-pound cost.[62] Keynes, who only shortly before had criticized expenditures for public works in a letter to the London *Times,* replied testily:

I am afraid that I have no useful advice to give you. For your letter only tells me that you are, after all, just like other architects. That is to say, unable to work within the figure prescribed, though fortunately, it seems, superior to some of them in at least warning your clients beforehand rather than bankrupting them after the event!

Anyway, my impression is that no more funds will be available locally, and that the choice lies between working within the quite substantial sum made available, and making way for a new architect.[63]

Gropius protested the tone and terms of Keynes's letter, patiently indicating that the client had set the final dimensions of the program, whereas the cost had been calculated on the basis of a school 30 percent smaller:

Your experiences with architects seem to have been of a very sinister character, but I hope nevertheless that after being in possession of the full facts, that you will support an appeal to the Council to reconsider the decision and to finish a scheme that started so favorably under your auspices.[64]

Keynes apologized but held firmly to his view that money would not be available locally and urged Gropius to seek further cost reductions.[65] He was correct: there were no additional funds and Gropius and Fry had to accept compromises. About this Leonard Elmhirst later wrote:

I remember contributing to a fund to enable him [Gropius] to be employed by the Cambridge County Council. …Unfortunately, shortage of funds for building the College meant cutting down Gropius' plan to the minimum so that it was not as interesting as it should have been.[66]

In late March 1937 funding was going badly for education; appropriations for armaments were cutting into other budgets. Of the 30,000 to 34,000 pounds needed, only 25,000 was available. By June it was clear that Gropius's design for the school could not be achieved for less than 45,000 pounds or, if cut to the quick, for less than 30,000.[67]

The increasing costs were particularly troublesome because Gropius's sponsors had declared a year earlier:

We do not anticipate that the work if undertaken by Messrs Fry and Gropius would cost any more than if undertaken by any other architects; in fact with the keenness of both for using, wherever possible, standard forms, it might even work out more cheaply.[68]

But Gropius had devised an innovative standardization, rather than utilizing that common to England. Pritchard attributed the rise in cost to the open, spacious plan required by Morris and reminded the latter that Gropius had warned from the beginning that funds were inadequate for Morris's "entirely new standard to be set in school construction."[69]

By August it was decided to omit the gymnasium and the terrace to reduce the cost to the amount available. But not until early the next year could Max Fry write

The long struggle over Impington is now at an end and it has been passed by the Committee. As time went on it became evident to Morris that he would have to keep the estimate down to the original figure voted by the Committee which meant getting more money from the Chivers family. I went up to Cambridge several times and had meetings with the various Chivers brothers and sisters. …It was a shame to see Morris having to waste his nervous energies. …But in one way and another we *did* manage to get another £2,000, bringing their total contribution to £8,000, *to be paid over 30 years!!*…

For the rest the deductions are made over a wide number of items, and the only real alteration is to the Library and lecture room which I have redesigned in a smaller scale as shown on the print I enclose. …

> Even so we would have been sunk at the last minute because I told Morris that we had done all I would allow, and there was still £1,000 to make up. He came into my office early the morning before the fateful Committee meeting to say that he had just got the £1,000 from the Halley Stewart Trust. It was just like a film.[70]

Not only budget but also the increasing scarcity of materials as war approached delayed the work;[71] the building was not completed and occupied until late in 1939. Although Morris had long since become cantankerous and impatient, Pritchard praised him for providing the enthusiasm and support that resulted in "this fine example of contemporary architecture at Impington." He added: "Its design has created a new architectural standard; it is already having a profound influence throughout the country and will be a landmark in English social and educational history."[72]

Despite the complement of distinguished English and refugee architects readily available, England made little use of their talents and missed an enormous opportunity in the development of housing design. Gropius, who by 1934 had amassed extraordinary experience in research, design, and construction of low-cost housing, was never asked to design or consult on such housing in England. Though England had been studying problems of housing for a longer time than Germany, the German experience had been far more intensive, experimental, and free of traditional constraints; to a greater degree than any other country, Germany benefited from and contributed to good design. Few public exhibitions in England treated housing for the lowest-income families. In fact, everything except low-cost housing was asked of the architects, despite the fact that the economy needed such investment at this time. Instead, middle-income houses and apartments, large stores, recreational structures, casinos, cinemas, zoos, schools, and factories were in demand. In 1937 Henry-Russell Hitchcock wrote:

> The existence of modern architecture on the Continent goes back some fifteen years and in England hardly more than five. …Today, it is not altogether an exaggeration to say that England leads the world in modern architectural activity. In part this is because Germany has for political reasons dropped from the running.[73]

Early in December 1934, immediately after Gropius's arrival in England, Robert Townsend, the secretary of the Modern Architectural Research (MARS) Group, had written to Gropius inviting him to take part in its activities. Organized in 1933 and continuing until January 28, 1957, MARS was affiliated with CIAM, through which Gropius had previously met several of this sixty-member organization. Among them were his partner, Maxwell Fry, Wells Coates, P. Morton Shand, László Moholy-Nagy, and Erich Mendelsohn. John Gloag, J. M. Richards, Serge Chermayeff, Ove Arup, and, subsequently, Marcel Breuer were also members.[74]

Its program involved study of the new architecture and its relationship to society, and matters of planning, materials, equipment, standardization, and the organization of the building industry. Public education was emphasized for architectural design, construction, and planning. In 1938 George Bernard Shaw described this group as representing

> a violent reaction against impressive architecture. It has no religion to impose. …It considers the health and convenience not only of the inmates but of their neighbours and of the whole town, as far as it is allowed to have its own way, though of course it is often baffled on this point just as Christopher Wren was.[75]

Despite the organization's problems of factions, finance, and organization, by the spring of 1935 preparations were under way for a great exhibition of contemporary architecture and town

planning that would demonstrate the group's philosophy and principles. The exhibition would be developed in stages and grow into an international one by 1938.[76] Gropius kept his promise to support the group's activities; in addition to participating in committees, he used every opportunity to further progress. He provided illustrations of exhibitions he had designed and volunteered his services, noting a possible deficit of 3000 pounds in the MARS exhibition budget. Gropius continued his effort to gain recognition and support for the group, and, throughout his stay in England, did not fail to include in lectures and discussions his very positive assessment of its purposes and potential. He particularly stressed the group's attempt to address the architectural needs of a changing world:

> I should like to draw your attention to the efforts of those architects in this country who try to get rid of the imitation of old styles, who want to face the problems of *our* day and *our* future and want to find a remedy for the wrongs and faults of our present life. I know they find it extremely difficult to introduce their methods of thinking, but I trust that they will succeed eventually. My feelings are very much with the "MARS Group," that group of English architects who are trying to bring the whole range of their profession again into harmony with our life of today.[77]

Although the exhibition included photographs and drawings of the Bauhaus, it displayed only a single work resulting from the collaboration of Gropius and Fry. This was a house designed in 1936 for Ben Levy and his actress wife, Constance Cummings, on Church Street in Chelsea, London. It was built next to a house designed by Erich Mendelsohn and Serge Chermayeff for Levy's cousin, Dennis Cohen. Both houses were well received by clients, neighbors, and the press. A reviewer for the London *Times* noted, "In a sense these are the most advanced buildings in London, but the odd thing is that they not only tone in with the general character of the neighborhood, but seem to have a definite relationship to some old, possibly eighteenth-century houses in the same street."[78] And the professional journals approved as well:

> This situation enables the two houses to serve as a practical demonstration of the affinities between the Georgian and the modern house, the more so as the two are linked together by a continuous wall along the street frontage and have been designed with collaboration between the architects to ensure the lining up of roof lines and so on, recreating thereby some of the spirit and unity of the Georgian terrace type.[79]

The shadow of events in Germany again fell across Gropius's path. He had earlier received a court notice regarding a hearing on charges that Wilhelm Guske, Landrat of Merseberg, had accepted a bribe in connection with the cooperative housing development in nearby Bad Dürrenberg. Gropius was initially asked to submit an affidavit explaining his role in the project, but was then subpoenaed to appear in court in Erfurt on February 18, 1936. The trial was postponed several times, but in November 1936 Gropius learned it was imminent.

He carefully prepared his testimony, which included the history of his own involvement in the project, for which he, through Sommerfeld, had been the architect and from which he had resigned when the town's building council refused to approve his flat-roof design.

As a German citizen Gropius's participation in the court proceedings was obligatory. To avoid it, he would have had to renounce his German citizenship and seek sanctuary in England. This he was unwilling to do. He had little apprehension about traveling to Germany, though conditions were steadily worsening there. After all, he made several brief trips to Berlin from London without

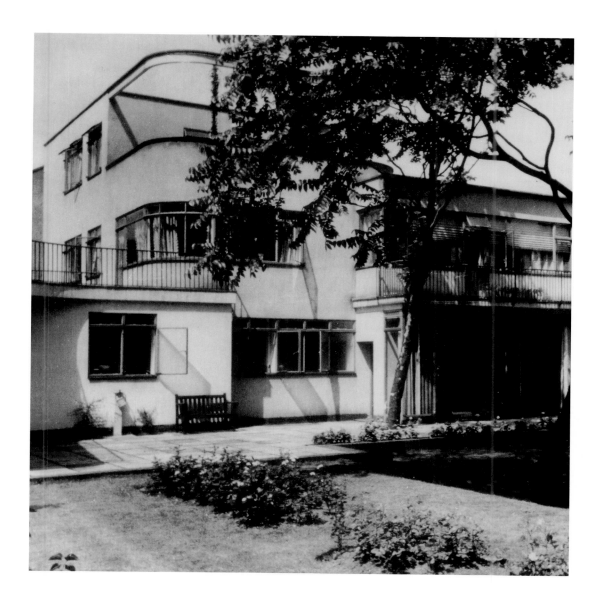

The house of
Benjamin Levy and
Constance
Cummings, by
Gropius and Fry
(and adjoining
Dennis Cohen
house, right, by
Mendelsohn and
Chermayeff,
London, 1936)

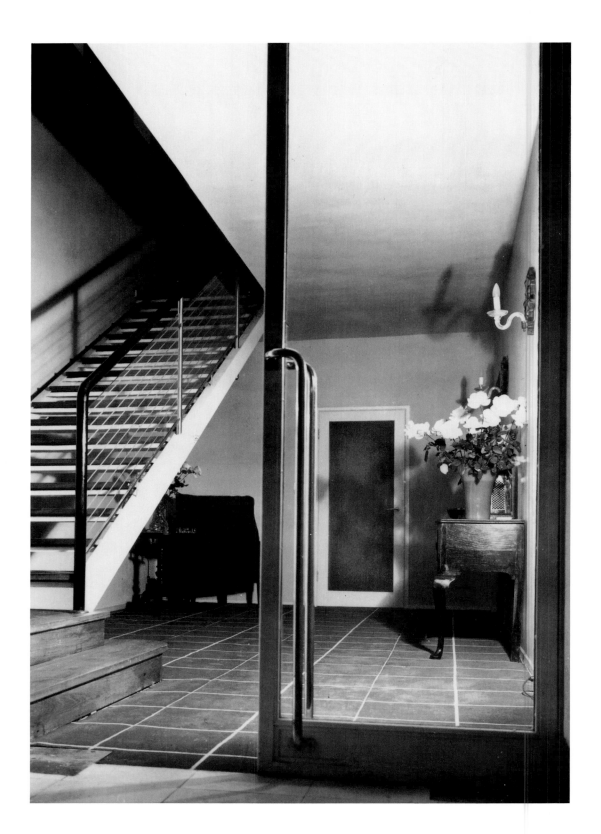

difficulty. Despite his uncompromising positions on design, education, and the freedom of professional associations, he was a German citizen in good standing. His every application for travel and work had been approved by the appropriate offices of the Third Reich.

Gropius departed London on November 23, crossed the Channel, and proceeded directly to Erfurt. His testimony was damaging to the government's case and unshakable; the Landrat was acquitted. In apparent retribution, Gropius was intercepted and questioned in Erfurt by the Gestapo. He was released and allowed to depart, only to be taken from the train at the border to have his baggage and papers searched scrupulously. His small address book revealed the name of Lion Feuchtwanger, a friend and the author of *Der Wartesaal, Jew Suess,* and other writings critical of Hitler and the Nazis, and already a refugee in France for some three years. It was only because Gropius's address book also listed the name of the fascist Dino Alfieri and he possessed an official permit allowing him to work in England that the police released him to continue his journey on a later train to London. He wrote to the court about his ill treatment:

> Shortly after my statement and taking the oath, I was arrested at the door of the court building by an official of the Geheime Staatspolizei, brought to the police building, and questioned for one hour as to my identity, my stay in London, where I am with the permission of the Reichskulturkammer, and about the details of my arrival and departure in Germany.
>
> On my way back to London, I was taken from the train the next morning and interrogated. When nothing incriminating was found, I was dismissed without apology for this incident. Only after a five-hour time loss could I continue my trip and for this purpose had to telegraph for money to Dutch friends in order to continue on the same day with the night boat since the day boat, for which my ticket was valid, had long since left. My presence on the next morning in London was urgently necessary for professional reasons.
>
> I ask you to realize what impression this degrading treatment has made upon me — a treatment generally reserved for criminal or political suspects. As a loyal German citizen, I feel this unjustified and unwarranted intrusion has denigrated my honor. The officials have of course only done their duty, but I ask the court, which is certainly concerned that their witnesses not be bothered in unjustified ways, to help me find the instigator of this blatant denunciation. The official answered, when asked, that he was not allowed to give me information on this procedure and source. I herewith ask the court for information on what steps should be taken to clarify the case.[80]

On December 3, 1936, the court replied merely that it must have been the police of some other jurisdiction.

Gropius continued to give what support he could to his friends from Germany. He never failed to take every opportunity to recommend Hans Scharoun. In a letter to the editor of the *Architectural Review* of November 1, 1936, Gropius noted three houses Scharoun had recently built — "As far as I know, it is the only modern architecture done in Germany today" — and that he would appreciate it if the magazine gave them some publicity, "as that cannot be done in Germany today." To Martin Wagner he wrote that he had been in Berlin recently and had seen Behne, Hoffmann, and Scharoun, all of whom he praised highly. He added:

> For days I sat in the basement, sorting out my life from the files and drawings.
>
> It was as interesting as it was depressing to see life in a town under organized control…it is a country of lost personal freedom, unbelievable tension and I believe that the crisis is near — one way or another.[81]

Adolf Sommerfeld, of whom Gropius had had only thirdhand news since leaving Germany, wrote directly to Gropius from Palestine, to which he had fled a year earlier. He asked for assistance of various kinds: money ("every pound would be of immeasurable help"), introductions for his son ("to good Jewish-English families"), and work for himself in the construction industry in England as a representative of a construction company in Palestine. He had arrived without any resources; in some desperation he referred to the original commission for the Bad Dürrenberg housing, which he had given to Gropius, and to Gropius's 1928 trip to the United States, which he had largely financed.[82] Responding immediately, Gropius wrote of his own acclimation to England and his optimistic view of Sommerfeld's future:

> I am appalled to hear that Sommerfeld has to begin anew in Palestine. I thought *sic transit gloria mundi,* but at the same time I thought of your old story that if one puts you with 50 pfennig and a pen on the Döhnhofplatz, you will turn up after a year with a million marks. I am full of confidence and hope about your energy and your broad shoulders, and although you have considerably changed the scene of the Döhnhofplatz, on the basis of your abilities, you will swing up to a dignified position again.

He mentioned families to whom he would introduce Sommerfeld's son, enclosed a five-pound note, and expressed the hope that "when in America" he would be able to do more: "I do not forget your kindness." He also spoke nostalgically of the changes in his life:

> This will then probably be the last and final stage of life after the many various lives one has started. So I begin to draw a line under my English balance and gear myself to the new thing. So one moves through the different levels of life with some longing for the old Germany and the friends there, who are scattered to all winds.[83]

Overtures from Harvard University: The efforts made throughout Gropius's stay in England to bring him to America were coming to fruition. Lawrence Kocher of the *Architectural Record* had been canvassing schools of architecture in the United States to determine their interest in obtaining Gropius for a series of lectures or a semester of teaching. Columbia was interested and wanted an exhibition as well. Dean George Edgell at Harvard had indicated that he was interested but, hampered by already committed budgets, suggested the spring term of 1936. Cornell, Yale, MIT, Princeton, and the University of Minnesota were without funds but hopeful and interested. Kocher inquired on December 11, 1934, about Gropius's availability: "Your coming…may lead to the establishment of an office by you. …Our group would form the opportunity for our own school of American Bauhaus." Gropius asked Kocher for two months in which to decide:

> First, I have not yet definitely decided to leave Germany for a long period, though the conditions might be awfully bad there. Besides that, there seems to be a great chance for me in this country to get very interesting practical work. …And, lastly, my knowledge of the English language is at present still so poor.[84]

In May 1935 a definite offer was made by Dean Everett Meeks of Yale University for a single lecture, for which they would provide a hundred-dollar honorarium and twenty-five dollars for traveling expenses. Gropius declined, asking for postponement to the following year. On June 6, 1935, Kocher again prodded Gropius for a decision regarding work in the United States. Gropius replied:

> You will know there is no possibility for a German leaving his country to get out any money. So I am not free in my decisions. You will agree it would be rather a risk to leave this country and my newly started jobs without having re-obtained an independent position.[85]

Kocher and Gropius continued to correspond and to discuss professional subjects. It was Kocher's initial interest, at least in part, that eventually was to prompt Joseph Hudnut, by then dean of the Graduate School of Design at Harvard, to invite Gropius in 1936 to the United States and to Harvard.

In mid-summer Hudnut cabled asking Gropius to meet him in London in the first week of August. The message came as no surprise, for Alfred Barr had informed him earlier of the visit. Walter and Ise had accepted van der Leeuw's invitation to visit Holland for the first weeks of August, so Gropius and Hudnut agreed on a meeting in Rotterdam on August 20. Their discussions were cordial and their ideas related, but Gropius was not convinced by Hudnut, whose brief tenure at Columbia University gave rise to some doubts about continuity; nor did he want to accept a position which would involve only teaching, as he was pining for work. Hudnut was persistent; while in Holland he had interviewed both J. J. P. Oud and Mies van der Rohe. He was not completely satisfied with either man, though he did sound out Oud and was refused. As for Mies, Hudnut was displeased with his unmarried state and informal household.

Hudnut returned to Cambridge and quickly renewed his efforts to engage Gropius. He had already asked President Conant of Harvard to appoint him.

> Tonight the President is leaving for a brief visit to England and, at my request, he will call upon you in London some time during the first week of October. I shall leave further discussion of our plans, therefore, in his hands and in yours. You will find President Conant a man to whom you can give your entire confidence, and I hope that you will not hesitate to tell him very freely your ideas in respect to the development of education in this country. May I add that I hope also that, as a consequence of your interview, we shall have the very great honour of being associated with you in our work.[86]

A discreet, hand-written note from Conant was received shortly thereafter, and the two men met on October 22. Gropius wrote to Hudnut that he "was very much impressed by his [Conant's] brilliant personality," and added, "We had a long interesting talk about aesthetics and education generally, but as he did not mention our subject, I did not either as I had no intention to anticipate. So I do not know so far his opinion."[87] Hudnut was most sanguine about the prospects for Gropius's appointment, and negotiations continued. Insisting that he could not come to Harvard unless he were allowed to practice on the side, Gropius obtained Conant's consent. Additionally, he would not be required to hold lecture classes. The president and dean conferred on Gropius's appointment on November 13, and Hudnut wrote that day that the formalities were under way and Gropius would be appointed as of February 1, 1937:

> I cannot tell you how happy I am at the apparently successful outcome of my plans. I hope most sincerely that you will find it possible to come to Harvard and I look forward with great pleasure to many years of collaboration with you. Your presence in Harvard University will not only be of the greatest possible value to this institution but, beyond that, I feel that the service you can render to the cause of architecture in this country is valuable beyond all calculation.[88]

At lunch on November 28, 1936, Gropius informed Pritchard that he would accept Harvard's offer. A few days later, Pritchard wrote generously:

> In many ways what you said…was not entirely a surprise. I had indeed made a note that I would have a talk with you about America in view of my own feelings about developments there in comparison with here. My delay in doing

so was unconscious because obviously I don't want you to go in the least; but one thing is perfectly clear — that whatever effect it may have on our Company, this must not influence you in any way at all as to whether you go or not.[89]

Pritchard hoped for a continuation of their association and an extension of Isokon to the United States. He listed some items to be completed if possible before Gropius left England: aluminum wastepaper basket, electric kettle, electric heater, table dumbwaiter, aluminum radio, Gropius's own designs for a chair, two tables, a tray, bedroom furniture, and a retail display corner. There were other items in wood and metal, including school furniture, which they were then studying; Breuer was to complete a plywood airplane seat and some stacking furniture.

On December 8 Hudnut cabled that the President and Fellows, the Harvard Corporation, had approved the appointment. In a subsequent letter, Hudnut explained his grand plan. His ten-year objective was to reorganize architectural education to meet the changing role of the architect, and "no one in the world...could be of greater help to me in this work than you." He would bring together under Gropius's guidance the best architectural students with all of the facilities and support necessary, so that each year Harvard could send out across the United States a dozen or more young men who had come under Gropius's influence. Without any assurance of their realization, Hudnut also mentioned opportunities for Gropius to practice as an architect, consultant, collaborator, and critic and to participate in professional societies.[90]

Gropius had asked for a delay in the appointment to April 1 in order to enable him and Maxwell Fry to complete a contract. He also pressed his earlier request for the appointment of Josef Albers, which he said would add a fundamental basis to the curriculum and which he himself would welcome "for professional as well as personal reasons. For it would make my own work more promising right from the beginning." Gropius also wrote of his satisfaction in knowing that there would be opportunities to practice, as "useful teaching needs a background of practice. So I hope to find a well-proportioned combination of both."[91]

Hudnut suggested that the subject of Albers wait until Gropius's arrival, because the Beaux-Arts-trained chairman of the architecture department, Jean-Jacques Haffner, would leave in February and Charles Killam, chairman of the School of Architecture, was ill and would soon retire. He also wrote that the American Institute of Architects would invite Gropius to their Detroit meeting and that the Museum of Modern Art would prepare an exhibition in his honor in May 1937.

Having only recently received permission to work in England and to extend his stay, Gropius now had to persuade the German government to allow him to transfer to the United States. On December 9 he wrote Ernst Jaeckh, formerly of the Deutscher Werkbund and then in England at the New Commonwealth Institute, that he had received that morning an official invitation from Harvard. He asked Jaeckh to use his influence in Germany to obtain the necessary travel and work permit, suggesting that the fact that he, a German, would replace a distinguished Frenchman at Harvard would be of interest to officialdom in terms of "cultural politics."

Before Christmas Jaeckh made contact with the German Propaganda Ministry and, with the intercession of Eugen Hönig, anticipated success. The German government, well aware of Gropius's attitude toward its political and social purposes and realizing that he was lost to them,

decided to make the best of the situation. To salvage appearances, however, Gropius would receive at least tacit permission from Goebbels, granted on the rationale suggested by Gropius that for the first time a German would replace a Frenchman, Jean-Jacques Haffner, a *diplôme* of the Ecole des Beaux-Arts, in such a role, and he thus would serve well the new Germany as an exemplary model of its greatness.

For Gropius and Ise 1937 began with renewed hope for the future. Every message from the United States indicated additional steps toward completing the traditional formalities of appointing a professor with tenure at Harvard. Letters of welcome from acquaintances and friends in the United States began to arrive, many of them prudently muted in view of the dignity of that appointment process. In January Gropius's appointment was made public, and he received congratulations from old friends like Herbert Bayer, who tempered his remarks with sorrow and nostalgia:

> I spent Christmas in the lap of my family (in Austria) and thought of you two as I do so often. Yesterday I heard per chance in a restaurant the song, "Itten Muche Mazdasnan," [Bauhaus song] which brought me to the verge of tears... .
>
> The news about your exodus from this worm-eaten continent I have received with real sorrow. We aren't that modern yet not to feel the impact of this new measure of distance... .
>
> The "nearness" of you both up to now was of course really an illusion, but at least it was that... .
>
> Since my exhibition [in London] has been deferred to a much later date, I shall not see you anymore.[92]

The German press obviously had been instructed to treat Gropius's move to the United States with deference. Gropius wrote to Jaeckh, "A load has fallen from my chest that this went well because I know that they have put me on their list as a cultural bolshevist."[93]

In his two and a half years in England, he had been busy but far from fully occupied. Maxwell Fry felt that Gropius had been underappreciated in England:

> Looking back on that period of partnership with Gropius, I have the sense of not properly appreciating my good fortune for two reasons: first, because England lay outside the currents of European thought and entered when the main flood was subsiding and retreating before totalitarianism; and second, because there is in the English character a vein of anarchism, amounting at times to pig-headedness, that rejects the logical approach and the commonly shared view in favour of going through the independent experience come what may.[94]

True, Gropius's alien status and new use of the English language, the unsettling prewar environment, the preoccupation of the population with "escapism" and of government with institutionalized bureaus contributed to England's minimal use of his talents. Furthermore, the national government appeared to have little future, and the 1937 upturn out of the depression was not anticipated. But these are hardly acceptable excuses. The missed opportunity was to be ruefully noted fifteen years later:

> The news that Professor Gropius is to be the architect of the new buildings at Harvard University...is another reminder of the extent to which America's gain has been Britain's loss, for during the period of his residence in Britain, before he went to America in 1937, very little advantage was taken of the presence here of so eminent a teacher and practitioner.[95]

Gropius was now fully engaged completing his professional work and involvements, expressing his

appreciation and bidding farewell to friends, closing their living accommodations, meeting English, German, and United States government regulations, and otherwise arranging the transition from England to the United States. Gropius and Ise's last weekend in England, March 6 and 7, was occupied with closing his office and an *auf wiedersehen* with Ati, who would remain temporarily at school in England under the watchful eyes of the Pritchards. They paid a final visit to the home of the Sackville-Wests at Sevenoaks in Kent, and packed their personal effects for shipping on Monday. On Tuesday there was a formal farewell dinner at the Trocadero. It was chaired by Julian Huxley, who had just written to Gropius recommending that he and Ise visit the TVA, still in its earliest stages, and Williamsburg, then undergoing restoration, and offering letters of introduction.[96] To the distinguished audience, which included H. G. Wells, Sir Herbert Samuel, and several American Embassy officials, Gropius spoke of his appreciation of the innate kindness of the British, but also of his keen disappointment in his own lack of success in advancing its architecture. Although he was homesick for Germany and already felt nostalgia for England and the English, he was filled with optimism for the future in the United States and at Harvard.

> In the different stages of my life I have always found it impossible to tackle new problems with my head turned back. It seems to me more fruitful to concentrate on the new task if one does not want to be turned into salt.... .
>
> But I am confident that the Atlantic will, as the years go by, be less and less of a barrier between two countries who have so many common tasks.[97]

Indeed, he anticipated returning to England to work during the summer with Fry to complete several projects and had purchased round-trip tickets, booking a return passage from New York to Southampton on the *Bremen* for June 20, 1937. Though it may have appeared that Gropius had some trepidation about the new venture, he was only being canny. When the English projects failed to proceed, he returned the eastbound tickets by the end of May.

On Wednesday, March 10, there was a final and most important meeting with Herr Jaeckh

regarding the travel and work permit formalities of the German government. The rest of that day and the next were spent with friends who came to Lawn Road for a quiet farewell. Gropius's entry in his diary for Friday, March 12, 1937, reads simply:

9° Abfahrt USA

THE FERTILE GROUND
1937–1952

Although less than ten years had elapsed, the United States that Gropius found in March 1937 was quite different from the country he had visited in May 1928. In that first visit he had encountered buoyant self-confidence, vitality, and opulent prosperity. It had appeared to Gropius that there was no limit to the opportunities for national as well as individual attainment. The 1920s had also brought a new outlook on life. The conventions and constraints of the end of the nineteenth century and the first decades of the twentieth had been loosened by the war and the postwar prosperity. There were new freedoms in behavior, dress, morals, religion, and politics. Still, innovations in the arts, so long inhibited by the academies and by lagging public acceptance, developed slowly. Prosperity itself inhibited these, for the nouveau riche sought recognition through the acquisition of the status symbols of past decades, and the already established sought stability in the maintenance of the old order.

Ise and Walter Gropius on the screened porch of their house in Lincoln

A Changing United States: The optimism of the twenties was pervasive, but the stock market failure in October 1929 would halt this euphoria. People all over the country suddenly suffered. They lost their savings, their investments, their jobs, and all hopes for a secure, prosperous future. Signs of the Depression became evident in each city: empty stores, bread lines, empty trains, "Hoovervilles" on the edges of towns and in other vacant spaces, and beggars wandering the streets. "One-third of a nation ill-housed" was not at all an overstatement.

Compounding the misery of the period was an extraordinary siege of inclement weather. Within the year following Gropius's arrival, a "hundred-year" hurricane traversed New England, tornadoes ravaged the Midwest, and a prolonged drought turned the worked-out farmland of the southern states into a dust bowl. The mass migration of the Okies to Southern California was a forced and bitter one, recorded in folk ballads, drama, literature, and in the annals of social maladjustment and anomie.

The Depression, worldwide by now, materially influenced the political equilibrium of every nation. A major part of Hitler's success in Germany resulted from it, and the parallel progress of Communism and Fascism was an obvious consequence of the unemployment and inflation. Almost

every country in Europe was heading toward major conflict, and the rehearsal for this in Spain was well attended by both participant and spectator nations. Hoping to appear as one of the latter, the United States government had approved neutrality legislation beginning in 1935, thus assuring a rightist victory in Spain. The public, already isolationist in attitude, was easily persuaded that noninvolvement was the proper course.

It was an introspective period in the United States. In 1933 the new president, Franklin Delano Roosevelt, had inaugurated the New Deal to remedy the nation's plight. It brought to government a new zeal, a passion for reform, and a social conscience, and it would grow into a wide range of programs attacking social and economic problems. In the belief that social motivation and social ends should determine priorities, the country was plunged into exploration of academic theories and experiments, some of lasting and desirable effect, others with flaws that took decades to discover.

When Gropius arrived at Harvard in April 1937, the nation was in turmoil. There had been waves of strikes throughout the United States since September 1936. Despite the government's best efforts, business in general attempted to restore and carry on practices that had led to the Depression. The country was building up to a recession, which began in the fall of 1937, and by early 1938 ten million of the labor force were unemployed — an economic problem not to be solved until ten million men had been drafted into World War II military service.

But the Depression was not without some benefits. It imprinted on those who weathered these years attitudes that were reflected in a whole new way of life. The interrelation of segments of American society and the interdependence of its economic system were discovered, as was the ability of a few to manipulate both. The responsibility of government to assist the individual citizen was fulfilled as never before. The New Deal was indeed just that — a new deal. With its encouragement, there began to grow a national consciousness of the American environment and culture. Previously only the Maecenases, the great titans of business, and the universities had provided cultural aid; now numerous government programs gave encouragement and stimulation to music, literature, mural and other painting, and to sculpture, theater, and dance. The Works Progress Administration (WPA) gave needed aid at a critical time, and many artists and writers survived the Depression only through its assistance.

European culture would be transplanted to the fertile soil of the United States.[1] Among the immigrant writers were Bertolt Brecht and Thomas Mann; Franz Werfel, along with Heinrich and Golo Mann, and Lion Feuchtwanger had been assisted in getting out of Germany by the United States consul in Marseilles. Immigrants also added to the country's music resources. Among them were performers Artur Schnabel, Adolf Busch, and Rudolf Serkin; conductors Arturo Toscanini, Bruno Walter, and Otto Klemperer; and composers Paul Hindemith, Ernst Krenek, and Igor Stravinsky. Stravinsky and Gropius were already friends.

A similar transfusion took place in the visual arts, with the arrival of Max Ernst, Fernand Léger, Piet Mondrian, Hans Hofmann, Georg Grosz, Hans Richter, and also a significant number of Bauhäuslers. Among the Bauhäuslers, who came both before and after Gropius, were Josef and Anni Albers, Moholy-Nagy, Mies van der Rohe, Marcel Breuer, Lyonel Feininger, and Herbert

Bayer. Along with Gropius, they greatly influenced art and architecture in the United States.

Within the institutionalized architectural profession, which had experienced constantly expanding opportunities for practice during the first decades of the twentieth century, there was little doubt about the rectitude of its traditional approach, except among a relatively few restless young men and still fewer iconoclastic older ones. Yet there was good reason for restlessness, and little reason for complacency. A century of adulation of French culture had produced an eclectic emulation. The classical arts and architecture of the Beaux-Arts became recognized symbols of financial success and political power, and their display served as social entrées.

It was natural that the architecture schools, from their beginnings with MIT in 1865,[2] would pattern their policies and programs on those of the Ecole des Beaux-Arts. Thus a student of ordinary means could study at one of a number of universities in the United States that boasted a genuine French *diplôme* of the Ecole as chief of design. Among these were Carnegie, Columbia, Cornell, MIT, Minnesota, Pennsylvania, Princeton, and Harvard, with Eugene Duquesne and Jean-Jacques Haffner. Elsewhere students could find worthy architectural schools that pursued Beaux-Arts principles and programs, or they could attend the Beaux-Arts Institute of Design in New York, which imitated its Parisian prototype even to its fancy-dress ball. In the 1920s a diploma from the Ecole des Beaux-Arts itself was still regarded as one of the highest social and academic distinctions.

As one result, education in the design fields continued its slow decline into obsolescence, myopic in the face of a changing society and unresponsive to a changing environment. But compared to the demands for educational change in Germany and other European countries, student dissatisfactions with the traditional form of architectural education in the United States following World War I were mild.

Apologists for the Ecole des Beaux-Arts correctly pointed out that the emphases of that ancient school differed from those of institutions in the United States that emulated much of its unique tradition. Frequently, the disciples of the Beaux-Arts in the United States were more rigorously orthodox than their Parisian masters. A Harvard alumnus wrote in 1920 complaining that the curriculum in architecture was directed more to producing chief draftsmen than architects, and that he had come to recognize the faults of the Beaux-Arts — though it improved the mind and character of the student "as Boston can hardly expect to do."[3]

The chairman of Harvard's School of Architecture, Charles Killam, responded generously, sending copies of the letter to distinguished practitioners for comment. One respondent noted his hope for modifications of the Beaux-Arts system to suit American needs. Espousing a two-stage program of studies, he would assign aesthetic aspects of architecture to undergraduate training, and "in the graduate school, [the student would allow] his imagination free play under the guidance of a great master unhampered as far as may be, by restriction as to hours or discipline, and building continually on his earlier undergraduate training."[4] There had been some change: the school now provided a choice between a master's degree in architecture and one in architectural engineering. With the appointment in 1922 of a young professor of fine arts, George Edgell, as dean of architecture at Harvard, attention to aesthetics and design was assured, but in a balanced unity with structure.

The establishment of architectural schools in the United States was not paralleled by the creation of programs in city planning. The Beaux-Arts provided little precedent. In Paris there had been few men of the stature of Tony Garnier concerning themselves with realistic city design, as he had in his 1901 Cité Industrielle. From time to time, however, the ateliers produced designs for a plaza, an esplanade, a workmen's community, a harbor development, an institutional complex, a railroad bridge, or other elements of a city. These were romantic, superficial in their lack of concern for economic or social factors. The physical design, as a contribution to aesthetics and civic pride, appeared to be a sufficient end in itself.[5]

The *1921 Year Book* of the Harvard University School of Architecture was illustrated by classical designs only. To the school's credit, many of these at least reflected some concern for structural considerations as well as exhibiting great drafting and delineating skills. Though stimulated by the occasional discovery of the work of European designers, adaptation or adoption of new directions in the United States was limited. The need to conform to past practices to obtain academic recognition or, in Depression-ridden professions, to please conservative and Francophile clients, persisted. Design faculties and professional societies appeared to be inert, apparently oblivious to, and perhaps incapable of, change. Until the late thirties, architectural education programs in the United States remained formal and stereotyped by their degree of connection with, or separation from, departments of engineering or fine arts. In 1931, Dean Edgell of Harvard remarked:

> I confess I have always felt a little worried at the amount of time we spend in doing beautiful Gallic-inspired designs for monuments, museums, and other excellent things....I am in favor of more attention paid in the School to the economic side, even though our professors of design raise the cry of Mammon.[6]

A few years later Edgell could note with nostalgia that his *American Architecture of Today,* well received in 1928 as authoritative, was a book "on the architecture that — alas — is rapidly becoming the American Architecture of yesterday."

Among the social and economic reforms of the New Deal was a housing program that offered new opportunities for architects and planners. The lack of precedent for government-aided housing developments led the architects to examine the European experience, particularly that of Germany. Traditional study in a period characterized by rapid change in materials and construction methods and social and economic requirements that were constantly in flux created a sense of ambivalence among the architects. Students, required to memorize the logic and proportions of classical building systems and to seek solutions to the Beaux-Arts design programs persistently given as studio assignments, were openly dissatisfied. Taking advantage of the uncertainty that beset both teachers and administrators, Joseph Hudnut began immediately upon his appointment as dean at Harvard in 1936 to unify the schools of architecture, regional planning, and landscape architecture as departments of a school of design.

The obsolete teaching practices, the not infrequent schisms between student and faculty, and the sporadic appearance of new architectural fads contributed to a sense of weariness and an unconscious search for new direction and a leader to clarify the approaches to architectural education and practice. That it was a Gropius and not a Le Corbusier or a Mies van der Rohe who found fertile ground for his ideas may have been circumstantial. Yet what was needed was his deductive rationality, not a polemical approach. The American students, under the impact of the Depression and the New Deal, sought social responsibility — and found it in Walter Gropius.

Arrival at Harvard University: Probably the United States first learned about Walter Gropius as an architect through his and Adolf Meyer's submittal to the Chicago Tribune Building competition in 1922. The local reaction at the time could be summed up as: "Surely this German is not serious with his 'mouse trap'!" Few architects in the United States then knew of the Faguswerk or of the Cologne Werkbund exhibition, nor did many educators know of the Bauhaus, then in its third year in Weimar. Moreover, Gropius's brief visit to the United States in 1928 had been largely unheralded. Yet it was that housing research trip as much as any other factor that led to his return in 1937.

An early self-introduction was his first article published in the United States, "The Small House of Today," which appeared in the *Architectural Forum*.[7] Another introduction resulted from a European study tour by Henry-Russell Hitchcock and Philip Johnson in 1931; their book, *The International Style,* published in 1932, recognized Gropius's contributions to contemporary architecture.[8] An exhibition that year at the Museum of Modern Art in New York included several of his works, and in the catalogue Gropius was described as the chief pioneer of the International Style, whose works had the most social significance.[9]

At Harvard, Dean Hudnut had smoothed the way for the announcement of Gropius's appointment. He had written the introduction to the new English edition of *New Architecture and the Bauhaus,*[10] had endorsed Gropius's views on the problems of the profession in an article in the December 1936 *American Architect,* and had hinted to colleagues that "one of the most distinguished of European architects and town planners" would be joining the faculty.[11] When the announcement was made in January 1937 that Gropius was appointed chairman of the Department of

Architecture, even the most traditional member of the Visiting Committee, Charles Maginnis, congratulated Hudnut:

> Thanks for the exciting news that Dr. Gropius is coming to Harvard. I can realize how happy you must be that you have so vivid a personality. The traditionalists will prepare to hide their diminished heads. It will be intensely interesting to see what develops from this dramatic immigration. Undoubtedly you have turned the eyes of the architectural world on Harvard, where you are centering such a powerful influence.[12]

Arrival in the United States, March 1937

Hudnut anticipated a smooth transition, for six months later, in reporting Gropius's arrival to a colleague, he wrote that "we are already in the general direction that he pursued at the Bauhaus."[13]

The transition from the Beaux-Arts to the Bauhaus curricular approach was facilitated by the departure of Jean-Jacques Haffner. Most of those studying under Haffner were graduates of Harvard's bachelor of architecture program. In the Depression years, some were scions of wealthy families, and their approach to architecture had little zest as they waited out the poor practice years. Nevertheless, even the most dilettantish among the students were becoming aware of a change in the architectural world — and in Haffner himself. He had long been aware that an era had ended and was frustrated by the professional hiatus of the Depression. His comments were sometimes nostalgic, sometimes made in a flare of temper — signaled by a reddening of his jowls, a narrowing of his eyes, a flick of cigarette ashes, and a "zut zut" in admonition or disagreement. Though only fifty-one years old and far from academic retirement age, he was not unhappy to leave the discordant atmosphere of the United States during the Depression and the confusing change in educational direction. He returned to his beloved France, where he maintained his architectural practice and his appointment as chief of design at the Fontainebleau School of Architecture.

Gropius and Ise arrived in New York on March 17, 1937, and he was formally introduced at Harvard on March 30. Within a month Gropius published his views on architectural education in an article long promised to the *Architectural Record*. He announced that his goal at Harvard was to develop within each young architect the ability to approach and cope with every new problem according to its technical, economic, and social prerequisites. He emphasized that "the satisfaction of the human soul is just as important as the material and…the intellectual achievement of a new spatial vision means more than structural economy and functional perfection."[14]

Gropius's ideas electrified the professions and the schools, and when Dean Emerson of MIT introduced him at the May meeting of the American Institute of Architects in Boston, he was greeted by a standing ovation and received still another when he had completed his address. A student who attended described that reception: "They clapped and clapped until Dean Emerson called him back — Gropius was blushing — he does not like applause. We were glad to see that the AIA appreciated him."[15]

Gropius's first spring was one of adjustment to a rigorous academic schedule, a calendar of social events, and completing arrangements for reassembling his German and English households. To Max Fry he reported the enthusiastic welcome afforded him, and his participation in the review of student work, though his "duties have not yet started officially."[16]

Though Gropius was optimistic, he was still cautious in his negotiations with the German government. Every stage in his journey — from abandoning Germany to leaving England to

Walter and Ati
Gropius in Lincoln,
1938

exporting his office materials from Berlin — required that he apply for permits from the appropriate bureaus. Gropius was careful to ensure that at no time were his actions accompanied by a denunciation of the Nazis or a renunciation of his citizenship. He was careful, in granting an interview to George Nelson for an article on him, to stipulate his conditions:

> As I explained to you when we met in London, I am anxious to be certain that no political hints whatsoever should be given as to the general German attitude against the art I am an exponent of. Since all cultural things in Germany are not at all settled, every statement from outside would be premature and infringe my personal position. I must insist therefore that my photographs and interview should be used only under the mentioned condition.[17]

There were reasons for his silence: overt actions or criticism by so prominent a personage against the Third Reich could have resulted in acts of retribution against his family and the Bauhäuslers and other friends, among whom the Jews, *Auslanders,* and the politically active had already suffered persecution. The unsettled status of Ati and the separation from her were worrisome. Ati was still at school in England under the watchful eye of Jack Pritchard, as her adoption papers had not yet been cleared in Berlin.

From Berlin, Herbert Bayer wrote in a nostalgic mood to "Dear Pia and Pius" and said he was trying to visualize their adjustment to the "new habitat…of Quakers, Puritans, old-fashioned buildings, etc. God knows how this Harvard University looks to you and how you will live. An unpleasant feeling creeps over my skin in imagining such a change. This may be plain laziness, not only *'Bodenständigkeit'*[18] since the soil here is not ardently loved by me." Now he repeated the appeal that came in every piece of mail from Europe: "Can't you get me a job in America? Just to get there for a few months?"[19]

Early in June Gropius held the first of what would become customary parties for master's degree students at the beginning and end of the school year — this time in his small hotel suite in Cambridge. Since there were not enough chairs, the guests sat on the floor, ate well, and talked of the United States, with Gropius and Ise contributing vivid memories of their 1928 trip. They also talked of the next day's review of the studio projects, which the students themselves were to judge. The anticipation of this event had drawn the students together, as had Gropius's emphasis on the benefits of collaborative study.

The first summer was spent preparing for the coming academic year, initiating plans for opening an architectural practice, and vacationing at "a marvelous little place on the shore" of Planting Island at Marion, Massachusetts, "where we are going to recover from…our social life…63 parties since we have been on American soil."[20] Gropius wrote letters of introduction from Planting Island for Breuer and Bayer, with some success. Breuer would be appointed a research associate in the school and Bayer would be engaged by the Museum of Modern Art. They were the first visitors to Planting Island, followed by Xanti Schawinsky and László Moholy-Nagy, who quickly revived the *joie de vivre* of earlier vacations. Alexander Dorner, who came with his wife, dubbed the gathering the "Summer Bauhaus." Of greater moment was the arrival on July 20 of Ati from England.

In October 1937 Hudnut assisted Gropius with his application for professional registration as an architect, a prerequisite for resumption of his practice. That month, following the clearance of Ati's papers and the receipt of their office and household properties from Germany, Gropius and

Ise quietly applied for United States citizenship, sponsored by Hudnut and Henry Shepley, vice chairman of the Visiting Committee. Gropius continued to exercise great care in his remarks about conditions in Germany.

Another concern was finding a more permanent residence. Gropius was much taken with the New England countryside, admiring its

> fresh optimism and boldness, and last but not least the dry clear air with its stimulating electricity. The landscape around Cambridge and Boston is fine and attractive and surprisingly unspoiled. The old white painted colonial houses, unpretentious and genuine in plan and appearance, won my affection. We are looking around in order to find a house for us in the country.[21]

Deciding on a rural setting in contrast to their Berlin and London apartments, Gropius and Ise reconnoitered the outreaches of Boston. Hudnut, who had hoped Gropius would choose the fashionable and elegant Beacon Hill in central Boston, if not the Brattle Street area of Cambridge, drove them everywhere. The town of Lincoln's virtually unspoiled beauty appealed to them most, and they found an old colonial house on Sandy Pond Road for September occupancy.

Gropius's first architectural commission in the United States was to be his own house, in the same community. His elation was obvious in a letter to Wells Coates:

> A wealthy lady here has offered me the site and capital for building a house of my own. I am going to start building in the spring, after the plans are finished. It is the second time in my life I have been given the happy opportunity of building a house of my own without having to provide the capital for it![22]

The lady was Mrs. James Storrow, an elderly, civic-minded, and progressive person who knew little about modern architecture but was interested in learning about it and who had accepted Henry Shepley's proposal that she provide a site and a commission for Gropius to build his own home to his own design. She was persuaded that a newcomer should have an opportunity to show what he could do. If the result was nonsense, it would die. If successful, it would be a contribution, and an auspicious beginning for Gropius.

Located only a short distance from the Sandy Pond residence and a fifteen-minute walk to Walden Pond, the $5^1/_2$-acre site is at the crest of a low hill, in an apple orchard in the partly open and partly wooded countryside. The house was a family enterprise, and wife and daughter joined Gropius and Breuer in its planning during the fall of 1937. There were difficulties. The Federal Housing Administration refused to provide mortgage insurance because it considered the flat roof to be unsuitable in neighborhoods of colonial design, vintage or not. Though the cost of the house was not more than $18,000, banks also were dubious about financing it until Cambridge banker George Macomber became interested and supported Mrs. Storrow in her sponsorship of Gropius. Construction began with the first thaw in March 1938. By the fall Gropius and Ise moved to their new home, where they would spend the rest of their lives.

Startlingly modern to American eyes, the house became a landmark. In 1974 the house, with its furnishings, was accepted by the Society for the Preservation of New England Antiquities, although Ise continued to live there until her death in 1983. It was SPNEA's first major twentieth-century acquisition and its first modern historic house; it is now open to the public. SPNEA's publication, *Gropius House,* gives a succinct description by Nancy Curtis:

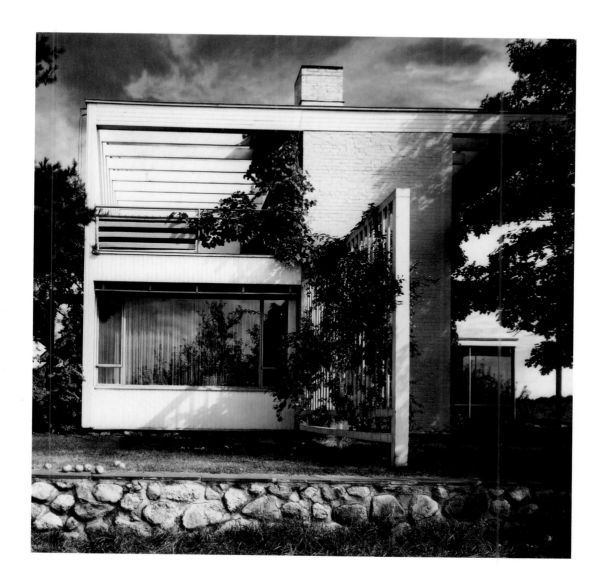

The Gropius house,
Lincoln, Massachu-
setts, 1937– 38
(now the property
of the Society for
the Preservation of
New England
Antiquities)

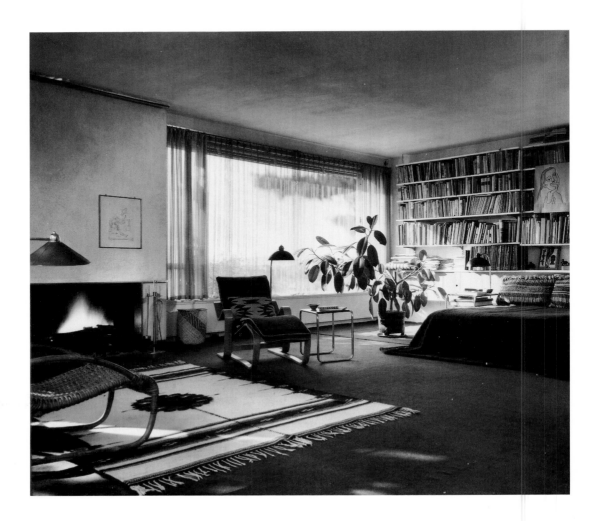

The living room. An
Isokon Long Chair,
designed by Breuer
for Pritchard's com-
pany, is placed by
the window

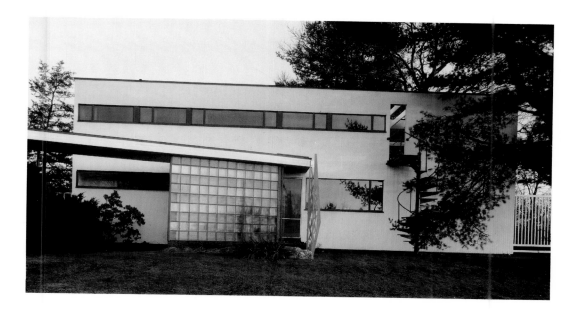

In designing his house, Gropius used the approach developed at the Bauhaus. The functional requirements of his family and his home office, the desire to feature the Bauhaus furniture he had brought with him from Germany, the challenges of an unfamiliar climate, the opportunities of the site, and the limitations of his budget were treated as givens in a complex problem. In deference to the traditional architecture of the region, he selected a vocabulary of typical New England materials and forms: wood painted white, brick chimney, screened porch, fieldstone foundation and retaining walls. He even used clapboards, although they are applied vertically and indoors. With the sole exception of the stair rail, all of the fixtures and building supplies were factory-made items readily available from catalogues and supply houses in this country. Still, despite the use of American materials and vernacular forms, the appearance of the house is decidedly European. It recalls the Masters' housing Gropius and his colleague, Marcel Breuer (1902-81), had designed for the Bauhaus, Dessau, in 1926: asymmetrical plan with flat roof and second-story terrace; ribbon windows and extensive use of plate glass; open floor plan; and prominent use of industrial materials like steel columns, spiral iron staircase, and glass block....

If the unadorned form of the house was startling, the the practicality of its design was uncontestable. Its open, compact plan eliminates corridors and wasted space. Kitchen and baths, stacked for economy, are outfitted with the most modern appliances and fixtures, including what in 1937 were novel devices — a dishwasher and a garbage disposal. The central drainage system running from the roof down through the house to a dry well eliminates tiresome and costly maintenance of gutters and downspouts. Similarly, the house is energy efficient, with passive solar gain in winter, projecting overhangs to ward off summer heat, and clever management of convection and drafts for good air circulation. The fact that the house still works like a "well-oiled machine" a half century later is a tribute to the careful planning that went into its design.

The house is first perceived as a spare white rectangle thrust into the landscape, but Gropius took pains to enliven its basic geometry with strategically placed curves and diagonals. On the north facade, the entrance marquee pushes forward at an angle, in counterpoint to the spiral staircase leading to the second-story porch. Inside, the staircase with its sinuous rail of welded tubular steel conveys the latent energy of a mainspring. The angled glass block wall

dividing study and dining room also implies motion and invites the visitor to progress towards the living room.

Beyond its satisfying play of forms, the house is enriched by humane touches that serve the needs of this particular family. Gropius recognized his twelve-year-old daughter's growing need for privacy and designed her bedroom with its own sun porch and outside entrance via the spiral staircase. He and his wife could discreetly keep an eye on her comings and goings from their two-person desk in the study below. The desk, which was designed by Breuer to Gropius's specifications for the Director's House in Dessau and built in the Bauhaus workshop, gives proof of lifelong collaboration between husband and wife.

The beauty of the site, atop a rise beside an apple orchard with views to distant hills, inspired a design that is deeply involved with nature. The house is linked to its surroundings by projecting entrance, terrace, screen porch, and vine-covered trellises. From within, large windows frame the landscape and expand the modest interior spaces. The subdued color scheme — throughout the house, a palette of whites, grays, and earth tones sparked by occasional red highlights — defers to the out of doors and modulates with the fluctuations of exterior light. The Gropiuses found that the house provided ideal growing conditions for houseplants, which became central to the decorating scheme, along with stones, shells, and branches. The house that is supposed to express reason in pure form has turned out to personify poetry as well. . . .

Today's visitor sees the house as it was in the 1960s, expressive of the Gropiuses' aesthetic vision and displaying their lifetime accumulation of memorabilia. The house contains an important collection of furniture, notably a veritable chronology of original and factory-made pieces designed by Marcel Breuer, from lightweight tubular steel chairs and tables conceived at the Dessau workshop to the plywood laminate lounge chair designed for the Isokon firm in England. The collection also includes an early desk designed by Gropius for his office at the Bauhaus.[23]

To Gropius the house in Lincoln, more than any other residence that he had occupied in his life, was "home." No matter what the vicissitudes of school, office, or world, it was his base, his sanctuary.

Mrs. Storrow was so satisfied with Gropius's response to her challenge that she allocated house sites not far away for Professors Walter Bogner, Marcel Breuer, and James Ford. She also provided land on nearby Woods End Road for John Loud to build a traditional colonial house so that old and new could be compared.

In 1939 Lewis Mumford wrote in the guest book, "Hail to the most indigenous, the most regional example of the New England home, the New England of a New World." To philosopher Alfred North Whitehead the house was bewildering in its departure from the classic and symmetrical. At the end of his inspection of it, he admitted, "I don't think at this late stage of life that I can acquire a new set of values which would allow me to savor its qualities."[24] The scholar Suzuki, who at age ninety visited Gropius, looked throughout the house and its grounds; refreshed by a five-minute nap, he launched into rare praise of its fitness and its accord with Zen principles.

There was continued reaction to Gropius's appointment to Harvard. Some architects became concerned that as teacher *and* practitioner, he might not only affect the future of design, but also direct commissions toward the new architecture and away from the established order. Recognizing how unsettled the exponents of the classic had become, both Dean Hudnut and architect Henry Shepley assuaged their colleagues' concerns (pointing out that they themselves were classicists) and assured practitioners that Gropius was primarily a teacher.

At the university, Gropius found a strange mixture of established custom and fierce independence of innovative thought. Hudnut had relegated the classic and imitative traditions to their places in history. Beaux-Arts attitudes and methodology, however, remained little altered at this time in the newly organized Graduate School of Design. Initially, change was obvious only within the confines of Gropius's own class of students, aspirants for the master's degree in architecture, but slowly it permeated the school. Replacements in faculty, among them Breuer and subsequently Gropius's own graduates, and a new program were to reestablish Harvard's preeminence in architecture.[25]

Gropius and Breuer were concerned that the structure be logically expressed in the design, as demonstrated in semi-working drawings. Though Gropius was later to state his regret that the students' ability to explain their ideas in sketches and other graphics had apparently passed with the Beaux-Arts period, he challenged them to find expression through fine line drawings without camouflage by architectural rendering. His requirements were so demanding as to leave little time for other courses, though he urged students to audit the lectures of the great men of Harvard. Although Gropius would give only one or two major talks to the entire school, he faithfully appeared twice every week at each student's drafting table, as did Breuer. His comments attracted nearby students, who frequently benefited more than the nervous individual whose new design was being criticized. His demeanor quiet, his words few, and his sketches still fewer, Gropius nevertheless elicited a response from each student. A gesture, a line from a stubby pencil out of his vest pocket, or a few questions were sufficient to direct a new attack. Frequently he appealed to the entire student group to concern itself with the realities of the housing problem and the requirements of the legislation then being shaped in Washington. He asked that they examine earlier experience and experiment in construction methods.

Each student was inspired to find a personal expression and interpretation of any project.

Gropius also encouraged collaborative efforts, perhaps of two architects with a city planner and a landscape architect, selected freely by the students themselves.

In contrast to his predecessor Haffner, Gropius was always in iron control of himself. Sometimes his own perplexity was revealed by his finger-twisting, a curling of his right eyebrow, and an even more careful search for appropriate words.

A balance was provided by Breuer's effervescence. He sometimes gave an artistic, light approach that, teamed with Gropius's fundamental and comprehensive one, offered the students an unforgettable experience. Frequently casual in his attention to a student's ideas and careful presentation, Breuer would enthusiastically project his own ideas, sometimes competitively with those of the older and more experienced students. As a result, many students found Breuer's criticisms capricious or superficial.

There were considerable differences in the kinds of students who had attended classes under Haffner and those who were carefully screened and selected by Gropius. Gropius's reputation, method, and program attracted many more applicants than he could admit. Out of some 125 he selected sixteen for his master's class. Most had experience, and through their exhibits demonstrated talent and potential. Review of their work frequently entailed correspondence, documentation, and decision — all of this in addition to exhausting pedagogy.

Gropius's already long academic day was extended by tasks carried home. To Ise's chagrin there was also mounting correspondence, much of it in reference to the founding of a school — the New Bauhaus — on Chicago's South Side by Moholy-Nagy. Moholy's advent in the United States, in contrast with those of other European refugees, was almost as auspicious as that of Gropius, who aided him in making a notable beginning as the director of the New Bauhaus. Classes there began on October 18, 1937, and shortly thereafter Moholy reported that the quality of faculty was high, the number of students, twenty-eight young men and women, was satisfactory, and that he planned to expand the school. Gropius addressed the convocation at the formal inauguration early in November.[26] His own first full school year at Harvard was progressing smoothly; his students were enthusiastic and the faculty cooperative.

Gropius had been long aware of his personal good fortune in reestablishing himself in the United States. On December 9, 1937, he wrote Arthur Korn, "I'm on the luckier side of those who left." He felt he had achieved much in a short time, but expressed his concern for those who were left behind in Germany: colleagues, Bauhäuslers, artists, intellectuals, family friends or *their* friends, or indeed almost anyone who may have crossed his path.[27] Gropius's mail was filled with their appeals for his help in coming to the United States, and in finding work once they had succeeded in doing so.

He had helped Breuer and Bayer in this way, and continued to seek additional work for them. Stressing their experience, he reminded Robert Davison that Breuer was the inventor of steel furniture and that Bayer had been the head of the advertising studio Dorland in Berlin and was working on the Bauhaus exhibition for the Museum of Modern Art. Both the younger men proposed to collaborate with Gropius on an exhibit for the coming World's Fair in New York in 1939.[28]

Gropius also tried to help Martin Wagner, for whom he successfully sought a teaching

appointment,[29] and Alexander Dorner. In January 1938 his effort would be rewarded by Dorner's appointment as director of the museum at the Rhode Island School of Design in Providence.

Among the first of the letters that followed from Europe that fall of 1937 was from Bauhäusler Ottie Berger in Yugoslavia. She had fled Holland, which she described as a "pre-Hell." It would be wonderful, she said, to land in the United States. She needed a permit and was trying to collect money due her to pay her passage. She referred to her longtime intimate relationship with Ludwig Hilberseimer; marriage could be a solution for her, but so far, that was personally difficult. "Hilbs" had nothing against it as far as they were concerned , but he believed that in marrying a Jew he would lose his passport.[30] Though Hilberseimer was by then reestablished in England, he did not marry her or otherwise attempt her rescue. Nor was Gropius able to assist her. She was unable to raise the needed escape funds, and eventually she was trapped and killed by the Nazis in Hungary.

Soon after his own arrival, Gropius again suggested that Josef Albers be invited to teach at Harvard, and in 1938 the appointment as visiting lecturer was made for a half year, with the understanding that a more lasting situation would follow.[31] The Hildebrandts also needed help. To Lily Hildebrandt, who had written a year earlier beseeching his aid, Gropius described his search for American sponsors for her husband and herself. He cautioned, "Do not expect too much, as there is such a rush, especially from the German side, that the interest is beginning to ebb, and for that reason one has to proceed carefully."[32] Correspondence over the next year lagged. The Hildebrandts were indecisive, and they did not take up tentative arrangements made in 1938 for them to lecture in the United States. In 1939 Gropius replied less cordially to another request by the art historian:

> I realise that something has to be done and I will do what I can. Last year it was still much easier. Pity that you broke it off. I have written to the same authorities regarding lectures and will let you know as soon as I hear from them. But you must realise that there are plenty of cases similar to yours at present, so that the chances have decreased a lot.[33]

Communication with Bauhäuslers was constant. Bayer, following preliminary arrangements to design the MoMA Bauhaus exhibition, had returned to Berlin to obtain proper emigration papers. Now he complained of his life in that city in his Christmas letter: "My painting has stopped entirely; it would be the rescue for my parched soul. The daily work takes all my time. I'm carrying my city winter face. My skiing has sunk so low I am even satisfied with the Grünewald."[34] Gropius increased his efforts to assist Bayer; correspondence (which would involve over two hundred letters) intensified in the spring of 1938, with the result that Bayer arrived on August 22. He quickly became engrossed in the Bauhaus exhibition.

The Bauhaus opened in December 1938, in the Museum of Modern Art's temporary quarters in Rockefeller Center. Gropius, of course, was very much involved and, given the tensions of the period, it was understandable that he would report to Bayer:

> [Alfred] Barr wrote me a long letter making suggestions for captions to be changed or added in the exhibition. He wanted also to make a statement about the number of Jews on our [Bauhaus] faculty. I refused to permit that, strictly, because I don't want to get into any discussions on that subject — despite the fact that we have had only one Jew among our whole faculty.[35]

In actuality, Barr was concerned with press and public reaction. He had anticipated criticism from

pro-Nazi sources; from pro-French/anti-German sources; from American isolationists; and from antimodernists as well as from those who regarded the Bauhaus as obsolete. Only the first group was of pressing concern, as there were already rumors that the exhibition was "Jewish." Many concluded that because the Nazis were against the Bauhaus, the names Gropius, Bayer, Moholy-Nagy, and others were "Jewish-Communist." Barr proposed a statement explaining the antagonism of the Nazis.[36] It was more emphatic than Gropius thought wise, and he rewrote it, omitting Barr's references to the hatred of influential Nazis for any kind of artistic innovation and to the fact that although Jewish students were welcomed by the Bauhaus, there were few Jews on its faculty. In his reply to Barr, Gropius argued:

> It might be well to make a statement as to the Nazi Government of today, but we should try to make it somewhat less aggressive against the Nazis so that it will look like a very objective statement. I think we should not, in any case, defend ourselves against the Jewish question...we have had only one Jew among seventeen artists on the Bauhaus faculty throughout the years, and not one on the technical staff, which comprised about twelve people all together. ...I see no reason why we should have to defend ourselves...against the foolish point of view of Hitler's. ...If you and your staff want to mention this personally to this or that reporter, it may be a good thing to do so; but I do not think we should incorporate any such statement officially into our exhibition captions. May I suggest this statement?
>
> "In 1933 the Bauhaus was closed by the National Socialist Government. Because the Bauhaus had developed during the Social Democratic regime, the National Socialists felt that it was related to the German Democracy and therefore should be excluded from the 'Third Reich.'
>
> "Actually the Bauhaus under Gropius and Mies van der Rohe had always been deliberately non-political in character. Its radical innovations took place in the fields of art and education and they were never related to any political party program."[37]

In fact, the exhibition catalogue does not carry either statement or address the matter directly.

The importance of the Bauhaus exhibition was acknowledged by Frank Lloyd Wright, who followed his visit with a trip to Lincoln to discuss the work and to meet with Gropius. Gropius described their meeting many years later:

> When Wright had dinner with me in my house in January, 1940, and we had a few hours of quiet conversation, I found him very bitter about the treatment he had received in his own country, and he referred particularly to the fact that I had been made chairman of the Department of Architecture at Harvard while he himself had never been offered such a position of influence when he was younger. He was very amiable and far from stung by any aggressive criticism on my part.[38]

In the Depression years of 1937-38, architectural commissions were not plentiful. More architectural offices closed than were opened. The practice Gropius and Breuer had started boasted few completed projects: its entire roster included his own home, that of Breuer nearby, and houses for James Ford at Lincoln and Josephine Hagerty at Cohasset. Sketches were made for others that were not built. The projects discussed as part of Harvard's overtures to him did not materialize. Still, even with the marginal budgets of the first years of his and Breuer's practice, his work gave employment to needy students, much of it in developing drawings for competitions and prospective commissions. Among the latter was the new building for the Museum of Modern Art. Initially, its patron-directors gave favorable consideration to the selection of Gropius as architect. Unfortu-

nately, one of these patrons, the influential Abby Rockefeller, had a change of mind. During a trip to Paris, she dispatched a long telegram to the museum governors and director explaining why the architect had to be a United States citizen.

Hudnut informed Gropius about Wheaton College in Norton, Massachusetts, which intended in the near future to put up a group of buildings, including a school of fine arts, a museum, a school of dance, and a theater. Hudnut and Alfred Barr, whose "judgment is highly valued by the President of Wheaton," had already recommended Gropius as architect. The college, however, decided to hold a competition for the arts center. Breuer and Gropius developed a proposal but came in second. In the end, their scheme was used as a prototype by others.

Gropius responded in kind to Hudnut's support. He wrote to an editor of the *Architectural Forum*:

I am anxious…to draw more public attention to Hudnut's achievements here at Harvard. No doubt he is the first man who has found a practicable way of bridging the old and the new in architecture, following this course very decidedly and with greatest care. On account of his modesty, he is much too much in the shade, and people do not know of his rare qualities and strength.[39]

He suggested an elaborate article on Hudnut's achievements; the editor responded by offering "a symposium on education, making Hudnut the spearhead."[40]

To Hudnut himself Gropius expressed his worry about an unexpected problem, that of having an office for private practice on school premises, as was done at the Bauhaus. A former graduate of the landscape school had denounced Gropius's architectural office in Hunt Hall to the Corporation: "This is the first act of hidden aggression I have experienced here."[41] Though it was not unusual in Germany for professors to carry on their professional work in their school offices and studios, and to utilize students in doing so, it was not permitted in the United States. Not only would nonfaculty practitioners object to unfair advantage, but the university, as a nonprofit institution, could not legally allow a private office to occupy its properties. Shortly thereafter Gropius rented space in a Harvard Square movie house.[42]

Soon after the Christmas recess there was intensive preparation by Gropius, Breuer, and the chairmen of the planning and landscape departments for collaboration between the student planners, landscape architects, and the architects in a case study for a large-scale housing and ocean-front recreation area utilizing a Boston Harbor site.[43] This was Gropius's first large-scale project in which the three departments were joined. It had followed a number of experimental sketch problems designed to overcome the customary separation of the three disciplines.

It was a successful undertaking and became the prototype for subsequent collaborations. Such work, in progress or as exhibited, interested alumni and other visitors to the school, curious as to the changes in education that were occurring. Among the visitors was A. Lawrence Kocher, who had persisted in his efforts to relate European and American architectural experience. Now he proposed establishing CIAM in the United States and holding its next Congress there.[44] The feasibility of this was doubted by Gropius: "So far as the next Congress is concerned, everything is still deep in a mess. …The greatest objection to New York…is the financial problem involved, as most of the members abroad may not have enough money to be able to pay to come over here."[45]

Gropius himself lacked funds sufficient to provide a worry-free trip abroad. His Harvard salary

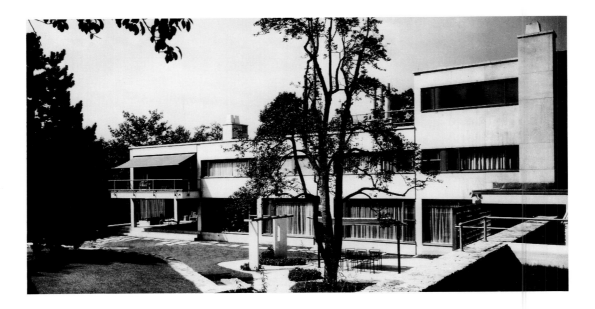

The Robert Frank House, near Pittsburgh, 1939–40. Gropius with Dahlen K. Ritchey and Marcel Breuer

was anything but munificent, and his private work was barely breaking even. In 1939 a small house for H. Chamberlain was built at Sudbury, Massachusetts, and a mansion was designed, with Dahlen K. Ritchey as associate, for Robert Frank in Pittsburgh.

During a trip to inspect the Frank house, then in its construction stages, Gropius visited the already famed "Falling Water," the home of Edgar Kaufmann, designed by Frank Lloyd Wright. Dramatically placed above a rushing waterfall, it greatly impressed Gropius; on his return to Cambridge he wrote to congratulate Wright on his design achievement.

The work in Pennsylvania led to still other opportunities for Gropius and Breuer. One of these was the interior of the Pennsylvania Pavilion at the 1939 New York World's Fair. This was a most curious structure, with an Independence Hall facade and a contemporary interior. George Howe, though a friend, could not hold back his criticism, noting the failure of Gropius and Breuer to have associated with a local architect.

Gropius's disappointment in not obtaining challenging commissions was intensified by projects that developed but failed to materialize. One of these, prepared with Breuer in 1939, was an overall campus plan for Black Mountain College, the experimental college in rural North Carolina.[46] Though their site plan and building schemes were uniquely appropriate, it did not seem possible to raise the funds required to realize them. Nor did the proposed form of construction lend itself to the level of skills and labor which the students and faculty of this cooperative school could provide. Subsequently Kocher prepared a design that accommodated unskilled and semiskilled labor. The outbreak of World War II disrupted both the building and academic programs of the college, as did the disintegration of its faculty and administrative organizations, and the college began to fade away.

It was now two years since Gropius arrived in the United States, and despite the Museum of Modern Art show, his lectures, his innovations in education at Harvard, and the building of the

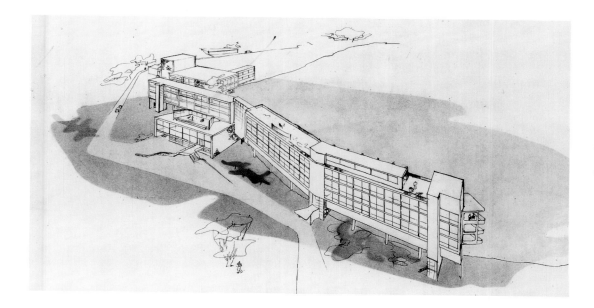

Frank house and the Pennsylvania Pavilion, he was still relatively unknown to the public. The professions and the schools, however, were more knowing, and invitations to lecture, to participate in conferences and juries, or to write became frequent. Initially, Gropius accepted few of these because of the time required for preparation. (After the war, he accepted as many as his schedule would permit, having built up a repertoire of lectures that could be adapted.) He lost no time in accepting invitations to participate in discussions on the improvement of the building industry. In February 1939 he participated in a Yale University conference on housing, where he met "the greatest men from the different branches within the building field."[47]

In Europe there were then few such discussions; the tempo of events, most of them undesirable, had accelerated. The effects of new actions by the Nazis were felt immediately in the United States in the increase of pleas for admission. Gropius and Ise opened their home to refugees, emptied their own pocketbooks and pledged future support, and aided them in reestablishing themselves. Albert Einstein, a friend from the days of the Circle of Friends of the Bauhaus, wrote from Princeton on behalf of architect Konrad Wachsmann, who was then in a French internment camp though he had fought with the French army against the Germans. The nearer the Germans came to Vichy, the more endangered became his position as a Jew. Einstein requested Gropius's assistance in facilitating Wachsmann's emigration to the United States, noting Wachsmann's Caputh house at Potsdam and other evidence of his unique ability; Wachsmann had also designed a house for him. Gropius wrote a personal letter to a former French ambassador to Germany who had been well acquainted with Gropius's parents in Berlin, asking him to obtain Wachsmann's release. This the Frenchman did, and with a visa facilitated by Gropius, Wachsmann arrived in Lincoln, undernourished and destitute, but safe.

Gropius's full realization of the deterioration of Germany and Europe surfaced slowly. Despite his knowledge of the conditions provided by refugees and obliquely by friends and family remaining

in Europe, Gropius continued to refrain from critical comment. Until late 1940, he expressed only his concern for the setback in social and cultural development resulting from the political tension in Europe. His personal and confidential letters to Coates, Pritchard, and Fry, who were all deeply engaged in England's preparations for war, appear oblivious to political realities, if not naive. In April 1939, when the bombing of Catalonia, the invasion of Czechoslovakia, and the horrors of *Kristallnacht* were known to everyone, Gropius wrote blandly to Fry:

> I hope so very much that that awful political tension in Europe may loosen a bit so that cultural problems can again come into their own. It is very hard for all of us that the mind of the average man today is too much hampered by all the political deficiencies to be open and relaxed towards those problems which are close to our heart.[48]

Six months later, with Europe wracked by war, Gropius's letters were melancholic and not yet resolute:

> It has turned out as I have feared for many years; and this time it will go through to the end more than ever before because it is not only the struggle between the "Have's" and the "Have Not's" but between the different ideologies which are at stake. . . .

> God knows how long it will go on. I don't see how this country can keep out of this war if it continues for another year or so. In my opinion nobody in all the civilized world will have the opportunity to stand aside.[49]

Yet another agonizing half year for England and Europe passed, and a letter to Fry expressed only Gropius's "grave concern" and the understated description, "lately it seems rather gloomy." He offered advice to the "too gentlemanly" English in their dealing with "that horrible Hitler," and told of his inclination "to smash the radio" that brought the news. He continued:

> I am surprised that even now most of the people haven't noticed yet that the situation in the world can be improved only by strategic steps towards thorough changes, instead of by tactical shilly-shallying. Maybe when this letter reaches you the avalanche will have rolled further down. . . .I hope they [Fry's wife and daughter] are still in the country and safe from German presents from the air.[50]

In that letter Gropius also described to Fry the complicated arrangements required to rescue Helena and Szygmon Syrkus from Warsaw:

> Great care must be taken not to do them harm by any pressure from a country which is not on good terms with Germany. Our friends in Zurich are working with those in Stockholm to bring them first out of Poland and then we must see what else can be done to provide a livelihood for them. Most of our other friends are out of German reach.[51]

But the rapid pace of the German Panzers would prove him wrong. Writing about the acceleration of war, Bayer was heated:

> Now the heavenly islands in Greece are getting their turn [from the Nazis]. Not even that can the Saubazi [Austrian swear word] leave alone. It is simply grotesque what is going on and the chances of stopping this murderous wave are getting ever smaller. I have given up answering letters from Germany since one cannot help to charge everyone who still participates in everything there with guilt, even when this may be unjustified.[52]

Another refugee, José Luis Sert, had been unable to gain recognition and thus to establish himself in the United States, but Gropius recommended him for academic positions and obtained lecture invitations for him. For a Harvard appearance, Gropius advised Sert to entitle his lecture "Can Our Cities Survive?" as it contained a challenge.[53] The illustrated presentation pleased the students but

failed to evoke any real interest on Hudnut's part. Gropius pursued the matter several months later,[54] but the dean, already concerned by the number of Europeans suggested by Gropius, thought it unwise to propose Sert following the recent nominations of Albers and Martin Wagner.[55] Somewhat discouraged by his reception in the United States, Sert considered settling in South America; Gropius immediately wrote to Bauhäusler Paul Linder in Lima, asking him to advise Sert.[56]

In the midst of all the bleak news from Europe, there were days of real pleasure, some of these wholly unexpected, when Gropius's cares were briefly forgotten. On a gray, chilly spring day in 1940, Igor Stravinsky and his companion of some twenty years, Vera de Bosset, arrived in good humor at the Gropius home in Lincoln. Stravinsky's appointment as the Charles Eliot Norton Professor for 1939-40 had given him and Gropius the opportunity to continue a friendship that had begun seventeen years earlier in Weimar. Now, offering news in exchange for drink, the Stravinskys announced that their wedding had taken place only an hour before in nearby Lexington.

There was little other respite. Gropius's desks at school, architectural office, and home were never free of tasks. His engagement books were filled with notations for weeks in advance. He was punctilious in correspondence; having recommended Hugh Stubbins, he now wrote to thank Hudnut for appointing him an instructor in architecture; having endorsed Alexander Dorner for a post at the Rhode Island School of Design, he now aided him in preparations for the *Rhode Island Architecture* exhibit at the Harvard Graduate School of Design in the fall.

Gropius's and Breuer's efforts to obtain work for their Harvard Square office were rewarded by the appearance of clients encouraged by the revival of the economy resulting from "defense" preparations. In addition, the capabilities of the office were augmented by those of the inventive Wachsmann, now healing from the adversity of war and internment. The first proposal in which Gropius and Wachsmann engaged was for a major recreation center to be located in Key West,

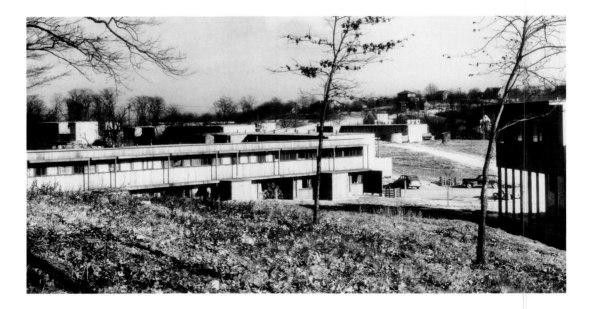

Aluminum City Terrace housing, New Kensington, Pennsylvania, 1941, with Marcel Breuer

Florida, on a site equivalent in size to four city blocks. Gropius envisioned a center for the entire family, young and old, with both indoor and outdoor facilities for the kinds of recreation possible in Florida's salubrious climate. The proposal could not be realized, given its low priority behind defense projects. It did provide, however, an opportunity for Walter and Ise to escape, even if briefly, the rigors of the New England winter. Deep-sea fishing off the Florida Keys was a memorable experience for Gropius, and they returned reluctantly to the snow and brisk routine of Lincoln and Cambridge.

Early in 1941 Gropius and Breuer, recommended by Robert Davison and James Ford to the federal government's Division of Defense Housing, were engaged to design a 250-unit development for New Kensington, Pennsylvania. This was to meet the needs of the anticipated expansion of the Aluminum Company of America. Despite the emergency nature of its program and shortages of materials and labor, the division wanted imaginative designs. The project, called Aluminum City Terrace, had become a political football between the protagonists of various governmental housing programs. Despite street barricades built to delay delivery of construction materials, the architects kept to the emergency schedule and delivered the housing in sixty days.

Every opportunity to criticize the dwellings was taken. The project was designated as "chicken-coop" design constructed by "refugee" architects selected by the New Deal government; there were complaints about its location above a more privileged residential area, and the introduction of the project children into the existing school system. Feelings ran high. Gropius and Breuer were reminded that they were not yet "Americans."

With the growth of America's involvement in the war in Europe, Gropius, like other emigrés, increasingly felt the paradox of his position. Though unsympathetic to the growth and power of Nazi Germany, he was a German — and this was sufficient to make him a suspicious person in the minds of many in the United States. But to emigrés of every nationality he remained an unfailing

source of counsel and refreshment — a man whose principles and actions had proven him to be beyond any circumstances resulting from geopolitics.

In the spring of 1941, within the school, the faculty was suffering year-end fatigue: pressures were high and tempers short. Trouble also had been brewing with Breuer. For a brief period, Breuer had worked enthusiastically at Gropius's side, but now he was restless. A younger master in the Bauhaus, second man in the Harvard master's class, and second name in the new architectural firm, he felt he had been too long in the shadow of Gropius. Given Breuer's impatience, a break was inevitable.

It came over an inconsequential incident in an end-of-term jury. Unusual for Gropius, he convened the jury fifteen minutes late. Openly rebuked by Breuer, Gropius simply said, "You would better leave that to my decision!" Thereupon Breuer informed Gropius that he was offended by the latter's conduct and misuse of authority, and that he intended to resign his teaching position.[57] He requested their professional partnership be dissolved on August 1, 1941, when current jobs, the New Kensington housing and the Abele house, were scheduled for completion. Two days later, Gropius accepted the resignation and dissolution of the partnership.[58]

It would not have been true to character for Gropius to abandon so promising a protegé, no matter how difficult a personality, and it was obviously his desire to close the schism between Breuer and himself when he wrote to their mutual friend, Bayer:

> What I feared for quite some time has now happened — a bust-up [between] Lajko and myself. The reason for it was a petty little thing, but suddenly I had to realize that I was associated in partnership not with a friend but with a foe. He [Breuer] is too deeply in love with himself, and the "*kleinmeister* complex" against the former Bauhaus Director [Gropius] has brought him to commit betrayal towards me. Also he doesn't need me anymore since he has had enough personal success now. I'm sad about it because I feel it not to be remedied.[59]

Bayer commiserated, writing about Breuer:

> He had talked to me several times about former difficulties which, I think, came from a certain oversensitivity on his part. But I thought that he might have learned some tolerance in the course of years. I regret this separation all the more since our most important work and achievements were so often the result of a happy collaboration.[60]

Despite the break, Gropius continued to befriend Breuer by providing him with references and recommendations for commissions and with support in his continuing teaching role.

The War Years: With the precipitous entrance of the United States into the war, the size of the faculty and student enrollment decreased. One result of the straitened circumstances was benign change: in April 1942 the school decided to admit women, initially from the Smith College Graduate School of Architecture and Landscape Architecture, located in Cambridge. The dean's announcement limited the arrangement to "the period of the war," then anticipated as relatively brief. Gropius wanted it to be on a permanent basis.[61] From the time of his arrival at Harvard he had spoken of the achievements of the women in the Bauhaus and had proposed collaborative architecture and landscape architecture projects with the women's school on Church Street. A few months later he commented on the changes to Moholy-Nagy:

> Here are quite some changes. The boys in Harvard drop out rapidly into the Army and Navy but the school is going

on through the summer after we have decided to take women. The Cambridge School of Architecture for girls is being dissolved and we will take the greater part of the students for the duration but maybe out of this will develop a co-education in our school.[62]

As Gropius foresaw, the innovation became a permanent and contributive one. Later, in discussing education methods for architects, he stated, "I do not think that we have to worry about the sexes. If the schools have equal rights and duties for both, you will find competent architects in both sexes."[63]

With the retirement of Henry Hubbard as chairman of the Department of Regional Planning in August 1941, tensions between planning and architecture eased and there more joint projects. Two years earlier, Gropius and Dean Hudnut had proposed, without involving Hubbard, a joint program of city and regional planning with MIT. Though the proposal was not adopted, it led to an exchange of students between the two schools and some collaborative efforts. At the same time, Hudnut put Martin Wagner in charge of regional planning studies and eased Hubbard out of his duties as chairman. With Hubbard's retirement, Wagner's role became more important. In January 1942 he and Gropius presented a lengthy paper to the students, in which they diagnosed the problems of cities, particularly in respect to housing, and presented a project for a master city plan to address postwar needs. Though Hudnut expressed some reservations about the project, Gropius and Wagner continued their efforts to stimulate discussion of the issues.[64]

During these years, there were no professional opportunities for large-scale planning for Gropius and only limited ones in housing. However, he began an association with Konrad Wachsmann to design and produce prefabricated structures. During the months that Wachsmann was recuperating in the Gropius home, they had worked out their Packaged House System and by March 1942 they had perfected the details of the system of bearing panels and wedge connectors and had applied for patents.

Robert Davison, invited by Gropius to review their work, expressed concern that the panel wood might split under the stress of the driven wedge, a fear that later proved to be groundless. He anticipated that Gropius would have difficulty in getting somebody to take up his system commercially: "Although it is theoretically far superior to most systems, most of the people now in the prefabricated house industry have very set ideas, generally their own, which would be hard to change."[65]

Prefabricated housing was of great interest to the military and other agencies of government because of its materials and labor-saving attributes as well as its ease of erection. To obtain war-scarce construction materials, form a corporation, obtain financial support, and win governmental endorsement and commissions, Gropius and Wachsmann frequently traveled to New York and Washington. Still encumbered by their enemy-alien status, they had to get travel permits for each individual trip.

By September 1942, Gropius and Wachsmann had persuaded New York investors to provide capital of $10,000 for building a test house in Boston and to establish the General Panel Corporation. Mass production of the Packaged House System also was started in California and appeared to be at least temporarily successful.

Drawing for
"Packaged House,"
Gropius with Konrad
Wachsmann, 1942

Gropius discussed prefabrication in his classes. In one exercise, he posed three problems: a suitable module, variety of appearance, and building group design. He explained his rationale:

It has become a major task of the architect to promote the use of the machine for the process of building — as it implies increasing economic advantages — and simultaneously to develop suitable means of design which would enliven the regimenting starkness of machine-made repetition. The development of such means of design has to start from the conviction that repetition of basic building elements can make for both beauty and utility.[66]

Unfortunately, the worldly problems of the General Panel Corporation were greater than those encountered in the academic realms of Harvard. Unlike Gropius's copper and Weekend Houses or his prototype houses of the 1927 Weissenhof Exhibit in Stuttgart, the General Panel House had to be constructed within wartime limitations on materials and skilled labor. In addition, investment capital was slow in coming, and producers proved reluctant. The public was more ready than the conservative mortgage banker to accept the house; the bankers, along with home builders, were already assuring veterans that they would come home from the war to a new suburban house of traditional design and construction.

Set back, but not discouraged, Gropius, in collaboration with Wagner, prepared a more comprehensive proposal for the postwar world than the one they had presented to their students in January. They now addressed the total environment, its planning and development, including, of course, the availability of housing with the qualities offered by the General Panel Corporation. They called for the involvement of the public in the planning and implementation processes and sought the decongestion of urban areas, bringing city and countryside into a close relationship. The need for mobility and the economic waste it engendered concerned them, and they advocated controls on the uses and cost of land through improved local administration. They held out promise of new efficiency and beauty in return for the public's imagination and rationality.[67]

The winter of 1942 was an arduous one, given the changes in routine, new responsibilities, and new constraints. Gropius was never allowed to forget that as a German national he was legally an enemy alien. He would be so noted through registration (number 1885751) and an Identity Card (number 2356). He was required to present himself periodically to the authorities, and if he desired to travel beyond Boston's metropolitan area for any purpose, he had to apply for permission seven days in advance. Nevertheless, it would appear that Gropius's wartime mobility was little inhibited by these constraints. His requests for travel permits were invariably accepted, and frequently by waiver of the seven-day application period.

Gropius was accepted by his neighbors and colleagues: he was never openly molested as an alien and there were only a few acts that could be interpreted as discrimination against him in public, in school, or at home. However, isolated incidents, such as the bombardment and staining of his and Ise's white-walled house by youths hurling tomatoes, did occur during the tense war period. Gropius chose to regard the incident as a prank rather than malicious mischief, since the tomatoes were taken from the garden of a "bonafide American" neighbor, James Ford. On another occasion, a charwoman spread the rumor throughout the community that Gropius rode on horseback into the woods every morning to a secret wireless transmitter, which he used to send coded messages to the enemy. Only the action of a prominent neighbor brought this gossip to a halt. Again Gropius

chose to interpret this act and the degree of acceptance it received as stemming from ignorance, rather than hostility.

Still, Gropius did not obtain certain commissions because of his status as an enemy alien. Hudnut, acutely conscious of Gropius's status, constantly suggested that Gropius maintain a low profile, advising him not to push himself forward or be too aggressive in seeking jobs during the war years. This counsel was so insistent that Gropius complained, "Hudnut wants me under a cloak!"; he noted that other aliens from the professions were received as heroes. Despite this constraint, he felt peculiarly indebted to Harvard University for its open acceptance of him, and he repaid its tolerance by expending even greater effort on his teaching and administrative duties.

Gropius followed the news of the war assiduously. Refugees, uniforms in Harvard Yard, reduced enrollments, billboards, rationing, and the casualty lists provided constant reminders of the war. He was concerned for a German people whose government he now knew had to be overthrown, and for his English friends, whose austere dignity in the midst of their suffering he admired. With the United States' deepening involvement, however, there was a change in the tone and content of Gropius's letters. At times they became even optimistic. In his correspondence with Max Fry, Gropius reported that there were only small inconveniences in transportation, his Lincoln home was most comfortable, and the school was going well now that women were being accepted as students. In early 1943 he noted that the effects of "total War were beginning to become a reality in the United States."[68]

In 1942 Mrs. Storrow had asked Gropius to study the subdivision of her great estate in Lincoln, on which he had built his home. When he had built there, the urbanization of areas contingent to great cities was almost indiscernible. Further development was held back by the war, and in 1942 the open space and quiet activity of Lincoln's earlier days persisted. Many of the fine white clapboarded homes of the pre-Revolutionary and Federal periods were still in use as farmhouses; others had been lavishly restored on large estates and were occupied by the wealthy, who commuted daily to Boston.

The hinterland of Lincoln remained relatively untouched. The country roads which served as feeders to the highway, almost hidden by the hedgerows and hills, barely disturbed the scene. Though the environment was rural, with tilled fields enclosed by well-mended drystone walls and rolling hills of apple orchards and woods, Lincoln's appearance was one of sober elegance. Gropius's initial appreciation of the area was only reinforced by his years of living within it, and he sought to protect the key qualities of the environment through his design for the use of the land.

The site plan for the Storrow estate was sketched out by Gropius, who had explored the estate on horseback and on foot, in the early spring of 1943. He proposed dividing the site into nineteen very large lots in addition to the Storrow estate and that of Harvard President Conant. Even the smallest property would be composed of three or more acres laid out insofar as possible to provide privacy for the owners and to include some unique features: a stone wall, a brook, a wooded area, or a particular view. Public spaces, woods, swamp, orchards, and cultivated fields were set aside, less as recreation areas than as nods to the tradition of the New England common. A school site and space for recreation were designated as well.

On June 12, 1944, Gropius became a United States citizen. He was elated. He felt himself to be accepted, no longer stigmatized by the label of "enemy alien." Having forsworn any residual allegiance to Germany, he could now conscientiously reconcile his pride in his Prussian-Huguenot lineage with his loyalty to the United States. He was at "home," and he consciously dispelled any lingering thought of Germany as the "Fatherland." As a citizen he could speak out, travel as freely as wartime restrictions would permit, and advance his professional associations and architectural practice.

There was encouragement in the stories Fry and others carried from Europe. Though Gropius hardly allowed himself to believe their portent, the shaping of resistance to the National Socialist dictatorship was already well known; on July 20, 1944, there was an abortive attempt on Adolf Hitler's life. Mounting successes by the Western allies led Gropius to reflect on the consequences of war in a letter to Fry:

> The horizon looks brighter now, fortunately, and it may be that by the time this letter reaches you there, the last phase of the war in Europe will have arrived, although the last run may be bloody and hard for both sides. It is really pathetic to think of what will be left of Europe after this war — I mean not only the visible destruction but that which has been destroyed in the human mind: it will have deteriorated a whole generation. . . . I cannot help thinking what would have become of a country which might have spent only a quarter of the amount of money spent for this war in making order in its own boundaries, building up settlements, schools and education. Such a country would be unbeatable — but the world seems to be not yet mature enough for such a step.[69]

Gropius was correct in his observation about maturity. The exigencies of the war had given greater credence to technological solutions than to humanitarian ones.[70] Thus it was not surprising that a report by a Harvard committee in September 1944 on the objectives of a general education in a free society gave scant attention to the visual arts and design professions.[71] In what was to prove to be one of the last joint efforts between Gropius and Hudnut, a strongly worded ten-page response to the report was sent to the committee through President Conant, a scientist without great depth of understanding of nonscientific areas.[72] More than two years passed before Conant asked them to further explain their viewpoints, and, without the collaboration of Hudnut, Gropius set out the need to relate emotional and intellectual faculties to "doing" in order to develop creative ability — an approach of integrating "doing" and "thinking" that he postulated could be accomplished through training in art.[73] Conant acknowledged his own lack of understanding of Gropius's suggestions, but encouraged him to pursue his ideas with the Department of Fine Arts and Dean Paul Buck.[74] The thoughtful statements prepared by Hudnut and Gropius were not heeded and the report was neither amended nor supplemented — an omission that fairly represented the contemporary view of the university's scholars toward the professional schools.

The blessings of citizenship did not include freedom from all problems. Indeed, Gropius's appreciation of the privileges of his new status led him to accept additional civic responsibilities. Few of these contributed to fame, and none to fortune. Among them were his continuing efforts on behalf of Black Mountain College, where daughter Ati was enrolled. It was from Black Mountain that the Danish novelist Isak Dinesen wrote to thank Gropius and Ise for introducing her to Robert

Dreier and Alexander Dorner; she also informed him of a faculty revolt against Dreier and Josef Albers in that already troubled school.[75]

Many of the problems of Black Mountain College were not dissimilar to those of the New Bauhaus in Chicago and its successor, the Institute of Design. Fortunately for the latter, it had the support of Walter Paepcke, the head of the Container Corporation of America and a man of wide interests; the products, offices, and factories of his firm reflected his concern for good design and for comprehensiveness. Through the New Bauhaus, Paepcke and Gropius met and became friends. As a result of Paepcke's interest, Gropius was appointed consultant architect to the Container Corporation in November 1944; he served as design consultant on the corporation's factory buildings until 1946, although his commitment to Harvard limited the amount of his work.

Paepcke recommended him for other design work, such as the proposed Milwaukee War Memorial. More importantly, Paepcke engaged him as consultant for the rehabilitation of Aspen, Colorado, and its establishment as an intellectual and recreation center. Soon thereafter Gropius recommended Bayer for the position of art director of the corporation, with the result that Bayer went to Aspen, where he gave leadership to creative arts activities as well as to the town's replanning and building. Gropius made the most of his own visits to Aspen, riding into the hills during those business trips which extended into weekends. But his academic responsibilities weighed upon him and quickly drew him back to Cambridge.

The school and the architecture department were quiet; the enrollment was not large, and graduating classes for the bachelor's degree, the first-level professional degree, were composed predominantly of women and students from other countries. In 1943 there had been eleven women and seven foreign nationals among the twenty-five June graduates; proportions were similar in the 1944 class. In the fall of 1944 Gropius again launched his master's degree course; there were no women despite the propitious previous year, and five of the men were over forty years of age. By early 1945, with war veterans returning to school with federal scholarship aid, the proportions had begun to change; of the thirty-four graduating students, nine were women, and from other countries there were eight men. The veterans' impact on the school was considerable, especially since there was a shortage of instructors, and Gropius felt he had to forgo his long-awaited sabbatical. Thanks to this sacrifice of personal time, the school prepared to expand its program. By the fall of 1945, though Harvard University had perhaps no more than half of its peacetime enrollment, the architecture department had 50 percent more than its earlier peak.

Gropius remained concerned for friends and family in Germany and England. For over a year, from early 1945 through much of 1946, Gropius sought information about his sister, Manon Burchard, known to have survived the war and thought to be living in Berlin-Charlottenburg. He approached Massachusetts Senator Leverett Saltonstall and the State Department. He wrote to the commander of the American armed forces in Berlin, as well as to young architects, planners, and others serving in the Berlin area who might aid in the search. He also turned to the Red Cross and to the American Friends Service Committee. Military investigators found Manon and her daughter living in straitened circumstances not far from what had been their home. Gropius then began to send as much as was allowed in funds and food to Manon and, through her, to other members of

the family and to friends. Though he begged her to join him in the United States, Manon refused, and more than a year elapsed before they would be reunited in Berlin.

A letter from Lily Hildebrandt dated January 30, 1946, finally arrived in June. Though Jewish, she had managed to survive, though now she was in most desperate straits. Gropius responded immediately:

> Your letter…seemed to be like news from another world. Letters from my German friends are piled up on my desk. Everywhere reports about losses of relatives and estates, about being tired because of fighting for the necessities of life. The corporal Adolf has piled up a glorious inheritance.[76]

At the same time Gropius wrote to Jack Pritchard about Lily's plight and the possibility of her moving to England. Several months later he wrote again to Pritchard, who had sent food packages to her: "Regarding parcels in Germany, we have been quite touched by your offer to help but I think we should not accept that because we know that you are not swimming in fat over there."[77]

The end of the war was less a time of rejoicing than one of relief and concern for the survivors, and of concern for the establishment of a just peace and a new life for the peoples of both vanquished and victorious countries. Gropius was initially sanguine in his view of European recovery. To Max Bill he expressed the hope that a new and better future might result from all the suffering:

> We are looking with greatest interest towards mental and spiritual development in Europe which, after having suffered so much, is more apt to develop new methods of future approach than we in the States, for the wealth of the States makes people here at present too conservative and too complacent. There is too much victory in the air which blocks the imagination, but that does not mean that there are not incredible possibilities here and the great optimism in genuine feeling in democracy of the average man gives a promise.[78]

A month later, less optimistic, Gropius wrote to another friend:

> The debacle over Germany is complete and the failure of the Allies to create conditions out of which a reasonable new world might grow is appalling. All news which might bring the thought of the Americans on a more constructive track is suppressed. The conspiracy of silence of the American press is a very serious trend.[79]

The Postwar Period: After the war, Gropius's planning philosophy found ready acceptance in Chicago and the Midwest by a large sector of the public. This acceptance had its roots in the architectural history of that portion of the country. Its frontier-like vitality and curiosity had been responsible for the architects of the Chicago school (like Louis Sullivan) and Prairie school (such as Wright in his early houses); their innovative work had stimulated architects throughout the country. There is no question that Chicago's New Bauhaus, and its successor school, the Institute of Design, under the leadership of László Moholy-Nagy and subsequently of Serge Chermayeff, advanced Gropius's philosophy in the Midwest. The basis for his greater involvement in the area had been well laid by February 23, 1945, when he addressed twelve hundred business and civic leaders at a meeting sponsored by the Chicago Association of Commerce, the Chicago Plan Commission, and the Institute of Design. His thoughtful analysis of urban problems and his hopeful outlook for Chicago stimulated the subsequent launching of the vast programs for redevelopment of its slum areas.[80] Gropius himself had "a feeling of extreme satisfaction about this Chicago event. It is somewhat like a dream to me that it should have been possible to assemble that type of crowd for my speech."[81]

It had indeed been a distinguished gathering. At the speakers' table, in addition to Gropius, were two university presidents, Robert Hutchins of Chicago and Franklin Snyder of Northwestern, as well as Ludwig Mies van der Rohe, merchant Marshall Field, and Mayor Edward Kelly.

The speech was widely reported and, among other effects, it initiated a correspondence with labor leader Walter Reuther on housing. Reuther was concerned that the benefits of prefabrication or industrialized housing might be offset ultimately by a concomitant reduction in construction employment.[82] Gropius replied that he foresaw no end to the housing shortages and the need for skilled as well as unskilled workers.

Before the end of the war leaders on Chicago's South Side established plans for postwar development. These would lead to one of Gropius's most elaborate experiences in city planning. In September 1945 he became consultant to the recently formed Planning Staff of Michael Reese Hospital, Chicago's largest private medical institution.

The hospital was faced with the choice of abandoning its present facilities to relocate in an area free of blighting factors, or remaining in its slum location and taking steps to recapture some of the qualities that had made the area Chicago's most fashionable residential district some seventy years before. Before Gropius entered the scene, a decision had already been made by the hospital's board, on the advice of city planner Walter H. Blucher, executive director of the American Society of Planning Officials, to remain and solve the hospital's and the area's problems by planning.

Gropius and Blucher were joined as consultants by Louis Wirth, professor of urban sociology at the University of Chicago. The initial Planning Staff itself included three of Gropius's graduates, as well as a graduate of the planning department of Harvard (the author), and a sociologist. Their responsibilities included planning the hospital's expansion and planning and stimulating private and public redevelopment of the entire twelve-square-mile southeast sector of the city, which included seven square miles of blight, the largest slum in the United States at that time. The hospital

campus would require a hundred acres to meet the community's needs in medical care, research, and education. Nearby was the rapidly growing Illinois Institute of Technology (IIT), whose Department of Architecture was headed by Mies van der Rohe and city planning studies were directed by Ludwig Hilberseimer. By 1946 the IIT, the Catholic Archdiocese, other institutions, industries, unions, and representatives of the community were persuaded to join with the hospital in forming the South Side Planning Board.

Gropius's initial role was to provide his "strongest criticism and guidance" in the preparation of "a sketch plan of the optimum development of the medical center campus," and then of a "more deliberate re-study of goals and preparation of several stage development plans."[83]

The Planning Staff had naively hoped that it would have sufficient authority and responsibility to coordinate, within close guidelines, the work of architects to be selected for projects in the development of the hospital's campus and the community. Unfortunately, the distinguished architects recommended by the staff for the hospital, Mies van der Rohe and George Fred Keck, lacked any social and cultural connections with the board members or a record of contributions to the parent charities federation. The interviews were dignified but colorless; there was little communication, let alone understanding, between the architects, who obviously did not relish salesmen's roles, and the uncomfortable board members. Design competence appeared to weigh little as a criterion for appointment.

By coincidence, while these plans were getting under way in November 1945, John Harkness, a young architect who had received his master's degree at the GSD just before the war, suggested to Gropius the formation of a cooperative office. Gropius was receptive. Harkness's friends and prospective members, architects Norman and Jean Bodman Fletcher, wrote to Gropius in some enthusiasm, looking forward to such a group under his "guidance": "Thus our aims become, not architecture for architecture's sake, but architecture for the sake of a healthy society."[84] Mrs. Fletcher, who had received a bachelor's degree in architecture at the GSD in 1944, also recommended as members architects Louis McMillen and wife Peggy, and Benjamin Thompson. Even before an initial meeting on Sunday, November 25, Gropius had already decided that it was a positive idea and that he would put his "eggs in the basket."[85] There was mutual agreement and the group, including Sarah Harkness and Robert McMillan, was formed within weeks. As The Architects Collaborative (TAC), their unique team practice was organized formally early in 1946.

A hospital board member's suggestion that Gropius and his TAC associates be brought in as a design coordinating team was met with poorly concealed dismay by the Planning Staff, who were Gropius-trained themselves, some with considerably greater work experience than the young partners of TAC. Reginald Isaacs, the planning director, explained to Gropius, "Introducing a new team to the study of this problem would be deemed by others as a reflection of inadequacy on our part and thus weaken our standing — whereas it is absolutely essential to continually strengthen our position."[86] Disappointed, but appreciating the staff's position, Gropius again recommended Mies van der Rohe.[87]

At the end of the first year of work on the Chicago project, impressed by the progress made

despite lack of precedent, Gropius stated in a staff report that the experience had proven that "all the phases of the community life are insolubly intertwined with each other and have a definite bearing on the long-range development problems" and that planning and architectural design were one indivisible whole. [88]

The Chicago project, though it would continue for years, was far from lucrative, and Gropius sought to expand his and TAC's practice. Initial growth of TAC was slow, very much dependent on the team's innovative house designs; and the members supplemented their incomes by teaching opportunities at Harvard in the Department of Architecture. In the TAC office two college campuses were being planned by Gropius and Norman Fletcher. The first of these was for Black Mountain College in North Carolina, for which the TAC architects served as consultants on the master plan and on the design and construction of dormitories. TAC also worked on the development plan of the Hua Tung Christian University of Shanghai, with the assistance of I. M. Pei,[89] who had been a member of Gropius's master's class and had just graduated from the GSD. Though a sensitively designed campus plan was complete and submitted, the continued strife in China forestalled its actual development.

The collaborative study project of a township Gropius had initiated at Harvard was being completed in the late spring of 1946. Gropius now proposed that a campaign be started to carry out the plans. He noted that subsequent to the building of the Greenbelt towns there had been no further attempts to build planned communities:

> The drawbacks of those first laboratory planning tests have been duly recognized and can be avoided in the future. Experts, as well as the laymen, seem to be more advanced now, understanding better the complexity of the problem involved in how to get better balanced communities. It might be very possible to get sufficient public support for action. The influence to be expected from such newly built townships would be immensely fruitful for the whole development in planning.[90]

With the completion of the school year and with office projects in hand, Gropius could take a long-awaited vacation with relative ease of mind. His diary for Tuesday, July 15, 1946, reads simply "Baker Bridge Road — 3 p.m. — off to Mexico."[91] Saturday announces "Mexico City," where Walter and Ise would remain for three weeks with short excursions to the countryside. They were entertained and escorted by Max Cetto, Jorgé Gonzales Reyna, and other faculty and students of the University of Mexico, as well as by muralist David Alfaro Siqueiros and other artists. In part, it was a busman's holiday, for Gonzales Reyna, a recent alumnus of the GSD, had proposed collaboration in the design of a church. For this the men inspected possible sites and reviewed and improved the sketches Gonzales Reyna had prepared. It was this visit that gave rise to a favorite story of Gropius's:

> I was in the house of Max Cetto in Mexico City at a party with Diego Rivera and Frank Lloyd Wright. When Wright came in, I had just started a discussion on teamwork. He sat down at my side and listened with a grin on his face. When I had finished, he said, "But Walter, when you want to make a child, you don't ask the help of your neighbor, or do you?" I answered, "If the neighbor happens to be a woman, I might."[92]

Thereafter, there were eight days by auto to Laredo, a few days in New Orleans, and home by the end of August.

With the advent of the new school year and the work at the office and on Chicago's South Side, the euphoric summer was quickly forgotten. Gropius was also concerned about the Institute of Design in Chicago and Moholy's failing health. Throughout the year Gropius's letters to Moholy and his wife, Sybil, urge his old colleague not to overwork. But Moholy could not slacken his pace, and in November Gropius related his concern to Sert:

I wonder whether you have heard already that Moholy fell deadly sick. He has a rare blood disease, a kind of leukemia. The situation seems to be very critical. ...He knows about his condition. ...The last diagnosis was that it...might be controlled at least for years. I hope that his great stamina and his strong heart will pull him through.[93]

Only days later, Moholy died in Michael Reese Hospital.

It was a truly personal loss for Gropius. Writing about the funeral to Moholy's first wife, Lucia, he told her, "I made a speech too and it was difficult for me to keep my countenance." In his eulogy he had praised Moholy's boundless vitality and his versatility in the vast field of design, and "the directness of his intuitive approach. Here was the source of his priceless quality as an educator, namely his never-ceasing power to stimulate and to carry away the other fellow with his own enthusiasm." To Sybil he wrote in great understatement on December 30, "I miss Moholy more than I can tell you." In reality, it was more than Gropius could tell anyone.

Without Moholy's energetic and persuasive leadership, the Institute of Design again faced crisis. Though Gropius recommended Serge Chermayeff as director, the Institute's problems were not ended with his appointment. Dissension resulted from the differences in his approach to administration, pedagogy, and design from those of Moholy, and from the critical attitude of his widow, who had wanted to be director.

Commissions in TAC's first years were not plentiful, and the opportunity to participate in a closed competition for an elementary school in Attleboro, Massachusetts, was welcomed. John Harkness, Louis McMillen, and Gropius were responsible for TAC's entry, which was awarded first

prize. A commission to build, not an elementary school, but a junior high school, was awarded to the firm two years later.

In these early years of TAC, Gropius's services continued to be more in demand than those of the struggling young firm. The Department of the Army appointed him to serve as a consultant on planning for the reconstruction of devastated Germany. At the end of July 1947 he went to Washington for briefing on his appointment as a visiting expert to the United States Military Governor of Germany, General Lucius D. Clay, on housing and city planning problems. Apprising Hudnut of his imminent flight to Germany he wrote that he felt "a strong urge to see for myself what is going on over there."[94]

Soon after his arrival in Berlin on August 5, Walter wrote to Ise, mindful of their first real separation in thirteen years:

> Saturday, 4:00 p.m. I left Westover in a DC4 cargo plane (military). After ¾ hour flight it was discovered that one of the motors was faulty, so back to the point of departure. After an hour left again for Newfoundland, where we arrived in Stevensville at 10:00 p.m. Two hours delay, then off over the ocean. In the fourth hour I woke suddenly, it smelled of smoke, I alarmed the crew who all jumped up like electrified; the plane was burning. Life belts and parachute harnesses were put on and we turned immediately to Newfoundland... .
>
> To my own surprise I was quite relaxed and calm while even the crew members were extremely nervous. ...With great effort the fire was kept under control until we finally landed again. ...In the early afternoon we left again. ...After ten hours smooth flight over fairy cotton clouds we reached the Azores. Landing took an hour in thick fog. Midnight dinner during a rainstorm. European atmosphere, twice departure alarm, finally at four in the morning off to Europe. Ten flight hours to Frankfurt, rough and bumpy over France, Paris below. In Frankfurt almost immediately into the Courier plane — I carried letters to General Clay — which brought me in one and a half hours to the Tempelhoferfeld in a bucketseat as you find in a rack-wagon. Then in a bus through the indescribable misery of Berlin to Dahlem... .
>
> In a car through the city...Berlin is a has been! A disintegrated corpse! Impossible to describe. The people bent down, bitter, hopeless. In the evening a meeting with Scharoun, Max Taut, Redslob, Lilly Reich — all so old looking that I scarcely recognized them. Only Scharoun still has fire. I shall go to him tomorrow.[95]

Gropius's day and night schedule was filled with briefings, conferences, and inspections with army staff members and officials of the military government. He found Clay to be well-meaning, but naive as to planning and redevelopment. Accustomed to ordering his engineers to provide an instant bridge or other construction, he requested Gropius to "make me a plan for Berlin."[96] Gropius warned that city plans were dangerously misleading if not made with great care. There were constant inquiries from the ever-present world press, to which Gropius replied guardedly. His attention was demanded by Deutscher Werkbund members, city mayors and building officials, radio talk show hosts, university faculty and students to whom he lectured, the public, and old friends. In addition to Wils Ebert, Hans Scharoun, Hans Hildebrandt, and Erwin Redslob, there were Bauhäuslers, among them Gerhard Marcks and Hinnerk Scheper. The latter, in hiding during the Nazi regime, now held an official position with Hans Scharoun and was responsible for the restoration and administration of historic buildings. Scheper had been persuasive in dealing with the occupying powers and had accomplished much, which he showed Gropius on an inspection tour.

Only a few months earlier, on June 5, 1947, General George C. Marshall had proposed the European Recovery Program. Shortly thereafter, food, medical supplies, seeds, machines, and raw materials flowed to the European countries. Gropius was questioned eagerly about the Marshall Plan by German industrialists, avid to reestablish their enterprises. Gropius could only say then that assistance was under way. After Berlin and Frankfurt, Gropius also inspected Bremen, Hannover, Stuttgart, Wiesbaden, and Munich, each more broken than the last.

Gropius submitted his report for General Clay. He described first the need for social as well as physical rehabilitation, noting that there had been basic changes in population, production, and transportation. He proposed a central committee or institute such as the past Reichsforschungs-gesellschaft or a National Resources Planning Board for all of Germany to do research "in the structure and functions of the whole middle European area, e.g., distribution and changes in population, inventory of means of production, of transport and of utilities, land-use maps, and legislation for zoning and eminent domain."[97] Such a committee would give directives to a "Ministry of Reconstruction," which would have broad powers to integrate planning and building, including control of essential materials. Gropius urged that eminent domain legislation, such as that in England, which he considered a desirable precedent, be prepared to avoid the perpetuation of obsolete city patterns within the destroyed areas.

As a means of social rehabilitation Gropius recommended the use of the "neighborhood unit." He believed that this concept would "challenge the citizen to participate responsibly within his local group, thus promoting democracy." Noting the shortage of manpower and materials, he called for a rationalization of building methods. He was critical of the "mechanistic and technocratic" rather than the creative approach (giving as an example of the former the work of his one-time Bauhaus manager Ernst Neufert, which he termed "over-standardization").

Gropius received hundreds of inquiries about his inspection trip. He described his impressions in a letter to Sybil Moholy-Nagy:

> Conditions in Europe are appalling. I had a most exhausting trip in Germany. People are like dry sponges clinging to everybody who comes from outside. The door was shut tight for twelve years. People came 30 hours by train from the Russian Zone to have half an hour's talk with me and that happened almost every day. It was very interesting but sad; not only the material deterioration but particularly the social one is beyond description and it is still going downhill.[98]

In another report for General Clay, Gropius, anticipating the possibility of a collapse of the Four Power agreement and hoping to resolve conflicting views among the powers as to the location of the capital of West Germany, examined the alternative choice of Frankfurt am Main. Despite his personal identification with and love for Berlin, his report was most objective in its analysis; its recommendations about Frankfurt were well received.[99]

Unfortunately, an unsubstantiated story alleged that Gropius was indiscreet in his use of his report, that he prematurely gave out a military secret. What actually had happened was that following his return to Lincoln from Germany but before his report was complete and his debriefing held in Washington, Gropius was awakened at three in the morning by one of the press wire services and bluntly asked, "Why were you in Frankfurt?" He replied that he could not give out information

before his debriefing. After it had taken place, Gropius was called again in the middle of the night, and he did then provide a brief story as to why he was sent. The newspapers reinterpreted Gropius's modest statement, publishing their delight in the cleverness of the United States in foreseeing the collapse of the Four Power agreement and in sending Gropius to Germany to probe into the facilities of Frankfurt. Such a story must have convinced the Russians that the Western Allies had never been serious about the agreement, which was true, but it was highly indelicate to trumpet it to the world! Gropius was much embarrassed and characteristically wanted to reply, but he was advised to let the matter die. His chagrin was great, and he told his story many times; to Martin Wagner's son, Bernd, he wrote:

> There has been a lot of wrong talk in the papers about my trip to Germany and what I did there. Sensational news about new plans for Frankfurt/Main were published but that was all an invention of the Press. All I was asked to do was give an outline how best to proceed with the planning of greater Frankfurt to be the capital of Western Germany so I sat down and lined out such a procedure, naming also people whom I thought would be appropriate for the job, but I made a definite suggestion that the planning should be done by Germans, not by Americans or the British.[100]

En route home from his August trip to Berlin, Gropius had reported on his experience in Germany to a not entirely sympathetic audience at the 1947 seventh reunion of CIAM in London (September 7-14). But he enjoyed the reunion with friends at the CIAM meeting. They now were older and subdued, recognizing that a new world had to be created and that they lacked the vigor to attain this alone. Back home he reported:

> By momentum of ideas the movement has spread on its own without our knowing it. New groups like the Czech, Argentine, and Cuban are certainly encouraging and it seems to be worth going on pushing in the same direction as we have done since 1928. ...I am digesting slowly all my impressions in Germany and England. It certainly is a dismal world and here where there is plenty of good life in the material sense, reaction is flourishing.[101]

Knowledge of Gropius's visit to Germany spread rapidly; the Bauhäuslers had been widely dispersed during the war, but even in faraway Shanghai, Richard Paulick had heard of it. He wrote asking Gropius's advice about leaving Shanghai to aid in the reconstruction of German cities, work for which he had received invitations.[102] Gropius replied most explicitly:

> My impressions have been devastating. It is unimaginable for somebody who hasn't seen the realities in Germany today, how deep the destruction has gone, spiritually and physically. It was particularly difficult for me to bring myself into a mood to talk in an encouraging and positive way. My only hope is in the spirit of the older generation, educated before Hitler. The youth who grew up under Hitler is cynical and very difficult to handle.
>
> No building whatsoever is going on in Berlin...it is not impossible that the Russians want to make a special show by rebuilding the university but only by very definite exceptional priorities could this be done under their command. ...I went into the Russian sector of Berlin several times, directed by my old Bauhaus friends, Scheper and Schmidtchen, and I will not forget what I have seen. The food in the Russian sector of Berlin is much worse than in the other three. ...You asked me whether I could advise you to go to Germany. I definitely cannot.[103]

Gropius's concern for the German people was shared by some at Harvard. John Coolidge, then director of the Fogg Museum of Art, proposed the training of numbers of young German architects and planners each year under Gropius's guidance. He also suggested that Harvard's Germanic

Museum was the most logical institution to correct the incredibly narrow and appallingly smug attitude of the United States toward the whole problem of reeducating Germany.[104] Gropius was enthusiastic; he suggested only that other European students be brought over as well. He noted that in the somewhat similar efforts of the great Allied program to "re-educate the Germans" much was achieved, but solid German standards and traditions were sometimes abandoned along with Nazi ideology.[105]

Redirection and adjustment were required not only of Germans but also of the Third Reich's victims who had managed to survive. Among the latter was Adolf Sommerfeld, who had amply justified Gropius's confidence in him. Though there had been little correspondence between them over a decade, the irrepressible and energetic Sommerfeld had moved to England and adjusted to his new life with extraordinary ease. No longer Adolf Sommerfeld, but now Andrew Sommerfeld, he was reinforced by his son's invention of and success with the Sommerfeld Track for aviation, and the acceptance of his own "toy building blocks," which were elements for prefabricated housing.[106] In February 1948 he wrote announcing his imminent arrival in the United States in search of expanded markets, and within days Gropius wrote that he had established contacts for him. Sommerfield never did follow up Gropius's recommendations nor pursue contacts that he himself had in the United States. In each of three countries, Germany, Palestine, and England, he had succeeded in establishing prosperous construction and materials firms; he had no real need to prove himself further. Unable to visit Lincoln in his bustling visit to the United States, Sommerfield nonetheless continued to correspond with Gropius. In one letter he proposed his introduction into an international consortium for the provision of prefabricated housing to Palestine. Evidently he had no knowledge of the General Panel Corporation, for he wrote: "Wachsmann…has some important business which it seems he cannot tackle. …I gathered that it is something to do with prefabricated houses. …I feel like an experienced surgeon who sees an operation being done by students, and regret that I have not been asked for my advice at least."[107]

This was a discouraging time for Gropius, with his concern for the Germans, conflicts at Harvard and in the Chicago project, and worry about Ise's health. In October 1946 she had had a disastrous automobile accident that nearly cost her her life; her right ankle was smashed and broken ribs penetrated her lung. She spent many weary, painful weeks in the hospital, during which Gropius was with her every possible moment, curtailing travel, shortening his Cambridge office and school hours, and bringing home much of his work. For two years she would be in wheelchairs and on crutches.

For quite some time, Gropius had been aware that Hudnut had cooled toward him and toward the faculty of the Department of Architecture in general. Yet for a decade Gropius and Hudnut had been not only a harmonious academic team, but also the best of friends, with mutual respect and admiration for each other's unique gifts.

To the public, Gropius *was* the school, though it was Hudnut who had made the break with classical tradition, had integrated the school's three separate departments, and had had the foresight to engage Gropius. Yet he was not sufficiently recognized, and he began to resent Gropius's presence. Jealous, he tried to weaken Gropius's position and to diminish his prestige. Small, almost

Left: With Joseph Hudnut, 1942

Right: Gropius's faculty meeting notes, circa June 1948

trivial, incidents of disagreement between them grew into major conflicts over school and departmental policies. For example, Gropius considered the postwar enrollment in the school to be too large for high-quality graduate education. Hudnut, concerned with budgetary problems, decided as dean to maintain a high rate of admissions. Unaccustomed to Hudnut making decisions unilaterally, Gropius termed his actions "dictatorial" and offered to relinquish the chairmanship of the architecture department to Hudnut and confine his own activities to the master's class, "as I do not want to be in opposition to you."[108]

By early spring of 1948 the friction appeared to Gropius to threaten the well-being of the entire school. His personal notes of this period are vibrant in their terseness of phrase and reflect his inner turmoil. One of them concerned a discussion Martin Wagner had with Hudnut in which the dean had complained that Gropius had too much power and ran the school materialistically, that he was discourteous, that he never recommended Hudnut's course to students, and that, without informing Hudnut, he had advised on the form and content of an Institute of Design exhibition in Chicago which was a challenge to Harvard's own basic design course, an exhibition Hudnut described as "rotten, dishonest and bad showmanship."

On his own, Hudnut sought to maintain his power by dealing unilaterally with individual teachers, bypassing the departmental chairmen and committees that he had established. TAC members who taught in the school and other instructors loyal to Gropius's precepts, or who thought they could gain by their allegiance, also formed a bloc, though it lacked voting power in faculty meetings. Thus most of the school was divided into two camps, while a third group desperately attempted to keep from being involved and timidly tried to anticipate the outcome of the struggle. Perhaps there was also a fourth camp, that of Martin Wagner, who took everyone to task for an inability to relate, to think clearly and creatively.[109]

Gropius's mood was further darkened when President Conant made an unfortunate error in

March 1948 in informing Gropius that he would reach retirement age on June 30, 1949, although — as Gropius reminded him — "Before the war…you commented…that in my case the usual age limited would not be considered…'because Harvard had only a few men of such distinction.'" Gropius explained that he had based his future plans on a continuing academic appointment and had not devoted sufficient time to building up his private practice; he had seen it more as a necessary adjunct of teaching than as a source of income, and therefore he had devoted 80 percent of his time to school duties.[110] His practice had produced only two to three thousand dollars per year since the war.

The retirement date was revised to June 30, 1953, when Gropius would be just past his seventieth birthday. Then Gropius learned that his pension, based on his relatively few years at Harvard, would be low. With mortgage, medical, and family commitments, and TAC not yet a highly profitable venture, his financial concerns would persist for several years.

It was the students who in August enthusiastically made the announcement of the official extension of Gropius's tenure. At this time the students also expressed their pleased reactions to the basic design course which had been offered that summer. For ten years Gropius had sought to have the regular curriculum include a basic design course — a parallel, in part, to the *Vorkurs* that was such an essential part of the Bauhaus program. He had hoped to have Josef Albers in charge of it. The course was, however, introduced in the summer curriculum of 1948 by Naum Gabo, who returned the following summer, while Albers taught it in the summer of 1950. Finally that year a regular course was funded for an experimental period of two years (though the salary was not sufficient to attract Albers).

Ever since his arrival at Harvard, Gropius had been invited to have his students work on solutions to the university's problems of space and design. By 1948 their projects included a classroom and student union for the Business School, a graduate library for Arts and Sciences, and a new building for the School of Design. There also were landscape proposals for Harvard Yard and planning for the extended campus and the surrounding communities.

A 1947-48 project involved the third-year students in planning student housing within the limits of the current Harvard building budgets. Their work would be reflected in a commission that Gropius and TAC developed for the university: seven dormitory buildings and a large dining-recreation center for graduate students. This was Gropius's first opportunity to carry out a major project at Harvard. He had gone to Conant and to Dean Paul Buck to obtain the commission for TAC. Thanks to Buck's interest in contemporary architecture and the president's own belief in Gropius, they agreed to the proposal, despite the traditional conservatism of Harvard's architectural projects.

Some 575 graduate students would be resident in the new complex. A greater number, including 450 graduate students residing in five older dormitories nearby, would share in the services and activities to be offered by the new center. The Harvard Corporation provided the land, funds for the Commons building, and maintenance. Conant solicited small sums for the project to avoid any large donor requirements or constraints. But this considered effort also led to a budget more stringent than usual.

Harvard University
Graduate Center,
Gropius and TAC,
1948 – 60

Under Gropius's direction, the design of the center departed from the Georgian style characteristic of Harvard's construction since the 1920s, much of it in architect Henry Shepley's good red brick and mortar. At the dedication of the Graduate Center on October 6, 1950, President Conant responded to a question that had been on the minds of many: why had Harvard not previously engaged the services of the Graduate School of Design on the planning of its new buildings? The Graduate Center, he implied, was the successful culmination of a long search to find some appropriate work worthy of the attention of a distinguished architect and the money to carry it out. In reality, the answer lay more in the long-established professional relationship between Harvard University and Boston architects and the persistent doubts about the propriety of Gropius maintaining a professional practice while on the faculty.

Gropius himself had doubts about his role at Harvard at times. His gloom was in part physical. He had gone through a complicated bladder and prostate operation. In addition, his practice with TAC was growing very slowly, and the battles with Hudnut had been emotionally wearing. Mentally and physically weary, he accepted an invitation to the Paepcke ranch at the end of the summer of 1950. In Colorado he found at least temporary respite in the beauty and peace of the mountain and valley landscape and, despite his operation earlier that year, in being once again on horseback. On his return to Cambridge, he wrote to architect Burnham Hoyt of his admiration of Hoyt's design of the Red Rock Theater near Denver and of his sadness about the onslaught of undirected development:

> I highly admire the humble way with which you have subordinated the architect under the great setting of nature. I was elated standing on a clear summer day looking into the great plain. Small things fall off your mind and, by sheer weight of the surroundings one feels closer to the great things of life.
>
> Driving down then from the Red Rock Theater to Denver, the sad impression of all the petty motels, filling stations and restaurants depressed me, and I thought what you would have made of such a large avenue which could attract the whole world by the grandness of its setting. People have lost their natural sense of beauty; they cannot see anymore. But deeds as your Red Rock Theater, I hope, will slowly open people's eyes again.[111]

Gropius's return was impatiently awaited by the Planning Staff in Chicago. There was conflict between it, the Michael Reese Hospital administration and board, on the one hand, and the federation of charities supporting the project. A board member, Ferd Kramer, seeking to clarify and strengthen Gropius's role, asked him for a statement. He made it via a letter to Kramer: "There has been unnecessary divergence between the goals of the Hospital and the development of the specific projects. Largely, advice affecting good architectural design has not been implemented." He then set out principles for the use of consulting services in general, and for himself if he were selected as architectural coordinator. These were to provide for the excellence and consistency of design, for the interrelatedness of all parts of the campus, and, with the community design, to avoid "the usual effect of piecemeal planning and to achieve an...entity for the whole hospital region."[112]

By early October 1951 Gropius would be engaged by the hospital as an advisor for specific buildings in addition to his consulting role. Only a few months later he expressed doubts about the course of design direction, given the anomalous role to which he had been so recently appointed —

one in which responsibility had not been made viable by an equal measure of authority. He complained:

> As I am not a full consultant, but only an advisor on the margin, I think it is not feasible to dictate to an architect a specific architecture. There are, of course, many solutions possible…but I think we aggravate the situation with them if we impose on them.…If an architect has been chosen, the trend of architecture must be established by him. That we are critical of what they do is another matter, and I think we are very much in agreement that the selection has not been very happy.[113]

The hospital board valued Gropius's contributions, though not to the extent of putting aside internal politics and inviting Gropius to be the architect of a major building.

A new opportunity opened for Gropius through his role as the hospital's consultant. The unfulfilled promises of the public housing programs and the crudeness of the urban-development approach to city rebuilding had created great dissatisfaction. The failures of government and private enterprise and the increasing hardships they wrought for the inhabitants of the dilapidated and deteriorated areas were brought out in a large-scale collaborative study at Harvard in 1950-51. The author, then a visiting critic in planning at the GSD, directed some sixty students and teachers from the master's class in architecture and advanced classes in landscape architecture and city and regional planning in a case study of Chicago's twelve-square-mile South Side.

Following its completion in June 1951, the collaborators' work was exhibited in Chicago and their recommendations developed by the South Side Planning Board and Planning Staff to stir again the redevelopment and renewal programs of city and state. In particular, new attention was given to the work of a student team that had reported on methods less disruptive to the community and less wasteful than those of total redevelopment, reinforcing earlier proposals by the Planning Staff for large-scale conservation and rehabilitation measures.

Despite this instance of successful collaboration within the school, tense feelings still permeated the school and affected the work. The author sought reconciliation, but Gropius felt that his efforts amounted to appeasement and that his simplistic approach was naive; he believed that Isaacs had missed the realities of the school's political life and that his peace-seeking efforts along this line would be useless:

> You know our collaborative problem, which I have enjoyed so much, has of course disrupted the ordinary trend of teaching within the classes concerned so that the picture might have been somewhat obscured to you. …There cannot be any doubt that the intensity of the staff has decreased somewhat on account of the hopeless situation of a Dean working against them.[114]

During the preparations for the new academic year of 1951-52, it was apparent that neither Hudnut's nor Gropius's attitudes had softened. The search began for a new chairman, who would also serve as dean; Gropius assumed the responsibility to search for his successor. On November 20 he requested that Milan architect-professor and CIAM colleague Ernesto Rogers submit his credentials to Conant.[115] He also communicated with José Luis Sert, who replied on November 30 that he was definitely interested. Gropius wrote to the author about him with some enthusiasm:

> I think I told you already recently that I have been seeing José Sert and that I pressed him hard that he should think twice and accept if he should be asked to come to the GSD. On account of the large commissions for South America,

he was very doubtful, but to my pleasure he just writes me that he has decided to accept the job, if it should be offered to him. …I think we should do everything to support him. …I am completely positive towards Sert. He is forty-nine years old; a very mature wise man and with a very broad philosophy of his own. (His very best assets are his manners, coming from the highest possible upbringing.) The only difficulty which we might encounter is that he is not yet an American citizen, but he is in the process of becoming one.[116]

By early February 1952 Sert was yet unknown as a candidate, and the candidates were Eero Saarinen, William Holford, William Wurster, and Wallace Harrison, and perhaps George Fred Keck of Chicago.

In what would prove to be his last lecture to the Harvard community as a professor, Gropius addressed an audience packing the Hunt Hall auditorium on the evening of March 25. He broadly interpreted his subject, "The Architect in Industrial Society," and dealt with the responsibilities of the design and planning professions to society and his view of the kind of education appropriate to fulfill them. He made no mention of the struggle engulfing the school, and friends and antagonists stood in an admiring ovation.

Though rumors of his retirement were heard, Gropius denied them. But on June 5, 1952, he was surprised to receive from Hudnut a notice of further curtailment in the faculty of architecture, particularly directed toward removing Norman Fletcher as Gropius's teaching assistant in the master's class. Other TAC associates had not been reappointed during the two previous years. A total of six positions from a staff of thirteen in the Department of Architecture were being canceled; three of these were held by TAC members and another was the Basic Design instructor.[117] Gropius strenuously objected that the quality of teaching would be diminished and that he could not carry a double load. Hudnut spoke of budget; the teaching would have to be less intensive. He added, gratuitously, that there would be a smaller enrollment.

On the same day, adding to Gropius's woe, Conant and the Corporation refused his request for a sabbatical in the second term of the following year. The rules did not permit such leave during the final semester before retirement (though Gropius had passed by two earlier opportunities for sabbaticals). Now, in a meeting with Conant on June 18, only hours before the final meeting of the Corporation for that year, he asked that his resignation be added to that day's docket. Conant agreed. On June 19 Gropius, a full year in advance of his intended departure, formally thanked the president for his past support and stated his compelling reasons for retiring; no longer able to contain his feelings regarding Hudnut, he added:

> I have convinced myself that a good school must continuously develop its inner growth. For years the negative attitude of the Dean has had a demoralizing and frustrating influence on the entire staff, keeping such natural development from unfolding. Therefore, I do not want to share any longer the responsibility for the deterioration of a good school resulting from the Dean's pathological unreliability.[118]

Gropius soon made public his resignation, giving as reason the need for drastic reorganization of the school by his successor, in view of the large reduction of staff and budget. To a former member of the Harvard community Gropius bitterly attacked Hudnut: "Nobody in the School understands that the President has kept Dean Hudnut for another year at a moment when the budget of the School is in dire straits because he hardly did any work and the running of the School could have

been easily done by the Chairmen."[119] The discord within the school did not diminish, and Hudnut himself soon resigned.

News of Gropius's resignation soon spread, and John Burchard, the dean of MIT's School of Architecture and Planning, invited Gropius to join the faculty on his own terms. He declined, saying that he wanted to concentrate on TAC projects, but did agree to sit on the school's Visiting Committee. At an age when other men relax in the glow of past accomplishments and enjoy the comforts of accumulated wealth, Gropius looked forward with great anticipation to the challenges of yet another new life.

EMERITUS CAREER
1952–1969

There would be no true retirement for Gropius from the affairs of the school. Despite his often-repeated protest that he should not be called upon to exercise *morte main* as former chairman, an expression he used in refusing — or accepting, ostensibly reluctantly — requests for his intervention, he still felt himself to be responsible and indispensable. He remained a pervasive influence in all that was taking place. President Conant had sought his advice, and Gropius had recommended strongly that Sert be his successor as chairman of the Department of Architecture and also be appointed dean; on January 21, 1953, the *Crimson* announced the appointment.

In February Sert visited Gropius in Lincoln, and Gropius "introduced him into the secrets of the school" in preparation for his takeover in the fall.[1] With Sert's appointment secured, Gropius lost no time in making recommendations on faculty appointments of outstanding European and American architects and planners "shown to be most loyal to our cause." He suggested that Charles Eames, Serge Chermayeff, and I. M. Pei or Paul Rudolph would make the strongest team, and he recommended that Isaacs be made the Charles Dyer Norton Professor of Regional Planning and chairman of a combined planning and landscape architecture department.[2]

In March Gropius arranged a meeting between Isaacs and Sert, who had had philosophical differences. The meeting was brief; they agreed to join the landscape and planning departments, though Isaacs insisted this be a temporary condition until planning could again stand alone. There was less agreement about the design emphases to be given to the curricula of the combined programs. This was resolved by outlining a broad initial approach, out of which would grow several opportunities for specialization. On this basis, Sert supported Isaacs's appointment. Gropius corroborated this to Isaacs: Sert "seems to be very satisfied, so everything goes all right."[3]

But everything did not go right. Though Sert had received almost a free hand in making changes in faculty, organization, and curriculum, they were not accomplished without resentment and acrimony. His new appointments were known long before they were made official by the Harvard Corporation, and his nominees were disparaged as being representatives of CIAM and unfamiliar with American practice and education and as having a singular orientation toward the architectural aspects of planning. In his first speech as dean, on March 17, Sert had set the stage for those

The German attaché, in Lincoln to award the "Grosse Verdienst Kreuz mit Stern," with Gropius and his granddaughter, Sarina Forberg, 1958

With John Rettaliata, president, Illinois Institute of Technology, Mies van der Rohe, and the author, 1953

criticisms. He had described city planning as a province of architecture and had said that only a person with the abilities, background, and approach of an architect was qualified to be a city planner.[4]

Gropius did get a respite from the politics of the school when he traveled to Chicago for the opening of a Bauhaus exhibition and a series of birthday celebrations. A tree was to be planted on the Michael Reese Hospital grounds in honor of his seventieth birthday on May 18. At the base of the pin oak and mounted on a boulder is a bronze plaque:

This tree was planted in appreciation of

WALTER GROPIUS

Architect and Educator

whose guiding hand contributed so much to the

planning of this campus and its buildings.

Three hundred friends gathered at Chicago's Blackstone Hotel for a heartwarming celebration and tribute. In his warm and stimulating introduction of his "old friend Gropius," Mies van der Rohe nostalgically referred to their employment under Behrens and described Gropius as "one of the great architects of our time, as well as the greatest educator in our field…a gallant fighter in the never-ending battle of new ideas." In his own address Gropius argued for comprehensiveness as opposed to stylistic labels, for diversity, and for teamwork. He referred to the tree planted on the hospital grounds in his honor:

> I want this to be a tree in which birds of many colors and shapes can sit and feel sustained. I do not wish to restrict
> it to species with square tail-ends or streamlined contours or international features or Bauhaus garb. In short, I wish
> it to be a hospitable tree from which many songs should be heard, except the fake sounds of the bird imitators.[5]

Returning to Cambridge, Gropius proudly received an honorary degree from Harvard at commencement. Though it was by no means his first such award, he expressed great pleasure in it: "The

Award of the Matarazzo Prize, São Paulo, 1954, with President Vargas (left) and Francisco Matarazzo

Harvard Commencement Day last week…was quite impressive. I felt like entering the Garden of the Gods. The Harvard people certainly know how to make it a real honor if they want to honor somebody."[6]

Travel and TAC: With rigid school schedules behind him, Gropius was free to travel, and in the late fall and winter of 1953-54, he visited South America. The culture of Indian and Spanish peoples and the historic architecture of Peru was of particular interest to him. Reunited with Bauhäusler Paul Linder, he also met Fernando Belaúnde Terry, later to be president of Peru and subsequently, in exile, to be professor of planning at Harvard. Gropius went on to Brazil, "a country where one can never be quite sure where the Metropolis ends and the jungle begins."[7] In São Paulo, at the Biennale, President Vargas presented Gropius with the Matarazzo Foundation's International Grand Prize in Architecture. The purpose of the 300,000 cruzeiro prize was "to crown the creative activities of an architect of any nationality whose work reveals international significance for the development of contemporary architecture."[8] The award occasioned no surprise, for the jury had included José Luis Sert, Le Corbusier, Alvar Aalto of Finland, and Ernesto Rogers of Italy, all of whom were fellow members of CIAM and who, to say the least, greatly admired Gropius.

In Brazil he met South America's famed landscape architect, botanist, and painter Roberto Burle-Marx, whose works "one cannot understand from the drawings. …In reality, they are most pleasant and done with a thorough understanding of plants and their character."[9] Though the architect whose work he admired most was Alfonso Reidy, he had some praise for Lucio Costa and a mixed opinion of Oscar Niemeyer.

> [Costa] seems to have been the first one with a clear vision of modern architecture and was instrumental in getting Oscar Niemeyer on his track. …Unfortunately [Costa] is a neurasthenic, and recently he has given up his own architecture altogether, giving as the reason that Niemeyer is so much more talented than himself.[10]

Gropius did not share Costa's judgment, reporting that "Niemeyer's buildings are interesting and fresh in conception but he seems to be little interested in details and so the executed buildings sometimes lack high quality." Perhaps, he commented, this was the result of architects not being given sufficient time to do their working drawings well.

Amazed by the contrast of jungle and urban area in Brazil and by the chaotic conditions resulting from the competition for space, he commented:

> I have never seen anything like it anywhere; so the urbanistic problem is in the foreground, but there are very few signs of putting in planning commissions with the power of decision. Everything is done in a haphazard way by doubtful politicians.[11]

Only a few months later, in May 1954, Gropius realized his long-standing ambition to visit the Far East, and Japan in particular. He was the first visitor there under the Rockefeller Foundation's program to further cultural exchange between East and West, and was already known in Japan through the Bauhaus. The announcement of the impending visit brought a deluge of invitations for articles, lectures, dinners, and discussions not only from Japan, but also from other countries. His route to Japan was via Hawaii, the Fiji Islands, Australia, the Philippines, and Okinawa. About Hawaii, Gropius wrote, "The most reconciling spot on earth where all races mix without tension to the everlasting credit of the U. S. ...It's good to know it exists."[12]

In Sydney, where he attended the convention of the Royal Australian Institute of Architects, he was greeted by Bauhäusler Ludwig Hirschfeld-Mock and Harvard alumnus Harry Seidler. The University of Sydney conferred on Gropius an honorary doctorate, the seventh such award by the university in a hundred years. In red robe and black beret, Gropius addressed the audience of a thousand on the question "Is There a Science of Design?" Though the speech was humanitarian and broad in context, the newspapers reported that it meant as much to architects as an Einstein speech would to physicists, and it stimulated columns of serious controversy over modern architecture.[13]

The Japan that Gropius visited was different from the Japan he had read about as a youth and different as well from the country that had so readily incorporated his ideas in its own Bauhaus-type school. With military occupation, which had lasted until 1952, Western culture, and not always its best aspects, began to penetrate the Japanese way of life. By the late forties the population was growing rapidly, and by 1954 there were more than 85 million people on 142,300 square miles of land, with a shortage of housing and other urban problems.

Gropius's architecture, with its principles of unity and diversity, totality of structure, and the importance of environmental setting, appealed to the Japanese. And Gropius was well prepared to admire Japan. The Japanese students he had met previously had touched him with their courtesy and sensitivity. He already had a waiting public there: Bunzo Yamaguchi had been employed as a draftsman in Gropius's Berlin office in 1929. Sutemi Horiguchi, who had played the leading role in the Secession movement in Japan in the 1920s, and would stir public interest in contemporary architecture and art with his magazine, had visited the Weimar Bauhaus in 1923.[14] A number of prominent Japanese architects had visited the Weimar or Dessau Bauhaus, among them Chikatada Kurata, who wrote a book on Gropius. Takehito Mizutani and Iwao and Michiko Yamawaki had attended the Bauhaus in 1930-32, and the Yamawakis had written a book on the Bauhaus in a series

on architecture. When the Bauhäuslers returned to Japan, they opened an architectural laboratory in the Ginza and gave emphasis to Albers's style of instruction. Their magazine *I See All* made the Bauhaus known to both professionals and the lay public. The Japanese military government closed the school in 1936.

Ise and Gropius arrived in Japan on May 19. Gropius followed a full schedule of daily activities, including luncheons and tea ceremonies, receptions and inspections, museum visits and Kabuki performances, and attempted to respond to a constant demand from architects for lectures on design, from reporters for comments on this or that temple, event, or person, and from photographers who swarmed around him seeking the perfect position and background.

On May 24 he lectured at the Kyoritsu Kodo auditorium to an audience estimated at thirty-five hundred, which was fifteen hundred more than could be seated normally and the largest audience he had ever addressed. He spoke for two hours through a Japanese interpreter, whom he thanked enthusiastically, as though the audience's very appreciative reception had been for the interpreter's words rather than his own.[15] Later the International House estimated that more than six thousand people had attended Gropius's four regular lectures, dealing with education and collaboration, poverty, city planning, and modular and prefabricated construction.[16]

Despite his popularity, Gropius found himself in a very strange position in Japan. Having steeped himself in Japan's ancient architecture, arts, and crafts before he came, he was interested in discussing the country's traditional culture, but he found this to be a most sensitive subject and feared he would be accused of emphasizing "folk art." He was respected for his efforts to try to do so, "knee-to-knee," but a few younger men, not fully comprehending his views, took issue. Tradition, they felt, must be interpreted by Japanese architects through their own study of the culture and the desires of the people. In accepting Western ideas, these young architects, Gropius discovered, had discarded the old culture simply because it had developed under a feudal regime. The flexibility of the house so admired by Gropius was for them a symbol of patriarchal control. Others opposed the use of the module of the *shaku* (3 by 6 feet), the *tatami,* and the *shoji* as determinants for contemporary design and objected to all forms of tradition as not being convenient to modern life.[17]

By 1954 the Japanese had again assumed responsibility for the growth of their schools, their industry, and their national life, and already had begun to display annoyance with the overemphasis on Western customs. Signs of a new nationalism had arisen. An article published in an architectural journal after Gropius's visit made political charges:

> There were two hidden intentions for the visit of Mr. Gropius. One was to propagandize American culture, and the second was to relegate Japanese culture to history. The first was to demonstrate that the American culture is so superior to the Japanese that Japan cannot catch up easily; and the second was by parading the traditional low level of culture to curb or restrict the rapid development of mechanical industrialization and preserve the Japanese system of handicraft so American control through colonialism might last longer.[18]

Still, Gropius's every word, action, and waking hour were faithfully recorded and published; in one observer's words, "He came to Japan in the midst of applause as though he were a conquering general."[19]

Gropius's delight in Japan made up for any shortcomings; he wrote ecstatically, "My experiences

At the imperial
villa, Katsura,
Japan, 1954

here are of unending beauty, tumbling from one excitement to the other!"[20] He found utmost beauty in the architecture of the Katsura Palace: "Katsura is simple and flexible; the buildings are appropriate in relationship to the gardens — qualities abandoned in so much of contemporary work."[21] He immediately became absorbed in Zen philosophy because it apparently produced such art.[22]

With a group of architects, professors, and others invited by the International House, Gropius inspected several cities during his stay. Noting the shortage of open space in Osaka, he stressed the necessity of planning the structure of the entire city prior to individual projects. "The government," he said, "must recruit able personnel, do research, and develop policies from social, economic, and aesthetic points of view. The city planners must establish the bases without being bothered by anyone, especially by politicians. Until such a day comes, no matter if good buildings are constructed, the city will be hell. Osaka had already lost its best chance of rebuilding right after the war; the big job must be done now."

In Hiroshima he admired the Peace Center designed by one of his companions, Kenzo Tange, an architect he felt would become a leader in architecture and planning and from whom he gained his strongest impression of contemporary architecture in Japan.

Gropius arrived at the fifteen-hundred-year-old Ise Shrine south of Nagoya at a most fortunate time: the end of a twenty-year cycle of reconstruction, when the complete rebuilding of the temple was under way. He was impressed not only with the extraordinary detail and construction methods, but also with the landscaped setting. One of the Japanese architects who accompanied him later recalled the scene:

> He gazed at the Shrine for a long time, standing on the gravel path. Probably there was a deep emotion streaming in his breast. We stood quietly. Meanwhile, it started to rain without making a sound in the trees around the temple. The Master said simply, "Let us go," and started to walk, his head bent.[23]

It was incomprehensible to him that the Japanese could have made a shrine — particularly the Ise Shrine — the symbol of fascism.[24] Only after several years of reflection did he feel that he had begun to understand the Japanese and their architecture.[25] Nevertheless, he enthusiastically inscribed a postcard that day: "Japan is in the lead with absolute and unusual genius!"[26]

In a letter thanking his hosts, Gropius was fulsome in his praise: "Japan is the best place to study the very medium of true architecture — space and human scale…slowly I begin to understand the background of your profound culture and its hardly recognized importance for the Western world." Only the Parthenon, he said, could compare with the high level of some Japanese buildings.[27] Japan had made a lasting impression on Gropius, and in the months and years after the momentous visit, his articles, lectures, and conversations were influenced by that experience.

Gropius and Ise left Japan in early August and began their long journey home via Hong Kong and Bangkok to Calcutta, Karachi, and Baghdad. There Harvard alumni Ellen and Nizar Ali Jawdat entertained them, a visit that had great portent. From Baghdad, they flew to Cairo, where, like any tourists, they visited the pyramids and Luxor and floated on the Nile. Then came a rest in Greece, where they fulfilled a long-standing engagement to meet their daughter, Ati, and her husband, Charles Forberg, on top of the Acropolis at noon on August 25, 1954. Following a brief stop in Rome, they moved on to still another family reunion in Hannover, and thence home.

Stimulated by the architecture he had seen during his travels, Gropius was now more than ever determined to leave professional associations and academic affairs to others and immerse himself in his practice. However, he found himself still inextricably linked by his friendships to past enthusiasms. In the voluminous correspondence awaiting his return was a letter sent by Sert to CIAM members in the United States regarding that organization's inability to establish itself in America, although many of its European expatriates, including himself, now formed a circle around Gropius. Gropius could not accept Sert's assertion that "our way of life in the U. S. makes it very difficult for a voluntary working group of architects to hold together more than a very short time"[28] and continued to support initiatives to continue the organization in progressive forms.

It was difficult to maintain enthusiastic participation in professional organizations in Europe as well. In Germany, however, and particularly among the now graying veterans of the Ring of Ten, there still persisted an interest in working together. The Ring had not disappeared with its affiliation with CIAM in 1928 or with the threat of persecution by the Third Reich. Those architects who had survived had received recognition for their endurance and were now rewarded with the projects of the extraordinary economic regrowth. Their common cause would continue to be the improvement of the profession. Admittedly, their interest was in good part nostalgic when in the spring of 1955 Richard Döcker called for a reunion to establish plans for the future of The Ring. Gropius could not attend but commented:

> I think we can be satisfied that we have definitely made a dent with our Ring activities, and I still remember our own surprise that the very fact of organizing our small group was sufficient to tip over the BDA even without any further action. "Der Sieg des Neuen Bauens" [the victory of the new building] is now a fact in all civilized countries.[29]

The reunion in late May 1955 was attended by Max Taut, Ernst May, Hugo Häring, Wassili Luckhardt, Heinrich Lauterbach, Döcker, and Hans Scharoun from the old Ring, and Paul

Baumgarten, Werner Hebebrand, and Otto Schweizer, new friends to complete the Ten. Gropius applauded their plan to rejuvenate The Ring by including professionals of the younger generation: "We are trying to do the same now in CIAM, to play it into the hands of younger men after we have run the show for twenty-five years."[30]

Unfortunately, "the victory of the new building" did not mean viable commissions would be available to match the enthusiasm of Gropius, invigorated by his visit to Japan. It appeared that every project that proceeded to completion was matched by another that failed in sketch or preliminary stages.

Two commissions that did progress to satisfactory completion were the Overholt Thoracic Clinic in Boston and the United States Embassy in Athens. The clinic was unique among the hospitals and other institutions of Boston in 1954 in providing offices and diagnostic facilities for doctors specializing in heart and lung diseases. It was Gropius's first project following his return from Japan, and its design by him and John Harkness displays his admiration of the modular structures of that country. The building appears light, economical, and rational in its modular frame; its wall panels and fenestration reflect a systematic interior organization; and it is attractive in its contrast with yet appropriateness to its setting.

Near the end of 1956 Gropius and TAC were awarded a commission for the embassy in Athens. The building, a unique example of Gropius's response to community and culture, also reflects the impression that the ancient structures of Greece had made upon him two years earlier. Its design, by Gropius and H. Morse Payne, Jr., is sympathetic to classic principles and utilizes the settled dignity of a temple. Though temple-like, the design was not a revelation of the gods; its development took painstaking effort. Completed in 1961, it stands in obvious courtesy to its environs at the foot of the Lykabettos near Mavili Square, a mile from the Acropolis and a short distance from the Athens Hilton Hotel. The view of the embassy, from whatever distance topography or intervening structures permit, relates its scale, proportions, and visible structure to the monuments of Greece.

Gropius's attention at this time was divided almost equally between practice and civic problems. The housing committee of the Massachusetts State Council for the Aging, of which he had become a member in June 1955, asked him to outline a project to investigate the sociological and psychological problems of aging persons in relation to types of housing. Gropius invited Isaacs to join him in the work. The project they envisioned required the collaboration of sociologists and psychologists, architects, city planners, public administrators, gerontologists, leisure-time consultants, home economists, cultural anthropologists, legislative experts, public finance experts, and others. The scope and interrelationships so intrigued Gropius that he reported on it to the committee on October 1, 1957, in advance of its complete formulation, and received approval to complete the original outline as a report.[31] Later, the now very extensive proposal, estimated to require thirty months and a quarter million dollars, was submitted to state and federal departments. Unfortunately, the foresight of the committee was not equaled by that of the government departments, and action was indefinitely postponed.

Gropius had delayed a winter vacation to see the study proposal through its submittal, but now, weary of the snow and ice that beset their Lincoln home, he and Ise went to Cuba in March. This

United States
Embassy, Athens,
1961. Gropius and
TAC

was their third visit. The faculty of architecture at the University of Havana, at the insistence of its students, had invited him to lecture in April 1949. They had gone again recently, in January 1957, when Ise wrote of their enjoyment of Latin hospitality and recalled Gropius's world tour: "I think Walter could travel around the earth today and always find himself guest of a former student who has proceeded to build a combination of modern approach with regional safeguards which is entirely delightful to live in."[32] Gropius was still enthusiastic:

> This is here a real treat; a very paradise. We are swimming daily for hours in the blue Atlantic, already brown all
> over. No people, the whole beauty is for us. Hot sun, no insects, absolutely quiet nights, unbelievable. You are in
> ice and snow. Cheers.[33]

But there had to be an end to such tranquility and a return to a still winter-bound New England, work, and a desk full of waiting correspondence, not to be alleviated until Walter's seventy-fifth birthday celebration two months later. The day was marked by festivities, among these a reception and an exhibition of his work at the Loeb Theater in Cambridge. As part of the celebration, the GSD alumni announced the establishment of the annual Gropius Lectures, to be delivered by an outstanding figure from architecture, landscape architecture, city planning, or the related professions. Gropius also received Germany's Grosse Verdienst Kreuz mit Stern award, presented by the German attaché in a ceremony in Lincoln with family and friends in attendance. The citation by his old friend Theodor Heuss, now president of the Republic, saluted Gropius as the father of twentieth-century architecture and recognized the benefit to Germany of his steadfast convictions, which had persisted through the vicissitudes of the "National Socialist System," expatriation, and readjustment.[34]

This was a period of international recognition. In June 1957 he had been awarded Germany's Goethe Prize, honoring him for "the pedagogic achievement evidenced by the foundation of the Bauhaus" and for "humanizing" industrial society by promoting a new architecture for housing and work.[35] In 1959 he would receive the AIA's Gold Medal. The citation applauded his efforts to unify art and science and acknowledged his pioneering role in relating theory and practice.[36]

In 1958 the Michael Reese Hospital project finally came to an end. In the twelve years in which Gropius served as consultant, a ghetto was revitalized through harmonious development and the growth of health, education, and religious institutions. The influence of Gropius and his alumni was evident in the designs for the entire South Side area in the programs for housing and redevelopment.

There had been, however, missed opportunities. Notably, although the Planning Staff availed itself of Gropius's advice, neither the hospital nor other community interests gave him any major architectural commission. Years later, a thousand miles away from the scene, and despite acknowledged accomplishments, Gropius, Isaacs, and a panel of experts at the 1961 Urban Design Conference at Harvard reviewed the early concepts and admitted dissatisfaction with the results that were actually attained.[37]

Gropius had experienced many such disappointments during his long life and, with new opportunities already at hand, did not permit himself to be discouraged. One such opportunity was a major commission in Iraq. Soon after his seventy-fifth birthday party, Gropius flew to Baghdad. Interested in the Middle East ever since his youth, when German investments and travelers made

that area well known in Germany, Gropius now had his first opportunity to work there as an architect. In part this had come about as a result of his visit to Baghdad en route home from Japan in 1954. At a cocktail party given by Nizar and Ellen Ali Jawdat in their home, Gropius had met a number of professors from the University of Baghdad. They spoke about the idea of a new campus bringing together the several colleges, then variously located in the central city. The idea of a university complex with Gropius as its architect grew, and in 1957 he was appointed by the Development Board and the Ministry of Works and Housing.

Nizar's father was prime minister, and the influential Jawdat family's admiration of Gropius had assured his appointment. He acknowledged this good fortune in a letter to Ise on November 6: "This relation to the Jawdats is of greatest importance for me and gives me a headstart everywhere. Nizar and Ellen are wonderfully helpful and everything seems to be toi toi toi — as good as could possibly be expected. Also my chances of being well paid as a 'world authority' are good." A few days later, on the plane en route from Baghdad to Athens, he wrote: "Yesterday I had lunch with the two great powers of this country, the prime minister, Nizar's father, and the chief of the Development Board, Mr. Pachichi. It took place in the garden of the Jawdat family." By coincidence, Le Corbusier had appeared that day and, being informed of Gropius's presence in Baghdad, had sought him out:

> Imagine, Corbu arrived yesterday! Looked wan. I could just manage to sit down with him for an hour and talk about everything under the sun. Three times he burst out sobbing about the loss of his wife. He was particularly warm and affectionate with me. He obviously needed someone to unburden his heart to and he has nobody. He has made a good contract with the Iraqis and is building a big stadium. . . .
>
> This morning we landed in Damascus where the airport was thick with jet planes and machine guns. May the heavens give us peace.[38]

There was already political unrest, and revolution would follow the next year. Through all of this, Gropius, with TAC's assistance, moved with aplomb, his great ability to adjust to new situations scarcely taxed.

In 1958 Gropius was, in effect, given the responsibility for defining educational policies, for the university had provided only a bare two-page typewritten statement as guidance for the educational, organizational, planning, and architectural program he would write. In doing so, he considered the experiences of other universities, the present-day needs and future of Iraq, the cultural and traditional requirements of its people, its growing population, and the increased competition for resources. With the government's approval of the proposed program, Gropius and TAC began the development of master plans and building designs for the campus and buildings.

During a return visit to Baghdad early in 1960, he began most poetically an otherwise prosaic account of his activities: "Quick before the surf returns; it is morning and mist has settled over the Tigris. . . . Our careful plans have had the right impact and there is appreciation all around. Today we are going into the financial negotiations, the most difficult part. One meeting follows the other."[39] On that same trip he wrote a week later from Athens:

> My prestige in Baghdad is sky-high and it won't be easy to maintain it on such a pinnacle. They wait in everything for my judgment when questions arise and then decide according to my proposal. Was with [Karim] Kassim [Prime

Minister of the Revolutionary Government] for 1 $^1\!/_2$ hours who was highly delighted about…our work. For the time being he has granted 85 million for the project. It is a miracle that we have managed to get all necessary decisions with binding signatures within one single week. I have sent a long telegram to the Premier, thanking him for the courtesy and efficiency of his government. Had to speak to 400 people on the spur of the moment and it came off very well. …[I] imagine I shall probably get the opera house in Baghdad. It was promised me. F. L. Wright will turn in his grave.

Jotted this down in the greatest haste.[40]

In TAC projects, Gropius's participation was often expected if not required by clients. This was true in the commission by the Oheb Shalom congregation of Baltimore, which, following an extensive search for an appropriate architect in 1958, appointed Gropius and TAC with the understanding that Gropius would direct the work. The congregation was a progressive one, its liberal philosophy established in the mid-nineteenth century by its German Ashkenazim founders. Though its Reform worship service recognized conservative religious traditions, the congregation wanted contemporary expression in its proposed temple, school, and community building. Ten years following completion of the temple, its president, who had served as building committee chairman in dealings with Gropius, wrote:

The concept of function was stressed and stressed again so that we have had a minimal amount of change required over these ten years. …Gropius had a grasp of our needs, as well as of the beauty he wished to impart, which represented a sort of "fourth dimension" in our final structures.[41]

Not everything was going as well. In the spring of 1960 came a reminder of past sadness — a letter from Alma Mahler Gropius Werfel. A copy of her recently published autobiography had been sent to Gropius in mid-1958.[42] It deeply implicated him. To the publisher and the waiting public he had made no comment, but it was a final blow to even a residual friendship. He had written to Alma at the time:

The love story which you connect with my name in the book was not ours. The memory of Mutzi should have prevented you from taking away the essential content of our *Erlebnis* and its literary exposure is bound to kill also in me the blossoms of memory.

The rest is silence.[43]

Now Alma sought to mollify him. She blamed her translator and editor for the erroneous material about Gropius in her autobiography and wrote, "I am more guiltless than you think!" and "I ask your forgiveness and shall attempt to make amends."[44] But it was too late. Gropius, whose sense of history was paramount, was deeply affected by Alma's inaccurate story.

Fortunately, he had much else on his mind, particularly in respect to his architectural practice. One project, the Pan American World Airways Building in New York City, became Gropius's most controversial commission. Everyone concerned — the owners (Grand Central Building, Inc., of which Erwin S. Wolfson was president), the architects (Emery Roth and Sons, with Gropius and Alex Cvijanovic of TAC and Pietro Belluschi as consultants), the tenants (principally the Pan American World Airways Company), and the city officials who approved the building — were both vilified and praised by architects, historians, art critics, journalists, and city planners. The building was declared to be a visual crime against city planning, a rape of its environs. Some critics complained that the "flow" of traffic around the building,[45] the "graceful flow" of Park Avenue,[46] and the "swift flow" of space[47] were interrupted by the Pan Am building, though evidently not by its companion, the Grand Central building, similarly sited.

In view of Gropius's lifelong fight against the disfigurement of the environment, it was not surprising that he would be amazed by the criticisms, which were also directed against the design of the building and its relationship to a harmony of scale with a Park Avenue that no longer existed. He asked:

Why does not any one of the critics realize the necessary consequences which have arisen from the complete change in height and magnitude of the buildings in Park Avenue, which condition has dwarfed the old Tower and called for a "new focus," a "new point of reference" in keeping with the new, greatly enlarged scale of the neighborhood?[48]

A year later he commented:

I was attacked for lending my hand at all in putting such a large building mass into an overcrowded area. One critic [Philip Johnson] even went so far as to suggest that this site of real estate worth millions should have been made into a green plaza. This suggestion is indicative of a prevailing urbanistic sentimentality, a blindness to new trends and to the changing order of scale and magnitudes of building masses in cities. The problem is not how to stem the tide of these new trends, but to find proper solutions for them.[49]

But Gropius was far from being alone in the defense of the building and the design decisions that shaped it. Among its many supporters was the editor of *Architectural Record,* Emerson Goble, who wrote about the desirability of the vertical city,[50] and New York art commissioner August Heckscher, who praised the series of spatial experiences created by the Pan Am building, the play of light upon its faceted sides, its silhouette, and its appropriateness of scale.[51] Edward Bacon refuted the criticisms regarding access, transportation, and congestion, and praised the contribution of the building to the design structure of New York and to Park Avenue's vistas.[52]

Time has also come to the defense of the design. No crisis has occurred in either pedestrian or

Gropius and Pietro
Belluschi at work
on the Pan Am
Building

vehicle traffic. The building has become a visual landmark. Sacrificing almost fourteen acres of office space to achieve a form that would relate to the visual importance of the site, it became a prototype, imitated many times in school and practice.

There were compensations in Gropius's life at that time. The practice was finally becoming financially successful, and he reported to his sister: "Finally, I may come into some money, never a possibility since I left Harvard. When I left Harvard in 1952 I was worried whether we would have enough for our old age. 1960 was a happy harvest year. It is wonderful that I experience that still."[53] In January 1961 Gropius and Ise began their vacation in Arizona, which Ise characterized as "the most brilliant idea we ever had. …Walter feels wonderful in the saddle again, the climate is most invigorating…we feel every minute here is a blessing."[54] This visit to a "unique place" was for Gropius "a dream of my youth come true." From that time, the dream would be renewed each year. No other vacation place could thereafter satisfy his desire and need for restoration of mind and body in a setting both tranquil and stimulating.[55]

The Return to Germany: By this time, Gropius was receiving more rewarding commissions and greater appreciation by the public and government institutions than ever before. This was particularly true in the new Germany. Such recognition began in the early 1950s when many Germans felt a need for a new architecture expressive of their country's new aspirations. Hannover Stadtbaurat Rudolf Hillebrecht, anticipating a visit and hopeful of a new building for Germany, reminded the public of Gropius's pace-setting Faguswerk exactly forty years earlier and spoke of future possibilities: "As once the Faguswerk near Hannover introduced the history of the new architecture, so could a new building by Gropius help toward the decisive breakthrough of the new architecture."[56]

In the mid-fifties when Gropius returned, West Germany was well along to recovery. It was

Looking down
Park Avenue
toward the Grand
Central Terminal
Office Tower
and the Pan Am
Building, 1958

nothing like the distorted state he abandoned in 1934, nor the war-ravaged country he saw with General Clay in 1947. Germany was now experiencing its Wirtschaftswunder, a miracle in terms of its economic regrowth. The rebuilt cities had prospered. The rich architectural heritage of Gilly, Schinkel, Gropius, Behrens, and Poelzig was not lost upon either East or West Germans, and restoration of their buildings was well under way. A principal lack in both Germanys was housing; obsolescence and war destruction created a need for tens of millions of new dwellings. Federal social welfare legislation had been restored and new opportunities opened. There was a public conscience and an acknowledged moral commitment to Israel and to the world. The deficit in Germany's cultural development was great. The prewar talent of that country, many of them Jews and liberals, had in large part migrated or been exterminated. There were no longer inexhaustible wellsprings to meet ordinary attrition in literature, theater, ballet, music, and architecture and art. But the universities, which had been devastated physically and intellectually, were now rebuilding with aid from abroad.

It was particularly poignant for Gropius to find Germany divided physically and spiritually. Bonn was, de facto, the capital of the West, though Berlin, an armed camp with its four occupying powers, was still the focus. Though the Berlin Wall was not yet built, there already existed the higher walls of ideology, the East oriented to the Soviet Union and the West to the United States. Only the S-Bahn still bound the East and West sectors together.

In 1952, as part of Germany's program to restore its housing, a competition was announced for a development plan for a bombed-out area in central Berlin; this was to be Interbau. More than sixty architects from fourteen countries participated, and the plan by Professors Kreuer, Jobst, and Schliesser was selected. Gropius was appointed to a committee responsible for approving changes, assigning priorities, selecting the architects for the buildings (one of whom would be himself), and managing the project.[57] He was highly critical of the overall site plan and

Apartment building by Gropius for the Interbau, Berlin Hansaviertel, 1955–57

the program. It seemed that although every building would have ample space, the designer of each apartment block was free to express his individuality without the need to relate to the work of other architects. "The coordination is bad," he wrote Ise, "more like a patternbook of architects than an organic integration."[58] In an attempt to bring some unity to the project, he soon contacted the architects of buildings adjacent to his own commission, Pierre Vago and Egon Eiermann. To Vago he wrote:

> I am disappointed that so far the arrangement [of buildings] is more a chart of modern architecture than an organic setup from a community point of view. I have made some suggestions, hoping that this deficiency still can be improved. The least we architects can do, however, would be to check up individually with the neighbors.

With the letters to both men he sent samples of colors and descriptions of materials he intended to use in his design, "so the three buildings can be displayed together."[59]

On August 27, 1955, Gropius had flown to Germany to complete contract negotiations for the Interbau apartment block commission. There was a quiet reunion with his family in Hannover followed by a strenuous schedule in Berlin. He was met with fanfare at the Berlin airport — by two senators, Bauhäuslers Scheper and Ebert, the BDA director, and a dozen photographers. This was followed by a press conference with some forty in attendance, an "off-the-cuff" radio address, and finally, dinner with the Bauhäuslers at a small café on the Kurfürstendamm. In several letters, hurriedly written, he described his activities. With more than a little nostalgia he reported that his boyhood home on the Kurfürstendamm was now part of his hotel, the Am Zoo.

Gropius delivered a major public lecture on September 19, which he clearly felt was successful:

> Yesterday night I gave my talk, the hall brimful 1300 people — tout Berlin. I believe it was a genuine success; the chancellor of the university and several senators were there, even a big commission from the Eastern Zone…there was the spontaneous reception and fantastic applause after my talk. The hall had to be closed by the police and several hundred people couldn't get in. The press is very good, sample enclosed.

Gropius felt "publicly courted," and though his plans for the Hansaviertel Interbau were exceptional, at that time, anything he submitted would have been accepted:

> There would be many jobs for me here, if there were only a financial solution to be found. ...The mayor [Suhr] as well as the building Senator [Schwedler] want to interest me for larger building jobs here. Most of all they would like to make me building dictator of Berlin. When I declined, they offered me building jobs of greater scale which sound quite interesting. ...The Senator for Building...wants my advice for some of the burning city planning problems. ...The city is still a tragically shocking sight, much more behind than the western cities.[60]

Le Corbusier also had been invited to participate in Interbau, but had differences with the German building authority on design and fee. Gropius sympathized, and commented to Wils Ebert on press criticisms of the project: "I am afraid that the Senate has not established very good public relations. The [press] attacks are partly very mean and often unjustified. I wonder how Le Corbusier will get through his low bedroom height."[61] Le Corbusier's complaints were not entirely unwarranted; Gropius and TAC felt the pinch of the stringent fee scale and the handicaps of the rigid Berlin building code. Fortified by a similar protest from Alvar Aalto, Gropius appealed to the director of the Interbau project that the architectural fees be augmented "to relieve the foreign architects who, on account of problems of money exchange and extra cost, are badly off with the low fee offered."[62]

A year and a half later, Le Corbusier's designs had not yet been accepted by the Interbau sponsors and the building authority, nor could he understand their reluctance to depart from their traditional procedures. Gropius again commented to Ebert: "I hear that Corbu has had even more serious fights with them. Their lack of respect [in] simply [changing] designs by a well-known architect is an impudence which should be rejected in terms which do not leave any doubt."[63] Despite the problems of communication, the five-hundred-unit apartment building by Le Corbusier was built in the Heilsberg Dreieck near the Olympic stadium, away from the Interbau as the temperamental architect had insisted.

In 1957 Gropius accepted a commission for the study of a site in West Berlin for a housing development, which came about through James B. Conant, former president of Harvard University. As High Commissioner, Conant wanted Berlin to be the cultural capital, a "showcase" for West Germany, and to support these purposes, housing was needed — and in a hurry. He had obtained increased aid from the United States for construction of emergency and more permanent housing, and Gropius and TAC were invited to prepare the master plan for a 650-acre site extending from Bruno Taut's and Martin Wagner's 1925 "horseshoe" housing development, Hufeisensiedlung, to a hundred yards from where the Wall would stand in the southeast section of West Berlin. The plan was prepared and architects were engaged to further develop portions of it and to prepare working drawings for construction. Gropius and TAC were also commissioned to design the center section, providing a variety of building types, spaces, and community facilities. Originally named Britz-Buckow-Rudow (BBR) for the old Brandenburg villages of its location, the development is now called Gropiusstadt and accommodates fifty to sixty thousand persons in a variety of housing types ranging from attached houses to thirty-story towers.

Gropiusstadt was charged with being a "town without a soul" and marked by "boredom," but many of these attacks focused on the lack of community facilities, which were planned but not fully

installed until 1967. Nor were the residential buildings completed immediately, and as a result there were not enough customers initially for a department store, café, pub, nurseries, open-air bath, cinema, or other entertainment and service centers. These would be a natural development after the planned housing was occupied.

Prior to the commission for the center section of BBR, Gropius had been invited by the Senate of West Berlin in 1962 to design a school according to established patterns. Initially he refused, explaining that "it would be foolish to come from the United States to build such a school which anybody could do." He then discovered that there were excellent plans, which had been shelved, for a new approach to school building that would permit children to stay in one school through the whole academic process. His proposal to build on these lines was accepted, and the first Gesamtschule was built in Gropiusstadt. The school complex is the largest within Gropiusstadt and serves as one of its major community centers. Some fifteen hundred children of elementary and secondary school ages attend this "Double School and Day Care Center." Based on a progressive approach to education that emphasizes individual capabilities within cooperative efforts, the school is a prototype for all Gesamtschulen in Germany. Its lists of would-be students are filled for years ahead, awaiting increases in both space and number of teachers.

Gropius became a frequent commuter to Germany during these years. He saw old friends — the Luckhardts and Lou Scheper, Hans Schwippert, Max Taut, Richard Scheibe, and Erwin Piscator — and made new ones, among them Frei Otto, whom Gropius described as "a splendid man, more scientist than artist, full of original ideas, round and thoughtful in his views."[64]

He also received several distinguished awards. A lifelong admirer of Goethe, Gropius took quiet pride in the award presented to him by the City of Frankfurt in a ceremony held in 1961 on Goethe's birthday, August 18, in the historic Paulskirche, crowded with hundreds of friends, officials, and press representatives. In November 1963 there was the Gurlitt medal. Gropius reported to Ise from

Düsseldorf: "Hans Schwippert called me up and asked whether we might have a drink together. I accepted but when I got there I found all the architectural colleagues assembled who expected me to say some golden words." There was an informal dinner for the presentation of the Gurlitt medal, awarded by the German Academy of City Building and Regional Planning. In the discussion that followed and lasted several hours, Gropius recounted his experiences and his griefs, and spoke of his desire to create a new kind of living through the planning of Gropiusstadt, including the development of a type of school needed, not only for today, but for the future. He reflected on how the increase of leisure time in modern society might be used more sensibly. The city planner, he emphasized, should create hypotheses about the future and then in collaboration with sociologists formulate proposals to enhance the cultural value of the less privileged classes through opportunities for both physical and intellectual leisure-time activities.

Back in Berlin, Gropius, now eighty, commented that he felt "terribly pressured; every day meetings from 9-6 with twenty-thirty people. ...Up to now I am bearing up well. 'Die Berliner Luft' certainly is my habitat."[65] Berlin, of all of Germany, was indeed "home" to Gropius. Following long absences, he would return to it with a quiet sense of belonging. Thus it was not inappropriate that the Bauhaus Archive would ultimately be built there, though it had been established in 1961 on the Mathildenhöhe in Darmstadt. Conceived by the art historian Hans Maria Wingler, the Bauhaus Archive is the repository and museum for the records and artifacts of the Bauhaus movement; it is the center for educational activities and for continuing research into the relationships between art and technology. From the beginning Gropius emphasized the need to establish a realistic financial basis for the archive and assisted in fund-raising. He had appealed to his old friend Andrew (Adolf) Sommerfield, once again successful in Germany:

Dear Adolphus Magnus:

After being highly honored in Frankfurt, I tried to catch my breath with Ise in this warm Island of laziness [Greece? Cuba?] How are you? You promised me help for the Bauhaus Archive in Darmstadt. I have given my 10,000 marks from my Goethe Prize to the Archive. You should double this modest gift and with that give the signal for other people to keep this source of culture supported in this lousiest of all worlds.[66]

Though fund-raising was only partially successful, activities and acquisitions rapidly increased. In the small space occupied by the archive, only a tenth of its collections could be exhibited. In 1964 it was decided to build a new building on the adjacent Rosenhöhe; Gropius was selected to be the architect, and under his and Alex Cvijanovic's direction, plans for the archive progressed from sketches to working drawings. Fund-raising, however, had become difficult. By 1966, despite Germany's "economic miracle," the increase in family wealth, the overt action by government to encourage art and architecture, and the growth of philanthropic foundations, there was little enthusiasm for creating the archive. Darmstadt was too poor to contribute. The state was not, but it was not interested in the Darmstadt location.[67] In 1968 Senator Schwedler proposed that the archive be built in Berlin. The city and federal governments were persuaded to support the idea, and the archive was moved to temporary quarters in that city while the plans were being revised to fit a new site and construction completed.

Philip Rosenthal, introduced by Gropius, became a member of the archive's Board of Directors

Bauhaus Archive,
model. Gropius
with Alex
Cvijanovic and
TAC, 1964

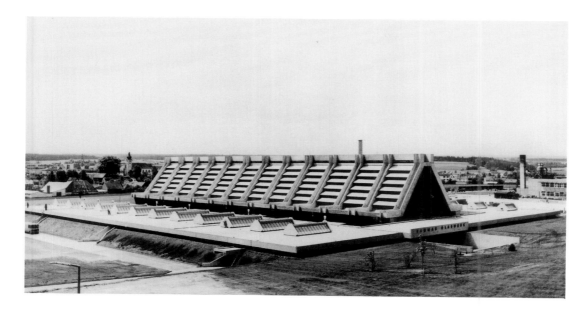

in 1968, bringing to it new vigor and a demonstrated interest in good design. Though a newcomer to Bauhaus affairs, Rosenthal's association with Gropius had begun in November 1963, when he asked him to design a china factory in Selb. Gropius, as in the Faguswerk of more than fifty years earlier, desired to design for the most advanced means of production and to contribute to the humanization of working conditions by taking account of the findings of psychologists and sociologists. Though the architects, Gropius and Alex Cvijanovic, could not wholly free the workers from the monotony of the manufacturing process, they did improve their environment by including a conservatory, aviary, information center, and leisure-time facility.

Rosenthal's satisfaction led to his commissioning Gropius and TAC for his Thomas Glass Factory in Amberg, now regarded as Gropius's finest factory design since the Faguswerk. The architects' functional solution to the traditional environmental problems of glassmaking resulted in the great scale and the high, steeply pitched roof of the central glass-blowing hall, popularly named the "Glass Cathedral."

Rosenthal was also dissatisfied with the quality and supply of housing available to his workers. In 1966 he asked Gropius to design modest-cost multiple housing for the employees at the Selb factory. These were three-story walk-ups with six dwelling units in each building. The plans were not used at Selb, but five such buildings were built near the glass factory in Amberg, with rents subsidized by the Rosenthal Company.

In 1968 there was still another commission from Rosenthal. This was for the design of china tea and coffee sets, which Gropius carried out with Louis McMillen and Katherine DeSousa of TAC. He was particularly pleased with this opportunity, the first such since his work for the Aluminium Company in London, and even more so when reminded of Schinkel's designs for the ceramic industry in 1820. For their design for the tea service, TAC was awarded a gold medal at the International Exhibition of Ceramics at Faenza, Italy.

China tea service for Rosenthal. Gropius, Louis McMillen, Katherine DeSouza, designers, 1968

The Rosenthal commissions led directly to one for the redesign of the town of Selb to meet a projected growth of population and to anticipate the resulting problems and new activities. In 1966 Rosenthal introduced Gropius to the mayor, Christian Hoefer, who was most receptive to new ideas. Gropius saw Selb as a prototype of small towns facing rapid growth, which would encounter problems that were general to many countries, though differing in detail. He believed that broad principles would result from its study. Earlier in 1966 a commission for a traffic plan had been awarded to Professor Kurt Leibbrand of the Verkehrs-und Industrieplanungs GmbH of Frankfurt am Main. Gropius formed a team with him and Cvijanovic to integrate traffic planning and town redesign. In 1968 a preliminary study was completed and published.

Return to England: Gropius's recognition in England equaled that in Germany, though by no means did it find equal expression in the form of commissions. However, the appreciation of the English was genuine and was acknowledged symbolically by the honors bestowed upon him. The first such was the award by the Royal Institute of British Architects (RIBA). In April 1956 Gropius returned to England to receive the honor.

The England he found had undergone enormous change from the country he had known in the mid-thirties. Despite her victory over Hitler, England had suffered grave damage, the repair of which strained the already tight economy and permanently altered the character of the nation. No longer could England be a great imperial power; rather she had to put all efforts toward solving domestic problems. The reduction of England's economic and political stature created frustration but also a new response from the intellectuals, who occupied an increasingly important role in society. This was one reason — aside from his obvious success in the United States — why Gropius may have been better received on his return to England than when he first arrived in 1934.

The warmth of the welcome extended by former associates and friends, who themselves had now

gained public recognition, was compensation enough for the years of difficult readjustment and struggle in the thirties. The award by the Royal Institute may have been as much in belated recognition of that as it was for new accomplishments.

Some 170 friends and admirers of Gropius met at dinner at the City Company of Ironmongers on April 12, 1956. Among them were many who had attended the farewell dinner in early 1937, including John Gloag, J. M. Richards, Henry Moore, Sir Herbert Read, and several Bauhäuslers. Lord Esher, as chairman of the Architecture Club, presided. Julian Huxley, who had presided at the 1937 farewell, spoke at the beginning of this happier event. Conjecturing on the reason for his invitation to speak, he noted that as a scientist interested in art he was a rare phenomenon, but this fitted with Gropius, whose "lifelong aim was to work for the reunification of art and science, without which there can be no true culture."[68] Other guests who also had attended the 1937 farewell now spoke. Max Fry was poetic in recalling the advent of Gropius:

> One of those world calamities that arise
> Proving to us a blessing in disguise.
>
> What could we lack, what was there then to fear
> As then, so now, we have our Walter Gropius
> And he is — what's the word — he's
> Cornucopius, Gropius.[69]

Henry Morris spoke, as did Jack Pritchard, who said that they were recognizing merits "that should have been obvious twenty years ago. ...The England of the 1930s was too insular and self-satisfied — perhaps too frightened of new ideas."

Gropius, though he had been ill from oyster poisoning and had been up all night, attempted to respond to the warmth of his friends' introductions. Looking like a ghost, he first described how he had felt in 1937: "My heart was then bursting with all kinds of emotions, sadness to leave this England, deep worry about my home country, apprehension about my new tasks in the United States." In actuality, he had been quick to reestablish himself in the sympathetic environment of Harvard, and he could now say with some aplomb: "Crossing the ocean as often as I have done has taught me to feel and react like one who has a tremendous stake on both sides and would no sooner favour one over the other side as he would one of his own legs over the other one." He praised the English for their systematic and experimental approach to the planning, development, and redevelopment of towns (an approach he would press for a year later at an urban design conference in Cambridge, Massachusetts):

> Nothing seems to be more needed as an example, as a demonstration, for all those who doubtfully hesitate on the threshold of our new era of industrial civilization, because they have no convincing proof that it will provide them with sustenance for real living in contrast to mere existing amidst the blind buffeting forces of relentless progress.[70]

Despite the air of nostalgia, it was a festive affair.

It was not the RIBA award or the loyalty of friends, however, that would reestablish Gropius as an architect in England. Rather, it was his role in the design of the Pan Am building in New York and the acumen of an English investor in that property that were to bring him again and again to

London. The initial purpose was to deal with the problems of Piccadilly Circus. For hundreds of years, the Circus has been a focal point of London's life. Schemes for its development had appeared for over a century and a half, beginning with a plan by John Nash in 1820. A project for the Monico site (so named for a restaurant that previously occupied the property) fronting on Piccadilly Circus was proposed in 1955. Jack Cotton's City Centre Properties, Ltd, was the entrepreneur, and the architectural firm of Cotton, Ballard and Blow, the designer. The original designs for the proposed multipurpose building were not considered adequate by architects, artists, the public, or the Royal Arts Commission, and their opinions were expressed in the newspapers, in the ministries, and in public hearings. Furthermore, the problems of pedestrian and vehicular traffic circulation into and around the Circus appeared to be without solution. Cotton accepted the suggestion of Erwin Wolfson, president of the company that owned the Pan Am building, that he consult Gropius. In mid-1960 Cotton asked him to serve as design consultant; he invited Richard Llewelyn-Davies and his partner, John Weeks, to be collaborators. The long delays in gaining approvals had cost Cotton a fortune and considerable ill will on the part of the public, and before Gropius could really inform himself about the site and project, he was put on television to calm the aroused feelings. Gropius was concerned by the possible reactions of English architects to his intervention, but was reassured by Davies. Though Davies agreed that there were always "a small number of mean-minded people in the profession who object to architects from abroad doing anything at all in this country," he was certain that Gropius would be "welcomed by all the progressive forces in architecture over here."[71]

The announcement of Gropius's involvement in the Piccadilly Circus project evoked new response from its opponents and from the press. One newspaper reported, "It seems that, to draw the teeth of the aesthetes after their savaging of his original proposals, Mr. Cotton has invited the formidable Dr. Walter Gropius."[72] But the future of Monico did not lie with placating the aesthetes. The problem remained one of finding a traffic solution that would satisfy the many organizations concerned with the Circus and soon enough to permit Jack Cotton to exercise his option on the property and to proceed with the construction. Unfortunately, the delays occasioned by disputes and divergence of views were inordinate, and by 1964 Gropius's involvement ended.

The demands made upon Gropius, still remarkably vital though now approaching eighty, had increased rapidly. When in Cambridge, his presence in London, Berlin, or Baghdad would be sought; when abroad, his attendance at meetings of TAC or with clients in America seemed crucial. Among the "demands" — or opportunities — presented to Gropius in mid-1960 was one by Jack Cotton to develop a proposal for a shopping, hotel, and entertainment center in Birmingham on an important central city site. With his TAC partner Benjamin Thompson, Gropius went to Birmingham, his first visit there for an architectural commission since the ill-fated project for Philip Sargent Florence in 1935. He took time to visit again the Florence property and noted that a single high-rise building was still the best way to preserve the site's now naturally enhanced beauty.

The programming of the complex city center was difficult and protracted; Gropius and Thompson prepared alternative schemes within the year, one of these a well-studied submittal of plans, facades, and model. Even then they found themselves in peculiar competition with Cotton's own architectural firm, Cotton, Ballard and Blow, and with his development organization, the City

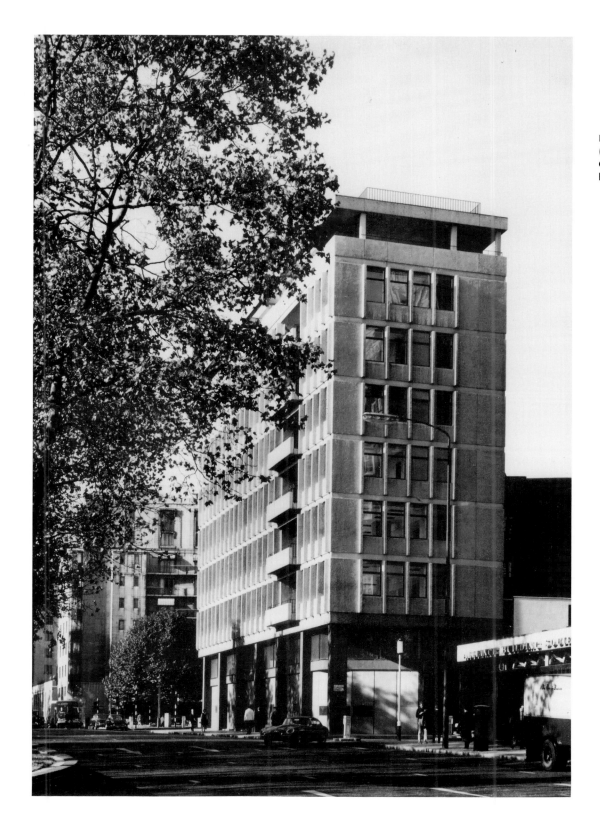

Park Lane Building
(later a Bunny
Club), London,
begun 1960

Centre Corporation, which had still other views. Though the Gropius-Thompson scheme received praise, it was directed to limited features of their design. The criticisms were of commercial-economic aspects, much more important to the entrepreneurs, who unfortunately had not made the most recent changes in the corporation's policies and program known to Gropius.

Cotton's ambition to build seemed boundless, and though several of his projects were in various stages of study during 1960, in August he proposed a building in Park Lane, London, with shops, offices, and apartments. Gropius and TAC were invited to collaborate with Llewelyn-Davies and Weeks, already brought in by Cotton, and the project began immediately. As in other work for Cotton, there again were several additional participants, including his architectural and realty firms. Despite the plethora of viewpoints, a program was developed, design differences ameliorated, and the not particularly distinguished building built. Though he regretted that of the three Cotton projects only Park Lane was constructed, Gropius later would see humor in the fact that the whole building would become a Bunny Club.

On January 23, 1961, Ben Thompson and Gropius congratulated Sir Richard Llewelyn-Davies, just then elevated to the peerage, who replied modestly, "I may be able to use the platform of the House of Lords to support some of the things which you and I believe to be important."[73] A few months later Gropius himself was singled out for new honors, this time by the Royal Society of Arts, who awarded him its Gold Albert Medal for 1961 in a ceremony at Buckingham Palace on November 7. He joined the company of distinguished recipients of the medal, among them Queen Victoria, Joseph Lister, Winston Churchill, and Queen Elizabeth,[74] and did indeed feel "embraced by England."

Practice in Canada and the United States: The Park Lane building was Gropius's last opportunity to build in England, while in Germany he continued to receive architectural commissions. In both countries, social activities filled any free hours in his calendar. By contrast, in Cambridge and Lincoln his free time was largely given to professional, political, and other causes. When, in 1959, he lent his name and prestige to the National Committee for a Sane Nuclear Policy, it was in reaffirmation of a position he had taken in March 1946; then he had foreseen the exploitation of atomic research by the military and called for civilian control.[75] Though he remained concerned about CIAM, he had long insisted that maintaining its integrity was the responsibility of the younger generations; yet members turned to him, not to the newcomers, to solve organizational problems.

Nineteen sixty-three, particularly, was a year of intensive activity and aggravation for Gropius; there were problems at Harvard in the Visual Arts program and in the Graduate School of Design. His correspondence with Sigfried Giedion in February 1963 reveals his discouragement:

About the Visual Arts Center here, I am much in the dark and so seems to be the [Visiting] Committee. I talked with [Arthur] Trottenberg the other day who was gloomy. I must blame Sert that he has let slip this unique opportunity…he is mainly interested in his building commissions and treats education as a second duty only. [Joseph] Passonneau whom he had engaged as Assistant Dean…has suddenly resigned and has created an embarrassing situation. In spite of this, Sert went on his trip around the world. His faculty is angry that he left them in this critical moment.[76]

Ten months later, Gropius had come to the conclusion that "Sert is a very bad administrator and, to my surprise, rather timid in his actions which have brought about a kind of stagnation in the School. . . . The real positive asset is that Ben Thompson [of TAC] has taken over the Architectural Department. . . . He has also tact enough not to collide with Sert, at least I hope so."[77]

The appointment of Thompson promised an auspicious era in the Department of Architecture, following a decade of uncertainty. The students were stimulated by him, but with Sert still a member of the department, and as dean in control of the budget, freedom of expression was dampened.

Unfortunately, the comment about Thompson's tact preventing a collision with Sert proved overly optimistic, and Thompson, in fact, involved Gropius in an embarrassing situation. Gropius had written forceful comments about Sert's administration to Thompson, who circulated the memo among the faculty. Discovering this, Gropius hastily sought to mend relations with Sert (whom he described to Thompson as his friend for thirty years); he was apparently successful. Thompson's dissatisfaction continued. He showed less interest in the school and his delegation of his responsibilities to others led to a student demand for his resignation, which he submitted. He also did not see eye to eye with his TAC partners, and on December 7, 1965, he informed them that he would withdraw from the firm.

Fortunately, Gropius found occasional respite from problems, and there was always time for celebration. On May 18, 1963, Gropius's eightieth birthday was marked by a gathering of eighty graduates and friends at Harvard in the Harkness Commons, fittingly a building he and TAC had designed fifteen years earlier. Alumni representing classes from each of Gropius's fifteen years at Harvard spoke briefly. I. M. Pei, speaking for the master's class of 1946, said: "When I first came to Harvard, Gropius did not understand my language. Gropius's contribution to the American architectural scene is that he brought us a common language." The great birthday cake was in the scale and shape of the Dessau Bauhaus. Albers's recently published portfolio, autographed by the artist for the occasion, was presented,[78] and letters and cables arrived from alumni and friends located all over the world. Gropius responded warmly:

> Since you have all combined forces to help me turn myself into that oddity called an octogenarian, I should at least try to repay you by giving a convincing demonstration on how to cope with such a situation. . . . I still feel like a rank amateur at this job of getting older.

He called for more cooperation among architects; he had good reason to feel strongly, having just returned from Gropiusstadt, where cooperation among the five architects selected had initially been a great problem. He spoke patiently about the controversy over the Pan Am building in terms of urban design and density, and the problems of society in an era of prosperity and change:

> Maybe this situation explains our present inability to work concertedly of which I spoke, but it has not eliminated the urgent need for it. I hope you will go on fighting for it; then I shall feel my eighty years were well spent in pursuit of this ever-distant aim: unity in variety. I hope that fate will permit me still to get a glimpse of coming unified accomplishments.[79]

It was not only "coming accomplishments" with which Gropius was concerned, but also very much those of the past: his own and those of his contemporaries. He chided Lewis Mumford for an article

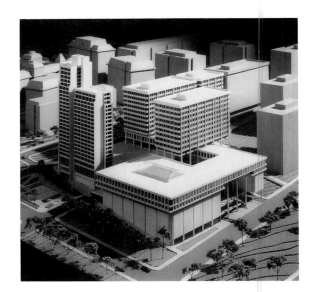

Place St. Cyrille,
Quebec, model,
1964–65. Gropius
and TAC

in which the author had dated the beginnings of modern architecture to the twenties, "first in France through Le Corbusier and Lurcat and later in Germany with Mendelsohn and Gropius."[80] Gropius countered:

> To my knowledge, neither Le Corbusier nor Lurcat have built any "modern" buildings before my Fagus Factory (1911) and the Office Building at the Werkbund Exhibition, Cologne (1913-1914). Mendelsohn's work appeared the very first time in public at an Exhibition for "Unknown Architects" which I arranged together with Bruno Taut in the Neumann Gallery, Berlin, in 1918.
>
> May I contribute this evidence for history's sake?[81]

Mumford hastened to cover himself:

> If I neglected to mention them it was only because I dated the beginnings of modern architecture, as I explicitly said in the article, to a period long before; and so I reserved the term "modern" with quotation marks to the movement which began in the twenties. Admittedly, your own work spans both periods. But I am sorry if you thought this summary description slighted or overlooked your leadership. If Le Corbusier has been unfairly identified as the central figure, that is surely the result of his literary flair, not his architectural innovations.[82]

Despite his consciousness of his historical role, Gropius was preoccupied with the present. At times he found it difficult to decide which projects he should devote his time to. When offers came from Canada, there was no hesitation, for he had not had previous opportunities to work in the country, about which he had great curiosity. In mid-May 1964, Gropius was introduced to Leslie Marlowe, an entrepreneur who intended to develop a large project on a twenty-four-acre site on Toronto's waterfront, a proposal that included a hotel, apartments, a merchandise mart and warehouse, and an office building; there would be a harborside park, ferry terminal, marina, and restaurants. By September Gropius and William Geddis had prepared a program, selected Crang and Boake of Toronto as associates, and arranged a contract with Marlowe.

A newspaper story about Gropius's visit to Toronto that month led to an inquiry by the Ontario

Association of Architects, which was concerned that such consultation would violate the Provincial Architects Act. TAC's participation as architect of the project would be construed as an admission that no architect in Ontario was capable of doing the project. TAC could be consulted in Cambridge but would not be permitted to come to Toronto in connection with the project. The names of Gropius or TAC could not be used in any connection with the work, "on drawings, job signs, press releases or in any form whatsoever." Inasmuch as architectural registration was open only to British subjects, an acceptable working relationship was sought.

By mid-January 1965 permission had still not been received for the proposed architectural consultation nor had Marlowe paid for TAC's services. Gropius and TAC, however, continued to design alternative schemes and early in April proposed that they provide consultation in Cambridge or Toronto through the device of a personal contract for planning services between Gropius and the client. In mid-June and again in early August Gropius reiterated TAC's request for payment. By December, Marlowe's financial backers had failed, the collection of the account had been placed in legal hands, and the project was finally closed out by TAC.

A second invitation to work in Canada had followed within months the beginning of the Toronto project. In November 1964 a proposed development for the Place St. Cyrille Commercial Center in Quebec gave Gropius his opportunity to visit that city. Attracted by its appearance, he termed it "the only European city on the Continent." He had been informed of the strong traditionalist feelings among Quebec citizens and that his concerns for continuity and relatedness would be tested.

The clients, Harvey Maron and I. R. Ransen, who had organized Place St. Cyrille Limitée as a project of their Mondev Corporation, had assembled a prominently located property adjacent to the Provincial Parliament building, and not far from the historic fort. The corporation proposed to construct a complex of office buildings, hotel, apartments, and commercial spaces. A principal problem was to preserve the aesthetic and historic qualities of the location, yet satisfy the economic requirements of the clients.

By spring 1965 there was consensus as to the program for the project, though at the last minute an additional page was inserted in the program summing up the differences between Gropius's approach of respect for the cultural environment and the attitudes of the architects and politicians, who wished to emulate the high-rise buildings of Montreal and Toronto as a symbol of a progressive and vigorous city. The page was removed before the report was presented to the prime minister. Apparently the prime minister's reaction was mixed, though he did express a desire to have Gropius's view on the development of the Parliament buildings as well as on other private ventures. Nevertheless, by June the Parliament had created its own development commission, and in July the provincial government took over the redevelopment area from the city, charging procrastination. The limitations placed on the development by these groups, the Historic Architecture Preservation body, and by Gropius himself reduced the amount of rental space, very much affecting the economics of the project and resulting in conflicts regarding fees. Adding to the confusion was the prime minister's declaration that the site would be needed for an enlargement of the Parliament building. Gropius finally asked that his name and that of TAC be disassociated from the project,

which shortly thereafter was quietly abandoned, and Gropius's hopes to build in Canada were ended.

At home, however, there were challenging commissions in which he was involved as a principal and to which he could turn with an architect's joy in directing work in all its stages from design through construction. One such project was the John F. Kennedy Federal Building in Boston's Government Center. In early 1961 a program for the building was developed with representatives of the General Services Administration, and the architectural studies proceeded. The building is composed of a twenty-six-story tower and a connecting four-story building, which form a backdrop for Boston's flamboyant city hall. The high-rise is divided vertically for increased office lighting, in the manner of the Thyssen building in Düsseldorf. To comments about the lack of an original form, Gropius replied in Miesian style, "We cannot make a new architecture every month!"

The program called for sculpture and painting to be integrated with the architectural design; the General Services Administration requested the architects to recommend the artists and works of art. First to be commissioned were Robert Motherwell, who created a mural for a prominent wall space, and Dimitri Hadzi, whose freestanding bronze sculpture memorializes Kennedy.[83] The building was dedicated on September 9, 1966. Gropius had been asked to speak at the ceremony and had prepared brief remarks, but was not called upon to deliver them; indeed, the building was hardly mentioned. The Kennedy family participated in force and spoke; it was an election year and the dedication became something of a political rally.

Gropius's days away from the TAC office were well occupied. Typically, rising early on a Saturday he attended to chores of house and garden; he mowed the grass once in a while without enthusiasm. There was a daily regimen of bird feeding and handouts for the raccoons. Squirrels were killed or driven off with a rifle. Horseback riding was reserved for Arizona or for the visits of the grandchildren. The unexpected became the expected. Ati and her family would come for a visit, or ten German architects would arrive for cocktails. Small wonder, then, that one friend, observing Gropius "resting" at home following a bout with intestinal grippe, recited: *"Wenn du denkst du hast'n, springt er aus dem Kasten!"* (When you think you have caught him, he jumps out of the box).

At times Gropius's international correspondence was as heavy as the domestic and accumulated to be dealt with on weekends. In 1961, with tensions over Berlin at their height (the Wall would be built in August), Gropius with many others endorsed a *New York Times* article that called for the city to be placed under the United Nations. This evoked many calls and letters from Germany as well as the United States, both supporting and strongly criticizing him.

His endorsement of a UN regency for Berlin notwithstanding, appreciation of Gropius and the Bauhaus continued to mount, not only in West Germany, but also in the East. There, the restoration of the Dessau Bauhaus building was under way and rehabilitation was intended for Törten, the Haus am Horn, and the Arbeitsamt; products of the Bauhaus were being collected and exhibited and Bauhäuslers honored. East German historians and other authors were writing about the Bauhaus era, giving overdue credit to Hannes Meyer for his contributions. Newspapers carried occasional items about invitations to Gropius to visit East Germany and his intentions to

John F. Kennedy Federal Building, Boston, 1961–66. Gropius with N. C. Fletcher and Sam Glaser Associates

do so. In actuality, no formal invitations had been tendered, though friends had brought him informal, though cordial, invitations; one of these came through Isaacs, who told him the people at Dessau wanted him there when the reconstructed Bauhaus building was completed.[84] West German friends were alarmed and nearly unanimous in advising Gropius not to go to the East. Fritz Hesse, the former mayor of Dessau, ascribed devious purposes to the East Germans, and warned that anything that Gropius might say or do, or any recognition that he might give to the East German reconstruction program, would be reinterpreted to serve as Communist propaganda when picked up by the international press. Hesse, unlike others who foresaw dire consequences, did not advise against a visit by Gropius, "but it must be remembered that for anyone who visits the labyrinth of that zone, it will be difficult to find the thread of Ariadne which would protect him against future unpleasant consequences."[85]

Gropius wanted to visit the East to see again his early works, to visit old friends, and to judge for himself the postwar reconstruction and housing efforts, but he was pragmatic enough to realize that his effectiveness in the West could be impaired. Without an official invitation and guarantees from the DDR government, the BDA, or the universities, he decided not to visit.

Then, too, Gropius was preoccupied with the work of TAC and specifically at that time with a commission for a development in Cleveland that came to him in May 1964 from Frank Porter. Though some of the TAC associates were not enthusiastic about the projected site in Shaker Heights, Gropius met with Porter in Cleveland and decided that the property was not without some advantages. Importantly, he found Porter to be open-minded; he was a collector of contemporary art and had a well-developed interest in design. The development proposal required almost three acres of office space to be constructed in two stages. The site and program, now expanded to include a bank, shops, a restaurant, and a parking garage, dictated a tower-type building, despite zoning height restrictions. Gropius persuaded the Shaker Heights officials to permit the construction of

a twelve-story office building and a several-story garage. It was less difficult to persuade Porter to include murals by Al Held in the public spaces of the office building. At the August 9, 1965, ground-breaking ceremony for Tower East, at which Gropius arrived dramatically by helicopter at the most appropriate moment, he stated:

> There is a relatively new urbanistic interest in the United States, supported by the President in his demand for more beautiful cities, that in new building projects the whole of the environment must be taken into consideration instead of making only piecemeal additions.

The successful project would lead to new opportunities for Gropius and TAC.[86]

Pleased with the progress on Tower East, Porter invited TAC to prepare a plan for the development of his 115-acre property in the village of Pepper Pike, about five miles east of the Shaker Heights development. He proposed six hundred town houses and apartments in medium- and high-rise buildings for upper-income families. The majority of these would be condominiums or cooperative housing. Subsequently the project was reduced in scope to two hundred condominium town houses, office buildings, and a shopping center. Though Gropius and John Hayes prepared master plans and elaborate models for the purpose of obtaining necessary zoning changes, by 1973 the project was dormant.

The new projects for which Gropius had a major responsibility were only a part of the current work on the drafting boards of TAC. The firm had expanded greatly and had long since outgrown the historic colonial house on the corner of Brattle Street and Appian Way in Cambridge and the half dozen additional suboffices scattered in old houses and commercial buildings in the general vicinity of Harvard Square. The problems of communication and management inevitably led to the decision to design, finance, and put up a building within which all operations would be centralized. Although many members of TAC would eventually contribute ideas to the design of the building, its initial planning was the responsibility of H. Morse Payne. Estimates of cost exceeded budget,

and Louis McMillen, with Payne and Peter Morton, hastily reworked and redesigned the schemes. The new building, unmistakably the work of TAC, was dedicated on November 16, 1966.

A few months after the TAC dedication ceremony, Gropius fulfilled a long-cherished ambition and in January 1967 left for a trip to Egypt, as well as Germany, Italy, Sicily, and Iraq. Though both he and Ise fell ill during the journey, it was an unforgettable event. Gropius reported, "I saw the Luxor Temple. Greatness in scale and detail, but almost intimidating. The human grace of Greece as I saw it in Sicily remains for me the very summit of all architecture."[87]

Arriving home on the weekend of February 24, Gropius attempted unsuccessfully to cope with the accumulation of correspondence and office questions. The virus he and Ise had contracted in Egypt had fatigued them both, and Ise had broken her wrist on the day of their arrival when she slipped on the icy steps to their entrance. The New England winter now seemed unbearable, and four days after their return, they went to Arizona to recuperate. The next day was Ise's birthday, and she was greeted by desert flowers and a note from Walter: "CERTIFICATE (Renewal!) As long as it still beats, my heart is yours…"

Awaiting Gropius's return from Arizona was the backlog of correspondence that had been untouched since early January. Among the letters was a request that he advise on the preparation of a great Bauhaus exhibit, a task he would enjoy. Begun as a project of the Royal Academy of Arts in London, the exhibition was now under the sponsorship of the German government and the Bauhaus Archive. The design was under the direction of Herbert Bayer; aided by Gropius, he sought the participation of Bauhäuslers, but during the ensuing months he found their egos frustrating. In some exasperation he wrote to Gropius on December 8, 1967, from Aspen, Colorado:

> [Ludwig] Grote is working very well now although he has…great trouble, as you have heard, with [Josef] Albers, Nina Kandinsky, etc. …When he spoke to Mies about participation, the answer of Mies was, "I have absolutely nothing to do with the Bauhaus." In spite of that, we will put him in the show and also Albers, unfortunately not as well represented as he would have been otherwise. I am certain we will not have any friends left after this exhibition.

Bayer was prophetic, for some Bauhäuslers felt their roles, contributions, and works were given inadequate attention, while some non-Bauhäuslers felt their own parallel development was of such importance that it should have been noted. The distinguished organizers, patrons, contributors, designers, and fabricators were reluctant to compromise their individual genius to the inflexibility of the scheduled opening in Stuttgart in spring 1968.

An exhibition of great beauty and vitality — and dedicated to Gropius — it was by any measure a success. Capacity crowds moved slowly through almost an acre of exhibit space containing one visual surprise after another. In reporting on his days in Stuttgart, Ise described Gropius as "walking on air, though on wobbly knees, as he insists."[88]

In September the Bauhaus exhibition opened in London. The *Times* reported Gropius's participation in the opening ceremonies: "Those who expected to see an elderly gentleman step up to the rostrum for a few faltering words of thanks were taken aback by an address delivered in trombone tones and packed with combative matter."[89] The exhibition drew a hundred thousand visitors in Stuttgart and similar numbers in London, Paris, and Amsterdam, and then traveled to

Ottawa, Chicago, Los Angeles, Buenos Aires, and Tokyo. For the first time the world confronted Bauhaus originals, two thousand of them, instead of a legend. Reports of the great numbers of young people attending delighted Gropius; their exuberance and obvious pleasure, and their costume, gave a sense of spontaneity to the exhibition.

Rivaling the festivals of the Bauhaus in gaiety was the observance of Gropius's eighty-fifth birthday, for which he had returned without delay from Stuttgart. The celebration was held at Harvard in McKim, Mead and White's stately 1895 Robinson Hall, where Gropius had taught, and overflowed into a great striped tent in the adjacent Sever quadrangle. There were flowers in profusion, hundreds of balloons, and buttons and straw hatbands cajoling all to "Vote Grope." Five hundred students, colleagues, and other friends, mellow with champagne, strawberries, and music, heard speeches and cables and letters read in praise of Gropius. To his great surprise and pleasure there appeared Jack Pritchard, his English patron and friend of thirty-five years, whose nostalgic remarks recalled other birthday celebrations. Harvard's president Pusey and others spoke briefly, and the president of the Federal Republic of Germany cabled his best wishes. Gropius's reply to all this was simple: "Live longer; through endurance you may become somebody!"

Age had not diminished Gropius's spirited defense of his principles. In late 1966 he canceled his subscription to the *Progressive* because he was "tired of the harangues by Messrs. Fulbright, Galbraith and Kennan" and "was listening in vain for a concrete proposal...to end the war in Vietnam."[90] The constant criticism without mention of achievements, he said, "creates a feeling of nausea." And early in 1968 he wrote John Kenneth Galbraith to protest the support given by the Americans for Democratic Action to the candidacy of Senator Eugene McCarthy. He discontinued his membership in the ADA, as its "new trend...runs against my own thought and conscience."[91]

The Bauhaus exhibition was still very much on Gropius's mind when later that fall he seated himself on Malcolm Ticknor's drafting stool to work on the design for the addition to the Huntington Galleries at Park Hills, Huntington, West Virginia. He had already visited various museums and had discussed the requirements of security, lighting, display, air conditioning, humidity, and surface materials with curators, collectors, and engineers. The Huntington Galleries became a most appreciative client, won over by the boldness and foresight of the master plan he presented for the phased expansion. Gropius's speech at the ground-breaking charmed them, for it was within their own objectives. He emphasized the value of the museum to their children and future generations:

> Children should be introduced right from the start to the potentialities of their environment, to the physical and psychological laws that govern the visual world and to the supreme enjoyment that comes from participating in the creative process of giving form to one's living space.

He also reminded the present generations that, "In a highly developed democracy, the intuitive qualities of the artists are as much needed as those of the scientist and the mathematician."[92]

One of the cables Gropius had received on his eighty-fifth birthday was from the German Foreign Office, which not only sent good wishes but also proffered a commission for the design of the residence of the German ambassador to Argentina. Six months earlier architect Amancio Williams of Buenos Aires had hinted that a commission for an embassy building was in the offing. Gropius

accepted the offer with some hesitation, fearing that this might be little more than an ordinary residence, too small to carry the expense of two architects, Williams and himself. By mid-June, however, negotiations were under way, and in November 1968, with Alex Cvijanovic, Gropius traveled to Buenos Aires to complete the agreements and examine a proposed site.

En route they paused in Lima, and again Gropius felt frustrated at not being able to visit the Incan fortress-city of Machu Pichu because of its high altitude. During an earlier trip he had contracted a bad cold in Arequipa and could not move to the higher level; now he knew that he would never see it. By December 1 in Buenos Aires, he had forgotten his despondence and said, "Alex, this is the place to buy solid leather suitcases; we have a great deal of travel ahead of us." He met again an old friend, Mrs. Victoria Ocampo, who long ago had published an article by Gropius, perhaps one of the earliest in Latin America.[93] He wrote home:

> Dear, just back from Victoria Ocampo's dinner. Old, great splendor. Park with fantastic trees from all continents, and wide view over the La Plata river. Amancio Williams and wife — descendant of the last Inca — and eight children in big old house, very nice civilized people. ...Mental tests of strength but I am feeling well all the same.[94]

At the Ocampo dinner Gropius provided a discreet lesson to Alex as to how a traveler should anticipate the festive occasions that almost inevitably arise on meeting clients and friends. Among the formally dressed guests, Alex was conscious of his travel-worn brown suit and shoes, and his youthful tie, and noted how Gropius in his usual dark suit, newly pressed, fresh white shirt, and small bow tie, appeared not only appropriately dressed for the event, but in a relaxed and receptive mood. Sensing Alex's discomfort, Gropius attempted to cheer him, saying, "Dress your mind and conversation to fit the occasion, and no one will notice your shoes."

Although the public's reaction to Gropius's visit to Buenos Aires was enthusiastic, there had been, from the very beginning, opposition from the mayor and others to the use of the Palermo Park plot, which the state had provided for the German government's use. Gropius and Williams, however, believed that they had overcome much of the criticism through the development of a novel design that permitted the passersby to view the park through the building. The residence was divided into a lower story, in good part depressed below street level, and a second story elevated well above eye level. The critics, however, remained unappeased.

On March 24, 1969, Amancio Williams reported that the new president, Juan Carlos Ongania, had requested the German government not to build in the park and had offered to exchange properties. Williams added that he saw no hope of building the embassy on the intended site, and indeed the Bundesbaudirektion soon notified Gropius of the suspension of the project.

The development of the ambassador's residence schemes and the visit to Buenos Aires had been exhilarating, but with the planning of the Huntington Galleries and other demands, they constituted a heavy program for a man of eighty-five. Though Gropius would not admit fatigue, it took little persuasion from Ise to get him to agree to a stay in Arizona. In early March they departed a still uncomfortable New England for a vacation; he wrote on arrival: "Here I am again right away on horseback feeling happy. It is good to be free of snow for a while...after cold and rain, the desert sun is brilliantly shining, recuperating us for the rest of the New England winter."[95]

Six halcyon weeks passed, then Gropius was back at his desk, preoccupied with a new

German ambassador's residence, Buenos Aires, model, 1968. Gropius and Amancio Williams and TAC.

commission. The client demanded his personal attention to ensure the appropriate design and atmosphere for the project, a small Kneipe, or pub, adjacent to the Baugenossenschaft IDEAL tower building in the Britz-Buckow-Rudow development in Berlin. Though a restaurant was originally included in the plan, a Gemeinschaftsraum — a common room — was provided as a way to foster community feeling. It was located on the top (thirty-first) floor with a view toward all directions from Mark Brandenburg to beyond the Berlin Wall into East Germany.[96] A restaurant of some kind was still needed, and Gropius proposed the Kneipe, which would serve as a coffeehouse in the afternoons, and as a restaurant/pub in the evenings. He recommended that it be on the west side of the tower building looking toward a bird sanctuary in a small wooded area. The client, a brewer named Schultheiss, and the IDEAL developer agreed that only Gropius was to create this intimate spot. Gropius wanted a local architect to carry these to completion and supervise the work once the program and sketches had been completed and approved. He gave the small Kneipe the same thoughtful attention that he gave to larger projects, concerned that it be an integrating opportunity, relating architecture to society. Impressed, the pub manager asked permission to call it the "Walter Gropius Kneipe."

Though the ordinarily restorative and reinvigorating Arizona vacation was only a few weeks past, by the latter part of April, Gropius felt a persistent weariness, and an occasional glandular pain, which he had noticed but ignored during the exhilarating days on horseback in Arizona. Diagnosing himself as suffering from no more than a passing cold, he brushed off Ise's plea that he consult a doctor and continued his daily stint of work and worry. He realized that he had to husband his energy and declined an invitation, explaining, "I am afraid I will not be in the position to accept any active part in your plans. I am now eighty-six years old and keep the remainder of my strength to still do some professional work here and abroad."[97]

His birthday was celebrated at TAC, and Gropius participated, attempting to cover up his illness. A few days later, he felt it imperative to attend the Gropius Lecture and exhibit at the Dana de Cordova Museum, only a short distance from his home. It was a painful and exhausting ordeal, and thereafter, persuaded by Ise, his doctor, and successive chills and fever, he agreed to treatment at home. The illness was diagnosed as inflammation of the glands, and efforts were made to reduce the fever and to get rid of the infection through medication and rest. Finally, much against his will, Gropius agreed to an examination at Boston's Pratt Diagnostic Hospital. When he was admitted on June 7 with a temperature of 104 degrees and terribly exhausted, doctors discovered that he was suffering from a staphylococcus infection in the blood; the seat of the infection could not be ascertained immediately.

During the first few days interns and residents would visit him and engage in conversation. Ise, concerned about so much activity, wanted them to leave. In discomfort, yet always the teacher, Gropius disagreed, saying, "How can these young doctors learn if you turn them away?" The window of his room overlooked the building site of the new Tufts Medical Center, which had been designed by TAC. The noises of construction, the dust, and the confusion irritated everyone except Gropius, who was quite content to spend his hospital days adjacent to an active building site. Within a fortnight, his extraordinarily vigorous constitution and will, and the enforced rest and antibiotics,

brought him to the point of recovery. Seated in a chair every day to improve his respiratory functions, or reclining in bed, Gropius would see his wife and daughter and, more briefly, his associates and a few friends.

Anticipating arrangements for a three-month convalescence at home before returning to work, the doctors routinely examined his heart, which had withstood very well the unusual demands placed on it by the weeks of high fever. The aortic valve, however, had been damaged by the infection and required replacement.

Unless he agreed to the implant of an artificial valve, the doctors warned, Gropius would be subject to heart attacks and would have but a short time to live. Though they explained that it was not an unusual operation, Gropius, exhausted from the battle and in the haze of the drugs used to eliminate the infection, refused. He felt that he would not survive either way. "I have had such rewards already during the past two years, my eighty-fifth birthday celebration, the Bauhaus Exhibit. . . . Why should I ask for more of life?" To which Ise could only reply with another question, "Do you want to leave me with all that responsibility?" Gropius replied only, "I'm too tired." Fortunately, there were then two days when his mind cleared and he could speak lucidly. He recognized that the decision to proceed with the operation was urgent. Although it was a serious procedure at his age, he determined to risk it rather than to live as an invalid. Now clear in mind, he greeted his wife with, "It would be absolute suicide if I didn't allow this operation — and I'm not ready for suicide." The operation was performed on June 15. It was successful, and again there was hope of a full recovery. Gropius's own description of himself as a "tough old bird" appeared justified. Two hours after the surgery, Ise could talk to him, but he could only press her hand in reply.

He made some progress for about a week, but he could do no more than recognize his family and the few friends permitted into his room. His lungs then became congested and could not supply oxygen to the blood and brain. He lost consciousness and died in his sleep early Sunday morning, July 6, 1969.

The announcement of his death was simple, as he would have wished it. The world's reaction was enormous. Radio and television announcements were immediate. Cable messages flooded his office and home. Within hours, there were newspaper stories and obituaries. In days, letters of sympathy arrived from some forty countries on six continents. In weeks, more formal tributes and articles appeared in magazines and journals. One newspaper's lead editorial stated, "The world was the beneficiary of his exercise in universality."[98] An article in an architectural magazine ended, "His soul will be found in any school where the purpose of architecture is taught with a respect for life and a love of man."[99]

On July 7, the family, associates, and old friends gathered at TAC to quietly salute Gropius with champagne, as he had requested. Ise described this small gathering as being exactly as Gropius would have wished it:

> Everybody who came was on friendship terms with him, but by no means always with each other. Since my husband was always worried about the lack of communication between people. . .he would have enjoyed knowing that these people found out that they all had one thing in common: their love and respect for him.[100]

In Arizona, 1968

At the gathering, his brief testament and charge to his friends, written thirty-six years earlier, was read:

Testament April '33

Cremate me, but ask not for the ashes. The piety for cinders is a halfway thing.

Out with it.

Wear no signs of mourning.

It would be beautiful if all my friends of the present and of the past would get together in a little while for a fiesta — à la Bauhaus — drinking, laughing, loving. Then I shall surely join in, more than in life. It is more fruitful than the graveyard oratory.

Love is the essence of everything.

Ise, you whom I have loved most, please put in order and manage my spiritual heritage; as to the property on hand, handle it as you see fit.

Remember Ati, whom I love. (June 48)

NOTES

Preface

1. Gropius, letter to Manon Gropius Burchard, Lincoln, Mass., February 16, 1963.

2. Gropius, letter to Herbert Bayer, Cambridge, Mass., March 19, 1951.

3. Gropius, letter to Herbert Bayer, Cambridge, Mass., April 30, 1951. G. C. Argan, *Walter Gropius e la Bauhaus* (Torino: Francesco Toso, 1951).

4. Sigfried Giedion, *Walter Gropius* (New York: Reinhold Publishing Corporation, 1954).

5. Gropius, *The Scope of Total Architecture* (New York: Collier Books, 1962).

6. Acceptance speech for the Gold Albert Medal of the Royal Society of Arts, London, November 1961. He repeated these words when accepting the Kaufmann International Design Award, January 4, 1962.

Prologue

1. Gropius, Testament, Berlin, April 1933.

Chapter 1

1. For the many variations in the family name from the sixteenth to eighteenth centuries, and other family occupations during that period, see *Deutsches Geschlechterbuch* (Brandenburgisches) (Limburg and der Lahn: Verlag von C. S. Starke, 1972).

2. In his adventurous life he had also served as tutor to the children of the diplomat Wilhelm von Humboldt and as traveling companion to J. S. Bartholdy.

3. A publishing house and a book and art shop building were also included in the design attributed to Schinkel.

4. Carl Wilhelm's son Paul, who had taken over the diorama and its exhibits, built an atelier and warehouse on the site of an earlier Gropius atelier, across the street from the diorama and publishing house; all paintings were lost in a fire in 1882 that completely destroyed the buildings.

5. Gropius, letter to Klaus Karbe, Cambridge, Mass., May 5, 1967.

6. Gropius, letter to his sister, Manon Gropius Burchard, Lincoln, Mass., February 16, 1963. Some members of the Gropius family in this period entered commercial activities established earlier, while others, including his uncles Erich and Felix, became landowners or farmers.

7. The design followed Schinkel's visit to Britain in 1826 and was one of three facades (Greek, Byzantine, and Gothic) that he was required to prepare for his client.

8. Though sometimes beginning at higher elementary school levels, the gymnasium level of education might reasonably be compared to present American senior high school plus one year or more of college. Two types of schools existed: the *Gymnasium*, which stressed the humanities and classical languages, and the *Realschule*, which stressed the sciences and modern languages.

9. Luise Honig Gropius, letter to Erich Gropius, Berlin, February 3, 1903.

10. Luise Honig Gropius, letter to Erich Gropius, Berlin, date unknown. Kempinski's was a well-known restaurant and wine shop on Leipziger Strasse in Berlin.

11. Acknowledging this on her eighty-fifth birthday, he wrote: "You were definitely an authority for me — perhaps even more than our mother. …Your human wholeness has always influenced me." Letter to Manon Gropius Burchard, Lincoln, Mass., February 1965.

12. This was a gift to Walter's mother from her aunt, Auguste Wahlaender, in 1889.

13. According to Klaus Karbe, Walter's mother was given the estate during her father's lifetime, and in 1890 she sold it to Henry Suermondt of Aachen. Walter Gropius said that the estate was sold by his grandfather, who retained 12 *morgen* (7.5 acres), which were left to his mother and which eventually were inherited by Walter and his sister, Manon.

14. Now Zarczyn, between Gryfino (Greifenhagen) and Chojna (Konigsberg). Its main group is now a state fertilizer plant. In 1965 the house still existed.

15. Now Gornico in the Walcz (Deutsch-Krone) district between Walcz and Miroslawiec (Markish Friedland).

16. Gropius, letter to Alfred Gropius, Lincoln, Mass., October 10, 1961.

17. Now Drawsko, Pomorski, and Lake Lubie, respectively.

18. Zuchow, now Pozrzadio Wlk., was located about twelve miles directly south of Dramburg on the road to Neuwedel and Woldenberg.

19. Under the partition of Poland by the Congress of Vienna in 1815, the Province of Posen was assigned to Prussia. Most of Posen, now Poznán, was at the turn of the twentieth century part of West Prussia.

20. Julius Caesar, *The Conquest of Gaul*, IV, 2.

21. Gropius, letter to his mother, Munich, July 5, 1903.

22. Gropius, letter to his mother, Munich, July 11, 1903.

23. Gropius, letter to Klaus Karbe, Cambridge, Mass., September 20, 1965. Martens, an architect in the office of Martin Gropius and Heino Schmieden, married Bertha, the eldest of Martin Gropius's seven daughters and second cousin to Walter.

24. Gropius, letter to his mother, Wandsbeck, September 29, 1904.

25. Gropius, letter to his mother, Wandsbeck, October 9, 1904.

26. Ibid.

27. Gropius, letter to his mother, Wandsbeck, November 7, 1904.

28. Gropius, letter to his father, Wandsbeck, January 5, 1905.

29. Gropius, letter to his mother, Wandsbeck, February 10, 1905.

30. Gropius, letter to his mother, Wandsbeck, October 23, 1904.

31. Gropius, letter to his mother, Wandsbeck, March 19, 1905.

32. Gropius, letters to his mother, Wandsbeck, October 10, 1904; March 13, March 19, and May 2, 1905.

33. Verified by Rudi Matz, a cousin of Walter who assisted Erich in the management of Janikow and who had been inspector for several years there, in an interview in 1965. Also letter from Klaus Karbe, Bad Godesburg, December 14, 1965: "Aunt Bertraut…swears on a stack of Bibles that Walter is responsible for the buildings…and that he furnished the designs."

34. Gropius, letter to Klaus Karbe, Cambridge, Mass., September 20, 1965.

35. Gropius, letter to his mother, Berlin, June 26, 1906.

36. Gropius, letter to his mother, Berlin, undated, believed to be January 1906.

37. The wise and kindly old man provided Walter's first exchange of any meaning with a Jew; the second was Lehman in the Wandsbeck Hussars Regiment during the training year.

38. Two of these buildings remain in use; one has been so remodeled as to be almost unrecognizable; the second, despite deterioration, is still easily identifiable.

39. Though technically German, almost all of the workers, foremen sometimes excepted, were Poles, many of them illiterate; they were subjected to harsh laws in an effort to transform them into Germans.

40. Gropius, letter to his mother, Berlin, June 16, 1906.

41. Gropius, letter to his mother, Berlin, June 26, 1906.

42. Gropius, letter to his mother, Berlin, July 17, 1906.

43. Ferdinand Tanner, "Die Bauhütten des Mittelalters," lecture, Stadtamthof, Joseph Mayr Vertaz, Regensburg, 1871.

44. Gropius, letter to his mother, Mittelfelde, February 15, 1907.

45. Also referred to as Herrenhaus Golzengut and Gorengut, in Thieme-Becker.

46. Gropius, letter to his parents, on board the *Albingia*, October 2, 1907.

47. Gropius, letter to his parents, Burgos, October 9, 1907.

48. Gropius, letter to his mother, Medina del Campo, October 21, 1907.

49. Gropius, letter to his mother, Avila, October 25, 1907.

50. Gropius, letter to his mother, San Sebastian, October 5, 1907.

51. Gropius, letter to his mother, Madrid, October 31, 1907.

52. Gropius, letter to his mother, Madrid, January 8, 1908.

53. Gropius, letter to his parents, Madrid, October 31, 1907. Initially he took for granted the privileged class in which he moved; on November 6 he wrote from Segovia, "Everybody has a lot of money, beautiful things, and an interesting social life."

54. Gropius, letter to his parents, Seville, December 16, 1907.

55. Gropius, letter to his parents, Segovia, November 6, 1907.

56. Gropius, letter to his parents, Toledo, November 15, 1907.

57. Gropius, letter to his mother, Madrid, December 26, 1907.

58. Gropius, letter to his mother, Seville, November 28, 1907.

59. Gropius, letter to his mother, Madrid, December 26, 1907.

60. Gropius, letter to his parents, Seville, December 16, 1907.

61. Lucius Grisebach, letter to Isaacs, Berlin, March 16, 1976.

62. Gropius, letter to his parents, Seville, December 16, 1907.

63. Gropius, letter to his father, Madrid, December 26, 1907.

64. Gropius, letter to his mother, Madrid, January 1908.

65. Gropius, statement, Cambridge, Mass., August 24, 1965.

66. Ibid.

67. A letter to George R. Collins, dated January 3, 1962, notes his first sight of the Guell chapel as being in 1961.

68. Gropius, statement, Cambridge, Mass., August 24, 1965.

69. Gropius, letter to his mother, Seville, undated, believed to be late spring 1908.

Chapter 2

1. AEG was a major client. It had grown from a research association formed in 1882 by Emil Rathenau to exploit Thomas Alva Edison's electric light bulb to the German Edison Company for Applied Electricity in 1883. It became the AEG in 1887. By the turn of the century it was one of the world's largest electrical engineering enterprises.

2. Gropius, letter to his mother, Medina del Campo, October 21, 1907.

3. Gropius, "Programm zür Gründung einer Allgemeinen Hausbaugesellschaft auf künstlerisch einheitlicher Grundlage m.b.H.," reprinted in *Architectural Review*, London (July 1961): 49–61. Also typescript of original manuscript in the Bauhaus Archiv.

4. Ibid.

5. Ernest Wasmuth, *Ausgeführte Bauten und Entwürfe von Frank Lloyd Wright* (portfolio) (Berlin, 1910). Another book by Wasmuth was published the following year in two editions: This was *Frank Lloyd Wright: Ausgeführte Bauten*. Understandably, Gropius tended to confuse these publications in his references to them in later years.

6. Gropius, letter to Karl Ernst Osthaus, Berlin, March 6, 1910. Quoted from Herta Hesse-Frielinghaus, ed., *Karl Ernst Osthaus, Leben und Werk* (Recklinghausen, 1971), p. 419.

7. Carl Benscheidt, interview, Alfeld, August 1964.

8. Gropius, "Monumentale Kunst und Industriebau," typescript, illustrated with photographs and sketches, January 29, 1911, p. 13; as translated by Reyner Banham in *A Concrete Atlantis: U.S. Industrial Building and European Modern Architecture 1900–1925* (Cambridge: The MIT Press, 1986), p. 198. [Ed.]

9. Ibid., pp. 188–194.

10. Gropius, letter to Joachim Hotz, Cambridge, Mass., September 27, 1968. This letter states that the design was done in 1910; other sources offer 1913.

11. Now Poznán in Poland.

12. Spiro Kostoff, *A History of Architecture: Settings and Rituals* (New York: Oxford University Press, 1985), p. 691. [Ed.]

13. The exhibition drew more than a million visitors in three months. They were served by forty-eight restaurants, food stands, and teahouses and entertained by orchestras, bands, puppets, and stage performances.

14. Gropius, letter to his mother, Berlin, April 1914.

15. Kostoff, *A History of Architecture*, p. 691. [Ed.]

16. August Endell, letter to Gropius, Berlin (?), May 28, 1914.

17. Gropius, handwritten statement, Lincoln, Mass., ca. 1965.

18. Ibid.

19. Gropius, "Monumentale Kunst und Industriebau," in Banham, *A Concrete Atlantis*, pp. 198–199. [Ed.]

20. Alma Mahler, letter to Gropius, Toblach, undated, believed to be June 1910.

21. Gropius, letter to Alma Mahler, Tobelbad, undated, believed to be June 1910.

22. Alma Mahler Werfel, *And the Bridge Is Love* (New York: Harcourt, Brace and Company, 1958), p. 52.

23. Alma Mahler, letter to Gropius, Vienna, undated, believed to be June 1910.

24. Alma Mahler, letter to Gropius, Vienna, July 8, 1910.

25. Alma Mahler, letter to Gropius, Vienna, August 27, 1910.

26. Alma Mahler, letter to Gropius, Vienna, undated, believed to be early September 1910.

27. Alma Mahler, letter to Gropius, Vienna, September 19, 1910.

28. Gropius, letter to Alma Mahler, Neu Babelsberg, September 21, 1910.

29. Alma Mahler, letter to Gropius, Vienna, October 12, 1910.

30. Alma Mahler, letter to Gropius, New York, undated, believed to be October 27, 1910.

31. Anna Moll, letter to Gropius, Vienna, November 13, 1910.

32. Gropius, letter to Alma Mahler, Berlin, undated, believed to be late May 1911.

33. Gropius, letter to Alma Mahler, Hotel Kummer, Vienna, undated, believed to be mid-August 1911.

34. Alma Mahler, letter to Gropius, Vienna, August 15, 1911.

35. Gropius, letter to Alma Mahler, Berlin, September 18, 1911.

36. Gropius, letter to his mother, Dr. Lahman's sanatorium "Weisser Hirsch," near Dresden, December 15, 1911.

37. Gropius, letter to Alma Mahler, Berlin, December 3, 1912.

38. Alma Mahler, letter to Gropius, Vienna, undated, believed to be May 6, 1914.

39. Gropius, letter to his mother, Le Quieux, September 19, 1914.

40. On September 25, 1914, Gropius was awarded the Iron Cross, Second Class.

41. Gropius, letter to his mother and the Burchards, Moussey, November 11, 1914.

42. Gropius, letter to his mother, Laitre, undated, believed to be January 5 or 6, 1915.

43. Gropius, letter to his mother, Feldlazarett 58, Wisch bei Strassburg, undated, early January 1915.

44. Gropius, letter to his mother, Wisch, January 16, 1915.

45. Dr. Rose, letter to Gropius's mother, Wisch, January 18, 1915.

46. Alma Mahler, letter to Gropius, Semmering, December 31, 1914.

47. Gropius, letter to his mother, Wisch, January 16, 1915.

48. Alma Mahler, letter to Gropius, Bristol Hotel, Berlin, undated, believed to be May 1915.

49. Alma Mahler, letter to Gropius, Berlin, undated, believed to be June 1915.

50. Manon Scharnweber Gropius, letter to Gropius, Berlin, May 24, 1915.

51. Manon Scharnweber Gropius, letter to Gropius, Berlin, June 7, 1915.

52. Lieutenant Gropius, 30th Reserve Division, 9th Reserve Hussar Regiment Headquarters, letter to his mother, from the field (believed to be Nancy-Epinal front), July 3, 1915. It was obvious that Gropius preferred Alma's middle name, Maria, to her first, which was loaded with remembrances of Mahler and Kokoschka.

53. Manon Scharnweber Gropius, letter to Alma Mahler, Berlin, July 11, 1915.

54. Alma Mahler Gropius, letter to Gropius, Vienna, undated, believed to be September 1 or 2, 1915.

55. Alma Mahler Gropius, letter to Gropius, Vienna, undated, believed to be September 1 or 2, 1915.

56. Alma Mahler Gropius, letter to Gropius, Vienna, undated, believed to be mid-September 1915.

57. This school had been founded in 1881 by the Grand-Ducal Saxon Central Office for Arts and Crafts. In 1902 van de Velde was invited to the school, where he established an Arts and Crafts Seminar. In 1908 he reorganized the school as the Grand-Ducal Saxon School for Arts and Crafts, which would also serve as a place for consultation between industry-trade and the crafts.

58. Van de Velde actually stayed in Germany until 1917.

59. Others suggested for the position by van de Velde were the sculptor Hermann Obrist and the architect August Endell.

60. Gropius, letter to his mother, Moussey, April 19, 1915.

61. Manon Scharnweber Gropius, letter to Gropius, Berlin, undated, believed to be late April 1915.

62. Henry van de Velde, letter to Gropius, Weimar, July 8, 1915. Quoted at length in Hans M. Wingler, *The Bauhaus* (Cambridge: The MIT Press, 1969; rev. ed. 1976), p. 21.

63. Fritz Mackensen, letter to Gropius, Weimar, September 26, 1915.

64. Fritz Mackensen, letter to Gropius, Weimar, October 2, 1915. This letter is quoted at length in Wingler, *Bauhaus*, p. 22.

65. Fritz Mackensen, letter to Gropius, Worpswerde, October 14, 1915. Quoted in Wingler, *Bauhaus*, p. 22.

66. Gropius, letter to Fritz Mackensen, Nancy-Epinal, October 19, 1915. This strongly worded response, more a declaration of viewpoint, is quoted in Wingler, *Bauhaus*, p. 22.

67. Alma Mahler Gropius, letter to Gropius, Vienna, undated, believed to be late fall 1915.

68. Gropius, "Recommendations for the Founding of an Educational Institution as an Artistic Counseling Service for Industry, the Trades, and the Crafts," written in the field while on active duty, Namur, Belgium, addressed to Grand-Ducal Saxon State Ministry, Weimar, 8 pp. typescript, January 25, 1916. Excerpted in Wingler, *Bauhaus*, pp. 23–24.

69. Gropius, letter to Ludwig Grote, Cambridge, Mass., February 15, 1949. Mackensen's letters to Gropius also reveal the authorities' bias against workshops because of their operating costs and industry's belief that they were in competition. Gropius added, "The final conception of the Bauhaus setup didn't take place until the end of 1918, after I had returned from the war to Berlin."

70. Lieutenant Gropius, letter to his mother, Nancy-Epinal, September 1915.

71. Alma Mahler Gropius, letter to Gropius, Vienna, undated, believed to be late September 1915.

72. Alma Mahler Gropius, letter to Gropius, Semmering, undated, believed to be late September 1915.

73. Gropius, letter to his mother, the Vosges, December 1915.

74. Gropius, letter to his mother, the Vosges, January 3, 1916.

75. Alma Mahler Gropius, letter to Gropius, Vienna, undated, believed to be January 1916.

76. Alma Mahler Gropius, letter to Gropius, Semmering, undated, believed to be March 1916. The remodeling of her three-story gambrel-house located on a hillside at Semmering near Vienna she had offered to Gropius as a way to bring them together. The earliest reference is in Alma's letter of November 8, 1910, from New York: "I shall send you my plans for the house at the Semmering and you can write to Mama everything that is lacking and what ideas you can add to it. …I want something in my house designed by you." On February 12, 1911, Frau Moll corresponded with Gropius on house matters. When, on February 9, 1912, Alma asked Gropius to make something out of "the totally messed-up plans for the little house," their love affair was at a low point. Gropius's plans called for a long fireplace wall constructed of massive native granite blocks in the living room. Now, in 1916, the porch to take advantage of the magnificent mountain views was added.

77. Alma Mahler Gropius, letter to Gropius, Semmering, undated, believed to be summer 1916.

78. Alma Mahler Gropius, letter to Gropius, Semmering, undated, 1916.

79. Alma Mahler Gropius, letter to Gropius, Semmering, undated, believed to be June 1916.

80. Alma Mahler Gropius, letter to Gropius, Semmering, undated, believed to be June 1916.

81. Manon Scharnweber Gropius, letter to Gropius, Semmering, June 2, 1916.

82. Gropius, letter to his mother, field headquarters, the Vosges, August 17, 1916.

83. Alma Mahler Gropius, letter to Gropius, Vienna, undated, believed to be September 1916.

84. Gropius, letter to his mother, the Vosges, undated, believed to be mid-October 1916.

85. Alma Mahler Werfel, *And the Bridge Is Love*, p. 89.

86. Gropius, letter to his mother, Vienna, January 23, 1916.

87. Alma Mahler Gropius, letter to Frau Gropius, Sr., Sylvester (New Year's Eve) 1916.

88. Alma Mahler Gropius, letter to Gropius, Vienna, undated, believed to be February–March 1917.

89. Gropius, letter to his mother, Vienna, March 26, 1917.

90. Gropius, letter to his mother, Communications School, Schloss Flawinne near Namur, Belgium, June 17, 1917. Gropius's tendency to send letters without dates was the despair of his mother (as it would be to his biographers). Responding to her complaint, he added,

"Today I have put a big date on top of my letter, does that satisfy you?"

91. Gropius, letter to his mother, Namur, undated, believed to be August–September 1917 because of the reference to "three war years."

92. Gropius, letter to his mother, Somme, November 11, 1917.

93. On January 3, 1918, he was awarded the Austrian King's and Queen's Military Merit Medal Third Class with War Decoration.

94. Gropius, letter to Karl Ernst Osthaus, Vienna, December 19, 1917.

95. Gropius, letter to his mother, France, January 7, 1918.

96. Gropius, letter to his mother, undated, believed to be January–February 1918. This statement by Gropius is almost unique; in other early correspondence there are references to Jews, but few of such critical nature. Subsequent letters show understanding and friendship toward Jews.

97. Gropius, letter to his mother, undated, believed to be January–February, 1918.

98. Alma Mahler Gropius, letter to Frau Gropius, Sr., Semmering, undated, believed to be February 1918.

99. Gropius, letter to his mother, field headquarters, April 10, 1918.

100. Gropius, letter to his mother, field hospital, May 1918.

101. Gropius, letter to his mother, Breitenstein, June 11, 1918.

102. Gropius, letter to Richard Meyer, "at the front," July 6, 1918.

103. Gropius, letter to his mother, Spital Grinzing/Vienna, Barracks 23, August 8, 1918. For his heroism under fire, Gropius received the Iron Cross First Class on August 4, 1918.

104. Gropius, letter to his mother, Vienna, August 17, 1918.

105. Alma Mahler Werfel, *And the Bridge Is Love.*

106. Ibid., p. 122.

Chapter 3

1. Gropius also was Adjutant, 30th Reserve Division, 9th Reserve Hussar Regiment Staff, 15th Reserve Corps.

2. Alma Mahler Werfel, *And the Bridge Is Love* (New York: Harcourt, Brace and Company, 1958), p. 129.

3. Ibid., p. 128.

4. Gropius, letter to his mother, Berlin, December 1918.

5. Alma Mahler Gropius, letter to Manon Scharnweber Gropius, Vienna, undated, believed to be early January 1919.

6. Gropius, letter to Alma Mahler Gropius, Berlin, February 12, 1919.

7. Alma Mahler Gropius, letter to Gropius, Vienna, undated, believed to be early March 1919.

8. Gropius, letter to Karl Ernst Osthaus, Berlin, December 23, 1918. Quoted from Herta Hesse-Frielinghaus, ed., *Karl Ernst Osthaus, Leben und Werk* (Recklinghausen, 1971), pp. 470, 471, 472 (notes 54, 58, 65).

9. Gropius, letter to his mother, Berlin, late January 1919. Erich Gropius died on January 18, 1919.

10. Gropius, letter to his mother, Berlin, undated, believed to be late January or early February 1919; the murder took place on January 15, 1919.

11. Gropius, letter to his mother, Berlin, undated, believed to be December 1918. On December 23 from Berlin, Gropius wrote to Osthaus: "I came here to participate in the revolution. The mood is tense here, and we artists have to strike while the iron's hot. In the Working Council for Art [Arbeitsrat für Kunst], which I have joined, there's at present a congenially radical atmosphere and productive ideas are being brought up."

12. This group included, among about forty initial members, Max Taut, Gerhard Marcks, Hans Scharoun, Max Pechstein, Georg Kolbe, and Hans and Wassili Luckhardt. Lyonel Feininger, Erich Mendelsohn, Adolf Meyer, Karl Ernst Osthaus, and Ludwig Hilberseimer were active supporters.

13. Ulrich Conrads, *Programme und Manifeste zur Architektur des 20. Jahrhunderts* (Bauwelt Fundamente 1) (Berlin, 1964), pp. 38ff.

14. Gropius, letter to his mother, Berlin, March 17, 1919.

15. Among its members were Lyonel Feininger, Gerhard Marcks, Otto Mueller, Erich Heckel, Karl Schmidt-Rottluf, Christian Rohlfs, Otto Bartning, Hans Poelzig, and Bruno Taut; many of their names would later appear on the rosters of other organizations.

16. It was not until 1929–30 that Frank Moller discovered the file in Gropius's office and with Gropius completed the drawings.

17. Gropius on the occasion of the showing at J. B. Neumann's "Graphic Cabinet" at 232 Kurfürstendamm, Berlin, April 1919.

18. Ulrich Conrads, *Programme und Manifeste zur Architektur des 20. Jahrhunderts*, pp. 43ff.

19. The exhibition, sometimes referred to as the Exhibition for Young Architects and Artists, also included the work of Hans Scharoun, Wenzel Hablik, and Hermann Finsterlin. Mies van der Rohe offered to send Gropius the plans of his neo-Schinkel house for Mme. E. L. J. Kroller in The Hague, done seven years earlier.

20. Iain Boyd Whyte, "Introduction" to *The Crystal Chain Letters*, ed. and trans. by Iain Boyd Whyte (Cambridge: The MIT Press, 1985), pp. 1–2. The following three paragraphs are an editorial addition distilled from Whyte's text.

The group's name has also been translated as "The Glass Chain." Whyte's book contains the complete correspondence. See also *Die glaserne Kette, Visionare Architekturen aus dem Kreis um Bruno Taut 1919–1920* (Berlin: Akademie der Kunste, and Cologne: Oswald M. Ungers, April 1966).

21. Bruno Taut, trans. in Whyte, *The Crystal Chain Letters*, p. 19.

22. Gropius, address to Arbeitsrat für Kunst, March 22, 1920, in Bauhaus Archiv, West Berlin, GN 2/3; quoted by Whyte, *The Crystal Chain Letters*, p. 2.

23. Ibid., p. 3.

24. Ibid.

25. Gropius, letter to his mother, Berlin, December 1918.

26. Gropius, letter to Ernst Hardt, Berlin, January 16, 1919.

27. Gropius, Proposed Budget, in Hans M. Wingler, *The Bauhaus* (Cambridge: The MIT Press, 1969; rev. ed. 1976), p. 26. [Ed.]

28. This may have been the first coining and use by Gropius of the word "Bauhaus."

29. The buildings occupied by both schools had been designed by Henry van de Velde between 1904 and 1911.

30. Gropius, letter to his mother, Berlin, March 31, 1919.

31. Wingler, *Bauhaus*, p. 31.

32. Ibid., p. 32. [Ed.]

33. Gropius, letter to his mother, undated, believed to be mid-April 1919.

34. Gropius, letter to Tomás Maldonado, November 24, 1963.

35. The prizewinning design, which Gropius later agreed was the work of Petr Röhl, was used for two years, though Gropius cared very little for it. He later asked Schlemmer to design a new seal, which became the official Bauhaus symbol from 1922 on. See Gropius, letter to Eckhard Neumann, Cambridge, Mass., March 25, 1968, and Gropius, letter to Wulf Herzogenrath, Cambridge, Mass., October 30, 1968.

36. Later a great many of these royalty contracts were made. Several Bauhaus models have influenced production all over the world, par-

ticularly those of lighting fixtures, furniture, textiles, wallpaper, and porcelain.

37. Among the students were Marcel Breuer, Joost Schmidt, Fred Forbat, Hans Volger, and Farkas Molnár.

38. Gropius was repeatedly charged with inconsistency in his design principles as a result of this house. Many times he felt called upon to respond; see his letter to Peter Blake, January 10, 1949. Gropius's Jena Theater was designed almost simultaneously.

39. This unsuccessful Putsch had been organized by an East Prussian government official, Wolfgang Kapp, and General Walther von Lüttwitz, commander of the Berlin area troops, with part of the new Reichswehr and a naval free corps, who seized the city and attempted to install a counterrevolutionary nationalist dictatorship. Ebert's government survived by moving to Dresden and then Stuttgart. The Kapp Putsch, as it became known, failed to attract support from other sectors of the army and rightist parties and was broken by the solid resistance of the trade unions, which called a highly successful general strike, though not without bloodshed.

40. Gropius, letter to Donald Egbert, Cambridge, Mass., October 14, 1948.

41. In "An Experimental House by the Bauhaus in Weimar," the lead article in the Bauhaus Book No. 3 compiled by Adolf Meyer, Gropius discusses the need for the industrialization of housing. His ideas had been expressed in 1910 to Rathenau. On October 31, 1911, Gropius wrote to Karl Ernst Osthaus from Berlin:

"I have the intention of carrying through by all possible means my ideas for the industrialization of small houses. …The innovation lies in the industrialization of the design: I have a box of building blocks of single building elements out of which I can, with the help of *existing* construction companies, put together houses according to local and individual needs. No one needs to know about this system. In actual cases, I can quietly carry through my principles (they are actually only the final results of already existing building practices) and, once they are successful, then talk about how they came about. The *actual case* is, of course, a question of survival. Under the framework of a real project, I have to have a possibility of coming up with a number of small houses, be it for industry or a garden city. …My preparatory work is available in sketches. This first realization of the idea is so important to me that, if need be, I would be willing to work at first without being paid."

Quoted in Hesse-Frielinghaus, ed., *Karl Ernst Osthaus,* pp. 462ff.

42. Hans Brandenburg, *Das Theater und das Neue Deutschland*, published by Eugen Diederichs (a member of the Society), Jena, 1919. Peter Behrens's theater studies of 1900 are given particular recognition, as is the work of other board members. Gropius's Bauatelier copy of the pamphlet carries Adolf Meyer's penciled signature. Gropius Archive, Lincoln, Mass.

43. Gropius, letter to Ernst Hardt, Weimar, June 22, 1921.

44. Gropius, letter to City Building Director Bandlow, Weimar, September 27, 1921. This very extensive explanation reveals in some detail his arduous days of practice.

45. Gropius, letter to Klaus Karbe, Cambridge, Mass., September 20, 1965. "The material which Carl Gropius had brought back from the Battle of Belle Alliance belonged to my Father, who gave it later to me. During the terrible inflation of 1923, I sold it to Adolf Sommerfeld in order to finance with that money the provisions for the Bauhaus canteen, since our students were in dire straits, coming penniless from the war."

46. Gropius, letter to Morton Frank, Cambridge, Mass., March 20, 1958.

47. Two hundred and sixty-three designs were submitted from twenty-five countries during November 1922. Twenty-five submittals from Germany alone were received, among them, in addition to that by Gropius and Meyer, entries by Max Taut of Berlin, Bruno Taut of Magdeburg, and Karl Barth of Wiesbaden.

48. Lyonel Feininger, letter to Frau Feininger, Weimar, May 30, 1919. Later, Bauhäusler Lothar Schreyer recalled how all who saw Alma were charmed by her beauty and superior bearing and the manner, more Viennese than Weimaranish, in which she presided over her salon. Interview, Hamburg, July 1964.

49. Gropius, letter to Klaus Karbe, Cambridge, Mass., June 17, 1968.

50. T. Lux Feininger, "Address on the Artist," The Putney School, Putney, Vermont, November 10, 1968.

51. Gropius, letter to his mother, Weimar, June 14, 1919.

52. Gropius, letter to Alma Mahler Gropius, Weimar, July 12, 1919.

53. Gropius, letter to Alma Mahler Gropius, Weimar, July 18, 1919.

54. Franz Werfel, letter to Gropius, Vienna, August 20, 1919.

55. Alma Mahler Gropius, letter to Gropius, Vienna, September 1919.

56. The letters from Gropius to Lily Hildebrandt of the 1919–23 period particularly are in the personal archive of her son, Reiner, and were made available by him to the author in 1974.

57. Gropius, letter to Lily Hildebrandt, Weimar, undated, believed to be September 1919. The comment on fund-raising is curious in view of Walther Scheidig's account in his *Crafts of the Weimar Bauhaus* (New York: Reinhold Publishing Corporation, 1966, p. 17) that Gropius in the period from "April to October 1919…could gratefully acknowledge nearly one million marks" in donations to a Bauhaus fund from friends and patrons.

58. Gropius, letter to Lily Hildebrandt, Weimar, undated, believed to be last week of October 1919.

59. Gropius, letter to Hans Curjel, Cambridge, Mass., October 19, 1961.

60. Gropius, letter to Lily Hildebrandt, Weimar, December 13, 1919.

61. Gropius, letter to Lily Hildebrandt, Weimar, undated, believed to be December 19, 1919 (or December 30, 1919) because of events described.

62. Gropius, letter to Lily Hildebrandt, Weimar, February 1, 1920.

63. Alma Mahler Gropius, letter to Gropius, Vienna, undated, believed to be early December 1919.

64. Alma Mahler Gropius, letter to Gropius, Vienna, undated, believed to be mid-December 1919.

65. Alma Mahler Werfel, *And the Bridge Is Love,* p. 142.

66. Alma Mahler Gropius, letter to Manon Scharnweber Gropius, Semmering, April 30, 1920.

67. Gropius, letter to his mother, Berlin, undated, believed to be late spring 1920. Gropius meant "cripple" in the sense of mental anguish, for he felt diminished by his travail.

68. Gropius, letter postmarked April 19, 1920. This appears to be the first of his letters to her in which he used the familiar *du*.

69. Gropius, letter from Weimar, undated, believed to be April 1920.

70. Gropius, letter to P. Russell Diplock, Cambridge, Mass., October 8, 1968.

71. Gropius, letter to Lily Hildebrandt, Weimar, undated, believed to be mid-May 1920 because of reference to wife and child.

72. Gropius, letter to Lily Hildebrandt, undated.

73. Gropius, letter to Lily Hildebrandt, Weimar, undated, believed to be June 1920.

74. Gropius, letter to Lily Hildebrandt, Weimar, undated, believed to be mid- or late October 1920.

75. Among them were Gyula Pap, Franz Probst, Friedl Dicker, Naum Slutzky, Anni Wotiz, Franz Singer, and Margit Tery-Adler, all of them destined to become noted in their own fields.

76. Gropius, letter to Lily Hildebrandt, Weimar, undated, believed to be December 1920.

77. Gropius, letter to Lily Hildebrandt, Weimar, undated, believed to be late spring 1921.

78. Gropius, letter to Walther Scheidig, Cambridge, Mass., October 3, 1966.

79. Ibid.

80. Gropius, letter to Lily Hildebrandt, Weimar, undated, believed to be December 1920.

81. Hans Bellmann, interview, Cambridge, Mass., 1965.

82. Gropius, letter to Lily Hildebrandt, Weimar, undated, believed to be late spring 1921.

83. Gropius, letter to Lily Hildebrandt, Weimar, undated, believed to be mid-1921.

84. Gropius, letter to Lily Hildebrandt, on the train from Hamburg to Frankfurt, undated, believed to be October 6 or October 13, 1921.

85. Gropius, letter to Lily Hildebrant, Weimar, undated, believed to be fall 1922.

86. Gropius, letter to Lily Hildebrandt, Weimar, October 14, 1919.

87. Gropius, letter to Lily Hildebrandt, Weimar, undated, believed to be mid-1922 because of Gropius's "full-year" and the reference to Schreyer, who had been appointed in mid-1921.

Six months earlier, in January–February, Gropius had applauded Lily's part in gaining new members for the Circle from among outstanding architects and artists: "I am tremendously happy that I could give you again joyfulness and *Kessheit* in spite of my uncompromising hardness so that you could unload your seductive powers on the architectural big shots. I would have liked to watch it…!"

88. Paul Klee, statement, Weimar, December 1921.

89. *Internationale Architektur*, the first book published by the Bauhaus in 1925, exhibits no predominant influence by De Stijl, although the work of Farkas Molnár and some other students show signs of it. Gropius in 1925 encouraged the publication of van Doesburg's *Principles of Neo-Plastic Art* as the sixth volume of the Bauhaus Books. It had originally been written in 1915 and revised during van Doesburg's stay in Weimar.

Asked later why he had not engaged more of his personal friends for the Bauhaus faculty, Gropius replied that he had sounded out some of these artists and architects but found them more interested in pursuing their own professions than in becoming teachers. Furthermore, the school was not ready to offer courses in architecture per se. However, Gropius did invite the imaginative Bruno Taut to join the faculty, but he declined in favor of becoming city planner for Magdeburg.

90. Attributed to Gropius, "Der freie Volkstaat und die Kunst," July 1922, typed manuscript, Bauhaus Archiv, Berlin.

91. Gropius, letter to Lily Hildebrandt, Weimar, undated, believed to be August 1922.

92. Gropius, letter to Lily Hildebrandt, Weimar, September 1922.

93. Gropius, letter to Lily Hildebrandt, Weimar, undated, believed to be mid-1922 because of Kandinsky's appointment and Gropius's own exhibition.

94. Gropius, letter to Lily Hildebrandt, Weimar, undated, believed to be October 1922.

95. Gropius, letter to Lily Hildebrandt, Weimar, possibly end of November or early December 1922 because of references to pending completion of the Chicago Tribune Tower entry. Strangely, Carl continued to design masks, costumes, and stage settings for his brother Oskar's classes.

96. Gropius, letter to Walther Scheidig, Cambridge, Mass., October 3, 1966.

97. The exhibition pamphlet has frequently been confused with the 1919 manifesto.

98. Each of three movements or acts of *Triadic Ballet* had a predominant color and manner: the yellow movement was lively and joyful; the black mysterious and fantastic; and the red stately and sonorous. For the dozen dances of the three movements there were a score of costumes, many designed and executed by Oskar's brother Carl. These were largely geometric configurations, doll- or puppet-like in appearance, and the music and lighting accented the new abstract forms of the choreography.

99. Gropius, "Le Corbusier," eulogy, Newsletter, Harvard Graduate School of Design Association, Cambridge, Mass., vol., 12, no. 1 (November 1965), p. 4.

100. Among these, Peter Behrens, Bruno and Max Taut, Hans Richter, Naum Gabo, Erich Mendelsohn, El Lissitsky, and Hermann Muthesius.

101. Though the association was not founded at that time, its purposes were not forgotten by Gropius. Five years later he saw them included in those of the newly established Congrès Internationale d'Architecture Moderne (CIAM).

102. George Muche, *Blickpunkt* (Tubingen: Verlag Ernst Wasmuth, 1963), p. 128.

103. Gropius, note to "the Frank sisters," Hannover, May 28, 1923, Gropius Archive.

104. Ilse Frank, letter to Gropius, Hannover, undated, believed to be early June 1923.

105. Ilse Frank, letter to Gropius, Adolfshutte, Dillenburg, undated, believed to be June 1923.

106. Ilse Frank, letter to Gropius, Ambach, undated, believed to be July 1923.

107. Gropius, letter to Lily Hildebrandt, Weimar, undated, believed to be late spring or early summer 1923.

108. Gropius, letter to his mother, Jena, August 20, 1923.

109. Gropius, "Le Corbusier," eulogy, Newsletter, Harvard Graduate School of Design Association, p. 4.

110. Ise Gropius, editorial comment, Lincoln, Mass., July 1974.

111. In July 1965 this author carried one more missive from Lily to Gropius. Like so many previous letters, it was answered by Ise Gropius.

112. Gropius, letter to Lieutenant General Hasse, Weimar, November 24, 1923.

113. Gropius, letter to Ise Gropius, Weimar, March 12, 1924.

114. Gropius, letter to Ise Gropius, Weimar, late March 1924.

115. Gropius, letter to Ise Gropius, Weimar, undated, believed to be late March 1924.

116. Gropius, letter to Lily Hildebrandt, Weimar, undated, believed to be spring 1924 because of the reference to "wife" and the "Yellow Brochure," which was published in 1924.

117. Ise Gropius, letter to Manon Gropius Burchard, Weimar, late May 1924.

118. Among them Peter Behrens, Adolf Busch, Marc Chagall, Oskar Kokoschka, Arnold Schönberg, Franz Werfel, Albert Einstein, Hans Poelzig, Gerhart Hauptmann, Josef Hoffmann, Igor Stravinsky, Adolf Sommerfeld, Herbert Eulenberg, and Hendrik Berlage.

119. Philosophische Akademie auf dem Burgberg, Spandorf-Erlangen,

1924–25. "The project is only now going to be good since I forced myself to make a radical change. New construction, no sandstone, still more simplicity in the arrangement. What tremendous work! But I feel wonderfully stimulated to swim so in the middle of the stream with the waves foaming around me." Gropius, letter to Ise Gropius, Weimar, March 1924.

120. In 1977 the vicissitudes of the project and the disappearance of Professor Hoffmann were explained in an article, "Spektakulare Plane: Denker-Weltzentrale" in the *Erlanger Tageblatt*, Erlangen, April 9, 1977. Two thousand marks were expended by the Gropius office, but not recovered from the client, for the salaries of Adolf Meyer, Farkas Molnár, Erich Brendel, and Marcel Breuer, among others.

121. Gropius, letter to Ise Gropius, Weimar, undated, believed to be late summer 1924.

122. Gropius, letter to Ise Gropius, Weimar, September 3, 1924.

123. Ise Gropius, letter to Gropius, Opladen, September 28, 1924.

124. See Gropius, letter to Lily Hildebrandt, Weimar, undated, believed to be fall 1922.

125. Gropius, letter to P. Russell Diplock, Cambridge, Mass., October 8, 1968.

126. Gropius, letter to Ise Gropius, Weimar, undated, believed to be September 1924.

127. Ise Gropius, letter to Gropius, Opladen, September 29, 1924.

128. Ise Gropius, letter to Gropius, Düsseldorf, October 4, 1924.

Chapter 4

1. Heinrich König, interview, Frankfurt am Main, July 1964.

2. Among these were Max Sichel, Walter Traulau, Richard Paulick, and Erich Brendel.

3. Fritz Hesse, *Von der Residenz zur Bauhausstadt* (Bad Pyrmont: Privately published, 1964), p. 212.

4. Ise Gropius, letter to Manon Scharnweber Gropius, Dessau, spring 1925.

5. Comparison of Weimar and Dessau rosters indicates that the majority of students remained in Weimar. However, Walther Scheidig, in his *Crafts of the Weimar Bauhaus* (New York: Reinhold Publishing Corporation, 1966), p. 6, states that "with few exceptions" the masters and students moved to Dessau.

6. In Weimar a few efforts had been made: for example, there had been the Festival of the Kites, and at Christmas the students provided gifts of their own making to the children in the historic Market Place.

7. Ise Gropius, editorial comment, Lincoln, Mass., August 1974.

8. Gropius, "Plan zur Errichtung einer Wohnhausfabrik," unpublished manuscript, Dessau, 1925.

9. Gropius, letter to Reichs Chancellor Hans Luther, Dessau, April 27, 1926.

10. *Zentralblatt*, Berlin, June 16, 1926. The catalogue to which he referred was that of the mail order house of Sears, Roebuck and Company. He saw the Hodgson House when he came to the United States in 1928.

11. There had been disagreement among veteran members and historians as to who and how many originally comprised Der Ring. A second list adds Hans Poelzig, Martin Wagner, Walter Curt Behrendt, and Peter Behrens. A third roster includes the original and second lists and the names of Otto Bartning, Otto Haesler, Ludwig Hilberseimer, Erich Mendelsohn, and Heinrich Tessenow. In July 1926 the *Berliner Tageblatt* reported a newly reformed group still larger in number, which included Arthur Korn, Ernst May, and Adolf Meyer. Der Ring persisted and renewed itself for more than a decade, and its constituency changed, thus in part accounting for the magni-

tude and variation in subsequent claims about membership. The name of Gropius remained on every list.

12. Gropius, letter to Doris Muhlschlegel, Cambridge, Mass., January 18, 1965.

13. Ise Gropius wrote, "Neufert threw out all earlier designs while we were on vacation in Italy." Editorial comment, Lincoln, Mass., August 1974.

14. Ernst Neufert, interview, Darmstadt, July 1964.

15. Among these, in addition to Gropius, were Le Corbusier (with Pierre Jeanneret), Mart Stam, Peter Behrens, J. J. P. Oud, Ludwig Hilberseimer, Richard Döcker, Hans Poelzig, Hans Scharoun, Max and Bruno Taut, and Ludwig Mies van der Rohe.

16. The international approach of the Weissenhof was unique, occurring less than a decade after World War I and a year before the first meeting of CIAM. The fact that funds could be obtained for such a project was a hallmark of the times.

17. On March 1, 1928, Breuer conferred with Gropius about the house and discussed the possibility of joining in Walter and Ise's trip to the United States. Ise Gropius, Diary, Dessau, 1928, p. 177.

18. Gropius, in his essay honoring Piscator, incorrectly places this interest and commission in the year 1926 and in Weimar. It is more likely to be 1927, as related by Robin Campbell in his *Erwin Piscator*, trans. Margaret Vallance (London: Arts Council of Great Britain and Shenval, undated, believed to be post-1970, probably 1973).

19. Gropius, letter to Tut Schlemmer, Dessau, summer 1926.

20. Paul Klee, letter to Gropius, Bern, September 1, 1926. The letter appears in full in Hans M. Wingler, *The Bauhaus* (Cambridge: The MIT Press, 1969; rev. ed. 1976), p. 120.

21. A year earlier Gropius implied that Klee and Kandinsky were beginning to regard their positions as sinecures. Letter to Ise Gropius, Dessau, September 1925.

22. Paul Klee, letter to Gropius, November 18, 1926. The Klees' preference for Mozart concertos was well known.

23. Dorothy Thompson, *New York Evening Post*, August 1926, p. 224; Ilya Ehrenburg, *Visum der Zeit* (Paul List Verlag, 1929), p. 225.

24. Gropius, letter to Wassili Kandinsky, Dessau, February 1927.

25. Karl-Heinz Hüter, "Bauhaus contra Bauhaus," *Deutsche Architektur* (East Berlin) 1 (January 1966).

26. Gropius, quotations (not in original sequence) from a letter to Roger D. Sherwood, Cambridge, Mass., August 9, 1963.

27. Gropius, letter to Heinrich Peus, publisher of *Volksblatt*, Dessau, January 15, 1928.

28. Gropius, letter to Heinrich Peus, Dessau, January 17, 1928.

29. Heinrich Peus, postcard to Gropius, Dessau, undated.

30. Wingler, *Bauhaus*, p. 136.

Chapter 5

1. Gropius, letter to Herr Orbanowski, Berlin, March 4, 1928.

2. Ise Gropius, letter to Hofrat Weiss, Dessau, March 7, 1928.

3. As of June 15 Gropius had not received reimbursement; accordingly he notified Mayor Hesse of his intention to vacate the house on June 18 and "I would therefore be particularly grateful if the agreed upon amount of 5,000 Marks for furniture and construction materials could be sent to my account 2822 at the municipal savings bank by Tuesday, June 19. I paid for those materials out of my own pocket and the city has taken them over, and I had to partially pay moving expenses and downpayments ahead of time."

4. In a letter to Dorothy Thompson, dated Dessau, March 4, 1928, Gropius stated that he was making the trip "with the help of the Carl Schurz Foundation." This is the only reference to the Carl Schurz

Foundation to be found in the Gropius Archive; evidently their sponsorship was not forthcoming. Many years later Gropius stated in an interview that a portion of the expense was borne by the Reichsforschungsgesellschaft.

5. Throughout their tour they kept careful notes toward the preparation of the technical reports for the Reichsforschungsgesellschaft and for Sommerfeld, as well as a journal of their observations and encounters to accompany the hundreds of photographs that they took. The language describing the journey as presented here is that of Walter and Ise Gropius, from their direct translation and quotation of their notes and journal.

6. Gropius, letter to Robert L. Davison, New York, May 26, 1928.

7. Later, with declining work in the office, the domestic staff was reduced to a cook and a maid; Ise took over the archivist's work, and the professional staff was otherwise diminished.

8. The housing project itself was originally proposed by Gropius and Moholy-Nagy in an exhibit for the Allgemeine Heimstätten Aktiengesellschaft, of which Adolf Sommerfield was General Director. Subsequently, the Gemeinnützige Aktiengesellschaft für Angestellten-Heimstätten (Cooperative Corporation for Employees' Homesteads) of GAGFAH sponsored its design and construction, and the commission for the overall direction was given to Bruno Taut and Otto Salvisberg. Sixteen architects, in addition to Gropius, participated in the project; they elected Heinrich Tessenow to be in charge and to give unity to the work. The project was divided into various areas of responsibility. Some 29 buildings, containing more than 120 dwelling units, were involved. Few of these were for single families; others accommodated as many as 12 dwelling units, including efficiency apartments for single men and women.

9. *Die Welt am Abend*, September 3, 1928.

10. News item, *Merseburger Tageblatt*, October 30, 1928.

11. Gropius, "Der Berliner Wohnungsbau," *Bauwelt*, December 6, 1928.

12. Gropius, "Successful Practices of Building Industry Organization in America," *Reichsforschungsgesellschaft* (Berlin), April 6, 1929.

13. Gropius, *Der Baukurier*, April 16, 1929.

14. Gropius, "Siedlung am lindenbaum," *Bauwelt* 35 (1931): 45–48.

15. Count Harry Kessler, *The Diaries of a Cosmopolitan, 1918–37* (London: Weidenfeld and Nicolson, 1973).

16. With Marcel Breuer in the Bauhaus, Gropius had conceived a similar structure in concrete.

17. Gropius, lecture, untitled manuscript, Brussels, November 27, 1930.

18. Gropius, "Wohnhochhäuser im Grünen," *Zentralblatt der Bauverwaltung* (Berlin), November 25, 1931, pp. 743ff.

19. "German Housing Experts Favor High Buildings in Cities," *Record and Guide* (New York), September 16, 1933.

20. Many of these were Wagner's friends from the Ring; he adamantly refused to involve Nazi-favored architects; understandably, the press was guarded in its appreciation of the exhibition. Scharoun, Hilberseimer, Poelzig, Eiermann, Max Taut, Mebes, Haring, von Steinbüchel, and Wagner himself each contributed a dwelling unit; Bruno Taut, Bartning, Mendelsohn, and Gropius each designed two units. Ten additional dwellings were the work of less well-known architects.

21. Gropius's Berlin office referred to this project as *darstellung der erweiterungen des standards*.

22. It is not known whether these were actually built, though working drawings and a form of specification contract for one scheme are in the Gropius Archive at Harvard University.

23. Karl-Heinz Hüter, "Bauhaus contra Bauhaus," *Deutsche Architektur* (East Berlin) 1 (January 1966).

24. Kurt Junghanns, "Hannes Meyer und das Bauhaus," *Deutsche Architektur* (East Berlin) 7 (July 1964).

25. Gropius, letter to Roger D. Sherwood, Cambridge, Mass., August 9, 1963.

26. Klee carried on until December 1931 and then left the Bauhaus for the Düsseldorf Academy.

27. Editorial articles in *Vorwarts* (Berlin), July 8, 1929, and in *Presse-Feder* (Berlin), August–October 1929.

28. Selman Selmanagic, interview, East Berlin, January 1965.

29. Ludwig Grote, interview, Munich, 1965.

30. L. Pazitnov, *Das Schöpferische Erbe des Bauhauses, 1919–1933* (East Berlin: Institut für angewandte Kunst , 1963), p. 31.

31. Gropius, letter to Nikolaus Pevsner, Cambridge, Mass., April 16, 1963.

32. Gropius, letter to Roger D. Sherwood, Cambridge, Mass., August 9, 1963.

33. Meyer's letter appeared in *Tagebuch* 33, August 16, 1930, pp. 1307ff.

34. In answer to Meyer's claim to have materially increased Bauhaus production, Gropius later asserted that though he did not remember the production figures for 1928 and later, it was definitely true that the financial standing improved after Gropius's resignation, but because of the impetus of the production developed under his own directorship before leaving.

35. Pazitnov, *Das Schöpferische Erbe des Bauhauses*, pp. 31, 32. That year Ernst May also arrived in Moscow with a group of students.

36. The Bauhaus exhibit shown there in 1931 was accompanied by a catalogue, *Die Kämpferin* (The Fighter), containing Meyer's statement: "Our experience with the Bauhaus has demonstrated that the Red Bauhaus as an institution of learning could not possibly exist under a capitalistic environment." Hannes Meyer, statement in *Die Kämpferin*, quoted in Walter Rudel, "Bauhaus — Ein Gesprach mit Walter Gropius," *Der Monat* (June 1969): 83.

37. Gropius, letter to Roger D. Sherwood, Cambridge, Mass., August 9, 1963.

38. Selman Selmanagic, interview, East Berlin, January 1965.

39. Lothar Lang, *Das Bauhaus, 1919–1933, Idee und Wirklichkeit* (Berlin: Zentralinstitut für Formgestaltung, 1965).

40. Though there are letters written on the stationery of the exclusive Monte Verita Hotel, they could not afford to stay there. Forty years later Ise explained that on occasion they did visit the elegant hotel for tea.

41. Gropius, letter to Ise Gropius, Berlin, undated, believed to be late summer 1931.

42. Pierre Jay, letter to Gropius, New York, June 11, 1931.

43. Gropius, letter to Pierre Jay, Berlin, October 20, 1931.

44. Uninvolved with these questions, Gropius and Le Corbusier concerned themselves with the establishment of an international set of symbols and colors for standardized city maps and with comparative construction costs.

45. Gropius, letter to Ise Gropius, Berlin, July 1932.

46. Gropius, letter to Ise Gropius, Frankfurt, July 5, 1932.

47. Gropius, letter to Ise Gropius, Frankfurt, July 23, 1932.

48. Gropius pursued these endeavors until 1933, when the entire factory was turned to the production of trucks and other vehicles for the Third Reich.

49. About this Gropius wrote, "After the General Secretary of the Werkbund, Dr. Jaeckh, reported that he had been seeing Hitler and

that he expected the anti-Jewish tendency of Hitler's would not be used against the Werkbund, I left the Board in protest." Letter and notes on Mrs. Lane's manuscript, "Architecture and Politics in Germany, 1918–1945," Cambridge, Mass., 1967.

50. Gropius, discussion notes, Cambridge, Mass., September 1968.

51. Karl-Heinz Hüter, letter to Isaacs, quoting E. Mendelsohn's *Letters of an Architect* (1961, p. 93), Berlin-Karlshorst, December 15, 1964. In a letter to Isaacs, Cambridge, Mass., January 7, 1965, Gropius countered the suggestion that he might leave Germany for Russia: "Dr. Hüter is wrong to assume that I went to Leningrad with the intention to [get] out of Germany. Not at all. I was invited by the Russians to give a lecture on housing and stayed there about ten days. It never entered my mind to stay there for longer or for good."

52. Gropius, letter to Sigfried Giedion, Berlin, April 10, 1933.

53. Hillebrecht had been a student and draftsman under Gropius at various times between 1928 and 1933.

54. Hans von Grünberg, "Landesplanung im Aufbau," *Berliner Tageblatt*, January 29, 1934.

55. Gropius, letter to Oberregierungsrat Hans Weidemann, Berlin, February 2, 1934. Though addressed to the President of the Province of East Prussia, the statement was sent to the Ministry of Propaganda in Berlin for transmittal.

56. Gropius and Martin Wagner, open letter to the government of East Prussia, Berlin, February 1, 1934. Though in his own correspondence Gropius always avoided the then usual closing phrase of "Heil Hitler" or "mit deutschem Gruss," he did in this instance adopt the latter.

57. Gropius, letter to Eugen Hönig, Berlin, March 27, 1934. A somewhat similar letter was sent on January 18, 1934.

58. Gropius, letter to A. Lawrence Kocher, Berlin, March 25, 1934.

59. A. Lawrence Kocher, letter to Gropius, New York, April 16, 1934.

60. Gropius, letter to A. Lawrence Kocher, Berlin, May 9, 1934.

61. A. Lawrence Kocher, letter to Gropius, New York, May 29, 1934.

62. Gropius, letter to A. Lawrence Kocher, Berlin, July 7, 1934.

63. Gropius, letter to Isaacs, Cambridge, Mass., July 20, 1965.

64. Luigi Pirandello and Guglielmo Marconi, presidents of the Volta Symposium and of the Reale Accademia d'Italia, respectively, Invitation to Gropius, Rome, May 31, 1934.

65. Alexander (Xanti) Schawinsky, letter to Gropius, Milan, September 16, 1934.

66. Baugilde, October 10, 1934, noted a law passed to this effect in September under the Reichskammer. Still another regulation believed to have become effective about October 1 further limited the amount of money that could be taken out of the country.

67. Eugen Hönig, letter to Gropius, Berlin, October 4, 1934.

68. Gropius, "Building Theaters," discussion paper at the Volta Congress of the Reale Accademia d'Italia, Rome, October 1934, manuscript, Gropius Archive. Also *Convegno di Lettere, Tema: Il Teatro Drammatico* (Rome: Reale Accademia d'Italia, 1935), pp. 154ff. and illustrations pp. 103ff.

69. Gropius, inserted comment following p. 174, *Il Teatro Drammatico*. He responded as well to Wijdeveld's criticism: it "could have been settled by a simple question. His conclusions proved wrong, because the angle of inclination of the amphitheater on his sketch…is much too acute."

70. Gropius, reply to critics, *Il Teatro Drammatico*, pp. 176, 177.

71. To those who knew the temperamental Marinetti, his remarks could have hardly come as a surprise; for thirty years, he had advocated "the theater of variety" in which exaggerated violence, eroticism, solemnity, beauty, religion, and other themes would be accompanied by overt actions to involve the audience: itching powders, obscenity, glue, overselling of tickets, and corrupting of the classics of theater and music — all of which denigrated the progressive theme of "futurism." Now he saw the immediate purpose of theater as creating within the Italian people a taste for war.

72. This also turned out to be Gropius's last public appearance in Zürich. The first was on September 10, 1927, sponsored by the Swiss Werkbund; Gropius spoke on "Industry's Task in the Construction of Dwellings." Mies van der Rohe also participated. Gropius's second lecture took place on February 14, 1931, in connection with an exhibit at the Kunstgewerbemuseum; he spoke on "Functional Architecture." A month later, on March 13, he spoke on "Low, Medium and High Structures" at the Engineers and Architects Association.

Chapter 6

1. Moholy-Nagy had left the Bauhaus in 1928 and arrived in England in the spring of 1935.

2. Michael Collins et al., *Hampstead in the Thirties -— A Committed Decade* (London: Hampstead Artists Council, Ltd., November 1974).

3. Gropius, letter to Andrew McLaren Young, Cambridge, Mass., June 10, 1968.

4. Jack Pritchard, interview, London, June 1964.

5. The name stood for Isometric Unit Construction, because, according to Pritchard, Wells Coates used isometric perspective in many of his drawings for the Lawn Road flats building and because the flats were in the form of modular units. (Jack Pritchard, *View from a Long Chair* [London: Routledge & Kegan Paul, 1984], p. 80.)

6. Gropius, "Farewell to England," London, March 9, 1937.

7. E. Maxwell Fry, letter to Gropius, London, July 3, 1934.

8. Gropius, letter to Manon Gropius Burchard, London, November 6, 1934.

9. Gropius, letter to Martin Wagner, London, November 23, 1934.

10. Gropius, letter to Martin Wagner, London, November 24, 1934.

11. Gropius, "Modern Buildings: Defense of Mass Production," *The Scotsman*, December 5, 1934.

12. Alfred Longden, letter to Gropius, London, December 23, 1934.

13. Dartington Hall, Ltd, "The [Chekhov] Theatre School" (Privately printed, 1936).

14. Leonard K. Elmhirst, letter to Katherine Montgomery, Dartington Hall, Totnes, Devonshire, August 9, 1968.

15. Gropius, letter to the Elmhirsts, London, December 25, 1934.

16. Gropius, letter to Martin Wagner, London, December 26, 1934.

17. Gropius, letter to Dartington Hall Trustees, London, January 6, 1935.

18. Gropius, letter to W. K. Slater, London, February 2, 1935.

19. Marcel Breuer, letter to Ise Gropius, Budapest, December 25, 1934.

20. Marcel Breuer, letter to Ise Gropius, Budapest, March 23, 1935.

21. Moholy reminded Gropius on March 28 of their intention to continue the publication of the Bauhaus books. Who would be the editor? The publisher? Gropius suggested that a letter would stimulate the Bauhäuslers to provide materials for such publications. By November 1935 the format of an exhibition and publication was established. In addition to Gropius and Moholy, leading contributors included Bayer, Breuer, Schawinsky, and Joost Schmidt. Only fifty names and addresses of Bauhäuslers had been collected but fewer than twenty could be verified, so rapid had been the dispersal of the Bauhäuslers and so sequestered had been the records of the Bauhaus by the Nazi officials.

22. Gropius, letter to L. Moholy-Nagy, London, April 4, 1935; L. Moholy-Nagy, letter to Gropius, Berlin, April 10, 1935.

23. Gropius, letter to Elizabeth Denby, London, February 24, 1935.

24. Ashley Dukes, letter to Gropius, London, May 31, 1935.

25. Gropius, letter to Frank Pick, London, May 11, 1935.

26. Gropius, letter to Jack Pritchard, London, April 7, 1935. Pritchard's generous offer included six months free rent and food and maid service. Gropius's rent beginning May 1, 1935, would eventually be reimbursed by his fees from Pritchard's Isokon furniture company.

27. Alma Mahler Gropius [Werfel], letter to Gropius, Vienna, June 19, 1935.

28. Gropius, letter to Wils Ebert, London, May 19, 1935. A letter of May 20, 1935, expressed Gropius's concern that a new, small apartment that was being prepared for their return to Germany would not be ready. It was in bad shape and even plumbing fixtures had to be replaced.

29. Jack Pritchard, letter to Gropius, London, July 31, 1935.

30. Gropius, letter to Jack Pritchard, London, October 17, 1935.

31. Jack Pritchard, letter to Gropius, London, October 22, 1935.

32. Jack Pritchard, letter to Gropius, London, October 25, 1935.

33. Gropius did not abuse this means of transferring funds, though they were his own. In October 1934 he had obtained 100 pounds while in Rome; in September 1935 some 60 pounds; and in July 1936 48 pounds.

34. Gropius, letter to C. H. van der Leeuw, London, September 19, 1935.

35. Ludwig Hilberseimer, letter to Gropius, Berlin, October 27, 1935. In November 1934 Gropius had been invited to become head of an architecture school in Ankara, with the idea of reorganizing it along Bauhaus lines. Gropius turned down the offer, but recommended Wagner. In the end, Wagner refused the director's position as well as the role of chief architect because he would have had to live in what he termed "the desert" of Ankara. He settled instead in Istanbul, which he found a more congenial "European" city, where he took a less advanced teaching job.

36. Hans Poelzig, letter to Gropius, Berlin, October 26, 1935.

37. Hans Poelzig, letter to Gropius, Berlin, January 27, 1936.

38. Gropius, letter to Martin Wagner, London, July 6, 1936.

39. Herbert Bayer, letter to Ise Gropius, Berlin, November 3, 1935.

40. Gropius, "Remarks, All-Timber Houses Competition," *Timber and Plywood* (London: Timber Development Association, January 11, 1936).

41. D. Oliver, letter to Gropius, and to Adams, Thompson and Fry, Architects, London, March 23, 1936.

42. Jack Howe, letter to Jack Pritchard, London, July 12, 1969; repeated in Jack Pritchard's speech, Gropius Exhibit, London, February 1974.

43. Ackerlay, letter to Gropius, London, May 6, 1936.

44. Gropius, letter to Ackerlay, London, May 12, 1936.

45. Hélène de Mandrot, letter to Gropius, Ardèche, France, May 8, 1936.

46. Gropius, letter to Hélène de Mandrot, London, May 14, 1936.

47. Hélène de Mandrot, letter to Gropius, Ardèche, May 18, 1936.

48. Gropius, letter to Hélène de Mandrot, London, May 25, 1936.

49. Hélène de Mandrot, letter to Gropius, La Sarraz, August 13, 1936.

50. Xanti Schawinsky, letter to Gropius, Milan, June 2, 1936.

51. Fritz Hesse, letter to Gropius, Dessau, August 14, 1936.

52. Gropius, letter to Lily Hildebrandt, London, September 28, 1936.

53. Gropius, *Rebuilding Our Communities* (Chicago: Paul Theobald, 1945), p. 53.

54. H. C. Dent, *The Village College in England* (The American School and University, 1946), p. 75.

55. Jack Pritchard, interview, London, June 18, 1964.

56. Gropius, quoted in Jack Pritchard's speech, Gropius Exhibit, London, February 1974.

57. Henry Morris, letter to Charles Fenn, November 1934, in Harry Ree, *Educator Extraordinary: The Life and Achievement of Henry Morris* (London: Longman Group, Ltd., 1973), p. 67.

58. Henry Morris, letter to Jack Mutzi, Cambridge, England, March 3, 1936.

59. Jack Pritchard, letter to Graham, London, March 7, 1936.

60. Jack Pritchard, letter to E. M. Nicholson, London, March 9, 1936; W. G. Constable, letter to Henry Morris, London, March 22, 1936.

61. John Maynard Keynes et al., letter to Henry Morris, London, April 4, 1936.

62. Gropius, letter to J. M. Keynes, London, February 9, 1937.

63. J. M. Keynes, letter to Gropius, King's College, Cambridge, February 11, 1937.

64. Gropius, letter to J. M. Keynes, London, February 22, 1937.

65. J. M. Keynes, letter to Gropius, London, February 24, 1937.

66. Leonard K. Elmhirst, letter to Katherine Montgomery, Dartington Hall, Totnes, Devon, August 9, 1968.

67. Henry Morris, letter to Jack Pritchard, Cambridge, England, June 17, 1937.

68. J. M. Keynes et al., letter to Henry Morris, London, April 4, 1936.

69. Jack Pritchard, letter to Henry Morris, London, June 21, 1937.

70. E. Maxwell Fry, letter to Gropius, London, January 1938.

71. Jack Howe of the Fry office took charge of the project when Gropius went to the United States early in 1937.

72. Jack Pritchard, letter to Henry Morris, London, April 24, 1940. Subsequently, the deficit in funds for the architects' fees was provided by the County Council.

73. Henry-Russell Hitchcock, Jr., "Modern Architecture in England," in Catherine K. Bauer and H.-R. Hitchcock, *Modern Architecture in England* (New York: Museum of Modern Art, 1937), p. 25.

74. Within the MARS Group there were many members who had already distinguished or would distinguish themselves in the housing, planning, and education fields. Among these were Elizabeth Denby in housing; Frederick Gibberd, William Holford, and Thomas Sharp in planning; and W. Harding Thompson, George Checkly, J. L. Martin, F. R. S. Yorke, Arthur Korn, B. Lubetkin, Robert Townsend, G. Dawson, Godfrey Samuel, and H. deC. Hastings, editor of *Architectural Review,* in education.

75. George Bernard Shaw, "Foreword" in *New Architecture,* catalogue for the MARS exhibition in London, New Burlington Galleries, January 11–29, 1938.

76. MARS Group, *New Architecture: An exhibition of the elements of modern architecture,* London, New Burlington Galleries, January 11–29, 1938. The MARS exhibit included a "hypothetical" town-planning scheme for London prepared more than a year earlier, which had been presented at the 1937 CIAM meeting.

77. Gropius, "Farewell to England," Trocadero, London, March 9, 1937.

78. *The Times* (London), 1936.

79. *Architectural Review,* 1936.

80. Gropius, letter to Erfurt Court, London, November 30, 1936.

81. Gropius, letter to Martin Wagner, London, December 27, 1936.

82. Adolf Sommerfeld, letter to Gropius, Tel Aviv, November 5, 1936.

83. Gropius, letter to Adolf Sommerfeld, London, December 15, 1936.

84. Gropius, letter to A. Lawrence Kocher, London, January 3, 1935.

85. Gropius, letter to A. Lawrence Kocher, London, June 14, 1935.

86. Joseph Hudnut, letter to Gropius, Cambridge, Mass., September 21, 1936.

87. Gropius, letter to Joseph Hudnut, London, October 24, 1936. That day he also informed his sister, Manon Burchard: "I had breakfast [sic] with the President of Harvard University. It was a very stimulating conversation but for the moment very restrained from his side. So I will not hear anything from the Senate session at Harvard, which will not take place there until later this year."

88. Joseph Hudnut, letter to Gropius, Cambridge, Mass., November 13, 1936.

89. Jack Pritchard, letter to Gropius, London, December 1, 1936.

90. Joseph Hudnut, letter to Gropius, Cambridge, Mass., December 8, 1936.

91. Gropius, letter to Joseph Hudnut, London, December 9, 1936.

92. Herbert Bayer, letter to Gropius, Berlin, January 25, 1937.

93. Gropius, letter to Ernst Jaeckh, London, February 4, 1937.

94. E. Maxwell Fry, "Walter Gropius," *Architectural Review* (March 1955).

95. *Architects' Journal*, February 3, 1949, p. 116.

96. Julian Huxley, letter to Gropius, London, March 3, 1937.

97. Gropius, "Farewell to England," Trocadero, London, March 9, 1937.

Chapter 7

1. Religion and philosophy were buttressed by refugee churchmen and scholars, among them Paul Tillich, Hans Reichenback, and Rudolf Carnap. Immigrant scientists, including Leo Szilard, Enrico Fermi, Edward Teller, and Albert Einstein, and mathematicians Hermann Weyl and Stanisaw Ulam, would make extraordinary contributions.

2. *Editor's note:* The bulletin of the Graduate School of Design, Harvard University, for 1946–47 gives the following history of architectural education at that institution (pp. 38–39; reprinted in Klaus Herdeg, *The Decorated Diagram: Harvard Architecture and the Failure of the Bauhaus Legacy* [Cambridge: The MIT Press, 1983], pp. 120–121):

"The first instruction in architecture at Harvard University was given by Charles Eliot Norton, whose lectures as early as 1874 included a descriptive and critical account of the history of architecture. In the winter of 1893–94 Professor H. Langford Warren, who was to become the first dean of the Faculty of Architecture, gave courses in the history of Greek and Roman architecture, the success of which was so immediate that in the following year courses in mediaeval architecture, architectural design and drawing were added....

"In 1895 a program was outlined which was intended as a complete academic training for architects. Courses in engineering and in graphics were added...and the whole was organized into a studied sequence. ...The degree *S.B. in Architecture* was awarded to students who completed this program.

"In 1900, for the first time in any American university, a professional course in landscape architecture was offered and shortly afterwards a four-year program leading to the degree *S.B. in Landscape Architecture....*

"In 1906 the instruction in both architecture and landscape architecture was placed upon a graduate basis and professional degrees in those fields were established. In 1912 the Schools of Architecture and of Landscape Architecture were organized as a separate division of the University under the Faculty of the Graduate Schools of Applied Science. In 1914 the Faculty of Architecture was created and given entire control over the curricula and degrees of the two Schools.

"Since 1909 the subject of city planning had been taught in the School of Landscape Architecture. ...In 1923 there was established in this School an optional curriculum leading to a degree which was especially designated as a degree in city planning. ...[In 1929] a separate School of City Planning was organized....

"In 1935 these three schools were united to form the present Graduate School of Design."

3. John T. Boyd, Jr., letter to Charles W. Killam, Chairman, School of Architecture, Harvard, New York, August 22, 1920.

4. C. C. Zantzinger, letter to Charles Killam, Philadelphia, September 15, 1920.

5. The first city planning school in the United States did not appear until 1929 (at Harvard), following by almost three decades the establishment of a landscape architecture curriculum.

6. Dean George Edgell, letter to Dean Warren Laird, School of Fine Arts, University of Pennsylvania, February 7, 1931.

7. Gropius, "The Small House of Today," *Architectural Forum* (March 1931): 266–278. The essay, however, was not the first statement of his ideas to be published in this country. It was preceded by Ise Gropius's profusely illustrated description of the Dammerstock housing development, subtitled by the magazine editor as "The House for Practical Use," which appeared in the August 1930 issue of *Architectural Forum*; this was followed by her "Modern Dwellings for Modern People," published the following year in *House Beautiful* for May.

8. Henry-Russell Hitchcock and Philip Johnson, *The International Style* (New York: W. W. Norton, 1932).

9. The exhibition *Modern Architecture* featured the work of nine pioneers, four of whom were Europeans: Mies van der Rohe, Oud, Le Corbusier, and Gropius. In the catalogue Johnson described Gropius as the "chief pioneer," and Hitchcock cited Gropius's works as having more social significance than those of any other modern architect. Alfred Barr's foreword noted that Gropius was the most sociologically minded of the four founders of the International Style.

10. In *New Architecture and the Bauhaus*, translated from the German by P. Morton Shand (New York: Museum of Modern Art, 1936).

11. Joseph Hudnut, letter to Oscar Sutermeister, Cambridge, Mass., December 2, 1936.

12. Charles D. Maginnis, letter to Joseph Hudnut, Boston, January 13, 1937.

13. Joseph Hudnut, letter to Gavin Hadden, Cambridge, Mass., April 15, 1937.

14. Gropius, "Architecture at Harvard University," *Architectural Record* (May 1937): 9.

15. James Doom, letter to his mother, Cambridge, Mass., June 6, 1937.

16. Gropius, letter to E. Maxwell Fry, Cambridge, Mass., April 8, 1937.

17. Gropius, letter erroneously addressed to *William* Nelson, London, September 14, 1935.

18. Attachment to one's own soil.

19. Herbert Bayer, letter to Gropius, Berlin, April 17, 1937. Gropius made his initial effort that month to bring Bayer and Breuer to the United States.

20. Gropius, letter to E. Maxwell Fry, Cambridge, Mass., June 7, 1937.

21. Gropius, letter to E. Maxwell Fry, Cambridge, Mass., April 8, 1937.

22. Gropius, letter to Wells Coates, Cambridge, Mass., January 25, 1938.

23. The preceding paragraph and the description were added by the editor. Forty years later Ise recalled that the move coincided with the great New England hurricane of September 1938, and that they were concerned about the large expanses of glass withstanding the unprecedented force of the winds.

24. As remembered by Gropius, "He quietly looked around for quite a while, and then stated, 'I suppose here I face a whole new set of aesthetics of the future, but I am afraid that I am now too old to assimilate it fully in my mind.'" Letter to Gilbert Herbert, Cambridge, Mass., May 25, 1956.

25. Hudnut, on Gropius's insistence, had interviewed Breuer and then secured for him an initial appointment as research associate. Gropius, letter to Hudnut, August 22, 1937.

26. Gropius participated in dedication ceremonies, which took place at the school in the afternoon. In the evening he lectured on "Education Toward Creative Design" following a festive dinner at the Palmer House.

27. Gropius acknowledged his own fortunate circumstance on many occasions. In a letter to Fry on March 19, 1940, he wrote thankfully, "I feel that I am an unusually lucky case among all the disasters around my friends — particularly those from Germany."

28. Gropius, letter to Robert Davison, Marion, Mass., September 4, 1937.

29. Gropius, letter to Joseph Hudnut, Marion, Mass., July 24, 1937.

30. Otti Berger, letter to Gropius, Yugoslavia, September 15, 1937. In June 1937 Gropius had written many letters to friends in England on behalf of Ludwig Hilberseimer, then newly arrived there from Germany; Hilberseimer claimed that Berger's deafness would not permit her entry into England. Gropius many years later said that Otti Berger was perhaps the Bauhaus's most gifted and successful weaver.

31. Though in 1940 Gropius was still seeking such an opportunity for Albers, it was not until late in 1949 that Gropius could extend a formal invitation for "Juppi" to take charge of the Basic Design Course. Gropius, letter to Josef Albers, Cambridge, Mass., December 15, 1949.

32. Gropius, letter to Lily Hildebrandt, Cambridge, Mass., November 14, 1937.

33. Gropius, letter to Hans Hildebrandt, Cambridge, Mass., January 19, 1939.

34. Herbert Bayer to Ise Gropius, Berlin, December 20, 1937.

35. Gropius, letter to Herbert Bayer, Cambridge, Mass., December 15, 1938.

36. Alfred J. Barr, Jr., letter to Gropius, New York, December 10, 1938.

37. Gropius, letter to Alfred J. Barr, Jr., Cambridge, Mass., December 15, 1938.

38. Gropius, letter to Vincent Scully, Cambridge, Mass., January 31, 1962.

39. Gropius, letter to Walter Saunders, *Architectural Forum*, Cambridge, Mass., May 4, 1938.

40. Walter Saunders, letter to Gropius, New York, May 21, 1938.

41. Gropius, letter to Joseph Hudnut, Cambridge, Mass., June 30 and July 22, 1938.

42. 1430 Massachusetts Avenue, Cambridge, Mass.

43. Henry V. Hubbard, Bremer Pond, Gropius, Breuer, "A Housing Group in South Boston," Harvard University Graduate School of Design, December 9, 1938, and January 12, 1939.

44. A. Lawrence Kocher, letter to Gropius, Forest Hills, New York, January 3, 1939.

45. Gropius, letter to A. Lawrence Kocher, Cambridge, Mass., January 5, 1939.

46. "Walter Gropius to Design New College Building," *Black Mountain College Newsletter*, 1:4 (March 1939).

47. Gropius, letter to Robert Davison, Cambridge, Mass., February 4, 1939.

48. Gropius, letter to E. Maxwell Fry, Cambridge, Mass., April 5, 1939.

49. Gropius, letter to E. Maxwell Fry, Cambridge, Mass., October 11, 1939.

50. Gropius, letter to E. Maxwell Fry, Cambridge, Mass., March 19, 1940.

51. Ibid.

52. Herbert Bayer, letter to Ise and Walter Gropius, Philadelphia, May 2, 1940.

53. Gropius, letter to José Luis Sert, Cambridge, Mass., January 31, 1940.

54. Gropius, letter to Joseph Hudnut, Cambridge, Mass., July 26, 1940.

55. Joseph Hudnut, letter to Gropius, North Head, New Brunswick, Canada, August 1, 1940.

56. Gropius, letter to Paul Linder, Cambridge, Mass., January 8, 1941.

57. Marcel Breuer, letter to Gropius, Cambridge, Mass., May 23, 1941. Breuer continued to teach until June 1946; he was granted a leave of absence for the ensuing year but received no further appointment.

58. Gropius, letter to Marcel Breuer, Cambridge, Mass., May 25, 1941.

59. Gropius, letter to Herbert Bayer, Cambridge, Mass., July 1941.

60. Herbert Bayer, letter to Gropius, London, July 7, 1941.

61. By 1941 Gropius had already sought means of enrolling men and women who showed great promise but did not otherwise fulfill the traditional requirements for admission, among these refugees without records or English language and others lacking undergraduate degrees but having experience. He found that his department could admit such prospects as "special students" who, following a successful semester, could enroll as degree candidates and be credited for all studies completed; he had proposed to Hudnut the extended use of this device until favorable rules could be obtained.

62. Gropius, letter to L. Moholy-Nagy, Cambridge, Mass., June 15, 1942.

63. Gropius, letter to Jane Drew, Cambridge, Mass., June 22, 1949.

64. Gropius and Martin Wagner, "Preliminary Program," Harvard University, Cambridge, Mass., January 20, 1942, 44 pp. Hudnut anticipated criticism of their plan and in a letter to Gropius on July 9 put Gropius and Wagner on guard, giving the following examples of comments they might receive:

"The plan is the work of architects and not of town planners...[and] they] use this as a means of spreading interest in modern architecture.

"The plan is an attempt to impose German ideas on Americans. It proposes regimentation, suppression of individual initiative. It doesn't take into account the American tradition in government. It is autocratic. It doesn't respect the Constitution....

"The work is a thinly disguised propaganda for socialism, or

communism, or some other dangerous social doctrine. The work is visionary, impracticable, and romantic.

"Gropius is trying to get a reputation as a town planner. He got rid of Hubbard and is trying to capitalize upon the brilliant reputation which the Department of Regional Planning acquired under Hubbard's direction. The Governing Boards have lost all control of the School of Design and are completely bullied by Hudnut who does everything that Gropius tells him to do."

65. Robert Davison, letter to Gropius, New York, May 7, 1942.

66. Gropius, "How to Combine the Economic Advantages of Machine-Made Repetition in Prefabrication with the Human Requirement of Individual Variation and Adequate Scale," Harvard University, April 16, 1942, typed manuscript, 2 pp.

67. Gropius and Martin Wagner, "Epilogue" to "The New City Pattern for the People and by the People," in *Conference on Urbanism: The Problem of the Cities and Towns* (Cambridge, Mass., 1942), pp. 95–116.

68. Gropius, letter to E. Maxwell Fry, Cambridge, Mass., January 6, 1943.

69. Gropius, letter to E. Maxwell Fry, Cambridge, Mass., September 22, 1944.

70. Charles P. Snow had not yet given the Rede Lecture on the two cultures. See *The Two Cultures and the Scientific Revolution* (London: Cambridge University Press, 1959).

71. Harvard Committee on the Objective of a General Education in a Free Society, report by the same title, Harvard University, Cambridge, Mass., Draft of September 1944 (published 1945).

72. Gropius and Joseph Hudnut, Memorandum, Cambridge, Mass., September 24, 1944.

73. Gropius, letter to James B. Conant, Cambridge, Mass., May 1947.

74. James B. Conant, letter to Gropius, Cambridge, Mass., June 14, 1947.

75. Isak Dinesen, letter to Gropius, Black Mountain, North Carolina, November 4, 1944.

76. Gropius, letter to Lily Hildebrandt, Cambridge, Mass., June 10, 1946.

77. Gropius, letter to Jack Pritchard, Cambridge, Mass., December 18, 1946.

78. Gropius, letter to Max Bill, Cambridge, Mass., November 20, 1945.

79. Gropius, letter to Ernest Rosé, Cambridge, Mass., December 27, 1945.

80. Gropius, *Rebuilding Our Communities* (Chicago: Theobald, 1945).

81. Gropius, letter to L. Moholy-Nagy, Cambridge, Mass., February 28, 1945.

82. Walter D. Reuther, letter to Gropius, Washington, D.C., June 22, 1945.

83. Isaacs, letter to Gropius, Chicago, September 4, 1945.

84. Jean and Norman Fletcher, letter to Gropius, Bloomfield Hills, Mich., November 11, 1945.

85. Gropius, discussion with Planning Staff, Chicago, November 17, 1945.

86. Isaacs, letter to Gropius, Chicago, March 13, 1946.

87. Gropius, letter to Isaacs, Cambridge, Mass., March 1946.

88. Gropius, "Preface" to Michael Reese Hospital Planning Staff's first annual "Progress Report," August 1945– December 1946, The Hospital, Chicago, 1946, pp. v, vi. Actually written October 28, 1946.

89. Pei, following his studies in Gropius's master class and graduation that June, had been appointed by Harvard as an Instructor in Architecture for 1946–47, and continued through summer 1948.

90. Gropius, letter to Joseph Hudnut, Cambridge, Mass., May 20, 1946.

91. Actually, "3° — Baker Br Rd — off to Mex."

92. Gropius, letter to J. M. Richards, Cambridge, Mass., October 5, 1953.

93. Gropius, letter to José Luis Sert, Cambridge, Mass., November 27, 1946.

94. Gropius, letter to Joseph Hudnut, Cambridge, Mass., July 29, 1947.

95. Gropius, letter to Ise Gropius, Berlin, August 5, 1947.

96. Gropius, discussion, Cambridge, Mass., February 1963.

97. Gropius, Report, Berlin, Germany, September 5, 1947.

98. Gropius, letter to Sybil Moholy-Nagy, Cambridge, Mass., October 8, 1947.

99. Gropius, "Proposed Planning Procedure for Frankfurt a.M. to be the Capitol of Western Germany," October 7, 1947, typed manuscript, 7 pp.

100. Gropius, letter to Bernd Wagner, Cambridge, Mass., April 12, 1948.

101. Gropius, letter to Morton Shand, Cambridge, Mass., November 7, 1947.

102. Richard Paulick, letter to Gropius, Shanghai, February 11, 1948.

103. Gropius, letter to Richard Paulick, Cambridge, Mass., April 6, 1948. Paulick did return to Germany and East Berlin, becoming a most valued member of the professional community.

104. John Coolidge, letter to Gropius, Cambridge, Mass., August 9, 1948.

105. Gropius, letter to John Coolidge, Cambridge, Mass., August 11, 1948.

106. Andrew Sommerfield, letter to Gropius, London, February 26, 1948.

107. Andrew Sommerfield, letter to Gropius, London, April 6, 1949.

108. Gropius, letter to Joseph Hudnut, Lincoln, Mass., March 22, 1948.

109. In a series of open letters to the faculty, Wagner suggested solutions of a kind acceptable to no one — so far had the differences widened. Martin Wagner, "An Open Letter…," Cambridge, Mass., December 12, 1949.

110. Gropius, letter to James B. Conant, Lincoln, Mass., March 27, 1948.

111. Gropius, letter to Burnham Hoyt, Cambridge, Mass., October 26, 1950.

112. Gropius, letter to Ferd Kramer, Cambridge, Mass., January 8, 1951.

113. Gropius, letter to Isaacs, Cambridge, Mass., July 8, 1952.

114. Gropius, letter to Isaacs, Cambridge, Mass., June 19, 1951.

115. Gropius, letter to Ernesto N. Rogers, Cambridge, Mass., November 20, 1951.

116. Gropius, letter to Isaacs, Cambridge, Mass., December 4, 1951.

117. Gropius had believed that he and his department had been singled out until early in the summer, when he was informed by Holford that the president told the planning and landscape departments that they would be dissolved unless they could provide their own funds. "It is a decision of the Corporation that all Graduate Schools must stand on their own feet." Gropius, letter to Isaacs, July 7, 1952.

118. Gropius, letter to James B. Conant, Cambridge, June 19, 1952.

119. Gropius, letter to Richard M. Gummere, Cambridge, August 14, 1952.

Chapter 8

1. Gropius, letter to Isaacs, Cambridge, Mass., January 26, 1953.

2. Gropius, letter to José Luis Sert, Lincoln, Mass., February 23, 1953.

3. Gropius was now consulted on every aspect of the school: the first-year program, the budgets for the several departments, the library, faculty appointments, the integration of the departments, the relationships with other schools, and the Ph.D. program and curricula.

4. Coleman Woodbury, letter to Lawrence M. Orton, Cambridge, Mass., May 11, 1953.

5. Gropius, Speech, seventieth birthday celebration, Chicago, May 18, 1953.

6. Gropius, letter to Isaacs, Cambridge, Mass., June 18, 1953.

7. Walter and Ise Gropius, card to Isaacs, Brazil, January 1954.

8. Brazil's monetary crisis made this first and last prize given, although a search was made for a second recipient.

9. Gropius, letter to J. M. Richards, Cambridge, Mass., February 26, 1954.

10. Gropius, letter to J. M. Richards, Cambridge, Mass., March 2, 1954.

11. Gropius, letter to J. M. Richards, Cambridge, Mass., February 26, 1954. Gropius gave an illustrated lecture during this visit; it was subsequently translated and circulated: "O Arquiteto E O Nosso Ambiente Visual."

12. Gropius, card to Isaacs, Sydney, Australia, May 1954.

13. Harry Seidler, letter to Gropius, Sydney, Australia, June 1954. Gropius also visited Melbourne, in a quiet, personal trip without public appearances.

14. A month after his arrival in Tokyo, Gropius received a warm letter of welcome from Horiguchi referring to his own visit to Weimar and regretting his inability to meet again because of ill health. He wrote also that he would dedicate his book *Katsura-Rikyo* to Gropius. Letter to Gropius, Ota-ku, Tokyo, Japan, June 14, 1954.

15. Masataka Ogawa, impression of Gropius in "Gropius and Japanese Culture," *Kokusai-Kenchiku* (1956).

16. Earlier Shigeharu Matsumoto of the International House had suggested that Gropius deal with the need for an effective housing policy; he believed that the devastation of World War II presented problems such as Gropius had faced in Germany. Gropius did so, emphasizing governmental participation in the application of industrialization to the modular precedents of Japan.

17. Tsutomu Ikuta, letter to Gropius, Tokyo, August 6, 1954.

18. Quoted by journalist Masataka Ogawa in "Gropius and Japanese Culture," who also said: "I do not discuss here whether or not there is such an intention in the American cultural policies, but I would not feel any such ambition from the profile of Mr. Gropius that I observed. …I write only about his profile, which was about his conscientiousness."

19. M. Masakazu Koyama, editorial, in *Walter Gropius Kokusai-Kenchiku-kyokai* (Tokyo) (1954).

20. Gropius, postcard to Isaacs, Kyoto, June 26, 1954.

21. Gropius, card to Isaacs, Tokyo, July 1954.

22. Gropius said that he knew nothing of Zen prior to preparations for the visit, that he had not discovered Zen philosophy directly, but through its architectural expression, particularly in Kyoto and Nara; he then studied the writings of Dr. Suzuki about the influence of Zen on Japanese life.

23. Kobayashi, *Leaders of Contemporary Design* (Tokyo, August 1962).

24. Tsutomu Ikuta, letter to Gropius, Tokyo, August 6, 1954.

25. Perhaps best illustrating Gropius's understanding was an article he contributed to a collection published in honor of Dr. Suzuki's ninetieth birthday: "Lesson in Intensification," in *Buddhism and Culture*, ed. Dusuma Yamaguchi (Kyoto: Nakam Press, 1960), pp. 197–200. This article was later incorporated into Kenzo Tange's book on the Katsura.

26. Gropius, postcard to Isaacs, Tokyo, August 6, 1954.

27. Gropius, letter to Shigeharu Matsumoto, Cambridge, Mass., October 22, 1954.

28. José Luis Sert, circular letter to all (United States) CIAM members of New York Group, Cambridge, Mass., undated, ca. 1954–55.

29. Gropius, letter to Richard Döcker, Cambridge, Mass., May 2, 1955.

30. Gropius, letter to Richard Döcker, Cambridge, Mass., June 17, 1955.

31. Isaacs, letter to Gropius, Cambridge, Mass., October 10, 1957.

32. Ise Gropius, letter to Isaacs, Cuba, January 18, 1957.

33. Gropius, postcard to Isaacs, Havana, Cuba, March 17, 1957.

34. Theodor Heuss et al., Vorschlagsbegründung, Bonn, Germany, May 8, 1958.

35. Dr. Karl Schiller, Rector, University of Hamburg, "Presentation of the 1956 Hansische Goethe-Preis of the Freiherr von Stein Foundation, Hamburg, to Walter Gropius," June 5, 1957, p. 32.

36. Gropius, letter to Paul Klopfer, Cambridge, Mass., July 21, 1959, including copy of citation.

37. "The Institution as a Generator of Urban Form," Urban Design Conference, Harvard University, April 4–15, 1961.

38. Gropius, letter to Ise Gropius, on the plane to Athens, November 10, 1957.

39. Gropius, letter to Ise Gropius, Baghdad, February 19, 1960.

40. Gropius, letter to Ise Gropius, Athens, February 26, 1960. By 1962 the University was well along in its construction stages.

41. Samuel L. Fox, letter to Samuel Stern, Baltimore, May 19, 1969.

42. Alma Mahler Werfel, *And the Bridge Is Love* (New York: Harcourt, Brace and Company, 1958).

43. Gropius, letter to Alma Mahler Werfel, Lincoln, Mass., August 17, 1958.

44. Alma Mahler Werfel, letter to Gropius, New York, April 6, 1960.

45. Vincent Scully, Jr., "The Death of the Street," *Perspecta* (Yale University, 1963).

46. Philip Johnson, "Our Ugly Cities," *Stone Magazine* (September 1966): 13.

47. *Life* magazine, feature article, May 1964.

48. Gropius, letter to Peter Blake, Cambridge, Mass., February 17, 1964.

49. Gropius, Birthday Address, Harvard University, Cambridge, Mass., May 18, 1963. Johnson had written: "To think, for 34 million dollars, what the land was worth, the city would have had green space at its heart — two dollars for each metropolitan citizen" ("Our Ugly Cities," p. 13).

50. Emerson Goble, "Pan Am Makes a Point," *Architectural Record* (May 1962): 195.

51. August Heckscher, letter to *The New York Times*, August 31, 1964.

52. Edmund Bacon, in *Progressive Architecture* (June 1963): 174.

53. Gropius, letter to Manon Gropius Burchard, Lincoln, Mass., January 13, 1961.

54. Ise Gropius, card to Isaacs, Castle Hot Springs, Arizona, January 28, 1961.

55. Gropius, conversation, Cambridge, Mass., spring 1962.

56. Rudolf Hillebrecht, "Foreword," *Gropius–Mies van der Rohe* (catalogue) (Hannover: Kestner-Gesellschaft, July 1951).

57. International Bauausstellung, Berlin 1957.

58. Gropius, letter to Ise Gropius, Berlin, September 23, 1955.

59. Gropius, letter to Pierre Vago, Cambridge, Mass., October 7, 1955. Vago's building was immediately adjacent; Eiermann's was some distance away.

60. Gropius, letter to Ise Gropius, Berlin, September 23, 1955.

61. Gropius, letter to Wils Ebert, Cambridge, Mass., February 8, 1956.

62. Gropius, letter to Herr Klawonn, Cambridge, Mass., March 6, 1956.

63. Gropius, letter to Wils Ebert, Cambridge, Mass., October 24, 1957.

64. Gropius, letters to Ise Gropius, October 30 and November 1, 1963.

65. Gropius, letter to Ise Gropius, Berlin, December 17, 1963.

66. Gropius, letter to Andrew Sommerfield, Cambridge, Mass., undated, ca. winter 1961–62.

67. Indeed, at that time, there was far more visible enthusiasm in East Germany for Gropius's and the Bauhaus's contributions, and there was proportionately greater government spending for the restoration of the Weimar and Dessau Bauhaus buildings, the Musterhaus am Horn, and Törten.

68. Julian Huxley, speech, dinner for Gropius, London, April 12, 1956, typescript, 2 pp.

69. E. Maxwell Fry, speech, dinner for Gropius, London, April 12, 1956, typescript.

70. Gropius, reply, dinner for Gropius, London, April 12, 1956, typescript, 3 pp.

71. Richard Llewelyn-Davies, letter to Gropius, London, July 28, 1960.

72. *Manchester Guardian*, November 30, 1960.

73. Richard Llewelyn-Davies, letter to Gropius, London, January 24, 1961.

74. Others were Napoleon III, Louis Pasteur, Ferdinand de Lesseps, Alexander Graham Bell, and Franklin Roosevelt.

75. Gropius, letter to Senator Leverett Saltonstall, Cambridge, Mass., March 25, 1946.

76. Gropius, letter to Sigfried Giedion, Cambridge, Mass., February 20, 1963.

77. Gropius, letter to Sigfried Giedion, Cambridge, Mass., December 27, 1963.

78. Josef Albers, *Homage to the Square*, ten works (New Haven: Yale University Press, 1962).

79. Gropius, Birthday Address, Harvard University, Cambridge, Mass., May 18, 1963.

80. Lewis Mumford, "The Case Against Modern Architecture," *Summa Magazine* (Buenos Aires, 1963).

81. Gropius, letter to Lewis Mumford, Cambridge, Mass., June 25, 1963.

82. Lewis Mumford, letter to Gropius, Amenia, New York, June 27, 1963.

83. Other distinguished artists considered included Richard Lippold, Alexander Calder, Jacques Lipchitz, Mark Rothko, Adolph Gottlieb, David Hall, Mirko Basaldelia, David Smith, Constantino Nivola, and Herbert Ferber.

84. Gropius, letter to Fritz Hesse, Cambridge, Mass., March 4, 1965.

85. Fritz Hesse, letter to Gropius, Munich, February 28, 1965.

86. Porter was a very pleased and loyal client. In subsequent years TAC planned or carried out additional projects, including a studio and garage for Porter, remodeling of his Cadillac Company building, a proposed development, "Beachwood," feasibility studies for the Deaconess Medical Center and Green Road Office Building, and a proposal for town houses on Pepper Pike.

87. Gropius, card to Isaacs, Luxor, Egypt, February 2, 1967.

88. Ise Gropius, letter to Isaacs, Berlin, May 11, 1968.

89. *The Times* (London), September 20, 1968.

90. Gropius, letter to Morris A. Rubin, Lincoln, Mass., October 19, 1966.

91. Gropius, letter to J. K. Galbraith, Cambridge, Mass., February 13, 1968.

92. Gropius, speech "on the occasion of the groundbreaking," Park Hills, Huntington, W. Va., ca. 1968.

93. Victoria Ocampo, publisher of *Sur*, was among the intellectuals jailed during the Perón era.

94. Gropius, letter to Ise Gropius, Buenos Aires, December 1968.

95. Gropius, card to Isaacs, Castle Hot Springs, Arizona, March 5, 1969.

96. It is not explained why in one letter Gropius referred to this as a *Gesellschaftraum* rather than *Gemeinschaftsraum*, or common room. It is rented to anyone for a celebration, a wedding, or a birthday party. Willy Brandt, when he came to Berlin, spoke to the nation from this place, as did the president of Germany.

97. Gropius, letter to William J. Riffe, Cambridge, Mass., May 12, 1969.

98. Ernest Williams, "We, Too, Are His Beneficiaries," *News-Sentinel* (Fort Wayne, Ind.), July 10, 1969.

99. S.A.K., "Magister Gropius," *Progressive Architecture* (September 1969).

100. Ise Gropius, letter to Maya Moran, Lincoln, Mass., August 8, 1969.

CHRONOLOGY

1883 • Born, Berlin, May 18, to Walther Gropius and Manon Scharnweber Gropius. Christened Adolf Georg Walter

1889–93 • Elementary school, Berlin

1893–95 • Leibniz Gymnasium, East Berlin

1895–1900 • Kaiserin Augusta Gymnasium, Berlin-Charlottenburg

1898 • Confirmed (Protestant), March 29

1900–03 • Steglitz Gymnasium, graduated February 28, 1903

1903 • Semester at Technische Hochschule, Munich

1903–04 • Volunteer apprentice, Solf and Wichards, Architects, Berlin

1904–05 • Volunteer military service, 15th Hussar Regiment, Wandsbeck

1905–07 • Königliche Technische Hochschule, Berlin-Charlottenburg (four semesters) • First buildings: Smithy, laundry, courtyard wall, granary, and workers' housing, Janikow; Metzner house, Dramburg; courtyard walls and gate, storage building, workers' house, wood fabricating plant for von Brockhausen, Mittelfelde

1907–08 • Travel in Spain

1908–10 • Assistant to Peter Behrens, Berlin-Neu Babelsburg. Designed office interior and furnishings for the Lehmann Department Store, Cologne • Travel in England and Austria with Behrens

1909–10 • Workers' housing, Golzengut

1910 • Proposal to Walther Rathenau for prefabricated housing • Opens architectural office with Adolf Meyer in Neu Babelsburg • Member, Deutscher Werkbund. Editor of *Jahrbücher,* 1912-14 • Meets Alma-Maria Schindler Mahler, June 4

1911–12 • Von Arnim house, Falkenhagen

1911 • Faguswerk, Alfeld-an-der-Leine, with Meyer

1912–13 • Hospital, Alfeld-an-der-Leine (proposal) • Agricultural storage buildings, workers' housing, offices, Pomerania, with Meyer

1913 • Interiors (Gold Medal), World Exhibition, Ghent • Diesel passenger car for Prussian Locomotive Works • Furnishings and interiors for Langerfeld and Mendel families, Berlin • Eigene Scholle housing development, Wittenberg, with Meyer

1913–14 • Housing for Bernburg Machine Company, Alfeld-Delligsen • Werkbund Exhibition, Cologne: factory, office building, and machinery hall; pavilion for Deutz Machine Factory, with Meyer; steel furniture for battleship *Von Hindenburg,* with Meyer; sleeping-car interior • Board member, Deutscher Werkbund

1914–18 • Military service, World War I: August 1, 1914, sergeant-major, 9th Wandsbeck Hussars; November 1, 1914, lieutenant, First Infantry; September 1, 1916, regimental adjutant; June 1917, teacher, military communications, Namur • Engagements include trench warfare in the Vosges, 1916-17; trenches on the Somme, 1917; battles near Soissons and Rheims, 1918 (wounded) • Citations include Iron Cross, Second Class, September 1914; Bavarian Military Medal IV Class with Swords, March 1915; Iron Cross, First Class, August 1918

1915 • Marries Alma Mahler, August 18

1916 • Interview with grand duke of Saxe-Weimar for post of director of the Grand-Ducal Saxon School of Arts and Crafts, Weimar • Daughter, Alma Manon, born October 5

1918 • Demobilized, November 18

1919 • Appointed, April 1, director of the Grand-Ducal Saxon School of Arts and Crafts and of the Grand-Ducal Saxon Academy of Fine Art, uniting these under the name "Staatliches Bauhaus, Weimar" • *Die gläserne Kette* (The Crystal Chain)

1920 • Divorce from Alma Mahler Gropius, October 11 • Reestablishes private office for architectural practice, Berlin, with Adolf Meyer

1920–21 • Adolf Sommerfeld house, Berlin-Dahlem, with Meyer and assistance of Joost Schmidt

1921 • Monument to those killed in the Kapp Putsch (*Denkmal für der Märzgefallenen*), Weimar • Municipal Theater, Jena, with Meyer

1921–22 • Kallenbach house, Berlin, with Meyer (proposal) • Row houses for Sommerfeld, Berlin

1922 • *Chicago Tribune* office building, competition project, with Meyer • Bauhaus cooperative housing site plan, Weimar • Bank, showrooms, and office building for Adolf Sommerfeld, Berlin, with Meyer (proposal) • Exhibition of Bauhaus work, Weimar, Berlin, Calcutta • Rauth house, Berlin (proposal)

1923 • Hausmann villa, Pyrmont, with Meyer (proposal) • Major exhibition of work of Bauhaus teachers and students, August-September • Haus am Horn, Georg Muche, with Meyer • Marries Ise Frank, October 16

1923–24 • Academy of Philosophy, Erlangen, with Meyer (proposal) • Founding of the *Zehnerring* (Ring of Ten)

1924 • The "Yellow Brochure" • Summer house for von Klitzing family, Timmendorf, with Meyer (proposal) • Faguswerk warehouse and service building, Alfeld-an-der-Leine, with Meyer • Hannover Paper Factory, Alfeld-Gronau, with Meyer • Political crisis between government of Thuringia and the Bauhaus; decision made to close the Weimar Bauhaus, December 26

1924–25 • Storage warehouse for Kappe, Alfeld-an-der-Leine, with Meyer

1925 • Removal of Bauhaus to Dessau; classes begin October 14 • Müller factory, Kirchbraak • Old age home, Alfeld (proposal) • Residence for Karl Benscheidt, Alfeld (proposal) • Remodelled residence of Karl Benscheidt Jr., Alfeld • Factory and prefabricated housing system, proposal presented to Oskar von Miller

1925–26 • Bauhaus building and student housing, Dessau • Masters' houses, Bauhaus, Dessau

1926–28 • Törten housing development

1927 • Two dwellings for Werkbund Housing Exhibition, the *Weissenhof,* Stuttgart • Total Theater for Erwin Piscator, Berlin (proposal) • Exhibition stand, German Association of Glass and Mirror Industries, Leipzig

1927–28 • Dammerstock housing development, Karlsruhe, competition, first prize. Appointed coordinator • Zuckerkandl house, Jena • Municipal Employment Office, Dessau, competition, first prize • Lewin house, Berlin-Zehlendorf • Hannes Meyer invited to join the Bauhaus

1928 • Resigns as director of the Bauhaus, February 4 • Visits the United States, March–May • Berlin office reopened • Exhibition hall and outdoor restaurant, Fischtalgrund, Berlin-Zehlendorf • 5000-unit housing project for Sommerfeld, Berlin (proposal) • Cooperative housing, Bad Dürrenberg (proposal) • First meeting of the Congrès Internationaux d'Architecture Moderne (CIAM), La Sarraz, Switzerland

1929 • Honorary Doctor of Engineering degree, Technische Hochschule, Hannover • Housing development for the Ministry of Internal Affairs, France (proposal) • Spandau-Haselhorst experimental housing project, Berlin, competition, first prize • "Am Lindenbaum" housing development, Frankfurt • Member, Board of Experts, Reichsforschungsgesellschaft • Modular furniture for the Feder Company, Berlin • Aschrott Home for the Aged, Kassel, competition

1929–30 • Siemensstadt housing cooperative, Berlin • Deutscher Werkbund Exhibition, Paris

1929–33 • Designs for Adler Automobiles

1930 • Ukrainian State Theater competition, Kharkov Palace of Justice, Berlin (proposal) • Departure of Hannes Meyer from the Bauhaus; appointment of Ludwig Mies van der Rohe as director

1931 • Wannsee Shores apartments, Berlin (proposal) • Prefabricated houses for Hirsch Copper and Brass Works, Finow • Palace of the Soviets, Moscow, competition • Exhibition of Gropius works, Zurich

1932 • German Building Exhibition, Berlin: two houses • Dissolution of the Dessau Bauhaus, October 1. School opened in Berlin-Steglitz on October 18 as private institution • "Standard Houses," Buenos Aires, with Franz Möller • Redesign of factory for Adler Automobiles, Frankfurt

1933 • Visit and lecture in Leningrad • Reichsbank, Berlin, competition • Bahner house, Klein-Machow, Berlin • Maurer House, Berlin-Dahlem

1933–34 • Recreation center project, Tiergarten, Berlin, with Rudolf Hillebrecht, competition

1934 • Lecture, Royal Institute of British Architects • Manon Gropius's illness, April • Volta Theater Conference, Rome, October 8-14 • Arrives in London, October 18

1934–37 • Private practice in England in partnership with E. Maxwell Fry

1934 • A. P. Simon project, Manchester, with Fry (proposal)

1934–35 • Dartington Hall cottages and theater, with Fry

1935 • Philip Sargent Florence project, Birmingham, with Fry (proposal) • St. Leonard's Hill housing development, Windsor, with Fry (proposal) • Papworth School, with Fry (proposal) • Death of daughter, Manon, April 21

1935–36 • Christ's College dormitory, Cambridge, with Fry (proposal) • Film Processing Laboratory for Denham Laboratories, with Fry • Design of products for London Aluminium Company

1936 • House for Ben Levy and Constance Cummings, London • Donaldson house, Shipbourne, Kent, with Fry • Beate (Ati), Ise Gropius's niece, joins the Gropiuses

1936–37 • Impington Village College, Cambridgeshire, with Fry • Product designs for Isokon Furniture Company

1937 • Arrives in United States, March 17 • Appointed professor of architecture, Harvard University, April 1 • New Bauhaus, Chicago, established; László Moholy-Nagy, director • Wheaton College Art Center, Norton, Massachusetts, with Breuer

1937–38 • Gropius house, Lincoln, Massachusetts

1937–42 • Architectural practice with Marcel Breuer

1938 • Breuer house, Lincoln • Hagerty house, Cohasset, Massachusetts • Bauhaus Exhibition, Museum of Modern Art, New York, designed by Herbert Bayer

1938–52 • Chairman, Department of Architecture, Graduate School of Design, Harvard University

1939 • Black Mountain College project, North Carolina, with Breuer (proposal) • Frank house, Pittsburgh, with Dahlen K. Ritchey and Breuer • Pennsylvania Pavilion, New York World's Fair, with Breuer

1940 • Recreation Center, Key West, Florida, with Konrad Wachsmann

1941 • Aluminum City Terrace, 250-unit housing project, New Kensington, Pennsylvania, with Breuer

1941–42 • Packaged House System and General Panel Corporation, with Konrad Wachsmann

1942 • Subdivision plan for Storrow Estate, Lincoln

1944 • Becomes United States citizen, June 12

1944–46 • Consultant to the Container Corporation of America

1945–58 • Consultant to Michael Reese Hospital Planning Staff, Chicago

1946–69 • Partner, The Architects Collaborative (TAC)

1946 • Kaplan house, Newton, Massachusetts, with TAC • Ryan house, Cambridge, with TAC • Clarence Howlett house, Belmont, Massachusetts, with TAC (proposal)

1946–49 • Member of Prefabricated Housing Industry Advisory Committee, Washington, D.C.

1947 • Planning and Housing Consultant to U.S. Military governor for Germany

1948 • Hua Tung Christian University project, Shanghai, with TAC and I. M. Pei

1948–53 • Chairman of eductional committee of the CIAM

1948–60 • Graduate Center, Harvard University, with TAC

1951 • Stichweh House, Hannover

1952 • Chairman, International Advisory Panel for UNESCO headquarters building, Paris • Submits resignation from Harvard, June 18 • Addition to American University, Washington, D. C., with TAC (proposal)

1953 • Boston Back Bay Center (proposal), with Pietro Belluschi, Walter Bogner, Carl Koch, Hugh Stebbins, and TAC

1953–54 • Visits South America

1954 • Matarazzo International Grand Prize in Architecture, São Paulo • Visits Japan and the Near East • Overholt Thoracic Clinic, Boston, with John Harkness

1955–57 • Interbau apartment building, Berlin Hansaviertel, with TAC • Royal Gold Medal of Royal Institute of British Architects • University of Baghdad, master plan, with TAC • Hanseatic Goethe Prize • Research on housing for the aged, with Reginald Isaacs (proposal)

1956–61 • United States Embassy, Athens, with TAC • Gropiusstadt, Britz-Buckow-Rudow, Berlin, overall plan, housing and school, with TAC

1958 • Award of *Grosse Verdienst Kreuz mit Stern,* Federal Re-

public of Germany •Pan-American World Airways Building, New York City, design consultant, with Alex Cvijanovic of TAC and Pietro Belluschi; Emory Roth and Sons, architects

1959 •Gold Medal, American Institute of Architects

1960–64 •Piccadilly Circus project, London, with TAC and Richard Llewelyn-Davies and John Weeks (proposal) •Park Lane Building, London (begun), with Llewelyn-Davies, Weeks, and TAC

1961–66 •John F. Kennedy Federal Building, Boston, with N. C. Fletcher of TAC and Samuel Glaser Associates •Bochum University project, with TAC (competition) •Double school and day care center, Gropiusstadt, with TAC

1963 •Gurlitt medal •Rosenthal ceramics factory and social hall, Selb, with TAC

1964–68 •Bauhaus Archive, Darmstadt, Berlin, with Alex Cvijanovic and TAC

1964 •Apartment-office project, Toronto, with TAC •Place St. Cyrille project, Quebec, with TAC •Kindergarten, Gropiusstadt, Berlin, with TAC •Apartment building for GEHAG, Gropiusstadt, Berlin, with TAC •Apartment building for IDEAL Baugenossenschaft, Gropiusstadt, Berlin, with TAC •Tower East, Shaker Heights, Ohio, with TAC

1966 •Housing development for Rosenthal, Amberg, with TAC

1967 •Thomas Glass Factory, Amberg, with TAC

1968 •China service for Rosenthal with Louis McMillen and Katherine DeSouza of TAC •City planning project for Selb, with TAC •Pepper Pike housing, Ohio, with TAC (plan)

1969 •Bauhaus Exhibition, Stuttgart •German ambassador's residence, Buenos Aires, with Alex Cvijanovic of TAC (proposal) •*Kneipe* (pub), IDEAL building, Gropiusstadt, Berlin •Dies, July 6

BIBLIOGRAPHY

For a comprehensive bibliography of works by and about Gropius, see Reginald R. Isaacs, *Walter Gropius: Der Mensch und sein Werk,* trans. Georg R. Meerwein, 2 vols. Berlin: Gebr. Mann Verlag, 1983, 1984. For an excellent corpus of illustrations see below, Winfried Nerdinger, *Gropius.*

The Architects Collaborative, 1945-1965. Ed. Walter Gropius, John C. and Sarah P. Harkness, Norman C. and Jean B. Fletcher, Louis A. McMillen, Benjamin C. Thompson. New York, 1966.

Bayer, Herbert, Walter Gropius, and Ise Gropius. *Bauhaus 1919-1928.* New York: Museum of Modern Art, 1938. New edition Boston, 1952.

Fitch, James Marston. *Walter Gropius.* New York, 1960.

Franciscono, Marcel. *Walter Gropius and the Creation of the Bauhaus in Weimar: The Ideals and Artistic Theories of Its Founding Years.* Urbana, IL, 1971.

Giedion, Sigfried. *Walter Gropius.* New York, 1954.

Gropius, Walter. *Apollo in the Democracy: The Cultural Obligation of the Architect.* New York, 1968.

_____. *Architecture and Design in the Age of Science.* New York, 1952.

_____. *The New Architecture and the Bauhaus.* London, 1935; New York, 1936.

_____. *Rebuilding Our Communities.* Chicago, 1945.

_____. *The Scope of Total Architecture.* New York, 1954.

_____. *Town Plan for the Development of Selb.* Cambridge, MA, 1969.

Gropius, Walter, and Konrad Wachsmann. "General Panel System." *Pencil Points* 24 (April 1943): 36-47.

Gropius, Walter, and Martin Wagner. "The New City Pattern for the People and by the People." In *Conference on Urbanism, The Problem of the Cities and Towns* (Cambridge: Harvard University, 1942), pp. 95-116.

Walter Gropius: Buildings, Plans, Projects, 1906-1969. Introduction by James Marston Fitch, text by Ise Gropius. Cambridge, MA, 1971.

Herbert, Gilbert. *The Dream of the Factory-Made House: Walter Gropius and Konrad Wachsmann.* Cambridge, MA, 1984.

Herdeg, Klaus. *The Decorated Diagram: Harvard Architecture and the Failure of the Bauhaus Legacy.* Cambridge, MA, 1983.

Nerdinger, Winfried. *Walter Gropius: The Architect Walter Gropius, Drawings, Prints, Photographs, Complete Project Catalogue.* Catalogue of the exhibition at the Busch-Reisinger Museum, Harvard University, Cambridge, and at the Bauhaus Archive, Berlin. Berlin: Gebr. Mann Verlag, 1985.

"In Search of a New Monumentality: A Symposium by Gregor Paulsson, Henry-Russell Hitchcock, William Holford, Sigfried Giedion, Walter Gropius, Lucio Costa, Alfred Roth." *Architectural Review* 104 (1948): 117-128.

Tange, Kenzo, and Walter Gropius. *Katsura: Tradition and Creation in Japanese Architecture.* New Haven, 1960.

Wachsmann, Konrad, and Walter Gropius. "House in Industry: A System for the Manufacture of Industrialized Building Elements." *Arts and Architecture* 64 (November 1947): 28-37.

Wingler, Hans M. *The Bauhaus: Weimar Dessau Berlin Chicago.* Cambridge, MA 1969; rev. ed. 1976.

ABBREVIATIONS

BDA	Bund Deutscher Architekten (Association of German Architects)
CIAM	Congrès Internationaux d'Architecture Moderne (International Congress of Modern Architecture)
GAGFAH	Gemeinnützige Aktien-Gesellschaft für Angestellten-Heimstatten (Cooperative Corporation for Employees' Homesteads)
GEHAG	Gemeinnützige Heimstätten-AG
KDAI	Kampfbund Deutscher Architekten und Ingenieure (Association of German Architects and Engineers)
MARS	Modern Architectural Research (MARS Group)
NSDAP	Nationalsozialistische Deutsche Arbeiter-Partei (Nazi Party)
RIBA	Royal Institute of British Architects
RKR	Reichsforschungsgesellschaft (Reich Committee for the Fine Arts)
TAC	The Architects Collaborative

INDEX

PICTURE CREDITS